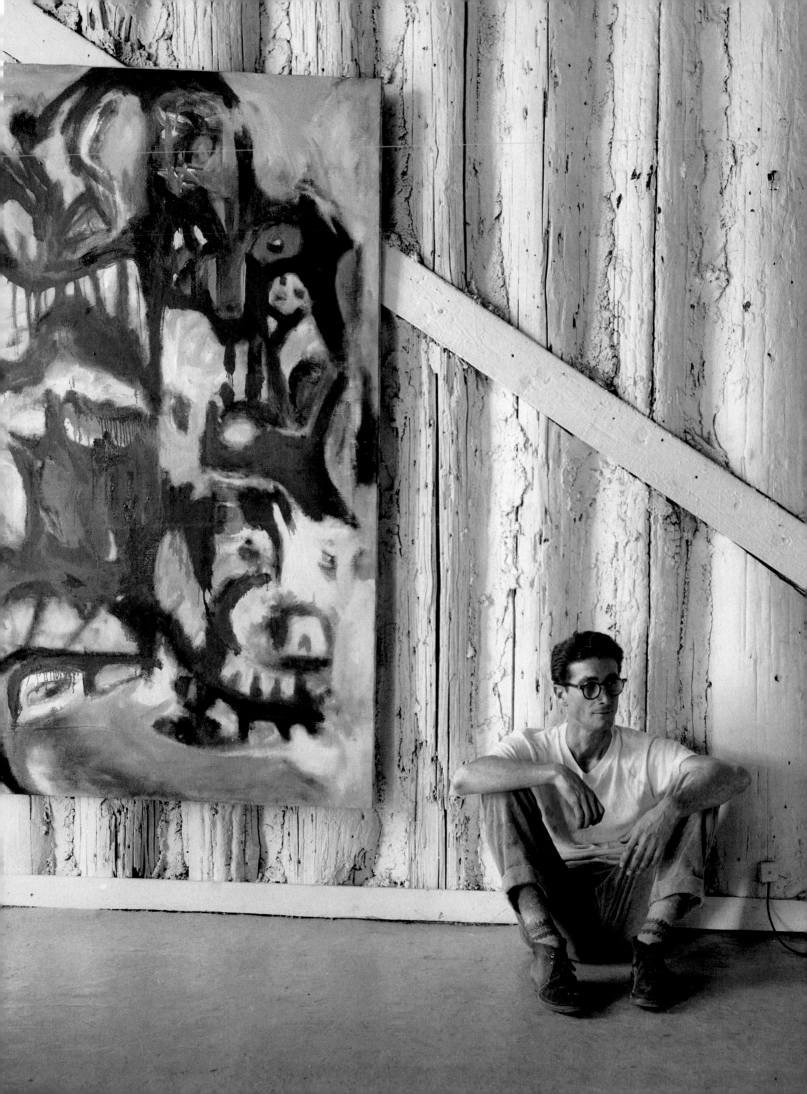

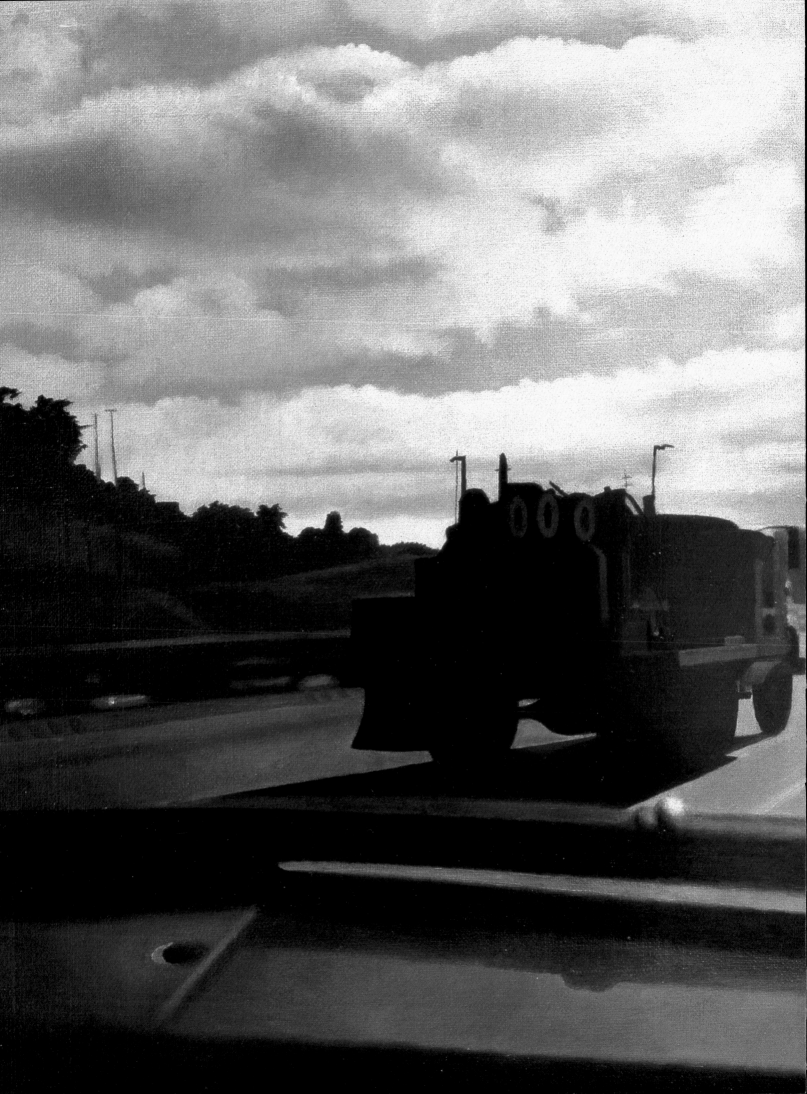

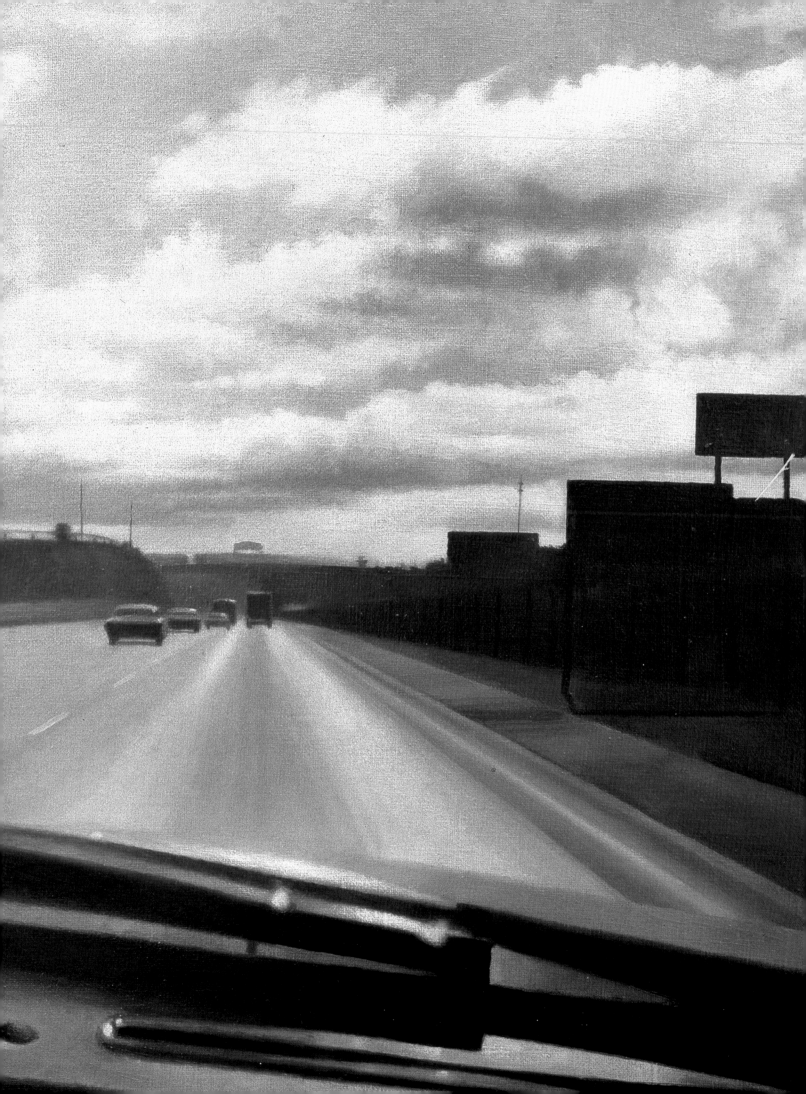

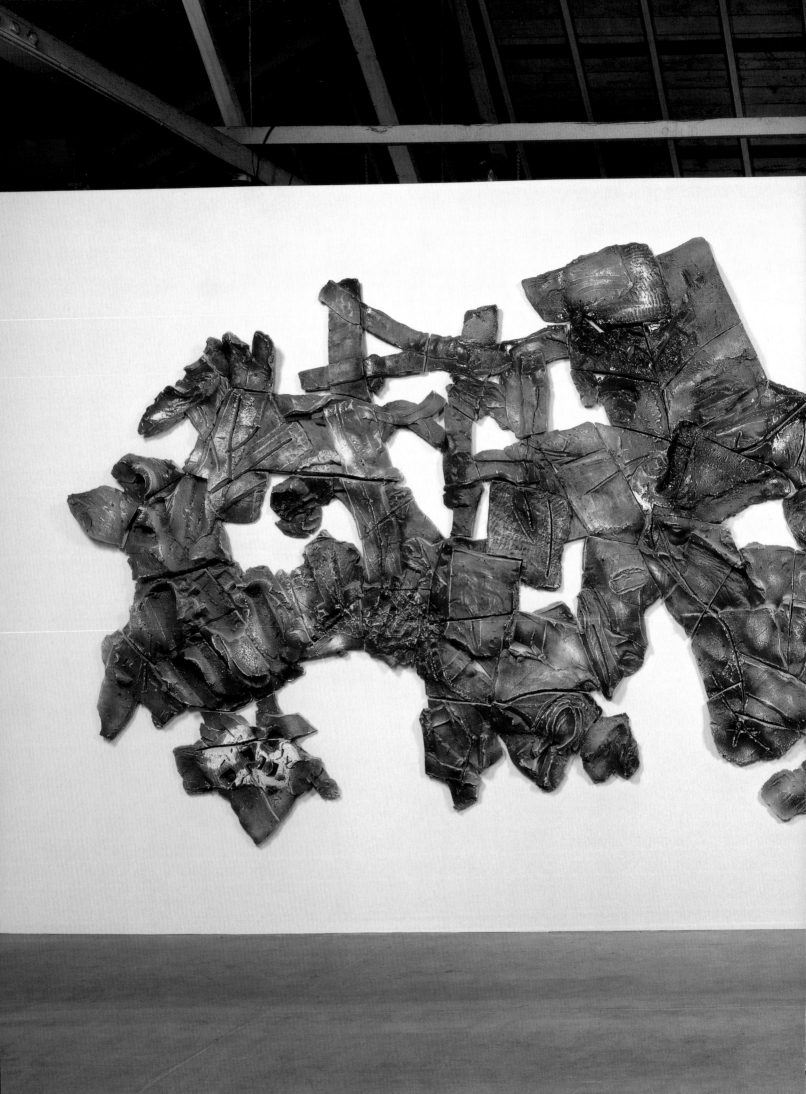

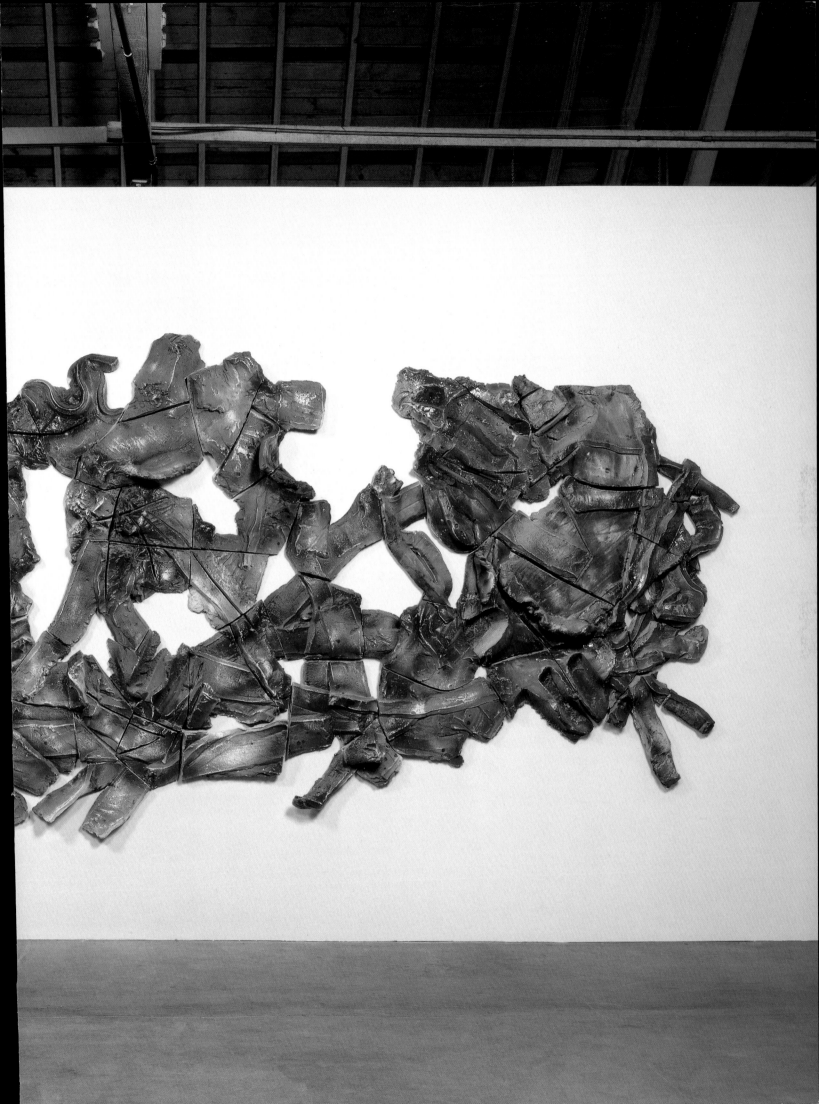

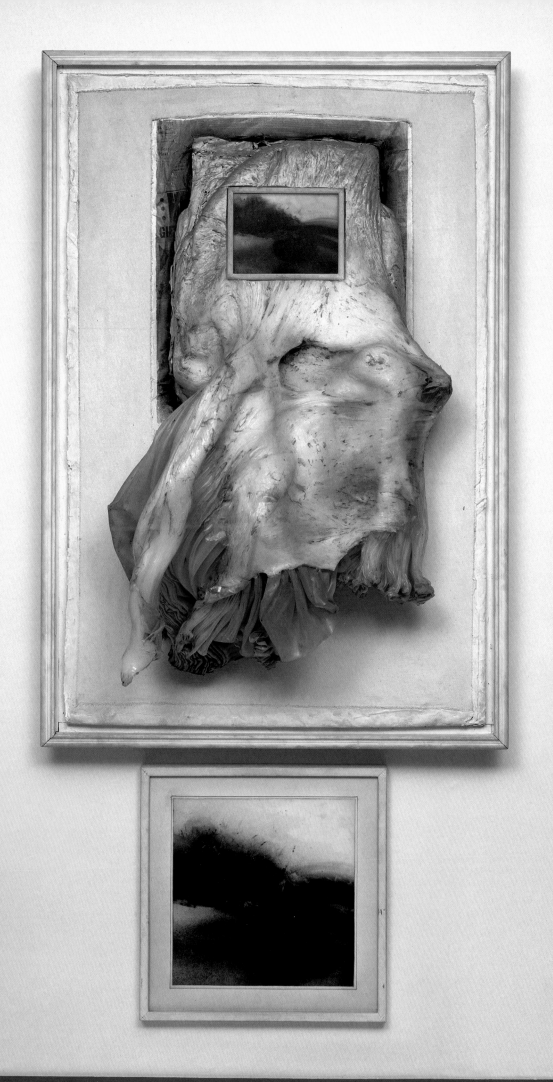

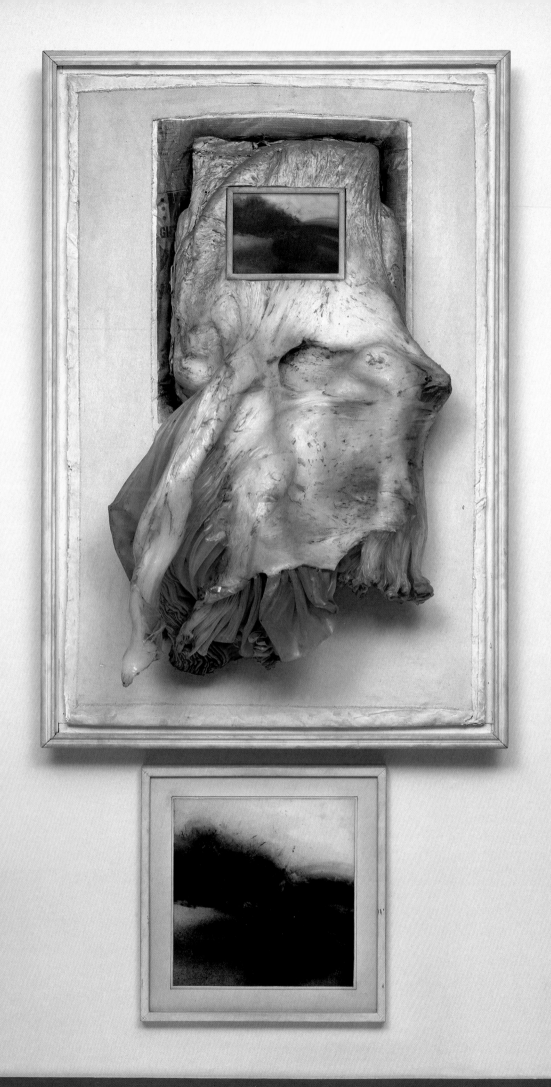

PACIFIC STANDARD TIME

Los Angeles Art 1945–1980

Edited by
Rebecca Peabody, Andrew Perchuk,
Glenn Phillips, and Rani Singh

With Lucy Bradnock

The Getty Research Institute and the J. Paul Getty Museum

The Getty Research Institute Publications Program
Thomas W. Gaehtgens, *Director, Getty Research Institute*
Gail Feigenbaum, *Associate Director*

Pacific Standard Time: Los Angeles Art, 1945–1980
Lauren Edson, Tobi Kaplan, Robin Ray, Laura Santiago, *Manuscript Editors*
Michele Ciaccio and Tobi Kaplan, *Project Editors*
Stuart Smith, *Designer*
Elizabeth Kahn, *Production Coordinator*

Typesetting by Stuart Smith with Diane Franco
Separations by Professional Graphics, Inc.
Printed in Singapore through CS Graphics

**Published by the Getty Research Institute and the J. Paul Getty Museum,
Los Angeles**
Getty Publications
1200 Getty Center Drive, Suite 500
Los Angeles, California 90049-1682
www.gettypublications.org

15 14 13 12 11 5 4 3 2 1

This volume is published on the occasion of Pacific Standard Time: Art in L.A.
1945–1980, an initiative of the Getty with arts institutions across Southern
California, and accompanies the Getty Research Institute's exhibition *Pacific
Standard Time: Crosscurrents in L.A. Painting and Sculpture, 1950–1970,* held
at the J. Paul Getty Museum from 1 October 2011 through 5 February 2012 and
at the Martin-Gropius-Bau in Berlin from 15 March through 10 June 2012.

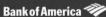

Presenting Sponsors The Getty Bank of America

Front cover: **Image of Simon Rodia's Watts Towers inspired by the photo-
graphs of Seymour Rosen and Julius Shulman.**

Back cover: **Ed Ruscha (American, b. 1937). *Standard Station, Amarillo,
Texas,* 1963** (see fig. 3.16).

p. i: **Arthur Richer at Syndell Studio (detail), 1957** (see fig. 2.6).

pp. ii–iii: **Vija Celmins (American, b. Latvia 1938). *Freeway* (detail), 1966**
(see fig. 3.20).

p. iv–v: **John Mason (American, b. 1927). *Blue Wall,* 1959.** Ceramic,
213.36 × 640.08 × 12.7 cm (84 × 252 × 5 in.). Los Angeles, collection of the artist.
Courtesy John Mason. Photo by Anthony Cuñha.

p. vi: **Ed Moses (American, b. 1926). *Hegemann Wedge,* 1971.** Powdered pigment,
acrylic, and resin on canvas, 243.84 × 208.3 cm (96 × 82 in.). Collection of Phyllis and
John Kleinberg. © Ed Moses, courtesy the artist.

p. vii: **Llyn Foulkes (American, b. 1943). *Flanders,* 1961–62.** Mixed media,
137.2 × 91.4 × 35.6 cm (54 × 36 × 14 in.). Santa Monica, California, collection of
Ernest & Eunice White. Courtesy the artist and Kent Gallery. Photo © Douglas M.
Parker Studio.

pp. viii–ix: **Wallace Berman in abandoned building on the Speedway in Venice,
California, ca. 1955–57.** Photo by Charles Brittin (American, 1928–2011).
Los Angeles, Getty Research Institute, 2005.M.11. Image © J. Paul Getty Trust,
Charles Brittin papers.

pp. x–xi: **Judy Chicago (American, b. 1939). *Multicolor Atmosphere* (detail),
1970** (see fig. 4.20).

p. xii: **Joe Goode (American, b. 1937). *Torn Cloud Painting 73* (detail), 1972**
(see sidebar 24, p. 226).

p. xvi: **Peter Voulkos building a sculpture in his studio, 1959** (see fig. 1.49).

Library of Congress Cataloging-in-Publication Data
Pacific standard time : / Los Angeles art, 1945–1980 edited by Rebecca Peabody…[et al.].
 p. cm.
 "This volume is published on the occasion of the Getty's citywide grant initia-
tive Pacific Standard Time: Art in L.A. 1945–1980 and accompanies the exhibition
Pacific Standard Time: Crosscurrents in L.A. Painting and Sculpture, 1950–1970,
held at the J. Paul Getty Museum, Los Angeles."
 Includes bibliographical references and index.
 ISBN 978-1-60606-072-8
1. Painting, American—California—Los Angeles—20th century—Themes, motives—
Exhibitions. 2. Sculpture, American—California—Los Angeles—20th century—
Themes, motives—Exhibitions. I. Peabody, Rebecca. II. J. Paul Getty Museum.
 ND235.L6P33 2011
 709.794'9409045—dc22

CONTENTS

ABOUT Pacific Standard Time: Art in L.A. 1945–1980

This impressive book, published in conjunction with a group of exhibitions at the Getty Center, is but one manifestation of an extraordinary collaboration titled Pacific Standard Time: Art in L.A. 1945–1980 that involves more than sixty museums and cultural institutions all across Southern California. The seeds of the initiative were planted a decade ago by the Getty Foundation and the Getty Research Institute when we first started to realize that Los Angeles was in danger of losing the historical record of its art. We began with the fairly modest ambition of identifying and preserving the archives that document the milestones of contemporary art in the postwar period in our region. We wound up with the most comprehensive and public collaboration by cultural organizations in Southern California, or perhaps anywhere, and one that is now itself a creative landmark.

The first activities that ultimately led to Pacific Standard Time occurred in 2001 when the Getty Foundation and the Getty Research Institute began to explore ways to preserve and interpret the history of avant-garde art in Southern California. The Foundation designed a grant program to identify the location of archival materials and, once found, to catalog those documents and make them accessible to scholars and the public. Simultaneously, the Research Institute began forming collections, conducting oral histories, and offering innovative and fascinating public programs. As a result of these efforts, we realized that the stories contained in all the archives were important and that they needed to be told through a series of exhibitions.

In 2008, the Getty joined together with the Los Angeles County Museum of Art, the Hammer Museum, and the Museum of Contemporary Art to form a planning team that sketched out a larger initiative. To support this initiative, the Foundation offered grants for exhibition research, bringing scholars from all over the world to Los Angeles; for the implementation of the exhibitions; and for the publication of catalogs. The ideas continued to flow from all quarters, and teams of curators and other museum staff members were formed to share information and to plan collective activities. Today, Pacific Standard Time has swelled to include more than sixty exhibitions and programs, a performance and public art festival, a Web site, and scores of related activities that will occur from October 2011 through spring 2012 in Los Angeles, up and down the California coast from Santa Barbara to San Diego and out to Palm Springs. I am proud that the Getty will host four Pacific Standard Time exhibitions, including the flagship show *Pacific Standard Time: Crosscurrents in L.A. Painting and Sculpture, 1950–1970*.

An effort like this takes hundreds of people to carry out, but I can thank only a few here. First and foremost are Joan Weinstein, interim director of the Getty Foundation, and Andrew Perchuk, deputy director of the Getty Research Institute, who are the true leaders and guiding intellects of the overall Pacific Standard Time initiative. We are all grateful to Gloria Gerace, managing director, without whom we never would have survived the sizable daily challenges of this enormous undertaking. At the Getty, I am deeply appreciative of my wonderful colleagues Thomas Gaehtgens, director of the Research Institute; Tim Whalen, director of the Conservation Institute; and David Bomford, acting director of the J. Paul Getty Museum, each of whom has played a significant role in Pacific Standard Time, along with many of their staff members. The Getty board of trustees has provided crucial support all along the way, and I particularly thank Mark Siegel, chair of the board, along with Louise Bryson, chair emerita, and Maria Hummer-Tuttle, who co-chaired the campaign to raise awareness about this initiative. Finally, I would like to congratulate the directors of all the partner institutions across Southern California for making Pacific Standard Time what is quite possibly the largest visual arts initiative ever undertaken.

Deborah Marrow
INTERIM PRESIDENT AND CEO, THE J. PAUL GETTY TRUST
May 2011

FOREWORD

At the Getty Center, the Pacific Standard Time initiative finds expression in this publication and four exhibitions. This book accompanies the Getty Research Institute's exhibition at the J. Paul Getty Museum, *Pacific Standard Time: Crosscurrents in L.A. Painting and Sculpture, 1950–1970,* a focused introduction to the distinctiveness of individual artists and movements, as well as to the diversity of practices found in Los Angeles in the early postwar era. At the Getty Research Institute, *Greetings from L.A.: Artists and Publics, 1950–1980* draws on documentary material and ephemera to contextualize the vibrant postwar California art scene. The Getty Conservation Institute's exhibition at the Getty Museum, *From Start to Finish: De Wain Valentine's "Gray Column,"* uses the work of L.A. sculptor De Wain Valentine to explore the science and conservation of art made from modern and industrial materials. The Getty Museum's exhibition *In Focus: Los Angeles, 1945–1980* presents photographs from the permanent collection made in Los Angeles by artists who were influenced by the city.

The history of Southern California art has been studied by some specialists, but the Pacific Standard Time initiative will finally bring that history to the attention of a larger national and international public and will present it based on thorough archival documentation and interpretation. The Getty Research Institute's *Crosscurrents* exhibition at the Getty Museum represents a major result of that initiative, and this book and the publications by our partner institutions will be lasting reference works documenting the endeavor. When the *Crosscurrents* and *Greetings* exhibitions travel to the Martin-Gropius-Bau in Berlin in the spring of 2012, they will bring the postwar art of Southern California and its historical context together in a single, groundbreaking presentation for an international audience.

The works of art in the *Crosscurrents* exhibition—paintings and sculptures created in the decades after the Second World War—manifest an originality of artistic production that allows us to speak of a distinctive California modernism. The visitor will discover styles and accomplishments different from those of the much better known New York modernism. The exhibition, which focuses on the specificity and originality of Los Angeles–based artists in the postwar era, demonstrates their lively artistic ambitions. In the years immediately after the war, an artistic infrastructure with major public museums had not yet fully developed in Los Angeles as it had in New York, Boston, Philadelphia, and Chicago. On the West Coast, European modern art was present only in private collections—of European émigrés and of such rare Americans as Walter and Louise Arensberg. These collectors owned mostly German expressionist, French surrealist, and Dada art rather than the impressionist, postimpressionist, and cubist works that predominated in New York collections.

In Los Angeles, a very distinct engagement with European artistic traditions merged with California art's unique expression of openness, mobility, modernity, individuality, light, and color to create a new aesthetic, one well suited to an innovative style of West Coast living. During the 1960s and 1970s, political activism and resistance spurred artists to new fields of discovery. Addressing social issues, especially those related to questions of race, ethnicity, and gender, artists engaged in conceptual art, video, photography, and performance. Through pop art in the 1960s and the conceptual and performance art scenes of the 1970s and 1980s, California artists acquired international reputations even before they were recognized in the United States. Despite this international standing, the variety and richness of the arts in California remained vastly understudied. The Pacific Standard Time initiative was therefore timely, even necessary.

We want to thank the many colleagues whose energy, knowledge, and experience helped make this book, the *Crosscurrents* exhibition, and Pacific Standard Time at the Getty Center a success. At the Getty Research Institute, Andrew Perchuk, deputy director, and Rani Singh, senior research associate, have to be mentioned above all. Glenn Phillips, principal project specialist and consulting curator, was an essential member of the exhibition and publication teams,

and he will co-lead the Pacific Standard Time performance art and public art festival. Rebecca Peabody, manager of research projects, was the point editor of this publication and the lead writer of its foreword and introduction. Catherine Taft, curatorial aassociate, significantly added to all phases of the exhibition and contributed extensively to the publication. Lucy Bradnock, Pacific Standard Time postdoctoral fellow, made crucial research discoveries that were vital to the project and also contributed extensively to the publication. Joshua Machat, senior project coordinator, and Melissa Piper, administrative assistant, handled the logistics and administration of the project with great skill. We owe a great debt to our external advisory committee—Ken D. Allan, Serge Guilbaut, Michael Lobel, Jane McFadden, Richard Meyer, Alex Potts, Lisa Turvey, and Dianne Perry Vanderlip—for helping in the conceptualization of the exhibition and publication, as well as to our steering committee for contributing in countless ways with their historical knowledge and practical abilities.

Finally, we want to thank our colleagues at the J. Paul Getty Museum, Getty Foundation, and Getty Conservation Institute for their extraordinary collaborative efforts, which improved all parts of the project. At the J. Paul Getty Museum, Quincy Houghton, associate director for exhibitions, offered crucial assistance with the many complex arrangements associated with the *Crosscurrents* exhibition and its tour to the Martin-Gropius-Bau in Berlin, and both Brian Considine, head of decorative arts and sculpture conservation, and Laura Rivers, associate paintings conservator, provided essential technical advice on the proper presentation and care of objects in the exhibition. Additionally, Timothy P. Whalen, director of the Getty Conservation Institute, and Tom Learner, senior scientist at the GCI, made enormous contributions to the research leading up to the exhibition, aiding in the assessment of extremely fragile and unconventional works of art.

David Bomford, *Acting Director*
THE J. PAUL GETTY MUSEUM

Thomas W. Gaehtgens, *Director*
THE GETTY RESEARCH INSTITUTE

PREFACE

This book is the culmination of a multifaceted research project nearly a decade in the making, but it is just one of that project's many outcomes. The sustained efforts of local, regional, national, and international collaborators have resulted in something unprecedented: a series of more than sixty thematically connected exhibitions, many with related publications and public programming, taking place in 2011 and 2012 across the Los Angeles region. All of this activity is directed toward displaying and writing the art history of Southern California. Pacific Standard Time is the title of the region-wide initiative, the title of a retrospective exhibition at the Getty Museum, and the title of this book—the exhibition's companion volume. Pacific Standard Time also encapsulates two ideas that drive these efforts: postwar American art history is fundamentally different when told from a West Coast perspective, and it is time for that history to be told.

Many of the most influential artists and art movements from the latter part of the twentieth century have strong ties to Southern California. Accounts of the region, however, tend to date the birth of Los Angeles's art scene to the 1980s—suggesting that earlier decades were empty of meaningful activity. In fact, from as early as the mid-1940s, Los Angeles artists were developing an indigenous modernism—one that drew on the cultures, communities, and industries distinct to the region, with both attention to and distance from other national and international modernisms. Until recently, however, this history was overshadowed by New York–centric views of modernism. Complicating matters further, the art-historical record of Los Angeles in the postwar years was incomplete and in danger of being lost.

The initiative known as Pacific Standard Time has a number of roots. It can be traced back to 2001, when the Getty Research Institute (GRI)—already engaged in researching Los Angeles's art history at the urging of then director Thomas Crow—organized a public conversation between the artists Vija Celmins, Dennis Hopper, and Ed Ruscha as part of Media Pop, a conference that explored the intersection of mass media and pop art. In that same year, Lyn Kienholz and Henry Hopkins approached the Getty Foundation—the grant-making division of the Getty, which supports the arts at an international level—and expressed concerns that Los Angeles's unique art history was in the process of disappearing. Both Kienholz and Hopkins had played important roles in the formation of Los Angeles's art scene, and they were right to be concerned. Many important artists had already passed away, and materials essential to the construction of a historical record—primary documents, personal papers, correspondence, oral histories—were dispersed. The small portion of this material that had been collected by institutions was largely uncataloged and therefore inaccessible.

Kienholz's and Hopkins's concerns echoed those of Research Institute scholars, and in 2002 the Foundation partnered with the GRI to document the art history of Los Angeles between 1945 and 1980. A dearth of scholarly books on the subject meant that efforts had to go toward fostering primary research. The Foundation first funded a survey of archival holdings in public and private collections; next, it awarded grants to inventory institutional collections, to make materials accessible to the public, and to survey other aspects of Los Angeles's art history, such as Chicano and African American art. The GRI had already acquired important archives from Los Angeles artists and gallerists—selections from which are published for the first time in this book and in related publications—and these efforts were reinforced by the partnership between the GRI and the Foundation. The GRI also conducted an ongoing program of oral histories and public conversations, called Modern Art in Los Angeles, which produced new materials for the archives. Following the example set by the GRI's Media Pop conference, the public conversations brought key players from Los Angeles's postwar art scene together to discuss the people, works, and movements that made history. At the same time, the Getty Conservation Institute (GCI) began working with the GRI on two research projects: one on the materials and techniques employed by the region's hard-edge painters, the other devoted to the study of

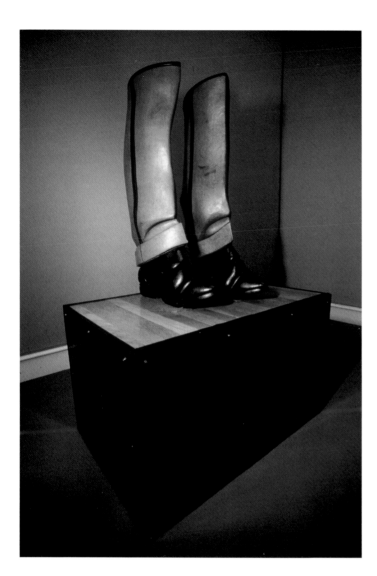

Stephan Von Huene (American, 1932–2000). *Tap Dancer*, 1967. Wood, metal and mechanical components, 120 × 90 × 75 cm (47.25 × 35.43 × 29.53 in.). Hope, Idaho, collection of Nancy Reddin Kienholz. © Petra von Huene, Hamburg. Photo by Sebastian Hartz.

resins and plastics used by a number of Los Angeles artists. Works by artists from both of these projects are included in the Getty Center's Pacific Standard Time exhibitions.

In 2008, after seven years of researching, documenting, collecting, and cataloging, the Foundation led an initiative that expanded the project to institutions across Southern California, supporting research and planning for scholarly exhibitions that made use of newly available resources. In 2010, the Foundation provided further support: for the exhibitions themselves, for exhibition catalogs, and for a performance and public art festival.

The results of the region-wide Pacific Standard Time initiative involve exhibitions, publications, and events that are broad in scope and reach, yet focused in conception and content. Venues with related exhibitions extend from Santa Barbara to San Diego and from Santa Monica to Palm Springs and include the the Getty Center, the Los Angeles County Museum of Art, the Museum of Contemporary Art, and the Armand Hammer Museum, among many other institutions. Some exhibitions focus on individuals or small groups of artists, such as Wallace Berman, Robert Heinecken, Sam Maloof, John Mason, Ken Price, Peter Voulkos, and Beatrice Wood. Others explore movements such as black film art, Light and Space, conceptualism, and feminist art. A number of them examine avant-garde uses of particular media, such as ceramics, performance, public art, film, video, painting, sculpture, photography, and woodwork. Several venues take display as their subject, investigating sites such as the Watts Towers Art Center, the Los Angeles Municipal Art Gallery, the Pomona College Museum of Art, alternative artists' spaces, and African American exhibition venues. The heterogeneity of Los Angeles culture is acknowledged by exhibitions that focus on African American, Mexican, Mexican American, Chicano, and Japanese American art histories. Finally, thematic treatments result in exhibitions that investigate subjects such as activism and social change, figuration and the body, experimental art, alternatives to the mainstream art market, and lifestyle design.

Documenting the tremendous diversity of Los Angeles's postwar art history is a daunting and exhilarating task—one that requires nothing less than a region-wide initiative, several dozen exhibitions with related publications, and six months of public programming. Pacific Standard Time is many things; perhaps most importantly, it is an unprecedented collective rethinking of a region's art history—a collaborative act that began by documenting the past but grew into a powerful statement about the potential of the present.

—Rebecca Peabody, Andrew Perchuk, Glenn Phillips, Rani Singh, and Joan Weinstein

Introduction

SHIFTING THE STANDARD
Reappraising Art in Los Angeles

Rebecca Peabody, Andrew Perchuk,
Glenn Phillips, and Rani Singh

This book surveys the Los Angeles art scene from the end of World War II until the beginning of the 1980s, an era in which almost everything of consequence in American art was viewed, and is largely still viewed, as emanating from New York. This bias has colored historical narratives to such an extent that, in most accounts of postwar modernism, artists working in Los Angeles receive scant attention.[1] When the occasional reference to Los Angeles artists is made, it often proves exceedingly difficult to categorize their work within the established terms of the discourse. For instance, Ed Ruscha has been placed in the normally antithetical categories of pop and conceptualism, while Robert Irwin has been uncomfortably squeezed into the equally antagonistic domains of color-field painting and minimalism. The inability to adequately describe work by L.A. artists is often the result of an almost unconscious internalization of the values of New York modernism, even by critics with extensive knowledge of the Southern California art scene and strong local sympathies.

This process is evident in the writings of two of the earliest critics who attempted serious explorations of modern art in California: Nancy Marmer and Peter Plagens. Marmer did an excellent job of detailing the effects of the reception of pop art and neo-Dada in her essay "Pop Art in California," published in Lucy Lippard's foundational book *Pop Art* (1966)—the first attempt in a widely circulated publication to come to terms with an indigenous California movement:

> Pop Art has probably played a much more aggressive role among local styles in California than its counterpart in New York, where the mode insinuated itself into an already active, various, and partially hostile *avant-garde*. On the West Coast, and this is especially true for the fluid Southern California scene, Pop Art has rightly been considered the active ingredient in a general house-cleaning that during the past three or four years has all but exterminated the last traces of prestige for local and imitative versions of Abstract Expressionism.[2]

While Marmer is correct to emphasize that abstract expressionism was never as dominant a style in Southern California as in New York or the Bay Area and is particularly prescient in the section of her essay that details the roles that Andy Warhol's 1962 exhibition at the Ferus Gallery and Marcel Duchamp's 1963 retrospective at the Pasadena Art Museum played in eliminating visible traces of action painting, her dismissal of the area's abstract expressionists as "local and imitative" is unwarranted, and her insinuation that Los Angeles lacked a pre-pop avant-garde is ahistorical. Although she makes the potentially interesting observation that pop art might be much broader in California than in New York, she does not propose a West Coast pop, settling instead for a brief survey that tries to incorporate all artists using common objects in their work, from assemblagists such as Edward Kienholz and Wallace Berman to the painter and book- and printmaker Ruscha to the collage artist Jess.

Plagens deserves enormous credit for producing the first and, until this publication, only book-length survey of advanced art in Los Angeles—*Sunshine Muse* (1974)—but he tended to internalize the prevalent art-world power dynamics in a manner that was openly self-defeating. Plagens begins his study with the assertion that "if you believe in Modern Art History and its obligatory riders (that good art deals with dialectically derived 'issues,' that good art bends the short-run course of future Modern Art History), it follows that the best breeding ground for good art is where competing ideas, esthetics, and artists are thickest and where regional niceties are thinnest—New York."[3] The "regions," as all areas of the country outside New York are referred to, will always produce an art that seems minor by New York standards. Plagens's conclusion is that the regions "are not the eastern seaboard—geographically, socially, or economically—and it's *not* likely we'll ever fully join the dialectical mainstream. Perhaps (to continue the strained metaphor) ours will always be a seasonal garden of odd little plants, and perhaps now is the time to learn how to cultivate it."[4]

In the past ten to fifteen years, Los Angeles's role in postwar art history has received increased attention in academic and critical circles. While exhibition catalogs have offered focused analyses of specific subjects, the field needs more comprehensive texts—surveys of ideas, catalogs of key moments, and spaces that accommodate basic historical storytelling as well as the anecdotes and first-person memories that bring the era to life. For these reasons, this publication has been designed with two functions in mind: to accompany the J. Paul Getty Museum's exhibition *Pacific Standard Time: Crosscurrents in L.A. Painting and Sculpture, 1950–1970* and, in concert with the efforts of partner institutions, to conduct the largest survey of Southern California art to date.

To that end, what follows is a scholarly review of art in Southern California, from 1945 through 1980. Organized in five chronological chapters, the story unfolds along the lines of interpersonal networks—the people, relationships, and ideas that influenced and characterized the region's artistic production—as well as the undulations of an art world in formation. While artists and works from the exhibition are discussed, this book exceeds the scope of the *Crosscurrents* exhibition in several important ways: by examining additional artists, artworks, and themes; by extending past the exhibition's end date to include the 1970s; and by incorporating archival and documentary material from the GRI collections.

Chapter 1 begins in the early 1940s and traces the emergence of multiple modernist practices. Unlike in those cities where modern art could be found in museums, in Los Angeles most major collections were in private hands. Postwar suppression of aesthetic and political leftism hindered museum exhibitions of modern art and drove many artists underground, further intensifying the private nature of modern art. Artists responded by forming communities of like-minded practitioners and by establishing networks that invented and described community. Several important groups developed during this time: early abstract-expressionist painters who connected Los Angeles to national and international modernisms and whose spheres of influence were extended by teaching in art schools; hard-edge painters who were not part of a literal community but nevertheless grouped themselves together based on perceived stylistic similarities; and the group of mostly male ceramic sculptors who worked closely together and consciously cultivated an artistic community.

By the 1950s, as chronicled in chapter 2, the art scene in Los Angeles was remarkably diverse: an increasing number of commercial galleries were paralleled by informal spaces that experimented with alternative means of art production, display, and dissemination. The use of found materials to make works of collage and assemblage reflected an interest in surrealism, jazz, and folk traditions, while handpress printing and mail-art practices allowed artists to move beyond the space of the gallery altogether to harness the networks that defined their communities. Throughout the decade, artists in Los Angeles maintained close relationships with those in the north of the state; many struggled, however, with the model of abstract painting prevalent in the Bay Area and worked toward forging a more individual sense of artistic identity specific to Southern California. As the 1960s dawned, artists became increasingly conscious of the implications of this expanding art world and of art's place in a rapidly changing society; the concerns of the counterculture and the methods and materials of assemblage art began to reflect this anxiety and to turn toward more clearly political ends.

By the early years of the 1960s, when chapter 3 begins, multiple iterations of the Los Angeles art scene had begun to coalesce around a core group, forming a small coterie of artists, gallerists, and critics who worked to construct a coherent and marketable image of L.A.'s "Cool School."[5] The gallery scene boomed, sales increased, and the new Los Angeles County Museum of Art promised a focus on local talent. A string of exhibitions brought together many Los Angeles artists and their New York counterparts under the rubric of pop, and several of Los Angeles's most celebrated artists would come to prominence in this category. Artists drew not only on the vernacular landscape of Los Angeles for inspiration but also on the materials and technological processes

indigenous to the region, techniques associated with the city's surf, motorcycle, and custom-car cultures, as well as its science and aerospace industries. In Los Angeles, pop would prove to be a peculiarly expansive category, one that embraced industrial finishes and abstract forms as well as the everyday objects and commercial design practices with which it was more commonly associated. The art boom of the 1960s inevitably drew criticism from both insiders and others; toward the end of the decade, several artists turned to practices that anticipated the conceptualism and institutional critique of art from the 1970s.

Chapter 4 shifts the focus from the illusion of a unified art scene to the reality of a fractured network of diverse artistic communities. The late 1960s and early 1970s saw a reorganization of Los Angeles's art schools, resulting in new and highly experimental educational experiences for both teachers and students. At the same time, many artists actively challenged the conventions of traditional artistic media and produced hybrid works that dissolved the boundaries between painting, sculpture, and performance. The use of new industrially linked and regionally specific materials brought art and technology together in exhibitions and in more broadly conceived creative movements such as Light and Space art. Meanwhile, the period's politically volatile climate encouraged artists to move beyond hermetic debates and open their practices to personal and political concerns, blurring boundaries between activism, resistance, and art making.

By the early 1970s, Los Angeles artists were questioning the materials, methods, sites, and experiences traditionally associated with art—lines of inquiry that moved the city even farther from the idea of a unified art world. Chapter 5 traces this decentralization across Los Angeles's sprawling landscape. Throughout the 1970s, artists in Southern California turned their attention from objects of art to sites of investigation. The boundaries between media blurred, conceptual and performative practices proliferated, and sculpture extended into site. Mass media became more visible in both the form and content of art, and photography transitioned into a commercially viable fine art. Once-prominent institutions failed, some replaced by innovative experimental spaces. Artists questioned what museum and gallery walls kept out as well as what they included. A heightened awareness of social injustice led many artists to use their practices to comment on art-world exclusions based on race and gender, as well as broader social problems such as violence against women. This subjective turn led to works of art that examined autobiography, the specificities of locality, and the limits of the body itself as a site of aesthetic exploration. A concurrent proliferation of visual culture gave rise to artworks that used journals, video, radio, and other media in order to reposition the concept of display. Chapter 5 concludes with the foundation of the Museum of Contemporary Art in 1980. The return of a high-visibility arts institution to Los Angeles promised a bright future for modern and contemporary art; at the same time, it gestured toward the difficulties inherent in collecting and displaying much of the experimental work that had characterized the decade.

No book, including this one, could include all of the people, places, objects, exhibitions, and actions that contributed to the formation of Los Angeles's art history. In addition to the restrictions imposed by time and page limits, scholars are still in the early stages of recovering the historical record. As a result, this book has not attempted to catalog artists and works of art. Rather, it surveys the main ideas, movements, and moments that shaped the era, with the goal of providing an intellectual common ground and a point of departure for anyone interested in Los Angeles's creative history.

Chapter One

FLOATING STRUCTURES
Building the Modern in Postwar Los Angeles

Andrew Perchuk and Catherine Taft

Towering above the expansive, low-rise cityscape of South Los Angeles, a series of sinewy spires stands on a large triangular lot at 1765 East 107th Street in the working-class, multiracial neighborhood of Watts. Seven steel-and-mortar spires—each built by hand, without scaffolding, to heights up to 99 feet—herald a complex structure of cement-formed arches, steps, benches, fountains, birdbaths, and a gazebo inlaid with colorful broken dishes, bottles, shells, and etched flower and heart patterns (fig. 1.1). Named *Nuestro Pueblo,* "Our Town" (but more commonly known as the Watts Towers), the structures were built, beginning in 1921, by self-taught Italian immigrant Sabato "Simon" Rodia, who had moved to the West Coast around the turn of the century to work on the railroads, in logging camps, and at rock quarries. Estranged from his family and largely unassimilated to American culture, Rodia channeled his creative drive and construction skills into the ornate, assemblage-like towers, which he developed and expanded over a thirty-three-year period.

Between 1921 and 1954, the years *Nuestro Pueblo* was under construction, the city of Los Angeles itself was being reshaped and reinvented to meet the needs and aspirations of a rapidly changing society. In the 1920s alone, more than 1.2 million newcomers settled in Los Angeles County. By the end of the Second World War, increased military spending in the state had helped to attract and employ an expanding, socially mobile middle class. Largely unaffected by these shifting demographics, Rodia diligently pursued his monumental undertaking, inventing a place for himself—a physical site imbued with decorative and symbolic signs of a complex cultural identity—within the city's overwhelming urban and industrial sprawl.

In 1955, Rodia hastily left Los Angeles for the small Northern California town of Martinez, leaving his towers and the deed to his property in the custody of a neighbor. In the years that followed, the towers, at first ignored, would be rediscovered as a public artwork and become, among other things, the subject of civic debate; a lodestone around which Los Angeles's modern art sensibility coalesced; a symbol of community in times of racial conflict and political upheaval; and, ultimately, a popular tourist attraction and city landmark. By the early 1960s, the Watts Towers were welcoming an estimated 50,000 visitors a year. But Rodia never returned to Los Angeles and rarely spoke to the public about his work. Partially due to Rodia's silence and his outsider status, the towers became a metaphor for a certain narrative of modernism in Los Angeles: for art that rose like a phoenix out of the desert valley, seemingly out of nothing. This misleading narrative—of a sui generis modern art—has shown remarkable resilience, surfacing repeatedly in scholarship, in the media, and even in statements by some of the city's leading artists.[1]

While it is true that in the years around the Second World War Los Angeles had only a fraction of the cultural infrastructure of New York or Paris, modern art in Los Angeles was not without foundations. The challenge for any historian of modern art in Los Angeles is to explicate the region's role in the development of pioneering art forms—hard-edge painting and large-scale ceramic sculpture, assemblage sculpture and Light and Space art, Chicano muralism and feminist art, for example—while also acknowledging the way many Southern California artists engaged with national and international modernisms.

UNDER CONSTRUCTION

The earliest and perhaps deepest roots of modernism in Los Angeles—without which a significant visual arts community could never have emerged—were the literal foundations of the region's modern architecture. The modernist (and somewhat utopian) impulse to build an idealized, or even fantastic, place for oneself within the Southland's natural and social topography was nothing new even in the 1920s, when Rodia began his monumental project. In fact, the idea flourished through the innovative designs of architects such as Milton J. Black, Craig Ellwood, Irving Gill, Richard Neutra, Rudolph M. Schindler, and Frank Lloyd Wright. Taking advantage of the open land and abundant natural resources of Southern California, these architects

developed fresh forms for public places—and, more predominantly, for residences—laying the basis for the popular look of midcentury California Modern (fig. 1.2). By the late 1940s, Los Angeles was presenting a new model of a twentieth-century lifestyle, one that embraced mobility, progress, open spaces, and personal expression. And, almost as naturally as it fit into the decentralized, sun-filled cityscape, the California Modern aesthetic garnered the support of local clients and patrons, turning Los Angeles into a successful architecture scene (see sidebar 1).

Whereas modern design became synonymous with West Coast living, modern art faced a far more complex and fraught nascence in Los Angeles. However, in much the same way that architecture in the city built its strength through private commissions, modern art would flourish through private collections, though at a pace that was sometimes haltingly slow.

LOCAL SUPPORT

The history of modern art's reception and influence in Los Angeles differs from that of many other major American cities. In the first half of the twentieth century, modern art was formally presented in galleries and museums in New York, Chicago, and San Francisco; in contrast, the few but important examples of modern art that existed in Los Angeles were housed primarily in

Figure 1.1.
Simon Rodia's Watts Towers (1921–54), Los Angeles, 1976. Photo by Seymour Rosen. © SPACES—Saving and Preserving Arts and Cultural Environments.

Figure 1.2.
Interior fireplace, Studio Residence B, Frank Lloyd Wright's residence for Aline Barnsdall, Hollywood, California, 1945. Gelatin silver print by Edmund Teske (American, 1911–1996). Los Angeles, Getty Research Institute, 96.R.9. © Edmund Teske Archives / Laurence Bump and Nils Vidstrand.

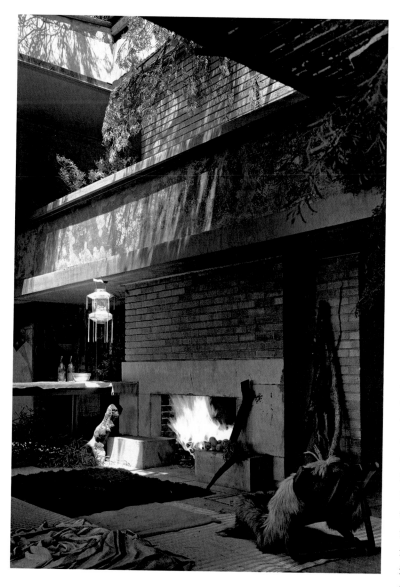

private collections. Such limited public access to major modernist works—a product of the city's guarded attitude toward the modern or avant-garde and its relatively young public institutions—resulted in the development of a largely "insider" art world in which the curious had to gain entrée into museum-like homes through personal relationships, word of mouth, or class field trips. Furthermore, the most significant collections of modern art in the city tended to favor German expressionism, Dada, and surrealism rather than impressionism, postimpressionism, and cubism, which predominated in other American art centers.

One important patron who fiercely supported modern art was Galka (Emilie Ester) Scheyer, a collector, dealer, and educator originally from Germany. She had moved to New York in 1924 with the goal of introducing to the United States the paintings of the Blue Four—American-born German artist Lyonel Feininger; Russian-born artists Alexei Jawlensky and Wassily Kandinsky; and Swiss painter Paul Klee (fig. 1.3).

Stylistically, the Blue Four shared an approach toward expressionism that emphasized spiritual and non-naturalistic representation in bold palettes, but their differences were as significant as their commonalities. Whereas Jawlensky reduced figurative elements to thick swatches of color, Kandinsky obliterated illusionistic components into flat arrangements of totally abstract, rhythmically geometric forms (fig. 1.4). Unlike other German expressionist groups, such as Der Blaue Reiter and Die Brücke (to which these four artists had earlier ties), the Blue Four formed their alliance only after each artist had established his independent career, and chiefly through Scheyer's urging. Scheyer worked vigorously to publicize their work and find a market for it in America—a goal she pursued by moving from New York to Los Angeles (by way of San Francisco) in 1930 in hopes of garnering Hollywood patronage for the artists. But to Scheyer, herself a patron, selling always came second to nurturing an appreciation for modern art. Accordingly, much of her

effort in Los Angeles was devoted to organizing parties and receptions for the Blue Four as well as lecturing on and arranging loans and exhibitions of their work. That Scheyer never achieved commercial success in Los Angeles—despite the city's affluent inhabitants—reflects the weakness of the local art market in the early 1940s. Eight years after her death in 1945, Scheyer's estate donated all 450 works of modern art to the Pasadena Art Institute, an important institution that, in 1954, would become the Pasadena Art Museum, turning its focus entirely to modernism.[2]

Though Scheyer failed to establish a lively market for modern art in Hollywood, the film industry did provide a small but dedicated group of collectors, including writer and director Billy Wilder, who started seriously collecting impressionist, surrealist, Latin American, and other twentieth-century works after he arrived in Los Angeles in 1934; actor Vincent Price, who began donating his collection of more than seven thousand pieces of Mesoamerican, African, Native American, and European artworks to East Los Angeles College in 1951; and director Josef von Sternberg, who owned a strong collection of German expressionist paintings, many of which he sold to finance his film *The Saga of Anatahan* (1953). Other notable L.A. collectors of the 1940s were Ruth Maitland, who added works by Georges Braque, Paul Cézanne, Henri Matisse, and Pablo Picasso to her inherited collection of nineteenth-century French paintings;

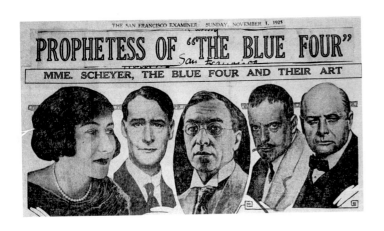

Figure 1.3.
"Prophetess of 'The Blue Four': Mme. Scheyer, The Blue Four and Their Art," *San Francisco Examiner*, 1 November 1925. Pasadena, California, Norton Simon Museum, The Blue Four Galka Scheyer Collection Archives. Courtesy the San Francisco Examiner.

Figure 1.4.
Wassily Kandinsky (Russian, 1866–1944). *Heavy Circles*, 1927. Oil on canvas, 57.2 × 52.1 cm (22½ × 20½ in.). Pasadena, California, Norton Simon Museum, The Blue Four Galka Scheyer Collection. Art © 2011 Artists Rights Society (ARS), New York / ADAGP, Paris.

"HOUSE—POST WAR." This was the statement, and challenge, posed by editor John Entenza when he announced the Case Study House (CSH) Program in the January 1945 issue of Los Angeles's *Arts and Architecture* magazine. Entenza recognized the potential inherent in America's radically altered landscape of housing needs and social shifts, as well as the promise of new industrial materials developed for the war effort. He predicted that the postwar era was "likely to expand considerably the definition of what we mean when we now say the word 'house.'"[1]

With the aim of creating innovative and practical prototypes for affordable modern housing, the CSH Program selected eight nationally known architectural firms and asked each to design and build a house in Southern California. From 1946 to 1947, the first six houses were landscaped, outfitted with modern furniture and appliances, and opened to the public for four-week periods, attracting more than 350,000 visitors. The program proved so successful that it was eventually expanded to include thirty-six designs and continued until 1966.

Even before the war, Southern California had begun to develop a distinct modernist vernacular architecture, most notably in houses designed by Richard Neutra and Rudolph M. Schindler. Distinguishing features were glass walls that incorporated the plentiful natural light and minimal separation between indoor and outdoor spaces. In the early years of the CSH Program, the designs were limited by a scarcity of materials and did not differ dramatically from other local modern architecture, although all included modular components. However, two never-constructed designs capitalized on the landscape and climate with great innovation. Ralph Rapson's plans for CSH No. 4, known as Greenbelt, incorporated a glass-covered garden strip in the middle of the rectangular house, while in Whitney R. Smith's designs for CSH No. 5, the various rooms of a house were connected only by gardens, eliminating corridors and wholly incorporating outdoor space into the layout.

By the early 1950s, many new materials were readily available and affordable. During this era of the program, architects produced some of the most iconic designs—houses that made innovative use of steel framing, aluminum siding, cork, and plywood and featured recent inventions like automatic garage doors, plastic screens, and sliding glass doors. Steel played an especially important role in the work of Craig Ellwood, Raphael Soriano, Pierre Koenig, and Charles and Ray Eames. The groundbreaking CSH No. 8 by the Eameses, for example, consisted of two steel-framed cubes covered in panels of glass and colorful plaster.

While the projects varied greatly over the program's twenty-one years, most were austere in design and compact in nature. Ultimately, though, transparent walls and unadorned horizontal planes mirrored in calm swimming pools became the program's hallmark and exemplified the allure of the Southern California lifestyle. The best known of these designs is Koenig's CSH No. 22. In Julius Shulman's photograph of this house, two women relax in a futuristic glass room that hovers precariously over the bright grid of Los Angeles, the globular lamp and its reflections glowing like planets. This masterful combination of ingenious engineering and domestic elegance defined a new standard of ultramodern living.

Over the years of the program's existence, it enjoyed international acclaim and its designs won numerous awards. Following the Bauhaus dictum that architecture must push modernism forward, the ambitious CSH Program shaped and honed an idea of modern design—the influence of which continues to reverberate today in Los Angeles and beyond.

Notes
1. John Entenza, "Announcement: The Case Study House Program," *Arts and Architecture* 62 (1945): 39.

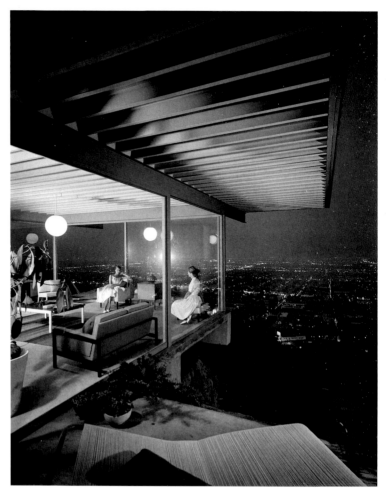

Pierre Koenig's Case Study House No. 22, Los Angeles, 1960. Photo by Julius Shulman (American, 1910–2009). Los Angeles, Getty Research Institute, 2004.R.10. © J. Paul Getty Trust, Julius Shulman Photography Archive.

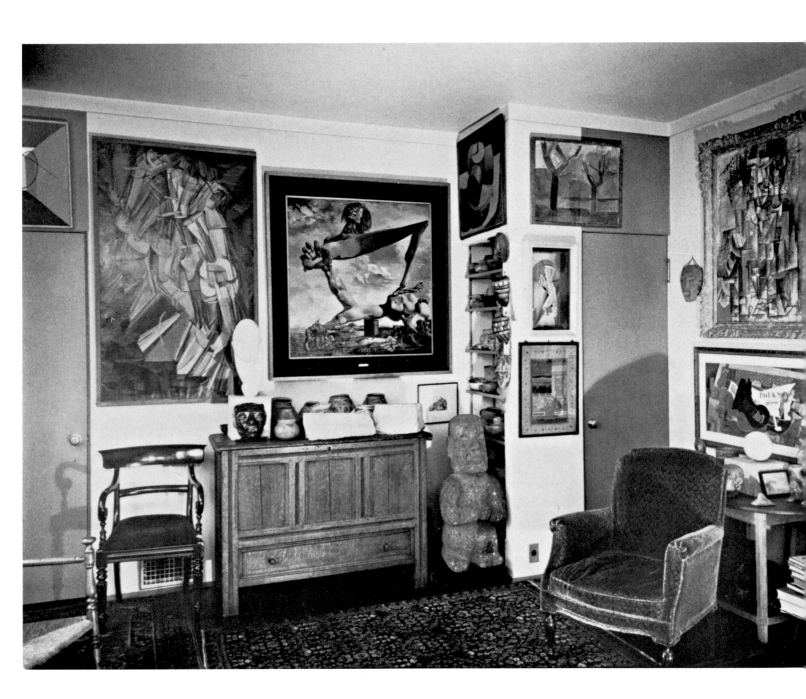

Figure 1.5.
**Interior of the sunroom in the Arensbergs' Hollywood home
at 7065 Hillside Avenue, Los Angeles, ca. 1944.** Photographer
unknown. Philadelphia, Philadelphia Museum of Art Archives,
Arensberg Archives; Series VIII, Photographs; Subseries C,
Residences; Sub-subseries 4, 7065 Hillside Ave. Credits for art on
the walls: © Salvador Dalí, Fundació Gala-Salvador Dalí / Artists
Rights Society (ARS), New York 2011. © 2011 Estate of Alexander
Archipenko / Artists Rights Society (ARS), New York. © 2011
Artists Rights Society (ARS), New York / ADAGP, Paris /
Succession Marcel Duchamp. © 2011 Estate of Pablo Picasso /
Artists Rights Society (ARS), New York.

Aline Barnsdall, who donated her sizable Frank Lloyd Wright–designed home to the City of Los Angeles for use as a public art park; and Walter and Louise Arensberg, who had been collecting works of European modernism since making their first purchase at the International Exhibition of Modern Art (the Armory Show) in New York in 1913 (see sidebar 2).

Among this small core of devoted collectors, the Arensbergs were perhaps the city's most influential early champions of modernism. Walter was a writer, poet, and cryptographer; Louise was heir to a textile industry fortune, which funded the couple's art collection. The Arensbergs had come to Los Angeles from New York in 1921, intending to stay only temporarily. Instead, they settled in, establishing their home in the Hollywood Hills at 7065 Hillside Avenue in 1927. The Hillside house, which was located just east of art dealer Earl Stendahl's home, was densely filled, salon-style, with more than four hundred works by artists such as Constantin Brancusi, Braque, Cézanne, Georgio de Chirico, Salvador Dalí, Max Ernst, Juan Gris, Fernand Léger, Joan Miró, Piet Mondrian, Picasso, Henri Rousseau, and Yves Tanguy. They also owned a significant collection of pre-Columbian objects.[3] Strong supporters of and close friends with Marcel Duchamp, the Arensbergs owned all three versions of Duchamp's famous painting *Nude Descending a Staircase* (1911, 1912, 1916) (fig. 1.5).[4]

Aware of the paucity of modern collections in Los Angeles and sympathetic to the curiosity and cultural hunger of the city's artists and students, the Arensbergs often invited visitors to view their world-class collection. Such guests included painter Philip Guston, who at the time was a student at Los Angeles's Manual Arts High School, and a young Walter Hopps, who eventually became one of Southern California's most important and forward-thinking curators.

Figure 1.6.
Louise Stevens Arensberg, Walter Arensberg, and Marcel Duchamp in the garden of the Arensbergs' home, Hollywood, California, August 1936. Photo by Beatrice Wood (American, 1893–1998). Philadelphia, Philadelphia Museum of Art Archives, Alexina and Marcel Duchamp Papers; Series X, Photographs; Subseries C, Portraits and snapshots; Sub-subseries 3, Marcel Duchamp with others. Photo courtesy Beatrice Wood Center for the Arts / Happy Valley Foundation.

Hopps first saw the Arensbergs' collection through his involvement in an extracurricular arts program at Eagle Rock High School; the visit provided an experience that profoundly affected him and shaped his future direction. Hopps asked Walter Arensberg if he might visit again, and Arensberg agreed. Until he left Los Angeles for college, Hopps went every Saturday for lunch with Walter and Louise, and those visits helped Hopps form a keen sensibility for modern and contemporary art. The Arensbergs also introduced Hopps to many artists with whom he would later work as a curator at the Pasadena Art Museum. One such artist was Duchamp (fig. 1.6); Hopps would eventually organize the first retrospective of Duchamp's work, in 1963 (see chapter 3, sidebar 15).

In the late 1940s and early 1950s, Duchamp made several trips to Los Angeles to visit his friends and patrons, and these visits often made local headlines (fig. 1.7). Although he spent quite a bit of time in the city, Duchamp had very little contact with L.A. artists, choosing instead to visit other European émigrés and contemporaries established in the international scene, notably the surrealist Man Ray. An American-born photographer, painter, and sculptor, Man Ray had spent the 1920s and 1930s among the avant-garde enclaves of Paris but had moved to Los Angeles in 1940, fleeing Nazi-occupied France. As Hopps later recounted, Man Ray was not welcome at the Arensbergs' home, having insulted the couple at one of the salon gatherings they hosted in their New York apartment.[5] Consequently, the two artists often met near Man Ray's studio and apartment at 1245 Vine Street (now known as the Villa Elaine building). The presence of both Duchamp and Man Ray in Los Angeles had a lasting effect on the conditions for modern and contemporary art in the city.

Duchamp, whose 'nude' once rocked nation, visiting in L. A.

Daily News **5**
LOS ANGELES, CALIFORNIA
SATURDAY, APRIL 23, 1949

Dali, famed surrealist, feted here

By KENNETH ROSS
(Daily News Art Editor)

Few painters have created greater sensations or are deemed more eccentric by the lay public than Marcel Duchamp. The name may not ring a bell as do those of Picasso or Matisse, but his painting of a "Nude Descending a Stair" remains the most famous of all modern pictures.

Unlike some moderns who carefully fall through Fifth Ave. show windows, Duchamp has never made a business of notoriety. Still, whatever he has done, including the fact that he has not painted for 25 years has been news.

Salvador Dali also arrived in Los Angeles this week and, as might be expected, was feted by a fashionable Brentwood party at which all picture magazine photographers were invited to shoot away at the spectacle of women and sheep strung up in the trees over Dali and his cocktail admirers.

A DANGEROUS TRIO

Duchamp, arriving from New York via a San Francisco roundtable discussion with Frank Lloyd Wright, and others, moved quietly into the home of an old friend who owns the "Nude" and 30 more of his works, and he would have moved out unannounced, had not our agents been on the alert.

Yet this is the man who sent to an art exhibit a porcelain urinal entitled, "Fontaine" and signed R. Mutt. When it was refused, he resigned from the executive committee. This week he renewed his friendship with two equally notorious pals, Max Ernst, who once exhibited an object in wood with a hatchet attached inviting people to chop away, and Man Ray, who, in New York, was the official head of screwball American activities. It is incredible that with three such men together in town nothing happened.

The reason is, of course, that their war is over; that whatever shockers they created were executed as part of the battle for modern art to shock an indifferent public from accepted and conventional ways of thinking and seeing. When Duchamp sent urinals and snow shovels to exhibits, it was not a gag but a challenge issued on the fundamental basis that a work of art should not be evaluated in

DAILY NEWS PHOTO OF NUDES
Shows successive positions of moving form

Figure 1.7.
Kenneth Ross, "Duchamp, Whose 'Nude' Once Rocked Nation, Visiting in L.A.," *Los Angeles Daily News*, 23 April 1949, 5. Los Angeles, Getty Research Institute, 2009.M.8. © 1949, Los Angeles Times, reprinted with permission. Art © 2011 Artists Rights Society (ARS), New York / ADAGP, Paris / Succession Marcel Duchamp.

Vincent Price at home with his art collection, Los Angeles, 1962. Photo by Julian Wasser (American, b. 1900s). © Julian Wasser, all rights reserved. Courtesy Julian Wasser and Craig Krull Gallery, Santa Monica.

ADDRESSING A CROWD of "fashion-affiliated" women (as the *Los Angeles Times* described them) on 10 December 1947 at the Elks Temple on Central Avenue, actor Vincent Price proudly announced, "We propose to show the art of our time in close relation with the lives we lead....Further-more, we plan to show the work of national and local contemporary artists in this exciting new endeavor."[1] The "endeavor" was the Modern Institute of Art, a free, nonprofit gallery dedicated to exhibiting the era's most challenging and important contemporary art—and a much-needed cul-tural resource for the Los Angeles region. Located at 344½ North Rodeo Drive in Beverly Hills, the institute opened on 12 February 1948 with the goal of becoming the West Coast equivalent of New York's Museum of Modern Art.

Directed by art critic Kenneth Ross (who later became director of Los Angeles's Municipal Art Department, which was famously accused of promoting communistic art), the Modern Institute of Art planned to exhibit work from notable L.A. collections and to attract national traveling shows that would otherwise bypass the city. Its inaugural exhibition, *Modern Artists in Transition,* presented forty paintings, of which all but four were from the collections of its Southern California founders, including collectors and art patrons Walter and Louise Arensberg and Leslie Maitland, art dealer Earl Stendahl, and actors Charles Laughton, Fanny Brice, and Vincent Price. Price, a longtime supporter of the arts, also served as the chair-man of the board of directors. The show featured canvases by Marc

Chagall, Fernand Léger, Henri Matisse, Joan Miró, Pablo Picasso, Auguste Renoir, Henri Rousseau, and Henri de Toulouse-Lautrec, as well as one version of Marcel Duchamp's *Nude Descending a Staircase* (all three of which the Arensbergs owned). It was a great success; as Alfred M. Frank, the New York–based editor and publisher of *The Art News,* put it, "This exhibition would be a sensation in New York."[2]

During the five months that he was the institute's director, Ross managed to recruit 1,500 members and to program nationally recognized exhibitions, lectures, film screenings, and concerts.[3] His successor, art historian Karl With, grew the membership to 2,500, even though the museum was plagued by budget difficulties and sporadic bad reviews. By spring 1949, the Modern Institute of Art's mounting financial troubles had finally reached a crisis point; at the end of April, the private institution closed its doors, having failed to raise the $20,000 needed for another year of operation.

The L.A. art world rallied in an effort to save the institute. According to news reports from early April 1949, students and instructors from the University of Southern California, the University of California, Los Angeles, and various regional art schools petitioned the institute's trustees to reconsider their vote to cease operations. More than 50,000 people had visited the institute in its fourteen months of operation, and the Institute had provided a vital center for contemporary art. As *Los Angeles Times* critic Arthur Millier warned, the "demise [of the Modern Institute] will be much more than a blow to the L.A. region's reputation as an art center. It would mean the loss of an educational art center of incalculable value....Everybody who stands to benefit from the life-enhancing activities of the Modern Institute of Art should rally to its support and make certain it will not close forever."[4]

Despite support from the public and the media, the Modern Institute became the first in a series of contemporary art institutions in Los Angeles to falter. This scenario was repeated in 1974 when the Pasadena Museum of Modern Art (formerly the Pasadena Art Museum) closed its doors and again in 1987 with the closure of the Los Angeles Institute of Contemporary Art (LAICA).

Notes
 1. "Modern Institute of Art Plans Special Exhibit," *Los Angeles Times,* 11 December 1947, A20.
 2. "New Institute of Art Exhibits Masters' Works," *Los Angeles Times,* 13 February 1948, 7.
 3. "With Heads Art Institute," *Los Angeles Times,* 31 July 1948, A6.
 4. Arthur Millier, "Plea Made to Reopen Modern Art Institute," *Los Angeles Times,* 10 April 1949, D6.

SOUTHLAND SURREALISM

Man Ray neatly embodies the marriage of Europe and California through surrealism; during his eleven years in Los Angeles, he completed more works of art than he had in the previous thirty years and eventually became recognized internationally as the most renowned visual artist living in the city. He turned his attention to painting (while continuing his photographic practice), producing canvases in Los Angeles that show the bold, primary colors found in his abstract lithographs of the late 1920s. The subjects of these works range from deserts and beaches—though often in destabilized representations—to intimate portraits of women that seem to capture the spirit of health, sex appeal, and beauty associated with the California life-style. His painting *Night Sun—Abandoned Playground* (fig. 1.8), for example, depicts a luminous sun against an orange sky, setting over a beach; in the foreground, an uprooted cypress tree, in silhouette, has fallen onto a Spanish-style house (possibly the artist's home). A series of photographs from about 1945 depict Man Ray's wife, modern dancer Juliet Browner, outdoors in the nude, her toned, tanned body providing a study in light and shadow as well as a model of vitality

Figure 1.8.
Man Ray (American, 1890–1976). *Night Sun—Abandoned Playground*, 1943. Oil on canvas, 51 × 61 cm (20.1 × 24 in.). Private collection. © 2011 Man Ray Trust / Artists Rights Society (ARS), NY / ADAGP, Paris.

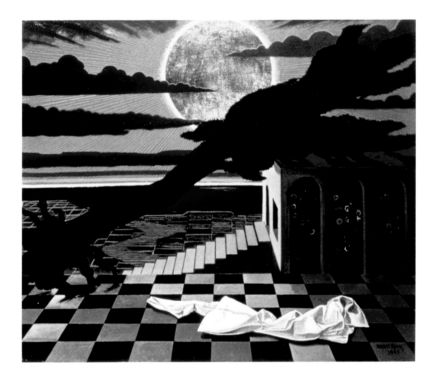

and youth. Another work, *Juliet and the Non-Euclidian Object* (fig. 1.9)—a brightly colored photograph of the dancer wearing a two-piece bathing suit and holding a multicolored polygon—seems to borrow stylistically from advertising and pinup photography while anticipating the pop sensibility of the 1950s and 1960s. Works such as these demonstrate the artist's acute awareness and assimilation of the Hollywood image-making machine.

In his first few years in the city, Man Ray exhibited in a number of spaces, including the Frank Perls Gallery in Hollywood (1941 and 1942), the Santa Barbara Museum of Art (1943), the Pasadena Art Institute (1944), and the Los Angeles County Museum of History, Science, and Art (a retrospective in 1945). But despite his growing reputation, commercial success evaded him, leaving him reliant on the patronage of director, screenwriter, and producer Albert Lewin and, later, of Metro-Goldwyn-Mayer actress and singer Mary Stothart. Like many European émigrés who relocated to Los Angeles during World War II—an elite group that included, among others, German poet and playwright Bertolt Brecht; Spanish filmmaker Luis Buñuel; German expressionist filmmaker Fritz Lang; Hungarian-born actor Peter Lorre; French

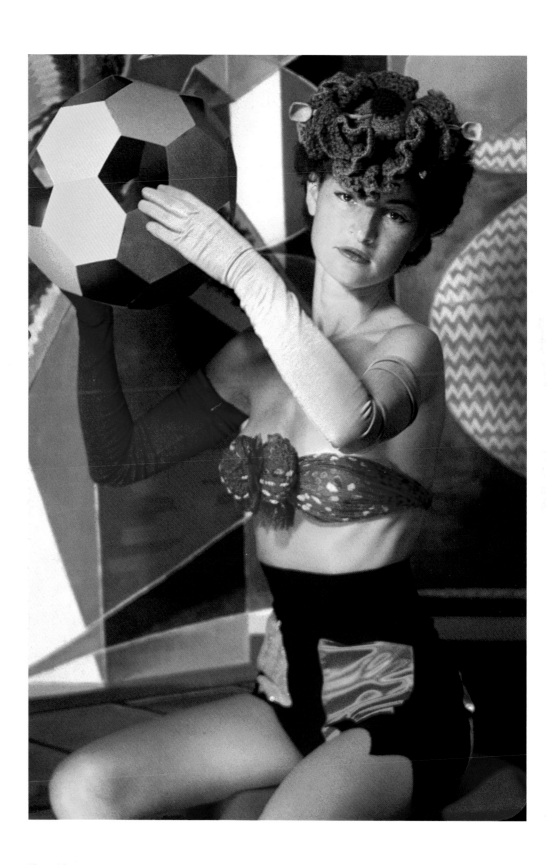

Figure 1.9.
Man Ray (American, 1890–1976). *Juliet and the Non-Euclidian
Object*, **ca. 1945.** Paris, Lucien Treillard Collection. © 2011 Man Ray
Trust / Artists Rights Society (ARS), NY / ADAGP, Paris.

filmmaker, actor, and producer Jean Renoir; and Polish actress and screenwriter Salka Viertel[6]—
Man Ray had hoped to put his talents to profitable use in Hollywood. Lewin introduced him
around the movie studios, but no real work developed for the artist until 1950, when Lewin used
a Man Ray painting and chess set as props in his film *Pandora and the Flying Dutchman.* Lewin
also commissioned him to photograph and paint a portrait of the film's female lead, Ava Gardner
(fig. 1.10). About this period, Man Ray later quipped, "There was more Surrealism rampant in
Hollywood than all the Surrealists could invent in a lifetime."[7]

Hollywood was certainly effective in introducing surrealism to postwar America at large.
After fleeing German-occupied France, Salvador Dalí spent eight years in the United States.
Dalí was in New York for most of this time, but his frequent visits to Los Angeles were fruitful:
he undertook commercial collaborations with Alfred Hitchcock in 1945 and Walt Disney in
1946. Working with Hitchcock, Dalí created the vivid dream sequence for the thriller *Spellbound*
(1945), in which Gregory Peck recounts his nightmarish vision of a wall-less gambling house
and the faceless and amorous characters therein. To create the dream set, Dalí flanked a sound-
stage with illusionistic curtains painted with eyeballs, which in the film are cut with a pair of
oversized scissors (alluding to the famous image in *Un chien andalou* [1929], Dalí's film collabo-
ration with fellow surrealist Luis Buñuel) (fig. 1.11). The scene progresses into an anthropomor-

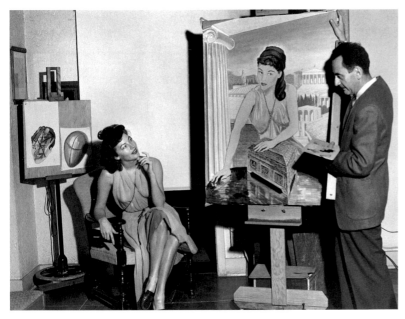

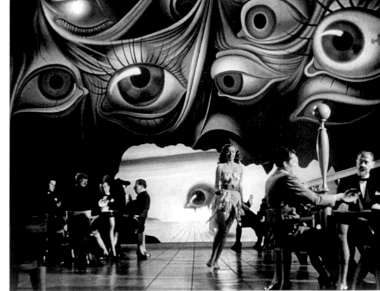

Figure 1.10.
Man Ray with Ava Gardner and a painting for the film *Pandora
and the Flying Dutchman,* 1950. Photo: Paris, Lucien Treillard
Collection. © 2011 Man Ray Trust / Artists Rights Society (ARS),
NY / ADAGP, Paris.

Figure 1.11.
Still from the black-and-white film *Spellbound* (1945; dir.
Alfred Hitchcock) showing a sequence designed by Salvador
Dalí. Art © Salvador Dalí, Fundació Gala-Salvador Dalí / Artists
Rights Society (ARS), New York 2011. Image: United Artists /
Photofest.

phic exterior setting, painted in signature Dalí style, in which Peck's character is chased down a
slanted roof by a giant pair of disembodied wings. The artist invented a similar environment for
his collaboration with Disney, *Destino,* a short animated film set to music in which an arche-
typal Disney maiden moves through a host of morphing ruins and desertscapes in search of her
romantic destiny (fig. 1.12). Although *Destino* was never fully realized in Dalí's lifetime, the
film's storyboard and approximately eighteen seconds of test animation were ultimately revived
by Disney Studios France, which completed the film as a six-minute short in 2003.

Beyond Hollywood, Southern California's art audience was exposed to surrealism through
a few key galleries and bookstores, such as Frank Perls Gallery, Barbara Cecil Byrnes's American
Contemporary Gallery on Hollywood Boulevard, and the Cowie Galleries located in the
Biltmore Hotel in downtown Los Angeles. Though the city has often been portrayed as devoid
of sophisticated culture, in fact Los Angeles had three notable avant-garde book dealers:
Stanley Rose, Jake Zeitlin, and Mel Royer, all of whom opened shops in the late 1920s and early

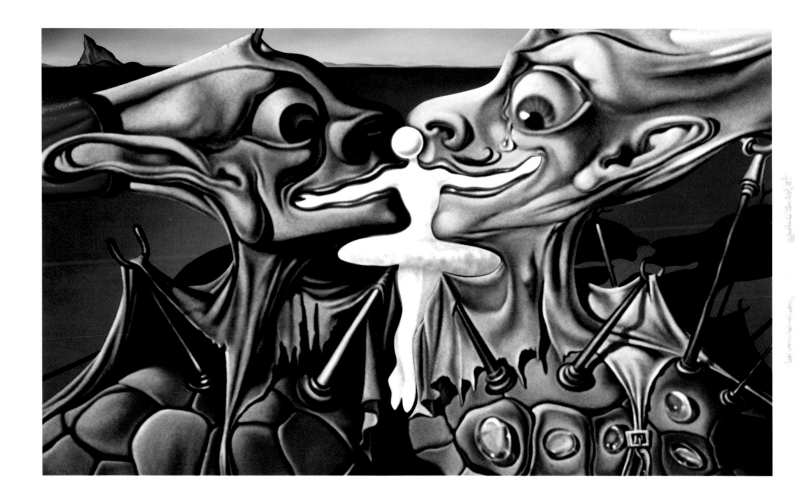

Figure 1.12.
Still from the color animated short *Destino* **(1945–2003)**
showing a sequence designed by Salvador Dalí. Art © Salvador
Dalí, Fundació Gala-Salvador Dalí / Artists Rights Society (ARS),
New York 2011. © Disney.

1930s. Their stores became dynamic centers for modernism that were particularly active in the last half of the 1940s. The Stanley Rose Bookshop and Gallery had been a meeting place for artists and Hollywood literati since the 1930s and had dealt in esoteric books well before the Beat artists began incorporating such philosophies into their artwork. Zeitlin opened his first Frank Lloyd Wright–designed bookstore downtown in 1928 and moved twenty years later to La Cienega Boulevard into a shop called The Red Barn. He had a proven record for exhibiting modernist prints, photographs, and drawings, including those of Käthe Kollwitz, Arthur Millier, José Clemente Orozco, Henrietta Mary Shore, and Edward Weston. Mel Royer was a former accountant who both produced and sold surrealist and Dadaist pamphlets, literature, and related material from his shop and gallery, which he opened in 1949 at 465 North Robertson Boulevard. Two years later, painter William Copley—using the name CPLY—had his first solo exhibition in this space (fig. 1.13). These shops functioned as crucial touchstones for Angelenos hungry for modern culture. Nevertheless, the sense that modernism in Los Angeles in that period was a

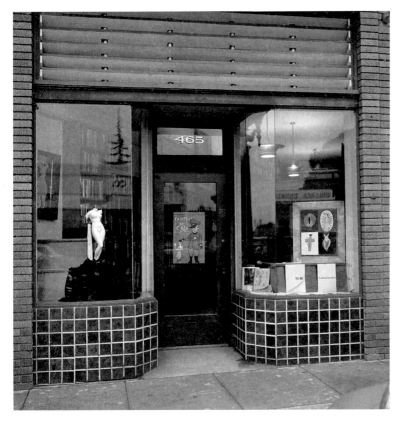

Figures 1.13a, 1.13b.
Exterior and interior views of the exhibition *CPLY: Paintings by William N. Copley*, Royer's Book Shop, Los Angeles, January 1951. Los Angeles, Getty Research Institute, 980024. Courtesy the William N. Copley Estate / Copley LLC.

blend of the arcane, the avant-garde, and the salacious—most brilliantly evoked in the hard-boiled detective novels of Raymond Chandler—may have had some basis in fact. In an interview about that era, Walter Hopps recalled, "I learned from Copley, that Royer made his real money by selling fancy pornography in the back room."[8]

The most ambitious presentation of surrealist art in Los Angeles, however, was the significant but short-lived and underappreciated gallery that Copley himself opened in 1948 in Beverly Hills with his brother-in-law, John Ployart. Though it operated for only one year, the Copley Gallery featured successive solo exhibitions of important modernists—René Magritte, Tanguy, Joseph Cornell, Man Ray, (Roberto) Matta, and Ernst, in that order—each with a brochure or small catalog accompanying the show (fig. 1.14). Man Ray's exhibition, called *Café Man Ray*, temporarily transformed the gallery into a sidewalk café, a type of establishment the Los Angeles health board had banned citywide during the late 1940s. According to curator

CATALOGUE

PAINTINGS

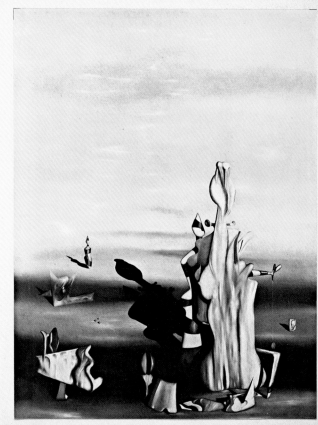

La dame à l' abscence

Figure 1.14.
Brochure from the exhibition *Yves Tanguy: Paintings and*
Gouaches, **Copley Gallery, Los Angeles, 1947.** Los Angeles, Getty
Research Institute, 980024. Courtesy William N. Copley Estate /
Copley LLC. Art © 2011 Estate of Yves Tanguy / Artists Rights
Society (ARS), New York.

James Byrnes, Copley kept a pet monkey in the gallery, which added some levity to the shows. As Copley recalled:

> [The gallery] happened I guess over a lot of beer and things like that. Both my brother-in-law and I were terribly excited about surrealism...and felt that we wanted to try it [in Los Angeles]. And I must say it was a wonderful experience because you lived for a solid month with a room full of Tanguy's [*sic*]. And then you lived for a solid month with a room full of Magritte's [*sic*]. And the process of osmosis was quite something. And the Max Ernst show was actually the first retrospective ever held of Max's...we had over three hundred pieces....[The gallery was] almost totally ignored. We were attacked by most of the critics....I didn't know what I was doing. I was enjoying it very much, but it certainly wasn't the greatest business venture you ever thought of. It was suicide, business-wise.[9]

In assembling these shows, Copley allegedly promised each artist's European dealer 10 percent of any sales. Sadly, the gallery sold only two works and Copley himself ended up buying pieces from each show. These works became the basis of the Copley Collection, a strong group of Dada and surrealist work that the artist auctioned off before his death. In February 1949, less than a year after it opened, the Copley Gallery closed and the dealer moved to Paris to pursue his painting.[10]

Although some of the efforts to promote Dada and surrealism in Los Angeles were short lived, the early exhibition of this art profoundly influenced a new generation of artists, writers, filmmakers, and musicians in Southern California; this stylistic lineage is visible in the assemblage sculpture of the 1950s, the pop art of the 1960s, and the video and performance art of the 1970s and 1980s. One compelling testament to the legacy of surrealism in the region is Ed Ruscha's *Artforum* magazine cover of September 1966 (fig. 1.15), which features a photo of his mixed-media piece *Surrealism Soaped and Scrubbed;* in the piece, the word "surrealism," in blocky

Figure 1.15.
Cover of *Artforum* 5, no. 1 (1966), featuring Ed Ruscha's *Surrealism Soaped and Scrubbed*, 1966. Art © Ed Ruscha. Cover © Artforum, September 1966.

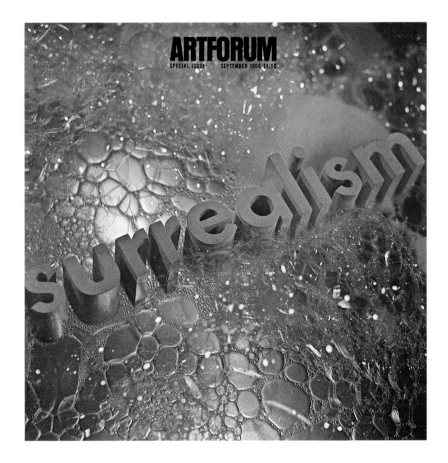

orange letters, seems to float over a bubbly iridescent surface of gold and blue. *Artforum,* one of the art world's most important periodicals, was based in Los Angeles from 1965 to 1967 and commissioned the cover from Ruscha, a local artist who epitomized the L.A. art scene of the 1960s: at once new, fashionable, and with international ambitions. In this witty and critical work, Ruscha seems to wash over the authority of European modernism (surrealism) while tipping his hat to a movement with deep roots in his (and *Artforum*'s) home city.

UNDER SUSPICION

The way modern art was experienced in Los Angeles—largely in the private realm rather than through public exhibitions—caused it to be viewed with a vague sense of mistrust. Though it acquired an aura of Hollywood glamour, cutting-edge art in Los Angeles was associated mostly with the émigré community and therefore was regarded as foreign and perhaps even un-American. Furthermore, modernism's champions in Los Angeles were often wealthy eccentrics like Aline Barnsdall, who lived unapologetically as a single mother decades before doing so was widely accepted, and Walter Arensberg, who spent much of his energy trying to prove that Francis Bacon had authored the works of William Shakespeare. While the connections between modern art and backroom erotica are contentious, the average citizen likely saw the movement as less than wholesome. It is perhaps unsurprising, then, that a conservative city like Los Angeles provided a difficult and even hostile environment for certain forms of art. Just as some artworks were injudiciously labeled "pornographic," modern artists—including (not surprisingly) many Dada and surrealist artists, such as Man Ray and Marcel Duchamp—were accused of spreading communism through their work. This sentiment was echoed elsewhere in the country, though to varying degrees. On 16 August 1949, U.S. representative George A. Dondero of Michigan delivered a speech titled "Modern Art Shackled to Communism" before the House of Representatives, igniting a widespread backlash against European artists, many of whom had originally immigrated to America to escape Nazi persecution. In his speech, Dondero decried modern art:

> I call the roll of infamy without claim that my list is all inclusive: Dadaism, futurism, constructionism, suprematism, cubism, expressionism, surrealism and abstractionism. All these *isms* are of foreign origin and truly should have no place in American art. While not all are media of social or political protest, all are instruments and weapons of destruction....Cubism aims to destroy by designed disorder....Expressionism aims to destroy by aping the primitive and insane.... Abstractionism aims to destroy by the creation of brainstorms. Surrealism aims to destroy by the denial of reason.[11]

As these claims escalated throughout the 1950s—a decade when McCarthyism spread fear and paranoia—and as civic and commercial support of avant-garde art diminished, many L.A. artists withdrew entirely from the public sphere and moved underground.

While this change can be traced to a number of factors and events in postwar America, in Los Angeles censorship infamously embroiled the one prominent public institution that was at least partially dedicated to the visual arts: the Los Angeles County Museum of History, Science, and Art. In 1947, James Byrnes—Los Angeles County Museum's first curator of modern and contemporary art—was put in charge of the museum's annual exhibition, a local tradition since 1940 that had typically included about six hundred works of art by Southern California artists (fig. 1.16). The problem, from Byrnes's perspective, was that real curatorial criteria had not been applied in selecting the art. The result was a stylistic smorgasbord and an expectation on the part of the public that every local artist (as a citizen and taxpayer) had the right to hang their works on the museum's walls. Hoping to raise the profile of art in the city, Byrnes restructured the exhibition that spring to include new categories for modern art.

3 Collaborative Couples CATHERINE TAFT

THE DOMESTIC PARTNERSHIP of practicing artists is neither a region-specific phenomenon nor unique to the postwar period. But in the late 1940s and early 1950s, Los Angeles was home to a noticeably large number of artist pairs who lived as husband and wife or committed partners, thereby creating an intimate artistic community within their home lives. Examples include painters Lorser Feitelson and Helen Lundeberg, Benji and Chisato Takashima Okubo, Jan and Maxine Kim Stussy, and Oscar Van Young and Lilian (Loli) Vann; ceramicists and muralists Albert Henry King and Louisa Anne Etcheverry King; critic Jules Langsner and painter June Harwood; and writer Christopher Isherwood and painter Don Bachardy. In each of these couples, both individuals sustained a creative practice independent of his or her partner. However, there were other artist couples who created and presented their work as a unified, cooperative undertaking, as did ceramicists Otto and Gertrud Natzler, and Otto and Vivika Heino; printmakers Leo and Helen Glen Mayrhofer; muralists and designers Arthur and Jean Ames; and designers Jerome and Evelyn Ackerman, and Charles and Ray Eames. It is significant that these collaborative couples tended to work in commercial areas of decorative art and design.

The Natzlers and Eameses, in particular, exemplify the viability of such working partnerships; in both cases, their names came to represent a kind of brand identified with Southern California modernism. The Natzlers arrived in Los Angeles from Nazi-occupied Vienna in 1938, bringing with them an international reputation for their decorative polished clay forms and original glazing techniques. In California, they began teaching and refining their techniques: Gertrud formed graceful pots, vases, plates, and bowls on the wheel, while Otto mixed and applied jewel-toned glazes, selected from among the 2,500 he developed. These simple objects were never pictorially decorated, which allowed their sculpted lines, curves, and unique finishes to serve as the focus of each vessel. The couple became renowned for pioneering experimentation with low-temperature firing and blistered surfaces and for the use of vivid red and yellow cadmium-oxide glazes. Natzler ceramics—each individually signed and numbered—were highly sought after by collectors and, in 1944, were featured in an exhibition at the Los Angeles County Museum of History, Science, and Art that the museum described as a "one-family" show. Two decades later, in 1968, collectors Leonard M. and Rose A. Sperry donated an extensive array of Natzler pots to the museum; their gift not only laid the foundations for the museum's ongoing acquisition and exhibition of contemporary ceramics but also showcased the Natzlers' vital contributions to California craft.[1]

Charles and Ray Eames met in 1940 at the Cranbrook Academy of Art in Michigan. Their design sensibility flourished in Los Angeles, where they moved in 1941. Shortly after their arrival, their furniture line was picked up by Evans Products (and later by Herman Miller, Inc.), which began manufacturing items such as the wildly popular Eames Chair. Eames architecture, furniture, and graphic designs—not to mention the couple's books, films, photography, exhibitions, and novelties like interlocking, stackable playing cards—simultaneously shaped and adapted to the relaxed West Coast lifestyle; by the end of the 1940s, their name had become synonymous with California Modern living. Their Case Study House No. 8 in Pacific Palisades, built in 1949, is a lasting testament to this era in taste (see sidebar 1). The couple continued their productive partnership through the 1960s and 1970s, devising designs for public and private spaces and embodying the spirit of collaboration.

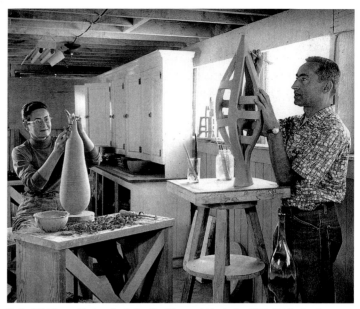

Gertrud Natzler working on a facsimile of her Viennese kick wheel and Otto Natzler forming an early ceramic construction while artists-in-residence at Brandeis Camp Institute, Simi Valley, California, ca. mid-1950s–1960s. Photo by Lotte Nossaman. Courtesy Gail Reynolds Natzler.

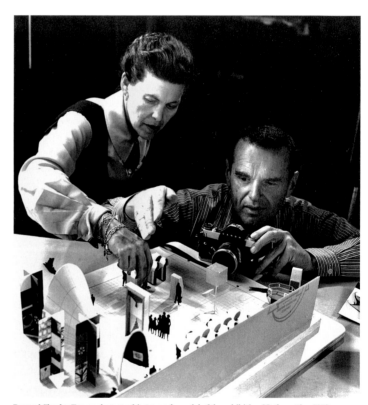

Ray and Charles Eames photographing an early model of the exhibition *Mathematica*, 1959. © 2010 Eames Office, LLC (eamesoffice.com).

Notes

1. Jo Lauria, "Mapping the History of a Collection: Defining Moments in Ceramics at LACMA," in idem et al., *Color and Fire: Defining Moments in Studio Ceramics, 1950–2000* (Los Angeles: LACMA, 2000), 25.

The change in format caused a near riot in the local community; artists excluded from the annual picketed the museum and threatened to tear artwork from the walls. The five hundred members of the California Art Club—a long-established professional organization for more "academic" (and largely regionalist) artists—went so far as to cart their rejected artworks to the museum steps, deriding the show as communistic (figs. 1.17, 1.18, 1.19). The controversy arose again in July of 1951 when Byrnes reorganized the annual to feature international and New York artists such as Dalí, Ernst, Matta, Robert Motherwell, Mark Rothko, and Tanguy, alongside California artists like Richard Diebenkorn, Helen Lundeberg, Oskar Fischinger, Ynez Johnston, and June Wayne. As the exhibition catalog explained, "Sixty paintings by sixty artists of Los Angeles and vicinity were selected by the jury from 1144 submitted by 727 painters. Our purpose in so drastically limiting the local representation was to maintain as far as possible the standard set by the eighty paintings invited by other sections of the country."[12]

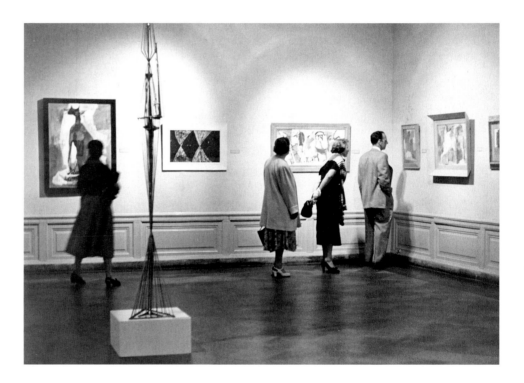

Figure 1.16.
Installation view of the annual exhibition *Los Angeles and Vicinity,* Los Angeles County Museum of Art, Los Angeles, ca. 1947. Photo courtesy James and Barbara Byrnes.

Although factions in the local art scene protested the annual, the international art community lauded it as a significant achievement. At the suggestion of the annual's jury of critics and other museum professionals, Byrnes set out to acquire work from the annual for the museum's permanent collection. Having raised $4,000 for the purchase of art, Byrnes proposed acquiring works by internationally renowned abstract painters Josef Albers, William Baziotes, Karl Knaths, Jackson Pollock, and Mark Rothko. Byrnes presented their work to the museum's board, emphasizing its educational value and its importance to the public collection. As Byrnes later recalled:

> [During the presentation] one of the trustees came up to me and said "don't make a fuss.... I think
> we can get this acquisition through." After much debate, the board said, "Byrnes, we've agreed to
> let you acquire two of the paintings with the proviso that you don't hang them on our walls. Keep
> them in your office and use them when you do lectures in the gallery and use them for educational
> purposes only."[13]

ART BATTLE

Conservative Los Angeles painters protest "radicals" hung in museum

The sunny Sunday calm of Los Angeles was shattered a fortnight ago when irate local artists and members of three art clubs stormed the steps of the imposing Los Angeles County Museum. They were vociferously displeased with the paintings chosen to hang in the museum's current show. Demonstrations of protesting artists are nothing new in the art world, but normally the protesters are "advanced" or "modern" artists fighting against being locked out by academicians. In Los Angeles, however, where normality is not normal anyway, the tradition was turned about. The museum protesters were a conservative group which turned out pretty, recognizable paintings. They were annoyed because the show favored what they called "radical" and "subversive" art.

The outraged painters set up their own canvases on the museum's steps and terrace and along its walls as examples of what should have been shown inside. Then they marched around the museum, demanding that the director resign. Instead the museum's staid and somewhat startled director, James H. Breasted Jr. (a member, incidentally, of Princeton '32, p. 51), remained in his oak-doored office and quietly called the police. Three radio patrol cars rolled up to the museum's entrance and a swarm of police waded through canvases of sunsets, mountain landscapes, pretty nudes and Chinese vases. They told the leader of the conservative group to get going. He insisted instead that the cops arrest him. Stumped, the police let him alone while he went busily about getting signatures for an oust-the-director petition from museum patrons, most of whom signed happily without knowing what the fuss was all about.

Some of the conservatives then went inside the museum and gave impromptu lectures on "good" and "bad" art, choosing the bad examples from the paintings in the exhibit. By the end of the afternoon the museum's director had offered, as a conciliatory gesture, to expand the show next year, shrewdly suggesting it be held somewhere else.

WITH ARM AROUND HIS MODEL, ARTIST EDWARD WITHERS POINTS TO PORTRAIT REJECTED BY MUSEUM

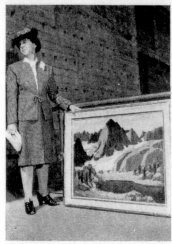

ARTIST Edith Waldo could not understand why museum would not hang her painting *Sierra Peaks*.

PICKETS on museum steps were harangued by Withers, painter of *Carol* (top) and head of local art club. The police arrived shortly.

ACCEPTED ART in show included this by Boris Deutsch, 1946 winner of $2,500 Pepsi-Cola prize.

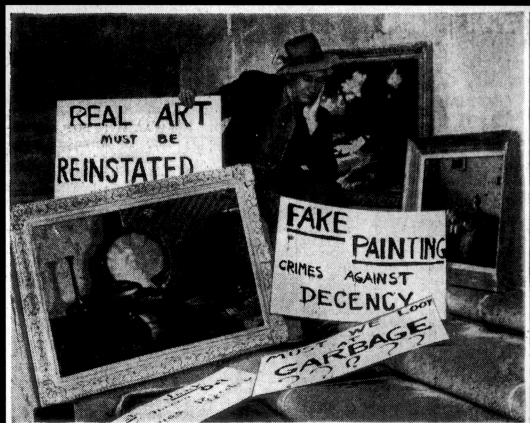

Los Angeles Examiner ★
Sat., May 17, 1947 Part 1—3

FIGHT FLARES ON ART SHOW

Whether paintings at the Los Angeles and Vicinity artists' exhibition at the County Museum are "radical" or "conservative" was a subject of hot dispute yesterday among local artists and critics.

The controversy, brewing since last Tuesday when the winning paintings were posted, was brought to a head on the museum steps at Exposition Park.

Displaying two of his own works which were rejected in the contest, "conservative" artist Roy Walter James carried placards denouncing alleged "radical" dominance of the exhibition.

TASTE RAPPED——

James, who lives at 331 North Heliotrope drive, classified a "radical" artist as a "normal person with a good education but without a good sense of taste."

'CONSERVATIVE'—Roy Walter James, self-described "conservative" artist, sits disconsolately among his rejected paintings and placards with which he picketed the Los Angeles and vicinity art exhibition at County Museum.

James charged that "radical" painters "gobbled up all the wall space," while paintings such as his own in the "conservative line of Da Vinci and Rubens" were ignored."

—Los Angeles Examiner photo.

Museum Art Show Blasted As Subversive

"Nuclear and atomic art," as exemplified in the current show at the Los Angeles County Museum, was blackballed today by the 500-member California Art Club as a display of "subversive propaganda."

Edward Withers, club president, unhesitatingly said the show had a "communist taint."

The blast ended five days of respite from attack for the annual Los Angeles and Vicinity art show at the Museum, where the last activity was a one-man picket line protesting selections for the exhibition.

Withers, in a letter to James H. Breasted Jr., museum director, called the 1947 exhibition "a shocking breach of the faith local craftsmen placed in your word to make the Museum available for

Figure 1.17.
"Art Battle: Conservative LA Painters Protest 'Radicals' Hung in Museum," *Life,* 16 June 1947, 40. © 1947 The Picture Collection Inc., reprinted with permission, all rights reserved. Photos by Jack Birns / TIME & LIFE Images / Getty Images.

Figure 1.18.
"Fight Flares on Art Show," *Los Angeles Examiner,* 17 May 1947, sec. 1, p. 3.

Figure 1.19.
"Museum Art Show Blasted as Subversive," *Hollywood Citizen News* 3, no. 44 (1947).

Figure 1.20.
Jackson Pollock (American, 1912–1956). *No. 15*, 1950. Oil on masonite, 55.9 × 55.9 cm (22 × 22 in.). Los Angeles, Los Angeles County Museum of Art, Museum Associates Purchase Award. Art © 2011 The Pollock-Krasner Foundation / Artists Rights Society (ARS), New York. Digital Image © 2009 Museum Associates / LACMA / Art Resource, New York.

Figure 1.21.
Rex Brandt (American, 1914–2000). *First Lift of the Sea*, ca. 1949. Oil on canvas, 66 × 91.4 cm (26 × 36 in.). Laguna Beach, California, collection of E. Gene Crain. Courtesy the Estate of Rex Brandt.

With this conditional approval, Byrnes acquired Pollock's *No. 15* (fig. 1.20)—a small action painting typical of the artist's rhythmic drip technique—for four hundred dollars, and an *Homage to the Square* (1951) by Albers—a stark geometric abstraction in black and grayish white—for one hundred and fifty dollars. Despite the board's warning, Byrnes immediately put the works on public view in the museum's second-floor gallery.

Byrnes's actions did not go unnoticed by the Los Angeles County Museum's board, a group characterized by its fear, conservatism, and anti-modern sentiment. The board required Byrnes to sign a loyalty oath affirming that he did not participate in anti-democratic or un-American activities, which was not uncommon for civil servants in the McCarthy era. Byrnes declined. "[When] I hadn't signed it, I was called in by the assistant director.... I said, 'I'm willing to sign the loyalty oath if I can eliminate...the part that says I do this willingly, and without reservation.' They said, 'You have to sign it fully, that's the whole idea.'"[14] Instead of signing the oath, the museum's first curator of modern art chose to resign; he left Los Angeles to become the director of the Colorado Springs Fine Arts Center, a small institution in the Rocky Mountains.

A censorious attitude toward modernism infected other art venues in the city as well. It surfaced in October 1951 in the wake of the annual All-City Outdoor Art Festival, a two-week series of publicly funded art exhibitions installed in parks throughout Los Angeles. Sponsored by the Municipal Arts Department and organized by its director, Kenneth Ross, the largest of these exhibitions was held at the Greek Theatre in Griffith Park and included a number of modern works by local artists. These nontraditional pieces quickly generated negative attention. In response to a rash of letters and complaints, city councilman Harold Harby (chairman of the Building and Safety Committee and a well-known conservative Democrat) launched an investigation into the outdoor art show, summoning Ross and a number of exhibiting artists to a city council hearing. Among the "ultramodern" artists (as Harby's committee called them) under scrutiny was Rex Brandt, whose canvas *First Lift of the Sea*—a brushy watercolor of a sloop sailing on the ocean—was alleged to depict a hammer and sickle (fig. 1.21). The ongoing hearings made national news; *Time* magazine reported, "This week the fight still raged. Promised Harby: 'I'm going to vote no more funds to the city art department as long as they put out this kind of stinkweed stuff.' Through it all, only one councilman declined the critic's chair. Said Ed Roybal: 'I don't think we should sit as art critics. Deciding what is good art should be left to men who know what they're doing.'"[15]

As aesthetic radicalism became synonymous, in many minds, with political leftism, the condemnation and suppression of modernism became ever more apparent in Los Angeles. In the summer of 1954, Harby led a campaign against Bernard Rosenthal's "subversive" public sculpture *The Family*—an abstracted bronze representation of a protective male figure standing behind those of a woman and a child—which, in 1952, the Municipal Arts Department and the Board of Public Works had commissioned to decorate the new downtown Police Department Building.[16] Byrnes was even reported to the FBI after giving a lecture at a "radical bookshop" on government support of the Works Progress Administration muralists. The political climate of the city, which was largely run by conservative business interests, had become ever more hostile toward modern art, and this attitude was reflected in the actions of both its cultural institutions and its civic leadership.

FASHIONING COMMUNITIES

Although an institutional foundation for modern art existed in Los Angeles, it was limited and replete with strictures. Anti-modern sentiments prevailed well into the 1960s, and the art institutions proved ineffective in nurturing the city's growing number of vanguard contemporary artists. Certain forms of modernism were increasingly viewed as affronts to polite taste, and artists working in these modes began, by necessity, to establish their own networks and communities.

Los Angeles's artistic communities in the late 1940s and early 1950s were shaped by both geographic and social factors. In a sprawling city like Los Angeles, artists who ended up living or working in close proximity naturally tended to develop connections and build a sense of community, and regional "centers" emerged in Claremont, Laguna, Laurel Canyon, South Los Angeles, Venice, and Pasadena (see sidebar 3). In addition, like-minded practitioners who were exploring similar media and styles began associating with one another, even if they were geographically dispersed. Southern California artists also fought isolation by forming business ventures, exploring alternative philosophies and religions, and engaging in shared leisure activities.

Of the numerous self-generated L.A. communities that emerged in Los Angeles, three in particular exerted powerful influences on the direction of modern art in the region: the circle of early expressionist painters, many of whom taught in art schools and helped to produce the artists who came of age in the late 1950s and 1960s; the loose affiliation of self-described Abstract Classicists, more commonly known as hard-edge painters; and the ceramic sculptors who formed a close-knit group, characterized by strong male bonding.

EARLY EXPRESSIONISTS

The late 1940s and early 1950s have often been characterized as a heroic moment for abstract expressionism, one dominated by larger-than-life painters such as Jackson Pollock, Willem de Kooning, and Robert Motherwell. For an art center to claim a place in the ongoing "triumph of American art," it needed a stable of significant resident artists associated with the movement, something New York and San Francisco certainly had. Los Angeles, lacking a visible constellation of painters, was largely ignored by critics, even though a number of first-rate painters were working in the city at the time. They included the cubist-inspired painters Leonard Edmondson, Peter Krasnow, Rico Lebrun (perhaps the most nationally recognized L.A. artist of the 1940s), Howard Warshaw, and June Wayne. Building upon a more organic understanding of cubism, artists such as Ynez Johnston infused aspects of *art brut* with the gestures of lyrical abstraction to extend the definitions of expressionism. More mainstream abstract-expressionist painters in Los Angeles included Hans Burkhardt, Knud Merrild (who, notably, was producing abstract drip paintings—what he termed "flux" paintings—before Pollock) (fig. 1.22), Richards Ruben, Hassel Smith (who exhibited in Los Angeles throughout the 1950s but didn't formally settle in the city until 1965), and Emerson Woelffer. Furthermore, painters Philip Guston, Reuben Kadish, and Jackson Pollock were all students in Los Angeles before being identified with the New York school.[17] Indeed, nearly all of the L.A. artists who would come to prominence in the 1960s— including John Altoon, Billy Al Bengston, Robert Irwin, Helen Pashgian, and Ed Ruscha—moved through an abstract-expressionist phase on the way to more mature work.

While there were numerous L.A. artists working in more naturalistic styles, including the popular American Scene painters of the 1920s through 1950s, the city's early expressionists constituted a small circle, many of whom were in frequent contact with Walter and Louise Arensberg. The couple nurtured ties to artists and movements in New York and Europe, helping to ensure that the art scene in Los Angeles did not sink into provincialism. The influence of these early expressionist painters was greater than their modest numbers might suggest because many also taught at various L.A. art schools: Chouinard Art Institute (now California Institute of the Arts); California State University, Los Angeles; Long Beach State College (now California State University, Long Beach); Jepson Art Institute; Pasadena City College; Stickney Memorial Art School; Otis Art Institute (known in the mid-1950s as the Los Angeles County Art Institute); and Art Center School (later Art Center College of Design), among others. These artist-educators were able to help the next generation understand the significance of national and international contemporary art trends as they were occurring.[18] Ed Ruscha, Joe Goode, and Larry Bell, for example, all studied under Emerson Woelffer at Chouinard, one of several L.A. schools where Woelffer taught from the late 1950s to the late 1980s.

Before moving to Los Angeles in 1959, Woelffer had been teaching in his hometown of Chicago at the Institute of Design, the Bauhaus-inspired school founded by Hungarian artist László Moholy-Nagy. In 1954, Woelffer was invited to teach at the Colorado Springs Fine Arts Center, an institution that had offered residencies and teaching positions to many of the nation's leading visual artists, including L.A. painters Ynez Johnston and Lee Mullican.[19] While an artist-in-residence there, Woelffer formed a close friendship with Robert Motherwell, with whom Woelffer shared various enthusiasms for jazz, avant-garde books, and African and Oceanic art. Woelffer's travels to the Yucatán, Naples, and Turkey in the 1950s and 1960s also informed his abstract-expressionist canvases and collages; works from this period, such as *Untitled (Yucatan)* (1950) (fig. 1.23) reflect hot tropical colors and suggestions of land meeting ocean. These gestures carried over into later work like *Man from New Hebrides* (1969), which was part of a series "dedicated to 'Dada Saids and Surrealist Heroes.'"[20] But what is perhaps more important than his reverence for these European movements is Woelffer's unorthodox use of both the stark contrasts of Bauhaus design and the bold gestures of the New York school. Many artists, including Ed Ruscha, have acknowledged Woelffer's important and lasting influence.[21]

Like Woelffer, Ynez Johnston—a native of Berkeley, California, who produced paintings, etchings, ceramics, mosaics, textiles, and sculptures—spent a significant amount of time in Mexico and Europe, where she absorbed influences ranging from Byzantine and early Christian art to Peruvian textiles, Indian miniatures, and painting by modernists living in France, such as Jean Dubuffet, Klee, Joan Miró, and Picasso.[22] In 1951, the Museum of Modern Art purchased Johnston's *Dark Jungle* (1950), a painting that reflects the kinds of dreamy organic worlds for which the artist became known. As the 1950s progressed, Johnston's brushstrokes relaxed into looser gestures, evident in *Azure Coast, 1956* (fig. 1.24). The foreground of this relatively large canvas is composed of an abstract architectural network of lines and hash marks. This compound geometric focus is set against an atmospheric background that echoes the central form's palette of mint green, watery blue, and smoky black. The painting is a transitional work that connects the fine line drawings of Johnston's early 1940s etchings and lithographs to her gracefully open watercolor and ink compositions of the early 1960s. Although Johnston returned to whimsical mosaic-like patterning in her later paintings and sculptures, her entire body of work is characterized by a liberal use of vivid colors.

While Johnston and Woelffer incorporated their experiences abroad into their artwork, another L.A. expressionist, Hans Burkhardt, developed his technique largely during a sojourn in New York. Burkhardt, a Swiss-born artist who emigrated to the United States in 1924, began his art studies in the late 1920s at New York's Cooper Union, then continued at the Grand Central School of Art. At Grand Central, Burkhardt developed a close friendship with artist Arshile Gorky, with whom he frequently collaborated; under Gorky's guidance and influence, Burkhardt began developing his own energetic style of lyrical abstraction suffused with fierce expressionism. By the time he moved to Los Angeles in 1937, Burkhardt was well versed in the Continental styles of geometric abstraction, cubism, fauvism, and early forms of surrealism. The bloody Spanish Civil War (1936–39) inspired Burkhardt to begin making explicit statements against violence in his work; *One Way Road* (1945) depicts a pathway receding toward a distant horizon; the post-apocalyptic landscape on either side of this road is crowded with fragmented forms that evoke bodies, bones, weapons, and machines. The work is a poignant commentary on war's destructive debris—human and otherwise—evoked through abstract imagery. Burkhardt's antiwar position would reappear throughout his career, most famously in his canvas *My Lai;* in it, Burkhardt reacts to the horrors of the Vietnam War through frenetic gestural brushstrokes and the use of real human skulls fixed to the canvas amid thick layers of oil paint (fig. 1.25).[23] The painting exemplifies Burkhardt's mature style: an individual interpretation of New York–school abstraction suffused with political content, a confluence of 1960s radicalism and the formal experimentation of abstract expressionism.

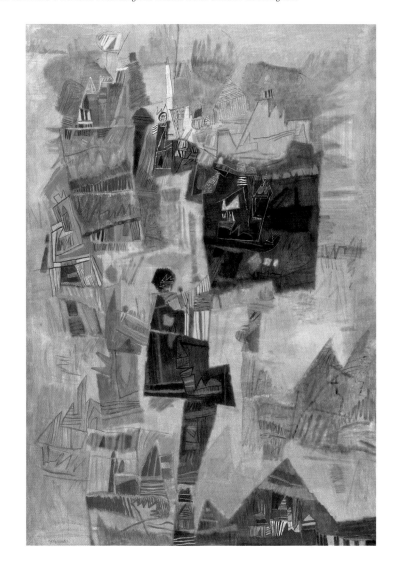

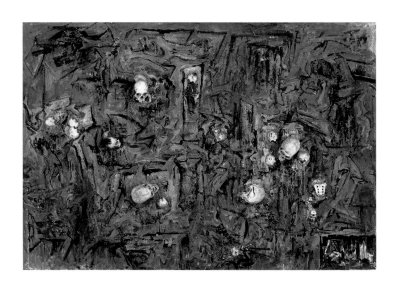

Figure 1.23.
Emerson Woelffer (American, 1914–2003). *Untitled (Yucatan),*
1950. Oil on canvas, 58.4 × 48.3 cm (23 × 19 in.). Private collection.
Image courtesy Hackett | Mill, San Francisco.

Figure 1.24.
Ynez Johnston (American, b. 1920). *Azure Coast, 1956,* **1956.**
Oil on canvas, 152.4 × 106.7 cm (60 × 42 in.). Los Angeles,
Los Angeles County Museum of Art. Courtesy Ynez Johnston and
Decker Studios, Los Angeles. Digital Image © 2009 Museum
Associates / LACMA / Art Resource, NY.

Figure 1.25.
Hans Burkhardt (Swiss, 1904–1994). *My Lai,* **1968.** Oil,
assemblage with skulls on canvas, 195.5 × 292.1 cm (77 × 115 in.).
Los Angeles, Jack Rutberg Fine Arts. © Hans G. & Thordis
W. Burkhardt Foundation. Courtesy Jack Rutberg Fine Arts,
Los Angeles, and Hans G. & Thordis W. Burkhardt Foundation.

Whereas Burkhardt's gestural abstractions often embody the anxieties and emotions of the human condition, Lee Mullican's canvases reveal his interest in transcendental states of human consciousness, as practiced by various world cultures. During World War II, Mullican joined the U.S. Army, an experience that took the artist to cities like Washington, D.C., and New York—where he visited major museums—as well as to Guam, Hawaii, the California desert, and Japan; later, he visited Mexico. Exposure to this variety of cultures and locales informed

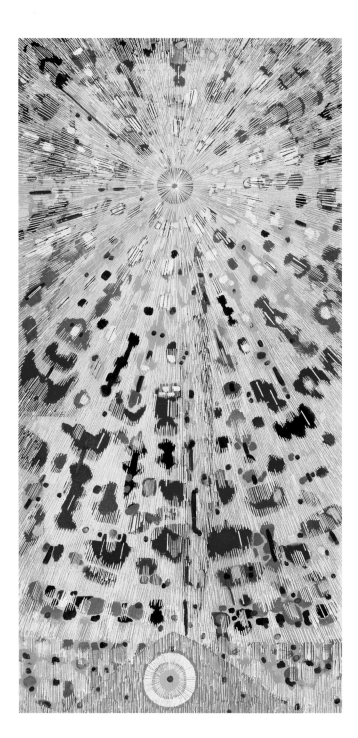

his understanding of modernism and influenced his deeply spiritual philosophy of art.[24] While many New York and European modernists had looked to African art for inspiration, in a trend popularly known as "primitivism," Mullican had turned elsewhere, to Shinto shrines, Native American ceremonies, and pre-Columbian statuary.

After his discharge from the Army Corps of Engineers, Mullican settled in San Francisco, where he became immersed in the city's vibrant art scene. With fellow painters Wolfgang Paalen—a major figure in Latin American surrealism of the 1940s—and Gordon Onslow-Ford, Mullican founded Dynaton, a movement that Paalen described as a "metaplastic" art form aimed at representing the limitless realities of inner space, modern physics, and cosmic realms. In working with Paalen and Onslow-Ford, Mullican gained an appreciation for early New Age philosophies and dissident surrealism (that is, surrealist approaches developed outside of Paris and the circle around André Breton). In a representative Dynaton work, Mullican's *The Ninnekah* (fig. 1.26), golden marks and patterning radiate outward from a circular center, creating a solar form evocative of some of the tribal art that so affected Mullican. The group's efforts culminated in an eponymous exhibition at the San Francisco Museum of Art in 1951, but despite the show's success, the group disbanded. Mullican moved from Northern California to Santa Monica, a Southern California beach city, to create a fresh start for himself.[25]

Initially, Mullican struggled to find a community in Los Angeles as sympathetic as the Dynaton group. Nevertheless, he resolved to stay, developing careers in both art and teaching, writing plays and exploring other art forms, and participating in the Instant Theatre directed by performance artist Rachel Rosenthal (see chapter 2, sidebar 11). His painting technique evolved, and he began composing more unified and contemplative pictures. As critic Jules Langsner wrote, "Composition for Mullican evolves through 'similarity.' Similarity of color, of form, of value and the minute complications of similar colors, values and forms."[26] This is evident in later work such as *Untitled (Venice)* (1967) (fig. 1.27), a canvas in which Mullican departs from his characteristic sunburst forms, painting interlocking geometries of red, blue, orange, and gold using a palette knife. This defined mark-making results in a complex network of interwoven lines and concentric circles. Surprisingly, perhaps, this cohesive but punctuated ground bears a strong affinity to the jagged abstract landscapes of Ynez Johnston and the saturated color fields of Woelffer. And, like Woelffer, Burkhardt, and Johnston, Mullican resisted a merely regionalist art practice. Instead, he and these Southern California contemporaries sought a broad international exchange and a lively engagement with major modernist movements, in which they saw themselves as integral participants.

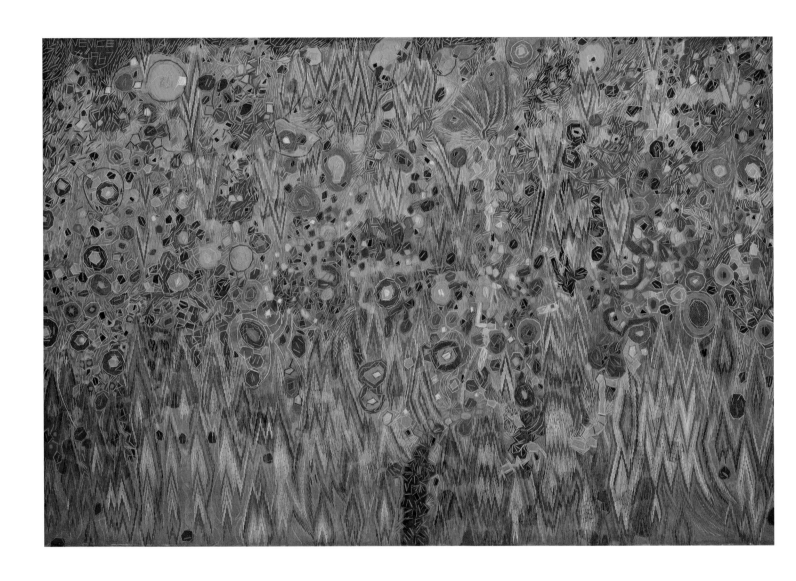

Figure 1.27.
Lee Mullican (American, 1919–1998). *Untitled (Venice),* **1967.**
Oil on canvas, 203.2 × 304.8 cm (80 × 120 in.). Los Angeles, Marc
Selwyn Fine Art. Courtesy Marc Selwyn Fine Art.

HARD EDGES, FLAT FORMS

Otherwise-isolated Southern California artists collectively promoted their careers and philoso-
phies of art in yet another way: by creating and marketing a group identity. The group that
would become the Abstract Classicists, which began to flourish in the mid- to late 1950s, repre-
sents a successful example of such functional unions. Painters Karl Benjamin, Lorser Feitelson,
Frederick Hammersley, and John McLaughlin shared a penchant for minimal, geometric
abstraction marked by the use of clean lines, bold colors, and flat, interrelated forms. Living miles
away from one another—Benjamin and Hammersley in the Inland Empire city of Claremont,
Feitelson in Los Angeles proper, and McLaughlin in the coastal town of Dana Point—the four
artists were aware of one another but did not generally spend time together or work side by

Figure 1.28.
Karl Benjamin (American, b. 1925). *Floating Structure #5,*
1962. Oil on canvas, 81.3 × 101.6 cm (32 × 40 in.). Los Osos,
California, collection of Michael and Willy Miller, LSFA 1269.
Art © Karl Benjamin. Courtesy Louis Stern Fine Arts. Photo:
Michael Faye Photography.

side. Nevertheless, in concert with a few important critics and curators, the artists were able to
invent a label for themselves—Abstract Classicism—and successfully position it as a movement
that was an alternative to New York abstract expressionism.

While Abstract Classicism, also called hard-edge painting, can be traced to European geo-
metric abstraction from the early twentieth century, the movement coalesced in Los Angeles
unburdened by the prewar history and politics of European modernism that was so decisive in
New York. An all-over abstraction, it emphasized unified composition rather than the push
and pull that the German American painter Hans Hofmann derived from European cubism and
brought to the New York school. Abstract Classicism was also a mode of painting that, while
totally removed from the au courant expressionism of the era, still retained a sense of rhythm,
balance, and movement across the surface of the canvas. The paintings of Karl Benjamin, for
example, are dynamic studies in color relationships in which geometric forms interlock at jagged
angles or float over a flattened picture plane (fig. 1.28). John McLaughlin's painted forms, by
contrast, are restrained arrangements of horizontal and vertical lines that employ muted colors
only to further a formal juxtaposition. Yet both McLaughlin and Benjamin (as well as the other
hard-edge painters) approached their paintings through both rational and instinctual processes

of selection and trial and error. Underlying this method is a high regard for purity and clarity, a trait that defines the artists as Abstract Classicists.

As early as 1951, Los Angeles County Museum curator James Byrnes had developed a "classical" category of abstract painting in his annual exhibition. However, the Abstract Classicists did not become an established affiliation until about 1955, when art historian Peter Selz moved to Claremont to chair Pomona College's art department and direct the college's gallery.[27] At the time, painting in Southern California was dominated by figurative, post-cubist work by artists like Millard Sheets and Rico Lebrun, both of whom established national reputations and were teaching in local art schools (Lebrun at Chouinard and Otis, and Sheets at Scripps College, Chouinard, Otis, and Claremont University College). In the early 1950s, the town of Claremont—where Benjamin taught elementary school and Hammersley taught painting and drawing at Pomona College—fostered an active painting scene in which the figurative styles of artists like Paul Darrow, Susan Lautmann Hertel, and Douglas McClellan predominated. It was Selz's friendship with Benjamin and Hammersley that set things in motion. As Benjamin later recalled:

> Peter came by [my house] and said, "What are we going to do about your career because you're not identified with anything? There are no schools." And so I said, "Well, there are other people around that are painting with these abstract shapes." I mentioned the three who I knew slightly [Feitelson, Hammersley, and McLaughlin] and Peter said, "Well, I'll have a show here at Pomona's gallery.". . . [Art critic] Jules Langsner got interested, and because he was interested, he gave all four of us good reviews.[28]

Recognizing that they shared a common approach to abstraction that stressed formal color relationships, rhythmic patterning, and cool compositions, Benjamin, Selz, and Langsner initiated a dialogue with Feitelson, Hammersley, and McLaughlin (fig. 1.29). Although McLaughlin and Feitelson, both born in 1898, were a generation older than Hammersley and Benjamin (born 1919 and 1925, respectively), the painters used similar techniques and shared the desire to champion a new trend. According to Benjamin:

Figure 1.29.
Curator Jules Langsner (far left) meets with the Abstract Classicists: (left to right) Karl Benjamin, John McLaughlin, Frederick Hammersley, and Lorser Feitelson at Feitelson's studio, 10 May 1959. From the cover of the Los Angeles Institute of Contemporary Art's *Journal*, no. 5 (1975). Photo by Harry Carmean. © Harry Carmean 1959. Paintings on the wall are by Helen Lundeberg. © Feitelson Arts Foundation. Courtesy Louis Stern Fine Arts.

> We had some meetings at Lorser's house or at my house. Nobody was talking about having the same
> philosophy or anything, it's just that we had this similarity. We decided that if we had a name, it
> would be something for critics to sink their teeth into. There were all kind of suggestions about what
> to use for a name, and we're still arguing who to blame for [Abstract Classicists]. I think it was prob-
> ably either one of the two art historians because I hated the term.... It was sort of merchandising,
> in a sense, and it worked in a way.[29]

Indeed, Langsner has been given much of the credit for the invention of this group: it was he who curated the groundbreaking exhibition *Four Abstract Classicists,* which opened in July 1959, not at the Pomona College gallery as intended but rather at the San Francisco Museum of Art. It then traveled to the Los Angeles County Museum, to London's Institute of Contemporary Art (March 1960, curated by Lawrence Alloway), and to Queen's University in Belfast, Northern Ireland.

Four Abstract Classicists presented the Southern California artists as "flying in the face of current fashions in art nomenclature."[30] The idea of a "classical" contemporary painting was counter to the raw emotion, energy, and alleged spontaneity of the established abstract-expressionist painters. But, as Langsner argued in the exhibition's catalog, applying classicism as a conceptual basis for abstract painting was a creatively vital and no less viable approach:

> The classicist might be described as a form conscious artist ... form as a primary force in esthetic
> experience is stressed in classical art.... [It] is defined, explicit, ponderable, rather than ambiguous
> or fuzzily suggestive.... Consequently, response to the [classical] work as an esthetic entity cannot be
> separated from active perception of form.... The California Abstract Classicists proceed from this
> intention.... The structural principle guiding these four artists is the same. The ways in which they
> elaborate the concept varies from painter to painter.[31]

Each of the four painters represented form as a clearly defined element—delineated by a hard, clean, painted border—set against complementary shapes or fields of color. In this sense, form and color became codependent compositional parts, a stylistic notion that Langsner termed "colorform." Selected jointly by Langsner and the artists, the works included in *Four Abstract Classicists*—ten by each artist for the California exhibitions and about three per artist when the show traveled abroad—reflected the diversity of colorform while demonstrating the stylistic logic that connected the four practitioners to one another.

Lorser Feitelson, the senior artist in the group, had become aware of a neoclassicist revival during his time in Paris in the early 1920s. It was a style that he continued to incorporate into his romantic, semiabstract paintings later in that decade and into the 1930s, and that formed the basis for post-surrealism—a movement Feitelson cofounded with painter Helen Lundeberg, who would later become his wife (see sidebar 4). Lundeberg, a former student of Feitelson's at the Stickney Memorial Art School in Pasadena, had been excluded from *Four Abstract Classicists;* however, she was an important proponent of hard-edge painting in her own right. Feitelson's two breakthrough series, *Magical Forms* (begun in 1944) and *Magical Space Forms* (begun in 1948), featured in *Four Abstract Classicists,* developed out of his post-surrealist renderings of foreshortened figures, vague horizon lines, and compound vanishing points. Painted to be "psychologically evocative without referring to the outer world,"[32] the *Magical Forms* works eliminate three-dimensional (or illusionistic) space to exaggerate the flux of geometric movement. This technique emerged from the late post-surrealist paintings, in which Feitelson began to compress illusionistic space, rendering scenes almost like theatrical stage flats or backdrops. In a photograph from the late 1940s, these paintings seem to suggest literal set dressing for a modern dancer (fig. 1.30). From this artificial flatness, the artist culti-vated a planar abstraction that appears to bend space within the compositional frame, hence

Figure 1.30.
Modern dancer with *Magical Forms* paintings by Lorser
Feitelson, ca. 1949. Photo by Geo. S. Fletcher. Art © Feitelson
Arts Foundation, courtesy Louis Stern Fine Arts.

Figure 1.31.
Lorser Feitelson (American, 1898–1978). *Magical Space Forms,*
1952. Oil on canvas, 152.4 × 101.6 cm (60 × 40 in.). Miami, collec-
tion of Fontainebleau Hotel, LSFA 169. © Feitelson Arts
Foundation, courtesy Louis Stern Fine Arts. Photo by Casey Brown.

Figure 1.32.
Lorser Feitelson (American, 1898–1978). *Untitled (Red on
White Optical),* **1964.** Oil on canvas, 152.4 × 101.6 cm (60 × 40 in.).
New York, D. Wigmore Fine Art. LSFA 216. © Feitelson Arts
Foundation, courtesy Louis Stern Fine Arts. Photo by Casey Brown.

the "magic" of these forms (fig. 1.31). In mature work from this series, he achieves a composi-
tional shift in which the negative space of the picture plane appears enlarged. This emptying-
out of discrete forms evolved into the increasingly minimal paintings in Feitelson's *Stripe* series
(fig. 1.32) and *Boulder* series of the early 1960s.

While Feitelson's roots were in European modernism (namely, purism, surrealism, and
cubism), John McLaughlin took the master Japanese artists as his departure point. In the
late 1920s, McLaughlin began studying, collecting, and dealing in Japanese art, a passion that,
during the war years, would lead the artist to serve in the Marine Corps as an interpreter at
California's Manzanar War Relocation Center—where Japanese American citizens were interned—
and as a field officer in Southeast Asia. His immersion in Asian cultures led McLaughlin to
take a philosophical and spiritual approach to art making that stressed the unity of man with
nature, simple forms, neutral colors, and the presence of emptiness. When his abstraction
matured around 1948, the artist turned to the rectangle, a form that could act as both planar ele-
ment and void. As the influential critic John Coplans described it, "McLaughlin's rigorously
limited formal means create large, simple areas of non-shape (a better definition might be fields
of force) in which his forms are unstable and in flux, continuously changing their relation-
ships within the canvas in a slow rhythm that eventually leads to stasis. The simplicity of
McLaughlin's elements is a denial of rhetoric and ornament rather than any form of abbrevia-
tion."[33] (See sidebar 5.)

Helen Lundeberg (American, 1908–1999). *Abandoned Easel #4*, 1946. Oil on cardboard, 13.3 × 26 cm (5¼ × 10¼ in.). Los Angeles, Louis Stern Fine Arts, LSFA 2606. Art © Feitelson Arts Foundation, courtesy Louis Stern Fine Arts. Image © Photography by Ed Glendinning.

Helen Lundeberg (American, 1908–1999). *A Quiet Place*, 1950. Oil on canvas, 40.6 × 50.8 cm (16 × 20 in.). Irvine, California, collection of Brent R. Harris, LSFA 2604. Art © Feitelson Arts Foundation, courtesy Louis Stern Fine Arts. Image © Photography by Ed Glendinning.

LATIN AMERICAN AND EUROPEAN SURREALISM exerted a strong influence on American art of the postwar period, in part because many surrealists who fled war-torn Europe for America helped popularize the prominent avant-garde movement in the United States. But even before World War II, a group of L.A. artists had organized the small school of post-surrealism—the first North American critique of surrealism. In "Explanatory Text for Six Paintings by Helen Lundeberg," an unpublished manifesto drafted in 1934, Lundeberg wrote:

> Post-surrealism is concerned with the creation of order through introspection rather than with the surface organization of introspective subject matter. It differs equally from the expressionist surrealism—which plays with caprice, with the unorganized psychic meanderings—and from the cubistic surrealism, which, in organizing subjective material, still clings to the traditional principles of objective-order.[1]

Lundeberg's text reveals that she originally used the term "new classicism" to define her theoretical stance, then crossed it out and wrote "post-surrealism" instead. It is no coincidence, therefore, that the word

"classicism" was later taken up for the momentous exhibition *Four Abstract Classicists* (1959) at the Los Angeles County Museum of History, Science, and Art. However, in deciding to define her artwork as "post-surrealist"—that is, as a reappraisal of a successful contemporaneous art movement from Europe—Lundeberg was making a bold move, especially for a woman artist living and working in Los Angeles in the 1930s.[2]

Post-surrealism in California can be defined by its lucid subject matter—images consciously rooted in reality rather than the dream imagery of surrealism—as well as its clear representations, theatrical compositions, and dramatic rendering of depth and shadow. Lundeberg and fellow painter Lorser Feitelson established a loose association of post-surrealists, a group that initially included Lucien Labaudt, Harold Lehman, Knud Merrild, and Étienne Ret, with Grace Clements, Philip Guston, and Reuben Kadish joining later. In November 1934, the first group exhibition of post-surrealist work opened at the Centaur Gallery in Hollywood (which later became the Stanley Rose Gallery); it was followed by group shows in San Francisco and New York. As the group's reputation grew, Feitelson, Lundeberg, and Merrild were even included in Alfred H. Barr Jr.'s high-profile exhibition *Fantastic Art, Dada, Surrealism* at New York's Museum of Modern Art (1936–37), the first in a series of five important exhibitions of contemporary trends.

In the late 1940s, Feitelson and Lundeberg began to shift from post-surrealism to hard-edge abstraction. A piece such as Lundeberg's *Abandoned Easel #4*—a seascape with an easel atop a sort of pier, with a lone figure in the background—is a clear precursor to her first completely abstract, hard-edge canvas, *A Quiet Place*. Although *A Quiet Place* is nonrepresentational and shows the artist's divergence from the pictorial aims of post-surrealism, it nevertheless retains the earthy palette, the stark rendering of shadow, and the introspective tone of *Abandoned Easel*; even the two paintings' compositions are similar, with the architectural components of the earlier work echoed by the bold, dark stripe running down the left edge of *A Quiet Place*. By focusing on the simplicity of what critic Jules Langsner called colorform, Lundeberg and Feitelson effectively transformed the psychological content of their post-surrealist style into a concentrated exploration of purely formal poetics.

Notes

1. Helen Lundeberg, "Explanatory Text for Six Paintings by Helen Lundeberg," unpublished manuscript (1934), corporate archive, Louis Stern Fine Art, Los Angeles, 1.

2. In 1952, Lundeberg also pioneered the Functionalists West movement, a group of abstract painters that included Elise Cavanna, Feitelson, Stephen Longstreet, and, by 1953, fourteen other artists—among them Hans Burkhardt, Leonard Edmondson, Jules Engel, John McLaughlin, Eva Slater, June Wayne, and Jack Zajac. Over the next two years, the group had a series of exhibitions at the Los Angeles Art Association, garnering reviews in *Art News* and the *Los Angeles Times*.

As his work developed into the 1950s, McLaughlin's investigations of symmetry and compositional centering became increasingly complex, using a technique of layering tonal bars on adjacent planes. In *Untitled* (fig. 1.33), for example, he has divided the canvas down the center, then split the left field again into two vertical fields, which are intersected by an off-white circle that quietly hovers against the stasis of the darker bars. In later works, like *#18-1961* (fig. 1.34), this tension among the perceived planes causes the geometric elements to shift forward and backward as the viewer struggles to reconcile them. In this and other canvases, beginning in the late 1950s, McLaughlin moved away from purely neutral color and instead began exploring shades that would heighten these effects: vivid light blues, deep red-oranges, and soft greens in relation to black, white, and gray.

McLaughlin painted not through the systematic logic of geometry or mathematics—as did so many of the European geometric abstractionists of the 1930s—but rather through an attention to the colors and juxtaposing forms that suggested themselves to the composition. Other hard-edge painters took a similar approach. Frederick Hammersley perhaps best articulated such spontaneity of process (in otherwise carefully planned paintings, executed by applying unmixed paint directly from the tube with a palette knife) through the notion of his "hunch" paintings, a kind of automatic or unconscious geometric painting that he first executed in 1950. As he explained in the catalog for *Four Abstract Classicists:*

Figure 1.33.
John McLaughlin (American, 1898–1976). *Untitled*, 1952.
Oil and casein on fiberboard, 81.5 × 122.1 cm (32⅛ × 48⅛ in.).
Washington, D.C., Hirshhorn Museum and Sculpture Garden,
Joseph H. Hirshhorn Purchase Fund, 1991. Photo by Lee Stalsworth.

Figure 1.34.
John McLaughlin (American, 1898–1976). *#18-1961,* 1961.
Oil on canvas, 12.19 × 1524 cm (48 × 60 in.). Private collection.

I compose a painting by hunch. A "hunch" painting begins by having several different sizes of canvas around. By seeing them every day I will for some unclear reason pick up one. Part of the time I have no idea what to begin with. I like the size and shape in front of me and I try to put marks on it to go with it. It seems to be a process of responding or reacting to a particular "liked" canvas.[34]

But unlike McLaughlin, who systematically organized his compositions to achieve a kind of Zen stasis, Hammersley produced a variety of vibrant compositional rhythms, as in *Up with in* (fig. 1.35).

Karl Benjamin developed his process to include the element of chance as well as intuition. In a series from 1965, for example, he asked his young daughter to select numbers from a hat that corresponded to colors, which the artist then painted on a gridded canvas. He explained, "I am an intuitive painter, despite the ordered appearance of my paintings. . . . I have been working with systems including relatively simple numerical progressions, modular constructions and random sequences. Images formed thusly emerged in very surprising and gratuitous ways. . . ."[35] In this sense, Benjamin's ordered processes may, surprisingly, be considered spontaneous, embodying the tension between structure and boundlessness that is characteristic of his colorforms.

In the early 1950s, Benjamin was painting in a predominantly cubist style, but his canvases—seascapes, street scenes, landscapes, and still lifes—were approaching total abstraction; architecture and the natural world were rendered with stark lines and bold areas of color. In 1955, Benjamin painted his breakthrough work *Small Totem,* which balances figure and ground to compose a unified, geometric whole rather than an illusionistic representation. Variations on this work eventually led Benjamin to his important *Interlocking Forms* series around 1957. In the latter series—examples of which were included in *Four Abstract Classicists*—jagged, vertical shapes form a cohesive picture plane while each distinct, lateral band of color breaks up the continuity to create a visual cadence (fig. 1.36). In *Stage II* (fig. 1.37), Benjamin's rhythmic patterning is executed in bright, saturated colors that perceptually thrust the geometric configurations toward the viewer. As Benjamin recalled, "McLaughlin used to kid me about my color. He'd always say, 'That is very seductive color, tsk, tsk, tsk. . . . You only use a color when you fill in the black part and the white part and you needed another element.'"[36]

Figure 1.35.
Frederick Hammersley (American, 1919–2009). *Up with in,* 1957–58. Oil on linen, 121.9 × 91.4 cm (48 × 36 in.). Claremont, California, Pomona College Museum of Art, museum purchase with funds provided by the Estate of Walter and Elise Mosher. Art © The Frederick Hammersley Foundation. Photo by Schenck & Schenck, Claremont.

Figure 1.36.
Karl Benjamin (American, b. 1925). *Interlocking Forms (Yellow, Orange, Black),* 1959. Oil on canvas, 107 × 122 cm (42 × 48 in.). Logan, Utah, Nora Eccles Harrison Museum of Art, Marie Eccles Caine Foundation Gift, 1994.31. Art © Karl Benjamin, courtesy Louis Stern Fine Arts.

Figure 1.37.
Karl Benjamin (American, b. 1925). *Stage II*, **1958.** Oil on
canvas, 127 × 177.8 cm (50 × 70 in.). Beverly Hills, collection of
Louis Stern, LSFA 11554. Art © Karl Benjamin, courtesy Louis
Stern Fine Arts. Photo: Michael Faye Photography.

5 Zen in the Studio CATHERINE TAFT

ZEN, A SCHOOL OF MAHAYANA BUDDHISM, emphasizes the attainment of enlightenment through meditation, intuition, and experiential insight. From its origins in seventh-century China (with the arrival from India of the teacher Bodhidharma), the philosophy spread to Vietnam, Korea, Japan, and, by the late nineteenth century, the West.[1] In the Americas and Europe, it seemed to offer a new way of understanding human existence and an alternative to traditional Western philosophy and religion— something many modern Westerners, especially Americans, were seeking. By the mid-1900s, California—with a history of tolerating unorthodox belief systems (from spiritualism to the New Age movement) and a population that included large numbers of East Asian immigrants—was especially open to the influence of Zen. Buddhism moved into mainstream culture after World War II and was embraced by a number of hard-edge painters and ceramicists, for whom it offered a rewarding approach to making and viewing art.

Painter John McLaughlin often spoke of the importance of Japanese art and philosophy to his practice, specifically citing the fifteenth-century Zen painter Tōyō Sesshū and his principle of *ma,* the "marvelous void." The notion of *ma*—a spatial emptiness that provides an essential focal point between two objects or subjects—is central to many of McLaughlin's compositions, such as *#8,* an understated canvas in which two parallel, black horizontal lines quietly border the bottom edge of an open white field. Critic Peter Selz noted that in McLaughlin's work—as in Japanese art, architecture, and even gardens—voids are important design elements that often serve as contemplative spaces. "McLaughlin understood and worked within this same aesthetic," wrote Selz. "He sought, unlike the method of most Western painting, to refrain from recording his own reactions or ideas."[2] Reducing his paintings to a few basic forms, McLaughlin strove to eliminate the self (or the artist's hand) from the picture plane, allowing the implicit beauty of line and color relationships to arise naturally. As McLaughlin himself explained, "My purpose is to achieve the totally abstract. I want to communicate only to the extent that the painting will serve to induce or intensify the viewer's natural desire for contemplation without benefit of a guiding principle. . . . This I manage by the use of neutral forms."[3]

Zen was also a presence in the burgeoning ceramics studio of the Otis Art Institute, directed by Peter Voulkos. Malcolm (Mac) McClain, one of Voulkos's first students, recalled that "on one occasion Arthur Ames [head of the Otis design department] kidded Voulkos about all the Zen books lying around the classroom, joshing that the 'whole shop was going Zen.' The next day, labels had blossomed on every artifact in the room: 'Zen' water faucets, 'Zen' chairs, 'Zen' clay."[4] Indeed, the working methods Voulkos developed were his own variant of Zen-inflected teaching, arising largely from his observation of *mingei* ceramics practice at the Archie Bray Foundation in Helena, Montana. There, proponents of *mingei,* including potter Shoji Hamada and Japanese philosopher Sōetsu Yanagi, had journeyed from Japan to present workshops. Roughly translated as "folkcraft," *mingei* is a movement that began in the late 1920s as an effort to revitalize artisanal traditions by combining reverence for the untutored peasant craftsmen of Japan's past with an underpinning in Kyoto-school Zen Buddhism. Voulkos had absorbed this methodology during his studies and applied innovations to his craft that stemmed from the Japanese style: asymmetry, architectonic form, abstract decoration, and chance effects. Through his distinctive techniques, Voulkos was able to bring the lessons learned from traditional craftsmen to bear on a series of issues being explored by contemporary Western artists.

Notes

1. The version of Zen that came to the United States was, however, quite different from the original. See Helen Westgeest, *Zen in the Fifties: Interaction in Art between East and West* (Zwolle: Waanders Uitgevers, 1996).
2. Peter Selz, "Abstract Classicism Reexamined," in John McLaughlin, *Western Modernism, Eastern Thought* (Laguna Beach, Calif.: Laguna Art Museum, 1996), 66.
3. John McLaughlin, *John McLaughlin: A Retrospective Exhibition* (Pasadena, Calif.: Pasadena Art Museum, 1963), 4.
4. Mac McClain, "Soldner: The Student, 1954–56," in Elaine Levin, Mac McClain, and Mary Davis MacNaughton, *Paul Soldner: A Retrospective* (Claremont, Calif.: Scripps College, 1991), 31.

John McLaughlin (American, 1898–1976). *#8,* 1966. Oil on canvas, 121.9 × 152.4 cm (48 × 60 in.). Chicago, The Marilynn and Carl Thoma Collection. Image courtesy Greenberg van Doren Gallery, New York.

Figure 1.38.
Helen Lundeberg (American, 1908–1999). *Sloping Horizon*,
1960. Oil on canvas, 101.6 × 101.6 cm (40 × 40 in.). Newport Beach,
California, Orange County Museum of Art, museum purchase
with funds provided through the prior gift of Lois Outerbridge.
© Feitelson Arts Foundation, courtesy Louis Stern Fine Arts.

Although Benjamin, Feitelson, Hammersley, and McLaughlin were most associated with the
hard-edge painting movement, other artists worked alongside them, including Helen Lundeberg
and later June Harwood, who married critic Jules Langsner. In the early 1950s, Lundeberg's
post-surrealist architectural scenes and still lifes gave way to an increasingly non-objective
subject matter; her canvas *A Quiet Place* (1950) (see illustration in sidebar 4) marked her first
foray into total abstraction and set a precedent for the artist's distinctive conflations of interior
and exterior space. The works that followed hint at structures—arches, doorways, bridges, cor-
ners of buildings, or freestanding walls—that recede into flat geometric fields of abutting color.
Lundeberg continued such investigations into the early 1960s through primarily dark, muted tones
that imply the umbra and penumbra of shadowy space. *Sloping Horizon* (fig. 1.38), for example,
is a composition of trapezoids, squares, and triangles in neutral shades; while painted on a kind
of axis, it appears to have no single horizon line. Nevertheless, the work references landscape
through its earthy colors and complex vantage points. In mid-1960s works, such as *Water Map*
(1963), *Blue Planet* (1965) (fig. 1.39), and *Cloud Shadows* (1966), Lundeberg's palette becomes
light and airy while her curvilinear compositions continue to allude to organic matter: a shallow
tide pool, the California shoreline, desert sand dunes, a thick field of grass, or silhouetted tree
trunks.[37] Although Lundeberg continued working into the 1990s, she is most often associated
with painters of the 1950s; a reconsideration of her work from the 1960s on reveals a rich style
at its peak.

Despite being excluded from the Abstract Classicists—an obvious case of sexism—
Lundeberg played a central role in several self-formed artist groups of the period.[38] Although
many of these groups have been lost from the cultural memory of Los Angeles, the Abstract
Classicists remain an important school of L.A. painting, in part due to the group's international
success and serious reputation. When British curator Lawrence Alloway opened his version
of Langsner's seminal California exhibition at the Institute of Contemporary Art, London, as
Four Abstract Classicists—West Coast Hard-Edge, the term "hard-edge" was officially coined.[39]
"West Coast hard-edge," an adaptation of Langsner's notion of "clean-edged forms," seemed a

Figure 1.39.
Helen Lundeberg (American, 1908–1999). *Blue Planet*, **1965.**
Acrylic on canvas, 152.4 × 152.4 cm (60 × 60 in.). Los Angeles,
Louis Stern Fine Arts, LSFA 1483. © Feitelson Arts Foundation,
courtesy Louis Stern Fine Arts.

A confirmed golfer, John McLaughlin applies the same "pure concentration" to his game as to his paintings, one of which stands on San Clemente links. McLaughlin plays twice a week, spends rest of his time composing abstractions which, he hopes, will "induce contemplation."

A motorcycle buff, Billy Al Bengston keeps two of the vehicles in his studio at Ocean Beach, primed for racing at nearby tracks. Their gleaming surfaces harmonize with the dazzling images of his paintings which he produces with the aid of spray guns, oil paints, plastics and lacquer.

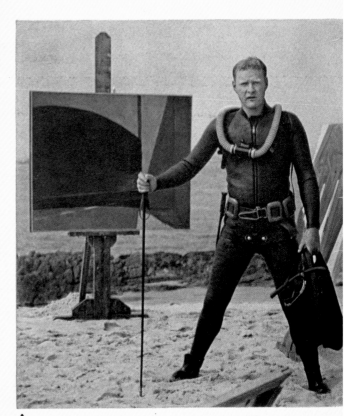

An expert skindiver, Roger Kuntz explores the waters of Crystal Cove, often spears seafood for his family. His paintings, however, are inspired largely by landlubber scenes—the curves, shadows and traffic signals of freeway networks and tunnels, which he flattens into abstract patterns.

straightforward way to describe the simplicity of these compositions, and the term caught on with the public. Hard-edge canvases, including those by Lundeberg and McLaughlin, cropped up in the 1960s as stylish backdrops for fashion and lifestyle photo spreads in magazines (fig. 1.40).[40] More importantly, the exhibition of hard-edge work in London gave a young David Hockney his first exposure to California culture. Like many young painters, Hockney was struggling under the weight of New York–school abstract expressionism; in West Coast hard-edge, the artist discovered an alternative school of painting that would make a lasting impression on his art and would factor into the lure of California as his eventual home.

OUT OF CLAY

Unlike the connections among the hard-edge painters, which seem to have been more strategic than sustaining, the ties that formed among the members of the ceramics studio at the Otis Art Institute (now Otis College of Art and Design) were deep and long lasting. In many ways, the Otis potters provided the first reproducible model of how to become successful L.A. artists. Peter Voulkos, John Mason, Ken Price, Billy Al Bengston, Henry Takemoto, Malcolm (Mac) McClain, and Paul Soldner formed the core of a nearly all-male group that spent most waking hours working and socializing together. The group's combination of overt machismo, hyper-competitiveness, and a tenacious work ethic would set a pattern for better-known L.A. "art gangs" of the future, such as the Ferus circle and the CalArts (California Institute of the Arts) mafia. But the group, under the charismatic leadership of Voulkos, was influential well beyond the social model it provided. The pot shop at Otis was, without doubt, one of the sites from which an original, indigenous modernism emerged in Southern California (fig. 1.41).

Peter Voulkos, after working at the Archie Bray Foundation in Helena, Montana (his home state), and teaching at Black Mountain College in North Carolina, was by 1954 garnering national attention for his innovations in ceramics. That year, he accepted an invitation from Millard Sheets, a painter and dean at Otis, to found a new ceramics program there. The program began slowly—Paul Soldner was the only student during the first quarter—but over the next year John Mason, Janice Roosevelt, Joel Edwards, Billy Al Bengston, Henry Takemoto, and Ken Price, among others, came to study with Voulkos (fig. 1.42). At the time, Otis lacked a pot shop, so Voulkos (along with Soldner) had to build and equip one; a new studio was eventually built at the school in 1958.

While the rest of Otis's program ran along fairly traditional lines, in Voulkos's courses there were neither lectures nor critiques nor grades; classes did not occur at set times and much of the activity took place in the middle of the night. For the first few years of the program, the instructor had no separate studio outside the school—he simply worked alongside his students. Voulkos later recalled that one of his goals at Otis was to connect with the excitement of the burgeoning modern art and architecture scene in Los Angeles in the mid-1950s: "We'd all go to class, and then the first thing we'd do is go off in three cars, driving around town, going to see whatever there was to see in galleries, drinking coffee and talking. We'd look at a new building going up or a show at a museum. Then we'd talk some more. Then we'd go to work."[41] As Soldner explained, "he didn't lecture, he didn't teach, he just worked."[42] Janice Roosevelt, one of the few women enrolled in the ceramics program, remembered that Voulkos "didn't come and tell you what to do unless you asked a technical question. He just assumed that you would watch what was going on and develop your own creativity."[43]

Despite the presence of Roosevelt and a handful of other women, the atmosphere at Otis was undeniably that of a boys' club (fig. 1.43).[44] The pot shop had few female participants at any given time and was characterized by pointedly male-oriented rituals and bonding. Voulkos was a veteran and many of the students had also served in the military; in this respect, the Otis pot shop reflected broader forces that were reshaping Southern California, where an enormous military presence created a booming economy and a large, aspiring middle class. The hierarchical and close-knit male community that characterized military society became the model for

Figure 1.40.
Page from **"Wide Open and Way Out,"** *Life*, 19 October 1962, **84.** Top: John McLaughlin posing with the painting *#21-1958*; left: Billy Al Bengston with *Hawaiian Eye* (1962); right: Roger Kuntz with *Tunnel Pattern* (1961). © 1962 The Picture Collection Inc., reprinted with permission, all rights reserved. Photos © Fred Lyon. Art © Billy Al Bengston. Art © The Estate of Roger E. Kuntz, courtesy Mary Kuntz.

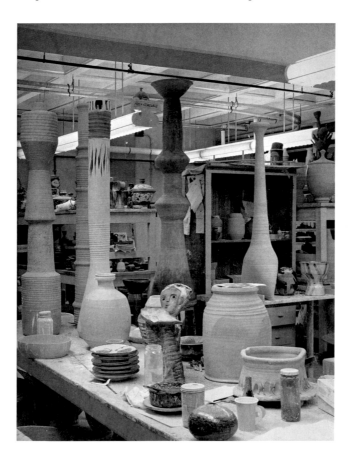

Figure 1.41.
The Otis pot shop, 1956. Photo by Paul Soldner (American, 1921–2011). © Soldner Enterprises and Stephanie Soldner Sullivan.

Figure 1.42.
Henry Takemoto, Peter Voulkos, and Jerry Rothman at Los Angeles County Art Institute (Otis), Los Angeles, 1957.

the region's leisure-based activities, which provided the underlying structure for the Otis group. The surf, custom-car, and motorcycle-club subcultures that attracted artists like Ken Price and Bengston—and that have played an outsized role in Southern California's image—were dominated by men. Mirroring the region's activities and communities, the L.A. art world embodied a cavalier culture of male kinship, camaraderie, and vigorous rivalry—as well as outright sexism—that persisted well into the 1970s.

In their late-night sessions, which again excluded all but a few women, the Otis group was, in the words of ceramics historian Garth Clark, searching for "a moment of epiphany during a caffeine and nicotine adrenaline rush."[45] They retrained themselves in how to approach basic ceramics situations, beginning with a deliberate attempt to negate some of the refinement that characterized the ceramics of the era. An early experiment involved greatly accelerating the

speed with which ceramics were constructed. "We used to have contests to see who could throw the fastest teapot," Voulkos remembered. "We tried to make a teapot in two minutes complete— throw it on the wheel, make a lid, a spout, real fast. . . . Had some of the weirdest-looking teapots you ever saw, some of them fantastically good."[46] Speeding up production was a way to test how far they could push materials and traditional modes of creating ceramics while still producing recognizable pot forms.

Despite such innovative exercises, by 1955 Voulkos had grown dissatisfied with the ceramics he was producing. He went back to Montana that summer, returning to Los Angeles in the fall with a new kind of work: assemblages of separate wheel-thrown elements. A characteristic piece is a pot from 1956 made up of several distinct forms joined together (fig. 1.44). The work coalesces around a central thrown cylinder, the only visible part of which is a base with a slashed cutout. Hand-formed slabs of clay were then roughly added to the thrown element, creating two distinct boxlike volumes in the center. The top of the piece was thrown separately and then slip-welded to two of the slabs to produce a flat shelf-like pedestal. Despite these manipulations, Voulkos's forms still retained an obvious identification with ceramics. As John Mason remarked, "They still looked very potlike; they had pot glazes on them, and the way they were linked together made them look like pot assemblages, really."[47] A pot assemblage, however, was not a form of ceramics that anyone had ever seen before, and Voulkos's work was as forward-thinking as it was strange: within a few years, assemblage would become the dominant form of L.A. sculpture, as seen in the work of Wallace Berman, Edward Kienholz, and George Herms.

However unique these pot assemblages were, they shared one quality with standard ceramics practice: a modest size. For ceramics to compete on an equal footing with the ambitious painting and sculpture of the era, they needed to scale up dramatically—but the artists were limited

Figure 1.43.
Peter Voulkos throwing in the Glendale Boulevard studio, **Los Angeles, 1959.** Photo by Henry Takemoto (American, b. 1930). Art © Mrs. Ann Voulkos, Voulkos Family Trust. Courtesy the Voulkos & Co. Catalogue Project.

Figure 1.44.
Peter Voulkos (American, 1924–2002). *Untitled,* 1956. Stoneware with slip and glaze, gas fired, 50.8 × 35.5 × 38.1 cm (20 × 14 × 15 in.). Private collection. Art © Mrs. Ann Voulkos, Voulkos Family Trust. Photo by schoppleinstudio.com. Courtesy the Voulkos & Co. Catalogue Project.

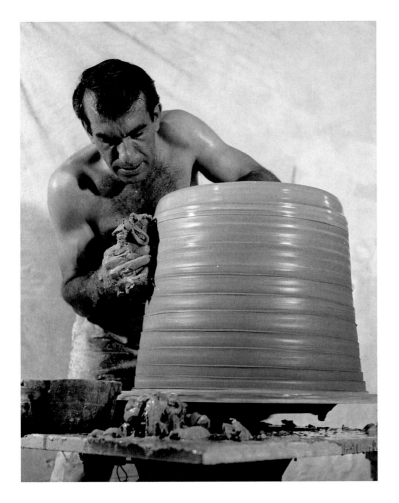

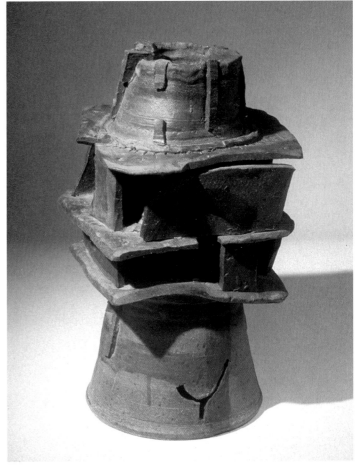

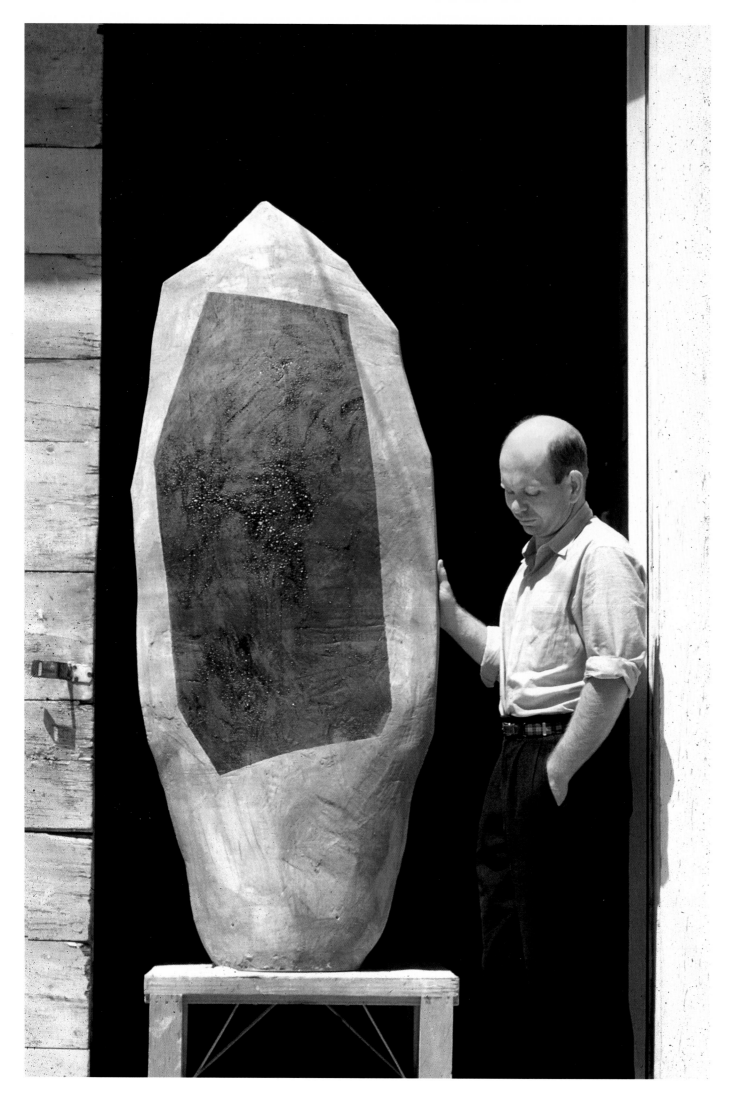

by contemporary ceramics technology. During the mid-1950s, however, the Otis group began to develop the means of producing ceramics of unprecedented size. To do so, they turned to industrial technology, a connection that would uniquely define Los Angeles art throughout this era (for example, see chapter 4, sidebar 21).

The Otis group modified the standard electric wheel by increasing its horsepower from one-quarter to one-half, allowing the artists to work on much larger masses of clay. In 1955–56, they adopted two crucial pieces of factory equipment from disparate industries for use in the studio. They brought in enormous humidifiers normally used in fruit-packing plants, which allowed large clay forms to stay moist while the artists were working on them. The studio also bought giant mixers that were used in industrial baking to knead hundreds of pounds of dough at a time. These machines, which mixed water with powdered clay, enabled artists to produce works that by the late 1950s weighed up to half a ton. Finally, in the studio that Voulkos began sharing with Mason on Glendale Boulevard in 1957, and later in the new ceramics building erected at Otis in 1958, Voulkos worked with Mike Kalan, a ceramics engineer at Advanced Kilns, to build two of the largest high-fire reduction kilns on the West Coast. The kiln in the Glendale Boulevard studio had a capacity of 120 cubic feet and was capable of firing pieces up to 6 feet in height. These innovations were central to Voulkos's and Mason's reassessment of ceramics as a medium, enabling them to transform clay from a material used to make objets d'art to a material that could function on an industrial scale.

In 1957, with the technical means in place, several of the Otis potters began producing truly large-scale ceramics. One of the first successful pieces—many did not survive the firing process—was John Mason's *Vertical Sculpture, Spear Form* (fig. 1.45), an eccentrically angled, two-sided work with sharply geometric glazed areas that echoed the outside form. This sculpture, more than 5 ½ feet tall, was for Mason both the beginning of a new chapter and—as the last major work for which he employed the potter's wheel—his final connection with traditional ceramics.

Soon thereafter, Mason employed several new methods at once to achieve monumental works that are as close to "action ceramics" as any ever produced. He would slam massive amounts of clay directly onto the floor, producing pieces in which the gestural violence of their making is forever imprinted on the finished form. Mason and Voulkos also built heavy-duty easels around their Glendale studio so that they would have flat surfaces for relief sculptures that could extend both horizontally and vertically (fig. 1.46). When the various sections were fired and fitted together, Mason had created an entirely new genre: ceramic walls, which undulated across their supports with a visceral rhythm. Finally, rather than shaping forms organically through the centrifugal force of the potter's wheel, Mason used either crude slabs or cut-and-layered strips to produce vertical sculptures that, despite the precise planning that went into their making, appeared to be contoured by the effects of natural forces. The vitality and seeming spontaneity of these works led the critic John Coplans to call them abstract-expressionist ceramics, a phrase that, as often as not, confused the actual terms that characterized the works of Mason and the other Otis potters. While a small number of works by Mason and Voulkos can usefully be associated with New York–school painting, most cannot. Coplans's rubric had the damaging effect of consigning the Otis ceramicists to a schema derived from New York art, one that carried an alien set of priorities: media essentialism, aesthetic purity, authentic gesture.

Figure 1.45.
John Mason with *Vertical Sculpture, Spear Form*, Los Angeles, 1957. Art © John Mason. Photo by Robert Bucknam.

Figure 1.46.
John Mason compacting clay on his easel for a large ceramic relief, in his studio on Glendale Boulevard, Los Angeles, ca. 1959–60. Photo by Robert Bucknam. Courtesy John Mason Studio.

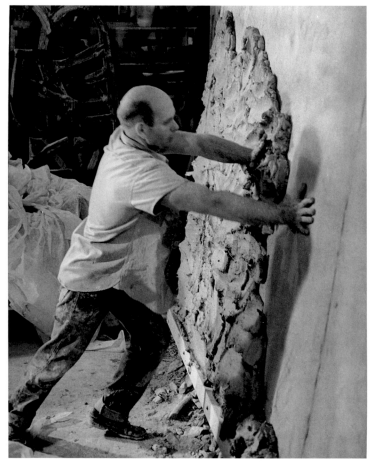

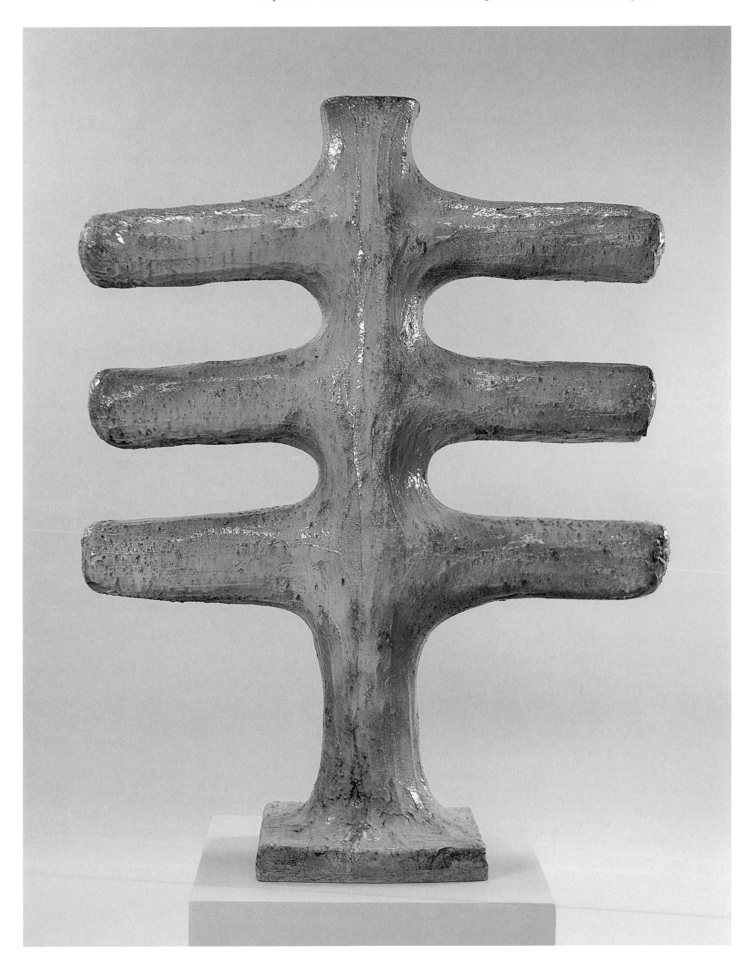

Figure 1.47.
John Mason (American, b. 1927). *Orange Cross,* 1963. Glazed stoneware, 162.5 × 124.4 × 40.6 cm (64 × 49 × 16 in.). Los Angeles, collection of Vernita Mason. © John Mason. Photo by Roxanne Hall Morganti.

Figure 1.48.
Peter Voulkos (American, 1924–2002). *Hack's Rock,* 1959. Stoneware on wood base painted with epoxy resin, 151.3 × 61.5 × 38.1 cm (59⅝ × 24¼ × 15 in.). Washington, D.C., Smithsonian Institution, Hirshhorn Museum and Sculpture Garden. Museum Purchase, 1987. Art © Mrs. Ann Voulkos, Voulkos Family Trust. Photo by Lee Stalsworth. Courtesy the Voulkos & Co. Catalogue Project.

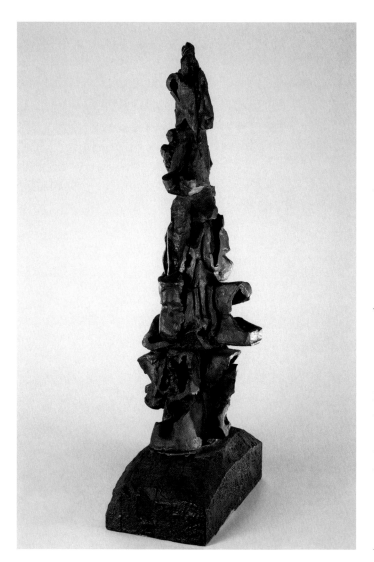

Whether or not Mason produced works that can usefully be described as abstract expressionist, this period of his career was very short lived. By the early 1960s, it was clear that structure was a far more important concern than gesture in his art. At the time, Mason was reading a great deal of systems theory,[48] European formalist art history, and early structuralism, and this inspired him to radically alter his formal vocabulary. He began to build armatures to support forms such as crosses and X shapes that were impossible to achieve through traditional ceramic construction. A work such as *Orange Cross* (fig. 1.47) encapsulates many of Mason's evolving concerns—a tension between geometry and materiality, an alternation of open and closed forms, and the nondecorative use of color—which put Mason's work at the forefront of a sculpture debate during the 1960s.

While Mason's move into large-scale ceramics represented a radical departure from his earlier methods, Peter Voulkos extended the lessons of his earlier multi-part assemblages into a series of step-by-step procedures: throwing, forming, joining, building, painting, firing (and sometimes repainting and refiring). Instead of the holistic or organic processes of traditional ceramics, Voulkos employed a temporality more akin to the assembly line. To work on such an enormous scale, Voulkos borrowed a method from architecture in which large, but often unseen, cylinders thrown on the wheel supplied a structural core upon which additional cylinders could be balanced or cantilevered. Next, Voulkos augmented these cylinders— as in *Black Bulerias* (1958)—with a small repertoire of slab elements that were formed by striking the clay with a paddle and manipulating it by hand until the slabs lost the symmetry that characterizes wheel-thrown ceramics. In 1959, Voulkos began to split his monoliths into combinations of closed and open forms, and by the end of the year, in works such as *Camelback Mountain* and *Hack's Rock* (fig. 1.48), he had completely torn the cylinders open.

To ensure that the pieces would not collapse during construction, Voulkos had to keep tight control over the state and quality of the clay (fig. 1.49). He described the challenges to stability that his process posed: "Knowing when the formed clay has dried enough—cured to just the right leathery consistency, hard enough so it does not collapse but still soft enough to be malleable, able to withstand more handling, plus the weight of the clay forms—is crucial."[49] Clay is challenging because if the water content is too high, a stack or cylinder will collapse in on itself, but if it is too dry, the piece becomes brittle and falls apart. Extra water cannot be added to drying clay, because this only moistens the surface and does nothing to the inner structure of the clay body. Once he had gotten the clay to the right consistency, Voulkos needed to work fairly rapidly on individual sections; it was essential to work both the inner structure and the adjoining outer form simultaneously because if one dried out before the other, they would not adhere.

The resulting works transformed ceramics' temporality not only in terms of production but in terms of perception as well. In *Little Big Horn* (fig. 1.50), slabs jut out from the structural core, partially visible through cracks in the superstructure, to form a series of faceted planes. The resulting discontinuous outline represents a complete break with the harmonious forms of earlier ceramics. It is impossible to extrapolate any one section on the basis of any other section, even if the two form adjoining planes. This disjunction is magnified by Voulkos's

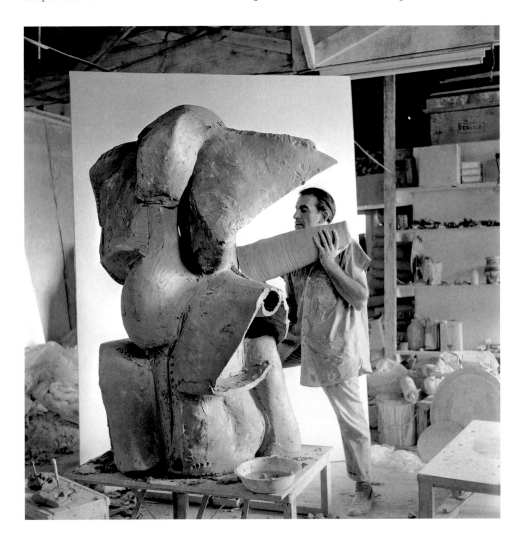

Figure 1.49.
Peter Voulkos building a sculpture in the Glendale Boulevard studio, Los Angeles, 1959. Photographer unknown. Courtesy Peggy Voulkos and the Voulkos & Co. Catalogue Project. Art © Mrs. Ann Voulkos, Voulkos Family Trust.

Figure 1.50.
Peter Voulkos (American, 1924–2002). *Little Big Horn*, **1959.** Polychromed stoneware, 157.4 × 101.6 × 101.6 cm (62 × 40 × 40 in.). Oakland, Oakland Museum of California, gift of the Art Guild of the Oakland Museum Association in memory of Helen Schilling Stelzner. Courtesy the Voulkos & Co. Catalogue Project. Art © Mrs. Ann Voulkos, Voulkos Family Trust.

treatment of the surface. He handled clay as if it were paint, either as a watery slip to be dripped, poured, or splattered across the surface or, in larger areas, as a field that could be scraped down or built up for textural or coloristic effect. Glazes were applied to magnify these effects. *Little Big Horn* has broad fields that are richly colored: a deep blue, for instance, makes one section on the right-hand side seem utterly flat. The plane adjacent to the left, splattered with a white slip, juts forward, making it seem unconnected to the flat blue and without any means of support. Voulkos's large-scale pieces coalesce only when they are experienced over extended time and from multiple viewing angles. This is largely because they are not conceptually cogent. Contrary to the aesthetics of earlier ceramics, the visual experience they present is, like the temporality of their manufacture, not cohesive but additive and aspectual, with dis-integrated stacks, surfaces, and moments that never come together into a unified whole.

While Mason and Voulkos decisively moved ceramics into sculpture, Henry Takemoto demonstrated that it was not necessary to completely abandon the vessel form to create significant works of ceramic art. Takemoto received his BFA from the University of Hawaii (his home state). There he had studied with Claude Horan, who made large-scale, wheel-thrown figurative pots, and with the German painter Josef Albers, whose theories on color had a profound effect on the young artist. After graduating in 1957, Takemoto moved to Los Angeles and enrolled in the MFA program at Otis to study with Voulkos. Relatively quickly, he started to produce his mature work, usually built up from coils of clay rolled between the hands and fired to stoneware. Although Takemoto did make abstract sculpture, many of his best works were either large, spherical

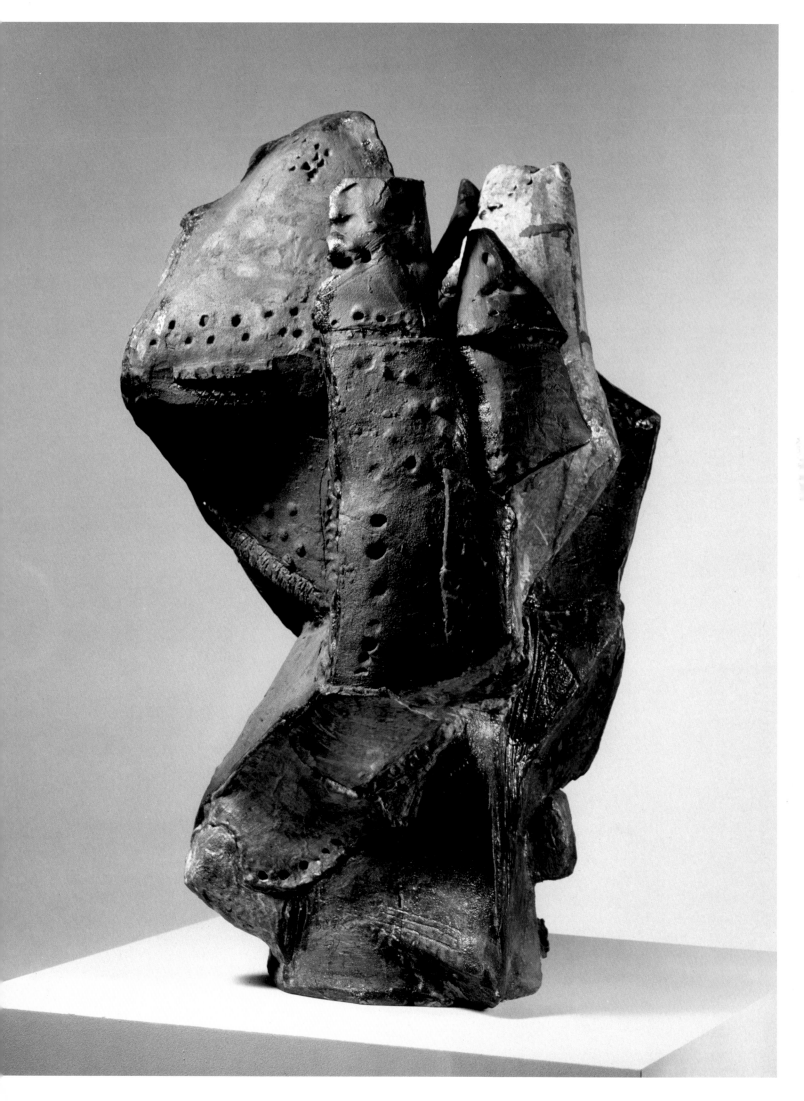

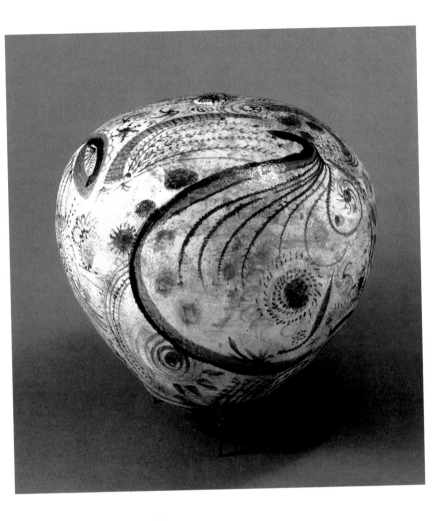

Figure 1.51.
Henry Takemoto (American, b. 1930). *First Kumu*, 1959.
Stoneware, glazed, 55.3 × 55.9 × 55.9 cm (21¾ × 22 × 22 in.).
Claremont, California, Scripps College, Ruth Chandler
Williamson Gallery, gift of Mr. and Mrs. Fred Marer, 92.1.113.
Courtesy Henry Takemoto. Image courtesy Scripps College,
Claremont, CA. Photo by Susan Einstein.

vases that were considerably wider at the top than at the bottom (fig. 1.51) or larger footed vessels with wide openings reminiscent of garden planters.

The quality that distinguishes Takemoto's work is his extraordinary surface treatment. The entire Otis circle was strongly influenced by the ceramics Pablo Picasso created after World War II, specifically by the way Picasso made color independent of form;[50] since the pot was already a relief, it was no longer necessary to simulate volume by shading. This freed hue and value from constructive functions, allowing them to be explored in their own right. In his ceramics, Picasso found a way to add color to sculpture in the round without producing illusionistic depth. It was Takemoto who built most dramatically on Picasso's innovations, covering his clay forms in either white englobe or brown earthen ground and then painting them with exceptionally beautiful calligraphic lines in either vivid blue or earthen red (fig. 1.52). Unlike Picasso's figuration, Takemoto's painted line had qualities of Miró's abstract surrealism; when applied to three-dimensional vessels, Takemoto's line produced extraordinary effects. In an *American Craft* article on ceramicist Kurt Weiser, critic Edward Lebow explains that Takemoto's work made a deep impression on others working in the medium, demonstrating the dual realities of pottery's surface and form. "When you looked at the drawing on Takemoto's pottery," Lebow quotes Weiser as saying, "the form would disappear. You regarded the form and the drawing seemed to slip from view." Lebow concludes, "Standing as they did on their own, their separate but mutual existence forced the mind to rapidly shuttle from one to the other, alternating between comparing and marveling, moving and pausing."[51] This assessment of

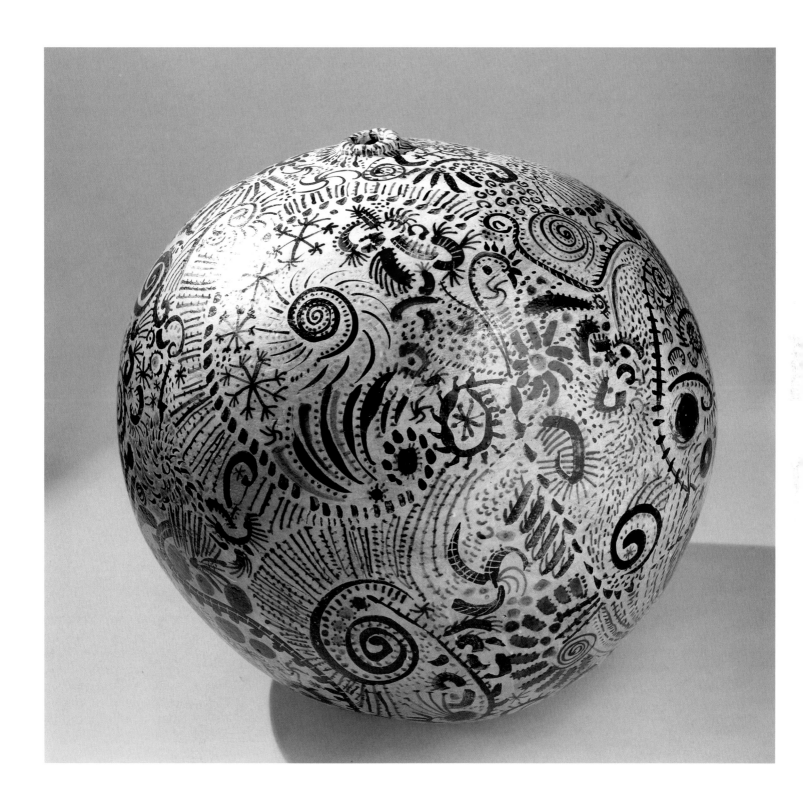

Figure 1.52.
Henry Takemoto (American, b. 1930). *Untitled,* **1959.**
Stoneware with iron and cobalt brushwork, 67.9 × 70.5 cm
(26¾ × 27¾ in.). Oakland, California, collection of Pier Voulkos.
Courtesy Henry Takemoto. Photo by Joe Schopplein.

Figure 1.53.
Ken Price (American, b. 1935). *Avocado Mountain,* 1959.
Glazed ceramic, 55.9 × 53.3 × 53.3 cm (22 × 21 × 21 in.). Los Angeles,
collection of James Corcoran. Courtesy Ken Price Studio.

Takemoto's stature in the field was broadly shared. When, in 1962, the U.S. Information Agency put together a major show of American ceramics traveling to Europe—part of a Cold War campaign of sponsoring exhibitions, most famously of abstract-expressionist painting—Takemoto's pieces were singled out as "perhaps, the outstanding works in the show."[52]

Unlike Mason, Voulkos, and Takemoto, Ken Price did not become renowned for making ceramics of extremely large scale. Although for a time he created work that fit securely within the Otis paradigm, he left the school in 1958 to attend Alfred University in upstate New York. As he later explained, "I went to Alfred to try and develop some low-fire, brightly colored glazes, but also to try and get away from the influence of Voulkos, which was very strong on me."[53] When he returned to Los Angeles in 1959, he at first produced relatively oversized vessels, such as *Avocado Mountain* (fig. 1.53), that were distinguished by their acidic colors and by small fissures in their ceramic bodies that contained biomorphic protuberances. Soon thereafter, he arrived at his signature style of small, rounded forms with impeccably finished surfaces in high-key colors. While Voulkos and Mason had experimented with low-fire glazes and even epoxies to expand beyond ceramics' normal earthen colors, Price adapted the spray-gun painting technique that Billy Al Bengston had introduced to West Coast art to produce works with extraordinarily vivid hues. Spray-painting the fired clay forms can be viewed as an even more radical departure from ceramics tradition than the procedures adopted by Voulkos, Mason, and Takemoto, but for Price it achieved an organic fusion of color and form. Commenting on his association with the movement Coplans labeled as "Fetish Finish," Price said:

> [T]he idea was that every aspect of the physical work should be brought to full resolution. This included the sides and backs of paintings and the underside of objects. A lot of people thought that was bizarre and excessive, but for me it was just a matter of finishing something. Some people think it's some kind of trick if you work up or polish the surface; when I do that I'm trying to get a balance between form, surface, and color.[54]

The finished sculptures manage to balance two usually antipathetic states: the sensual and the abject (see fig. 3.35). On the one hand, their rounded, perfectly formed shapes pierced by darker apertures have a sensuous, bodily quality; as Price put it, "My work has evolved

Figure 1.54.
Ken Price (American, b. 1935). *Green and Cream,* 1966. Glazed ceramic, 10.2 × 21.6 × 8.9 cm (4 × 8½ × 3½ in.). Collection of the artist. Courtesy Ken Price Studio. Photo by Zoe Zimmerman.

into these naturally erotic forms. And the colors I use are sensual too."[55] On the other hand, the disturbing forms that protrude from or lurk inside Price's sensuous exteriors have been described by the critic Lebow as "compellingly repulsive."[56] Price himself has cataloged the associations these forms conjure up in the imagination of the viewer: "mountain peaks, breasts, eggs, worms, worm trails, the damp underside of things, intestines, veins, and the like" (fig. 1.54).[57] Part of the work's ability to maintain an unresolved tension between opposing states is that it resists conceptualization and language, insisting on the primacy of perception, a feature that would become a hallmark of Southern California art. Price insists that the way to understand his work "is to experience it physically.... I'm not trying to get critical distance. I want to get inside as far as I can, and deal with the internal logic of the work itself."[58]

It is hard to overstate the Otis group's centrality to the development of Los Angeles as a vital art center. Critics such as Coplans, and at times the artists themselves, have perpetuated the myth that they were overlooked or operating against a backdrop of benign neglect. In fact, Voulkos had nine solo exhibitions between 1954 and 1960, and he was one of the first artists of his generation to be represented by a prestigious L.A. gallery—in his case, Felix Landau, where he showed from 1956 until Landau closed his galleries in the 1970s. The first show of objects at Ferus, the gallery that was to dominate the L.A. scene from the late 1950s to the mid-1960s, was an exhibition of Otis ceramics, and John Mason and Ken Price were among the gallery's core artists. Voulkos and Mason had mid-career exhibitions at the Pasadena Museum, and the group was the subject of one of the first major thematic exhibitions of L.A. artists. In Los Angeles, the work of the Otis group destabilized the notion that media purity was the core of modernist art practice, and their art had an enormous impact on a generation struggling its way out of abstract expressionism in a place without much critical or institutional support.

The ability to form any lasting artistic community in Los Angeles was always hard fought and provisional, as the examples of the hard-edge painters and other avant-gardes attest. The centrifugal force of the region's sprawl and the very real repression of artistic freedom drove groups of artists underground and constantly tested the coherence of any network, making even promising movements seem to dissolve with barely a trace. In the face of these challenges, the creative communities that emerged in the 1940s and 1950s were instrumental in establishing what it meant (and still means) to be a Los Angeles artist. With the prospects of earning a living from one's artwork virtually nonexistent, nearly all the expressionists, hard-edge painters, and ceramicists taught for much of their careers (a professional decision that continued into the twenty-first century). Teaching provided more than a livelihood; it offered a primary affiliation and sense of community that remained strong, sometimes for decades after formal connections to an institution had ended. Midcentury artists shaped the values and ideas of younger generations in other ways, mostly through the examples they set. The Otis group, for instance, would drive around town seeking out the region's culture; they participated in surf, custom car, and motorcycle subcultures; and they became associated with popular music. In these and other ways, postwar L.A. ceramicists demonstrated that what happened outside of the studio could be as essential as what happened inside. To make a lasting, cultural contribution in Los Angeles, being an "artist" seemed to require an all-consuming vocation; it did not start when a class was in session nor stop when it was time for dinner. This distinctive approach shaped the sense of self, the nature of intellectual exchange, and the space for meaningful expression in Southern California.

It is better to be moist with love than to sweat with intellect.
—Robert Alexander[1]

An emphasis on body rather than intellect had become a well-established cliché in American bohemia in the years after World War II. Artists trying to express not only their postwar anxiety but also a radical critique of a progressively conformist society called on—among other sources— instinct, popular culture, directness, and raw feelings. That is why a portion of American liberal society became fascinated with the free gesture, individuality, and experimentation of abstract-expressionist art. In the mid-1950s, the Los Angeles art scene provided a place where raw bohemian explorations of the self (exemplified in the work of Beat artists like Wallace Berman and Robert Alexander) were transformed into a more cautious and slick avant-garde discourse geared toward a larger public. *Action*—an exhibition of abstract-expressionist paintings set up in the merry-go-round building on the Santa Monica pier in 1955—marked a pivotal moment in this transformation. Organized by curator Walter Hopps, the show simultaneously reflected the politically charged nature of contemporary public discussions about art in the early 1950s, including expressions of the Beat generation, and demonstrated a new and growing interest in the radical and critical potential of a slick, modern avant-garde art. In Los Angeles, art was moving out of the underground and into the Southern California sun.

In exhibiting American abstract painting, Hopps made a major statement at a time when some in Los Angeles were still debating the sanity of modern art. Indeed, it was only five years earlier, in 1950, that word had come from New York that modern art was not subversive after all, nor was it un-American.[2] The final years of the 1940s in Los Angeles had been characterized by frantic and relentless attacks on art by conservative voices, such as that of Congressman George A. Dondero, whose speech in the U.S. House of Representatives in August 1949 attacked modern art for being "shackled to Communism."[3] Shortly afterward, in direct response to this developing hysteria, Gifford Phillips founded the magazine *Frontier,* which was subtitled *The Voice of the New West.* Focusing at first on political commentary, over the course of several years it expanded to cover theater, music, film, television, and the visual arts. Eventually, *Frontier* represented the cutting edge not only of artistic avant-garde discourse but also of liberal politics; for Phillips the two were inseparable. The first editorial in *Frontier,* in November 1949, clearly expressed his vision for California and the West:

> This new frontier no longer involves large unexplored tracts of land. Its undiscovered areas lie in the realm of the mental, moral and social—rather than in the physical. Today's frontier challenges us to explore a social order which is still in the making....*Frontier* is a new magazine of public affairs. It is especially designed for the pioneers of today, and for everybody who wants, above all, to create a mighty, new society in the West.[4]

It was from Los Angeles that the Western frontier was being redrawn, rethought, and redesigned in the wake of an economic boom.[5] The Wild West, according to Phillips, would once again be the place of the pioneer— and this pioneer would have a brilliant modern future. The pioneer of the 1950s was a forward-looking individual, open to novel concepts, forging ahead while the rest of the press was still conservatively looking backward. Art would be an important weapon in what *Frontier*'s editors conceived as a reorganization of Western society; by 1956, Gerald Nordland had become the magazine art critic to advance this goal.

Despite still-strong resistance, modern art had slowly begun to reach a curious and interested public. The excitement of the postwar economic boom, clearly evident in Southern California, transformed the relationship among intellectuals, connoisseurs, and the public at large. In "This Age of Conformity," an article published in 1954 in the political and literary journal

View of the exhibition *Action,* Santa Monica, California, 1955, with Jay DeFeo's *Untitled—Tree* in the foreground.. Photographer unknown. Art © 2011 The Jay DeFeo Trust / Artists Rights Society (ARS), New York. May not be reproduced in any form without permission of the The Jay DeFeo Trust.

Partisan Review, critic Irving Howe alluded to the emerging and rapidly expanding modern art scene in Los Angeles: "To be sure, culture has acquired a more honorific status, as restrained ostentation has replaced conspicuous consumption: wealthy people collect more pictures or at least more modern ones, they endow foundations with large sums—but all this is possible because 'intellect' no longer pretends to challenge 'wealth.'"[6] A new market was being created for modern art, though somewhat problematically, in Howe's opinion: "Where young writers would once face the world together, they now sink into suburbs, country homes and college towns. And the price they pay for this rise in social status is to be measured in more than an increase in rent."[7]

A few years earlier, just at the moment when modern art started to become visible in Los Angeles, many surrealists working in the United States—among them William Copley, Gloria de Herrera, Marcel Duchamp, and Man Ray—had moved to Europe. An exhibition in 1951 of abstract expressionism at Frank Perls Gallery in Beverly Hills indicated a shift away from surrealism (though surrealism's influence would continue to resonate in Los Angeles for decades). In an essay written for the show's catalog, artist Robert Motherwell rehearsed several ideas that would later underpin Harold Rosenberg's 1952 essay on abstract expressionism, "The American Action Painters."[8] Motherwell insists on a certain amount of freedom of expression, if not a form of automatism, located at the center of the creation of painting as a sign of personal freedom.

As art historian Fred Orton observes, the word "action" is a loaded one;[9] it empowers both artist and viewer to take control of their own

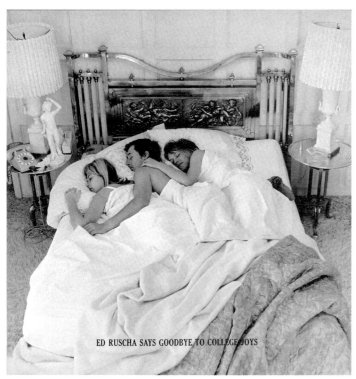

"Ed Ruscha Says Goodbye to College Joys," *Artforum* 5, no. 5 (1967): 7. Photo by Jerry McMillan (American, b. 1936). Courtesy Jerry McMillan and Craig Krull Gallery, Santa Monica.

existence to define an identity, and to do so in opposition to the capitalist ideal represented by the "man in the gray flannel suit." As such, it carried the possibility for personal revolt and insurrection. Abstract expressionism, Orton rightly insists, was not modern art (formal games) but rather the art of the modern (the expression of personal relation to the time). The difference is crucial. Action was not a formal exercise but a scream, violence against the rapidly invaded personal life. With abstract-expressionist painting, individual creativity could challenge a situation that saw a slow integration of the individual into an "organization man" lost in "the lonely crowd."

In the years prior to the *Action* exhibition, intellectuals were being persecuted by Congressman Dondero and his followers, prompting writers and artists to retreat to the safety of hermetic bohemianism. In the mid-1950s, when Hopps was planning the *Action* show, private galleries like Syndell Studio (founded by Hopps) and the NOW Gallery (founded by his friend Edward Kienholz) offered places where artists could express forms of modern dissidence through art. These galleries played a crucial role in preserving spaces of resistance; over time, however, their embrace of a marginal position would prove to be irreconcilable with the increasingly public role that art played in Los Angeles and with the increasing commercialization of Beat culture (by 1959, as *Life* documented humorously, several businesses were providing fashionable beatniks to perform poetry at upper-class parties: it had become hip to be Beat).[10]

The title of Hopps's 1955 exhibition, *Action*, clearly announced the show's revolutionary stance. In recalling Rosenberg's explication of the subversive possibilities of abstract expressionism, *Action* represented a similarly combative gesture. It functioned as a courageous signal for the general public, which did not often realize that it was possible, in an age of conformity and fear, to be different and exert individual freedom—including sexual freedom. The individual creativity at the heart of abstract expressionism offered the possibility of challenging the relentless co-option of the individual.

The *Action* exhibition allowed Hopps to escape the hermeticism of the Beat avant-garde in favor of a more public presence. The exhibition was mounted in the 20,000-square-foot merry-go-round structure on the Santa Monica pier: paintings were hung on the building's supporting pillars, on canvas stretched around the stationary carousel, and on the carousel's brass posts. Hopps's installation resituated the discourse of modern art firmly in the public realm, triggering a newly vibrant avant-garde life, one that overwhelmed the bohemian tradition, which was itself vanquished by success. For the duration of the *Action* exhibition, the Santa Monica merry-go-round was transformed into a subversive environment—in contrast to the Disneyland theme park, which opened in July of the same year. While Walt Disney created the alluring attractions of Disneyland to draw national and international tourists, Walter Hopps harnessed a halted carousel to make modern experimental art visible. Avant-garde (or "high") culture invaded the space of popular, youthful entertainment, engaging a diverse local crowd with a blend of jazz, experimental music, and Bay Area abstract painting. Although Hopps chose the Santa Monica pier only because all other options had fallen through,[11] the site—a public place of popular entertainment—took on a powerful symbolic force: abstract expressionism was coming to town!

The subversion that Hopps orchestrated was a fun one indeed. The merry-go-round stood at a standstill, bound in canvas, displaying abstract paintings. The usual turn of the carousel and the repetitive rise-and-fall motion of its painted horses were replaced by the unpredictable traces of the expressive movement of the human body—the "action" that Motherwell and Rosenberg had identified in abstract expressionism. The merry-go-round had stopped rotating to usher in a completely different kind of revolution. The mechanical was replaced by the human—by paintings that evoked human expressive movement and brought about individual

pleasurable anxiety, full of surprises, irregularities, and dazzling colors. Human action replaced mechanical fascination.

The display, with its wild hues and surfaces that spoke of action, did not meet with an entirely uncritical public, as the artist Gordon Wagner described in his notebook:

> There were Braces of aesthetic looking folks, gaunt and half starved, women as frail and as beautiful as a white narcissus with slough eyes. Could be natural could be Hashish who knows. The more violent spectators were the wieght [sic] lifters of muscle Beach.... One fellow was so furious over the way the artist had expressed himself that he bent a 1" dia [diameter] bar of steel double to vent his fury. Another wieght [sic] lifter put a sign on the great "orange job" reading "out of order.".... Comments were thrown fast and furious. What are you people doing kidding. What a joke. What lunatic asylum do you represent. It was fun & stimulating.[12]

Above all, it was the mix of visitors and reactions that appealed to Hopps, who later recalled:

> It attracted the most totally inclusive mix of people—Mom, Dad, and the kids, and Neal Cassidy and other strange characters, and the patrons of a transvestite bar nearby. I got Ginsberg, Kerouac, and those people to attend. It's amazing they came. Critics I'd never met before showed up. It had a big attendance. So I wanted to work, as it turns out, both ways.[13]

Ever the modernist, Hopps is ambivalent. He oscillates between desiring integration and rejection, between the simple enjoyment of popular culture and its transformation into a subversive tool. This dialectic would also inform the way he ran the Ferus Gallery, which he founded with Kienholz in 1957.

The *Action* exhibition was pivotal in transforming the cultural landscape of Los Angeles. Hopps launched the Ferus Gallery with an exhibition of abstract expressionism that echoed his efforts in the merry-go-round. But by 1960, the situation had changed markedly; by then, Ferus was housed in a pristine new space designed by the businesss-oriented art dealer Irving Blum. Any remnants of bohemia were gone, replaced by a less strident avant-garde strategy that articulated a new definition of the image of Los Angeles—one reflected in Disney's sanitized theme park. This new direction was characterized by an emphasis on cleanliness, modernity, transparency, and plasticity—at a time when, ironically, Los Angeles magazines and newspapers were beginning to call attention to pollution, and smog became the talk of the town (see sidebar 25).[14] By the mid-1960s, L.A. art wore the shiny armor of Finish Fetish sculpture and was marketed to the entire country.

The so-called L.A. Look was redefined and sold to a new class of liberal collectors ready to invest in a reformed, cleaned-up art scene—one that portrayed even sex in sanitized terms. According to this new impulse, when the "stud" is having fun in bed with girls (as in an image by Ed Ruscha in *Artforum* in January 1967), it is clean fun, in white sheets, in a deluxe Hollywood bed belonging to the new highbrow constituency. If the bed is shared, this is no longer seen as a sign of socialism. It is a new day, a new world. It is the 1960s, after all.

Love is not gone but simply no longer really moist!

Notes
1. Flyer for Press Baza, 1957, Charles Brittin papers, Getty Research Institute (2005.M.11), box 4, folder 3.
2. A pamphlet titled "A Statement on Modern Art" was signed by the Institute of Contemporary Art in Boston, the Museum of Modern Art in New York, and the Whitney Museum of American Art, also in New York. See Elizabeth Sussman et al., *Dissent: The Issue of Modern Art in Boston*, exh. cat. (Boston: Institute of Contemporary Art, 1985), 88–89.

3. George A. Dondero, "Modern Art Shackled to Communism," at the 81st Congress 1st Session, House of Representatives, 6 August 1949.
4. Gifford Phillips, "Today's Frontier," *Frontier* 1, no. 1 (1949): 2.
5. See Carey McWilliams, *Southern California: An Island on the Land* (Santa Barbara: Peregrine Smith, 1973), 371–78.
6. Irving Howe, "The Age of Conformity," *Partisan Review* 21, no. 1 (1954): 12.
7. Howe, "The Age of Conformity," 10. By 1955, the time was ripe for Clement Greenberg's long and important article, "American Type Painting," *Partisan Review* 22, no. 2 (1955): 179–96.
8. Robert Motherwell, preface ("The School of New York"), in *Seventeen Modern American Painters*, exh. cat. (Beverly Hills: Frank Perls Gallery, 1951), reprinted in *The Collected Writings of Robert Motherwell*, ed. Stephanie Terenzio (Oxford: Oxford Univ. Press, 1992), 83: "The process of painting them is conceived of as an adventure, without preconceived ideas on the part of persons of intelligence, sensibility, and passion. Fidelity to what occurs between oneself and the canvas, no matter how unexpected, becomes central. The specific appearance of these canvases depends not only on what the painters do, but on what they refuse to do. The major decisions in the process of painting are on the grounds of truth, not taste." Harold Rosenberg, "The American Action Painters," *Art News* 51, no. 8 (1952): 22.
9. Fred Orton, "Action, Revolution and Painting," *Oxford Art Journal* 14, no. 2 (1991): 11.
10. Paul O'Neal, "The Only Rebellion Around?," *Life,* 30 November 1959, 119–30. See also "Rent-a-Beatnik" photos in Fred W. McDarrah and Gloria S. McDarrah, *Beat Generation: Glory Days in Greenwich Village* (New York: Schirmer Books, 1996), 211, 216; and Arthur and Kit Knight, eds., *The Beat Vision* (New York: Paragon House, 1987), 28. Beatniks also became popular on television, for example, in the shows *The Many Loves of Dobie Gillis* (1959–63) and *77 Sunset Strip* (1958–64).
11. See Ken Allan, "Reflections on Walter Hopps in Los Angeles," *X-TRA Contemporary Art Quarterly* 8, no. 1 (2005): 1.
12. Gordon Wagner, notebook from 1951–55, Gordon Wagner papers, Special Collections, Charles E. Young Research Library, University of California, Los Angeles (Collection 1594), box 28, folder 2. Reproduced here with the author's original spelling, capitalization, and punctuation.
13. Hans-Ulrich Obrist, "Walter Hopps hopps hopps: Hans-Ulrich Obrist Talks with Walter Hopps," *Artforum* 34, no. 6 (1996): 60–63.
14. See Francis H. Packard, "The Politics of Smog," *Frontier* 7, no. 6 (1956): 11–12; "Let Them Eat Smog," *Frontier* 7, no. 9 (1956): 3–4; George H. Fisher, "And Still More Smog!," *Frontier* 8, no. 1 (1956): 10–11; George H. Fisher, "Poison in the Air," *Frontier* 10, no. 12 (1959): 5–9, 15.

Chapter Two

PAPA'S GOT A BRAND NEW BAG
Crafting an Art Scene

Lucy Bradnock and Rani Singh

On 18 May 1955, an unusual exhibition called *Action* opened in the merry-go-round building on the Santa Monica pier (fig. 2.1). Hung on tarpaulins stretched over the carousel were a number of large-scale abstract paintings by artists working in California (fig. 2.2). Works by Richard Brodney, Jay DeFeo, Roy De Forest, Sonia Gechtoff, and Hassel Smith—many of them associated with the California School of Fine Arts in San Francisco—were displayed alongside those by L.A. artists Gilbert Henderson, Craig Kauffman, and Paul Sarkisian. At the opening party of the "merry-go-round show," an assortment of artists, Beat poets, and Muscle Beach weightlifters mingled to the strains of fairground music and jazz.

Action was conceived by the ambitious young curator Walter Hopps, who was motivated by what he perceived as a widespread failure to recognize work being made on the West Coast. According to a flyer announcing the exhibition, the show represented "an attempt to begin to provide the concepts and facilities for the exhibiting of indigenous contemporary works."[1] Atypical by design, the exhibition pointed both to the paucity of opportunities available to artists in Los Angeles in the mid-1950s and to the creative solutions that such restrictions could bring about. The decade that followed would be characterized by the development of a fledgling art scene in Los Angeles and the struggle to forge a distinct artistic identity for the city.

As the logistics of organizing *Action* made clear, this development was not an entirely smooth ride. Paintings brought from the Bay Area had endured an arduous journey in a dilapidated truck; several venues were considered and rejected; and though the exhibition flyer, designed by Craig Kauffman, lists Richard Diebenkorn among *Action*'s participants, his inclusion was vetoed by Paul Kantor, the L.A. gallery owner who, in 1952, had given Diebenkorn his first solo exhibition in Los Angeles.[2] Kantor's reluctance to permit Diebenkorn to participate in such an idiosyncratic event is indicative of the divergent motivations behind Los Angeles's various new enterprises: those driven by commercial ambitions and modeled on the art-world structures of Europe or New York and those that embodied the pursuit of a more alternative course, whether by choice or necessity. These different impulses sometimes led to fraught relations between gallerists, but both types of endeavor were necessary to the sustenance of art in Los Angeles during the late 1950s. Their concurrent development allowed for a certain amount of overlap. Many artists, even those marginalized because of race or gender, enjoyed the artistic and social fluidity that this situation permitted as well as the sense of solidarity that accompanied the challenges of being an artist in a newly developing art world. In many ways, the now legendary Ferus Gallery, about which more will be said later, epitomized the collision of the mainstream and the underground. But there is more to the history of the L.A. art scene in the fifties and sixties than a single enterprise; the often neglected period just prior to Ferus's establishment was a complex constellation of people and venues: an art world in formation.

Figure 2.1.
Announcement for the exhibition *Action,* Santa Monica, California, 1955. Design by Craig Kauffman (American, 1932–2010). 24 × 32 cm (9½ × 12⅝ in.). Washington, D.C., Craig Kauffman papers, ca. 1950–97, Archives of American Art, Smithsonian Institution.

SHAPING AN L.A. GALLERY SCENE

At the turn of the 1950s, only a handful of galleries existed in Los Angeles, most of them private and many located in the lobbies of big hotels.[3] La Cienega Boulevard, then known as Restaurant Row, would become renowned in art circles by the end of the decade as Gallery Row. A small

number of arts professionals started galleries in that area in the early 1950s, many of them as a sideline to the slightly more lucrative business of picture framing. Paul Kantor started as a partner in a frame shop—the Framecraft Gallery on nearby La Brea Avenue—before opening the gallery that bore his name. Esther Robles had set up Esther's Alley Gallery as part of Esther Stoeffen Framing on La Cienega. In 1948, before Felix Landau established his La Cienega art gallery, he opened the Fraymart Gallery on Melrose Avenue; it featured a redwood interior designed by the distinguished local architect Gregory Ain.

Landau had come to Los Angeles from Austria via New York (fig. 2.3). He dealt in works by Austrian artists such as Gustav Klimt and Egon Schiele, but he also exhibited local artists, including John McLaughlin (starting in 1952) and Craig Kauffman (his first solo show was mounted at Landau in 1953). Like Landau, Kantor dealt in a mix of modern European and West Coast art, including exhibitions of German expressionism and solo shows for Lee Mullican

Figure 2.2.
Gordon Wagner (American, 1915–1987). Sketch of the installation of *Action,* 1955. 13.1 × 20.3 cm (5¼ × 8 in.). Los Angeles, University of California, Los Angeles, Charles E. Young Research Library, Gordon Wagner Papers (Collection 1594). © Estate of Gordon Wagner, courtesy Tobey C. Moss Gallery. Image courtesy Department of Special Collections, Charles E. Young Research Library, University of California, Los Angeles.

(from 1952), Richard Diebenkorn (in 1952), and Ynez Johnston (from 1953). While the owners of these fledgling commercial galleries relied on prints and drawings by big names such as Pablo Picasso, Henri Matisse, Paul Cézanne, and Marc Chagall to generate income, they were keen to represent local talent as well.

In the latter half of the decade, this small group of galleries was joined by several new establishments. In 1959, the New York art dealer Virginia Dwan opened a gallery in the Westwood area of Los Angeles, designed by Morris Verger, a student of Frank Lloyd Wright. Dwan showed work by New York artists Philip Guston, Franz Kline, Claes Oldenburg, Robert Rauschenberg, and Larry Rivers, as well as French Nouveaux Réalistes Arman, Yves Klein, Martial Raysse, Niki de Saint Phalle, and Jean Tinguely. The notable *Boxes* exhibition in 1964 included works by Joseph Cornell, James Rosenquist, and Andy Warhol, among others (fig. 2.4). Everett Ellin operated a gallery on Santa Monica Boulevard from 1958 to 1959 and opened another on the Sunset Strip in 1960. That same year, the Rex Evans Gallery opened on La Cienega. Primus-Stuart, run by Edward Primus and David Stuart (former owner of the Jazz Man record shop in Hollywood), opened in 1961, showing pre-Columbian art and artifacts as

Figure 2.3.
Felix Landau, 1952. Photo by Frank J. Thomas (American,
1916–1993). Courtesy the Frank J. Thomas Archive.

Figure 2.4.
**Virginia Dwan in the exhibition *Boxes*, Dwan Gallery,
Los Angeles, 1964.** Photo by Julian Wasser (American, b. 1900s).
Works of art in the background are (left to right): Joseph Cornell,
Sun Box Series (ca. 1960); James Rosenquist, *Toaster* (1963); and
Andy Warhol, *Heinz Box and 4 Brillo Boxes* (1963). Art © The
Joseph and Robert Cornell Memorial Foundation / Licensed by
VAGA, New York, NY. Art © James Rosenquist / Licensed by
VAGA, New York, NY. Art © 2011 The Andy Warhol Foundation,
Inc. Artists Rights Society (ARS), New York. Photo © Julian
Wasser, all rights reserved. Courtesy Julian Wasser and Craig
Krull Gallery, Santa Monica.

well as works by young contemporary artists; David Stuart continued in this direction when he struck out on his own in 1963.

While previous generations of L.A. artists kept apprised of contemporary artistic trends mainly through secondhand accounts and reproductions—or, as noted in chapter 1, through tours of private collections—galleries like these were beginning to bring to Los Angeles the works of renowned contemporary artists from New York and Europe, many of whom visited Los Angeles. In 1962, several local artists, among them Edward Kienholz, Billy Al Bengston, and Ken Price, witnessed Saint Phalle's infamous shooting paintings, in which the artist fired a rifle at canvases hung with bladders of paint. By 1960, *Art in America* was reporting from Los Angeles that "in the last few years more than a dozen galleries have sprung up here and these now appear to be permanently on the scene."[4]

Many newly arrived gallerists struggled to make sales in a city where there were few buyers for works of modern art, even those made by well-known European artists. This state of affairs began to change over the course of the 1950s, thanks in part to initiatives in education. In 1957, the UCLA Extension Program, which offered adult education classes, published *Looking at Modern Painting,* a textbook for the uninitiated student of twentieth-century painting, complete with artist biographies, a glossary of major movements, and suggestions for further reading. The book was accompanied by a set of slides and formed the basis of classes taught by UCLA graduate students in art history, among them James Demetrion, Henry Hopkins, Shirley Nielson, and Nielson's husband, Walter Hopps. Classes were held at the homes of wealthy students, many of whom were also interested in collecting. Hopkins later recalled that they covered well-known modernists such as Wassily Kandinsky, Piet Mondrian, and Picasso, but soon expanded to include less well-known California artists, among them some who had shown in *Action.* "We could go beyond the [textbook]," Hopkins explained, "and begin to open up, maybe bring in some of the art of the area and discuss things a little more widely. We'd talk about prices. We'd talk about the art market. We'd talk about any number of things beyond what the course was devised for."[5] The instructors discussed the works of Clyfford Still, Hassel Smith, Diebenkorn, and other contemporary artists from Los Angeles. Students were encouraged to visit artists in their studios, thus facilitating encounters between art patrons and younger artists. According to *Art in America,* "Not the wealthy, seasoned collectors but the young married couples have become the backbone of today's art sales, and people are really buying as never before…and these new homeowners are collecting contemporary art because they cannot afford the Old Masters and the French Impressionists. Instead, they are championing West Coast artists."[6] This development would have a significant impact on the art market by the mid-1960s. Many students of Hopkins and Hopps, including Elyse and Stanley Grinstein, Betty Asher, and Fred and Marcia Weisman, became steady collectors in the area, offering emotional as well as financial support to a generation of artists. They went on to amass some of the most important collections of L.A. art. In 1964, Gifford Phillips, himself an important collector, would observe in an *Art in America* editorial that "there are at present seventy legitimate commercial art galleries in Los Angeles," while "gross sales to Los Angeles collectors has [*sic*] now reached ten million dollars a year."[7]

LOS ANGELES'S OTHER SPACES: THE ALTERNATIVE SCENE

As the art world in Los Angeles expanded, the rise of galleries such as Landau, Kantor, Dwan, and Ellin was paralleled by the emergence of more informal, less commercial ventures. As in earlier decades, artists held small-scale exhibitions in private homes, in churches (important especially for African American artists), or on wall space offered by sympathetic businesses: cafés, bookstores, and movie theaters. At Books 55, on La Cienega Boulevard, proprietor Norman Rose offered not only exhibition space but also occasional lodging for a struggling artist and the opportunity of paid work in his San Francisco warehouse. Like Royer's Book Shop, the antiquarian bookstore where William Copley had exhibited in the 1940s, Books 55 (named for

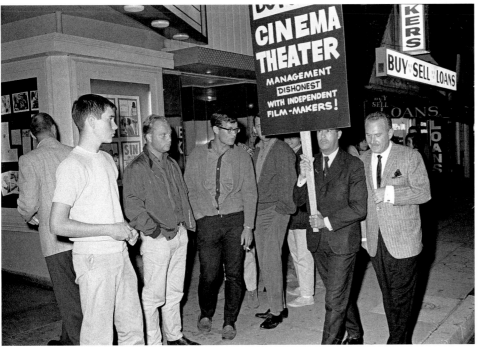

Kenneth Anger (holding sign) and Raymond Rohauer (right) in front of the Cinema Theatre, Los Angeles, 1964. Photo by Charles Brittin (American, 1928–2011). Los Angeles, Getty Research Institute, 2005.M.11. Image © J. Paul Getty Trust, Charles Brittin papers. Courtesy Kenneth Anger.

IN POSTWAR LOS ANGELES, the avant-garde film scene hovered at the edge of the city's celebrated film industry, largely ignored by a Hollywood preoccupied with its glamorous star-and-studio system. But experimental art films did find a local audience, in out-of-the-way venues that often commingled the functions of art gallery, coffee shop, social club, and movie theater. By the 1940s, the growing production of avant-garde films from the United States and abroad spawned a network of exhibitors and distributors with survival strategies as innovative as the films that they promoted.

Clara Grossman's American Contemporary Gallery on Hollywood Boulevard, founded in 1943, was one of the city's first venues for experimental film. Organized by a group of Hollywood communists, the gallery survived by offering a subscription series, for which members paid an annual fee; screenings included workers' education initiatives, silent cinema, documentaries, international films, and works by local filmmakers.[1] The participants, a mix of Hollywood luminaries and avant-garde artists, lent Grossman's venue a uniquely Angeleno cachet: major directors Billy Wilder and D. W. Griffith mingled there with artists like Man Ray, Jules Engel, and Oskar Fischinger, and with filmmakers James and John Whitney, Kenneth Anger, and Curtis Harrington. Anger and Harrington, filmmakers who eventually stood at the vanguard of experimental cinema, first met at the gallery and in 1947 formed Creative Film Associates, a distribution cooperative that screened their films and those of their contemporaries.

In the late 1940s, screenings began at the Coronet Theatre at 366 North La Cienega Boulevard. Initially home to the Ballard Film Society, the theater was renamed the Coronet Louvre when Raymond Rohauer took over in 1950. Rohauer crafted some of the era's most innovative programs by screening Hollywood films and international cinema alongside an increasingly sophisticated slate of experimental works. His tenure, which lasted until 1961, was not without controversy: among other things, he was accused of unlawfully appropriating some films for his personal collection. However, for nearly a decade his nightly screenings inspired a generation of filmmakers and curators by presenting a diverse array of films that otherwise would have been unavailable in Los Angeles.

By the 1960s, there were art-house cinemas across the city, and audiences enjoyed broad access to international and experimental films. In 1963, the Cinema Theatre on Western Avenue premiered its Movies 'Round Midnight programming, a fusion of pulp and high art that embodied the decade's countercultural sensibility. This late-night series, the brainchild of theater manager Mike Getz and local programmer Michael John Fles, kicked off on Columbus Day with the irreverent declaration, "Oct. 12, 471 Years Ago Columbus Discovered America. Today you discover the New American Cinema." The inaugural screening offered a triple feature: Jack Smith's *Flaming Creatures* (1963), Stan Brakhage's *Dog Star Man Part I* (1962), and Gregory Markopoulos's *Twice a Man* (1963). Movies 'Round Midnight became central to Los Angeles's avant-garde, and its diverse program of narrative and experimental film, psychedelia, and music attracted an eager audience of local artists, Beats, and young hipsters. The venue's late nights and theatrical guests became legendary, with a vice squad seizing *Scorpio Rising*, crowds protesting the interminable length—5 hours 20 minutes—of Andy Warhol's *Sleep* (1963), and Kenneth Anger staging a solo picket after accusing the projection booth of stealing a print of his 1954 occultist film *Inauguration of the Pleasure Dome* (above). By the mid-1960s, a new venue for the experimental exhibition of art and cinema was catering to the city's hippie community. Housed on the Sunset Strip in a former funeral parlor amid rock clubs and coffee shops, Cinematheque 16 paired cinema and rock 'n' roll with the promise of psychedelic experiences. During the 1970s, as the visual arts received increased federal funding, a new network of venues emerged. The programming strategies pioneered by Pasadena Filmforum, the Los Angeles Independent Film Oasis, and the Theatre Vanguard asserted experimental cinema's artistic legitimacy and laid the groundwork for today's vibrant avant-garde community.

Notes
1. David E. James, *The Most Typical Avant-Garde: History and Geography of Minor Cinemas in Los Angeles* (Berkeley: Univ. of California Press, 2005), 216.

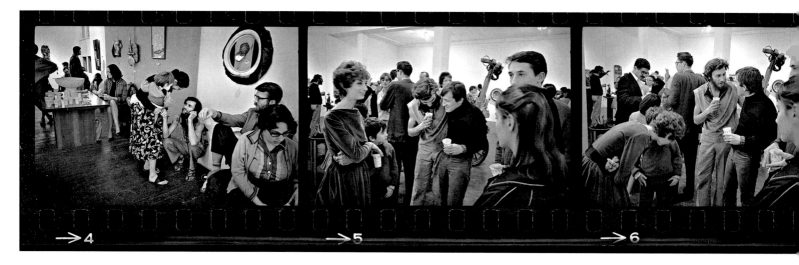

Figure 2.5.
Opening party for George Herms exhibition, Aura Gallery, Los Angeles, 1962. Photo by Marvin Silver (American, b. 1938). Courtesy Marvin Silver and Craig Krull Gallery, Santa Monica.

Figure 2.6.
Arthur Richer and Wallace Berman at Syndell Studio, with Richer's art in the background, 1957. Photo by Charles Brittin (American, 1928–2011). Los Angeles, Getty Research Institute, 2005.M.11. Image © J. Paul Getty Trust, Charles Brittin papers. Art courtesy Lauri Richer.

the year it opened) provided a meeting place for like-minded artists, poets, and writers. Another art venue was Vons Café Galleria, a Laurel Canyon coffeehouse that drew a young bohemian crowd. There, in 1955, Edward Kienholz exhibited a group of abstract wooden reliefs. Kienholz also organized exhibitions of other artists' work in the foyer of the Coronet Louvre Theatre, negotiating with its manager, Raymond Rohauer, to use the space free of charge in exchange for remodeling work (see sidebar 7). Through Rohauer's program of avant-garde European cinema, the Coronet's audience was well versed in the subversive tactics of Dada and surrealism; that audience was readily receptive to the work of Kienholz's friends and contemporaries. Kienholz would initiate a number of curatorial ventures over the years, often in improvised spaces like the Coronet.

Set in familiar local places, these kinds of alternative ventures merged sociability, domesticity, and display. Even the more clearly delineated galleries also functioned as places to gather socially (fig. 2.5). An important early example was Syndell Studio (fig. 2.6), established in 1954 in the low-rent premises of a former real-estate agency in L.A.'s Brentwood neighborhood (see sidebar 8). The founder was Walter Hopps, with Ben Bartosh and Betty Brunt, Craig Kauffman (Hopps's friend from high school), Jim Newman (whom Hopps had met at Stanford University), and Michael Scoles. Syndell was a progressive place, offering "a glimpse of avant-garde art," in the words of critic Jules Langsner.[8] While Syndell might have seemed more professional than the Vons Café or the foyer of the Coronet, it was not necessarily more lucrative—although there were the occasional successes. "Miraculously," Hopps later recalled of Kienholz's 1956 exhibition there, "two works sold."[9] Works of art were often traded for goods and services, a transaction typical at a time when straightforward sales of art were rare (see chapter 3, sidebar 14). For Wallace Berman (fig. 2.7), whose early years had been spent as a pool hustler, and wheeler-dealer Kienholz, whose truck carried a sign with the jack-of-all-trades boast "Ed Kienholz: Expert" (fig. 2.8), striking a deal was part and parcel of being an artist in Los Angeles. Though commercial in name, galleries like Syndell were visited mainly by friends and colleagues and artworks were often exchanged as gifts. Syndell's business hours were irregular, in part because Hopps was still a student at UCLA but also because spending long hours on-site held little appeal for such an energetic young man. Nonetheless, Syndell Studio was an important model, and those associated with it would go on to found some of the most significant avant-garde galleries in California: NOW and Ferus in Los Angeles, and the Dilexi Gallery in San Francisco.

In 1956, Kienholz won the contract to coordinate the All-City Outdoor Art Festival at Barnsdall Park. He invited Hopps to collaborate: "You're going to be in charge of all bullshit," Kienholz declared, "and I'm going to be in charge of work."[10] While Kienholz carried out the manual labor necessary to complete the project, Hopps negotiated with artists, galleries, and

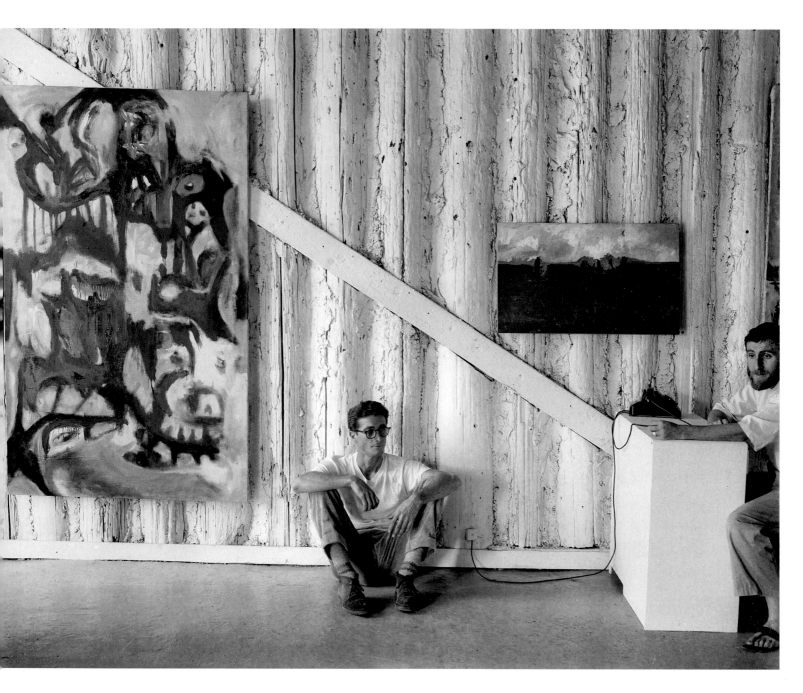

the city authorities. Alongside the usual juried selections, Hopps incorporated booths devoted to art from L.A. galleries, including those of Felix Landau and Esther Robles, as well as Syndell Studio. Despite his attempts to integrate his own gallery with the more commercial ventures, the tension between professionalism and Beat bohemianism—with its rejection of authority and materialism, its libertarian values, and its dropout reputation—was still very much in evidence. Hopps later recalled seeing Berman and a number of poets reclining in the shade of the park's trees, while he and Robert Alexander labored to install the exhibition. "I said to Ed, 'It's nice they're here. What are they doing here?' He said, 'Oh, I hired them.' I said, 'They're not doing anything.' He said, 'What do you expect them to do? They're poets…they're just here.'"[11]

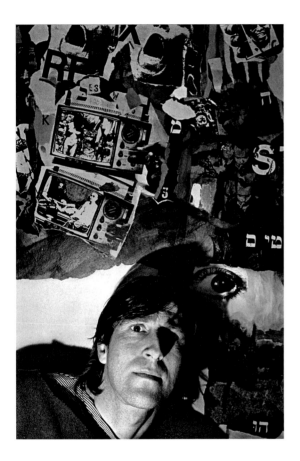

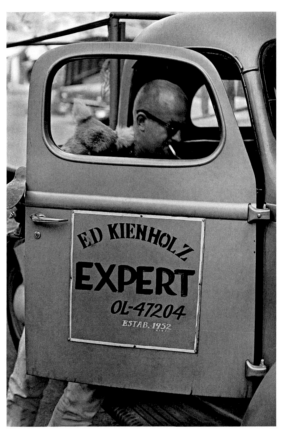

Figure 2.7.
Wallace Berman with his collage *Papa's Got a Brand New Bag,* **1965.** Photo by Marvin Silver (American, b. 1938). Courtesy Marvin Silver and Craig Krull Gallery, Santa Monica. Art courtesy the estate of Wallace Berman and Michael Kohn Gallery, Los Angeles.

Figure 2.8.
Edward Kienholz, 1962. Photo by Marvin Silver (American, b. 1938). Courtesy Marvin Silver and Craig Krull Gallery, Santa Monica.

In August 1956, Kienholz established the NOW Gallery in the greenroom of the Turnabout Theatre, also on La Cienega Boulevard. The gallery's name suggests some of the urgency of these short-lived ventures (NOW would last less than a year), and the impulse to find vital new forms of expression linked to everyday experience. As with Syndell, sales were not expected and occurred only rarely. The program of exhibitions at the NOW Gallery focused on California artists. It included an inaugural exhibition of the Navajo-inspired paintings of Gordon Wagner; solo shows devoted to Lois Lazarus, Eva Sheff, and Mark Szeka; and a display of the abstract paintings of Gerd Koch, who would be included in an exhibition at the Ferus Gallery the following year. Perhaps the most significant chapter in the short history of the NOW Gallery was an exhibition conceived as a sequel to the *Action* show of 1955. *Action*[2] (Action Squared), as the successor show was called, was organized in 1956 by Hopps and Alexander on behalf of Syndell Studio and was held at the NOW Gallery. It included many of the same artists as the earlier merry-go-round show, including Jay DeFeo, Sonia Gechtoff, Wally Hedrick, Gilbert Henderson, Craig Kauffman, Paul Sarkisian, and Julius Wasserstein. But it was smaller in scale and

IN ORAL HISTORY INTERVIEWS conducted with various Los Angeles artists and curators of the 1950s, the same peculiar story keeps cropping up. Recounted by Walter Hopps, Craig Kauffman, and Jim Newman, among others, it concerns a mentally disturbed farmer who was killed early one morning when he stepped in front of a truck on a quiet country road somewhere in the Midwest. Hopps placed the incident in Nebraska in 1952; Kauffman, in Ohio in 1954. Despite discrepancies such as these, their accounts all agree on one thing: the name of the unlucky farmer was Maurice Syndell.[1] When Hopps opened his first gallery in Brentwood in 1954, he named it Syndell Studio after this farmer, whose death, according to the story, Hopps's friend Newman had witnessed. As Hopps explained, it was "too absurd that this man dies in obscurity."[2]

The name was also attached to a number of artworks displayed in the gallery. Hopps later recalled that "in those years, art publicly attributed to Syndell, a deranged and institutionalized man in the Midwest, was made in a consistent style by a variety of Southern California artists."[3] Among those who may have created works under the name Maurice Syndell were the poet Ben Bartosh and his wife, Betty Brunt, poet-mathematician Michael Scoles, Edward Kienholz, Newman, and possibly even Hopps himself. At their hands, the obscure farmer was reconfigured as an avant-garde artist. It was an act that toyed with the notion that artistic attribution conferred market value and offered a tongue-in-cheek response to the continuing criticism of Los Angeles as a cultural backwater, the unsophisticated country bumpkin of modern art. Just as Hopps and Newman had hoped, Maurice Syndell did not die without recognition, though his name lived on in a city far from his home and only among a tiny audience.

The name chosen for the Ferus Gallery in 1957 was also a memorial of sorts. In part, it was a tribute to James Ferus, an artist from Hopps's former school, Eagle Rock High School, who had died young. But Hopps was quick to dispel the notion that the appellation was mere earnest homage: "there was as much deliberate irony as there was a genuine kind of memorial. It was two-edged, something very involved about what we felt was living art and how it would be named after someone who was no longer alive."[4] The success of the name lay in this ambiguity, its potential to carry several possible meanings at once: it meant "wild" or "untamed," according to Wallace Berman's Latin dictionary; and to Hopps, a former anthropology student, it evoked the physical prowess of *Ferus hominis*, the primitive humans he vaguely (though mistakenly) remembered from Alfred Kroeber's *Anthropology* textbook.[5] For David Meltzer, the name articulated the exclusivity of the gallery: "most art, initially, is dissident, so when it says 'Fer us' it means not 'fer you.'"[6]

When Henry Hopkins opened a gallery across the street in 1960, he was mounting a challenge to the dominance of the group of artists that had coalesced around the Ferus Gallery. He countered the Ferus gang's studly reputation by naming his enterprise the Huysman Gallery, after Joris-Karl Huysmans, the nineteenth-century French decadent novelist. As the commercial art scene in Los Angeles continued to grow, choosing a gallery name was a playful artistic strategy used to convey a serious message, an important means of constructing an identity and declaring an avant-garde stance.

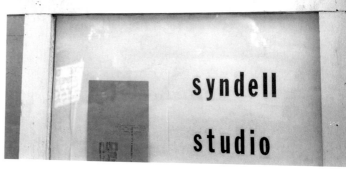

Arthur Richer at Syndell Studio, 1957. Photo by Charles Brittin (American, 1928–2011). Los Angeles, Getty Research Institute, 2005.M.11. Image © J. Paul Getty Trust, Charles Brittin papers.

Notes

1. The story probably refers to a farmer and World War II veteran named Maurice Sindel, who (according to his death certificate) died in Williams County, Ohio, on 6 June 1953, as the result of a traffic accident.

2. Walter Hopps, interview by Thomas Crow, Andrew Perchuk, and Rani Singh, 16 November 2003, transcript, "Modern Art in Los Angeles: The Beat Years," 15, Pacific Standard Time collection, Getty Research Institute (2004.M.30).

3. Walter Hopps, "Edward Kienholz: A Remembrance," *American Art* 8, no. 3/4 (1994): 124.

4. Walter Hopps, interview by Betty Turnbull, 4 October 1975, cited in *The Last Time I Saw Ferus, 1957–1966*, exh. cat. (Newport Beach, Calif.: Newport Harbor Museum of Art, 1976), n.p.

5. Hopps, interview by Betty Turnbull. In the transcription of the interview, Hopps's reference is to "Prober's Anthropology," most likely a typographical error for Alfred Kroeber's *Anthropology: Race, Language, Culture, Psychology, Prehistory* (1948). In fact, Kroeber does not mention any such classification.

6. David Meltzer, quoted in Kristine McKenna, *The Ferus Gallery: A Place to Begin* (Göttingen: Steidl, 2009), 162.

mounted in the gallery rather than the fanciful merry-go-round venue that Hopps had chosen for the earlier exhibition, a decision that lent it a more professional veneer than its predecessor's. Though the exhibition focused primarily on painting, one room of the gallery was devoted to mixed-media work by Alexander: collages and a collection of minute works made from pins and cigarette butts.

Alexander would later declare that spaces like Syndell and NOW provided room for the "art enrichers"—the self-styled "outlaws" who were too anarchic for establishments like Kantor and Landau.[12] Many of these early exhibition ventures more closely resembled a form of art practice than a commercial strategy. The Exodus Gallery, an artists' cooperative run by printmaker Connor Everts on Sixth Street in San Pedro, relied on membership fees to further its aim of providing opportunities for young artists to exhibit work. During the few years of its existence, in the latter half of the 1950s, Everts mounted exhibitions of work by numerous young artists, making his own work and publishing that of others (fig. 2.9).

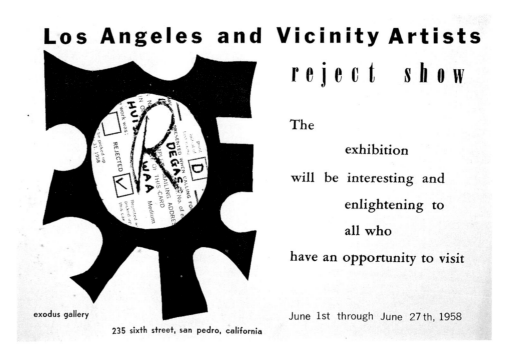

Figure 2.9.
Invitation to the *Los Angeles and Vicinity Artists Reject Show,* Exodus Gallery, San Pedro, California, 1958. 13.6 × 20.3 cm (5⅜ × 8 in.). Image courtesy Connor Everts.

One of the more legendary, but least viewed, temporary art exhibitions was George Herms's "secret exhibition" in 1957, installed among the foundation blocks of a row of demolished buildings in Hermosa Beach. Visited by only a handful of friends on a single day, the works were then abandoned to the elements and left to decay. In part, Herms's aim was to return the works to their origin: he had accumulated their component parts while beachcombing or scavenging vacant lots in the area. The "secret exhibition" played gently on the commodification of artworks engendered by the emergent gallery system and the fraught experience of surviving as an artist (see sidebar 9).

BACK AND FORTH: ARTISTIC NETWORKS

Artist-run gallery spaces emerged in response to the dearth of opportunities for artists to show their work. They reflected the artists' desire to take control of the display of artworks and to disseminate them beyond the boundaries of the newly established commercial galleries. This subversion was enacted not in opposition to the commercial model but by using that model's tools and practices. Although Exodus, NOW, and Syndell were informal in atmosphere, they all had official business cards (fig. 2.10). Exhibitions at these alternative galleries would, like shows

DILEXI gallery
471 broadway
san francisco
yukon 2-8960

FERUS gallery
736a la cienega los angeles

PRESS ▪ BAZA
8205 santa monica boulevard
OLdfield 4-7070

PHOTOGRAPHY
CHARLES BRITTIN
914 NORTH DOHENY • LOS ANGELES 69 • CR 4-3695

PRESS ▪ BAZA
PRINTING FOR CERTAIN PEOPLE
SANTA MONICA 8205 WEST

syndell studio
11756 Gorham West Los Angeles GRanite 73161

at more mainstream venues, be accompanied by official announcements, posters, and invitations, sent to a tightly knit group of friends. The printer of choice was Robert Alexander's Press Baza, which undertook "printing for certain people" (see sidebar 10).

At the same time, artists associated with these spaces were exploring new ways of sharing their work beyond the walls of galleries. Alexander, Berman, Ben Talbert, and actor-artists Dean Stockwell and Russel Tamblyn, among others, used the postal service to disseminate small-scale collage works that typically combined word and image, incorporating photography, drawing, print collage, and found pictures (figs. 2.11, 2.12, 2.13, 2.14). Hand-printed missives were sent as Christmas cards, birth announcements, invitations to exhibitions or parties; often, cards were sent simply as word of continued existence. Communicating artistic meaning beyond their function as conveyors of news, these pieces stand as important early examples of mail art.

For many, sharing works of art was a private, intimate act, and a great number of artworks made by this circle of artists were never exhibited publicly. This was the case with many of the works made by Stockwell, a former Hollywood child star, who began creating intricate collages of found pictures that mingled historical and contemporary imagery and sources. In *Smith* (1958), for example, a magazine image of the towers of Westminster Abbey is superimposed on a page torn from the L.A. phone book. Tamblyn made dense, intricate collages and mail-art objects and collaborated with San Francisco poet Jack Hirschman on a handmade artist's book. Tamblyn's embrace of several modes of art making was typical of this group of artists, many of whom experimented with collage and assemblage, poetry, photography, and filmmaking. Both Stockwell and Tamblyn made short experimental films—among them Stockwell's *For Crazy Horse* (1958) and *Pas de trois* (1965) and Tamblyn's *Rio Reel* (1966)—which were shown only to friends in private settings, far removed from the Hollywood system in which the actors worked. Wallace Berman was similarly private about the one film that he made, posthumously titled *Aleph* (1958–76) by his son Tosh. It was shown only in the Berman family home, Tosh recalls, projected onto the refrigerator and accompanied by a sound track of jazz from Berman's record collection.[13] The film's stream of rapidly montaged imagery overlaid with paint and transfer lettering expresses the same aesthetic of ephemerality and fragmentation as Berman's mail-art objects.

The private interactions through which these works were shared embody the dynamic of exchange that characterized the artists' lives. Through mailed works, artists were able to stay connected with one another even though they were based in far-flung neighborhoods across the L.A. area (Herms in Hermosa Beach, Brittin in Venice, the Bermans in Beverly Glen, Alexander at the "Baza Shack" on Santa Monica Boulevard). Networks of friends and colleagues stretched beyond the limits of Los Angeles's immediate vicinity north to San Francisco. In the Bay Area, artists like Bruce Conner, Jay DeFeo, Wally Hedrick, and Jess were part of an art scene centered on the 6 Gallery, the East-West Gallery, the Dilexi Gallery, and the Batman Gallery. These provided both a parallel to and an inspiration for the Southern California galleries and kept artists traveling frequently up and down the coast.

Between 1955 and 1964, Berman worked sporadically on a mailed journal called *Semina*. Its nine issues spanned his several moves—from Los Angeles to San Francisco in 1957, to Larkspur in 1960, and back to Los Angeles the following year. Berman produced *Semina* on a warped Kelly handpress given to him by William "Batman" Jahrmarkt, who would later found the Batman Gallery. Seven of the *Semina* issues, including the first (fig. 2.15), consist of loose-leaf cards printed with poems, photographs, and artworks, in no prescribed order; one issue is bound; and one comprises a single folded sheet. The journal functioned as a group exhibition of sorts, a collection of words and pictures sent by mail, to be unpacked and rearranged at leisure, transforming the passive reader into an active participant. In many ways, *Semina* was a collective effort, and many of its recipients were also contributors. Berman mixed his own writings and visual artworks with those of others, including Robert Alexander, Charles Brittin,

Opposite, clockwise from top left:

Figure 2.11.
Dean Stockwell (American, b. 1936). Mailer addressed to George Herms, postmarked 10 October 1966. Collaged paper, ink, and stamp on cardstock, 16.2 × 10 cm (6⅜ × 4 in.). Los Angeles, Getty Research Institute, 2009.M.20.

Figure 2.12.
Wallace Berman (American, 1926–1976). Mailer addressed to the Herms family, ca. 1960s. Collaged photograph, letterpress, ink, and stamp on cardstock, 12.8 × 8.2 cm (5 × 3¼ in.). Los Angeles, Getty Research Institute, 2009.M.20. Courtesy the estate of Wallace Berman and Michael Kohn Gallery, Los Angeles.

Figure 2.13.
Wallace Berman (American, 1926–1976). Mailer addressed to Edmund Teske, ca. 1968. Collaged photograph of Berman's *Untitled* (1957), letterpress, ink, and stamp on cardstock, 9.9 × 7.6 cm (3⅞ × 3 in.). Los Angeles, Getty Research Institute, 2005.M.10. Courtesy the estate of Wallace Berman and Michael Kohn Gallery, Los Angeles.

Figure 2.14.
Russel Tamblyn (American, b. 1934). Mailer addressed to George Herms, postmarked 19 December 1966. Collaged photograph, ink, and stamp on cardstock, 11.6 × 9 cm (4½ × 3½ in.). Los Angeles, Getty Research Institute, 2009.M.20. © Russel Tamblyn.

OK

GEORGE H.
2215 N. TOPANGA Blvd
TOPANGA,
CALIF.

love d.

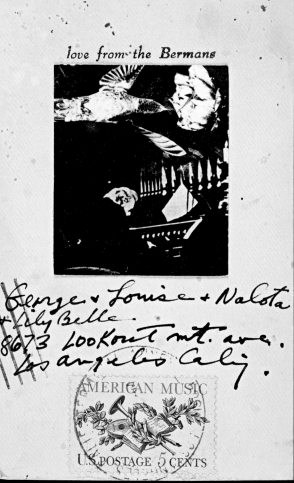

love from the Bermans

George + Louise + Nalota
+ Lily Belle.
8673 Lookout mt. ave.
Los angeles Calif.

Christmas
1966 Love from
 The Tamblyns

Herms
2215 So. Topanga Blvd.
Topanga, California

E TESKE
1400 MURRAY DR.
L.A. CALIF.

love from the Bermans

Cameron, Llyn Foulkes, Walter Hopps, David Meltzer, John Reed, Dean Stockwell, Aya Tarlow, and Zack Walsh. Berman frequently signed his work with initials, pseudonyms, the Hebrew letter *aleph,* or not at all, playing with the commercial validation implied by attribution. To his friends, Berman's mystical persona was just as much a work of art as the objects he made, and he was viewed by many as something of a shaman. To others, however, he was merely a "goofball."[14]

As literary scholar Stephen Fredman has noted, *Semina* was not just a reflection of Berman's circle and its preoccupations. It also functioned actively to "coalesce a community that was at odds with the official world."[15] Its title evokes dissemination, the fecundity of scattered seeds (indeed, Berman appears as a seed-sowing extra in Dennis Hopper's 1969 film *Easy Rider*). Berman remained reticent about his own artistic influences, but the loose-leaf cards that make up many of *Semina*'s issues offer clues to what he and his contemporaries were reading. They reveal not only strong ties with contemporary American poetry but also an awareness of European, particularly French, writers: Antonin Artaud, Jean Cocteau, Paul Éluard, Paul Valéry, and Charles Baudelaire. Like others in his circle, Berman owned a copy of Robert Motherwell's

Figure 2.15.
Complete contents of Wallace Berman's *Semina*, no. 1 (1955), consisting of paper sleeve with works by various artists and poets. Sleeve: 19.1 × 10.2 cm (7½ × 4 in.). Los Angeles, Getty Research Institute, 2864-801. Courtesy the estate of Wallace Berman and Michael Kohn Gallery, Los Angeles.

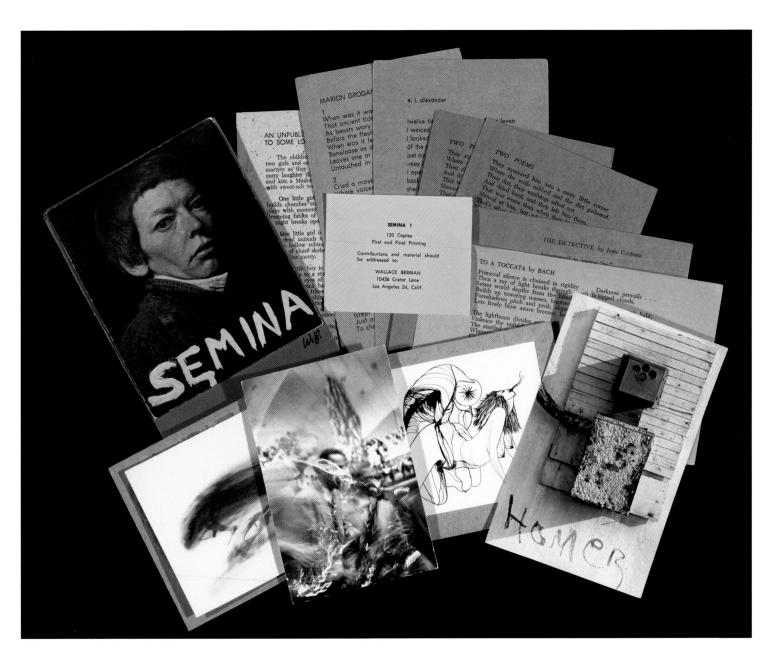

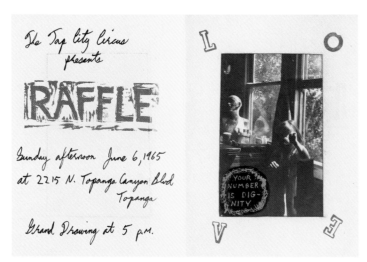

George Herms (American, b. 1935). **Invitation to "Raffle," 1965.** Letterpress, woodblock, rubber stamping, and photograph on folded cardstock, 19 × 28 cm (7½ × 11 in.). Los Angeles, Getty Research Institute, 2010.M.38. Courtesy George Herms.

George Herms at "Earful" Tap City Circus, 1972. Gelatin silver print, 25.2 × 20.2 cm (10 × 8 in.). Los Angeles, Getty Research Institute, 2009.M.20. Photo by Jerry Maybrook (American, b. 1942). © Jerry Maybrook.

BEGINNING IN 1961, Southern California assemblage artist George Herms organized a number of carnivalesque events to raise money and stave off eviction from wherever he was currently living. These "Tap City Circus" benefits combined elements of an auction, a picnic, and a performance, gathering the local artist community together for a day of solidarity and fun. The term "tap city," which Herms traces to jazz, means "Tapped out. Broke. Ready to tap dance on street corners."[1] By combining "tap city" with "circus," Herms infused his ongoing financial predicaments with an oddly celebratory tone. To live by your wits, he later explained, you have to know how to throw a raffle. The Tap City Circus is the "highest example of using life's pitfalls as a springboard."[2]

Herms inaugurated the Tap City Circus in August 1961, when authorities in Larkspur, California, condemned his boathouse on the marshes as a public nuisance and evicted him and his family. At "New Sense on the Marsh," the punning title for his moving sale, Herms disposed of much of his artwork and hosted a potluck. A second eviction in 1962, when he was living in Topanga Canyon, on the western outskirts of Los Angeles, prompted him to organize a "Tap City Circus Motion Benefit" in the garage of his friend and neighbor Jean Paul Pickens, a banjo player. Herms's invitation card announced "works by G. Herms. Bluegrass music by J. P. Pickens." Beginning with "Raffle" in June 1965, Herms organized a series of benefits at his home in Topanga Canyon. For each raffle, held roughly every eighteen months through 1972, he created two sets of numbers. The first set—consisting of small numbered cards with poetry or imagery on the back—served both as raffle tickets to be purchased for a dollar and as souvenirs to take home. The numbers in the second set were placed in a satchel or printed on a board, and one of the children at the party was asked to pick one. Those with the winning number received a book or a print or could elect to squirt the artist with a hose; participants worked their way up to a grand prize consisting of an artwork chosen by the winner from those displayed throughout Herms's house.

Herms announced and promoted his raffles through colorful printed cards made on his handpress, in the tradition of his friends Robert Alexander and Wallace Berman. He would print between 100 and 150 woodblock and letterpress cards per event, running them through the press five times to accumulate the colors. When finished, he would hand stamp each invitation with his "L-O-V-E" insignia and mail them off. By 1966, the handpress had become the Love Press.

Puns, mirror readings, and invented words convey Herms's circus humor. He followed his "Raffle" benefit with "Roofle." The "Rain Poem" on the reverse of the ticket—"I can see the sky through the roof!"—was a plea for money to repair his shingles. "Baffle" used words, rather than numbers.

Prizewinners at "Waffle" received a "wall full of effluvia"—in other words, a trove of prints from the Love Press. After "Rawful" came "Earful," featuring Herms under his pseudonym "Paul Mistrie" and signage bearing his aphorism, "The Ear and the Eye are One," with a tongue-in-cheek attribution to one of his heroes, Harpo Marx.[3]

The elaborate naming of the raffles, their careful staging, and the laborious production of the ephemera required more time and effort than Herms could possibly have recouped in raffle funds. The Tap City Circus raffles, born out of financial hardship, unfolded as performances animated by the originality and wit of their hand-printed signage. Commercially unviable, this artistic enterprise points to an irony that Herms may have intentionally cultivated. Indeed, the raffles' quixotic blend of childish antics, disciplined craft, and seeming indifference to life's practicalities represents a form of conceptual art that Herms made his own.

Notes

I wish to thank George Herms for the invaluable information he provided on the Tap City Circus.

1. George Herms, *The Prometheus Archives: A Retrospective Exhibition of the Works of George Herms*, exh. cat. (Newport Harbor, Calif.: Newport Harbor Art Museum, 1979), 10.

2. Herms's explanation of how to live by your wits is paraphrased: George Herms, interview by Andrew Perchuk and Rani Singh, 3 March 2009, Getty Research Institute. The quotation about the Tap City Circus appears in Herms, *The Prometheus Archives*, 10.

3. Cards announcing these benefits and two later raffles—"Orange Out" in 1982 and "Eyeful: A Motion Benefit" in 1994—are preserved in the Herms archive at the Getty Research Institute, Los Angeles (2009.M.20).

The Dada Painters and Poets and old copies of the surrealist magazines *View* and *VVV,* and he frequently went to the surrealist films screened at Raymond Rohauer's Coronet Theatre.[16] American "little magazines" and poetry journals such as *Black Mountain Review, Origin,* and *Evergreen Review* were staple reading matter; their influence on L.A. artists is evident in the output of Alexander's Press Baza and Herms's Love Press, established in the mid-1960s to publish the work of Herms's poet friends. Herms's printed works, which constitute a significant part of his artistic output, point to a delight in wordplay and punning. While Berman adopted the Hebrew letter *aleph* as a personal symbol, Herms stamped the word "L-O-V-E" on his constructions, mail art, and correspondence.

THE "SMASHED-TOY SCHOOL": JUNK ART IN SOUTHERN CALIFORNIA[17]

By the time Gordon Wagner showed at the NOW Gallery in 1956, he had already gained a reputation as an abstract painter of some note and was being compared to the Bay Area abstract expressionists and to the surrealist painters. Since the late 1940s, however, he had also made sculptures out of objects found on Redondo Beach and in Topanga Canyon, and during scavenging missions to the vast garbage dumps in the Mojave Desert. His constructions—made of rusting machine parts, driftwood, toys, photographs, and faded scraps of fabric—are rooted in the locations of these treasure hunts (fig. 2.16). Wagner reconfigured outmoded and discarded objects into totem-like sculptures such as *Seven Actors* (1952) or wall-mounted reliefs like *The Mexican Night Clerk* (fig. 2.17). Though Wagner, born in 1915, was a bit too old to be a bona fide member of the Beat generation, which emerged in the mid-1950s, his exhibition at NOW points to the relevance of his work for the younger artists in Los Angeles.

Figure 2.16.
Gordon Wagner in his studio, ca. 1964–66. Photo by Harry Drinkwater (American, b. 1919). © Harry Drinkwater. Art © estate of Gordon Wagner, courtesy Tobey C. Moss Gallery.

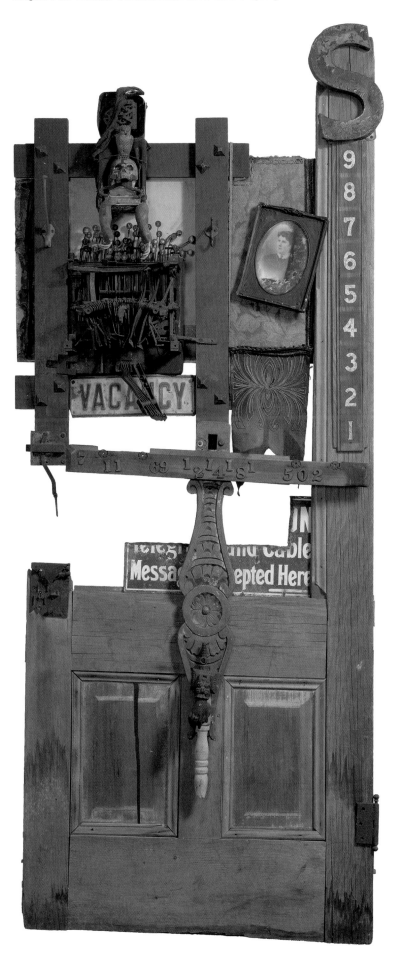

Figure 2.17.
Gordon Wagner (American, 1915–1987). *The Mexican Night Clerk*, 1960–65. Assemblage, 208 × 86.4 × 12.7 cm (82 × 34 × 5 in.). Los Angeles, Tobey C. Moss Gallery. Art © estate of Gordon Wagner, courtesy Tobey C. Moss Gallery.

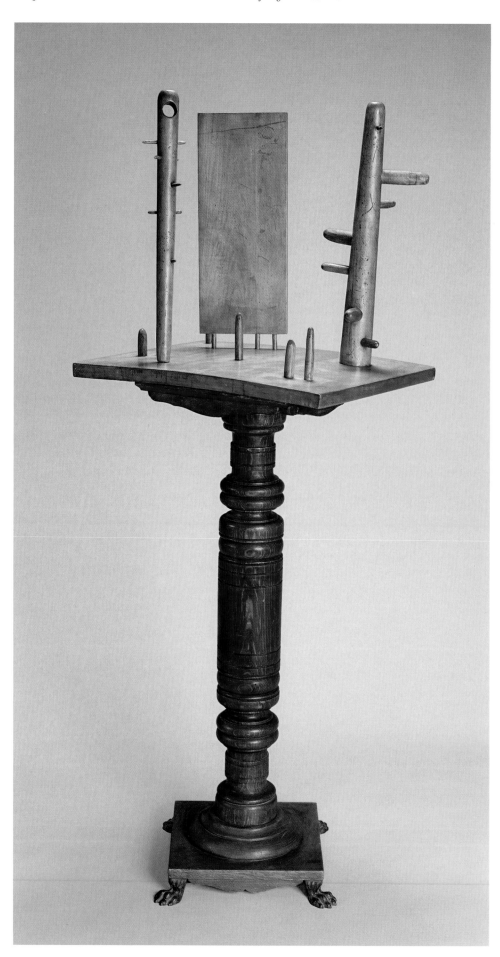

Figure 2.18.
Wallace Berman (American, 1926–1976). *Homage to Hermann Hesse*, 1949, modified in 1954. Wood, 149.9 × 53.8 × 45.4 cm (59 × 21³⁄₁₆ × 17⁷⁄₈ in.). Collection of Joy Stockwell. Courtesy the estate of Wallace Berman and Michael Kohn Gallery, Los Angeles.

Berman's early construction *Homage to Hermann Hesse* displays a visual affinity with Wagner's early wooden sculptures, and both share a concern with the formal and intellectual value of found materials (fig. 2.18). The work had its beginnings as early as 1949. While Wagner salvaged driftwood from the beach, Berman rescued remnants from his workplace, the Salem Furniture Company. Sections of polished wood evoke the hand of the craftsman as opposed to the mass-produced plastics popular in contemporary design. The parts are fashioned into a construction that resembles a collection of totems or a three-dimensional board game. Hesse, to whom the work is dedicated, was the author of *The Glass Bead Game,* a novel that inspired Berman's interest in game systems and chance. Here, as in much work of the 1950s, assemblage speaks to the marvelous potential of the chance encounter (so prized by the surrealists), of a fascination with language and its games, and of the improvisations of jazz. These influences are echoed in Berman's works of the 1960s: the vibrant rhythms of the collage *Papa's Got a Brand New Bag* (fig. 2.19), the ghostly rubbed portraits in *Untitled (Faceless Faces with Kabala)* (fig. 2.20), and the grids of iterated found imagery in the Verifax works Berman made on an outmoded reproduction machine (fig. 2.21).

While *Homage to Hermann Hesse* retains the elegance of carved wooden sculpture, other work made of found materials more directly references the grime and material precariousness of the junk aesthetic. This, and the sense of dark sensuality that many works displayed, led some critics to describe them, using a term borrowed from jazz and blues, as "funk art."[18] Other critics focused on the activities of finding, gleaning, and collecting that united these artists in the role of ragpicker or bricoleur, choosing the designation "assemblage." Much of the early critical framing of this kind of art was played out in the pages of *Artforum,* founded in San Francisco in 1962 as the first publication with a commitment to West Coast art. In an *Artforum* piece typical of much of the early writing on junk art, Donald Clark Hodges identified this work with a critique of consumption engendered by capitalism in the United States, an "object lesson" in the usefulness of waste.[19] Thus, assemblage in Southern California was framed in terms of nostalgia for a kind of life that was rapidly disappearing from Los Angeles, supplanted by the built-in obsolescence of postwar consumer culture and the rapacious development of far-flung suburbs. Drawing on folk traditions and the practices of vernacular American art (such as those embodied in Simon Rodia's Watts Towers), artists produced works that celebrated the beauty to be found in broken, discarded, or outmoded objects. Some works carried with them the romantic historical aura of a specific location, such as the fused drapery and lamp in Wagner's *Sir Deauville* (ca. 1964), which he salvaged from a twenties-era Santa Monica beach club gutted by fire in 1964. Nevertheless, there was more at stake in these works than collecting and preserving fragments of the past; artists such as Wagner, Berman, and Tony Berlant were concerned with reinvigorating the objects by presenting them in a new context. Berlant scavenged a range of materials in the early years of the 1960s—including carpets, clothing, wood, feathers, and metal of various kinds— which give texture, pattern, and even subject matter to two-dimensional works that combine aspects of assemblage and collage.

John Outterbridge, who would arrive in Los Angeles in 1963, embraced the junkyard as a site of human, as well as material, discovery. He chose discarded objects that related to universal experience as well as to his own past and that offered a symbolic expression of the exclusion that lay at the core of African American experience.[20] Betye Saar's assemblage and collage constructions similarly merge personal and family history with broader themes of cultural and political segregation. In both *View from the Palmist Window* (fig. 2.22) and *The Phrenologer's Window* (fig. 2.23), Saar pasted eclectic objects and imagery—sun and moon symbols, fragments of advertising, vintage photographs, the lid of a tin can—inside found wooden window frames. The works allude to the practices of phrenology and palmistry, raising questions about how identity is construed and constructed.

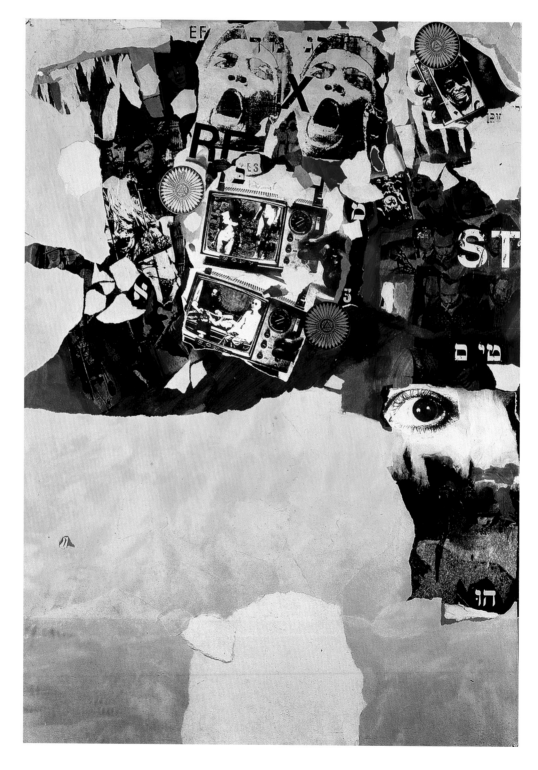

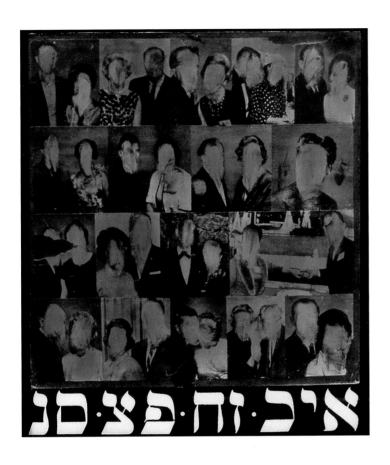

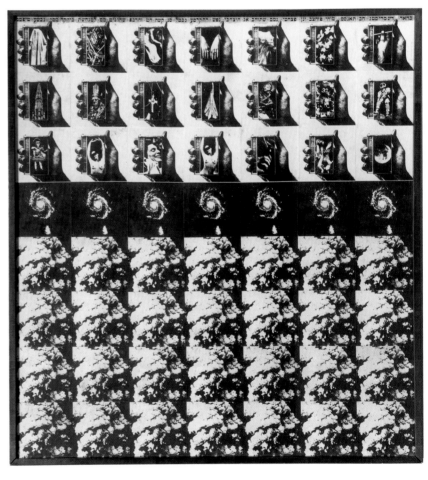

Figure 2.19.
Wallace Berman (American, 1926–1976). *Papa's Got a Brand New Bag,* 1964. Mixed-media collage, 113 × 81.9 × 5.1 cm (44½ × 32¼ × 2 in.). Los Angeles, collection of David Yorkin and Alix Madigan. Courtesy the estate of Wallace Berman and Michael Kohn Gallery, Los Angeles.

Figure 2.20.
Wallace Berman (American, 1926–1976). *Untitled (Faceless Faces with Kabala),* 1963–70. Verifax collage, positive with orange, Kabala at bottom, 87.6 × 77.5 cm (34½ × 30½ in.). New York, collection of Nicole Klagsbrun. Art courtesy the estate of Wallace Berman and Michael Kohn Gallery, Los Angeles. Image courtesy Nicole Klagsbrun.

Figure 2.21.
Wallace Berman (American, 1926–1976). *Untitled (Verifax Collage),* 1969. Verifax collage on board, 121.9 × 114.3 cm (48 × 45 in.). Berkeley, California, collection of Michael D. Fox, courtesy Steven Wolf Fine Arts. Art courtesy the estate of Wallace Berman and Michael Kohn Gallery. Photo by Joe Schopplein.

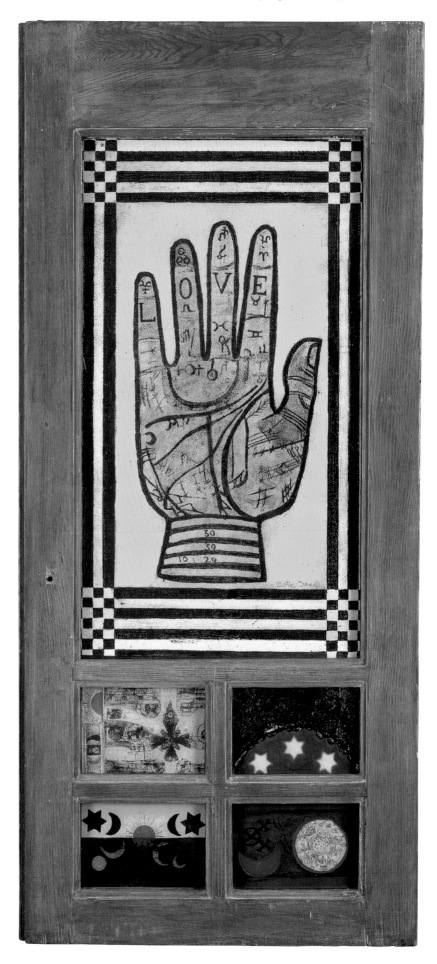

Figure 2.22.
Betye Saar (American, b. 1926). *View from the Palmist*
Window, **1966.** Five color etchings, A.P., framed in window,
signed, 85.7 × 38.7 × 5.1 cm (33¾ × 15¼ × 2 in.). Manoogian
Collection. Courtesy Michael Rosenfeld Gallery, LLC,
New York, NY.

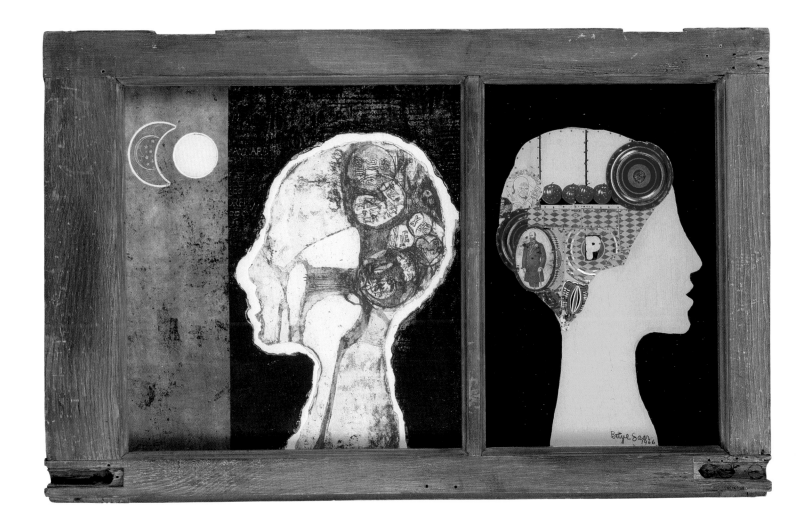

Figure 2.23.
Betye Saar (American, b. 1926). *The Phrenologer's Window,*
1966. Assemblage of two panel wood frames with print and
collage, 47 × 74.6 × 3.8 cm (18½ × 29⅜ × 1½ in.). New York,
Michael Rosenfeld Gallery. Courtesy Michael Rosenfeld Gallery,
LLC, New York, NY.

Assemblage was informed by an interest not only in old things but also in ancient thought—
including the cultures of Mexico, the traditions of the Navajo and Hopi, and the philosophical
teachings of Buddhism, Taoism, Hinduism, and mystical Judaism—which permeated Beat cul-
tural production. Berman's works betray his ongoing fascination with the mystical symbolism
of the Kabbalah, which is evident in the parchment works he exhibited in 1957 and in his adop-
tion of the letter *aleph* as a personal moniker. The artist Cameron created graphic works filled
with the esoteric symbolism of the occult and allusions to Greek mythology (fig. 2.24). George
Herms incorporated astrological references in works such as the wall-mounted assemblage
Saturn Collage (1960) and his *Zodiac behind Glass* series of boxes (1965–66), which incorporate
collage and found materials with drawing and fragments of verse. In the small-scale collage
works of Robert Alexander, scraps of poetry inspired by surrealism and by Sufism, a mystical
branch of Islam, are mingled with found photographs, hand- and footprints, and, in the case of
Blood of a Poet (1956), his own blood. Materials deteriorated through age are layered with signs
and symbols, half-hidden meanings in lost languages, signposts toward expanded conscious-
ness, and assertions of bodily presence. A fascination with the material accumulation of knowl-
edge is evident in two of Herms's most important assemblage works from the early 1960s: the

Figure 2.24.
Cameron (American, 1922–1995). *Untitled (Portrait of Crystal),* **ca. 1961.** Ink and gouache on wood panel, 110.5 × 29.8 cm (43½ × 11¾ in.). Santa Monica, California, collection of Scott Hobbs. Courtesy the Cameron Parsons Foundation.

Robert Alexander (American, 1923–1987). **Box for business cards, 1957.** Mixed media, 6.4 × 16.2 × 9.8 cm (2½ × 6⅜ × 3⅞ in.). Los Angeles, Getty Research Institute, 2005.M.11. Courtesy the Temple of Man, Inc.

AMONG THE PAPERS of photographer Charles Brittin at the Getty Research Institute, there is a small box covered in layers of collaged material, including a page of Braille and a handwritten receipt from a Toledo furniture company dated 2 December 1906. An antique tin pillbox is glued to the upper left-hand corner of the box top, with the druggist's instructions scrawled on the label: "For Pain, one every two hours." This curious little package bears the typed inscription "glory to brittinday '57 / o beauty! / o movement!" It opens to reveal Brittin's business card and a small photograph of his friend Robert Alexander in profile. The name of the imprint, "Press Baza," based on Alexander's nickname, is stamped on one side of the box. This birthday present, given to Brittin by Alexander in 1957, is on one level a personal creative exchange between artist-friends. On another level, it exemplifies the larger career aspirations that would become a prominent feature of the L.A. art world as it grew in complexity during the 1960s.

Brittin is best known for his photographs of Wallace Berman's arrest at the Ferus Gallery in 1957 (on obscenity charges) and for striking portraits of the bohemian denizens of Venice Beach, where he lived. As an activist-documentarian, he photographed civil rights protests in the 1960s. Speaking to an interviewer many years later, he remarked that he thought of the images he made in the mid-1950s not so much as art but as a form of gift giving: "we were creating little treasures...pleasures to share with each other."[1] Alexander's decorated box is a contradictory sort of treasure; the intimate engagement it invites implies a precious cargo, yet the box contains not a valued relic but a business card, a mundane tool of professional identity.

The printed fragments on the box have diverse origins: a religious pamphlet, directions for the use of an impotency aid called a "rigido-splint,"

lines of poetry, and a betting slip from a racetrack. Inside the pillbox is an early twentieth-century photographic portrait of a boy with a high collar, making the box into a kind of locket. This eclectic mix of materials reflects the avant-garde's interrogation of the urban, the outmoded, and the poetic as a means of transforming the everyday into art; both Alexander and Brittin were well acquainted with the surrealist and Dadaist precedents at work. The business card itself is a mode of self-promotion not unrelated to the manifestos, posters, and exhibition announcements that art subcultures have used to advertise their group identities since the beginnings of modernity.

Robert Alexander's Press Baza was the printer of choice for the announcements and brochures that circulated in the underground art worlds of Los Angeles and San Francisco in the 1950s. Though his birthday gift and business-card design subvert the symbols of commercial enterprise, he nevertheless clearly understood the importance of crafting a professional image. Alexander made this box for his friend in 1957, just as the rising gallery scene on La Cienega Boulevard was beginning to transform the art community in which he and Brittin were involved. The mix of earnestness ("o beauty! o movement!") and irony in Alexander's gift, the intertwining of the subcultural and the professional that it evinces, may express his simultaneous resistance to and engagement with the commercial development of the art scene in Los Angeles.

Notes
1. Charles Brittin, interview by Rani Singh, 28 November 2006, Pacific Standard Time collection, Getty Research Institute (2008.M.34).

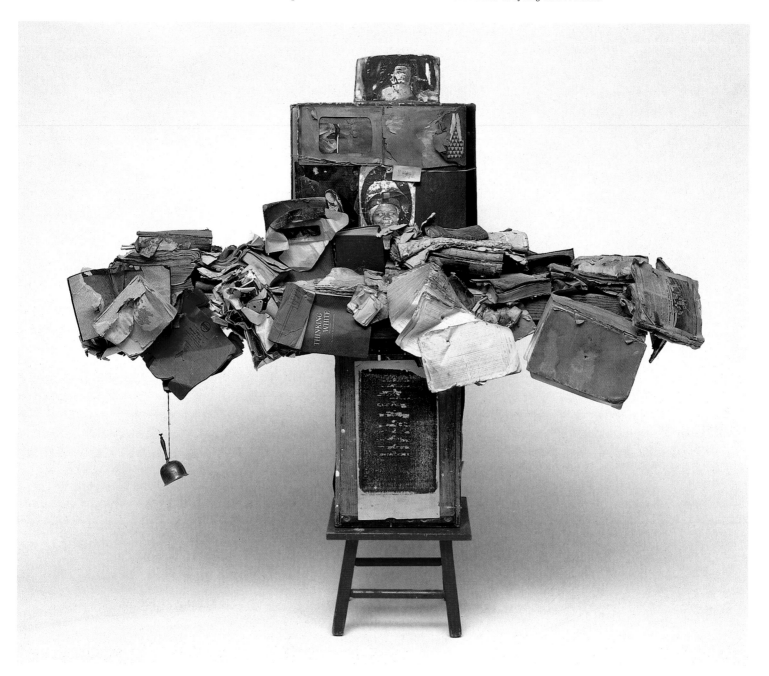

Figure 2.25.
George Herms (American, b. 1935). *The Librarian*, 1960.
Wood box, papers, books, loving cup, and painted stool,
144.8 × 160 × 53.3 cm (57 × 63 × 21 in.). Pasadena, California,
Norton Simon Museum, gift of Molly Barnes. Courtesy George
Herms.

anthropomorphic sculptures *The Librarian* (fig. 2.25), made from old books found in a dump in
Larkspur, and *Poet* (fig. 2.26), a bundle of pages and a rusted klaxon mounted on a wooden ped-
estal. The two works represent for Herms two distinct approaches to assemblage sculpture: one,
a multitude of things and materials thrown together to create what Herms has often called a
"tossed salad" assemblage; the other, a carefully focused combination of just two or three objects.

In 1961, *Poet* was included in the landmark exhibition *The Art of Assemblage* at the
Museum of Modern Art (MoMA), New York, which confirmed assemblage as a major medium
of the twentieth century and helped to popularize the term. Although the curator, William C.
Seitz, had traveled to the West Coast to choose works for the show, California artists made
up only a small percentage of the MoMA exhibition: in addition to Herms's sculpture, Seitz
selected Kienholz's *John Doe* (1959) and *Jane Doe* (1960), and works by San Francisco artists
John Baxter, Bruce Beasley, Bruce Conner, and Jess. Wallace Berman refused to cooperate,
declining to show Seitz any of his work. The exhibition catalog defined assemblage as a signifi-

cant strategy of the artistic avant-garde, with an important (and authenticating) European lineage in Dada and surrealism. John Coplans would disagree, refuting the Dada legacy of assemblage, presenting it instead as a radically new art form tied specifically to Los Angeles.[21]

The Los Angeles work that Seitz seems to have found most relevant to his project was one that he could not display in the galleries of MoMA: the Watts Towers, which Seitz featured prominently in the pages of his catalog. But Seitz's definition of assemblage as an essentially urban form of expression failed to take account of the craft or folk undercurrent in a lot of work in Los Angeles in the 1950s. While Seitz's "collage environment" was situated in the urban grid of Manhattan, much California assemblage in the 1950s was located in the rural environments of Redondo Beach, Venice, or Topanga Canyon. "A sort of dropping-off place between San Francisco and Venice,"[22] Topanga was at various times home to Wallace and Shirley Berman, George and Louise Herms, and Gordon Wagner; many others passed through. It enticed

Figure 2.26.
George Herms (American, b. 1935). *Poet*, 1960. Papers, string, klaxon, wire, and wooden pedestal, 69.5 × 67.3 × 52.1 cm (27³⁄₈ × 26½ × 20½ in.). New York, Neumann Family Collection. Courtesy George Herms.

artists, poets, musicians, and bohemian types with low rent, hip cafés like the Gashouse, and folk-music spots such as Bob and Doi DeWitt's. Louise Herms called it "the home for rebels, the ones that are different."[23] In addition to a fertile artistic atmosphere, the area provided more tangible bounty: quantities of junk that washed down the creek provided ready material from which to make works of art.

Larkspur, in Marin County, provided a similarly pastoral refuge in Northern California. For a time, the Berman and Herms families lived in rustic houseboats in Larkspur's estuarial marshes. The informal gallery that Berman established there in 1960 echoed the artist-run spaces in Los Angeles, but it took the do-it-yourself aesthetic to an extreme (fig. 2.27). Berman described his gallery in a letter to Charles Brittin: "next to the ark i [*sic*] live in," he wrote, "or rather about thirty yards away there is a one room pad—right on the water—no roof—beatest [*sic*] walls—no glass on windows—dirtyish white—greatest textures—am thinking of having *one day* exhibitions there for select creative thinking people to view."[24] On a collaged mailer sent

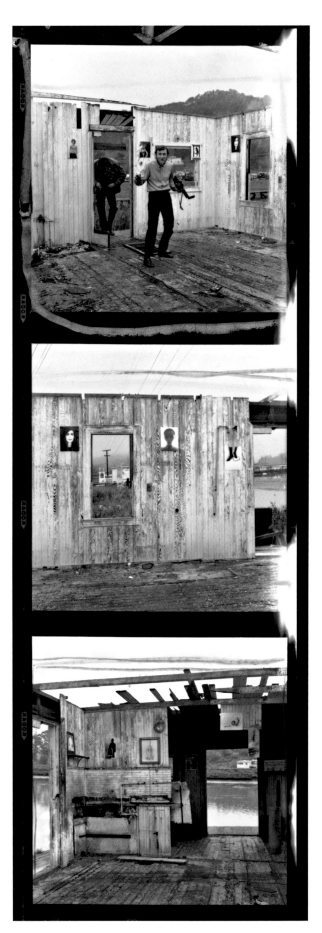

Figure 2.27.
Semina Gallery (with Wallace Berman), Larkspur, California,
1960. Photo by Charles Brittin (American, 1928–2011).
Los Angeles, Getty Research Institute, 2005.M.11. Image
© J. Paul Getty Trust, Charles Brittin papers.

Figure 2.28.
Wallace Berman (American, 1926–1976). *Invitation to John
Reed exhibition, Semina Gallery, Larkspur, California,*
1960. Collaged photograph, letterpress, and ink on cardstock,
15 × 8.5 cm (5⅞ × 3⅜ in.). Los Angeles, Getty Research Institute,
2005.M.11. Courtesy the estate of Wallace Berman and Michael
Kohn Gallery, Los Angeles.

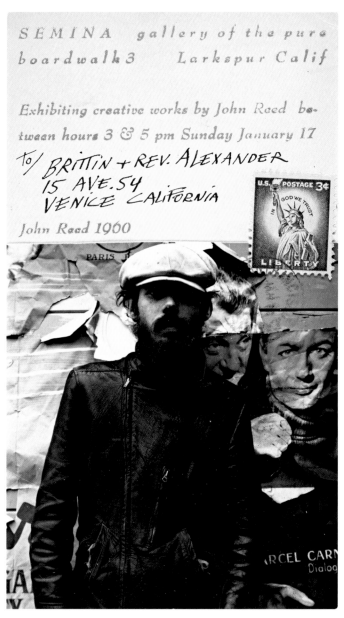

to Alexander, he indicates his houseboat with an arrow, labeling it—surely with a hint of irony, given the area's isolation—"the new scene." As Berman predicted, exhibitions at the Semina Gallery lasted only a couple of hours, usually on a Sunday afternoon. Despite the remote location and the very short hours, dozens of friends would make the journey north from Los Angeles and San Francisco to see the shows, lured by delicate handmade invitations (fig. 2.28).

THE FOUNDING OF FERUS

Buoyed by the success of the temporary exhibition they had organized in Barnsdall Park, and with their respective enterprises winding down by the end of 1956, Hopps and Kienholz joined forces once again to create a more permanent art space. They opened Ferus Gallery on 15 March 1957, and it was soon recognized as "an easily accessible gallery devoted to showing only the most avant of the avant-garde in Pacific Coast art."[25] In its first manifestation, the gallery was more or less an extension of the projects of Syndell Studio and the NOW Gallery, though Jim Newman remembers it as a busier place with a stronger sense of community than those earlier projects.[26] The division of labor, outlined in a contract drawn up on a hot-dog wrapper, was similar to the arrangement at Barnsdall Park: Hopps took responsibility for selecting artists, curating exhibitions, and coordinating promotion of the gallery; Kienholz handled the day-to-day running of the space. Robert Alexander (fig. 2.29) played a central, though informal, role in both planning and practical matters: hammering, painting, and printing flyers to ensure the gallery's successful debut. Though not officially a cooperative, Ferus certainly had the feel of one; it was, Kauffman's then wife, art collector Vivian Rowan, later recalled, "a seat-of-the-pants operation."[27] The gallery's appearance also conformed to the early Beat aesthetic: it was located at the end of an alley behind an antique shop, maintained erratic hours, and made little effort to sell work. The proprietors did, however, manage to look sufficiently solvent to retain the respect of their competitors, Kantor and Landau.

Shortly after Ferus opened in 1957, Hopps offered Alexander the financial backing to set up a workshop to produce posters and other printed matter for the gallery's exhibitions. The venture, Stone Brothers Printing, opened in a storefront on Sawtelle Boulevard and operated simultaneously as studio, salon, and general hangout, as well as a print shop. Stone Brothers reflected the kind of collective ambitions that Hopps and Kienholz also initially held for Ferus.

Figure 2.29.
Robert Alexander, ca. 1957. Photo by Charles Brittin (American, 1928–2011). Los Angeles, Getty Research Institute, 2005.M.11. Image © J. Paul Getty Trust, Charles Brittin papers.

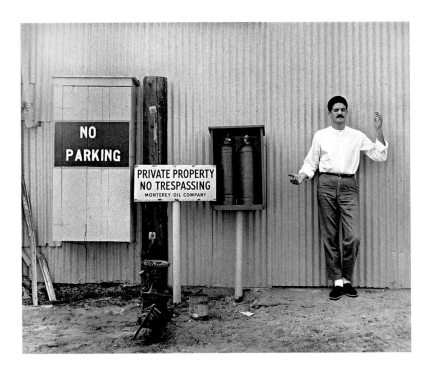

Run jointly by Alexander and Berman, its frequent visitors included poets Alexander Trocchi and David Meltzer, and artists Ed Moses, Craig Kauffman, Billy Al Bengston, and George Herms. The premises hosted poetry readings, as did Ferus, and Rachel Rosenthal's Instant Theatre troupe, for which Alexander produced printed mailers, announcements, and programs, performed there as well (see sidebar 11).

In June 1957, Berman had a solo exhibition at the Ferus Gallery. It included the torn-parchment works inscribed with Kabbalistic signs, *Homage to Hermann Hesse,* and three enigmatic assemblage sculptures: *Untitled (Cross)* (fig. 2.30), *Temple* (fig. 2.31), and *Panel* (1949–57), all later destroyed. Berman's friends remember the show as a quietly spiritual installation, but others did not share this view. *Cross* incorporated a small-scale photograph depicting sexual intercourse at such close range that it verged on abstraction. Berman had been nervous about including the piece in the show, worried that it might be deemed pornographic, and he had sought reassurance that the gallery would support him if there was trouble. The chronology of subsequent events is still debated, but evidently an anonymous complaint was made, and the Los Angeles Police vice squad came to investigate. Failing to locate the offending work, the police scoured the rest of the exhibition, finally focusing their attention (possibly at Kienholz's direction, though perhaps independently) on a psychedelic erotic drawing by Cameron that was part of a *Semina* issue scattered on the floor of Berman's *Temple.* The authorities shut down the exhibition and arrested Berman. Unprepared for trial, he received a conviction and a fine of $150, paid by Dean Stockwell. The incident precipitated Berman's disillusioned departure from what he called "this city of degenerate angels" for the more liberal San Francisco.[28] Prevailing accounts have framed this incident as a retreat in the face of censorship, but in fact the exhibition remained in Southern California: it was reinstalled at the Exodus Gallery alongside work by the printmaker, educator, and pacifist Sister Corita Kent.

Berman's notorious exhibition was not the first solo show at the gallery; that honor had been granted to Sonia Gechtoff, a San Francisco painter who had participated in the merry-go-round show in 1955. She had also shown in the inaugural group exhibition at Ferus, *Objects on the New Landscape Demanding of the Eye* (1957), which included many of those artists featured in the *Action* exhibitions: Jay DeFeo, Frank Lobdell, and Hassel Smith, alongside L.A. artists Arthur Richer, Richard Diebenkorn, John Altoon, Craig Kauffman, and Ed Moses. The grouping reflected Hopps's continued interest in the artists he had met in San Francisco. It also pointed to the close ties that this group of L.A. painters maintained to abstract expressionism: they were indebted stylistically as much to Bay Area painters who had emerged from the California School of Fine Arts as to the prevailing style of the New York school.

The artist with perhaps the most uncompromising dedication to the heroic project of abstract expressionism was Arthur Richer. Hopps had shown Richer's large canvases at Syndell Studio in 1955 and gave him a solo show at Ferus in 1957. His contemporaries have recalled that Richer's wild, unpredictable character was directly reflected in the gestural quality of his works: "the painting just went flying everywhere," according to his Ferus colleague Ed Moses.[29] Works like *Samurai* (1958), with broad passages of black and white paint on bare canvas, evince Richer's raw energy and his physical engagement with the process of painting; but they also reveal the influence of Asian art in both their titles and their lyrical calligraphy. Richer's tenacious dedication to painting allied him with John Altoon; the two sometimes collaborated by jointly hurling paint onto vast canvases. Both artists were involved with the Berman circle (a drawing by Altoon had appeared in the second issue of *Semina*), while simultaneously forming the core of the group of abstract painters that centered on the Ferus Gallery. Even as the Semina and Ferus groups drifted in different directions, Altoon in particular managed to navigate both worlds with charismatic ease.

Altoon had been offered his first exhibition at the Santa Barbara Museum of Art, and shortly after it opened in 1953 he had another show at the Artists' Gallery in New York. He is known to

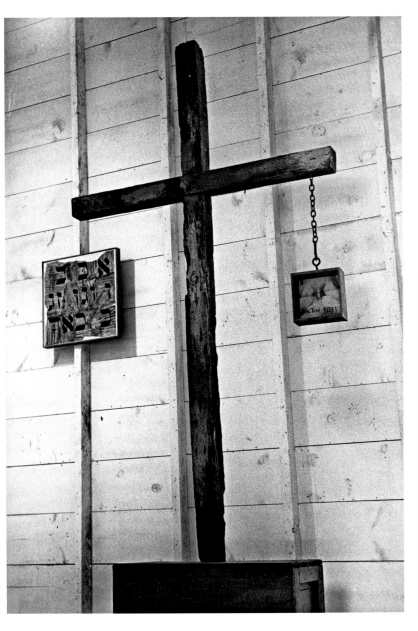

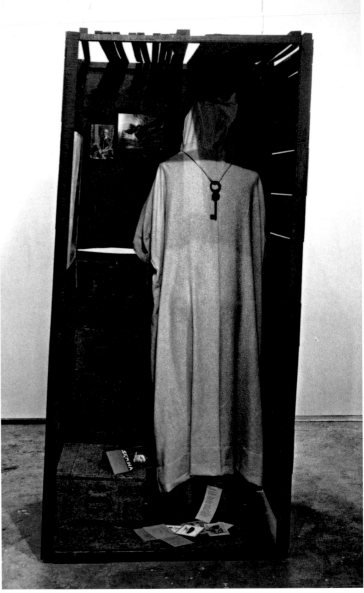

Figure 2.30.
Installation view of two works by Wallace Berman: on wall at left, *Untitled* (1957); in foreground: *Untitled (Cross)* (1956–57) (destroyed), Ferus Gallery, Los Angeles, 1957. Photo by Charles Brittin (American, 1928–2011). Los Angeles, Getty Research Institute, 2005.M.11. Image © J. Paul Getty Trust, Charles Brittin papers. Art courtesy the estate of Wallace Berman and Michael Kohn Gallery, Los Angeles.

Figure 2.31.
Installation view of Wallace Berman's mixed-media assemblage *Temple* (1957) (destroyed), Ferus Gallery, Los Angeles, 1957. Photo by Charles Brittin (American, 1928–2011). Los Angeles, Getty Research Institute, 2005.M.11. Image © J. Paul Getty Trust, Charles Brittin papers. Art courtesy the estate of Wallace Berman and Michael Kohn Gallery, Los Angeles.

have destroyed much of this early work; what remains evinces Altoon's keen awareness of the
European and East Coast avant-garde—especially the automatism and free association integral to
surrealism and action painting—gleaned over the four years that Altoon had spent in New York
and Europe. These influences sat somewhat uneasily with Altoon's professional training in com-
mercial illustration at the Los Angeles County Art Institute (Otis), the Art Center School, and
Chouinard Art Institute; in fact, the conflict between these divergent impulses is evident in much
of the work that he produced throughout the 1950s and 1960s. In January 1958, he exhibited at
Ferus alongside Jay DeFeo and Edward Kienholz. Altoon's muted painting *Portrait of a Spanish
Poet (Lorca)* (1954–59), included in his exhibition at Ferus in 1961, has an elegiac subject matter
that belies its abstract forms and links it to the interests of figures like Berman and Alexander as
much as to the abstract-expressionist influence of Northern California artists.

Figure 2.32.
John Altoon (American, 1925–1969). *Untitled* **(from the *Ocean
Park* series), 1962.** Oil on canvas, 182.9 × 213.4 cm (72 × 84 in.).
Newport Beach, California, Orange County Museum of Art,
museum purchase with additional funds provided by Dr. James B.
Pick and Dr. Rosalyn M. Laudati, Mr. Ward Chamberlin, Mrs. E.G.
Chamberlin, Patricia Fredericks, Mr. and Mrs. Carl Neisser,
Mr. and Mrs. John Martin Shea, Mr. and Mrs. Samuel Goldstein,
Zada Taylor, Mr. David H. Steinmetz, and Mrs. Bernard McDonald.
Courtesy the estate of John Altoon and Braunstein/Quay Gallery,
San Francisco. Photo by Gene Ogami.

In 1962, Altoon moved to a new studio at 127 Marine Street, which straddled the border
between Venice and the Ocean Park neighborhood of Santa Monica. The area was full of vacant
storefronts and abandoned buildings, which meant cheap studio space. Altoon's friend Larry
Bell lived next door; nearby were Billy Al Bengston (who lived in the former Venice News building
at 110 Mildred Avenue), Jerry Byrd, Charles Emerson, Robert Irwin, Ed Moses, and Ken Price.
The time he spent in Marine Street would be pivotal for Altoon. In less than a year, he com-
pleted the eighteen paintings, drawings, pastels, and gouaches that constitute the *Ocean Park*
series; they went on view as a solo exhibition at the Ferus Gallery and were included in the
exhibition *Fifty California Artists* (1962) at the Whitney Museum of American Art in New York.
The colorful visceral and biomorphic forms at the centers of *Ocean Park*'s spare canvases sug-
gest a move away from the immediate gestures of action painting toward a more cerebral practice,
but one that is still rooted in the specificity of Altoon's surroundings: the colorful areas of paint
resolve themselves into forms that suggest a lifeguard chair, a fish, or the sun (fig. 2.32).

Llyn Foulkes, who showed at the Coronet in 1957 and at Ferus in 1959 and 1961, produced
richly textured paintings that combine abstract and figurative painting with collage, drawing,
text, and found materials. His works evince not only the abstract-expressionist influence of his

SHORTLY AFTER HER ARRIVAL in Los Angeles in 1955, French-born dancer and performer Rachel Rosenthal began to run improvisation workshops that attracted both inexperienced and seasoned actors alike. When she enthusiastically suggested that the group perform for an audience, however, all but a handful left, having been warned by their agents to steer clear of "anything so weird," as Rosenthal put it. Undeterred, she founded Instant Theatre with those who remained. Over the next decade, Instant Theatre's cast and home were constantly in flux. The tenacity with which Rosenthal kept the company going until 1966—despite a perpetual lack of funds, no stable location, and little critical attention—is nothing short of remarkable. "We just did it," Rosenthal later recalled, "every which way we could. We did it in storefronts. We did it in lofts. We did it in dance studios. We did it in homes. We did it in garages. We did it all over the place."[1]

Like the alternative gallery ventures that characterized the L.A. art scene in the 1950s, Instant Theatre adopted a do-it-yourself approach, motivated in part by necessity and in part by an attraction to the countercultural philosophy of the underground scene. The first of the troupe's many temporary homes was a modest workshop space adjacent to Hollywood's Circle Theatre; at other times, they performed at Stone Brothers Printing, the studio hangout on Sawtelle Boulevard run by Wallace Berman and Robert Alexander. The arrangement of yet another of their homes, a storefront on Pier Avenue in Santa Monica, was typical: one of the actors lived in a bedroom in the rear; actors changed in the cramped bathroom, which doubled as a prop room; and audience members, mainly friends, sat on mismatched chairs or cushions on the living-room floor. Props and sets were fabricated from donated scraps and found materials—"an improvisation of a garden gate, a tire, a masked manikin, and umbrella hung from a rope line"—and provided a point of departure for the actions of the actors.[2] The result was "neither a happening, a psychodrama, nor a rehearsal," explained poet Jack Hirschman; it was a highly stylized theater piece that merged object and body, movement and mime, speech, sound, music, and colored lighting.[3] The multiple elements were combined in a rigorous process of disciplined spontaneity. Hirschman describes one piece in which Rosenthal, wearing a black dress and a battered red hat, circled a man whose costume featured a rubber doll at his waist. The "grotesque mime" enacted through their back-and-forth movements was punctuated by staccato utterances articulating hostility and obsession. Entwined, they spun slowly to the floor, crying and groaning, while a female manikin looked on, eventually collapsing on top of them.[4]

Instant Theatre's sets resembled the assemblages that Rosenthal's artist friends were making at the time. And her inspiration came, like theirs, from the improvisational structures of jazz and concrete poetry and from the dreamlike juxtapositions of surrealism. Central to her work was the radical model of Antonin Artaud, whose manifesto "Le théâtre de la cruauté" (The Theater of Cruelty) called for the abandonment of the script in favor of a direct, visceral theatrical experience with the power to change society.[5] Though Rosenthal's artistic practice would evolve over the course of her long career—from Instant Theatre to the more explicit feminist politics of her "body art" performances in the 1970s and 1980s, the intense physicality explored in the *Doing by Doing* workshops of 1980–83, and her recent return to group improvisation—her commitment to the transformation of both audience and performer remains unwavering.

Notes

1. Rachel Rosenthal, oral history interview by Moira Roth, 2–3 September 1989, Archives of American Art, Smithsonian Institution.
2. Jack Hirschman, "Instant Theatre" [1963], in Moira Roth, ed., *Rachel Rosenthal* (Baltimore: Johns Hopkins Univ. Press, 1997), 91.
3. Hirschman, "Instant Theatre," 90.
4. Hirschman, "Instant Theatre," 93.
5. Antonin Artaud, "Le théâtre de la cruauté," in idem, *Le théâtre et son double* (Paris: Gallimard, 1938). Published in English as *The Theater and Its Double*, trans. M. C. Richards (New York: Grove, 1958).

King Moody and Rachel Rosenthal in an Instant Theatre performance, ca. 1960. Photo by Charles Brittin (American, 1928–2011). Los Angeles, Getty Research Institute, 2005.M.11. Image © J. Paul Getty Trust, Charles Brittin papers.

Chouinard teacher Richards Ruben, who also showed at Ferus, but also the Beat aesthetic of assemblage, the dark preoccupations of surrealism, and his admiration for Salvador Dalí. In several works of this time, Foulkes collaged found vintage postcards into the textured surfaces of gestural brushwork. *Flanders* (1961–62) (see p. vii), in which an amorphous mass of melted plastic tarpaulin lurches from the picture plane into the space of the viewer, typifies Foulkes's engagement with the precariousness of picture making as a physical undertaking and as a representational proposition. His struggle with the nature of painting allied him with his contemporaries at the Ferus Gallery during its early years. But he also practiced assemblage, turning the walls of his studio into one large assemblage work that incorporated found objects as well as smaller artworks made by himself and his friends (fig. 2.33).

Exhibitions at Ferus during the first few years sampled a wide variety of approaches to abstract expressionism and consolidated the standing of a core group of L.A. artists. While Syndell Studio had introduced Bay Area art to Los Angeles, Hopps gradually shifted the emphasis at Ferus from Northern to Southern California. L.A. artists in this period were striving to escape the influence of their San Francisco counterparts. "We felt that the real painting was being done up there," Craig Kauffman explained. "My own response was to do a series of very 'clean' paintings, which were my first mature work."[30] Kauffman's solo show at Ferus in 1958 included the paintings *Still Life* (1957), *Studio* (1958), and *Tell Tale Heart* (fig. 2.34), all bearing the hallmarks of late abstract expressionism in their gestural paint application and large areas of loose coloration. Though they reflect the influence of Bay Area abstraction, they also articulate Kauffman's conscious ambition to adopt a position in opposition to it.

Altoon and Kauffman were key figures in the first years of the Ferus Gallery—and later, too, even as the nature of the gallery changed. Kauffman, who had exhibited at Felix Landau in 1953, had long been associated with the more avant-garde activities of Hopps, his childhood friend (fig. 2.35). They and their Ferus colleagues forged a strong sense of community identity, in part through many hours spent at Barney's Beanery, a hangout on Santa Monica Boulevard, and shared a determination to carve out distinctive personal styles through the innovative use of materials and a growing emphasis on process and surface over and above the symbolic content of the work.

Billy Al Bengston began to experiment with industrial techniques and materials, motivated by an interest in surface that he developed as a student of the ceramicist Peter Voulkos. Bengston's early paintings were in the abstract-expressionist mode (fig. 2.36), but his solo show at Ferus in 1960 signaled a new direction. Inspired in part by Jasper Johns's *Flag* and *Target*

Figure 2.33.
Interior of Llyn Foulkes's home in the Eagle Rock neighborhood of Los Angeles, 1964. Courtesy Kent Gallery.

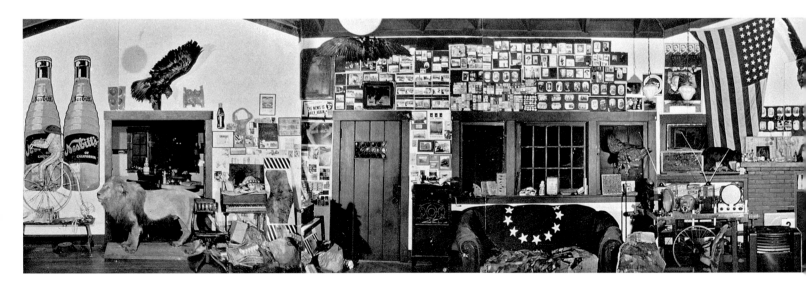

Figure 2.34.
Craig Kauffman (American, 1932–2010). *Tell Tale Heart*, 1958.
Oil on linen, 174 × 124.5 cm (68½ × 49 in.). Pasadena, California,
The Robert A. Rowan Collection. © Estate of Craig Kauffman.

Figure 2.35.
Craig Kauffman, ca. 1955. Photo by Ed Moses (American, b. 1926).
Image © Ed Moses. Courtesy Ed Moses.

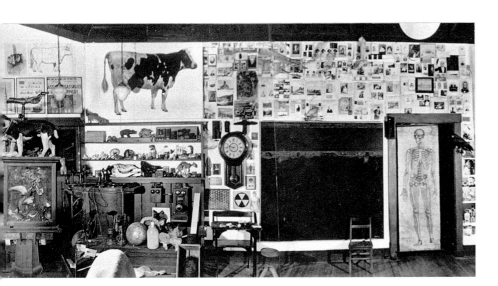

paintings, the works in this show centered on the symbol of the heart, locating it in a simple geometric frame that allowed him to focus his investigations on the paint surface. The so-called Valentines show opened, appropriately, on 14 February 1960, and included paintings such as *Grace* (1959), *Sofia* (1960), and *Marilyn* (1959–60) (another musing on surface contained, perhaps, in the homage their titles pay to Hollywood starlets). The exhibition's centerpiece was the geometric canvas *Big Hollywood* (1960), Bengston's largest painting to date; it was meticulously painted using six different brushes to achieve a variety of surface textures. Bengston had incorporated a variety of paints and finishes into the Valentines, from delicate watercolor to oil impasto, but the exhibition precipitated a radical change in medium for the artist, who declared that "it was the end of oil paint for me."[31] At his third solo exhibition at Ferus, in 1961, he introduced rapidly executed motorcycle paintings, which, in their depiction of bike parts, anticipated the utilization of automobile paint on masonite and the lacquer spray-paint techniques that characterized his later works.

Ken Price, another student of Voulkos's, shared Bengston's fixation with craftsmanship, finish, and color, and with the possibilities offered by industrial techniques. Price eschewed the physical monumentality of Voulkos's ceramic sculpture, as well as his teacher's tendency toward earth tones, in his debut exhibition at Ferus, which comprised small-scale, brightly colored cups and mound forms, presented in wooden boxes. Though the Ferus Gallery had initially been hesitant to represent a ceramic sculptor, Price became a key gallery artist and had two more solo exhibitions (fig. 2.37). By 1961, he had started to use industrial enamels and automobile lacquers to achieve higher color and an immaculate finish. The resultant egg-shaped forms incorporate brilliant color combinations that demonstrate, according to Hopps, the influence of not only jazz and bebop but also the vibrant aesthetic of surfboards.

Kauffman's work, too, showed a trajectory toward process and surface over subject matter. Returning from abroad in 1963, Kauffman encountered the new work of his friends Bengston and Price in the Martha Jackson Gallery in New York and was struck by how quickly new materials and techniques had changed the direction of their work:

> Billy Al Bengston had started using spray paint and Ken Price had already started making "clean" things. They had really moved very quickly. Then I went back to Los Angeles—back to my old work, which changed in something like three or four months. In that period it moved onto flat plastic. The whole feeling was very definite for us. Billy Al Bengston had talked about industrial materials and attitudes and so forth, which implied another direction for us—and then everything just kind of exploded.[32]

Influenced by the developments in the works of Bengston and Price, Kauffman produced *Git le coeur,* also titled *Tell Tale Heart (Second Version)*. With this work, Kauffman moved from oil on linen to acrylic paint on Plexiglas; instead of the painterly finish of earlier canvases, these works show a striking purity of color and an embrace of new materials that anticipated his turn to vacuum-formed plastic in 1964. Kauffman's repeated

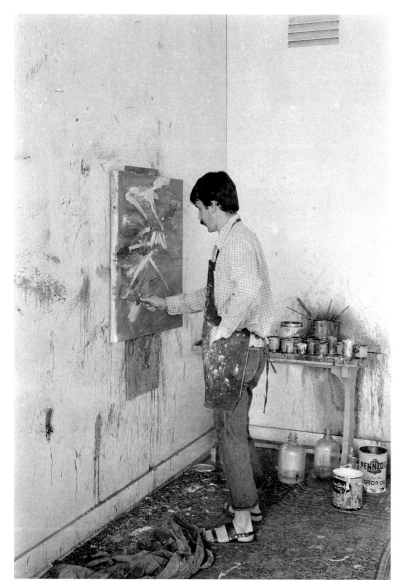

Figure 2.36.
Billy Al Bengston in his studio, ca. 1957. Photographer unknown. Courtesy Billy Al Bengston.

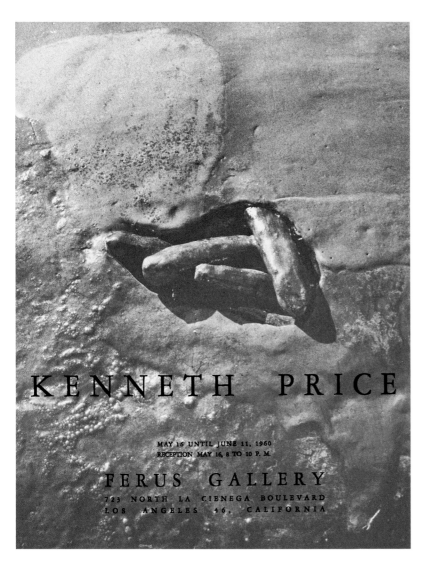

Figure 2.37.
Poster for Ken Price exhibition, Ferus Gallery, Los Angeles,
16 May–11 June 1960. 25.5 × 33 cm (10 × 13 in.). Los Angeles,
Getty Research Institute, 2009.M.37. Courtesy Ken Price Studio.

invocation of "clean" art placed it in opposition to the use of impasto and the mythical mark making of much abstract-expressionist painting as well as to the funky aesthetic and romantic symbolism of assemblage. Though the organic forms of Kauffman's works from 1958 are still evident in the pendulous shapes of the early 1960s, the painterly qualities that tethered his painting to abstract expressionism would be expunged by 1962. He explained the new sensibility in terms of rigor: "In a perverse way," he said, "I like to make paintings in which you can't make a mistake, can't paint over, but instead have to build rather than correct, like Oriental art."[33]

Ferus offered many artists their first listed exhibition. For Ed Moses, who was still in art school at UCLA, the gallery opened up possibilities beyond the strictures of the university art department and provided a professional venue for his graduate show in 1958. Moses recalls his younger self as cocky and self-assured, a "real painter": in other words, an abstract expressionist.[34] The impasto of his works from that time was influenced by a sojourn in New York in 1958 and 1959—where he sought out the artists who frequented the Cedar Tavern, a favorite hangout of abstract expressionists such as Willem de Kooning and Franz Kline—and a brief stay in San Francisco in 1960, where Moses shared studio space with Frank Lobdell, Hassel Smith, and Clyfford Still. Moses exhibited at the Area and Barone Galleries in New York and received glowing reviews. Dore Ashton of the *New York Times* judged the work "outstanding."[35] In San Francisco, where he mingled with Joan Brown, Manuel Neri, Jay DeFeo, and Wally Hedrick in the Fillmore district, Moses created *Dalton's Waffle #1* (fig. 2.38). Merging assemblage and abstract painting, he tightly packed a wooden picture frame with crumpled pages from an entire Sunday issue of the *San Francisco Chronicle,* embedded small objects in the mass, and stuck it all in place with shellac varnish. Though Moses's time in San Francisco was short, the work that he made there was crucial in the way it refigured paintings as objects, demonstrating the kind of experimentation with materials that would characterize his career and that anticipates his later resin paintings.

The *Roses* series of large-scale works in pencil on paper, begun in 1961 and exhibited at the Ferus Gallery in December of that year (fig. 2.39), represent a fundamental shift away from those early paintings. The rose patterns, copied from a cheap Mexican oilcloth, are enmeshed in a dense mass of insistent graphite strokes that fill the paper between and inside the flower silhouettes. Though inspired by the bright imagery of mass culture and informed by the all-over field of abstract expressionism, the works operate neither in the abstract-expressionist mode nor as pop art (as it would be defined later in the decade). Instead, they demonstrate a concern for the relationships between line and space and between form and ground that grew out of Moses's early training in architectural drawing (fig. 2.40). The works in this series do not fall within any ready category or style, but they express Moses's steadfast commitment to the medium of drawing, at a time when his colleagues were creating the highly polished works that would come to define the "L.A. Look."

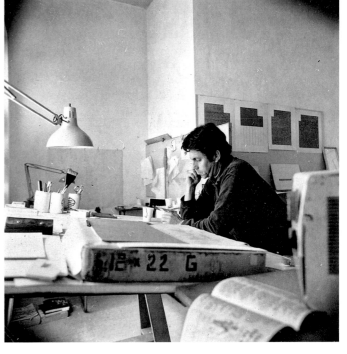

Figure 2.38.
Ed Moses (American, b. 1926). *Dalton's Waffle #1*, 1960.
Crushed newspaper, shellac, and wood, 100.3 × 88.3 cm
(39½ × 34¾ in.). San Francisco, collection of Jim Newman
and Jane Ivory. © Ed Moses, courtesy the artist.

Figure 2.39.
Ed Moses (American, b. 1926). *Rose #3 (Some Roses Are)*, 1961.
Graphite on Strathmore board, 155.6 × 104.8 cm (61¼ × 41¼ in.).
Los Angeles, Museum of Contemporary Art, partial and promised
gift from the collection of Laura-Lee and Robert Wood. © Ed Moses,
courtesy the artist.

Figure 2.40.
Ed Moses, ca. 1966. Photo by John Waggaman, courtesy Ed Moses.

The Beat atmosphere that had characterized Ferus during its early years waned notice-
ably as the 1950s came to an end. Poetry readings gave way to glamorous opening parties that
were documented by the fashionable photographer William Claxton (see sidebar 12). The Ferus
group characterized themselves as masculine and hardworking, deliberately adopting an iden-
tity in opposition to artists such as Berman and Herms. It was a stance that would reach its
apotheosis in 1964, when Bengston, Irwin, Moses, and Price took part in a group show brazenly
called *The Studs.* The exhibition poster, which incorporated an illustration of a pioneer unload-
ing lumber from a horse-drawn cart, aligned the artists with the archetype of the resourceful and
hard-working frontiersman (see p. 306). Despite their divergence from the Bay Area school of
abstract expressionism, this core group of painters remained true believers in abstraction (at least
in theory), going so far as to blackball artists who "copped out" by turning to figuration.[36]

As the sale of artworks at Ferus slowly increased, the ambitions and expectations of both
Hopps and his stable of artists began to shift. Hopps was seeking a business partner when
one day, so the legend goes, a debonair figure swept into the gallery, guiding a pair of collectors
around the premises with such authority that Hopps offered him a job on the spot. This was
Irving Blum, who in both appearance and demeanor inspired comparisons with Cary Grant. In
Blum's previous job—choosing artworks to decorate the offices of Knoll Associates, a high-end
New York furniture company—he had amassed an impressive list of contacts among artists,
dealers, and museums. After Knoll's founder died in 1955, Blum's thoughts had turned to starting
his own gallery. Sensing that the New York art world was saturated, Blum moved to Los Angeles
and began carefully assessing its gallery scene. Kienholz, eager to devote more time to his own
work, reluctantly agreed to sell his share of the business to Blum for the princely sum of five
hundred dollars.

Blum knew that success in Los Angeles required a high degree of showmanship and com-
mercial savvy, and his actions reveal a business agenda that precipitated an abrupt shift in the
gallery. In November 1958, Hopps and Blum moved the establishment across the street, forgo-
ing a Beat sensibility in favor of clean white walls: the "perfectly designed contemporary Beverly
Hills setting."[37] With the new premises, designed by Blum, came a drastic reduction in the num-
ber of artists Ferus represented and renewed ambitions to make money. Financial backing
was essential: Hopps prepared a list of potential investors, including the collectors Gifford Phillips
and Vincent Price. The wealthy widow Sayde Moss agreed to support the gallery with $8,000 a
year for five years, until Ferus turned a profit.

Blum's arrival at Ferus heralded the gallery's transition from a sociable, alternative space
to a more straightforward business. For a time, Kienholz, in many ways the epitome of the early
Ferus, refused to set foot in the gallery without written authorization. A tongue-in-cheek letter
from Blum on 27 June 1959—granting the "artist, forager, balladeer, and crack pistol shot"
Kienholz permission to enter the "sacrosanct premises" of Ferus to fix a door hinge—illustrates
how fraught the atmosphere had become.[38] During the time that Kienholz was a director of
Ferus, he had shown his own work there only once. His departure would mark the end of his
career as a gallerist and curator, but it also allowed him to exhibit work at Ferus without a con-
flict of interest. His collage constructions were displayed alongside works by Bengston in a
show at the new gallery in 1959, and he had a solo show the following year. Its centerpiece was
an assemblage sculpture that both satirized and paid homage to Kienholz's former partner, Walter
Hopps III, or, as Kienholz refigured him, *Walter Hopps Hopps Hopps* (figs. 2.41, 2.42). Adding
Hopps's trademark glasses and skinny necktie to a motor-oil advertising mascot known as the
Bardahl Man, Kienholz represented his friend as a street hustler hawking miniature works by
Willem de Kooning, Franz Kline, and Jackson Pollock out of his coat lining. The satire, deriding
Hopps's penchant for the New York school, is reinforced by the notes and lists housed in com-
partments on the back of the figure—handwritten by Hopps at Kienholz's request. One such list,
"Major Artists I Want To Show," consists not of those L.A. artists that the Ferus Gallery had

Figures 2.41, 242.
Edward Kienholz (American, 1927–1994). *Walter Hopps
Hopps Hopps* **(front and back), 1959.** Paint and resin on wood,
printed color reproductions, ink on paper, vertebrae, telephone
parts, candy, dental molds, metal, pencil, and leather, 221 × 106.7
× 53.3 cm (87 × 42 × 21 in.). Houston, The Menil Collection, gift
of Lannan Foundation. © Nancy Reddin Kienholz.

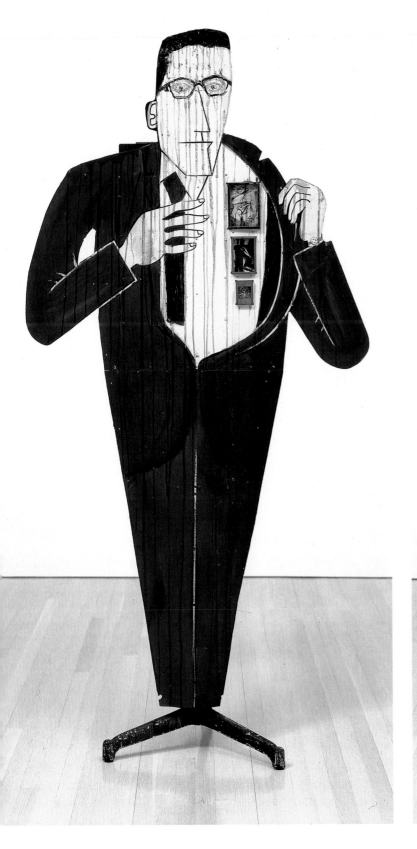
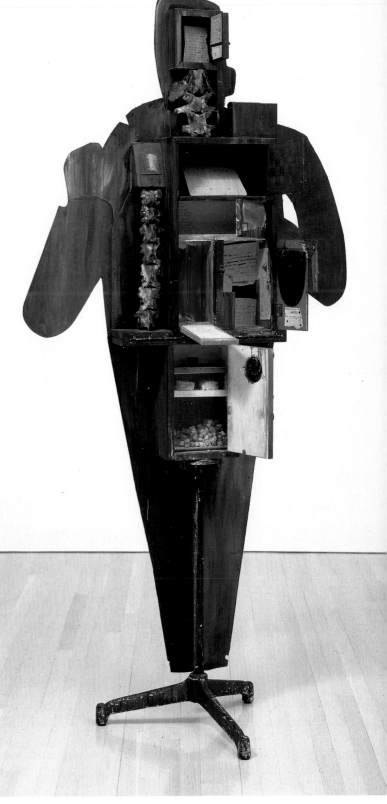

championed but rather of puns on the names of East Coast figures: "Willem de Conning," "Franz Climb," and "Robert Nothingwell." Other compartments are labeled "People w/ influence or money" and "Competitors and Other Un-Informed Types." Kienholz's parodic construction indicates the high stakes for Los Angeles artists at the end of the 1950s: with the rapid development of the art scene came the threat of being left behind.

ART AS A SOCIAL FORCE

Kienholz's works of the early 1960s contrast strongly with the whimsical surrealism of Wagner's figures and the mystical wordplay of Berman and Herms. They evince a macabre vision of social and personal trauma. Grisly tableaux depict themes of prostitution, hollow marital intercourse, and adolescent copulation, as well as the physical and emotional trauma of abortion, the terrors of birth, and the imminence of death. "It is an art made for no one's living room," wrote critic Philip Leider in 1964, one that "owes more to Lenny Bruce than to Surrealism, and more to Allen Ginsberg than to Marcel Duchamp."[39] They are works that elicit both repulsion and grim fascination in their viewers, and the abject nature of Kienholz's grimy materials reinforces

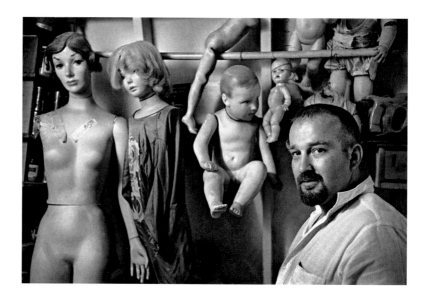

their sordid subject matter (fig. 2.43). In Kienholz's works, the hermetic games typical of Berman's *Semina* seem to sour in the face of increasing social, political, and artistic frustration. The works elicited both widespread criticism and long lines of visitors, for though they drew on personal experience (his wife's harrowing illegal abortion, for example, and Kienholz's job at a mental institution in 1948), they also addressed the broader social concerns of the postwar period through the use of horror and black comedy. In *The Future as Afterthought,* a mass of soiled, damaged rubber dolls are strapped awkwardly together atop a wooden pedestal in a way that suggests dangerous overpopulation and evokes the form of the atomic mushroom cloud (fig. 2.44). At its base, a dismembered doll head seems to melt and scream in silent agony, its eyes closed tight in the face of inevitable looming disaster.

The uncanny effect of broken dolls also appealed to L.A. artists Fred Mason and Ben Talbert, who scavenged parts and molds from a Kewpie doll factory in Santa Monica. Talbert's works in collage and assemblage combine intensely erotic, and often disturbing, subjects with imagery evoking America's aggressive militarism or the dangers of national ideology—the American flag appears in several works, its symbolic ideological power undercut by nude models and advertising slogans culled from popular magazines and pornography. In the freestanding assemblage

Figure 2.43.
Edward Kienholz in his studio, 1962. Photo by Marvin Silver (American, b. 1938). Courtesy Marvin Silver and Craig Krull Gallery, Santa Monica.

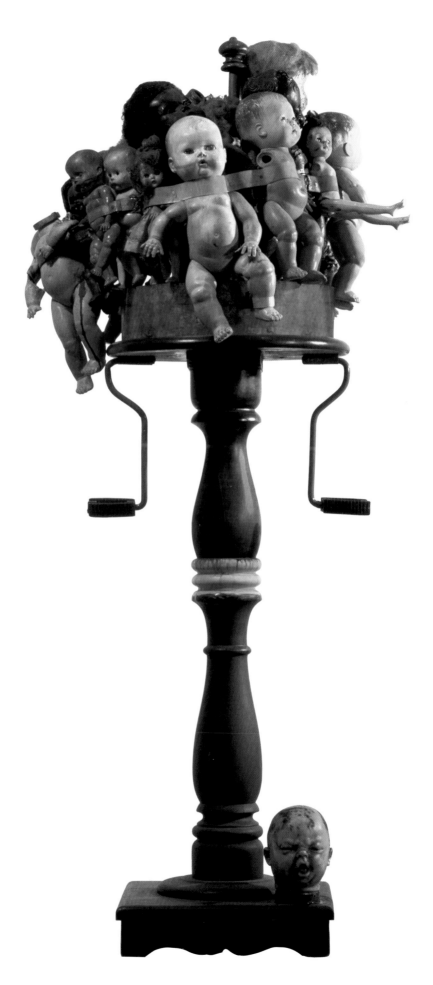

Figure 2.44.
Edward Kienholz (American, 1927–1994). *The Future as Afterthought,* 1962. Paint and resin on plastic and rubber doll parts with sheet metal, tricycle pedals, and wood, 137.2 × 53.3 × 43 cm (54 × 21 × 16 15/16 in.). Berlin, Onnasch Collection. © Nancy Reddin Kienholz. Courtesy L.A. Louver, Venice, CA.

The Ace (1962–63), photographs of war heroes and pinup girls are juxtaposed with an atomic blast and the figure of Death. It is tempting to see these more politically engaged works as auguring the social upheaval that would affect Los Angeles as it approached the mid-1960s. For many artists, as the civil rights struggle and the war in Vietnam gained momentum, it was no longer possible to remain apolitical. Assemblage came to be seen as a medium freighted with political significance and capable of conveying antiauthoritarian sentiment or searing social critique. Even Berman's poetic journal *Semina* would shift its tone in the final issues: he put an image of an execution by electric chair on the cover of No. 7 (1961); the theme of apocalypse and social victimhood pervades No. 8 (1963); and the cover of the ninth and final issue (1964) bears an altered photograph of the shooting of Lee Harvey Oswald. Increasingly, artists responded to specific events in the wider world. Kienholz's boxed construction *The Psycho-Vendetta Case* (1960), like Bruce Conner's wax figure *CHILD* (1959–60), grew out of the protracted controversy that surrounded the execution of San Quentin inmate Caryl Chessman; Conner's assemblage *Black Dahlia* (1960) alluded to the notorious Hollywood murder case of 1947; and the L.A. artist Arthur Secunda made works that directly referenced the deaths of John F. Kennedy and Che Guevara.

At the same time, an ambitious and energetic group of younger artists was emerging from the Chouinard Art Institute. Henry Hopkins, still a graduate student at UCLA, was drawn to the work and the attitude of artists like Joe Goode, Larry Bell, and Ed Ruscha. Hopkins had been Ruscha's first paying customer, buying the painting *Sweetwater* (1959) in installments while he was still a teaching assistant. This foresight might have paid off handsomely in later years; instead, an overzealous art student scavenged the canvas from Hopkins's office, believing it to be unfinished, and covered it with a thick layer of paint. Ruscha's painting could not be salvaged and exists today in photographs only. Hopkins's first exhibition, organized at the university's Dickson Gallery as part of his doctoral thesis, spanned three generations of Southern California painters, including well-established artists like Lorser Feitelson and Helen Lundeberg alongside younger artists like Billy Al Bengston, Linda Levi, and Eva Slater.

In 1960, after finishing his degree, Hopkins opened the Huysman Gallery across the street from Ferus, on La Cienega Boulevard, to showcase the new generation of local talent. Soon after the gallery opened its doors, Joe Goode approached Hopkins with a proposal for an exhibition to be called *War Babies,* which was to serve as a statement for the generation of artists who had come of age in the wake of World War II. It opened in May 1961 and featured Goode's work alongside that of Ed Bereal, Larry Bell, and Ron Miyashiro. The exhibition was in part a reaction to the dominance of the Ferus group. "Their whole ambition in life," Hopkins said of the participating artists, "was to knock off, philosophically and esthetically, the artists across the street, to knock off Kenny Price and Ed Kienholz and Irwin. I liked that competitiveness, so I did an exhibition."[40] The works on display disrupted the pristine new gallery space, to Hopkins's consternation: Goode's work included a series of paintings of bold star shapes in impasto (fig. 2.45) but also a large cardboard box piece that he nailed roughly to the gallery wall. This piece, like many of the works in *War Babies,* was antithetical to the "clean" aesthetic propounded by Bengston and Kauffman—and which Bell, who exhibited a single "saddle painting" at Huysman, would embrace soon after. Miyashiro showed small paintings with darkly erotic undertones that anticipated the somber, machine-like quality of his *Concord* sculptures of 1963 and 1964 (figs. 2.46, 2.47, 2.48). Bereal contributed thickly encrusted constructions like *Fokker-D7* (1958) and other works made of leather pouches filled with reeking, oil-drenched materials and decorated with swastikas (fig. 2.49). In a similar vein, Bereal's later sculpture, *American Beauty* (fig. 2.50), overlays the loaded imagery of the swastika, the Balkan cross, and Uncle Sam, inviting the viewer to bend and peer inside its illuminated form. The *War Babies* artists represented a variety of artistic styles. While Larry Bell and Joe Goode became associated with Finish Fetish and California pop art, Miyashiro and Bereal continued to work in the

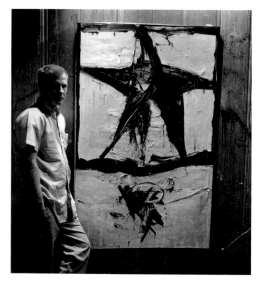

Figure 2.45.
Joe Goode in his studio, 1961. Photo by Jerry McMillan (American, b. 1936). Courtesy Jerry McMillan and Craig Krull Gallery, Santa Monica. Art © Joe Goode.

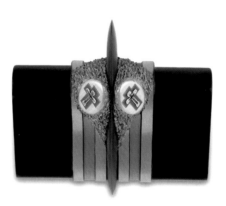

Figure 2.46.
Ron Miyashiro (American, b. 1938). *Concord #9*, 1963. Wood, cardboard, and acrylic, 27 × 38.3 × 21 cm (10⅝ × 15⅛ × 8¼ in.). Los Angeles, Cardwell Jimmerson Contemporary Art. Courtesy the artist and Cardwell Jimmerson.

Figure 2.47.
Ron Miyashiro (American, b. 1938). *Concord #11*, 1964. Wood, cardboard, papier-mâché, and enamel, 38.1 × 31.8 × 31.8 cm (15 × 12½ × 12½ in.). Laguna Beach, California, the Buck Collection. Courtesy the artist and Cardwell Jimmerson.

Figure 2.48.
Ron Miyashiro (American, b. 1938). *Concord #8*, 1963. Wood, cardboard, and enamel, 29.5 × 14.9 × 15.9 cm (11⅝ × 5⅞ × 6¼ in.). Studio City, California, collection of Diana Zlotnik. Courtesy the artist and Cardwell Jimmerson.

assemblage vein. The exhibition. marks a moment when the art world in Los Angeles was rela-
tively fluid, before these categories were clearly defined.

Ultimately, it was the poster for *War Babies* that drew the most attention (fig. 2.51). It
showed the artists, photographed by artist Jerry McMillan, gathered for a meal of stereotypi-
cally ethnic foods—the African American artist Ed Bereal with a chunk of watermelon, Jewish
artist Larry Bell eating a bagel, the Irish American Goode with mackerel, and the Asian
American Miyashiro with chopsticks—around a table draped with an American flag. At a time

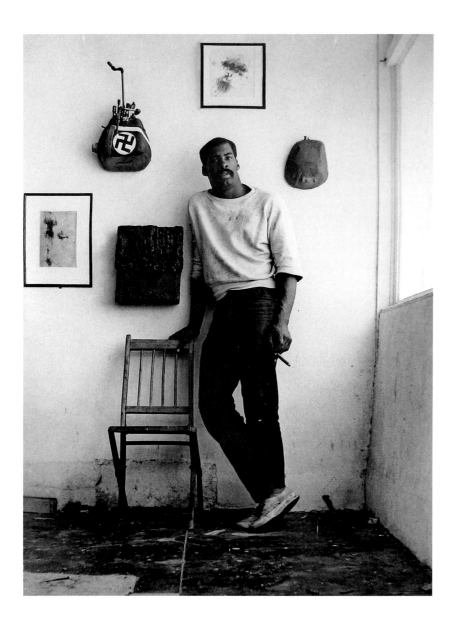

Figure 2.49.
Ed Bereal in his studio with (clockwise from top) *Untitled*
(1959), *Blohm und Voss* (1959), *Fokker-D7* (1958), *Untitled*
(1959), and *Focke-Wulf FW-109* (1960–61), 1961. Photo
by Jerry McMillan (American, b. 1936). Courtesy Jerry McMillan
and Craig Krull Gallery, Santa Monica.

Figure 2.50.
Ed Bereal (American, b. 1937). *American Beauty,* 1965.
Metal, paint, and tree branch, 127 × 79 × 30.5 cm (50 × 31 × 12 in.).
Santa Monica, California, collection of Betty and Monte Factor.
Photo by Larry Hirshowitz, courtesy the photographer.

when the House Un-American Activities Committee was holding hearings in California, the
controversy that greeted this provocative image caused the gallery's backers to withdraw their
support; Huysman closed shortly thereafter. In Hopkins's view, the incident highlighted the
inequality that still existed in the city and its art world: "It brought all my social instincts to the
fore, and I very patiently explained that if they were all beautiful young women in spangled cos-
tumes and football games, then they wouldn't have any qualms about [the use of the flag]. It was
only because these were some people who were multi-racial and that bothers you, and you have
no business being upset by that."[41] A similar wave of disapproval greeted Walter Hopps's 1962

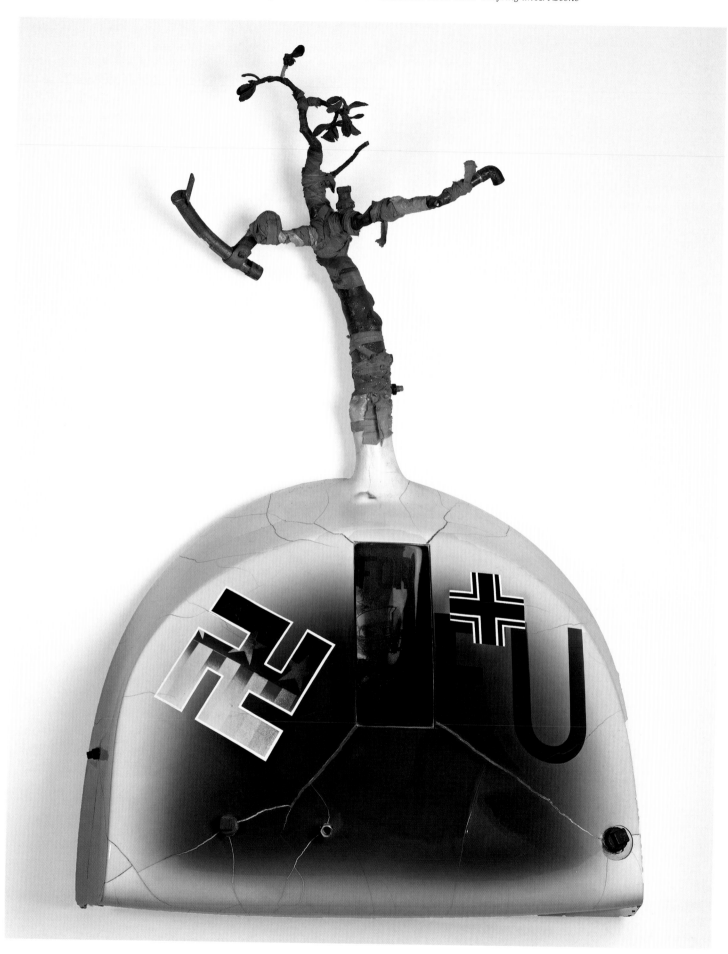

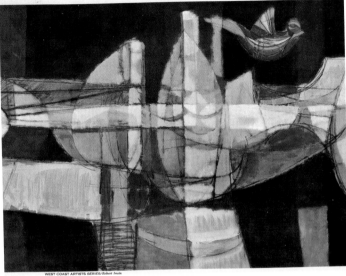

chet **BAKER**
pacific JAZZ records

WEST COAST ARTISTS SERIES/*Robert Irwin*

Cover of the album *Chet Baker Pacific Jazz Records,* West Coast Artists Series, featuring a work by Robert Irwin, 1956. Design by William Claxton (American, 1927–2008). Courtesy Demont Photo Management, LLC. Art © 2011 Robert Irwin / Artists Rights Society (ARS), New York.

PHOTOGRAPHER WILLIAM CLAXTON epitomized West Coast Cool. Charming and debonair, he and his wife, model Peggy Moffitt, were at the center of Los Angeles's art world in the 1950s and 1960s; his informal photographs of friends, gallery parties, and exhibition installations would become the definitive chronicle of the scene at its most glamorous. Claxton also created iconic photographs of jazz artists that embodied the look of the cool West Coast jazz movement.

Born in 1927 in Pasadena, California, to a musically inclined family (his mother played harp and piano), Claxton suffered from asthma as a child. With physical activity restricted, he spent time at home listening to Big Band music on the radio and creating scrapbooks with pictures of his favorite musicians and orchestra leaders, fashioning a virtual nightclub in his mind. His brother would take him to Hollywood clubs to see Art Tatum, Count Basie, Duke Ellington, and other top performers. Though tall for his age, Claxton was obviously a minor, so he donned a coat and tie in order to gain entry to the nightclubs. He became a regular at Billy Berg's and the Streets of Paris, in Hollywood; the Haig, in the mid-Wilshire neighborhood; the Tiffany Club, in MacArthur Park; and Brothers, in South Central Los Angeles.

Even before Claxton made his mark as a professional photographer, the jazz performers he admired often allowed him to take their photographs. In the early 1950s, when he was still a psychology student at the University of California, Los Angeles, Claxton began photographing musicians who were part of the flourishing Los Angeles jazz scene. While photographing Gerry Mulligan at the Haig in 1952, Claxton met Richard Bock, who asked if he could use Claxton's photos on the cover of the record of the concert. "Oh, you have a record company?" Claxton asked. "No," came the reply, "but by morning I will have!"[1]

True to his word, Richard Bock founded Pacific Jazz Records—and Claxton became the company's art director and chief photographer, with his photos appearing on hundreds of album covers, many of which he designed. When 33⅓ rpm LPs came on the scene in 1948 (replacing 78s), the larger format offered a new outlet for Claxton's creations. Claxton expanded on the format's potential by paying close attention to the typography and design of the album cover. On the back of the covers, he provided biographies of the musicians, critical essays, and intelligent supportive material about the LPs, becoming one of the first to present this type of erudite information to a hungry album-buying public. At the same time that the L.A. art scene was gaining notoriety, Claxton created the West Coast Artists Series, designed to bring visual artists into dialogue with jazz musicians; artist John Altoon was set up in the studio with guitarist and composer Jim Hall to paint a jazz-inspired canvas, while Robert Irwin was given a recording of trumpeter Chet Baker and asked to create an original album cover. Claxton's unique aesthetic involved bringing the musicians to outdoor, often quintessential California locations—an approach that gives his photographs and album covers their distinctive look and feel. Having musicians pose with their instruments on a sunwashed beach rather than in a smoke-filled bar may have been without precedent, but Claxton thought it was a natural fit: "California musicians were healthy, even the junkies were into health food."[2] Claxton's photographs used a unique visual aesthetic to chronicle the trajectory of postwar American jazz, including bebop, West Coast Cool, hard bop, and the flowering of free-form improvisation. His covers for Pacific Jazz Records came to define West Coast jazz's distinctive look and earned him the respect of the musicians he photographed. At a late-night recording session in 1956, Jack Lewis, of RCA Victor, asked Shorty Rogers, the composer of a just-recorded Pete Jolly Trio side, what the tune was called. Shorty shook his head, then said, "Hey man, how 'bout *Clickin' with Clax?*"[3]

Cover of the album *West Coast Jazz Volume Three,* 1957. Photo and design by William Claxton (American, 1927–2008). Courtesy Demont Photo Management, LLC.

Notes

1. William Claxton, public conversation with Rani Singh at "Côte à Côte—Coast to Coast: Art and Jazz in France and California," 13–15 November 2007, Getty Center; Contemporary Programs and Research Event Recordings, Institutional Archives, Getty Research Institute (2009.IA.23).

2. Claxton, public conversation with Singh (2009.IA.23).

3. William Claxton and Namekata Hitoshi, *Jazz West Coast: The Artwork of Pacific Jazz* (Tokyo: Bijutsu Shuppan-Sha, 1992), 10.

Figure 2.51.
Jerry McMillan (American, b. 1936) and Joe Goode (American, b. 1937). Poster for the exhibition *War Babies*, Huysman Gallery, Los Angeles, 1961. 55.6 × 43.4 cm (21⅞ × 17 in.). Los Angeles, Getty Research Institute, 2006.M.1. © Joe Goode. Courtesy Jerry McMillan and Craig Krull Gallery, Santa Monica.

exhibition *Directions in Collage* at the Pasadena Art Museum. Irate members of the American Legion and the Veterans of Foreign Wars descended on the museum, outraged in particular by George Herms's assemblage *Macks* (1962), which incorporated a tattered and soiled American flag alongside a bicycle tube, a rusty wrench, scraps of wood, and a reproduction of an old master painting (fig. 2.52). The museum made the courageous decision to stand behind the work, but an anonymous vandal broke into the premises and tore the flag from the assemblage. Such incidents act as a reminder that, even in 1962, the public often regarded modern art with suspicion.

The title *War Babies* was intended to unite the exhibition's participants, despite their different ethnic backgrounds and the diverging interests that, even at this early stage in their careers, were evident in their work. The show was ahead of its time in representing an ethnically diverse group of artists in an era when the emergent art world was still largely a white male preserve. Bereal was one of a very few African American artists to participate in the avant-garde scene centered on La Cienega Boulevard. Elsewhere, however, galleries and informal exhibition spaces were springing up that offered greater visibility to artists of color. Melvin Edwards was one who achieved early success and moved with ease through the overlapping circles and scenes of the L.A. art world. At San Bernardino Valley College in 1964, he organized the exhibition *Yes on 10: Los Angeles Images,* which comprised work by a group of ten artists, including Bereal and Miyashiro. Edwards's work of that time—a series of welded metal sculptures titled *Lynch Fragments* that he began making in 1963—bears some similarity to Miyashiro's in its machinist qualities, and the two artists were close friends. In wall-hung

CENTER OF CONTROVERSY—This collage caused the Pasadena Art Museum to close an exhibition of collages briefly Friday after protests that the work degraded the U.S. Flag. The museum later decided to reopen the show with the collage remaining. The work is a "nostalgic reminiscence of early America."

Times photo

Art Show Shuts Down Briefly in Flag Dispute

But Pasadena Museum Will Reopen Today With Collage Which Stirred Up Protests

An exhibition of collages in the Pasadena Art Museum will be reopened to the public today despite storm clouds hanging over a controversial work by artist George H. Herms.

The exhibition was shut off from public view briefly Friday in the face of protests that a Herms entry symbolizing the American past degraded the Flag.

The collage, described as a "nostalgic reminiscence of an earlier American way of life," was composed of such artifacts as a bicycle tube, an automobile crank and a torn and crumpled fragment of the Stars and Stripes.

Opened on Tuesday

The show opened Tuesday. It included several collages by Herms and other artists. By Thursday, there had been complaints from several Pasadena citizens and demands that the Herms work come down.

Rather than create a cause celebre, the museum first asked Herms, who concocted the collage in his hilltop retreat at 19712 Valley View Dr., Topanga Canyon, to withdraw it from the exhibition.

But Herms refused, said Dr. Thomas Leavitt, museum director, taking the stand that if any of his work went, all of it had to go.

"Rather than cause a furor," said Dr. Leavitt, "we decided to close the whole exhibit, temporarily."

But later, after consulting with the museum's legal counsel and members of the board, Dr. Leavitt said the bars would come down today.

He said he personally considered the Herms collage "beautiful," and was satisfied that the museum's trustees would stand firm against any criticism of pressure for its removal.

Meanwhile the bearded, 27-year-old artist remained aloof in his aerie far from Pasadena. He went serenely about his work, piecing together new works and pausing occasionally to tootle on a bamboo flute.

ARTIST — George H. Herms, whose collage stirred dispute which briefly closed art show.

Figure 2.53.
Melvin Edwards (American, b. 1937). *Afrophoenix 1*, 1963.
From the series *Lynch Fragments*. Welded steel, 31.8 × 24.1 × 10.2 cm
(12½ × 9½ × 4 in.). Chicago, Art Institute of Chicago, restricted gift
of Stanley M. Freehling, 1997.411. Courtesy Melvin Edwards.

Figure 2.54.
Melvin Edwards (American, b. 1937). *Inside and Out*, 1964.
From the series *Lynch Fragments*. Welded steel, 30.5 × 22.2 × 14.6 cm
(12 × 8¾ × 5¾ in.). Redlands, California, collection of David Lawrence.
Courtesy Melvin Edwards.

Figure 2.55.
Melvin Edwards (American, b. 1937). *Sonday*, 1964. From
the series *Lynch Fragments*. Welded steel, 31.75 × 17.8 × 19 cm
(12½ × 7 × 7½ in.). New York, collection of the artist. Courtesy
Melvin Edwards. Photo by Kristopher McKay.

works like *Afrophoenix 1* (1963), *Inside and Out* (1964), and *Sonday* (1964), chains, cogs, and welded metal bars jut dramatically out into the space of the viewer (figs. 2.53, 2.54, 2.55).

The Watts Towers Arts Center, located in South Los Angeles, was one of several important gathering places for artists not represented by the galleries farther west. For a short time in 1964, it was run by Noah Purifoy, the first African American artist to train in fine art at Chouinard. His home had for some years been a gathering place for African American artists, including many who would later show with the Brockman Gallery in South Central Los Angeles, such as Dan Concholar, Alonzo Davis, Melvin Edwards, and John Outterbridge. At the Watts Towers Arts Center, Purifoy began to organize workshops for local youth, often utilizing materials scavenged from the predominantly African American Watts neighborhood. Assemblage took on an immediate social meaning for Purifoy: he viewed junk as a material with tangible connections to the social and economic deprivation of the area, where broken appliances littered the sidewalks and trash collection was unreliable.

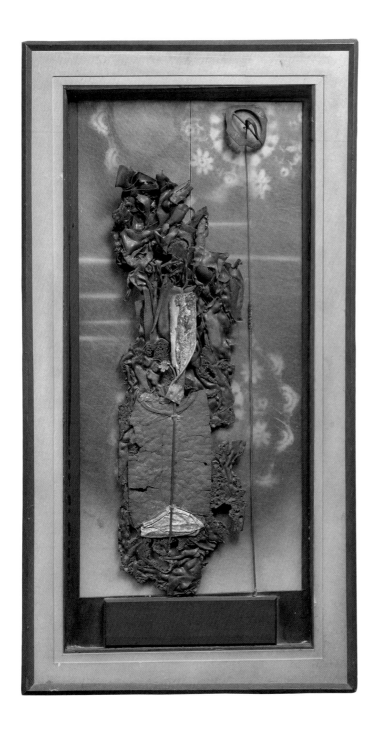

Figure 2.56.
Noah Purifoy (American, 1917–2004). *Untitled*, 1966.
Mixed media, including debris from the Watts rebellion
of 1965, 76.2 × 40.6 cm (30 × 16 in.). Los Angeles, private collection.
Courtesy the Noah Purifoy Foundation.

Figure 2.57.
Noah Purifoy (American, 1917–2004). *Watts Riot*, 1966.
Assemblage of acrylic on burnt wood and other debris,
132.1 × 94 cm (52 × 37 in.). Los Angeles, California African
American Museum, collection of Friends, the Foundation
of the California African American Museum, gift of the Estate
of Alfred C. Darby. Courtesy the Noah Purifoy Foundation and
the California African American Museum.

In Watts, racial tension and anger about social and economic inequalities came to a head on 11 August 1965, when protests against the arrest of a young local man escalated into violence. The uprising lasted for four days, fueled by rage over poverty, housing shortages, alienation, discrimination, and institutional racism. Buildings in Watts were burned and local stores were looted. The Watts rebellion resulted in the deaths of thirty-four people and injuries to more than a thousand; nearly four thousand arrests were made, and property damage has been estimated at $40 million. In the wake of the violence, the political content of assemblage assumed a new salience. Purifoy's materials were no longer discarded objects of decay but the charred remnants of social and physical combustion. "While the debris was still smoldering," Purifoy recounted, "we ventured into the rubble like other junkers of the community, digging and searching, but unlike others, obsessed without quite knowing why."[42] He and his colleague, the

artist and musician Judson Powell, collected three tons of charred wood, scorched and twisted metal, and other rubble from the streets of Watts. They charged a number of L.A. artists (Frank Anthony, Deborah Brewer, Max Neufeldt, Ruth Saturensky, Leon Saulter, Arthur Secunda, and Gordon Wagner) with the task of making works of art from this mound of material—a goal they reached in just thirty days. The resulting exhibition opened at the Watts Towers Arts Center in 1966 and was titled *66 Signs of Neon,* named after the lead drippings of the neon signs that had burned in the streets of Watts and that were incorporated into many of Purifoy's and Powell's works for the show. Among these are a number of delicately wrought sculptures suggestive of jewelry or pressed flowers (fig. 2.56). Also on display was Purifoy's *Sir Watts,* a battle-weary figure bursting with bric-a-brac. In the more abstract *Watts Riot* (fig. 2.57), burnt wood, signage, and other debris are fashioned into murky fields of color. These works are far removed from the confrontational horror of Kienholz's assemblages. Rather, informed by Purifoy's professional training in social work and his strong belief in the healing power of art education, the works convey a positive message. Purifoy likened the collective endeavor to Simon Rodia's transformation of cast-offs into beauty: "It can make people here realize that their junk, their lives, can be shaped into something worth-while."[43]

Following its debut at the Watts Towers Arts Center, *66 Signs of Neon* was displayed at several California university galleries (fig. 2.58). The exhibition toured the country (a few works even traveled to Germany for exhibition there), returning to Los Angeles, somewhat the worse for wear, in 1969. In the intervening three years, the artistic landscape had changed significantly. The Ferus Gallery had closed in 1966; in 1967, two years after Virginia Dwan established her gallery in New York, the Westwood branch would lower its shutters. The closure or departure of some early commercial galleries marked an end to this first flush of development in the art scene of Los Angeles. But their tenure—and the ambitious projects of artists who sought to develop new modes of art production, display, and dissemination—foreshadowed the city's future as a world-class art center.

Figure 2.58.
Judson Powell, Noah Purifoy, and Sandra Corrie in the exhibition *66 Signs of Neon,* University of California, Los Angeles, 1966. Photo by Harry Drinkwater (American, b. 1919). © Harry Drinkwater.

13 *Roxy's* ALEX POTTS

***ROXY'S*—AN INSTALLATION** with multiple parts, each with its own title—was the first of a series of elaborate tableaux of modern life that established Edward Kienholz's American reputation in the mid- to late 1960s. Shown at the Ferus Gallery in Los Angeles in 1962 (next page, top) and at the Alexander Iolas Gallery in New York the following year (next page, bottom), *Roxy's* became one of Kienholz's best-known creations. Along with *Back Seat Dodge '38* (1964), it was at the center of the controversy generated by Kienholz's retrospective in 1966 at the Los Angeles County Museum of Art, when accusations of pornography were brought against the exhibition by the Los Angeles County Board of Supervisors—a turn of events that made Kienholz into an instant celebrity and the show into a popular success. *Roxy's* was also instrumental in establishing his reputation in Europe; it was exhibited at the 1968 *Documenta* in Kassel, Germany, representing what *Time* magazine characterized as a "bizarre and even gruesome realism...that may be the most important new trend signaled by Documenta IV."[1]

Responses to *Roxy's* and to Kienholz's other tableaux of the period usually emphasized the artist's uncompromisingly direct rendering of real-life subjects and his apparent disregard for artistic form—his sealing off, "deliberately and methodically, every possibility of an esthetic response," as one critic put it.[2] Favorably disposed critics saw the absence of aesthetic qualities as integral to the work's ability to convey its highly charged content with such immediacy; those who responded negatively took the view that the result was somewhat cheap and sensational, not to be seriously regarded as art. Most commentators, though, were intrigued by the work's powerful impact and commented on how vividly it portrayed certain disturbing realities of contemporary American society.[3] A lingering unease about Kienholz's rough-and-ready realism and his apparent lack of concern for formal mediation may explain why his reputation among East Coast cognoscenti in the United States was relatively short lived. He dropped out of view for several decades, until interest in his work revived in the 1990s—though he remained throughout an important figure for the Los Angeles art world. Even today, some critics view his work as cheap and naive because of its direct approach to politically charged subject matter,[4] while those who celebrate its powerful realism and expressiveness often do so without paying much attention to its inherent complexity.

The subject of the scenarios in Kienholz's tableaux is immediately clear—*Roxy's* is a brothel, with madam and prostitutes; it carries the name of a once-well-known real brothel in Las Vegas. The sexual content is crudely blatant: the figure named "Five Dollar Billy" lies prostrate on an old sewing machine stand that, when it was first shown, could be operated by viewers to pump the body up and down. This type of subject might lead a viewer to expect that the artist is offering a clearly defined social message, something Kienholz deliberately does not do. Instead, he creates ambiguity: the figures of the other "girls" are not as overtly sexualized; they are more projections of personality—in some cases, curiosities bordering on caricature—than embodiments of sexual fantasy or disgust. The brothel scene is represented without commentary rather than in an explicitly moralizing way. What, if anything, is being critiqued?

A similar mix of complexity and overt meaning is evident in Kienholz's early object-like assemblages, such as *The Future as Afterthought* (1962) (see fig. 2.44). That work has been described as resembling an atom bomb mushroom cloud; certainly the threat of nuclear annihilation weighed heavily on people's minds in 1962, the year of the Cuban missile crisis.[5] Such ideas hardly come immediately to mind, however, as one confronts this striking and incongruous object. An awkward structure made up of disparate objects, the piece has an overall effect that is more ludicrous than deadly serious. A heterogeneous clutch of different-size dolls, most of them unclothed and some partially dismembered, are strapped unceremoniously together atop a wooden stand. Jutting out from the upper ledge of the stand is a pair of tricycle pedals, suggesting that the doll cluster might take off somewhere—though not very fast, particularly given that the pedals are not positioned for a cycling motion but instead dangle downward. Far below, on the base, is an isolated, extremely discontented-looking doll's head, possibly grieving about being left behind. Kienholz indicated that a comic element was integral to the conception of work such as this: "I started putting titles on things, humorous titles, because it made them kind of less important...a lot of titles came out as jokes. It turned out that all of the jokes were...socially and in some cases politically pertinent."[6] The idea suggested by the title—that we might be living in a society for which the future is afterthought—is undeniably disturbing, but it hardly encompasses the many other associations that the work conjures up.

One of the more perceptive essays on Kienholz argued that his tableaux prove "the point which the self-styled Realists all miss: that a pictorial reality depends on a tension between the real (the materially actual) and the abstract (symbolism and invention)."[7] In *Roxy's*, the figures are certainly both real and radically non-naturalistic. "A Lady Named Zoa" takes the form of a manikin's leg supported by a metal stool, a doll's head and arms, and a torso partly made from an old post-office dispensing machine, bearing a sign that promises to deliver two envelopes and two stamps if one inserts a nickel and pulls the handle "all the way out." Paid sex is represented here as a banal and mechanical financial transaction. The figure looks decidedly incongruous and the associations it calls up are in the end indeterminate—neither sexy nor repulsive, as they would be in conventional satirical or moralizing images of brothel scenes. The figure named "The Madam," an amply sized dressmaking dummy decked out in shabby clothes and topped by a bewigged boar's skull, might at first look monstrous, but this easy association is partly countered by the sampler hung around her neck containing the Lord's Prayer. Viewed over a period of time, after it loses some of its shock value, the figure can take on the air of a fusty presiding presence that is no longer particularly threatening or disturbing, even if it is not exactly reassuring, either.

Roxy's differs from Kienholz's subsequent tableaux in that it is not quite a conventional installation—the placement of the figures and the identity of many of the props are not predetermined and can be varied considerably each time it is exhibited. It was conceived as an environment but also as a display of individual sculptures. Each of the eight figures, including the one that is a mini-tableau, "Miss Cherry Delight" (which takes the form of a dressing table with an array of personal possessions and a rotating head set inside the mirror frame), is displayed on a pedestal. The poster for the first showing of *Roxy's*, at the Ferus Gallery in 1962, featured images of two of the figures set against a blank background, while the ad for the second showing, in New York, pictured all eight figures arranged in a row, accompanied by Kienholz, who was similarly perched on a pedestal. The entry on *Roxy's* in the catalog of the 1966 exhibition at the Los Angeles County Museum listed each sculpture separately. *Roxy's*, then, is both a tableau and a sculpture gallery, suggesting a parallel between customers viewing girls in a brothel and art lovers viewing statues of nude or scantily clad women in a museum. The positioning of the figures, as well as many of the accessories and furnishings, varied considerably from venue to venue. Even the overall arrangement of the environment was not entirely fixed: the installation was usually divided into two spaces, but sometimes the smaller vestibule would have a figure in it—either "The Madam" or "Ben Brown" (the boy keeping tabs and handing out towels)—and sometimes it would not, while the larger furnished room was variously adapted to show the remaining figures.

Kienholz has made it clear that the work has taken a different form "every time it's been installed. It depends on...the walls, the shape of the rooms, the height of the walls, the kind of wallpaper I buy for them." While he took pains to find period furnishings appropriate to the 1940s setting, many of these varied from venue to venue, acquiring something of the

Partial view of the first installation of Edward Kienholz's *Roxy's*, Ferus Gallery, Los Angeles, 1962.
The figures on the right (foreground to background) are "Ben Brown," "A Lady Named Zoa," "Fifi, A Lost Angel," and "The Madam." Three other permanent features of the work are also visible: the army uniform, the portrait of General MacArthur, and a period jukebox. Photo by Seymour Rosen. © SPACES—Saving and Preserving Arts and Cultural Environments.

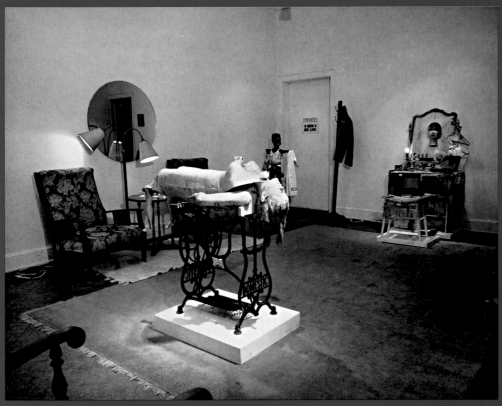

Partial view of the second installation of Edward Kienholz's *Roxy's*, Alexander Iolas Gallery, New York, 1963. The figures (left to right) are "Five Dollar Billy," "Ben Brown," and "Miss Cherry Delight," with the army uniform next to the door. Photographer unknown. Los Angeles, Getty Research Institute, 940004.

character of the city where they were being shown. Kienholz recalled that in Paris, where *Roxy's* was displayed in a former Rothschild mansion, it took on a "very elegant, very beautiful" look, while in Stockholm it became "sort of hokey...more crassly commercial."[8] The one proviso is that the figures remain the same, even if their juxtaposition is subject to considerable variation, with no groups or pairs necessarily belonging together. For the viewer, a sense of the work as a whole forms in the mind as a virtual image. *Roxy's* cannot be identified with a single picture. Rather, it exists as total environment that is felt more than seen, playing itself out as a shifting constellation of partial pictures that home in on a particular figure or local scenario. In publications on Kienholz, the illustrations of *Roxy's* often confusingly show shots taken from several quite different installations.

The complexity of *Roxy's* also comes from the images included in the decor, some of which evoke a world beyond the closed environment of the brothel. On the wall is a photo of General Douglas MacArthur, the hero of the American army's World War II Pacific campaign. A saccharine Maxfield Parrish reproduction contains ideal female nudes that contrast with the inelegant and in some cases aggressively awkward shapes and costumes of Kienholz's "girls." The inclusion of rudimentary machine parts in some of the figures is echoed in a curiously suggestive way in the image on a calendar pinned to the wall: a swankily dressed "Liberty Belle" juxtaposed with a large metal bell advertises a company specializing in "motor reboring" and "machine work." The viewer is placed in different time frames: the immediate present of the work itself and the period of the interior, specified by the June 1943 calendar. The war taking place at the time visibly intrudes into the cloistered world of the brothel, and allusion is made to the rampant prostitution "serving" army and navy recruits in wartime. The military uniform hanging on a stand, apparently belonging to one of the unseen customers, further suggests the distant presence of war and of the seamy side of army life.

The 1969 short film *Kienholz on Exhibit* includes the responses to *Roxy's* by visitors to the 1966 exhibition in Los Angeles.[9] Several saw it as disgusting pornography, or as picturing an uncharacteristically sordid aspect of American life. Others commented on its character as a widely resonant social scenario that could not be pinned down in this way. In one visitor's view, "this is exactly what's going on in everyone's mind," while, according to another, it showed the "human condition...as it exists today....It sets down in tableau form our ills and unhappinesses...plus some of the humor that's attendant on the age." Kienholz himself asserted that "my *Roxy's* is a combination of eighteen-year-old remembering, blue movies, imagination and whatever."[10] Despite the apparent crudity of the idea of a brothel scenario, the work delivered no single meaning, however much it provoked viewers into imagining one. At some moments, it can present itself as a comfortingly nostalgic, homey environment animated by the sound of old popular tunes; at others, as a scene of flagrantly demeaning prostitution. Both extremes are integral to the reality Kienholz evokes.

If the term "realism" can be applied to any work of the mid-1960s, it surely fits Kienholz's productions. Most anti-formalist work that sought to break down the boundary between art and life was not figurative in the way Kienholz's was. New realist or pop art generally focused on objects rather than the human figure, with representations of the latter usually presented in multiples. There were real live figures in Happenings, to which Kienholz's tableaux were often compared, but experimental work generally avoided artistic depictions of the human figure that could readily be associated with traditional realism. Where life-like figures were deployed, the ultra-illusionism was conceived as breaking with artistic realism's formal protocols. More often, the figure was subjected to systematic processes of formalization, as with the abstract whiteness and dulling of detail produced by the plaster-coated fabric surfaces in George Segal's sculptures from this period. The non-naturalistic aspects of Kienholz's figures, by contrast, do not suggest formal intent. They seem to be rendered with a view to achieving a gritty sense of reality and a striking, if at times incongruous, expressiveness.

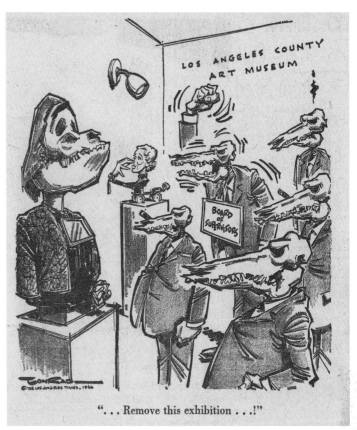

Paul Conrad (American, 1924–2010). "...Remove this Exhibition...!" editorial cartoon, *Los Angeles Times*, 24 March 1966. Los Angeles, Getty Research Institute, 2009.M.30. Used with permission of Kay Conrad.

The complexity of Kienholz's real-life scenarios, paradoxically, derives in part from the apparent simplicity and directness of the realist devices he deploys and the way these both amplify and conflict with one another. In *Roxy's*, the evidently misshapen bodies and the literal realism of the furniture and carpets and clothing suggestively play off against one another. Found objects—a hog's skull, an ordinary stamp-dispensing machine, or a doll's head—stand in for body parts that they do not resemble but whose reality, paradoxically, seems more vividly conjured up as a result. What distinguishes Kienholz's work from that of assemblage artists like George Herms and Bruce Conner, for whom the reality of the objects and materials is similarly important, is the strong element of vividly realistic representation. Kienholz creates a complex, self-disrupting realism that operates literally as well as in a naturalistic and hallucinatory mode.

Notes

1. "Exhibitions: Signals of Tomorrow," *Time*, 12 July 1968, 73.

2. Philip Leider, "Kienholz," *Frontier* 16, no. 1 (1964): 25.

3. See, for example, in addition to Leider, Barbara Rose, "New York Letter," *Art International* 7, no. 3 (1963): 65–68; John Coplans, "Assemblage: The Savage Eye of Ed Kienholz," *Studio International* 170, no. 867 (1965): 112–15; and Suzi Gablik, "Crossing the Bar," *Art News* 64, no. 6 (1965): 22–25.

4. Hal Foster et al., *Art since 1900* (New York: Thames & Hudson, 2004), 2:418–20.

5. Walter Hopps, ed., *Kienholz: A Retrospective* (New York: Whitney Museum of American Art, 1996), 103.

6. Edward Kienholz, interview by Lawrence Weschler, 1977, transcript, "Los Angeles Art Community: Group Portrait, Edward Kienholz," 216–17, Center for Oral History Research, UCLA Library.

7. John Anthony Thwaites, "Kienholz and Realism," *Art and Artists* 8, no. 6 (1973): 26.

8. Kienholz, interview by Weschler, 237.

9. *Kienholz on Exhibit*, dir. June Steel, 21 min., color (n.p., 1969).

10. Kienholz, interview by Weschler, 233.

Chapter Three

FOR PEOPLE WHO KNOW THE DIFFERENCE
Defining the Pop Art Sixties

Ken D. Allan, Lucy Bradnock, and Lisa Turvey

In 1968, the Los Angeles County Museum of Art (LACMA) held a retrospective of work by Billy Al Bengston. Visitors to the exhibition, designed by architect Frank Gehry, encountered at its entrance a wax figure of Bengston posed with a real motorcycle (fig. 3.1). For many, Bengston had come to represent the quintessential articulation of Los Angeles's 1960s art boom, his uncompromising persona inseparable from his radical art practice. A key player in the group of artists that had congregated around the Ferus Gallery, Bengston had no fewer than five solo shows at the gallery between 1958 and 1963. In 1961, a series of paintings based on the figure of the motorcycle and its parts (tachometer, carburetor, license plate, nameplate, and cylinder head) had alluded to Bengston's other occupation—racing motorcycles—enshrining him as the ultimate Ferus "stud" and leader of the so-called Ferus gang (fig. 3.2). With Irving Blum at the helm, the gallery's opening parties teemed with glamorous young things keen to be part of L.A.'s in-crowd—a scene critic Philip Leider dubbed the "Cool School."[1] Ferus artists strutted with a confidence bred by increased critical attention and actual sales. "What these artists have developed," wrote critic John Coplans in the June 1964 issue of *Art in America,* which reproduced Bengston's painting *Buster* on its cover, "is an aggressive and high-spirited arrogance that only young and talented men can have."[2] Bengston's art was as uncompromising as his personality. His show at Ferus in 1963 featured a number of large canvases upon which his signature chevron stripes were encircled with haloes of vibrant sprayed lacquer. The titles of several works invoked Hollywood celebrities—*Sonny* (Tufts) (fig. 3.3), *Troy* (Donahue) (1961), *Buster* (Keaton) (1962), and *Busby* (Berkeley) (1963). A later work, *Tubesteak* (1965), bore the name of a legendary Malibu surfer. A review in *Time* magazine explained these "paintings by Pop Artist Billy Al Bengston" by citing the artist's own bravura justification: "It is social comment...everyone wants to be topkick."[3]

While *Time* unquestioningly labeled Bengston a pop artist, Coplans would coin another term to describe the work of Bengston and many of his peers: "Fetish Finish" (or "Finish Fetish,"

Figure 3.1.
Wax statue of Billy Al Bengston, at the entrance to the exhibition *Billy Al Bengston,* Los Angeles County Museum of Art, Los Angeles, 1968. Installation design by Frank Gehry in collaboration with the artist. Photo by Marvin Rand, © The Marvin Rand Living Trust. Art © Billy Al Bengston.

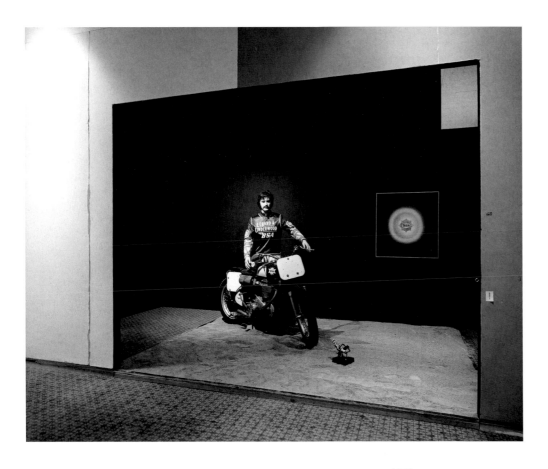

as it would become more widely called), which emphasized a predilection for sensuously colored, immaculate surfaces painstakingly achieved. In the catalog for the 1966 exhibition *Ten from Los Angeles,* Coplans defined this trend as peculiar to Southern California: "A sense of ambience manifests itself in the handling of subject matter, in the overall treatment (by the incorporation of aspects of the intensely reflective quality of California light) and in the relative newness of all surfaces (Los Angeles proliferated within living memory)—for example, by the use of shiny, bright, new materials and clean surfaces."[4] The newness that Coplans identified in so-called Finish Fetish sculpture aligned with accounts of pop art that focused on pop's appropriation of the modes and processes of advertising, illustration, and commercial design in a high-art context and on its depiction of mass-produced consumer products. Though few artists in Los Angeles would fulfill these criteria in a straightforward manner, several working in the

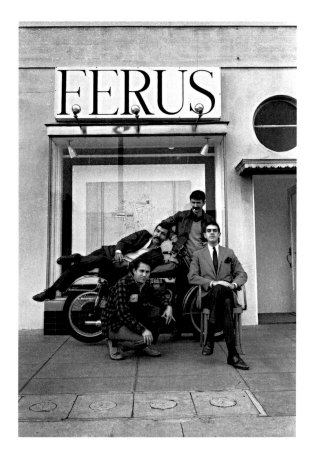

Figure 3.2.
(Clockwise from top right) Billy Al Bengston, Irving Blum, Ed Moses, and John Altoon outside the Ferus Gallery, Los Angeles, 1959. Photo by William Claxton (American, 1927–2008). Courtesy Demont Photo Management, LLC.

1960s—including Bengston—would occupy a category that Nancy Marmer outlined in "Pop Art in California," her chapter in Lucy R. Lippard's 1966 primer, *Pop Art:* those "whose style, rather than subject, has been influenced by what might be called a Pop stance."[5] Thus, while the consumer-oriented subject matter of pop and the abstracted formalism of Finish Fetish or even minimalism might seem poles apart, several points of similarity emerged in the context of Los Angeles art: both pop and Finish Fetish emphasized surface, utilized technologies tied to industrial or consumer culture, combined handcrafting with industrial fabrication, mixed painterly aspects with sculptural ones, and integrated representational modes with abstract ones.

Critical writing of the period reveals the fluidity with which these terms were used on the West Coast. This situation was symptomatic of the less rigid boundaries that governed the still-developing L.A. art world. The relative youth of Los Angeles's art scene meant that there were fewer institutional and practical infrastructures than in New York. Fewer strictures,

Figure 3.3.
Billy Al Bengston (American, b. 1934). *Sonny,* **1961.** Oil
on masonite, 91.4 × 91.4 cm (36 × 36 in.). Billy Al Bengston
Studio Holdings. Art © Billy Al Bengston. Photo by Brian Forrest.

however, meant more freedom for artists, who took a variety of approaches and exhibited a flex-
ibility of style that made L.A. pop much more diverse than its New York counterpart—and more
difficult to classify. The elastic rubric of Leider's "Cool School" designation—like the "L.A.
sensibility" proposed by critic and curator Barbara Rose and the "L.A. Look" described by artist
and critic Peter Plagens—referred equally to artists whose work was also called Finish Fetish
or pop.[6] Furthermore, pop might encompass all of those other terms. Indeed, in Los Angeles
in the 1960s, pop would become a peculiarly expansive category, one that embraced industrial
finishes and abstract forms as well as the everyday objects and commercial design practices
with which it was more commonly associated elsewhere. The critical distinctions between styles—
most notably between pop and minimalism—did not ring as true in California as they did in
New York: in their East Coast expressions, these styles were regarded as polar opposites, while
on the West Coast they seemed to be expressions along a continuum.

ART SCENE EXPLOSION

By the turn of the sixties, Los Angeles had come of age as an art city. In the first half of that decade,
its art scene was in ascendance: communities of artists coalesced around commercial galleries,
shared studio spaces, and worked together on collaborative projects. That Bengston's exhibitions
at Ferus in 1962 and 1963 came hot on the heels of his first solo show at the Martha Jackson
Gallery in New York is indicative of an increased awareness of and interest in Los Angeles art-
ists. The Ferus Gallery remained a hive of activity, showing some of the city's best-known
young artists in the pristine white space that Blum had designed at the beginning of his tenure
at the gallery (fig. 3.4), as well as hosting significant exhibitions of New York artists, including
Jasper Johns, Andy Warhol, Frank Stella, and Roy Lichtenstein.

Figure 3.4.
(Left to right) John Altoon, Billy Al Bengston, and Irving
Blum at the Ferus Gallery, Los Angeles, 1960. Photo by
William Claxton (American, 1927–2008). Courtesy Demont
Photo Management, LLC. Art © Billy Al Bengston.

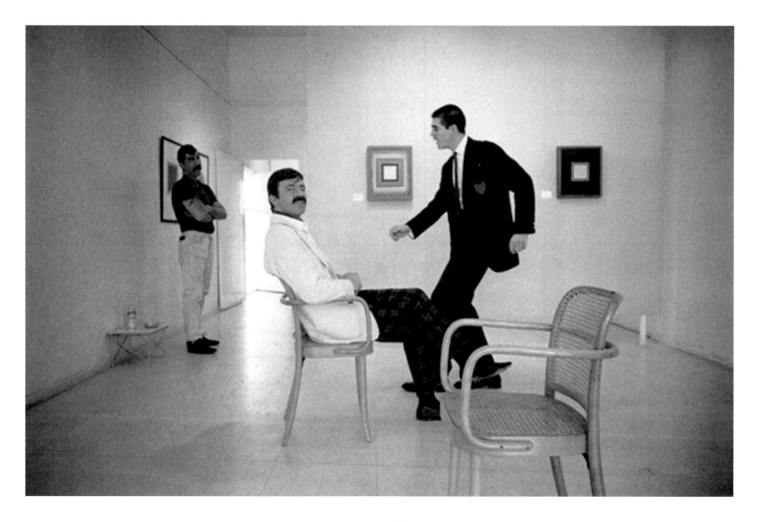

Ed Ruscha (American, b. 1937). *Tooth*, 1970–75. Oil on canvas, 50.8 × 61 cm (20 × 24 in.). Los Angeles, collection of Merle Glick. © Ed Ruscha.

IF YOU WERE AN ARTIST with a toothache in Los Angeles in the second half of the twentieth century, you might have found your way to Dr. Merle Glick.

In 2010, Glick—retired and living in his art-packed home amid Larry Bell boxes, Ken Price ceramics, and Ed Ruscha paintings—shared his reflections on the art collecting that was intertwined with his dental practice from 1955 to 2002.

It began simply enough. "[Ferus Gallery director] Irving Blum is my wife's cousin," Glick explained, "and he would come to our house for dinner maybe three nights a week. One day he called up and said to my wife, 'Pearl, could I bring a starving artist with me for dinner?'"[1] The artist was John Altoon, and after dinner Altoon asked Glick if he would be willing to trade art for dentistry. Merle, Pearl, and Irving all agreed that helping out the artist was the right thing to do.

Artists often trade art for services, including health care, but in Los Angeles during the 1950s, 1960s, and 1970s—the decades before there was a real market for L.A. art—the practice was key to an artist's survival. Consequently, Altoon's arrangement with Glick opened the door to a whole community of artists. "John was quite a salesperson," Glick recalled. "To every artist he knew, he said, 'You gotta go to Merle Glick; he'll do your dentistry for *nothing*. . . . The next guy was Billy Al [Bengston]. And soon it was all the guys in the Ferus stable. It was Ed Kienholz, Craig Kauffman, Ed Ruscha. [Gallery owner] Nicky Wilder became a patient, and he asked me if I'd trade with David Hockney, Ronald Davis, and Peter Alexander."

From this crowd of now-distinguished but then-unknown artists, Glick exacted no payment. "Whenever they felt like they wanted to give me something, they gave it to me."

Among the works in Glick's house is a Ruscha painting with the word "TOOTH" floating in the sky. Initially, Glick had reservations about displaying the work in his office. "If I put an Ed Ruscha up, then Kenny Price would be upset, or if I put up an Eric Orr, then how would Larry Bell feel? But then, in the middle of my career, I got bolder." Soon the painting hung opposite the dental chair, where patients could gaze at it while Glick worked on their teeth.

A brass water sculpture by Orr stands in Glick's garden, reflecting the afternoon light. Glick counts this among his favorite pieces. He is also fond of the Ruscha word painting *Truth* (1973), which he selected because it rhymes with "tooth."

Glick calmly admitted that he "didn't have a critical eye. . . . I didn't have the eye that Irving had, or Eli Broad, or some of the other collectors." Nor did he ever imagine how much some of the art, much of which he has donated to museums, would be worth today. Perhaps like other medical professionals who number among the major collectors of midcentury L.A. art, Glick had a different motive for trading. "The artists were down to earth. We had our dental friends, we had my wife's high school friends, but we just kind of took a liking to the artists. I always felt for the artists because I think they had a rough life."

"We did talk," he said, eyes narrowed as if gazing into the past. "You do get a certain rapport while you're waiting for the Novocain to take effect."

Notes
1. All quotes in this essay are from a personal interview by the author with Merle Glick, 10 May 2010.

While Felix Landau, Virginia Dwan, and Everett Ellin continued their project of showing local, national, and international talent (fig. 3.5), they were joined in the 1960s by a number of new dealers and gallerists, including Rolf Nelson, Nicholas Wilder, and David Stuart (fig. 3.6). Nelson and Wilder, in particular, would come to rival Ferus in representing important West Coast artists. Nelson had arrived from the Martha Jackson Gallery and had run the short-lived but significant L.A. outpost of the Dilexi Gallery, Jim Newman's San Francisco enterprise. When Nelson established his own venture in 1963, it rapidly became a major outlet for new work from Los Angeles, San Francisco, and New York. Wilder arrived on the scene in 1965, opening a gallery with financial backing from a group of friends; in support, Barnett Newman consigned a major painting to Wilder and allowed him two years to pay his share of the sale. Wilder, whose gallery was home to his two pet dogs and, on occasion, his 1962 Bentley, was renowned

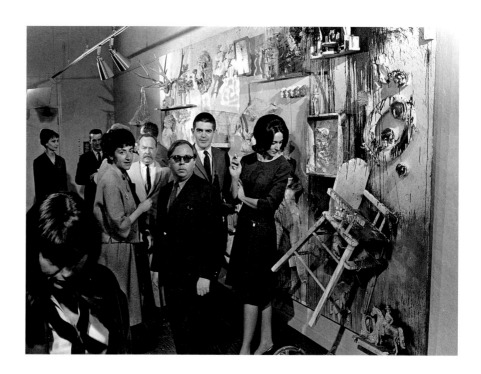

Figure 3.5.
New York–based curator Henry Geldzahler (center front) and Irving Blum (center rear) at the opening of Niki de Saint Phalle's exhibition, Everett Ellin Gallery, Los Angeles, 1962. Photo by William Claxton (American, 1927–2008). Courtesy Demont Photo Management, LLC. Art © 2011 Niki Charitable Art Foundation. All rights reserved / ARS, NY / ADAGP, Paris.

as a debonair figure with a taste for scotch as well as for chili dogs from Pink's, a popular Hollywood hot-dog stand.

Wilder recalled that La Cienega Boulevard was a place built on enthusiasm and ambition, where "the agenda was to make an art scene, to be important."[7] His gallery was one among nearly three dozen along the "spread of five art-choked blocks from the north 900s to the 500s and now spilling southward," as one local commentator described that stretch of La Cienega.[8] Sales were not always brisk and sometimes involved exchange and barter rather than cash. Nevertheless, works of art changed hands, thanks to a loyal cadre of collectors whose tastes since the late 1950s—shaped in part by Walter Hopps, Shirley Nielson, and Henry Hopkins through the University of California, Los Angeles (UCLA), Extension Program— paralleled the fortunes of the L.A. art world. On Monday nights, when the Turnabout Theatre was closed and thus more parking was available, La Cienega's galleries stayed open late into the evening for what became known as the Art Walks. These occasions were as much about socializing as business. *Time* magazine reported that "from all over come matrons out for culture, art students, kids on an inexpensive date, a scattering of beatniks. There are even some artists, recognizable by their uniform: paint-splattered jeans, work- men's shirts, big brown belts for hooking thumbs into."[9] Monday night on La Cienega was

"quite possibly not only the best free show in town but also one of the most popular institutions in Los Angeles County."[10]

That Los Angeles could nurture and sustain contemporary art was the result of local and national factors. Support for artistic production was one element of city and state boosterism, so effective at this moment that Gallup polls in the late 1950s and early 1960s consistently ranked California as the most desirable vacation destination and an ideal place to live.[11] It was Los Angeles, of course, that seemed to crystallize the salient features of California life (sunshine, beaches, youth, movie stars, hot rods, optimism) in the popular imagination. By 1960, Los Angeles was the country's third-largest city, with the rate of its population growth eclipsing that of every other American metropolis. Efforts to establish Los Angeles's artistic identity took place alongside, and were integral to, efforts to define its identity in general, especially in the wake of postwar prosperity and its

Figure 3.6.
Rolf Nelson at his gallery, Los Angeles, ca. 1964–66. Photo by
Jerry McMillan (American, b. 1936). Courtesy Jerry McMillan
and Craig Krull Gallery, Santa Monica.

attendant changes—including the construction of the freeways, the burgeoning of the aerospace industry, and the building not only of skyscrapers but of thousands of single-family homes.

If the art of Los Angeles attracted increased notice at this moment, so too did art in general. The growing appreciation and market for contemporary art—epitomized, it seemed, by pop—was covered not only in an expanding art press but in the national popular press. Articles in periodicals such as *Ladies' Home Journal* and *Vogue* trumpeted new work and bore few traces of the hostility and suspicion that had often characterized the reception of avant-garde art up until only a few years prior. In addition, with the efflorescence of abstract expressionism in the 1940s and 1950s, mainstream magazines, including *Time* and *Life,* had begun reporting on contemporary artistic production, and their coverage of Los Angeles kept pace with (and in some cases predated) that of more specialized art publications. For example, a *Life* article from 1960 noted that "the cultural cactus patch has begun to bloom, even beyond the dreams of art patrons, concert impresarios or dealers in pictures, records or books," and in October 1962, the *Saturday Review* declared that "Los Angeles is, as everyone knows by this time, second only to New York City as an art market."[12]

One of the most concrete markers of L.A. art's transformation from its largely private, underground roots in earlier decades to a more public, official scene was the completion in March 1965 of the Los Angeles County Museum of Art (LACMA) at its new location in L.A.'s

Hancock Park neighborhood. The complex of three buildings surrounded by pools and fountains was designed by William L. Pereira Associates; it represented the largest American museum building project since the opening of the National Gallery of Art in Washington, D.C., in 1941. At long last, Los Angeles could boast a major art museum. In its first seven months, LACMA mounted ten special exhibitions, published seven catalogs, and welcomed one and a half million visitors.[13] In the *Los Angeles Times*, critic Henry J. Seldis hailed the possibilities that the new institution held for contemporary art practice: "We may stand at the threshold of a new cultural maturity if all this activity would be reflected in qualitative increase in artistic output."[14]

Yet inevitably, as had been the case when the city's art collection was housed in the Los Angeles County Museum of History, Science, and Art in Exposition Park, striking a balance between exhibiting local artists and favoring national and international names would prove to be an ongoing struggle. The first curator at the new location, Maurice Tuchman, had been hired from the Guggenheim Museum in New York, and his inaugural exhibition was a retrospective of New York–school painting from the 1940s and 1950s. Local artists would clamor for greater representation at LACMA throughout the sixties, even as Edward Kienholz, Ken Price, Robert Irwin, and others would show there.

The presentation of modern and contemporary art at the museum was not without its problems, as the impact of conservative suspicion toward modern art was still being felt well into the 1960s. In 1966, when Tuchman organized an exhibition of work by Kienholz, including *Back Seat Dodge '38* (1964), the work was met with heated controversy, with Kienholz being accused of pornography and profanity for his grimy depiction of backseat sex. The L.A. County Board of Supervisors, led by Warren Dorn, attempted to shut the exhibition down; they failed, and the controversy served only to encourage a museum-going public, who lined up around the block to see the show (fig. 3.7). This episode illustrates not only the public's openness toward contemporary art but also the increasing awareness on the part of artists toward the business of exhibiting: Kienholz had made a deal with the museum to receive half of the box office takings, a move that had initially seemed naive but in fact proved exceptionally canny.

About 20 miles northeast of LACMA, the Pasadena Art Museum had already become established as another place to view modern and contemporary art of local, national, and international significance, thanks to its acquisition of the Galka Scheyer Collection in 1953. In the 1960s, the museum would hire two notable curators: Walter Hopps, who left the Ferus Gallery for Pasadena in 1962, and John Coplans, who succeeded him in 1967. Hopps in particular was key to the museum's success and to ensuring its relevance for a community of local artists: "for every non-Californian we'd do," he recalled, "there would…be a comparable California show."[15]

In addition to the fertile ground and the willing institutions, another force played a role in promoting Los Angeles as a lively and vital art center: the thorough, deliberate maneuvering by a small but devoted set of local writers, critics, and editors. Periodicals such as *Art News, Art International,* and *Art in America* provided occasional outlets for enthusiastic pronouncements, but the linchpin publication was *Artforum,* founded in San Francisco in 1962. Editor Philip Leider recalled the strategic nature of *Artforum*'s mandate:

> So one night when we were all in my house on Mason Street, Hopps, Blum and me and Coplans, we laid out the battle plan. We were going to make a case for the artists that we liked in both Los Angeles and San Francisco. Basically we set up a war room, and we were now going to proceed to elevate the artists, and ideas of art, that were important to us. Walter was going to be the museum guy and Irving was going to be the dealer, I was going to be the editor, and what we needed was a critic. John was going to be the critic. And no matter what else we did, the consistent thing we were going to do was that we were going to push people like Kenny Price, we were going to push people like Billy Al Bengston, we were going to push people like Bob Irwin.[16]

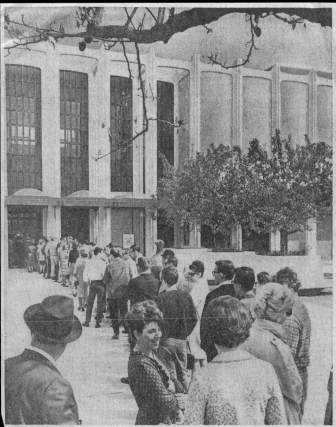

AT THE OPENING—Line forms outside County Museum of Art for public showing of Kienholz exhibition.

RESTRICTED VIEW—Thomas Chambers, art museum guard, waves Mrs. Don Corvan, 24, back from ··· exhibit, "Back Seat Dodge—38." Door of car, whose headlights are aglow, was opened only to tour groups.
Times photos by Frank Q. Brown

NO GIGGLES IN THE GALLERY

Public Sees Art Exhibition; Consensus: Not Pornographic

BY HARRY TRIMBORN
Times Staff Writer

The Kienholz exhibition at the County Museum of Art opened to the public Wednesday, leaving many of the day's 1,500 visitors wondering what the fuss was all about.

The consensus on the works of Edward Kienholz which kept county officials and the art world in an uproar for more than a week was unmistakable—the exhibition is not pornographic.

Not even "Five Dollar Billie" and "Back Seat Dodge—'38" titillated the visitors. There wasn't a giggle from the entire gallery.

"Five Dollar Billie," a woman's torso on a sewing machine stand, and the Dodge which shows the somewhat abstract figures of a couple in an erotic embrace, had been attacked by Supervisor Warren M. Dorn and others as "revolting" and "pornographic."

Little Change Detected

Both remained in the showing of 47 Kienholz works as a result of a "compromise" agreement between the museum trustees and county supervisors that changed nothing but the size of "Billie's" display platform.

An hour after the 10 a.m. opening of the exhibit Wednesday, two museum employes placed "Billie" on another platform about twice the size of the original.

The new stand did not prevent visitors from seeing the four-letter words carved on "Billie's" torso, which Dorn had demanded be shielded from public view.

When the big moment came for the opening of the door on the Dodge for the first public look inside, young and old alike studied the scene inside with serious expressions, then walked away shaking their heads.

The car door was opened 32 times during the day, enabling about 85% of the 1,500 visitors to view the scene inside, said Mrs. Lionel Bell of the Docents Council, a women's volunteer group that conducts museum tours. Dorn had insisted that the car interior be banned to public view.

What they saw they found "tragic" and "depressing," but definitely nothing to stimulate the sex urge.

Scene Called Tawdry

Mrs. Virginia Ames, of Los Angeles, found the car interior "a tawdry scene."

"It was almost like taking a cold shower," she said.

Mrs. Leslie Stern, of Long Beach, described the Dodge display as "like a medieval morality play."

This, according to Kienholz, who stayed away from the public debut of his works, is the intent of the display—to show the sordidness of lovemaking in a back seat.

Mrs. Helen Connolly, 54, objected to the restriction that limited the exhibition to persons 18 and older, unless they have parental consent.

"This is just a bit of life," she said. "Kids 13 and 14 are doing this sort of thing. You can't keep life away from kids by protecting them from the seamy side of it."

"Roxy's," the house of prostitution that contains "Billie," also left visitors emotionally cold. Many indicated that they got the artist's declared message—prostitution is a degenerate activity that rips away spiritual

Please Turn to Page 35, Col. 1

ART MUSEUM

Continued from Third Page

values and reduces prostitutes to the status of lust-gratifying machines.

Mrs. Don Corvan, 24, wondered if the entire show was not a ruse.

"I think he (Kienholz) is putting us on," she said.

The door to the Dodge was opened for the first time Wednesday at 11:15 at the request of Virginia Ernst, 25, an art history graduate student who is writing a thesis on Kienholz.

When the doors to the Lytton Gallery housing the exhibit opened at 10 a.m., about 200 persons were waiting in line.

As the visitors, many of them young people, filed into the building, a man paraded in front of the museum with signs reading "Believe in Christ" and "Kienholz' Work is unGodly."

And acting museum director Kenneth Donahue reported that an irate visitor complained about the Kienholz work and said to a guard: "There is no excuse to having all these erotic pictures in a public museum. They should be removed."

The visitor, said Donahue, was complaining about 17th and 18th century paintings of nudes in another gallery. He had gotten into the wrong line.

So intent was Leider on the promotion of California art, in fact, that he initially wanted to name the magazine *Art West.* In the summer of 1965, Leider, Coplans, and Charlie Cowles moved *Artforum* from San Francisco to Los Angeles. They rented office space above the Ferus Gallery, initiating a fruitful symbiosis that would persist until the magazine's departure from Los Angeles in 1967 for the more established New York scene.

The connection between *Artforum* and Ferus brought a good deal of attention to a small group of artists. In 1964, when Leider identified the Ferus and Rolf Nelson Galleries as the Cool School hub of the L.A. avant-garde, he named the artists connected to the galleries as its primary members: Robert Irwin, Ken Price, Larry Bell, Billy Al Bengston, Ed Ruscha, Joe Goode, and Llyn Foulkes.[17] In the mid-sixties, artists represented by Ferus were the subject of covers, multiple feature articles, and numerous exhibition reviews in *Artforum.* The terms that appeared in the pages of the publication—"L.A. Look," "Finish Fetish," "Cool School"— have long dominated literature on this most notorious generation of Los Angeles artists. For many, Ferus would epitomize what it was to be an L.A. artist, and, despite Los Angeles's richly complex art scene during that period, the gallery and its stable still command popular and critical attention.

PAINTERS OF COMMON OBJECTS

The increased national and international attention given to art in Los Angeles was defined and driven by the central role that the city, its artists, and its galleries played in the formation and definition of pop art. The years 1962 and 1963 were crucial in this regard: during the fifteen months between July 1962 and October 1963, an array of pivotal exhibitions opened, including the first museum exhibition of pop art, *New Painting of Common Objects,* curated by Hopps at the Pasadena Art Museum (fig. 3.8); Andy Warhol's first solo exhibition, of his *Campbell's Soup Cans* at the Ferus Gallery (fig. 3.9) (and Primus-Stuart's mocking display of actual soup cans a few doors down); another Warhol exhibition, of his Elvis and Liz paintings, in 1963; the pop group show *My Country 'Tis of Thee* at the Dwan Gallery; the arrival of the Guggenheim exhibition *Six Painters and the Object* at LACMA and the creation of the accompanying California-centric exhibition *Six More;* and the survey exhibition *Pop Art, U.S.A.,* curated by Coplans at the

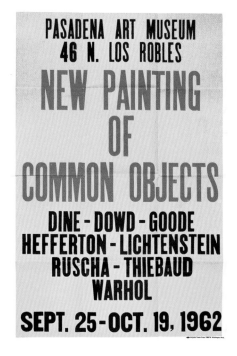

Figure 3.8.
Ed Ruscha (American, b. 1937). Poster for the exhibition *New Painting of Common Objects,* Pasadena Art Museum, Pasadena, California, **1962.** 107.6 × 71.1 cm (42⅜ × 28 in.).

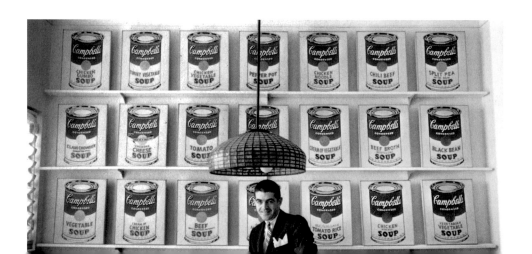

IN 1963, Marcel Duchamp's first solo museum exhibition, *By or of Marcel Duchamp or Rrose Sélavy,* opened at the Pasadena Art Museum. It was curated by Walter Hopps, who had met Duchamp in the late 1940s while on a high school field trip to the Hollywood home of art collectors Walter and Louise Arensberg. Perhaps more than any other event of this period, the Duchamp exhibition drew international attention to the Los Angeles art world and to the relatively unknown Pasadena Art Museum.

Duchamp's career was marked by his repeated attempts to upset any stable meanings of art or definitions of himself as an artist. Duchamp's readymades (literally, sculptures already made because they consisted solely of found objects presented as works of art) and his assisted readymades (altered versions of readymades) had solidified his identity as a challenging avant-garde artist in the first decades of the twentieth century. For *By or of Marcel Duchamp or Rrose Sélavy,* he used the traditional framework of the museum retrospective as an opportunity to both subvert and solidify his place in history. A particularly intriguing episode occurred when Duchamp added to the significance of one of his assisted readymades by "re-making" it to mark the opening of the exhibition. Originally created in 1916 with help from Walter Arensberg, *With Hidden Noise* contains an object that rattles within a spool of twine affixed between two brass plates. On Duchamp's instruction, Arensberg placed something inside the spool but was not allowed to tell Duchamp what it was. As Calvin Tompkins reports in his book *The Bride and the Bachelors,* Duchamp apparently authorized Hopps to dismantle the work in 1963 in order to discover the identity of the "hidden noise"—although the source of the noise still remains a secret.[1] With this gesture, Duchamp stretched the meaning of the piece across time to encompass his relationship with Arensberg in 1916 and Hopps in 1963.

Duchamp's most notorious activity while he was in Pasadena, however, was his game of chess with a naked woman in a gallery that contained a replica of his famous work in glass, *The Bride Stripped Bare by Her Bachelors, Even (The Large Glass)* (1915–23). Duchamp supposedly gave up art for chess in 1923, when he stopped working on *The Large Glass;* for this reason, the Pasadena chess game served the purposes of the museum retrospective. Photographer Julian Wasser documented the event; the resulting image draws on themes from *The Large Glass,* which was positioned between the two chess players: the nude "bride," played by writer Eve Babitz (a friend of Hopps and Wasser); and the "bachelor," played by Duchamp, who was unmarried for much of his life. *The Large Glass* is highly complex—it is part map, part painting, and part blueprint for an imaginary machine that runs on the masturbatory power of a group of bachelors fixated on an unattainable bride. The idea that fantasy is more powerful than the realization of one's desires is a key message of the work. Given that the nearby fantasy factories of Hollywood had been churning out product since Duchamp began work on *The Large Glass* in the 1910s, the provocative photograph of Duchamp and his nude "bride" sitting across the chessboard from each other fits perfectly with the Southern California site of his first retrospective exhibition.

Notes
 1. Calvin Tompkins, *The Bride and the Bachelors: Five Masters of the Avant-Garde* (New York: Penguin, 1968), 39.

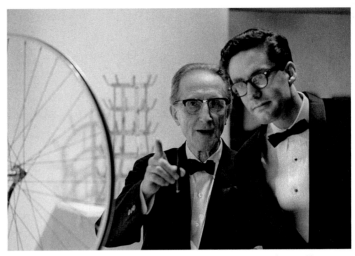

Marcel Duchamp (left) and Walter Hopps at the Duchamp retrospective, Pasadena Art Museum, Pasadena, California, 1963. Photo by Julian Wasser (American, b. 1900s). Art © 2011 Artists Rights Society (ARS), New York / ADAGP, Paris / Succession Marcel Duchamp. © Julian Wasser, all rights reserved. Courtesy Julian Wasser and Craig Krull Gallery, Santa Monica.

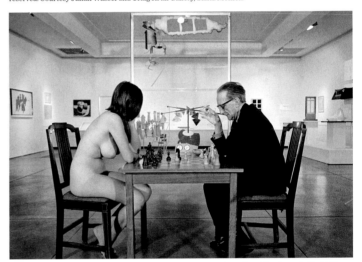

Eve Babitz (left) and Marcel Duchamp playing chess in front of a replica of Duchamp's *The Bride Stripped Bare by Her Bachelors, Even (The Large Glass),* Pasadena Art Museum, Pasadena, California, 1963. Photo by Julian Wasser (American, b. 1900s). Art © 2011 Artists Rights Society (ARS), New York / ADAGP, Paris / Succession Marcel Duchamp. © Julian Wasser, all rights reserved. Courtesy Julian Wasser and Craig Krull Gallery, Santa Monica.

Oakland Art Museum. In 1963, a retrospective of the work of Marcel Duchamp at the Pasadena Art Museum offered a timely historical lineage for the city's recent flurry of pop exhibitions: Duchamp's transformation of ordinary objects into art, his use of humor and sex, and his cultivation of an ironic, eccentric, and inscrutable persona made him the perfect precursor to pop (see sidebar 15).

These exhibitions helped bolster the city's reputation as a place where cutting-edge contemporary art was being made and exhibited, and they also launched the careers of a number of artists. In *New Painting of Common Objects,* Hopps included three works by each of the eight artists in the show, ensuring that young, local artists (Robert Dowd, Joe Goode, Phillip Hefferton, Ed Ruscha, and Wayne Thiebaud) were given equal footing with those from New York (Jim Dine, Roy Lichtenstein, and Andy Warhol). Goode and Ruscha, recent graduates of Chouinard Art Institute and only in their mid-twenties, fared especially well; indeed, when Coplans reviewed the exhibition in *Artforum,* Goode's *Happy Birthday* (fig. 3.10) appeared on the magazine's cover. The Pasadena Art Museum purchased just one work from the show, Robert Dowd's painting of a five-dollar bill, *Part of $5.00* (1962). Both Dowd and Hefferton were painting banknotes before Warhol became famous for doing so (fig. 3.11). Hefferton would show at Rolf Nelson's gallery in 1964, with an ingenious announcement designed as a banker's check (fig. 3.12).

Figure 3.10.
Joe Goode (American, b. 1937). *Happy Birthday,* 1962. Oil on canvas and oil on glass milk bottle, 170.5 × 170.18 × 20.32 cm (67⅛ × 67 × 8 in.). San Francisco, San Francisco Museum of Modern Art, gift of the Gerard Junior Foundation. Art © Joe Goode.

But he and his friend would drop out of subsequent narratives of pop art, overshadowed by their contemporaries.

Goode's *Happy Birthday* and *Purple* (1961) were exhibited again, during the summer of 1963 in the LACMA show *Six More,* curated by Lawrence Alloway to augment the Guggenheim's *Six Painters and the Object* when it came to the West Coast. To complement works by Dine, Lichtenstein, Warhol, Johns, Robert Rauschenberg, and James Rosenquist, Alloway presented those by Bengston, Goode, Hefferton, Ruscha, Thiebaud, and Mel Ramos. In the slender catalog that accompanied the show, Alloway specifically invoked the label "pop art" while taking his cue from Hopps in his emphasis on painters who depict "known signs and common objects."[18] In the fall of 1963, the Oakland Art Museum's exhibition *Pop Art, U.S.A.* included the work of Bengston, Dowd, Goode, Ruscha, and Thiebaud as well as that of Tony Berlant, Jim Eller, and Richard Pettibone. Eller's *Scrabble Board* (fig. 3.13) was exhibited alongside a motorcycle helmet that the artist had commissioned from custom-car artist Von Dutch Holland. Eller was one of the few Los Angeles artists who fulfilled Nancy Marmer's requirement that true pop harness both the matter and manner of commercial culture, but the brevity of his artistic career meant that he, like Hefferton and Dowd, would not become widely known.

Figure. 3.11.
Robert Dowd (standing) and Phillip Hefferton on the lawn of their studio, Los Angeles, 1962. Photo by Mara Devereux Dowd. Courtesy Mara Devereux Dowd.

Figure 3.12.
Announcement for Phillip Hefferton exhibition, Rolf Nelson Gallery, Los Angeles, 1964. From *Artforum* 2, no. 7 (1964): 5.

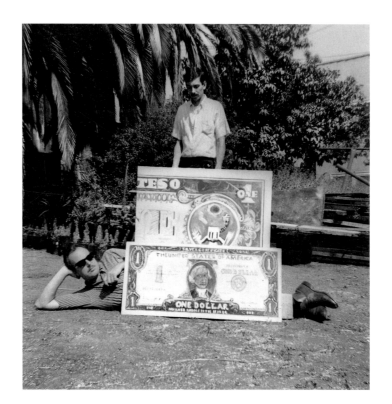

Figure 3.13.
Jim Eller (American, b. 1943). *Scrabble Board*, 1962. Scrabble board and three tiles, 35.6 × 35.6 cm (14 × 14 in.). Laguna Beach, California, the Buck Collection. Art courtesy Jim Eller. Image courtesy Los Angeles Valley College and Larry Lytle.

As early as 1963, Alloway had written in the *Six More* catalog that "Pop art, as the tendency looks like being called for a while, has been consistently misunderstood by its critics and, maybe, by those who like it."[19] Reviewing *Six More,* Don Factor quickly concluded that "the generalizations made about 'Pop Art' have very little to do with the work exhibited."[20] Leider would later warn readers that "all of the Pop artists might make 'new paintings of common objects,' but not all of the new painters of common objects could easily be classified as Pop artists."[21] According to Hopps, *New Painting of Common Objects* "wasn't a Pop show, per se"; nevertheless, it was quickly hailed as such by critics eager to equate the work of Los Angeles object painters with their New York contemporaries.[22] The LACMA showing of *Six Painters and the Object* and *Six More* implied a certain equivalence between Los Angeles artists and their New York contemporaries; the term "pop" united the two coasts—even though, as Factor pointed out, "three thousand miles and a great many painters separate the two sources."[23]

Indeed, although the depiction of everyday, often consumer, objects provided a point of similarity between Los Angeles and New York pop artists, there were notable differences in the way pop was manifested on the East and West Coasts. As the works included in these exhibitions indicated, in the 1960s, L.A. artists, unlike Warhol and Rauschenberg, rarely used mechanical-reproduction techniques; only a few (among them Ruscha) utilized the visual language of graphic design and advertising; and they did not depict images drawn from mass media with the frequency of Lichtenstein, Rosenquist, or Warhol. Wallace Berman's Verifax collages—created beginning in 1964 on an early predecessor of the photocopy machine—were an exception, comparable to Rauschenberg's silk-screened compilations of mass-media imagery. Yet Berman was not included in any pop show, and his pop designation in the critical literature was short-lived, perhaps because of his association with Beat culture and his frequent use of the arcane symbology of esoteric traditions. More often for artists in Los Angeles, the processes of photographic reproduction provided a means to complicate the relationship between mass production and artistic craftsmanship. Vija Celmins and Llyn Foulkes evoked photography only to bypass its mechanistic qualities by way of craft: Celmins's graphic representations of newspaper clippings and of ocean waves are almost mistakable for photographs, and the sepia

tones and repeated mountain landscape views in the work hung, salon-style, in Llyn Foulkes's show at Rolf Nelson in 1963 (fig. 3.14) evoke photographic modes but remain painterly, described by one critic as "hand-made 'photographs.'"[24] The print shop Gemini Graphic Editions Limited, founded in 1966, would build on these kinds of projects, allowing artists to create works that challenged the boundaries of straightforward mechanical reproduction (see sidebar 16). Gemini worked equally with local artists and those visiting from New York, but in the context of these early pop exhibitions the emphasis on craftsmanship sets apart many of the L.A. artists from their New York colleagues. The painterly finish of Hefferton's and Dowd's banknotes stand apart from Warhol's silk-screened ones of just a few years later. While the two Warhol soup can paintings included in *New Painting of Common Objects* and Lichtenstein's *Ice Cream Soda* (1962) in *Six Painters and the Object* all delineate consumer products in bold graphic presentations that emphasize their superficial branding, Ruscha's *Box Smashed Flat* (1961), also in Hopps's show, indicates the substance behind the trademark: Ruscha depicts not only the exterior packaging but also the smeared raisin blot that speaks of messy interior contents.

Marmer identified Ruscha as coming "closer to 'pure' Pop than any of the other artists working in the style on the West Coast," and he would become one of the best-known exponents of pop art in Los Angeles.[25] Ruscha expressed ambivalence about the influence of Los Angeles on his work, sometimes dismissing it ("I doubt that my work would be much different if I lived in

Figure 3.14.
Installation view of Llyn Foulkes's exhibition, Rolf Nelson Gallery, Los Angeles, 1963. Photographer unknown. Art © Llyn Foulkes, courtesy the artist and Kent Fine Art, New York.

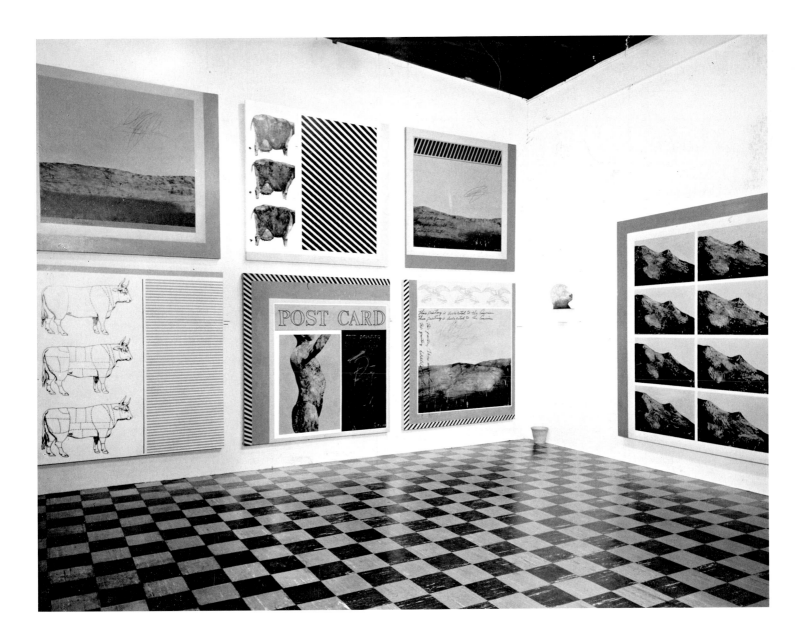

Chicago or New York or anywhere else"[26]) and other times acknowledging it ("the iconography of this place does mean something special to me…it feeds me and it feeds my work"[27]). The pop label, however, came easily: Ruscha depicted some of the city's best-known symbols, including the Hollywood sign, the Twentieth Century-Fox sign, and, in more sober and documentary representations, LACMA, the Sunset Strip, and various elements of the city's changing built environment during the 1960s. Ruscha joined the Ferus stable in 1963, and his paintings from the period show him processing various art-historical precedents through the filter of his training in graphic design and advertising in an approach to the visual that is often keyed to the verbal. In two important early works, *E. Ruscha* (1959) and *Actual Size* (fig. 3.15), he works through the formal aftermath of abstract expressionism in pop, testing its valorization of flatness, process, and accident; *Talk about Space* (1963), included in *Six More* and *Pop Art, U.S.A.*, sends up the pieties of the modernist monochrome and color-field painting; and a series of field guide–like renderings of birds and fish recall the narrative incongruities and scalar irregularities of some surrealist painting.

 Standard Station, Amarillo, Texas (fig. 3.16) submits a generic, or "standard," example of roadside architecture to emphatic frontal treatment, and it condenses pictorial elements to the register of design. Included in Ruscha's second solo exhibition at Ferus, in 1964, the painting is based on a photograph in his first artist's book, *Twentysix Gasoline Stations* (1963). The source image is monumentalized by the transposition to oil on canvas, in particular by the addition of the three klieg-light–like beams. A plunging upper-left-to-lower-right diagonal, one of Ruscha's formal trademarks, divides the canvas, but the device (which, like the use of stark primary contrasts and pristine, architectonic depiction, is a testament to a background in graphic design and advertising) is less an effectuation of perspective than an elementary illustration of how to render it. Although Ruscha's title locates his subject in Texas, he ties the

Figure 3.15.
Ed Ruscha (American, b. 1937). *Actual Size,* 1962. Oil on canvas, 182.9 × 170.2 cm (72⅟₁₆ × 67⅟₁₆ in.). Los Angeles, Los Angeles County Museum of Art, anonymous gift through the Contemporary Art Council. Art © Ed Ruscha. Digital Image © 2009 Museum Associates / LACMA / Art Resource, NY.

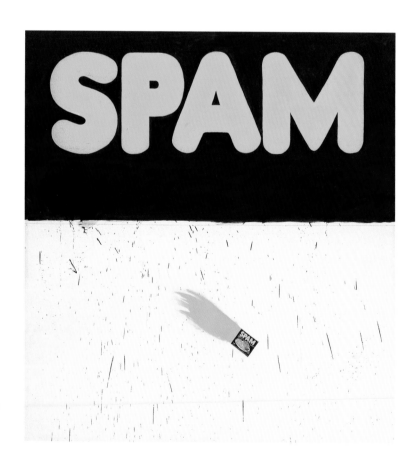

way in which that subject is represented—here, frontality despite a masquerade of recession—to the spatial particularities of his adopted hometown: "Los Angeles to me is like a series of store front planes that are all vertical from the street," he said in 1981. "There's nothing behind them; it's all façade here."[28]

Ruscha did depict pop-like subject matter in some works—the occasional comic book character or comic strip, for example—but his depictions of language distance him from other pop artists, for whom such depictions were infrequent and incidental. His subjects are words, and, while Ruscha is fond of saying that words "exist in a world of 'no size,'" on his canvases, words become palpable, three-dimensional things—on fire, in clamps, fragmented, in motion, and, later in the decade, rendered liquid—that emphasize their objecthood.[29] As if to reassert the presence and heft of his compositions in the face of the superficiality that he saw as particular to Los Angeles, for several of his early 1960s paintings, Ruscha painted the title along the spine of the canvas, accentuating each painting's three-dimensionality.

This interest in actual space as opposed to depicted space, in the actual object versus the depicted object, or in the conjunction of the two, is also evident in the 1960s work of Ruscha's friend, fellow Oklahoman and Chouinard classmate Joe Goode. From his early paintings of isolated objects such as telephones or baby rattles, Goode had moved in 1961 to painting works like those included in *New Painting of Common Objects* and *Six More:* monochrome canvases consisting of large fields of heavily impastoed pigment with subtly varied surfaces, in front of which sit milk bottles covered in paint. The canvases are hung low to the floor so that the bottles make literal the figure-ground relationship between the two components of the work. Goode continued investigating that relationship in subsequent variations, by painting the bottles the same color as the canvas, for example, or by painting a faint, contrasting outline of

Figure 3.16.
Ed Ruscha (American, b. 1937). *Standard Station, Amarillo, Texas,* **1963.** Oil on canvas, 164.9 × 309.4 cm (64⅞ × 121¾ in.). Hanover, New Hampshire, Hood Museum of Art, Dartmouth College, gift of James Meeker, class of 1958, in memory of Lee English, class of 1958, scholar, poet, athlete and friend to all. Art © Ed Ruscha.

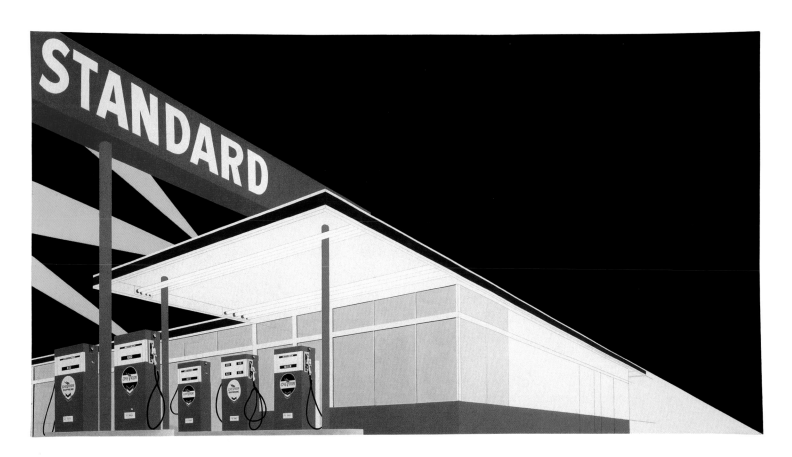

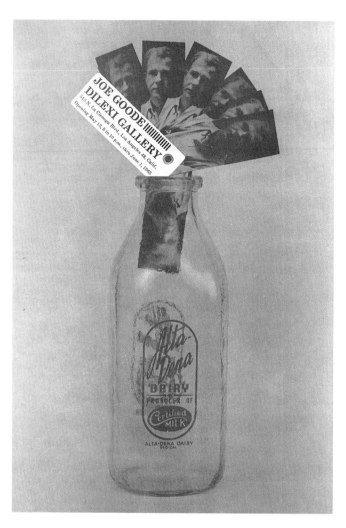

Figure 3.17.
Poster for Joe Goode exhibition, Dilexi Gallery, Los Angeles, 1963. 31.2 × 22.9 cm (12⅜ × 9 in.). Los Angeles, Getty Research Institute, 2009.M.30. Photos in poster by Jerry McMillan (American, b. 1936). Courtesy Jerry McMillan and Craig Krull Gallery, Santa Monica.

the bottle on the canvas. Positioned at the foot of the paintings, Goode's milk bottles allude to front doorsteps and carry psychological connotations of small-town life. But these paintings also orient the viewer's attention to the intersection of the floor and the bottom edge of the painting, emphasizing the viewer's bodily relationship to the paintings as objects and, at the same time, as fields of color. They borrow from the traditions of assemblage and the surrealist object—indeed, Philip Leider likened them as much to the work of Bruce Conner as to that of Warhol and Lichtenstein—as well as from the paintings of Jasper Johns.[30] For Goode himself, still fresh from Chouinard, labels seemed somewhat superfluous: "someone called me a pop artist, and I thought—I didn't care what they called me as long as I was in the show."[31]

The milk-bottle paintings were followed by a set of impastoed monochromes with areas scraped away. Into these areas, Goode inserted drawn depictions of houses based on photographs found in the real-estate section of the newspaper. In addition to valuing the object in its own right, rather than for its consumer status or as a reproduction, this process hints at another distinction between L.A. pop and its eastern manifestation. The introduction of photographic material or techniques did not symbolize the abdication of the artist's hand, or the blurring of the line between fine art and commercial art, or the draining of emotion from the mass-reproduced image; instead, photography was invoked only to reassert the artist's powers of illusion over and above those that might be enabled by the camera.

From the beginning, Goode eschewed what he would subsequently describe as the "PR factor that was Irving Blum" and the Ferus Gallery;[32] the dissemination of his work at different Los Angeles galleries in the sixties is an instructive counterpoint to the dominance of Ferus.

Figure 3.18.
Installation of Joe Goode's staircases, Nicholas Wilder Gallery,
Los Angeles, 1966. Photo by Frank J. Thomas. Courtesy the
Frank J. Thomas Archive. Art © Joe Goode.

Following his inclusion in the 1961 exhibition *War Babies* at Henry Hopkins's Huysman Gallery, Goode went on to exhibit the milk-bottle paintings at the L.A. branch of the Dilexi Gallery (fig. 3.17). Later in the decade, he would also exhibit at the Nicholas Wilder Gallery. In 1966, Wilder mounted a show of Goode's staircase works (fig. 3.18), simple constructions of carpeted stairs that abut the gallery walls or corners at different heights. Too narrow to be walked on and leading nowhere, they prompt a perceptual double take that is similar to, if less subtle than, the one occasioned by the milk bottles.

LOS ANGELES: CITY OF POP

As Walter Hopps later recalled, when Andy Warhol learned of Hopps's intention to show the artist's work at the Ferus Gallery in 1962, Warhol's reaction spoke volumes: "Warhol, who had never been to California, answered with some excitement, 'Oh that's where Hollywood is!' In the sea of magazines and fanzines scattered on the floor, so deep it was hard to walk around, were all those *Photoplay* and old-fashioned glamour magazines out of the Hollywood publicity mill. So a show in L.A. sounded great to Warhol."[33] Warhol himself remembered his impression, driving to Los Angeles for his second Ferus show in 1963, that "the farther west we drove, the more Pop everything looked on the highways."[34] This notion led many to claim Los Angeles as an inherently pop landscape (fig. 3.19), a city of endless freeways and feature-less boulevards, where shiny automobiles rolled past a stream of gas stations, used-car lots, supermarkets, plastic advertisements, and hot-dog stands, from the glitz of Hollywood to the gaudy spectacle of the beach.

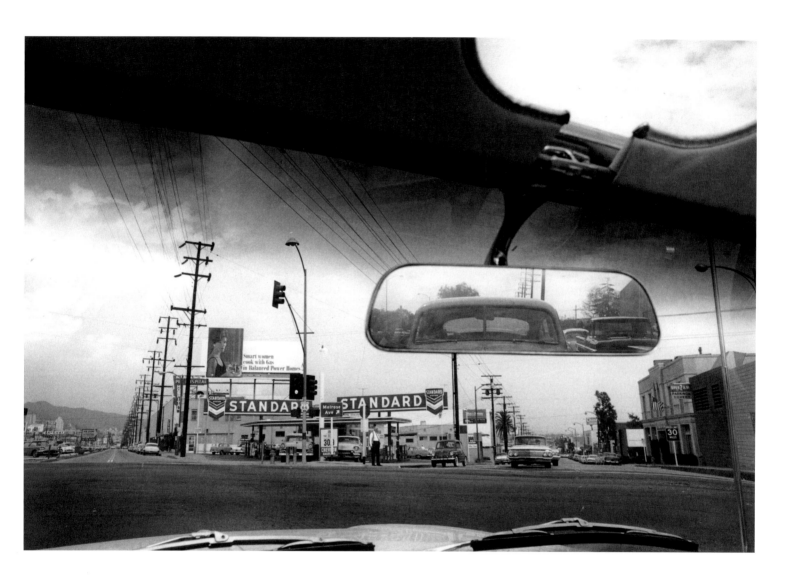

Figure 3.19.
Dennis Hopper (American, 1936–2010). *Double Standard,*
1961. Gelatin silver print, 40.6 × 61 cm (16 × 24 in.). © The Dennis
Hopper Trust. Courtesy the Dennis Hopper Trust.

AT A NEW YEAR'S EVE PARTY in December 1965, Stanley Grinstein and Sidney B. Felsen sat down with master printer Kenneth Tyler to plan the founding of a new print workshop and publishing house. Though primarily businessmen, Felsen and Grinstein had a keen interest in contemporary art: Felsen had attended Chouinard Art Institute; Grinstein and his wife, Elyse, were avid collectors who had been exposed to modern art at the Westside Jewish Community Center and had participated in Walter Hopps's classes on modern art at the University of California, Los Angeles, Extension Program. Embarking on a printing and publishing endeavor was new territory for all concerned; there was, Stanley Grinstein recalls, "no plan, no goal, except it seemed like fun."[1]

Gemini Graphic Editions Limited (Gemini G.E.L.) opened in 1966 as a modest lithography shop and artists' studio. For the shop's first print edition, Tyler arranged for artist Josef Albers—with whom Tyler had worked at June Wayne's Los Angeles print shop Tamarind Lithography Studio—to produce the series *White Line Squares* (1966). Albers's series required an advanced level of precision color matching that distinguished Gemini as a promising print shop from the outset. But the elderly Albers never set foot in the Los Angeles workshop, remaining instead at his Connecticut studio while Felsen and Grinstein traveled back and forth with samples.

Eager to engage more directly with artists on site, Grinstein and Felsen decided to foster collaborations with a younger generation, including, in the first years of operation, visiting New York artists Robert Rauschenberg, Jasper Johns, Claes Oldenburg, Roy Lichtenstein, and Frank Stella, who made his first prints at Gemini. Gemini also hosted Los Angeles artists such as Wallace Berman, Ed Ruscha, Joe Goode, Vija Celmins, Bruce Nauman, John Baldessari, and Ronald Davis. At the heart of the burgeoning L.A. art scene, Gemini served as an important meeting place where artists from the East Coast and West Coast could mix.

Though Gemini was founded as a print publisher, it also functioned as an artists' atelier, one characterized from the start by experimentation, technical and material innovation, and artist-led collaboration. "Gemini gave you the feeling that they could do anything you wanted," Oldenburg later recalled.[2] The projects that resulted from this approach put printmaking on a par with painting and sculpture. In the same way that the conventions of those media were beginning to be questioned in the late 1960s, Gemini interrogated what it meant to make printed multiples. With rolls of uncut paper sourced directly from the mill, artists working at Gemini were able to work on a larger scale than ever before. Rauschenberg's *Booster* (1967), a 6-foot-tall lithograph created from X-rays of the artist's body, thus dispensed with the conventional small scale of printmaking while also forging a new hybrid technique that combined lithography and silkscreen printing.

Ruscha's series *1984* (1967) disrupted the notion of the printed multiple by adding tiny hand-painted flies on each sheet, rendering each one unique. Oldenburg's *Profile Airflow* (1969), a molded polyurethane relief of a 1937 Chrysler Airflow mounted over a two-color lithograph, dissolved the boundaries between two-dimensional print editions and sculptural multiples. For the 1971 edition of *Sawdy*, Edward Kienholz acquired fifty doors from Datsun pickup trucks, then pasted on the windows screen-printed images of his notorious tableau *Five Car Stud* (1969–72), which had first been set up in the parking lot at Gemini. These sorts of inventive and original projects have defined the workshop that, even forty-five years after it was founded, remains at the forefront of contemporary printmaking.

Notes

1. Stanley Grinstein, conversation with Andrew Perchuk, Sidney B. Felsen, John Baldessari, and Ed Ruscha, at *Modern Art in L.A.: 40+ Years with Gemini G.E.L.,* 27 May 2009, Getty Center.

2. Claes Oldenburg, *Artists at Gemini G.E.L.: Celebrating the 25th Year,* ed. Mark Rosenthal (New York: Harry N. Abrams, 1993), 112.

Artists gather at Gemini G.E.L., 8821 Melrose Avenue, Los Angeles, 1967. Photographer unknown. Courtesy Sidney B. Felsen and Stanley Grinstein.

Figure 3.20.
Vija Celmins (American, b. Latvia, 1938). *Freeway,* **1966.** Oil on
canvas, 44.5 × 67 cm (17½ × 26½ in.). New York, collection of
Harold Cook, PhD. Art © Vija Celmins. Courtesy McKee Gallery,
New York.

In the 1950s and 1960s, the rapid expansion of Southern California's freeways confirmed the reputation of Los Angeles as a city delineated by the car. Vija Celmins's painting *Freeway* (fig. 3.20), included in her exhibition at the David Stuart Gallery in 1966, depicts the 405 Freeway (the first section of which opened in 1961), which Celmins regularly took from Venice to her job at the University of California, Irvine. Based on a photograph taken through the windshield of Celmins's car, *Freeway* looks out onto a public realm from a place of private solitude. It recalls the atmosphere of Celmins's earliest paintings of quotidian objects around her studio (fig. 3.21), common objects presented against dim, featureless backgrounds. Though Celmins's paintings differ significantly

from those of New York pop artists concerned with identifiable brands and the bright graphics of mass culture, *Freeway* undoubtedly epitomizes one of L.A. pop's defining features, and perhaps its most obvious one: the centrality of the automobile, whether as a literal subject, a point of view (the slanting perspective of the windshield suggests Ruscha's steep angles), or a material technique (as in the automobile lacquers used by Bengston and others).[35]

The idea of depicting Los Angeles's highways occurred to another expatriate artist, David Hockney (fig. 3.22). He moved to L.A. from England in 1963, landing, as he exclaimed in a postcard to his English dealer John Kasmin the following year, in "the world's most beautiful city" (fig. 3.23). But, he later observed, "there were no paintings of Los Angeles. People then didn't even know what it looked like. And when I was there, they were still finishing up some of the big freeways. I remember seeing, within the first week, a ramp of freeway going into the air, and I suddenly thought: 'My God, this place needs its Piranesi; Los Angeles could have a Piranesi, so here I am!'"[36] Although Hockney had disavowed any affiliation with pop's development in the United Kingdom and was not included in any exhibitions of West Coast pop in the 1960s, he created some of Los Angeles's most iconic pop images—not, ultimately, of freeways, but of swimming pools, backyards, and sleek modernist houses.

As was the case with Warhol, the Los Angeles of Hockney's imagination was inspired by illustrated magazines: not those that peddled Hollywood glamour but, rather, beefcake magazines such as *Physique Pictorial,* published in Los Angeles by Bob Mizer (see sidebar 20). Many of the paintings Hockney executed in the years he lived in Los Angeles feature attractive, tanned young men at rest or play—icons of gay domesticity. They also conjure the outdoor lifestyle of Southern California, the "very un-English" luxury that Hockney encountered in Beverly Hills, and his fascination with Californians' exuberant use of water—"Americans take showers all the time,"
he remarked.[37] The figure in *Man in Shower in Beverly Hills* (fig. 3.24) is statuesque, his muscular limbs, buttocks, and torso described in broad strokes of the thick, unmodulated acrylic to which Hockney had switched (from oil paint) upon moving to Los Angeles. Although his subject derives from a black-and-white photograph, the artist takes pains here, as in many works, to emphasize surface artifice: attention is lavished on the rug's patterning, and water is depicted as stylized, even decorative; the man's body is flattened, his hands unfinished and feet obscured; and the spatial recession signified (but not actually effected) by the curtain is offset by the shower's gridded tile, which reiterates the painting's flat, square support.

Hockney charmed Los Angeles's collectors and gallerists, becoming friends with Nicholas Wilder as well as with Fred and Marcia Weisman and Betty Freeman. His reputation as a chronicler of Los Angeles leisure came after the fact, however; it was established in part by British

Figure 3.21.
Vija Celmins in her studio, Venice Beach, California, 1966.
Photo by Tony Berlant (American, b. 1941). Art © Vija Celmins.

1723, Ocean Park Boulevard.
Santa Monica. California. U.S.A.

My dear Kas,

I just recieved your letter today. — Mark forewarded it on to me from New York. I didn't realise you had enough pictures to go to all the exhibitions you mention.

You must come here, it really is beautiful. Right now I'm sat in my studio overlooking the 'ole Pacific. the sun is shining and the temperature is about 78° (according to the Radio)

Its really an incredible place. To get a driving licence for instance; this friend of Charles who met me took me up to the dept of Motor Vehicles. where you fill in some questions (about the California highway code). I got four wrong but they allow you six mistakes. I took the form back to the counter. and they then said I could take the driving test. — immedrately — positively no wait, . er. For this, I just drove round two blocks and parked it.

So now I have a shiny Ford Falcon to get around in.

I am at the moment working on a painting of Pershing Square Los Angeles. I'm all set up with canvases paints etc, and a pile of drawings. I've also got a nice healthy looking fan, and I'm taking vitamin pills etc. to build me up.

I bought a new pair of glasses in New York. Perfectly round ones. — á la Harold Llyod. I think they suit me.

Glad to hear your keeping up the bowling. I tried to ring Sheridan last night (collect) as Charles Alan who I rang, said he was trying to ring me, — very worried about my driving — Well I'm a good as the next old lady.

Keep up the good work, and I'll lend you my bycycle when you come here.

Regards to everybody

Love

David.

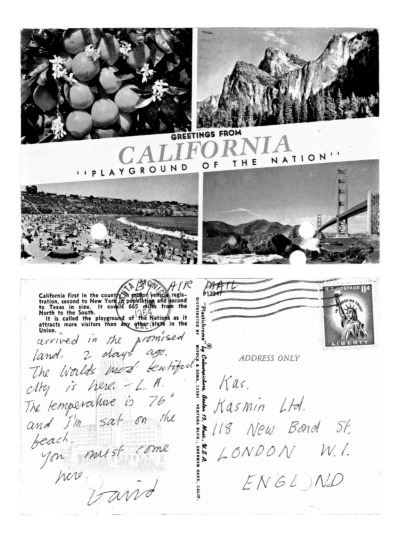

Figure 3.22.
Letter from David Hockney to John Kasmin, 20 February 1964.
30.5 × 21.6 cm (12 × 8½ in.). Los Angeles, Getty Research Institute,
2001.M.1. © David Hockney.

Figures 3.23a, 3.23b.
Postcard from David Hockney to John Kasmin (front and
back), 1964. 8.9 × 13.8 cm (3½ × 5½ in.). Los Angeles, Getty
Research Institute, 2001.M.1. © David Hockney.

architectural critic Reyner Banham, who chose the painting *A Bigger Splash* (fig. 3.25) for the cover of his book *Los Angeles: The Architecture of Four Ecologies,* published in 1971. The painting depicts that most emblematic of California good-life appurtenances, the swimming pool, beneath a flat, high-noon sky, in the moment after a diver has entered the water. The pool abuts a stylized modernist dwelling and is flanked by a director's chair, both markers of the Hollywood glamour that Hockney courted. If the artist's subject is superficial, his methods are considered, even sober, evincing a deliberate engagement with modernism. We might read the uninflected, airless sky as a send-up of the fields of postpainterly abstraction; the condensing of foreground, middle ground, and background as an architectonic takeoff on geometric abstraction; and the laboriously painted splash as a spoof on an action painter's splatter. As is the case with much West Coast pop of the 1960s, lighthearted content belies sophisticated formal workings.

Los Angeles artist Robert Graham also drew on California clichés. He constructed small-scale dioramas encased in plastic, merging minimalist cuboid forms with miniature suggestions of quintessential modernist interiors (figs. 3.26, 3.27). These polished Plexiglas enclosures evoke the transparency and seriality of minimalism and the shiny surfaces of Finish Fetish; at the same time, sand, plastic palm fronds, and naked wax figurines (complete with tan lines) allude to the sun, sea, and sex of the mythical California lifestyle. Place registers powerfully in many of Graham's works of this period, both in terms of the distinctive topography of Los Angeles and in the atmospheric conditions—airiness, reflectivity, and expansiveness—evoked in much Finish Fetish sculpture.

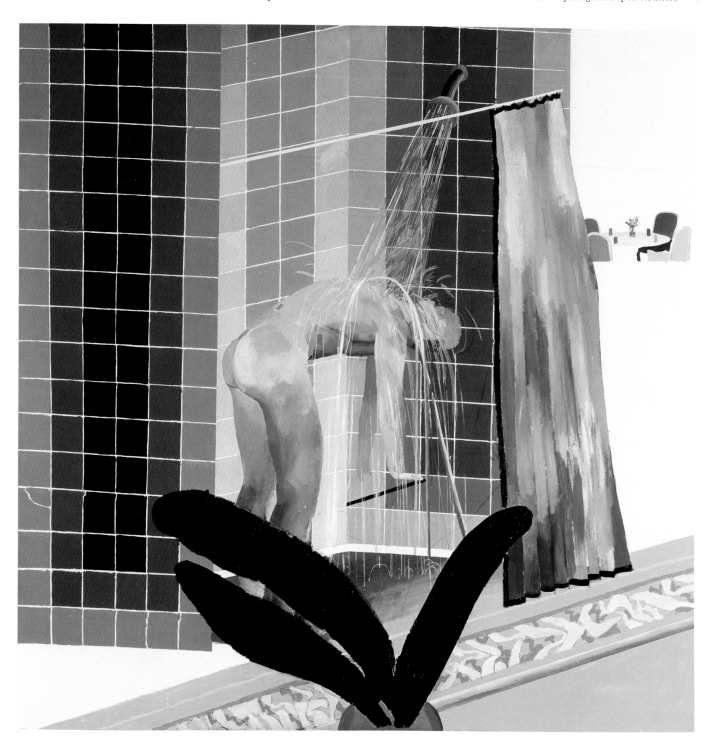

Figure 3.24.
David Hockney (British, b. 1937). *Man in Shower in Beverly Hills,* **1964.** Acrylic on canvas, 167.3 × 167 cm (65⅞ × 65¾ in.). London, Tate Modern. Art © David Hockney. Image © Tate, London 2010.

Figure 3.25.
David Hockney (British, b. 1937). *A Bigger Splash*, **1967.** Acrylic
on canvas, 242.5 × 243.9 × 3 cm (95½ × 96 × 1⅛ in.). London,
Tate Modern. Art © David Hockney. Image © Tate, London 2010.

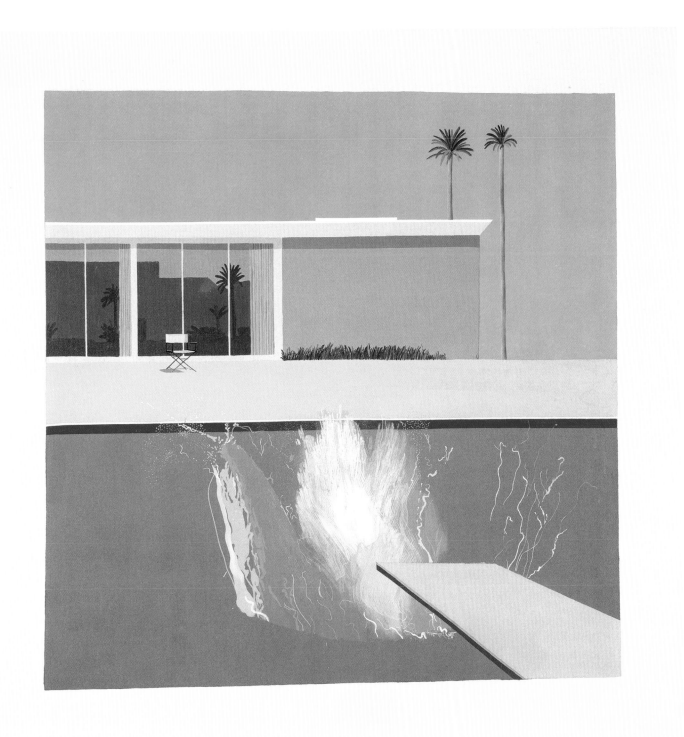

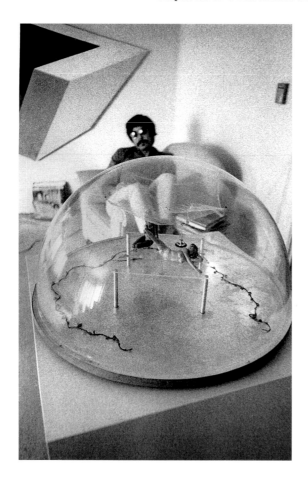

Figure 3.26.
Robert Graham at home, Los Angeles, 1967. Photo by Jerry McMillan (American, b. 1936). Courtesy Jerry McMillan and Craig Krull Gallery, Santa Monica.

These qualities also informed the L.A. works of Richard Diebenkorn, who, of all artists at work in Los Angeles at this time, was among the most well known internationally. However, Diebenkorn was somewhat removed from the city's more visible Ferus scene. Although the artist had been included in the first exhibition at Ferus in 1957, he remained aloof from the city's various artistic communities, eschewing the gallery representation that other artists sought. Diebenkorn had moved to Los Angeles from Berkeley in 1966 and settled in Santa Monica, drawn to that area by the quality of the light. In 1967, he began the *Ocean Park* paintings and drawings, his best-known body of work. This remarkable series splits a hairline difference between abstraction and representation. The artist acknowledged the works' real-world referents: their boxlike compartments, often further subdivided by wedges and diagonals, correspond to boundaries between elements within the landscape—sea and land (literally, ocean and park)—and between natural and artificial elements. Certain configurations suggest architectural structures, others the changing conditions of the light that filtered through the transom windows in Diebenkorn's studio. The immediate environment features prominently in Diebenkorn's paintings, yet the suggestions of sun, sky, sea, grass, and road in compositions such as *Ocean Park No. 67* (fig. 3.28) are rendered abstract through expansive fields of color, rectilinear armatures keyed to the edges of the canvas, and the frontal flatness of the picture plane. *Ocean Park No. 26* (fig. 3.29) presents expansive, murky areas that are suggestive of landmasses and that achieve a precarious balance with the hints of light conveyed by translucent gray slivers and a notch of yellow. Residue of Diebenkorn's method of layering, building up, and scraping down paint remains visible, as do traces of the work's underlying charcoal scaffolding—pentimenti of depth and process that harness their subject, the ethereal Santa Monica landscape. Despite these hints of recession, however, Diebenkorn's compositions remain, like much contemporaneous pop painting, emphatically frontal.

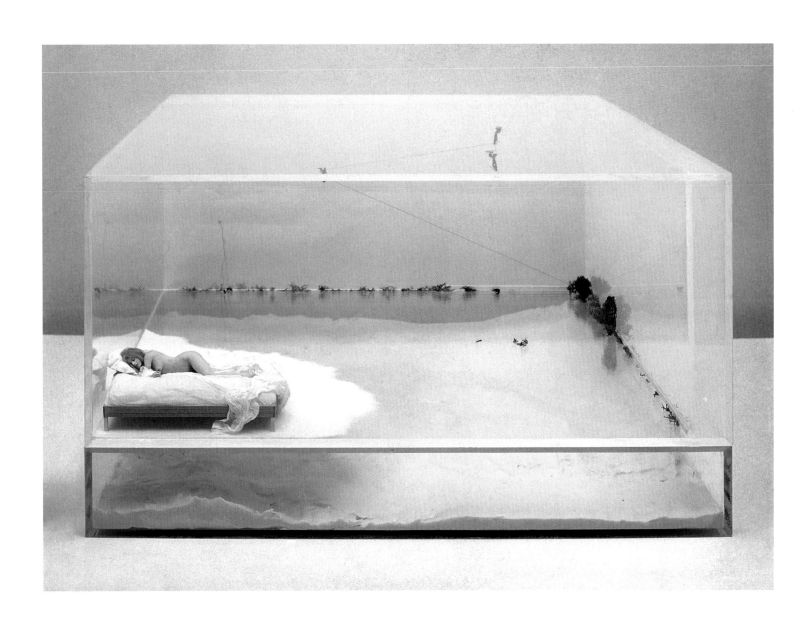

Figure 3.27.
Robert Graham (American, 1938–2008). *Works 53,* 1969.
Mixed-media environment, 27.9 × 55.9 × 55.9 cm (11 × 22 × 22 in.).
Private collection. Photo courtesy Hans Neuendorf.

Figure 3.28.
Richard Diebenkorn (American, 1922–1993). *Ocean Park No. 67,*
1973. Oil on canvas, 254 × 205.7 cm (100 × 81 in.). Collection
of the Fisher family. © The Estate of Richard Diebenkorn, Catalogue
Raisonné #1482.

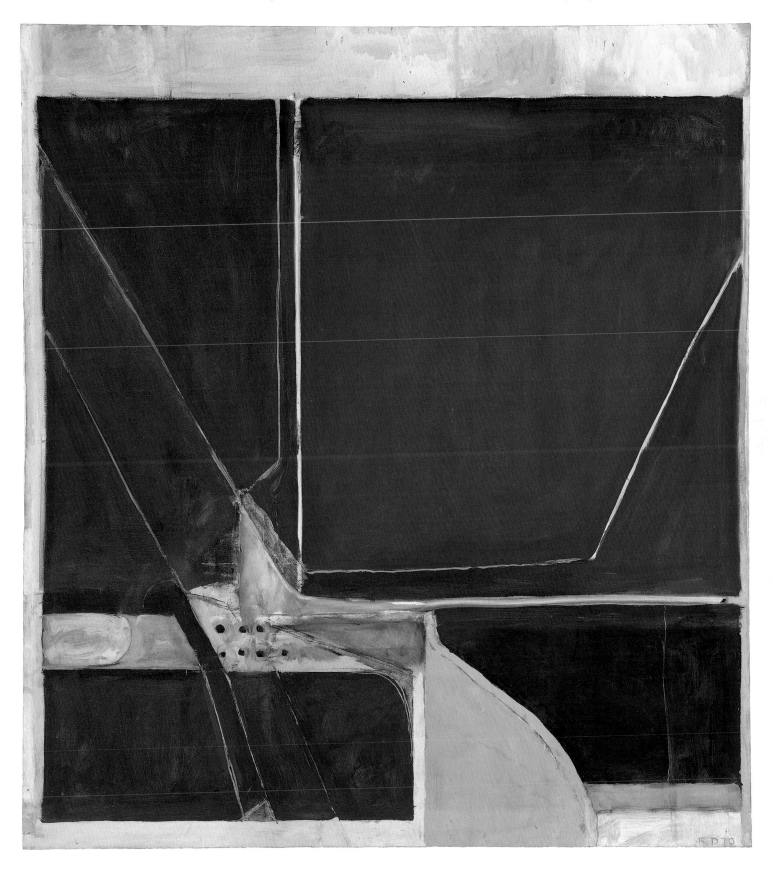

Figure 3.29.
Richard Diebenkorn (American, 1922–1993). *Ocean Park*
No. 26, **1970.** Oil on canvas, 225.4 × 205.7 cm (88¾ × 81 in.).
Leawood, Kansas, Nerman Family Collection. © The Estate
of Richard Diebenkorn, Catalogue Raisonné #2415.

FABRICATING COMMON OBJECTS

What many saw as the preemptively pop landscape of Los Angeles provided material inspiration as well as subject matter. Plastic predominated in both a consumer and industrial context, as innovative materials and processes that had been developed in military and aerospace laboratories were made available to the public. In the 1960s, artists began to create works using materials such as Plexiglas acrylic sheeting, fiberglass, and thermoset plastics that set and hardened into shape, as well as the acrylic lacquers favored by the automotive industry. In a group of works from 1962 to 1963, Kaufman replaced the painterly gestures of oil on canvas with acrylic on Plexiglas (fig. 3.30). This embrace of new materials and the striking purity of color anticipate Kauffman's more radical shift in materials—his turn in 1964 to the kind of plastic vacuum-forming techniques that he had seen in commercial advertising, from vast gas station signage to the wall-mounted molded-plastic fruit at his local doughnut shop. Since there was little information widely available on the vacuum-forming process, Kauffman approached the fabricating firm Planet Plastics to learn how to work with this new technique. The resulting works—vacuum-formed acrylic reliefs with acrylic lacquer sprayed on the reverse—are painting-sculpture hybrids, low reliefs that literalize the relationship between figure and ground. Crisply delineated forms in bright saturated colors, often achieved through the use of commercial signage paints, position these works close to pop, while their seamless and impeccably shiny surfaces allied Kauffman to Bengston and other Finish Fetish artists.

In 1967, Kauffman began to make a series of polished convex lozenge-shaped wall reliefs that swell toward the center (fig. 3.31). In these, and in his "bubble" pieces from 1968 to 1969, industrial lacquers are applied on the reverse, initially in startlingly bright color combinations; in later manifestations, Kauffman harnessed the iridescent quality of Murano automotive paint to create pearlescent hues in softer pinks, whites, grays, and greens. While literally reflective, Kauffman's wall reliefs also seemed to glow from the inside. This intimation of transparency was realized in his *Loops* series (fig. 3.32), which he made in 1969 and included in a mini-

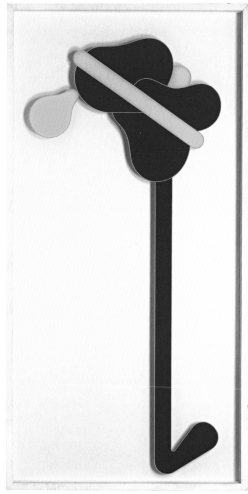

Figure 3.30.
Craig Kauffman (American, 1932–2010). *No. 4*, 1963. Acrylic on Plexiglas, 203.2 × 106.7 cm (80 × 42 in.). Pasadena, California, Vivian Kauffman Rowan Collection. Art © Estate of Craig Kauffman.

Figure 3.31.
Craig Kauffman (American, 1932–2010). *Untitled*, 1968. Sprayed acrylic lacquer on vacuum-formed Plexiglas, 48.3 × 141 × 25.4 cm (19 × 55½ × 10 in.). Pasadena, California, Norton Simon Museum, Museum Purchase, Fellows Acquisition Fund. Art © Estate of Craig Kauffman.

Figure 3.32.
Craig Kauffman (American, 1932–2010). *Untitled*, 1969. Acrylic lacquer on plastic, 185.4 × 120.7 × 22.9 cm (73 × 47½ × 9 in.). Los Angeles, Los Angeles County Museum of Art, Gift of the 2011 Collectors Committee, M.2011.19. Art © Estate of Craig Kauffman, courtesy Frank Lloyd Gallery.

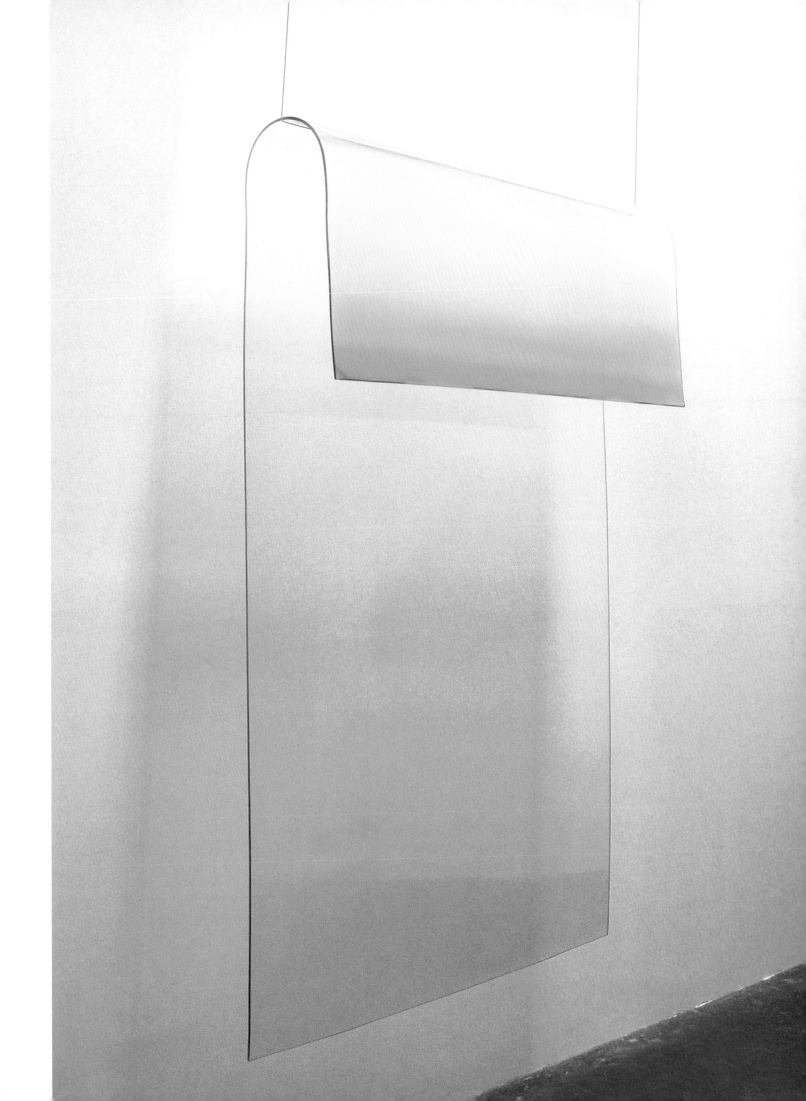

retrospective at the Pasadena Art Museum the following year. Each work comprises a sheet of Plexiglas that Kauffman molded into a looping fold at its top then sprayed with subtle gradations of acrylic paint. Hanging suspended from a wire a few inches from the wall, the objects seem to hover, and the color on their surface appears also in the shadows the works cast on the wall behind. Though Kauffman's loops represent his continued exploration of color and of industrial materials, the phenomenological nature of their display brings them close to minimalism as it began to be defined in the second half of the 1960s.

Kauffman's shift toward integrating color into the material substance of the work was paralleled by the elimination of the figurative elements of his earlier paintings. For his friend Billy Al Bengston, the use of abstract symbols such as the double sergeant stripes, or chevron— at once denotative sign and abstract pattern—had enabled a focus on pattern and surface. As in Bengston's earlier "Valentines" paintings, which centered on the symbol of the heart, the chevron was first rendered in oil on canvas. Bengston soon began painting on masonite and aluminum, however, using dazzling, multihued fields of spray-gunned industrial polymer paint and

Figure 3.33.
Billy Al Bengston polishing one of his works of art, 1962. Photo by Marvin Silver (American, b. 1938). Art © Billy Al Bengston. Courtesy Marvin Silver and Craig Krull Gallery, Santa Monica.

high-gloss nitrocellulose lacquer, applied in dozens of layers. By including *Buster, Troy,* and three other works by Bengston in the exhibition *Six More,* Alloway was indicating that they be considered pop art, though some critics struggled with the tension between the works' abstract qualities and their movie-star titles and hot-rod allusions.[38] Indeed, the ability to occupy both seemingly antithetical realms is a key characteristic of the expanded notion of pop as it was manifested in Los Angeles. The materials and techniques of Bengston's works of the 1960s were those used to custom-detail the gas tanks of the motorcycles he raced at a semiprofessional level on the Ascot Park dirt track in Gardena (in fact, at the time his Ferus show opened in 1963, it was through racing rather than art that Bengston supported himself financially). In his use of spray lacquer to produce opalescent surface color, Bengston created works that speak to the specificity of Los Angeles's automotive and custom-car culture, just as his motorcycle paintings had referenced that subculture in their subject matter. "Los Angeles, of course, was and is a car culture," Bengston has explained. "So I used car and sign-painting materials and colors the way an artist would any other kind of color."[39] Indeed, Bengston was photographed polishing his work like a car (fig. 3.33). The fusion of surface with image in these works exemplifies one of the features Marmer identified as particular to L.A. pop: "an ascetic, mechanical, and highly polished formalism—a style which may have learned its ironic distance and commercial sheen

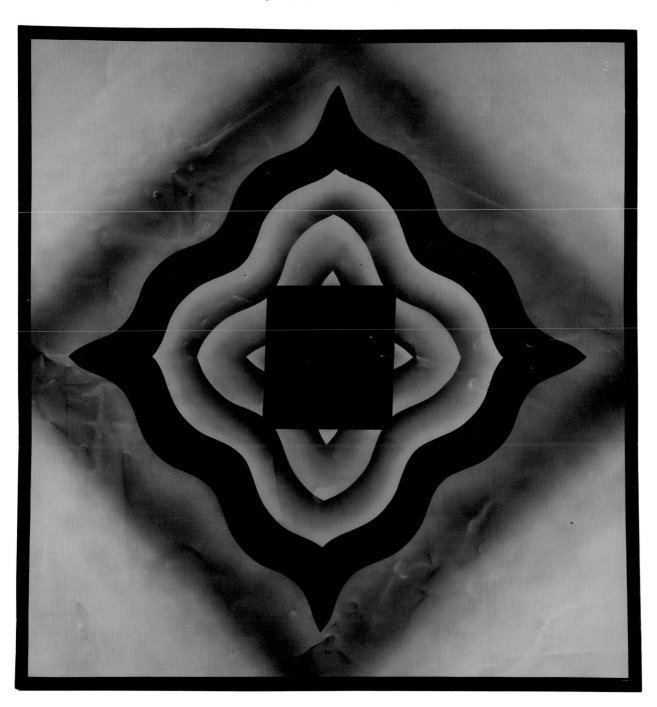

Figure 3.34.
Billy Al Bengston (American, b. 1934). *Big Jim McLain,*
1967. Polyurethane, lacquer on aluminum, 152.4 × 147.3 cm
(60 × 58 in.). Los Angeles, collection of Joan and Jack Quinn.
Art © Billy Al Bengston.

from Pop, but not its abstract iconography."[40] For Philip Leider, writing in 1964, it was precisely that abstract iconography—the reiteration of the chevron—that most closely allied Bengston with pop, in its deadpan refusal of deeper metaphorical meaning.[41]

In 1966, Bengston began a series called the *Canto Indentos,* or the *Dentos* for short, that would occupy him for the next five years. In works such as *Holy Smoke* (1966) and *Big Jim McLain* (fig. 3.34), Bengston pummeled sheets of aluminum with a ball-peen hammer to create creased and dented surfaces that he sprayed with layers of lacquer, blocking out chevrons and other shapes with adhesive tape. He finished the works with a coat of clear polyurethane. The installation of the *Dentos* at the Riko Mizuno Gallery in 1970, in which they were lit only by candlelight, drew attention to their sculptural presence as well as the changeable nature of their appearance. These works at once hide (in their flickering, lustrous finishes) and acknowledge (in the facets that lend them corporeality) the record of the artist's hand.

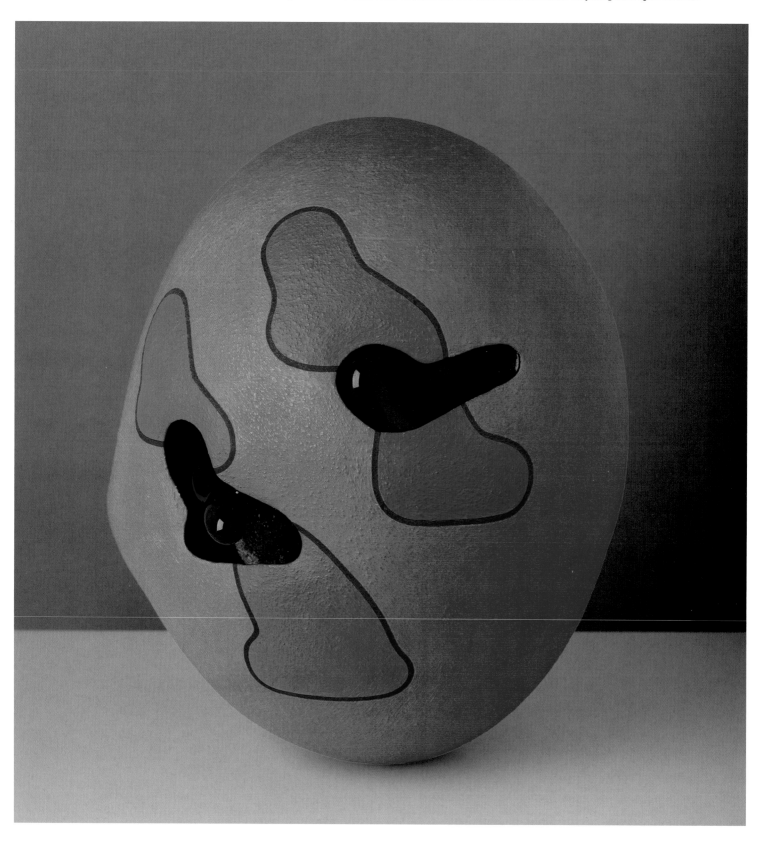

Figure 3.35.
Ken Price (American, b. 1935). *BG Red*, **1963.** Fired clay with
acrylic and lacquer on wooden base, height: 25.4 cm (10 in.).
Santa Fe, New Mexico, collection of Mr. and Mrs. Gifford Phillips.
Courtesy Ken Price Studio. Photo by Taylor Sherill.

This duality, typical of L.A. pop, is evident, too, in the ceramic sculpture of Bengston's Ferus colleague Ken Price, who had begun in the early sixties—while sharing both a studio and paints with Bengston—to use industrial enamels and automobile lacquers. The resulting works, such as *BG Red* (fig. 3.35), are immaculately finished with intense colors and sharp lines that recall the elaborate pinstriping techniques of car customization. Like Kauffman, Price later experimented with Murano paint, which a motorcycle salesman in Ventura had introduced him to. The label "Finish Fetish" implies something superficial, but the way in which the surface gloss of Price's sculptures of this period coexists with the interior space suggested by their biomorphic forms renders the term insufficient.

Iconographic and material allusions to hot-rod and motorcycle culture certainly contributed to the boys'-club reputation of Bengston, Price, and their Ferus colleagues, a reputation that was enacted equally in the environment of the artists' Venice studios, the motorcycle racetrack, and the popular hangout Barney's Beanery. Leider's "Cool School" was, after all, unapologetically and exclusively heterosexual, white, and male. For Judy Gerowitz (who would later change her name to Judy Chicago), it was an atmosphere of macho exclusion: "I still felt that I had to hide my womanliness," she recalled, "and be tough in both my personality and my work."[42] With her friend and UCLA classmate Lloyd Hamrol, Gerowitz enrolled in an eight-week course at an auto-body school to learn spray-painting techniques, and she underwent apprenticeships with boat workers and pyrotechnicians. Gerowitz's *Car Hood* (fig. 3.36) was created in sprayed acrylic on the hood of a Chevrolet Corvair from the early 1960s. Its bright colors and emblematic designs are reminiscent of works by Bengston, whom Gerowitz admired greatly; but it also reads, according to the artist, as a vaginal form being penetrated by a phallic arrow. In 1966, Gerowitz showed two installations, *Sunset Squares* (fig. 3.37) and *Rainbow Pickett,* at Rolf Nelson. Both were modular works that utilized the angles and dimensions of the gallery space, activating the space of the viewer: the first comprised four rearrangeable square frames

Figure 3.36.
Judy Gerowitz (Chicago) (American, b. 1939). *Car Hood,* 1964.
Sprayed acrylic lacquer on Corvair car hood, 109 × 125 × 11 cm
(42¹⁵⁄₁₆ × 49³⁄₁₆ × 4⁵⁄₁₆ in.). Stockholm, Moderna Museet.
Art © 2011 Judy Chicago / Artists Rights Society (ARS), New York.
Photo © Donald Woodman.

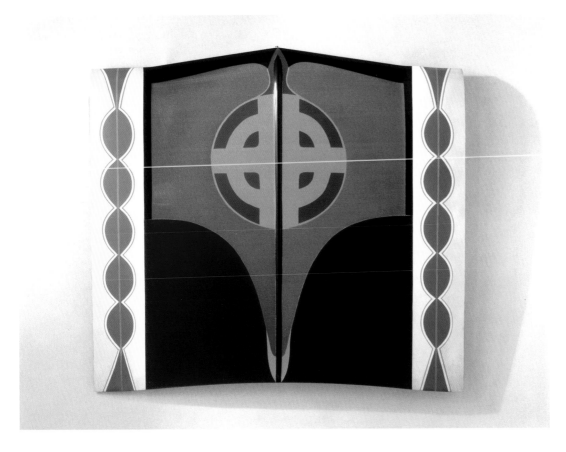

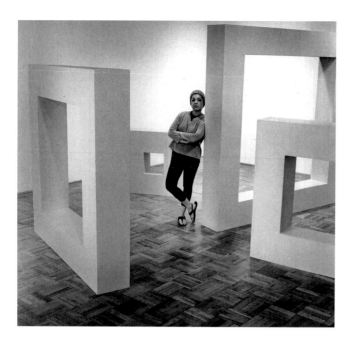

Figure 3.37.
Judy Gerowitz (Chicago) with her *Sunset Squares* installation,
Rolf Nelson Gallery, Los Angeles, 1966. Photo by Jerry
McMillan (American, b. 1936). Art © 2011 Judy Chicago / Artists
Rights Society (ARS), New York. Courtesy Jerry McMillan and
Craig Krull Gallery, Santa Monica.

of various sizes in pale greens and pinks; the second was a series of six trapezoid beams ranging
from 4 to 14 feet in length, set between the floor and wall of the gallery at a 45-degree angle. Both
were striking in their assertion that pop painting had now become a "thing," a structure, with color
and form unified and inserted into the architectural space of display.

The inclusion of *Rainbow Pickett* and works by John McCracken and Larry Bell in the
seminal exhibition *Primary Structures: Younger American and British Sculpture,* organized
by curator Kynaston McShine at the Jewish Museum in New York in 1966, closely associated
the work of these L.A. artists with the discourse of minimalism as it emerged on the East
Coast. Indeed, there were clear affinities between the West Coast Finish Fetish sculpture being
produced in the 1960s and the work of those New York artists—including Carl Andre, Donald
Judd, Robert Morris, and Tony Smith—displayed in *Primary Structures.* Like their East Coast
counterparts, several Los Angeles artists produced geometric, often modular, forms using
industrially fabricated materials. The surface of these forms, and the ways they were affected
by changing conditions of light and space, were paramount; and the viewer's experiences with
the objects, over time, were considered constituent aspects of the works. The treatment of
color as integral to form unites the work of McCracken and Kauffman with the colored volumes
of Judd or the neon works of Dan Flavin (though it sets them apart from Morris or Andre, who
both produced works in more sober tones). Many of these similarities were reiterated in the
LACMA exhibition *American Sculpture of the Sixties* in 1967, the catalog for which included an
article by John Coplans on the technological specificities of 1960s sculpture as well as writings
on minimalism by Lawrence Alloway, Clement Greenberg, and Barbara Rose. But though they
were in dialogue with their New York counterparts, works produced by California artists repre-
sent an original, indigenous strain of sculpture. Gerowitz, McCracken, and Bell all displayed
a concern with the craft of their processes; this, and the origins of their techniques in automo-
tive and surf culture, reinforce the need to acknowledge the close relationship in Los Angeles
between minimalism, pop, and Finish Fetish. It was a relationship that put off some critics:
Peter Plagens admired the similarities between Gerowitz's *Rainbow Pickett* and the work
of Morris or Judd but expressed disdain for what he saw as the distraction of her "fruity" color
choices: the otherwise minimalist beams were spray-painted in pastel-hued latex paints that
anticipate the candy shades of glossy acrylic in later works such as *Big Blue Pink* (fig. 3.38), part
of the *Flesh Gardens* series that she produced after she had changed her name to Judy Chicago.[43]

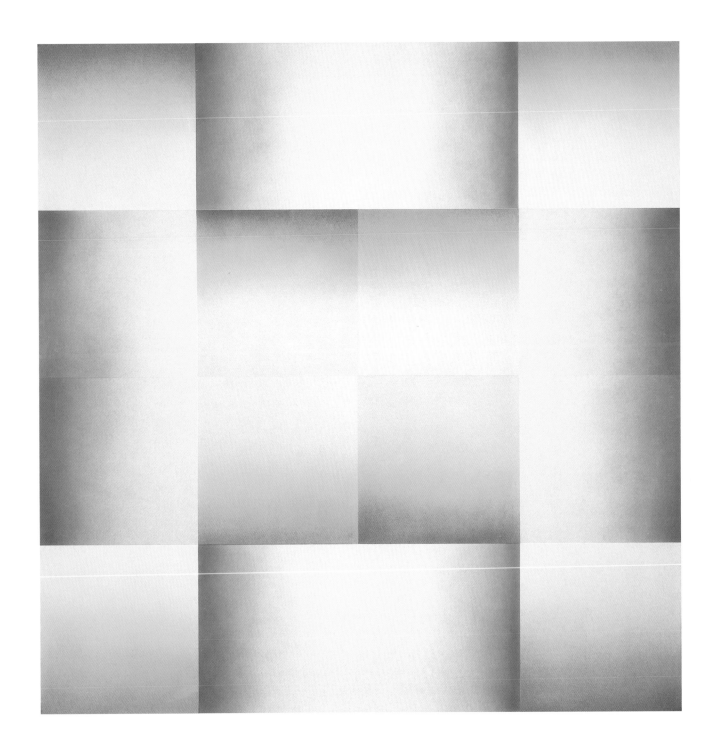

Figure 3.38.
Judy Chicago (American, b. 1939). *Big Blue Pink*, **1971.** Sprayed
acrylic lacquer on acrylic, 243.8 × 243.8 cm (96 × 96 in.). From
the *Flesh Gardens* series. Los Angeles, Jancar Gallery. Art © 2011
Judy Chicago / Artists Rights Society (ARS), New York. Photo
© Donald Woodman.

It was McCracken's pristine cuboid sculptures that would come to define West Coast minimalism in the minds of many. McCracken was represented in *Primary Structures* by the sculptures *Manchu* and *Northumberland* (both 1965), part of a group of works first shown at the Nicholas Wilder Gallery in June 1965. These works comprised small-scale box forms made of plywood and fiberglass, which were given a high-gloss lacquered finish in two colors. The reflective surfaces were countered by recessed slots that drew attention to the interior of the work and by evocative titles like *Mykonos* and *Theta-Two* (fig. 3.39). The sculptures' perfect finish and abstract, three-dimensional form anticipated McCracken's signature plank works, which he began creating in 1966. The plank works were made in the artist's Venice studio by applying between twenty and thirty coats of automotive lacquer to a fiberglass-and-plywood body between 8 and 10 feet in length. Later, McCracken substituted colored polyester resin for the lacquer, poured horizontally to ensure a perfectly even surface, which was sanded and polished. This latter technique brought McCracken very close to the processes of surfboard manufacture,

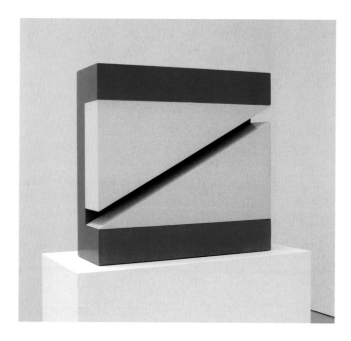

while his interest in the effects of light playing off the colored surfaces of these and later block and cube pieces aligned him with Bengston and Bell. Conceptually positioned between painting and sculpture, the planks quite literally occupied a place in contact with both wall and floor.

McCracken's work was included in the exhibition *A New Aesthetic,* organized by Barbara Rose at the Washington Gallery of Modern Art in 1967; though Rose would take issue with the term "minimalism," the show was considered a seminal event in the development of this new strain of sculpture. When Michael Fried wrote the polemic essay "Art and Objecthood," which denounced minimalist sculpture (or "literalism," as he called it), he included McCracken in his list of minimalist artists, as did Robert Morris in two of his four "Notes on Sculpture" essays in defense of minimalism.[44] The anthropomorphic quality of the planks and their acknowledgment of the space occupied by the viewer seemed to Fried to place them firmly within the minimalist camp. But McCracken's playful titles—like *For People Who Know the Difference* (fig. 3.40) and *There's No Reason Not To* (1968)—reject the absolute purity pursued by his East Coast counterparts, undercutting the seriousness of the works' minimalist credentials.

Some artists and critics found Los Angeles's pop sensibility in its vernacular architecture and consumer gloss or in the techniques of its surf and custom-car culture; others looked to

Figure 3.39.
John McCracken (American, 1934–2011). *Theta-Two,* **1965.**
Nitrocellulose lacquer, fiberglass, and plywood, 53.3 × 55.9 × 19.1 cm (21 × 22 × 7½ in.). New York, David Zwirner Gallery. Courtesy the artist and David Zwirner, New York.

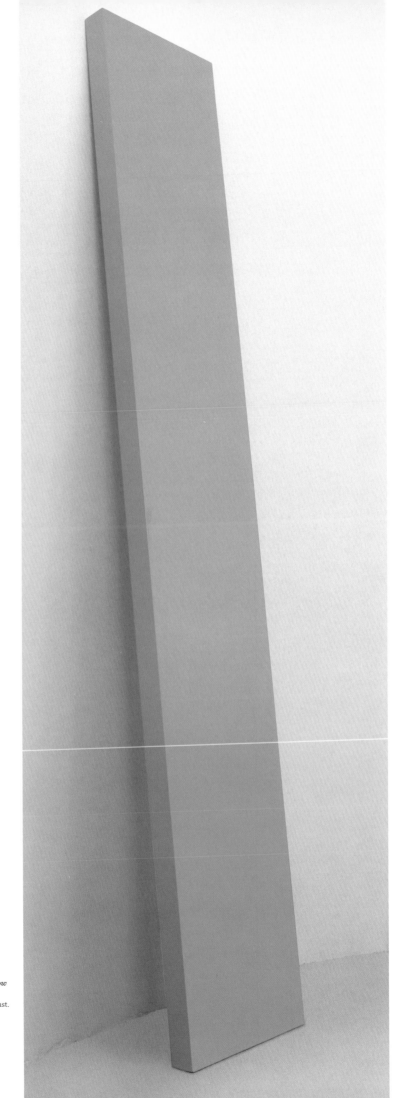

Figure 3.40.
John McCracken (American, 1934–2011). *For People Who Know the Difference*, 1967. Polyester resin, fiberglass, and plywood, 304.8 × 8.3 × 51.4 cm (120 × 3¼ × 20¼ in.). The Mohn Family Trust. Courtesy the artist and David Zwirner, New York.

the region's industrial processes, including the booming aerospace industry, for inspiration. In all cases, the connection to locality is one defining feature of L.A. pop, whether in its subject matter or in the manner of its making. Another defining feature is the particularity with which L.A. artists approached the quality of their plastics, polyester resins, industrial pigments, and industrial coating methods; such particularity led artists in Los Angeles to familiarize themselves with the relevant technologies and to participate in the processes of manufacture to a greater extent than did, say, Morris, Flavin, or Andre, who tended to use prefabricated materials that were often store-bought or produced by others. In many cases, artists in Southern California extended material processes beyond the scope reached by industry: Peter Alexander and Helen Pashgian experimented with cast polyester resin, while De Wain Valentine developed new techniques for large-scale resin casting. Frederick Eversley, a trained engineer, pioneered processes of casting liquid plastic centrifugally in order to create polished parabolic and concave sculptures in vivid hues. Norman Zammitt worked with a highly technical lamination process that allowed him to encase precise blocks of color within translucent laminated sheets of acrylic, constructing "dangerously beautiful boxes" that offset clear frontality with the discovery of multiple layers inside (fig. 3.41).[45]

Larry Bell's works in glass utilize industrial coating processes to create works that are similarly concerned with the mechanics of perception. Though the coating technologies that he would explore were developed in the aerospace industry, he was first inspired to use etched and mirrored glass while working at a commercial frame shop during his time at Chouinard. Bell began using scrap pieces of glass to make shallow wooden shadow boxes, and, intrigued by the suggestion of volume provided by the glass, he soon incorporated pieces of glass into his

Figure 3.41.
Norman Zammitt (American, 1931–2007). *3807-10,* 1965. Plexiglas with baked enamel, 40.6 × 38.1 × 27.9 (16 × 15 × 11 in.). Logan, Utah, Utah State University, Nora Eccles Harrison Museum of Art. Marie Eccles Caine Foundation Gift. © Norman Zammitt Estate.

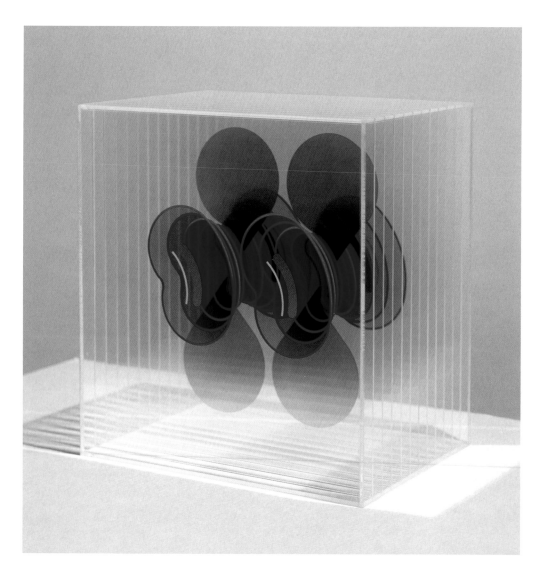

AFTER SPENDING FOUR YEARS in Paris at the height of the Algerian War of Independence, politically minded painter Irving Petlin came to Los Angeles in 1964 to teach at the University of California, Los Angeles. Radicalized after witnessing the brutal methods the French government often used to suppress dissent over its colonial policies, Petlin sought to raise awareness of similar forces at play in 1960s America. Initially, Petlin doubted that he would find support in what he considered the largely apolitical art world of Los Angeles; but in the spring of 1965, John Weber hosted a meeting at the Dwan Gallery for about sixty members of the art community, and the Artists' Protest Committee (APC) was launched.[1]

The APC drafted a statement against the increase of troop levels in Vietnam, the U.S. invasion of the Dominican Republic, and the police crackdown on civil rights marchers in Selma, Alabama, and then began organizing protest activities in the Los Angeles area. With art openings and the building of the new Los Angeles County Museum of Art attracting publicity, and Los Angeles announcing itself as a capital of culture in the mid-1960s, the art scene became a perfect stage for drawing attention to social issues. On the weekend of 15 May 1965, the APC attempted to disrupt this newly thriving art scene on La Cienega Boulevard, Los Angeles's Gallery Row. The APC held a "white-out" of the galleries, covering the works on display with posters featuring a white-on-black image that symbolized their demand to stop the escalation of violence: a ladder with the word "stop" at the bottom. They then targeted the popular monthly Monday Night Art Walk on La Cienega on 17 May. People strolling to the galleries that night witnessed a protest line of artists and students holding placards and walking up and down the street between crosswalks, backing up traffic. According to art critic Philip Leider's report in the left-wing magazine *Frontier*, one driver became irate and drove through the throng, propelling two marchers onto his hood while police stood by and refused to help.[2]

Other than the *Los Angeles Free Press* and *Frontier*, the news media mostly ignored the protests; as a result, members of the APC sought to make a more visible statement that would garner better media coverage. In February 1966, they constructed the Artists' Tower of Protest, often called the Peace Tower, on a vacant lot at the busy intersection of La Cienega and Sunset Boulevards. The tower was surrounded by a display of panel paintings, 2-by-2-feet each, donated by 418 artists, including Frank Stella, Roy Lichtenstein, and Elaine de Kooning. Designed by artist Mark di Suvero and architect Kenneth H. Dillon, the 60-foot-tall polyhedron structure was built of welded steel and tension cables, similar to di Suvero's other sculptures from this period. Many local artists helped construct the tower, but in particular Judy Gerowitz (later known as Judy Chicago) and Lloyd Hamrol worked closely with di Suvero. As the organizers had hoped, the Peace Tower was given nightly TV news coverage and became a source of controversy. During the project's three-month life span (from late February to May 1966), the tower was often a site of violent conflict. Almost every night, according to Petlin, there were attempts to vandalize the art and burn the wooden sign that declared "Artists Protest Vietnam War."[3] Petlin and other supporters repeatedly had to fight off attackers. Several men from the Watts neighborhood showed up to help guard the Peace Tower in a striking gesture of solidarity between the antiwar movement and the disenfranchised Los Angeles community recently rocked by the Watts rebellion of 1965.

More than other APC activity, the construction of the Peace Tower and the group's targeting of the Monday Night Art Walk demonstrated that La Cienega Boulevard had become an important setting for the intersection of cultural politics and artistic discourse in the 1960s.

Notes

1. Irving Petlin, "Peace Tower: Irving Petlin, Mark Di Suvero, and Rirkrit Tiravanija Revisit the Artists' Tower of Protest, 1966," *Artforum* 44, no. 7 (2006): 253.
2. Philip Leider, "Art: The Demonstration," *Frontier* 16, no. 9 (1965): 22.
3. Petlin, "Peace Tower," 254.

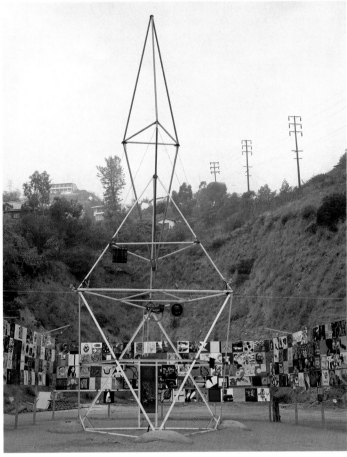

The Artists' Tower of Protest (Peace Tower), Los Angeles, 1966. Photo by Charles Brittin (American, 1928–2011). Los Angeles, Getty Research Institute, 2005.M.11. Image © J. Paul Getty Trust, Charles Brittin papers.

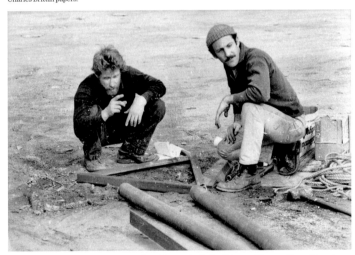

Mark di Suvero (left) and Lloyd Hamrol working on the Artists' Tower of Protest (Peace Tower), Los Angeles, 1966. Photo by Charles Brittin (American, 1928–2011). Los Angeles, Getty Research Institute, 2005.M.11. Image © J. Paul Getty Trust, Charles Brittin papers.

Figure 3.42.
Larry Bell (American, b. 1939). *Untitled,* **1969.** Mineral-coated glass, 101.6 × 101.6 × 101.6 cm (40 × 40 × 40 in.). New York, Pace Gallery. Art © Larry Bell, courtesy the artist. Photo by Ellen Labenski, courtesy Pace Gallery.

paintings, ultimately abandoning canvas altogether to begin creating the cubic forms that would make up his work of the 1960s. In Bell's early cube works, he used coated glass panes fabricated to his specifications by a Los Angeles company; however, when several broke while in transit to New York for an exhibition at the Pace Gallery, Bell was forced to seek another source. This predicament brought the artist into contact with Ionic Research Labs, a Queens-based novelty metalizer company that made Christmas tree baubles and toy cap pistols. In 1966, inspired by the processes of manufacture that he saw at Ionic Research, Bell purchased his own Kinney vacuum-coating chamber, which he transported to Los Angeles in 1967. The chamber allowed him to apply thin films of semitransparent substances to sheets of glass, using a process by which metals such as aluminum, chromium, rhodium, and silicon monoxide were vaporized inside the chamber and their particles deposited on the surface of the glass. Instrumental in Bell's early engagement with the process was a copy of the classic textbook on the subject, *Vacuum Deposition of Thin Films* by Leslie Holland, first published in 1956.

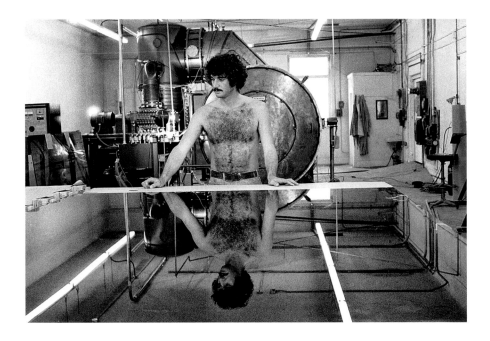

Figure 3.43.
Larry Bell in his studio, Venice Beach, California, 1969. Photo by Malcolm Lubliner (American, b. 1933). Courtesy Malcolm Lubliner and Craig Krull Gallery, Santa Monica. Art © Larry Bell, courtesy the artist.

The results articulate the seemingly paradoxical simultaneity of surface and volume, containment and openness. They demonstrate the artist's fascination with both the reflection and absorption of light and evince his interest in the possibilities opened up by the transparent and reflective qualities of glass. Bell's works are concerned with the physicality of looking, rather than the production of symbolic meaning. Nicholas Wilder later described seeing one such work at Ferus (fig. 3.42), his terms evoking the Light and Space art to come: "You walk up to this cube that's forty inches of smoked glass, and you start inspecting it. And then what happens? In the refractions of the light, the object is extended several meters out—and you. Your body is physically inside the parameters of the object you're viewing. What has that done to you?"[46] Later works, produced in an even larger chamber, emphasize the phenomenological effects of reflective surfaces. In an untitled wall piece of 1967, Bell partially coated 10-foot-long glass strips of black and white glass with Inconel (a reflective nickel-chrome alloy) and hung them at intervals along a wall up to 25 feet long, producing striking optical effects that seem to dematerialize the wall as the viewer approaches.

For Bell, the noisy mess of machinery at Ionic Research Labs held more allure than the sterile environment of his previous glass fabricator, inspiring him to pursue a more physical engagement with the processes of making his work (fig. 3.43). Although artists like Bengston

and Bell drew from the techniques of industrial manufacture, they eschewed the cheap or disposable connotations of mass production that pervaded postwar consumer culture and that had widely informed critical understanding of pop on the East Coast. Rather than absenting the hand of the artist by using the machine, Finish Fetish objects reasserted the centrality of the craftsman, just as more straightforward L.A. pop works did. John Coplans stated as much in 1966, when he included the work of Bell, Price, and McCracken in the exhibition *Five Los Angeles Sculptors* at the art gallery of the University of California, Irvine: "Essential to the realization of the acute formal relationships and qualities of surface finish desired," Coplans wrote, "craftsmanship also serves to indefinitely maintain these effects."[47] In addition, rather than position their practices in opposition to painting, the Finish Fetish artists courted painterly effects in their work, from opticality to illusionism to, especially, color, which functioned as a structural element. In many cases, the resultant works, such as Pashgian's translucent spheres or Eversley's richly hued parabolas, have a lush gemlike quality. The works' sunset hues and full-spectrum effects, in turn, imparted a particular Los Angeles sensibility, one redolent of airiness, sensuality, even pleasure. Even as Finish Fetish works anticipated the direction of Light and Space, however, they also recalled the celebratory glossiness of pop materials.

In its anthropomorphic mien and its occupation of the realm between painting and sculpture, either a Larry Bell cube or a John McCracken plank might arguably stand as the quintessential minimalist object. But these objects also speak to the particularity of L.A. pop in their use of industrialized techniques specific to the region, their material relation to California subcultures or regional industry, and their incorporation of light and reflectivity. If the likes of Goode and Ruscha fit Hopps's conception of pop by virtue of their engagement with the "common object," then Bell, Bengston, Gerowitz, Kauffman, and McCracken might all be considered sculptors of common objects. They demonstrate that L.A. pop found inspiration not only in the signs and common objects of the human-made environment but also in its materials, colors, and surface effects.

An interest in the ethereal effects of light, reflectivity, and airiness was not confined to sculpture. Sam Francis's Los Angeles paintings also embody these qualities, inviting comparisons with many of his Finish Fetish contemporaries. Francis's move to Los Angeles in 1962 was followed by an aesthetic shift: the organic forms of his earlier paintings were relegated increasingly to the margins of the canvas, allowing for the aeration of its central regions. In *Mako* (fig. 3.44), titled for Francis's fourth wife, artist Mako Idemitsu, atmospheric expanses of white interiors are banded by unmodulated strips of vivid color. Francis often likened these paintings to massive white sails—the comparison at once implying flatness and objecthood—and described them using the rhetoric of action painting, proposing the canvas as an arena of encounter: "The space at the center of these paintings is reserved for you," he wrote about them. "These paintings approach you where you are."[48] Throughout his career, Francis traveled widely and maintained other studios and residences, but Santa Monica remained his home base until his death there in 1994. Although he was friendly with Ed Moses, Billy Al Bengston, Ken Price, Larry Bell, Ed Ruscha, David Hockney, and Edward Kienholz, the artist's eminence then, as now, was only intermittently, and often minimally, tethered to Los Angeles. In the fall of 1969, Francis had shows at both Felix Landau and Nicholas Wilder, his first solo exhibitions in Los Angeles since his arrival in the city. The last sentence of Henry J. Seldis's review hints at Francis's long-standing absence from the more visible gallery scene: "It is high time that Los Angeles has the chance to see these recent results of this enormously gifted painter's career as it is ripening into true mastery."[49]

Figure 3.44.
Sam Francis (American, 1923–1994). *Mako,* **1966.** Acrylic on
canvas, 381 × 274.3 cm (150 × 108 in.). Private collection. Image
© 2011 Sam Francis Foundation, California / Artists Rights Society
(ARS), New York.

FROM POP TO CONCEPTUALISM

With increasing national and international attention being paid to art and artists in Los Angeles, the community that cohered around La Cienega Boulevard developed a strong sense of group identity, though one that expressed a growing feeling of unease about the implications of this publicity and about art's role in society more broadly. This situation would be articulated with particular intensity in the mid-1960s, when the art community was mobilized in the name of political action in the first artist-led protests against the war in Vietnam (fig. 3.45). In 1965, the Artists' Protest Committee (APC) coordinated a "white-out" of the galleries on La Cienega, held a silent vigil outside the new Los Angeles County Museum of Art, and disrupted the Monday Night Art Walk by walking continuously up and down the street between crosswalks (see sidebar 17). In 1966, when the committee organized the construction of the Artists' Tower of Protest, or Peace Tower, in the heart of the arts district, a number of well-known L.A. artists, including Larry Bell, Craig Kauffman, Melvin Edwards, Lloyd Hamrol, and Judy Gerowitz (Chicago), immediately became involved. Others, including Kienholz, Bengston, Ruscha, and Robert Irwin, declined to participate.

While the APC demanded direct action on the part of its members, several other artists engaged in more self-referential activities that addressed the personal and political implications of the city's newly fortified institutional and market structures. Performative parody offered many artists a means to simultaneously engage in and send up the structures that had so successfully marketed Los Angeles art. Joe Goode's 1969 calendar of his fellow artists and their cars (see pp. 312–13) appropriated the clichés that attended the promotion of L.A. pop and the rise of the art scene. At a "Signature Rally" organized by the Art Museum Council of LACMA to launch the calendar, guests were invited to meet the artists—including John Altoon, Bell, Bengston, Graham, McCracken, and Ruscha—and view their cars, while "a 'pit crew' of lovely ladies of the museum council" served cocktails and car-shaped cookies.[50] The event, oscillating between parody and complicity, recalled Philip Leider's concerns in *Frontier* that the museum's opening four years earlier had had "more to do with the culture-boom than with culture."[51]

Edward Kienholz, who had long been uneasy about the commercialization of Ferus under Irving Blum, sold "concept tableaux" for works that, if purchased, he himself would execute. An exhibition at the Eugenia Butler Gallery in 1969 further questioned the notion of artistic value by displaying a set of watercolor paintings identifying things that Kienholz wanted (including a color television and for Blossom Tuchman, Maurice Tuchman's wife, to stop smoking); if a patron made good on the artist's wish, he or she would receive the painting. Other works were stamped with a cash value ranging from $1 to $10,000, a percentage of which Kienholz would receive if the work was subsequently resold. While seen as a spoof, the show also underscored some of the questions circulating among artists and critics on both coasts in the late 1960s, questions about different models of buying and selling art, about how value accrues to art objects, and about the contemporary fate of modernist values of singularity and originality.

The ramifications of the market and the value it placed upon the artist's name were also explored in a Ferus Gallery exhibition by Richard Pettibone in 1965 (fig. 3.46). As the exhibition poster explained, Pettibone had "meticulously executed selections from Asher, Factor, Hopper, Janss, Rowan and Weisman collections," producing diminutive, fastidious replicas of works by Duchamp, Warhol, Lichtenstein, and Ruscha. The ironies of Pettibone's work were manifold: he was making reproductions of works that themselves were, or invoked, other reproductions, and his minute paintings challenged notions of value and salability in a gallery that not only had shown many of the artists Pettibone copied but was itself a symbol of financial viability.

Billy Al Bengston, seemingly the epitome of the Ferus phenomenon, also challenged the dominance of the commercial gallery system. In 1969, he established what he called Artist Studio (fig. 3.47) in his quarters on Mildred Avenue in Venice, mounting short-run exhibitions of work by friends, including McCracken, Bell, Price, Don Bachardy, Berlant, Moses, Goode,

Figure 3.45.
Announcement for antiwar peace walk, **1967.** 29.1 × 17.9 cm (11½ × 7 in.). Los Angeles, Getty Research Institute, 2005.M.11.

WANTED

$2,000 REWARD

For information leading to the arrest of Richard Petti-bone alias Bull alias Pickens etcetry, etcetry. Reported having meticulously executed selections from Asher, Factor, Hopper, Janss, Rowan and Weisman collections for exhibition at the Ferus Gallery on Tuesday, December 14th, 1965. Known also under name Lee Enrose.

ALL NEW WORK
by
**MOSES, BENGSTON
BACHARDY, BELL
GOODE, BERLANT
DAVIS, RUSCHA
PRICE, ALEXANDER**

A
SPECIAL EXHIBITION
ONE WEEK ONLY
LABOR DAY ➤ SEPT. 13th
11 AM ➤ 5 PM

Artist Studio
Call 392-1287
Cable: A STUD

Figure 3.46.
Poster for Richard Pettibone's exhibition, Ferus Gallery, Los Angeles, 1965. 34.3 × 25.3 cm (13½ × 10 in.). Los Angeles, Getty Research Institute, 2009.M.37.

Figures 3.47a, 3.47b.
Billy Al Bengston (American, b. 1934). Announcement for group exhibition at Artist Studio, Venice, California (front and back), 1970. 10.3 × 12.6 cm (4⅛ × 5 in.). © Billy Al Bengston. Courtesy the artist.

Alexander, and Ruscha. The work was sold directly, with artists keeping all profits, entirely sidestepping the gallery system.

These kinds of projects reflected a heightened self-consciousness about the rapid development in the 1960s of Los Angeles's gallery scene, which reached its apex in the middle of the decade. Of course, the hubs of production and display that centered on the L.A. neighborhood of Venice and on La Cienega Boulevard were then (as in the 1950s) countered by other focal points, such as the Pasadena workshop that Judy Gerowitz shared with Lloyd Hamrol; the Tamarind Lithography Workshop; the Watts Towers Arts Center; and the corridors of Golden State Mutual Life Insurance Company, which housed the company's African American art collection (see sidebar 18). Nevertheless, the fortunes of the Ferus Gallery and its cohorts were seen as representative of the larger L.A. art world, and that world shifted considerably in the latter half of the decade. In 1966, having been proved correct in his assumption that he "wasn't going to make any money out of this," Rolf Nelson was forced to close his gallery;[52] Virginia Dwan closed her Los Angeles branch the following year; and Walter Hopps, finally succumbing to exhaustion and the tensions surrounding the ambitious new building plans, left the Pasadena Art Museum. The Ferus Gallery also closed in 1966, nearly a decade after it opened. In 1968, LACMA's exhibition *Late Fifties at the Ferus* emphasized that the once-vanguard enterprise was already history. Blum continued his dealings in Los Angeles, at the Irving Blum Gallery, until 1972, when he, too, returned to New York. In the summer of 1967, *Artforum* left Los Angeles and the scene its critics had helped create, also relocating to New York.

The disappearance of so many familiar names from the La Cienega scene opened up room for new gallery owners—including Molly Barnes, Eugenia Butler, and Riko Mizuno (see sidebar 19)—and also for new approaches to art making. Though Kienholz, Pettibone, and Bengston would have only tangential relationships to what, by the late 1960s, would be known as conceptual art, their projects of that time partake of common features: an emphasis on a work's generative idea, which was often relayed through text and sometimes to the exclusion of image or material form; a questioning of modernist ideals of authorship, craft, and originality; and an often utopian aspiration to bypass established structures for exhibiting, distributing, and selling art. Conceptual art's national and international variants had a distinct presence in the Los Angeles of the late 1960s, with several exhibitions showcasing conceptual artists from New York, such as the Dwan Gallery's exhibition of Sol LeWitt's work, in April 1967, and Ace Gallery's *Wall Show* and Eugenia Butler Gallery's *Conception–Perception,* both in the summer of 1969. Butler, who had operated Gallery 669 on La Cienega in partnership with Riko Mizuno, established her own gallery in 1968, where for three years she showed work by various conceptual artists, including Joseph Kosuth and Robert Barry.

John Baldessari and Ed Ruscha would emerge as the two lions of West Coast conceptualism. That both artists were concurrently linked to pop—often considered anathema to conceptual art—indicates an important inflection of L.A. conceptual art, which remained tied to objects, even paintings, as it simultaneously questioned their status. "The present art scene continues to allow for object art as well as conceptual art, and often a combination of the two—as frequently the abstract concept takes concrete form," wrote Peter Selz in a 1969 review.[53] Baldessari worked in National City, near San Diego, studying intermittently at San Diego State College, the University of California at Berkeley, UCLA, Otis Art Institute, and Chouinard, before moving to Santa Monica in 1970. His first work was in painting, but by late 1965 he was, he said, "weary of doing relational painting and began wondering if straight information would serve."[54] In *Cremation Project* (1970), Baldessari burned all of the paintings he had made between May 1953 and March 1966 still in his possession. He published an affidavit in the *San Diego Union* announcing the project, and exhibited the ashes, marked with a memorial plaque, in the exhibition *Software: Information Technology: Its New Meaning for Art,* curated by art and technology theorist Jack Burnham at the Jewish Museum in New York in 1970.

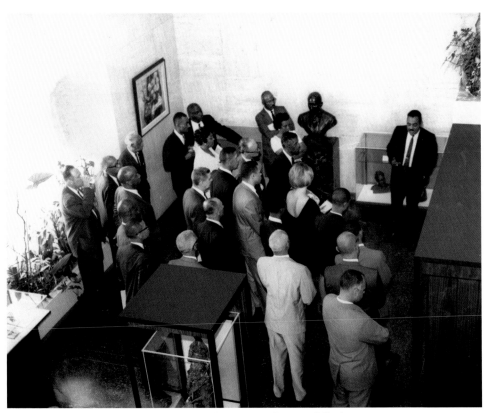

William E. Pajaud addresses visitors at the launch of the Golden State Mutual Negro Art Collection, 1965. Photographer unknown. Los Angeles, UCLA Charles E. Young Research Library Department of Special Collections. Golden State Mutual Life Insurance Co. records, 1886–1985 (Collection 1434).

ON 22 JULY 1965, on the eve of Golden State Mutual Life Insurance Company's fortieth anniversary, its directors gathered with members of the community to dedicate the company's newly founded "Negro Art Collection." It numbered fewer than twenty works, including portraits by Richmond Barthé and Hughie Lee-Smith of Golden State Mutual's three African American founders, and two murals painted in 1949 by Hale Woodruff and Charles Alston with scenes depicting the achievements of African Americans in California's history.

Situated on the corner of Western Avenue and Adams Boulevard, the firm occupied an impressive building designed by the renowned black architect Paul R. Williams, but it had sprung from humble origins in a single room. Since its founding, Golden State Mutual had played an important role, selling life insurance to African Americans when most other insurers would not. In doing so, it had become not only a leading financial institution but also a source of admiration and pride in the black community. In its collecting mandate and its patronage of African American artists, Golden State Mutual would offer a similar lifeline to artists who were not embraced by the Los Angeles gallery system.

The idea for the collection had been proposed by William E. Pajaud, a watercolorist and illustrator who ran the company's public relations and advertising department. Pajaud was appointed curator of the collection and given $5,000 per year for acquisitions; though his budget was meager, Pajaud was able to acquire works at reduced prices from African American artists impressed by the company's socially conscious project. Initially, acquisitions were limited to two or three per year, but the pace steadily increased and, over the next twenty-two years, Pajaud amassed well over two hundred pieces. These included works by Dan Concholar, Alonzo Davis, David Hammons, John Outterbridge, Betye Saar, Charles White, and Pajaud himself. They were hung in the building's corridors, meeting rooms, and offices and were displayed in the foyer in specially designed teakwood cases.

The collection gave the predominantly African American community in L.A.'s West Adams neighborhood a rare opportunity to view works by African American artists at a time when, as Pajaud explained, "there was no place anybody could go and see black art."[1] Regular tours for local schoolchildren were conducted by uniformed guides chosen from among the company's employees—though the children were often as impressed, Pajaud recalls, by the building's elevator, or its massive computer, as by the art.[2]

The Golden State Mutual murals were intended to reclaim the role of African Americans in the nation's history; the art collection was intended to showcase African American cultural production that would otherwise remain invisible. In 1965, in the context of a community struggling to assert its voice, this objective was expressed through the rhetoric of collective experience: "The elements of vigor, social protest and group consciousness inherent in the paintings and sculptures," declared the company's executive vice president Edgar J. Johnson, "lead to an understanding of the life and thought of the American Negro people."[3] The Golden State Mutual African American Art Collection—which was sold at auction and dispersed in 2007—remains significant as the first attempt on the West Coast to collect and display art by African American artists.

Notes
1. William Pajaud, interview by Karen Anne Mason, 1993, transcript, "African-American Artists of Los Angeles: William Pajaud," 218, UCLA Library, Center for Oral History Research.

2. Pajaud, interview by Mason, 203.

3. "Negro Art Collection Dedicated," *Inside Golden State Mutual*, fall quarter (1965): 4; Golden State Mutual Life Insurance Co. records, Department of Special Collections, Charles E. Young Research Library, University of California, Los Angeles (Collection 1434), box 36, folder 9.

WRONG

Between 1966 and 1968, Baldessari executed a number of works based on photographs of commonplace suburban sites in Southern California. The images, which were printed directly on canvas using a photoemulsion process, were each identified by a caption-like label, including "ECON-O-WASH, 14TH AND HIGHLAND, NATIONAL CITY CALIF.," and "LOOKING EAST ON 4TH AND C, CHULA VISTA, CALIF." In their depiction of unremarkable sites and their use of the techniques of mass reproduction, these works are redolent of Baldessari's early relation to L.A. pop; their text-image pairings and blunt descriptors partake of the conceptual art preference for straight data even as the banality of their content seems to undermine the seriousness with which East Coast conceptual artists worked with information. Baldessari treads a similar line in *Wrong* (fig. 3.48), using an image—of himself, standing in front of a palm tree and a house—whose very artlessness (the tree appears to be sprouting from his head) both instantiates the conceptualist valorization of the "deskilled" photograph and, in its exaggerated amateurishness, sends it up. Baldessari's canvases of the late 1960s were stretched and primed by someone else, their words lettered by a sign painter he had hired. This removal of the artist's hand—another important conceptual art characteristic—is even starker in word-only paintings such as *Quality Material* (fig. 3.49). Part of a series of paintings featuring text from art history books and commercial sources, these works unmask the pieties and insularity of art criticism as well as the aridity of didactic texts, presaging the artist's career-long attunement to the different contexts in which images are circulated and information about them is learned.

Baldessari's interest in language as "straight information" distanced him from Ruscha, whose depictions of words on canvas tended to show words as physical objects possessed

Figure 3.48.
John Baldessari (American, b. 1931). *Wrong*, 1966–68. Photoemulsion with acrylic on canvas, 149.9 × 114.3 cm (59 × 45 in.). Los Angeles, Los Angeles County Museum of Art, Contemporary Art Council. Courtesy the artist. Digital Image © 2009 Museum Associates / LACMA / Art Resource, NY.

Figure 3.49.
John Baldessari (American, b. 1931). *Quality Material*, 1966–68. Acrylic on canvas, 172.7 × 143.5 cm (68 × 56½ in.). New York, collection of Danielle and David Ganek. Courtesy the artist.

QUALITY MATERIAL - - -

CAREFUL INSPECTION - -

GOOD WORKMANSHIP.

ALL COMBINED IN AN EFFORT TO
GIVE YOU A PERFECT PAINTING.

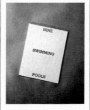

Figure 3.50.
Ed Ruscha (American, b. 1937). Poster for *Books by Edward Ruscha*, ca. 1968. 44.5 × 57.2 cm (17½ × 22½ in.). Los Angeles, Getty Research Institute, 2009.M.30. Art © Ed Ruscha.

Figure 3.51.
Letter from the Library of Congress to Ed Ruscha, 2 October 1963. Courtesy Ed Ruscha.

THE LIBRARY OF CONGRESS

WASHINGTON 25, D. C.

PROCESSING DEPARTMENT
EXCHANGE AND GIFT DIVISION

Refer to: AG
October 2, 1963

Dear Mr. Ruscha:

I am, herewith, returning this copy of Twentysix Gasoline Stations, which the Library of Congress does not wish to add to its collections.

We are, nevertheless, deeply grateful for your thoughtful consideration of our interests.

Sincerely yours,

Jennings Wood, Chief
Exchange and Gift Division

Enclosure

Mr. Edward Ruscha
2215 Echo Park Avenue
Los Angeles 26, California

of a concrete materiality. However, in their work, the two artists share other defining features of California conceptualism, principally an attraction to narrative and humor. Ruscha's importance to conceptual art stems from the sixteen photo-based artist's books he produced between 1963 and 1978—slender volumes comprising spare photographs and minimal text that were offset printed and published in editions of a few hundred to a few thousand (fig. 3.50).[55] Los Angeles figures prominently, but rather than the brassy Hollywood sheen evoked in Ruscha's paintings, the books inventory less-lovely aspects of the city's built and natural environments, from architecturally bland dingbat apartment buildings in *Some Los Angeles Apartments* (1965) to empty,

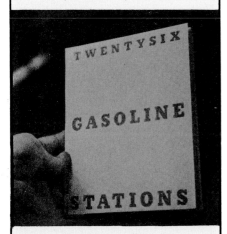

oil-stained lots in *Thirtyfour Parking Lots in Los Angeles* (1967) to vacant, unappealing land parcels in outlying areas in *Real Estate Opportunities* (1970). In their substitution of cheap printed matter for singular artwork, their foundation in task-oriented premises, and their use of affectless and instrumental snapshots, Ruscha's books exemplify many features of conceptualism as it was then theorized and has since been historicized. His submission of *Twentysix Gasoline Stations* to the Library of Congress and incorporation of the book's subsequent rejection from that institution into an advertisement in *Artforum* (figs. 3.51, 3.52) approaches the realm of institutional critique.

Yet Ruscha's books also complicate the oppositions on which conceptual criteria depend, both because they exist as painstakingly crafted objects (rather than merely as contextual practice) and because they demand careful reading. *Every Building on the Sunset Strip* (1966), for example, must be unfolded and rotated to be seen in its 25-foot-long entirety (fig. 3.53).

Figure 3.52.
"Rejected Oct. 2, 1963 by the Library of Congress Washington 25, D.C." Advertisement by Ed Ruscha in *Artforum* 2, no. 9 (1964): 55. © Ed Ruscha.

Figure 3.53.
Ed Ruscha holding his book *Every Building on the Sunset Strip* (1966), 1967. Photo by Jerry McMillan (American, b. 1936). Courtesy Jerry McMillan and Craig Krull Gallery, Santa Monica. Art © Ed Ruscha.

IN ACCOUNTS OF the Los Angeles art scene, the late sixties are typically portrayed as a period of decline or retrenchment—a time when several galleries that had helped to establish the city's vibrant reputation closed their doors.[1] Less noted, but no less notable, was the appearance of a new wave of gallerists, many of them women. Molly Barnes (who gave John Baldessari his first solo exhibition in 1968) and Eugenia Butler (whose gallery promoted conceptual artists such as Baldessari and Allen Ruppersberg) are two prominent examples. Perhaps the dealer with the strongest impact, however, was Riko Mizuno, whose gallery operated from 1967 into the 1980s.

Mizuno's accomplishments as a gallerist, as well as the longevity of her career, are all the more impressive if one takes into account her circumstances and the prevailing attitudes toward gender and ethnicity. The art world, like the rest of postwar America, was male dominated, and—though a few artists, such as Isamu Noguchi and Matsumi Kanemitsu, had attained some visibility—there were virtually no dealers of Asian descent working in contemporary art. In addition, Mizuno was not only an immigrant who had to build her own network of artists and clients from scratch but also a divorced working mother.

In 1967, Mizuno took over a storefront previously occupied by Rolf Nelson and renamed it Gallery 669, after its address on La Cienega Boulevard. A hint of her acumen and character can be gleaned from her somewhat unorthodox inaugural exhibition, which consisted of works

on paper by the novelist and painter Henry Miller. The belated stateside publication of Miller's *Tropic of Cancer* in 1961, and the ensuing obscenity trial, renewed Miller's renown in the United States.[2] The opening night consequently drew to the gallery an impressive mix of cultural figures, including playwright Arthur Miller, fellow dealer Felix Landau, and artists such as Sam Francis and Lee Mullican.

Mizuno organized a well-received exhibition later that year by the Fluxus artist Ay-O. In 1968, Mizuno entered into a partnership with Eugenia Butler. During this time, the gallery hosted a show by Joseph Kosuth only a few doors down from Baldessari's exhibition with Molly Barnes— an early meeting of New York and Los Angeles conceptualism.[3] When her collaboration with Butler ended, Mizuno reopened the space under her own name and began working with established artists from the region, many of whom had shown at the Ferus Gallery, including Billy Al Bengston, Robert Irwin, Ed Moses, and Ken Price. The pieces they produced for her gallery, though, were frequently far more experimental than their previous work had been.[4]

What set the Riko Mizuno Gallery apart was not just the overall caliber of its exhibitions but also the extensive support it offered to up-and-coming local artists.[5] Thus, in 1972, the gallery served as the site for *Deadman*, one of Chris Burden's first gallery-based performances, within a week of hosting an early performance and exhibition of films by Jack Goldstein—all while four of its artists (Chuck Arnoldi, Jud Fine, Ed Moses, and Tom Wudl) were featured in the historic fifth installation of *Documenta* (1972), curated by Harald Szeemann. Indeed, the names of artists who showed with Mizuno read like a list of notables of the Los Angeles art world: Vija Celmins, Frank Gehry, Jim Isermann, Mike Kelley, Alexis Smith, and Doug Wheeler, in addition to those mentioned above. It was in this way that Mizuno's reputation grew far beyond the small storefront in which she started.

Notes

1. See, for instance, Peter Plagens, *Sunshine Muse: Contemporary Art on the West Coast* (New York: Praeger, 1974).

2. Miller's *Tropic of Cancer* (1934), which originally had been published in Paris and smuggled into the country, was declared a work of literature and not obscene by the U.S. Supreme Court in *Grove Press v. Gerstein* (1964). The case is frequently credited with paving the way for other literary works of the sexual revolution.

3. See Jane Livingston's perspicacious review of both exhibitions in *Artforum* 7, no. 4 (1971): 66.

4. For his 1970 show, for instance, Moses created an environment by removing the gallery's ceiling and letting sunlight stream in. See fig. 4.18, this volume.

5. On this point, Elizabeth Baker, writing in 1971, suggests that "Los Angeles dealers are not very engaged with Los Angeles art, either established or new; yet even the youngest of the New York avant-garde is shipped in." See Elizabeth Baker, "Los Angeles, 1971," *Artnews* 70, no. 5 (1971): 28.

Riko Mizuno at her gallery during the installation of Peter Plagens's exhibition, Los Angeles, 1971.
Photo by Peter Plagens (American, b. 1941). Los Angeles, Getty Research Institute, 2010.M.84.

The books parody many of the tenets of conceptualism: arbitrarily or vaguely numbered titles ("twentysix" or "some") seem to mock the conceptual predilection for seriality, while humor and occasionally narrative undercut the serious objectivity claimed by many analytic conceptual artists. Ruscha even seems to poke fun at certain conceptual strategies in *Business Cards* (fig. 3.54), a book made with Billy Al Bengston that documents, in a photo-essay, the artists making business cards for each other, which they exchange at a dinner at a Beverly Hills restaurant. The repeated rubber-stamped dates and photographs of photographs seem to mock conceptual artists' rejection of craft and visual pleasure and their tendency to include bureaucratic documentation, bad photocopies, and poor photography in their work.

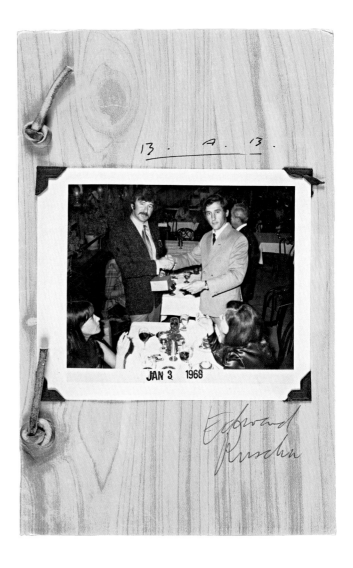

Figure 3.54.
Billy Al Bengston (American, b. 1934) and Ed Ruscha (American, b. 1937). Cover of *Business Cards*, 1968. Artists' book, 22.2 × 14.3 × .95 cm (8¾ × 5⅝ × ⅜ in.). Los Angeles, Getty Research Institute, 89-B22756. © Billy Al Bengston and Ed Ruscha. Photo by Larry Bell.

In suggesting that the artists were now in business for themselves, *Business Cards* anticipated the discourses of institutional critique. The same can be said of Ruscha's painting *The Los Angeles County Museum on Fire* (fig. 3.55). Eleven feet wide, it depicts the museum in precise detail against a horizonless, indeterminate landscape that is serene and airless save for the flames and smoke erupting from the museum's Ahmanson Building. Ruscha acknowledged the work's provocative power by presenting it as if it were a conceptual performance: the invitation to the opening at the Irving Blum Gallery, where it was shown behind a velvet-covered stanchion, came in the form of a Western Union telegram that concluded, "LOS ANGELES FIRE MARSHAL SAYS HE WILL ATTEND STOP SEE THE MOST CONTROVERSIAL

PAINTING TO BE SHOWN IN LOS ANGELES IN OUR TIME STOP." Although the artist admits that his subject is scandalous, he tends to depoliticize the painting, calls the fire an afterstatement, and prefers to speak about how the piece "contained another generality (about my work): to make a big picture with something off in the corner going on."[56] With its multiple, incompatible vanishing points; conjunction of atmospheric, aerial, and linear perspective; and range of painterly styles from the gently gradated, smoggy backdrop to the meticulously rendered lines of the building, the formal complexity of *The Los Angeles County Museum on Fire* plays with the definition of painting. But it is hard to ignore the work's larger social and historical resonances—to the Watts rebellion of 1965 specifically, but also to the museum's uneasy relationship to local contemporary artists and to the idea of Los Angeles as a major art center. More generally, the painting alluded to the current conditions for making and exhibiting art in Los Angeles as the decade came to a close. Was painting going up in smoke along with the museum meant to safeguard and promote it—and did anyone care? The critical labels that had seemed so important to the marketing of Los Angeles's art scene at the start of the 1960s had increasingly started to provide, by the end of the decade, the fodder for conceptual practices that interrogated the structures not only of the art world but of art itself; the ebullient confidence of an art world in its adolescence had given way to the complexity of maturity.

Figure 3.55.
Ed Ruscha (American, b. 1937). *The Los Angeles County Museum on Fire*, **1965–68.** Oil on canvas, 135.9 × 339.1 cm (53½ × 133½ in.). Washington, D.C., Smithsonian Institution, Hirshhorn Museum and Sculpture Garden, gift of Joseph H. Hirshhorn, 1972. Art © Ed Ruscha. Photo by Lee Stalsworth.

AN ILLUSTRATION BY TOM OF FINLAND (né Touko Laaksonen) on the cover of the May 1964 issue of *Physique Pictorial* portrays a beefy man in a leather biker jacket and boots disciplining a shirtless, equally strapping fellow. A motorcycle wheel and fender peek into view from the bottom right-hand corner of the image. The words "Physique Pictorial" are inscribed on an unbuckled belt floating above the two men. The implied narrative (which becomes more explicit inside the magazine) is that the shirtless fellow has accidentally damaged the leather man's motorcycle and so must now attend to the needs of both the dented bike and its surly owner.

Copies of *Physique Pictorial* from the early 1960s are available for purchase on eBay and from more specialized vendors, such as gay bookstores and vintage magazine shops. This particular copy, however, is not for sale. It resides in the special collections of the Getty Research Institute as part of the Charles Brittin papers. Brittin was a photographer who documented the Los Angeles art and poetry scenes in the 1950s and 1960s and later focused his camera on the civil rights and antiwar movements. His work betrays none of the extravagant homoeroticism of Tom of Finland's drawing or the camp appeal of early 1960s physique magazines. The unexpected appearance of *Physique Pictorial* in the Brittin archive suggests the presence of overlapping social, creative, and photographic scenes within Los Angeles circa 1964. And it speaks to the ways in which visual materials circulate beyond their intended audiences to reach viewers with different cultural affiliations and identities.

This essay considers Los Angeles as both the site of production for *Physique Pictorial* and as a visual lure or fantasy image for the magazine's far-flung readership. It focuses first on the magazine's founder and chief photographer, Bob Mizer, then on its most famous reader, artist David Hockney.

BOB MIZER

In 1945, a young man named Bob Mizer founded the Athletic Model Guild (AMG), a physique photography studio operating out of the large, somewhat ramshackle house he shared with his mother in the Pico-Union district of Los Angeles.[1] Mizer found a ready supply of male models among aspiring Hollywood actors and Venice Beach bodybuilders. In 1947, he was convicted of distributing obscene materials (specifically, photographs of those models) through the mail. Mizer served six months on a prison farm before his conviction was overturned on appeal.

Upon his release, Mizer resumed his photographic enterprise in an effort to both support himself financially and defy what he viewed as censorship. In 1951, after several publications refused to run ads for AMG, he launched *Physique Pictorial,* a magazine populated by pictures of oiled, muscular, and nearly naked young men, sometimes in the guise of prison inmates, Roman gladiators, or sailor buddies. While illustrations by Tom of Finland and other artists appeared regularly in *Physique Pictorial,* its pages were primarily devoted to photographs shot in and around the Mizer home: in the backyard swimming pool surrounded by faux classical statuary, on a rooftop rock garden, in a tiled shower stall, in the kitchen, in the den, or in other rooms. In many instances, Mizer conjured abstract, iridescent backdrops by projecting light through goblets, serving bowls, or other pieces of his mother's Fostoria glass collection. In addition to lending her glassware, Mrs. Mizer made some of the posing pouches (G-strings for men) worn by the *Physique* models.[2] Her son's magazine offered a disarming combination of desire and domesticity, of virtually naked men posed against homespun backdrops and modest, midcentury decor.

Compared with rival publications, *Physique Pictorial* was the most direct in acknowledging homosexuality and the most outspoken in defending freedom of expression. The May 1964 issue, for example, featured an item titled "Open Letter to Those Who Oppose Physical Culture Books." In response to characterizations of *Physique Pictorial* as deviant or dangerous, Mizer wrote:

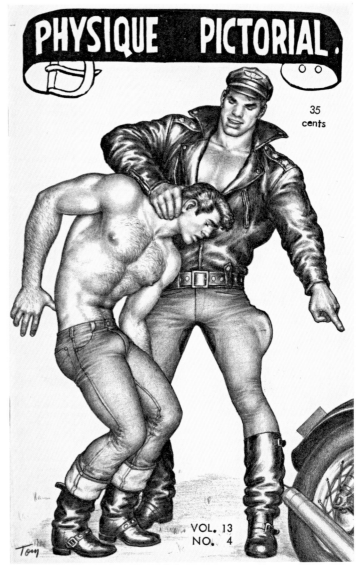

Cover of *Physique Pictorial* 13, no. 4 (1964), featuring an illustration by Tom of Finland (Finnish, 1920–1991). Los Angeles, Getty Research Institute, 2005.M.11. Printed with permission by Athletic Model Guild LLC.

We have read and listened to many tirades opposing various publications, including physique books, and have yet to discover a truly valid reason [for such attacks].... Seeing a briefly clad, handsome boy with a twinkle in his eye is no more likely to cause a happily married man to desert his wife and develop a homosexual liaison, than the infinitely greater barrage of bosoms and magnificent displays of female pulchritude in movies, TV, and magazines have been effective in making basically "queer" boys start chasing girls. Let's all show a tolerance for ideas we can't understand. Live and Let Live—and we'll get along a little better![3]

Mizer defends visual pleasure while insisting that images cannot "make" their viewers turn either homo- or heterosexual. He calls for mutual tolerance in the face of difference. Published five years before the Stonewall riots in Greenwich Village that marked the birth of the gay liberation movement, Mizer's letter was at once lighthearted and politically audacious. It countered the heterosexual logic of American popular culture with the queer "twinkle" of physique photography.

DAVID HOCKNEY

In the late 1950s, David Hockney enrolled as a postgraduate painting student at the Royal College of Art in London. While in school, he began to acquire copies of *Physique Pictorial*, which was just becoming available in the United Kingdom. During his last semester, Hockney's study of art and his interest in physique photography intersected:

> At the Royal College of Art, in those days, there was a stipulation that...in your diploma show you had to have at least three paintings done from life. I had a few quarrels with them [the faculty] over it because I said the models weren't attractive enough; and they said it shouldn't make any difference, i.e. it's only a sphere, a cylinder, and a cone. And I said, well, I think it does make a difference, you can't get away from it....So I got a copy of one of those American physique magazines and copied the cover; and just to show them that even if the painting isn't anatomically correct I could do an anatomically correct thing, I stuck on one of my early drawings of the skeleton and I called it in a cheeky moment *Life Painting for a Diploma*. It's mocking their idea of being objective about a nude in front of you when really your feelings must be affected.[4]

In responding to the academic requirement for life painting, Hockney insists on the importance of the artist's libidinal investment in the studio model he depicts. Far from the dispassionate study of the human body as an ensemble of volumetric forms ("it's only a sphere, a cylinder, and a cone"), Hockney proposes a necessary link between artistic achievement and sexual attraction.

In the next part of this recollection, Hockney proceeds to complain, rather nastily, about the "old fat women" that the Royal College of Art was allegedly in the habit of hiring as life models at the time and the need for what he calls "some better models." Better, for Hockney, meant young, male, and muscular. According to the artist, he successfully lobbied the Royal College to hire one such model, a man named Mo McDermott, for its life classes—only to discover that "nobody else at the college wanted to paint him; they didn't like painting male models, so I had him to myself."[5]

Hockney may have had McDermott all to himself, but in *Life Painting for a Diploma* he showcased not McDermott's body but that of an American

David Hockney (British, b. 1937). *Domestic Scene, Los Angeles,* 1963. Oil on canvas, 152.4 × 152.4 cm (60 × 60 in.). Private collection. © David Hockney.

physique model. At the top of the painting, he included the word "physique," or rather the bottom two-thirds of that word, reminding us that the body on display had already appeared in a commercial magazine prior to its painted transcription by the artist. Further mocking the directive to study the live model, Hockney appended to his work a sketch of a skeleton in profile—a view of the human body after death rather than "from life."

In 1963, while still living in London, Hockney painted a composition titled *Domestic Scene, Los Angeles,* which portrays a man in a skimpy apron and tube socks washing the back of his male companion. The space in which this "domestic scene" unfolds is particularly difficult to parse. The showering man, for example, stands in neither a bathtub nor a shower stall but a bucket or planting pot, while, on the right edge of the composition, a red telephone floats free of spatial context altogether. As viewers of the painting, we too are suspended somewhere between reality and reverie.

CRUEL STEPBROTHERS

Domestic Scene, Los Angeles can be linked to a specific visual source in *Physique Pictorial*. The July 1962 issue features a photo spread of stills from a 13-minute AMG film titled *Cruel Stepbrothers*. Shot in Mizer's home, the film tells the "Cinder-fella" story of Bob Page, a young man "who has to do all the hardwork [sic] of the house while they [his older stepbrothers] loaf about."[6] In the final still in the *Physique Pictorial* spread, Page is shown in a patterned waist apron washing the back of one stepbrother while the other watches.

Like nearly every other photographic image in the magazine, the *Cruel Stepbrothers* stills were available for purchase as individual (enlarged) prints; hence the order number that appears atop each still. The film itself could also be purchased in either 8 mm or 16 mm format. *Physique Pictorial* thus served double duty as both a freestanding magazine and a mail-order catalog of AMG photographs and films. Whether or not the models in the magazine may also have been available for a price, Mizer provided readers with a fantasy of what it might look like to see (or have) such strapping young men at home.

The still from *Cruel Stepbrothers* explains some of the more curious features of *Domestic Scene, Los Angeles* (a man standing in a bucket, another in apron and tube socks). It also explains why the domestic interior in Hockney's painting seems so cursory and indeterminate. The domestic space on view in *Physique Pictorial* was at once real (it was the home shared by Mizer and his mother) and a stage set for AMG films and photographs. Household items and interiors were repurposed as props and scenery for a series of loosely plotted, all-male vignettes ranging from *Cruel Stepbrothers* to *Belligerent Cowboy* and *When a Plumber Needs a Friend*. The spatial ambiguity and passages of near abstraction in *Domestic Scene, Los Angeles* amplify the pleasurable instability of the domestic scenes in *Physique Pictorial* while dispensing with their flimsy narrative pretexts. In Hockney's painting, as in Mizer's magazine, a chair, phone, or potted plant served less as a fixed element in a room than as a movable prop in the service of fantasy.

In a British film documentary made in 1983, Hockney describes *Physique Pictorial* while photo spreads from the magazine flash upon the screen:

> These are not, uh, very popular magazines; they're only cheap little, in a way, just cheap little gay magazines, that's what they were. But the suggestions, the visual suggestions, from it interested me enough to take me there [Los Angeles]. And all in my mind, I suppose, [I] built up a picture, I even painted a picture which I called *Domestic Scene Los Angeles*...and it was made just before I went to Los Angeles and it was in a sense things like that that attracted me there.[7]

Even as Hockney dismisses *Physique Pictorial* as trashy and insignificant, he also credits its "visual suggestions" with inspiring him to

Bob Mizer. *Cruel Stepbrothers.* From *Physique Pictorial* 12, no. 1 (1962): 23. Printed with permission of Athletic Model Guild LLC.

move halfway around the world. However embarrassing the artist may have found these "cheap little gay magazines," they provided a fantasy of Southern California powerful enough to draw him to the place. In Hockney's mind, according to one of the artist's friends at the time, "Los Angeles meant boys."[8]

Shortly after arriving in California in the winter of 1963–64, Hockney sought out the real location of the Athletic Model Guild: "I went to visit the place where *Physique Pictorial* was published in a very seedy area of downtown Los Angeles. It's run by a wonderful complete madman and he has this tacky swimming pool surrounded by Hollywood Greek plaster statues. It was marvelous!"[9] At once drawn to and contemptuous of the "tackiness" of Mizer's home and neighborhood, Hockney was equally ambivalent about the physique models on the premises: "They're all a bit rough looking, but the bodies are quite good. The faces are terrible, not pretty boys, really."[10]

Neither the tawdriness of the setting nor the "rough" look of the boys dissuaded Hockney from purchasing a cache of photographs from Mizer or from continuing to find inspiration in the pages of *Physique Pictorial*. In *Man in Shower in Beverly Hills* (see fig. 3.24), Hockney borrows the male physique (and the pattern of shower tiles) from the black-and-white photographs in Mizer's magazine and deposits them within a space of luxuriant color and modernist kitchen chairs, of pale-rose area rugs and phallic houseplants. Hockney extracts the male nude from the commercial context and "tacky" production values of *Physique Pictorial*, from individuating names, facial features, and order numbers. He transplants the eroticized body (but not the "terrible" face) of the physique model from the downscale Pico-Union district to upscale Beverly Hills. In effect, Hockney cleans up Mizer's "rough trade" model and moves him to L.A.'s much tonier Westside.

Hockney was drawn to America—and, more specifically, to Los Angeles—not by its art scene or museums but by the photographs he saw in a homoerotic magazine. *Physique Pictorial* was not simply waiting, however, for Hockney (or any other fine artist) to elevate it into the realm of aesthetic value. Mizer's magazine had its own visual logic and rhetorical strategies, its own audience and commercial ambitions, not to mention its own poetics of Los Angeles.

Beyond the professional output of recognized artists lies a vast inventory of expressive forms and creative projects that have yet to be taken fully into account. Without forsaking the achievement of leading lights such as David Hockney, let us expand our sense of what counts as art history. There are, after all, many more "cheap little magazines" to retrieve and reread.

Notes

1. For biographical information on Bob Mizer and his mother, Delia, see Dian Hanson, *Bob's World: The Life and Boys of AMG's Bob Mizer* (Cologne: Taschen, 2009). See also Bob Mizer and Winston Leyland, *Physique: A Pictorial History of the Athletic Model Guild* (San Francisco: Gay Sunshine, 1982).

2. [Bob Mizer], "Open Letter to Those Who Oppose Physical Culture Books," *Physique Pictorial* 13, no. 4 (1964): 2.

3. [Mizer], "Open Letter," 2.

4. David Hockney, *David Hockney* (New York: Harry Abrams, 1976), 88.

5. Hockney, *David Hockney*, 88.

6. "Cruel Stepbrothers," *Physique Pictorial* 12, no. 1 (1962): 22.

7. David Hockney interview, in Don Featherstone, dir., *David Hockney: Portrait of an Artist* (London: London Weekend Television, 1983).

8. R. B. Kitaj, "Portrait," in Maurice Tuchman and Stephanie Barron, eds., *David Hockney: A Retrospective*, exh. cat. (Los Angeles: LACMA, 1988), 3.

9. Hockney, *David Hockney*, 98–99.

10. Hockney, *David Hockney*, 99.

Chapter Four

DURATION PIECE Rethinking Sculpture in Los Angeles

Donna Conwell and Glenn Phillips

SOME L.A. SCULPTURES

On Christmas Eve 1974, artist Chris Burden participated in a lengthy interview for the L.A. morning talk show *Philbin & Company.* The show's host, Regis Philbin, was primarily interested in Burden's 1971 performance *Shoot* (fig. 4.1), in which Burden had fellow artist Bruce Dunlap shoot him in the arm with a .22 rifle. Philbin, baffled as to what the work might mean, was incredulous when Burden explained that *Shoot* was a sculpture:

> **PHILBIN:** Why did you allow yourself to get shot?
>
> **BURDEN:** It was a piece of sculpture, and it was the best thing I could think of doing at that time. That's why I did it.
>
> **PHILBIN:** [*laughing*] Chris has got me here. We're gonna—hang in there Chris and we're gonna solve this together. As a piece of sculpture—
>
> **BURDEN:** Right.
>
> **PHILBIN:** You allowed someone to shoot you—
>
> **BURDEN:** Right.
>
> **PHILBIN:** With a gun.
>
> **BURDEN:** Yeah.
>
> **PHILBIN:** And in your mind, that was the sculpture, the result of you being shot.
>
> **BURDEN:** No, just the moment when I was getting shot was the sculpture, just that instant when the bullet traveled from the gun into my arm. And then after that it's all over. That was the sculpture; it was less than a second.
>
> **PHILBIN:** And was it worth it?
>
> **BURDEN:** Yeah. It was a good piece.

If Burden's answer seemed coy, it was not unique to the interview with Philbin. Burden had, for instance, given a similar explanation to the L.A. police officers who had arrested him during his performance of *Deadman* (fig. 4.2), in which he had covered himself with a tarpaulin and lain down in the street next to two emergency flares, right beside the parked cars and moving traffic on La Cienega Boulevard outside of the Riko Mizuno Gallery: "I'm just trying to make a sculpture."[1]

Nor was this expanded definition of sculpture peculiar to Burden's artistic practice. In 1969, the young L.A. sculptor Barry Le Va produced *Velocity Piece #1: Impact Run, Energy Drain* at Ohio State University (he produced a second version of the piece at the La Jolla Museum of Art in 1970), in which he ran back and forth between two walls, violently flinging himself against them until he could no longer proceed. He later remarked:

> The distance between the far walls of the gallery was about fifty-five feet, enough to maintain quite a speed. I'd say the first few runs took me about three seconds, then longer and longer up to about seven seconds. After a while I was in extreme physical pain, but I'd anticipated that because I'd made test runs in my studio beforehand.... After a while my arms were bleeding. When I hit the wall, blood would fly onto the opposite wall. All these physical traces were left as part of the piece, skin from my elbows, sweat marks, blood. I wanted the record to be as complete and clinical as possible.[2]

Figure 4.1.
Chris Burden (American, b. 1946). *Shoot*, 1971. Performance at F Space, Santa Ana, California, 19 November 1971. Courtesy Chris Burden Studio.
"At 7:45 p.m. I was shot in the left arm by a friend. The bullet was a copper jacket .22 long rifle. My friend was standing about fifteen feet from me."

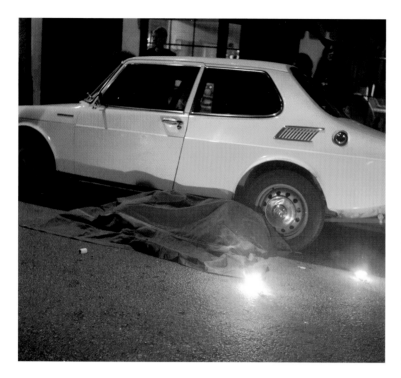

Le Va performed the action alone in the space. Two tape recorders (one at each end of the gallery) captured the sounds, and the playback of these tapes in the gallery space constituted the artwork. For Le Va, the action was continuous with his sculptural practice, which at that time typically involved scattering materials such as felt around large areas, or tossing flour or chalk into the air and allowing it to settle over the gallery floor. Running into the walls was, in a sense, like tossing flour: a sculptural gesture that left traces for the viewer to decode.

Another work from 1969, Douglas Huebler's *Duration Piece #15— Global* (fig. 4.3), became the basis for a dazzling explication of contemporary sculpture by critic and poet David Antin in an April 1972 lecture at Pomona College in Claremont, California. This was Antin's first "talk piece"—an improvisatory lecture/performance that he would record and then typeset as a poem titled "Talking at Pomona." Huebler's work consisted of an FBI Wanted poster and an accompanying statement in which the artist certified that the owner of *Duration Piece #15* would pay a reward for the apprehension of the pictured criminal according to a diminishing scale active throughout the year 1970 (the award began at $1,100 in January 1970 and fell by $100 each month thereafter). Amid a larger discussion about the state of contemporary art, Antin explained why *Duration Piece #15* should primarily be considered a work of sculpture:

[…] what was this kind of creepy work i mean what was this man doing intervening was he as it were an auxiliary policeman he says "no im not an auxiliary policeman im a sculptor" and you say "youre a sculptor" "yes yes im making a piece of sculpture" […]
now huebler sees it hes chipped away a certain amount of the physical materiality of sculpture and yet retained the kind of displacement character of minimal art that is the work is entirely displaced spatially […]

now you say to yourself "but huebler thats not physical space" and huebler says "no but its real space" its very real space police action only occurs in real space sculpture occurs in real space its a sculpture sculpture is real space this is real space real space is experience space its not physical space its not three-dimensional twenty by twenty space its not the space of this room […][3]

Meanwhile, Antin's wife, artist Eleanor Antin, learned that such sweeping definitions of sculpture were by no means universally accepted. In 1972, she produced *Carving: A Traditional Sculpture* (fig. 4.4), a series of 148 photographs documenting her attempts to reduce the size of her body—"carving" it down—through thirty-seven consecutive days of dieting. The work was solicited by the Whitney Museum of American Art for its Sculpture Annual and then refused on the grounds that it was not sculpture—a rejection all the more notable because it was carried out by Marcia Tucker, who, as one of the curators of the seminal 1969 exhibition *Anti-Illusion: Procedures/Materials* (in which Le Va had exhibited a flour piece), was associated with the most radical redefinitions of sculptural practice known in New York at the time.

Were these works sculptures? This is not the type of question we even debate today, so thoroughly have such ephemeral and bodily practices been accepted into our definitions of art making. However, the fact that artists saw fit to describe these works somewhat provocatively

Figure 4.2.
Chris Burden (American, b. 1946). *Deadman*, 1972. Performance on La Cienega Boulevard in front of the Riko Mizuno Gallery, Los Angeles, 12 November 1972. Relic: canvas tarp, folded: 2.5 × 38.1 × 25.4 cm (1 × 15 × 10 in.), open: 134.6 × 179.1 cm (53 × 70½ in.); case: 24.8 × 49.5 × 36.8 cm (9¾ × 19½ × 14½ in.). Private collection. Courtesy Chris Burden Studio. "At 8 p.m. I lay down on La Cienega Boulevard and was covered completely with a canvas tarpaulin. Two fifteen-minute flares were placed near me to alert cars. Just before the flares extinguished, a police car arrived. I was arrested and booked for causing a false emergency to be reported. Trial took place in Beverly Hills. After three days of deliberation, the jury failed to reach a decision, and the judge dismissed the case."

BANK ROBBERY

WANTED BY FBI

EDMUND KITE MC INTYRE

I. O. 4268
4-10-69

FBI No. 342,327 F

14 O 27 W III Ref: 11 12 28
M 32 W M II 18 32 32 32

ALIASES: Charles W. Embick, Edmund Kate McIntyre, Edmund Kice McIntyre

Photograph taken 1966 Photographs taken 1968

DESCRIPTION
AGE: 22, born September 7, 1946, Pleasantville, New Jersey
HEIGHT: 6'1" to 6'2" EYES: hazel
WEIGHT: 170 to 180 pounds COMPLEXION: medium
BUILD: medium RACE: white
HAIR: blond, brown NATIONALITY: American
OCCUPATIONS: automobile mechanic, commercial artist, laborer, silk-
screen worker, truck driver
SCARS AND MARKS: scar right wrist; tattoos: Maltese cross and "13"
left forearm, 3 dots left hand
REMARKS: may wear mustache, reportedly uses narcotics
SOCIAL SECURITY NUMBER USED: 545-66-4355

CRIMINAL RECORD
McIntyre has been convicted of resisting arrest.

CAUTION
MC INTYRE IS BEING SOUGHT FOR BANK ROBBERIES WHEREIN A
HANDGUN WAS USED. CONSIDER DANGEROUS.

Federal warrants were issued on December 31, 1968, at Los Angeles, California, and on January 17, 1969, at Miami, Florida, charging McIntyre with bank robbery (Title 18, U. S.
Code, Sections 2113a and 2113d).

IF YOU HAVE INFORMATION CONCERNING THIS PERSON, PLEASE CONTACT YOUR LOCAL FBI OFFICE.
TELEPHONE NUMBERS AND ADDRESSES OF ALL FBI OFFICES LISTED ON BACK.

Director
Federal Bureau of Investigation
Washington, D. C. 20535

Identification Order 4268
April 10, 1969

Duration Piece #15

Global

Beginning on January 1, 1970 a reward of $100.00 will be paid to the person who provides the information resulting in the arrest and conviction of Edmund Kite McIntyre wanted by the Federal Bureau of Investigation for Bank Robbery (Title 18, U.S. Code, Sections 2113a and 2113d). On February 1, 1970 $100.00 will be reduced from that first offer making it $1,000.00; it will be reduced another $100.00 on the first day of each subsequent month until there will exist no reward at all on January, 1971.

1. (Douglas Huebler), guarantee (by my signature below) the full payment of the reward offered above. In the event that this piece has been purchased from me at any time between September 1969 and January 1971 the then owner will have assumed responsibility for payment of such a reward.

(The price for this piece is $1,000.00: from that sum I will reimburse its owner any amount that he pays as a reward in completing the destiny of its design).

This statement and the "Wanted" publication (FBI No. 342,327 will constitute the finished form of this piece on January 1, 1971 unless Mr. McIntyre is apprehended and convicted in which case copies of all attendant documents concerning his conviction will join altogether to form the piece.

September, 1969 DOUGLAS HUEBLER

3/4

Figure 4.3.
Douglas Huebler (American, 1924–1997). *Duration Piece #15—Global* (detail), 1969. Top: dry-mounted photostat, 57.8 × 57.8 cm (22¾ × 22¾ in.); bottom: typewritten text, pencil on paper, 48.3 × 39.4 cm (19 × 15½ in.). Private collection. © Douglas Huebler Estate / ARS, New York. Courtesy of the Douglas Huebler Estate and Paula Cooper Gallery, New York.

as sculpture reminds us that traditional ideas about the boundaries between artistic media still held enough sway in the late 1960s as to need attacking. The artists' goal was not specifically to enlarge the realm of sculpture but rather to liberate other media from inherited conventions. A work like *Carving* plays with the idea of sculpture by documenting how one artist shaped a three-dimensional object—her own body—over time. More importantly, however, the work shows that photography, when freed from traditional pictorial criteria such as composition and form, can communicate ideas in new and challenging ways. Similarly, when artists disrupted traditional associations between specific media and their typical implementations (separating performance from theater, for example; or film and video from cinema and television; or language from literature), they discovered new territory for aesthetic and conceptual investigations. As artists moved to engage more directly with the world at large as an arena for perception and meaning, the concept of sculpture became a common ground. If artists could use photography, text, or their own bodies to direct our attention to expanses of time, to actions, to whole sectors of society and its systems, then perhaps they could manipulate our perceptions like so much sculptural material and reveal new things to us about our world.

This dissolution of boundaries between traditional media was one of the primary achievements of art in the late 1960s and 1970s. The process was carried out across an artistic community that was becoming vastly more international and interconnected, but a confluence of factors led Southern California to be particularly fruitful terrain for these investigations. To begin with, the region's artists had never taken those boundaries to mean much anyway—

Figure 4.4.
Eleanor Antin (American, b. 1935). *Carving: A Traditional Sculpture*, 1972. 148 black-and-white photographs and a text panel (not shown), each photograph: 17.7 × 12.7 cm (7 × 5 in.); text panel: 39.4 × 26 cm (15½ × 10¼ in.); 79.4 × 518.2 cm (31¼ × 204 in.), installed. Chicago, Art Institute of Chicago, Twentieth-Century Discretionary Fund, 1996.44. Courtesy Ronald Feldman Fine Arts, New York.

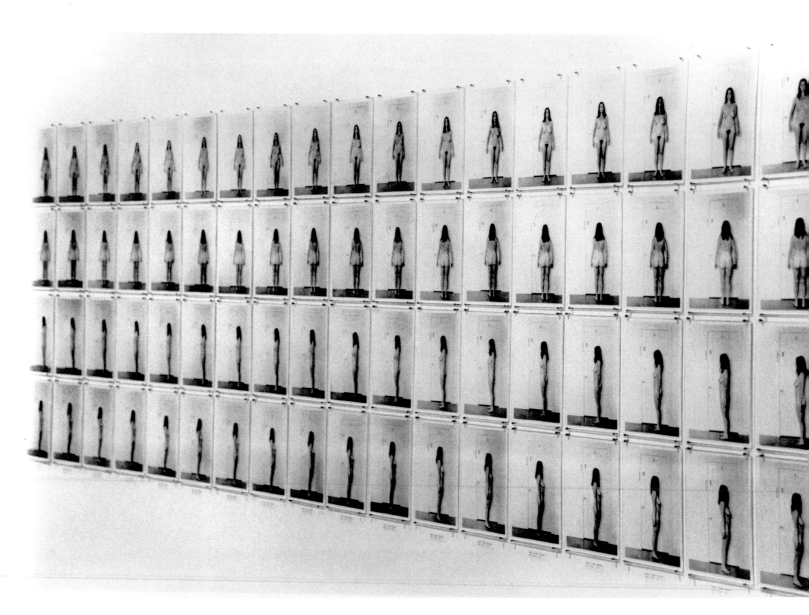

for L.A.'s assemblage and pop artists, the distinctions between media were particularly fluid, and artists' use of new synthetic materials and industrial processes in the mid-1960s had led to hybrid forms of work that would strongly, if subliminally, influence the next generation of artists. That next generation grew in number, as ambitious new art schools recruited influential teachers and energetic students. Southern California's art schools became hosts to the most advanced and experimental ideas about art, while also finding those ideas turned to new ends. The period's volatile political climate and the rise of Southern California as a center for many activist movements created a politicized field that for many artists shifted art's priorities away from hermetic debates about the definition of sculpture and toward a more socially engaged practice that would use any available means to interrogate its surroundings.

It is difficult to construct a linear narrative of this period. So much happened more or less concurrently, among artists who were not always aware of one another's progress. Ideas were in the air, operating across a distributed field of simultaneous activity and investigation. Southern California's many contributions to the development of global conceptualisms—postminimalism, video art, performance art, conceptual art, and feminist art—can be traced within the overlapping trajectories of those international movements. However, the contributions also have an indigenous context that too often has been either stripped away entirely or distorted by negative stereotypes about "La La Land." Many artists found their paths to conceptualism through Southern California's great regional development of the late 1960s: Light and Space art. When examining how boundaries between artistic disciplines broke down in Los Angeles during this period and why L.A. artists seemed so often to be reconfiguring definitions of sculpture en route to nonsculptural forms of art, the perceptual environments of Light and Space are often lurking in the background.

"AN EXPERIENCE OF SPACE AND OF LIGHT"
In 1964, Robert Irwin began producing his "dot paintings," slightly convex canvases painted bright white and covered in meticulous arrays of tiny red and green dots that were slightly denser toward the center of the painting and somewhat less dense at the edges. When viewed from a distance, the paintings present no image whatsoever; instead, they create a pulsing optical sensation in the viewer that *Artforum* editor Philip Leider called an "experience of space and of light."[4]

By 1967, Irwin had begun a new series known as the disc paintings (fig. 4.5), which evolved from a challenge he had posed for himself: to create "a painting that does not begin and end at an edge but rather starts to take in and become involved with the space or environment around it."[5] Irwin created convex aluminum discs, typically about 5 feet in diameter, which were sprayed with almost imperceptible rings of shaded matte paint. Attached to the wall by a rear armature, the discs appeared to hover about 20 inches from the wall surface and were surrounded by four overlapping circular shadows cast by the four spotlights illuminating them from above and below on each side. Writing about a show of the disc paintings organized by John Coplans at the Pasadena Art Museum in 1968, critic Melinda Terbell noted, "While one could not perceive the earlier [dot] paintings without considerable concentration, in these an even more intense visual effort is required in order to experience the whole effect, which is the illusion that the painting dematerializes completely—actually becomes one with—a part of the walls beside it and the space in front of it."[6] Appearing to float ambiguously in the gallery space, Irwin's disc paintings not only engaged the viewer in a perceptual experience but also seemed to open up an interstitial space between painting and sculpture.

The creation of such hybrid perceptual objects emerged from a line of inquiry that was proliferating in multiple directions throughout Southern California. The so-called L.A. Look or Finish Fetish artists achieved recognition in the mid-1960s by utilizing advanced technologies specific to the region—particularly plastic and industrial coating processes—

to create painterly, optical surfaces on objects that focused on the mechanics of human perception. John McCracken coated basic forms, such as planks and columns, with a highly reflective lacquered surface (see figs. 3.39, 3.40). Larry Bell applied thin films of molecular metal to glass, producing cubes, and later panels, with reflective and transparent qualities (see fig. 3.42). Craig Kauffman created glossy back-painted wall reliefs using vacuum-formed acrylic plastic (see figs. 3.31, 3.32). The painted and glazed surfaces of these objects blurred the division between painting and sculpture, and their reflective and translucent surfaces began to dissolve the easy distinction between object and environment.

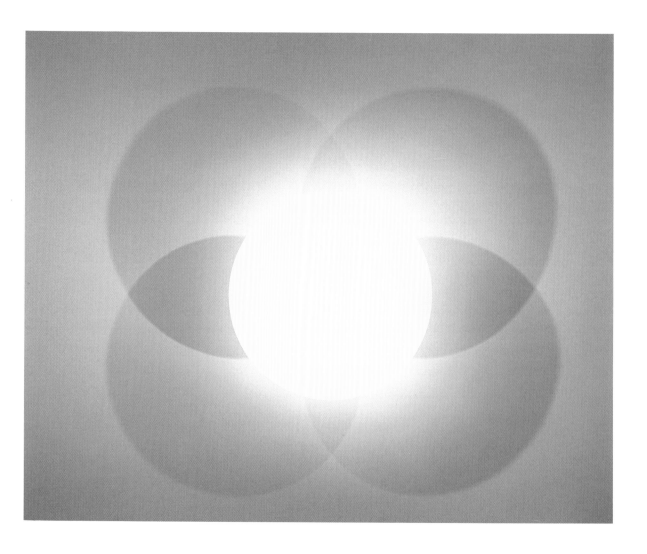

Figure 4.5.
Robert Irwin (American, b. 1928). *Untitled,* **1968.** Synthetic polymer paint on aluminum and light, diam. of disc: 153.2 cm (60⅜ in.). New York, Museum of Modern Art, Mrs. Sam Lewisohn Fund. Art © 2011 Robert Irwin / Artists Rights Society (ARS), New York. Digital Image © The Museum of Modern Art / Licensed by SCALA / Art Resource, NY.

A subsequent generation of L.A. artists continued to build on this tradition. Peter Alexander, De Wain Valentine, and Helen Pashgian, among others, explored the perceptual effects of industrial materials through their experiments with highly polished polyester resin, a material that appeared on the market in 1966. Each artist used color as a sculptural element, "integrating it with the manufacturing method and physical configuration of the object."[7]

Alexander created semitransparent cubes, wedges, and bar-shaped volumes cast from tinted resin. One of his earliest works, from 1966, is a cube containing a white cloudlike shape created by introducing drips of dye to uncured resin during the casting process (fig. 4.6). In the late 1960s, Alexander began making slender vertical wedges that are barely visible at their apex and become increasingly solid and infused with pigment as they reach the ground. In contrast, Alexander's "Leaners" from the early 1970s are at their most transparent along their edges,

Figure 4.6.
Peter Alexander (American, b. 1939). *Small Cloud Box*, 1966.
Cast polyester resin, 12.7 × 12.7 × 12.7 cm (5 × 5 × 5 in.). Santa Monica,
California, collection of the artist. © Peter Alexander.

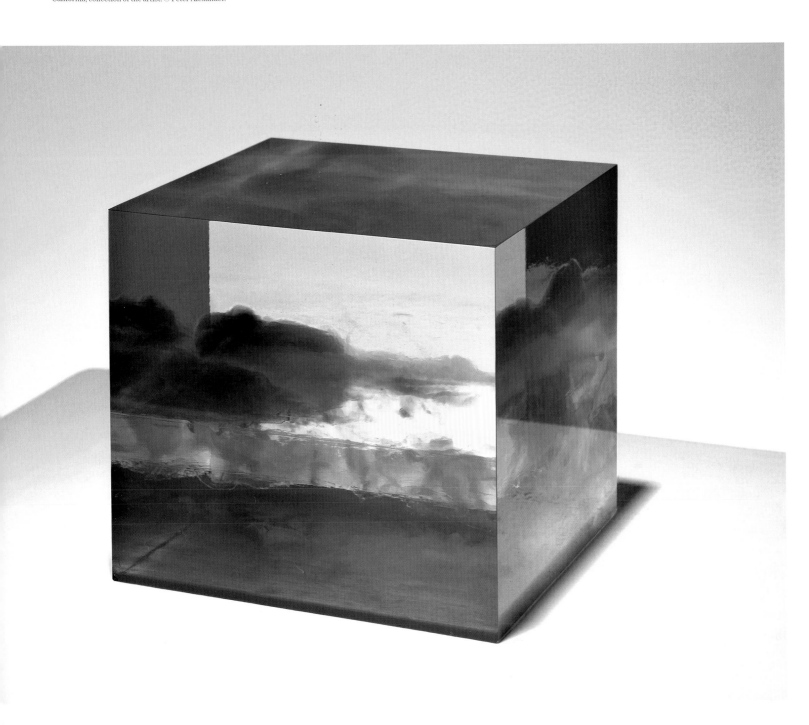

with color that seems to intensify in the middle (fig. 4.7). Valentine worked with polyester resin to produce translucent freestanding concave or convex discs, columns, and other volumes throughout the later 1960s and early 1970s (fig. 4.8). Through his collaboration with Hastings Plastics, based in Santa Monica, Valentine developed new casting techniques and a more durable resin that enabled him to create large-scale works up to 12 feet high and 8 feet wide. Pashgian moved from painting into sculpture and produced transparent tinted-resin spheres and discs, creating an illusion of floating color that would change hue as the viewer moved around the work (fig. 4.9).

While the term "Finish Fetish" has often been applied to the work of Alexander, Valentine, and Pashgian because of their highly polished surfaces, it was not pristine surfaces that preoc-

cupied these artists. As Pashgian noted, "If there is a scratch on the surface that's all you see. But the point is not the finish at all. The point is to be able to interact with the piece... to see into it, to see through it... that's why we need to deal with the finish, so we can deal with these other issues."[8] Alexander, Valentine, and Pashgian were fascinated by the transparent quality of polyester resin, which enabled them to create objects that drift into and out of the viewer's perceptual field (see sidebar 21).

With rare exceptions, boldly colored sculptures made from space-age materials did not fare well with New York critics, particularly amid the prevailing monochromes of minimalism. The exhibition *A Decade of California Color* (1970) at the Pace Gallery, which featured the work of thirteen artists, including Bell, Kauffman, Valentine, Alexander, and McCracken, was savaged by critic Joseph Mashek in *Artforum.* Noting, in reference to Los Angeles's weather, that "not since the invention of bronze casting has anything of consequence happened in that kind of climate," Masheck ranted that "the whole California *Weltanschauung* bristles us up and makes New Yorkers feel for a moment extraordinarily responsible and even puritanical.... [T]he prospect of hip young drop-out types hanging out in Venice, Calif., making fancy baubles for the rich amuses us. Easy materials, easy designs; why shouldn't we notice that their attitude toward color is just as facile? It is apparently as easy to rack up in Los Angeles as an artist as it is to be a stringer of beads or an importer of herbals."[9]

Masheck's aversion seems to have stemmed equally from a disdain for California, a disdain for new materials (he referred to Alexander's sculpture as a "polyester toothpick"), and a disdain for seeing sculpture employ color in a painterly manner. It was a different situation, however, for the critics who embraced Ronald Davis's use of these same materials and even brighter colors in the service of painting. Davis had begun working with polished resin in 1966, producing flat, clear shapes that could be painted from behind like glass, affixed to a protective fiberglass support, and hung on the wall. The painted imagery, often dazzling in its colors, made the objects look something like abstracted architectural models seen from strange angles. But they were rendered with such astonishing perspectival

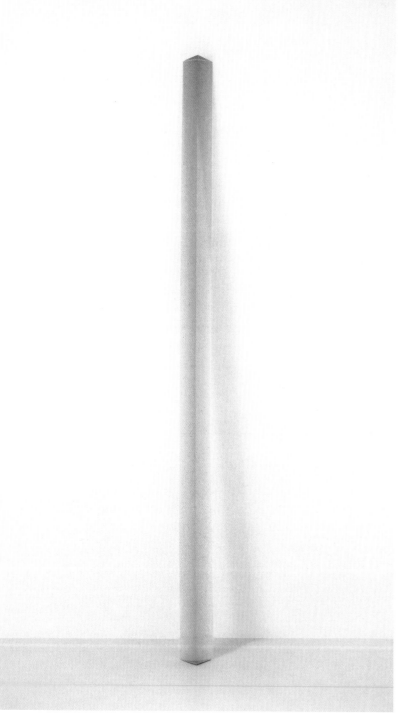

Figure 4.7.
Peter Alexander (American, b. 1939). *Untitled (Leaner)*, 1970. Polyester resin, 266.7 × 14 × 7.6 cm (105 × 5½ × 3 in.). Private collection. © Peter Alexander.

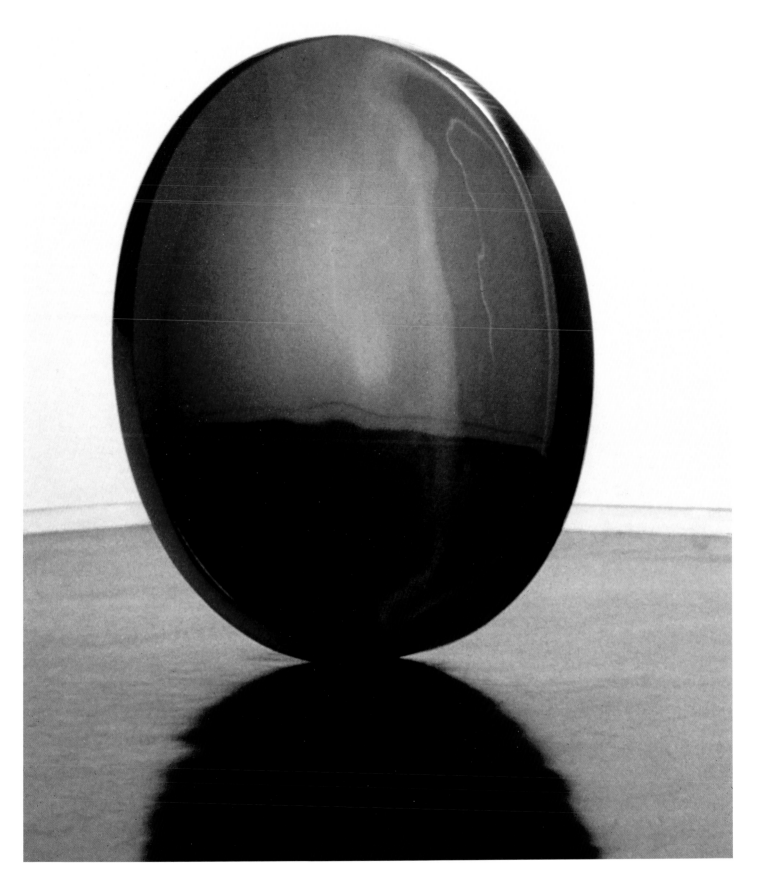

Figure 4.8.
De Wain Valentine (American, b. 1936). *Red Concave Circle,*
1970. Cast polyester resin, 243.8 × 243.8 × 30.5 cm (96 × 96 × 12 in.).
On loan from Bank of America Collection. © De Wain Valentine,
courtesy the artist.

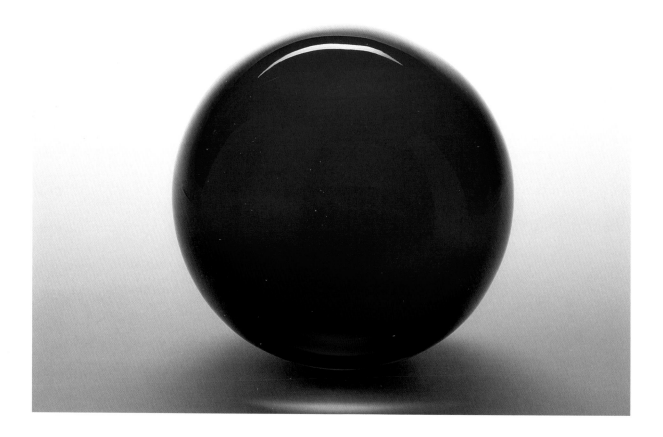

Figure 4.9.
Helen Pashgian (American, b. 1934). *Untitled*, 1969. Cast sphere, colored polyester resin, diam.: 17.8 cm (7 in.). Pasadena, Norton Simon Museum, gift of the artist.

accuracy that, upon first encounter, viewers would sometimes have difficulty believing that the paintings were not real objects protruding into space, an effect that John Elderfield described as creating "flat surfaces where logically one would think they could not possibly exist."[10]

Davis's work arrived at a time when Frank Stella's shaped canvases were being hailed as the vanguard of American painting while also, in their perfect reduction, seeming to signal the end of modernism's great explorations of pictorial flatness. Davis appeared to offer a way out, or at least a new direction, for abstract painting as it was being discussed by the most advanced academic critics of the time, and his objects were embraced as pure painting. *Six-Ninths Blue* (1966) graced the cover of *Artforum*'s April 1967 issue (fig. 4.10), in which Michael Fried wrote that Davis's works "are among the most significant produced anywhere during the past few years, and place him…at the forefront of his generation." Davis's career took off, and he began to exhibit at Leo Castelli in New York and the Kasmin Gallery in London. New York critics saw his work as particularly relevant to discussions of modernist painting derived from Clement Greenberg's theories, and the plastic qualities of Davis's paintings were largely ignored in favor of discussing how he had combined traditional, illusionistic perspective within abstract paintings that, like Stella's, used shaped supports whose edges were coextensive with the depicted form. "What incites amazement," Fried noted, "is that that ambition could be realized in this way—that, for example, after a lapse of at least a century, rigorous perspective could again become a medium of painting."[11]

It required adept logical maneuvering to sidestep Davis's relation to current sculpture in Los Angeles. In describing Davis's "colored plastic," for instance, Fried would not say that the work was an object, but that it "imitates the materiality of solid things."[12] Davis's accomplishment, to Fried, was to utilize two-point perspective in such a way that viewers had the sensation of being simultaneously suspended above the depicted objects and tilted toward them, an illusion that "does not excavate the wall so much as it dissolves the ground under one's feet: as though

Robert Irwin watching Jack Brogan polish the surface of an acrylic prism in Brogan's studio, Venice, California, 1971. Photo by Ralph Samuels. Courtesy Jack Brogan Studio.

IN 1965, when Jack Brogan established Design Concepts, his fabrication business in Venice, California, he quickly distinguished himself as a specialist in creating one-of-a-kind objects.[1] Brogan was one of many subcontractors supporting the aerospace, consumer goods, and construction industries in the Los Angeles region; his earliest projects included prototypes of a train engine and a space station for Garrett Corporation, a pioneering industrial and defense contractor. Emphasizing nonstandardized production methods and low-volume output, Brogan's business responded in equal parts to a market for custom fabrication and to Brogan's deep interest in *techne,* the principles behind doing or making something. From the start, Brogan focused the business operations on building his already encyclopedic knowledge of materials and processes, accrued through experience as a cabinetmaker, patternmaker, and chemical analyst, and in the automotive industry. Fabricators often draw on technical knowledge from multiple fields in order to complete their projects; in Brogan's case, however, the opportunity to pursue interdisciplinary work was a motivating factor rather than a result.

Within a year of opening his business, Brogan was hired by his friend Robert Irwin to produce the first of several acrylic prisms, the largest of which would be 32 feet high. The artist had not been able to find a company that could cast acrylic planks longer than 4 feet or polish them to optical clarity. Working solely from Irwin's verbal descriptions and sketches, Brogan was tasked with developing and perfecting multiple steps: laminating the acrylic blocks in a nearly seamless fashion, developing a pressurized clamping system, and producing completely new grades and compounds of polishing oxides. In order to do this, Brogan had to design and create special tools, and this turned out to be the most important part of the project. Using what could be called found technology, Brogan adapted existing processes for new applications: he developed a clamping system using hydraulic pistons originally designed to raise and lower truck gates; he took oxides normally used in paint filler and graded them into finer particles; and he modified hand tools initially made for polishing metal and wood so that he could use them on plastic. Ultimately, Brogan was able to define texture, clarity, and other specific characteristics of the prism by finding production correlates in uncustomary methods, a skill honed by constant practice in making prototypes. Working with Brogan was a turning point for Irwin, who would later say, "Jack influenced my thinking in terms of how I solve problems."[2]

By 1981, more than 90 percent of Brogan's business was devoted to art fabrication and conservation. The change in focus (from aerospace commercial jobs to art) was facilitated, in part, by the shop's location from 1965 to 1975: the building was on Lincoln Boulevard, less than a mile from the Mildred Avenue studios of Irwin, Peter Alexander, Ronald Davis, and other artists who gravitated toward new materials and processes and, consequently, could benefit from Brogan's services. More importantly, Design Concepts offered artists a production model similar to their own—unusual for an industrial shop—involving considerable research and experimentation, sometimes for a single object. Furthermore, Brogan was willing to invest his own time in extensive research, amortizing the cost over future work he might do with the same artist, or with the same material. The clean-room setup and polishing techniques developed for Irwin's acrylic prisms, for example, were later used in fabricating resin works for Helen Pashgian and Peter Alexander and for the conservation of works by all three artists. The methods used in the late 1980s to polish John McCracken's mirror-finished stainless steel sculptures relied on techniques originally developed for resin surfaces in the 1960s.

While it is true that being in the right place at the right time was instrumental to Brogan's shift toward art fabrication in the late 1960s, it is even more accurate to say that artists were as much a catalyst for Brogan's work as he was for theirs.

Notes
1. All information about Jack Brogan is from Margaret Honda, *Found Technology: The Art Fabrication Business of Jack Brogan* (Ann Arbor, Mich.: University Microfilms, 1991).
2. From a personal interview by the author with Robert Irwin, 1 February 1989, San Diego, Calif. See Honda, *Found Technology,* 46n77.

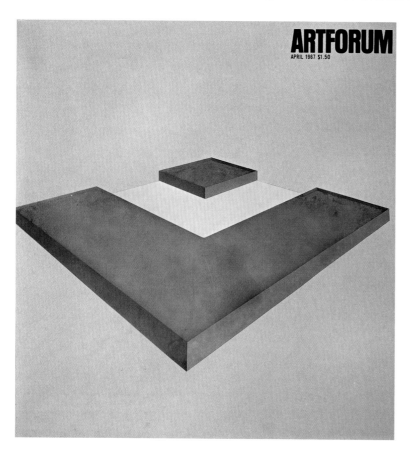

ARTFORUM
APRIL 1967 $1.50

Figure 4.10.
Cover of *Artforum* 5, no. 8 (1967) featuring Ronald Davis's
Six-Ninths Blue, 1966. Art courtesy Ronald Davis. Cover
© Artforum, April 1967.

experiencing the surface and the illusion independently of one another were the result of stand-ing in radically different physical relations to them."[13] It is unclear whether Davis originally meant for his smooth surfaces and illusionistic renderings to create this sort of tension, but he paid attention: by the time he produced his extraordinary *Dodecahedron* series in 1968–69, he had begun to confuse some of his compositions with abstract expressionist–style drips and splatters that were at odds with the impeccably rendered shapes behind them, thus making explicit the conflict between flatness and illusionism that had been celebrated by Fried (figs. 4.11, 4.12). In her review of these paintings in the May 1968 issue of *Artforum,* Annette Michelson upped the ante on Fried, writing that Davis was using not two-point perspective but three-point perspective, and that the illusion was not that the viewer was above and tilted toward the object but that the object appeared "as being situated below the spectator and as tilted toward him."[14] Furthermore, Michelson asserted that Davis was not reviving a tradition that had been dead for a century but rather harking back to Paolo Uccello's perspective studies of a *mazzocchio* from the mid-fifteenth century.

Whether or not any of this was true, Davis's work was certainly related to the work of his peers in Los Angeles, who were also experimenting with resins, reflective surfaces, and intense optical effects. However, there was little critical vocabulary in place in New York at this time that could have allowed the sculptural and painterly aspects of these works to be reconciled within a single treatment. In debating whether the viewer feels to be floating above or looking down into Davis's paintings, Fried and Michelson had fixated on a side effect of the works' main event: the dramatic heightening of one's awareness of the space around the object—a quality that was becoming identified as a key aspect not of painting but of minimalist sculpture. Though Fried continued to consider Davis's work as pure painting, he would, just two months after publishing his article on Davis, issue his seminal article "Art and Objecthood," in which he attacked minimalism's attentions to spatial contexts and surroundings as a degraded form

Figure 4.11.
Ronald Davis (American, b. 1937). *Vector*, 1968. Acrylic on plastic, 143.5 × 345.4 × 5.4 cm (56½ × 136 × 2⅛ in.). London, Tate Modern. Image © Tate, London 2010.

Figure 4.12.
Ronald Davis (American, b. 1937). *Black Tear*, 1969. Cast polyester and pigment, 154 × 345 cm (60½ × 136 in.). Pasadena, California, The Robert A. Rowan Collection.

of theater that threatened the modernist legacies of both painting and sculpture.[15] Indeed, the emerging debate around minimalism could have provided the perfect context and vocabulary for many of the Southern California artists who were working with resins and translucent or reflective surfaces. In "Notes on Sculpture, Part II," for instance, artist Robert Morris observed that "the better new work takes relationships out of the work and makes them a function of space, light, and the viewer's field of vision.... One is more aware than before that he himself is establishing relationships as he apprehends the object from various positions and under varying conditions of light and spatial context."[16] In 1965, Donald Judd had described a broad range of hybrid objects that seemed to fall outside typical notions of both painting and sculpture, including works by L.A. artists as diverse as Bell, Ken Price, and Edward Kienholz. A handful of L.A. artists, including Bell, McCracken, and Judy Gerowitz (who later took the name Judy Chicago) were included in early surveys of minimalism in New York.[17] Yet as the critical reception of minimalism began to crystallize around investigations of scale and presence in pieces that featured strong gestalts, there was little room for Southern California's investigations of color and translucence in works that aimed to confuse or destabilize vision. Los Angeles's new artists were, in a sense, producing works that were too hybrid, too integrated into their surroundings, or too much on the verge of disappearing.

Many L.A. artists moved beyond producing objects at all, focusing instead on architectural interventions or spatial modifications designed to induce powerful perceptual effects in the viewer. Beginning in 1966, James Turrell developed a series of works in which modified halogen projectors cast precisely shaped fields of light into corners or recesses within a room. Playing with perspective in a manner similar to that of Davis, Turrell used the projections to create the illusion of three-dimensional geometric forms made from saturated masses of light (fig. 4.13). "The space generated was analogous to a painting in two dimensions alluding to three dimensions, but in this case three-dimensional space was being used illusionistically."[18] Turrell was able to do away entirely with discrete sculptural objects and instead provide the viewer with the ephemeral illusion of an object. By 1967, painter Doug Wheeler had also begun experimenting with light, placing fluorescent bulbs inside large vacuum-sealed white acrylic boxes that hung on the wall. The cool, even light that seeped from these boxes would appear to infect an entire room, suffusing it with light that felt thick, as if filtered by fog. Reviewing Wheeler's 1968 show at the Pasadena Art Museum, critic William Wilson described Wheeler's work as being "like Mark Rothko's [*sic*] spilled from their frames.... Space and light are dimensional while the work seems to have been conceived two-dimensionally like an old-fashioned painting."[19] The sentiment came close to Wilson's description of a Davis painting one year earlier: "its movement turns wall space into air and the air space in the gallery into something more solid because we are more aware of it."[20]

Wheeler would soon abandon the acrylic boxes, achieving the same effects by working, like Turrell, only with light (fig. 4.14). By 1970, artists such as Irwin, Michael Asher, Tom Eatherton, and Eric Orr were also creating perceptual works that were no longer objects—illusionary or not—but entirely immersive environments that modified architecture and lighting to create heightened sensations in the viewer. Irwin began working with translucent scrims to destabilize viewers' perceptions of space and depth. Orr created a number of pitch-black acoustic environments before shifting to less technologically complex works involving alchemical materials such as lead, gold, fire, and light. In 1972, he used thin membranes of paper to create *Zero Mass*, a luminescent oval space that seemed to dissolve the gallery walls, creating for viewers the sensation of floating within undifferentiated space.

For Michael Asher, perceptual environments provided a bridge to a completely new kind of art making. Moving from painting into sculpture in the mid-1960s, Asher worked briefly with painted wood, heat-molded Plexiglas, and aluminum and glass wall pieces before starting to create dematerialized environments in 1969. For the Whitney's *Anti-Illusion: Procedures/Materials* exhibition the same year, he installed an air blower to create a barely perceptible

Figure 4.13.
James Turrell (American, b. 1943). *Afrum (White)*, 1966.
Quartz-halogen projected light, dimensions variable. Los Angeles, Los Angeles County Museum of Art, purchased with funds provided by David Bohnett and Tom Gregory through the 2008 Collectors Committee (M.2008.60). Digital Image © 2009 Museum Associates / LACMA / Art Resource, NY. Art © James Turrell.

curtain of air across part of an entranceway. In exhibitions at the La Jolla Museum of Art and the Museum of Modern Art (MoMA), New York, that same year, he modified gallery spaces using sound damping materials and highly controlled lighting to destabilize vision and heighten awareness of spatial volume.

When invited by Hal Glicksman to create a new work for the Gladys K. Montgomery Art Center at Pomona College in 1970, Asher devised a project whose original intent was to combine modifications of light, sound, and airflow in a single work (figs. 4.15, 4.16, 4.17). Asher disrupted the museum's gallery and lobby, building new walls to create two triangular spaces that were joined into an hourglass shape by a short passageway just 2 feet wide. The ceiling was lowered to just 6 feet 10 inches, and there were no interior lights. The smaller of the two rooms connected directly to the museum entrance, and the sole light fixture at the entrance portico was modified with a light-diffusing material that cast a pale, even light. Most importantly, the doors were removed from the museum entrance, leaving the installation perpetually open to the outside. During the day, the outer room was filled with California sunshine; at night, it was filled with moonlight and a pale blue glow from the portico fixture and streetlamps outside. In either case, the only illumination in the rear gallery came from the narrow opening, creating a dematerialized feeling inside the room. The precise arrangement of these spaces elicited peculiar phenomenological effects for viewers, not only of light but also of sound. The rear gallery seemed to amplify and distort sounds coming from the outside, and some viewers felt the air pressure change noticeably between the two rooms. For most visitors, the work was seen

Figure 4.14.
Doug Wheeler (American, b. 1939). *Eindhoven, Environmental Light Installation,* 1969. Installation, 365.7 × 487.7 cm (144 × 192 in.). Washington, D.C., Hirshhorn Museum and Sculpture Garden, Smithsonian Institution, Joseph H. Hirshhorn Purchase Fund, 2007, The Panza Collection. Art © Doug Wheeler. Photo by Lee Stalsworth.

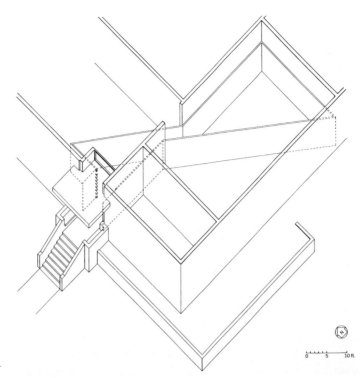

Figure 4.15.
Documentation drawing by Lawrence Kenny of Michael
Asher's installation at the Pomona College Art Gallery,
Claremont, California, 1970. Drawing produced for Michael
Asher, *Writings 1973–1985 on Works 1969–1979* (Los Angeles:
Museum of Contemporary Art Los Angeles, 1983), 35–36.
Drawing © Michael Asher.

Figure 4.16.
View from entrance to inner structure of Michael Asher's
installation at the Pomona College Art Gallery, Claremont,
California, 1970. Photo by Frank J. Thomas (American, 1916–1993).
Courtesy the Frank J. Thomas Archive. Art © Michael Asher.

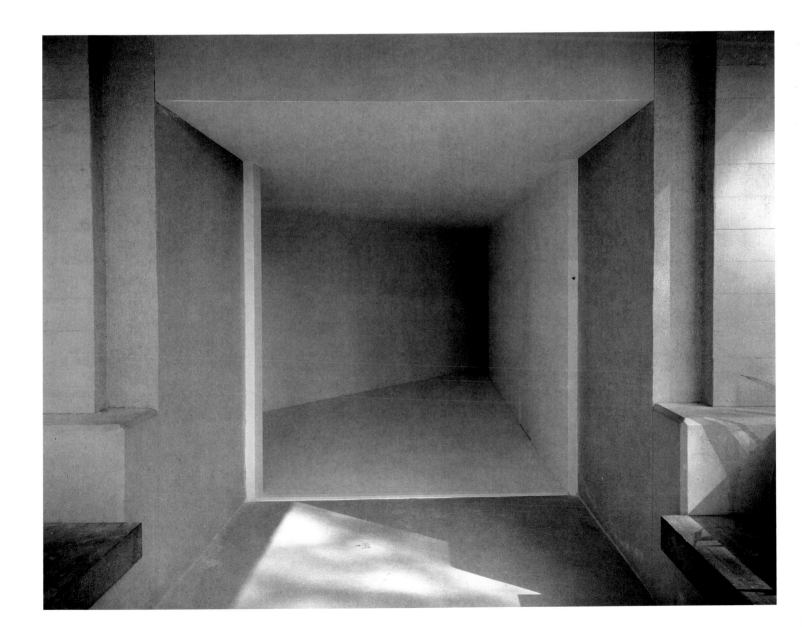

Figure 4.17.
View from large triangular area toward the passageway to
the small triangular area of Michael Asher's installation at
the Pomona College Art Gallery, Claremont, California, 1970.
Photo by Frank J. Thomas (American, 1916–1993). Courtesy the
Frank J. Thomas Archive. Art © Michael Asher.

within the conventions of perceptual installation art that had been cropping up throughout the region. But in removing the museum's doors while also closing off access to the rest of the gallery and offices, Asher had created a situation in which the artwork was at odds with the normal functioning of the museum. Asher's project was intended in part to prompt consideration of how museums operate, of the levels of access they provide, and of the relationships between institutional priorities and the needs of contemporary artists. Asher's approach became a means of pointing to the role of art institutions and the systems under which they operate. This "institutional critique," as it came to be known, signaled a new direction in Asher's work, one that would dominate much of his practice for the rest of his career (see chapter 5).

As the 1970s progressed, critics began referring to a "Light and Space movement" that had happened in Southern California during the late 1960s and early 1970s. The term was applied sometimes to the perceptual environments of artists such as Irwin, Turrell, and Wheeler and sometimes to the sculptures of artists such as Alexander, Bell, and Pashgian. However, the asso-

ciated artists did not necessarily agree that they were part of a movement. While they were aware of and mutually influenced by one another's work, most Light and Space artists felt that their works dealt with specific topics—formal, perceptual, psychological, or spiritual—that were independent of the work of their peers.

However, even if there was never a Light and Space "movement" in Southern California, there were certainly enough shared interests among artists that they may be described as a community. Across Los Angeles, experimentation with new plastics and resins and the creation of perceptual environments were widespread phenomena that seem to have seized the imaginations of numerous artists, both well known and obscure. In fact, what has been classified as Light and Space art was, if anything, simply a symptom of the specific, unique environment in Los Angeles in which a confluence of technical, craft, and scientific industries made new materials available to artists at a time when they had access both to expansive definitions of art and to empty spaces in which to experiment—not only with plastics and light but also with fog, smoke, and vapors. Thus Ed Moses removed part of the wall, ceiling, and roof of Riko Mizuno's gallery for his solo exhibition there in 1969, allowing sunlight to rake changing patterns of light across the floor through the remaining wooden slats in the ceiling (fig. 4.18). When visitors

Figure 4.18.
Installation view of Ed Moses's solo exhibition, Riko Mizuno Gallery, Los Angeles, 1969. Art © Ed Moses, courtesy the artist.

Figure 4.19.
Judy Gerowitz (Chicago) (American, b. 1939), Lloyd Hamrol
(American, b. 1937), and Eric Orr (American, 1939–1998).
Dry Ice Environment 2, 1968. Performance with 22 tons of dry
ice, Century City, Los Angeles. Photo by Lloyd Hamrol. © 2011
Judy Chicago / Artists Rights Society (ARS), New York.

entered the gallery, Moses would throw rice polish into the air to reveal the shapes of the sun-
beams. Judy Gerowitz collaborated with Lloyd Hamrol and Eric Orr on dry-ice environments
(fig. 4.19), and she produced multiple outdoor *Atmosphere* performances involving flares and
colored smoke (fig. 4.20). Sam Francis and James Turrell—both pilots—devised performances
conducted from airplanes that utilized the sky over Los Angeles. Francis also sent skiers spew-
ing colored smoke down a slope in Japan and produced a massive colored-smoke spectacle
with helicopters in Tokyo Bay (figs. 4.21, 4.22). Francis and Gerowitz even approached the National
Aeronautics and Space Administration (NASA) with a proposal to add pigmentation to the
exhaust gas of rockets being launched regularly from Vandenberg Air Force Base. Mason Williams
and Bruce Nauman each developed plans for skywriting works, with Williams's *Sunflower*
being realized in 1967 (fig. 4.23). Nearly one-third of the proposals received by the Los Angeles
County Museum of Art (LACMA) for its Art and Technology program involved artists who
wanted to create light environments or works that would attempt to create hovering or materi-
alized masses of light.

Figure 4.20.
Judy Chicago (American, b. 1939). *Multicolor Atmosphere,*
1970. Performance at the Pasadena Art Museum, Pasadena,
California. Photo © Through the Flower Archive. Art © 2011 Judy
Chicago / Artists Rights Society (ARS), New York.

Figure 4.21.
Sam Francis (American, 1923–1994). *Snow Painting,* **1967.**
Performance in Naibara, Japan, winter 1967. Photo by Toshio
Yoshida. © 2011 Sam Francis Foundation, California / Artists
Rights Society (ARS), New York.

Figure 4.22.
Photograph of Sam Francis's *Helicopter Sky Painting,* **a**
performance in Tokyo Bay, Japan, 8 June 1966. From a bro-
chure documenting the event. Los Angeles, Getty Research Institute,
2004.M.8. Gift of the Estate of Samuel L. Francis. Art © 2011 Sam
Francis Foundation, California / Artists Rights Society (ARS),
New York.

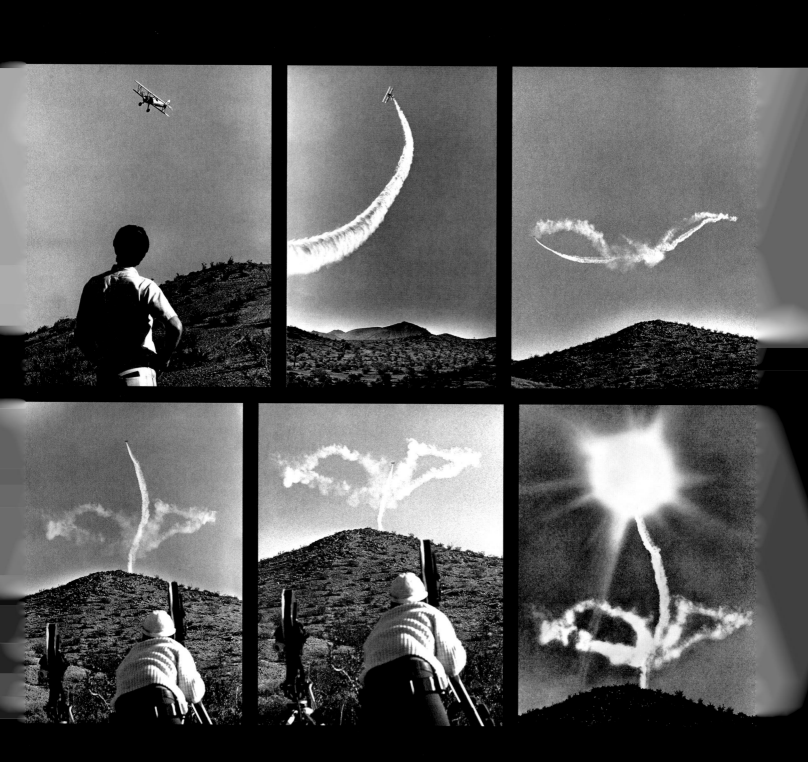

Figure 4.23.
Mason Williams (American, b. 1938). *Sunflower*, 1967.
Skywriting performance near Apple Valley, California, 11 July 1967.
Photos by Tony Esparza. © Tony Esparza / 12 Star

EXPERIMENTING WITH ART AND TECHNOLOGY

Light and Space art emerged from a much broader context in Southern California, in which an open-minded creative class of scientists, fabricators, and industry professionals were both prevalent and amenable to collaboration. By the mid-1960s, Southern California had become an international center for aerospace and defense organizations such as Lockheed Aircraft and the Jet Propulsion Laboratory (JPL) , for advanced scientific research institutions such as the California Institute of Technology (Caltech), and for established movie and television corporations, including Universal Film Studios. The region increasingly came to be seen as ideally suited for the merger of art and technology. As Douglas M. Davis reported in *Art in America* in 1968, "Young sculptors in California seem particularly open to the use of new materials and methods, surely because of the presence there of what are sometimes called 'esoteric' industries, especially those involved with space technology."[21]

An interest in uniting art, science, and technology was evident throughout the United States from the early 1960s to the early 1970s. In 1962, for instance, NASA founded the Artist's Cooperation Program. Two other key institutions were established in this period: Experiments in Art and Technology (E.A.T.)—a nonprofit foundation started in 1966 in New York by engineers Billy Klüver and Fred Waldhauer and artists Robert Rauschenberg and Robert Whitman to promote creative collaboration among contemporary artists, engineers, and scientists[22]—and the Center for Advanced Visual Studies (CAVS) at the Massachusetts Institute of Technology (MIT), launched in 1967 by artist György Kepes as "a laboratory where the most advanced technological tools [could] be tested for their applicability in the newly emerging scale of artistic tasks."[23]

Los Angeles founded its own chapter of E.A.T. (E.A.T./L.A.) in March 1969 following several years of independent, informal activity. While it received less attention than its counterpart in New York, the organization had more than three hundred members, including artists Oliver Andrews, Ruth Baker, John Baldessari, Channa Davis, Allan Kaprow, Barbara T. Smith, and De Wain Valentine; filmmaker Eric Saarinen; composer and experimental musician Joseph Byrd; curators Hal Glicksman, Barbara Haskell, and Henry Hopkins; arts administrator Jan Butterfield; collector Betty Asher; Caltech physicists Elsa Garmire and Amnon Yariv; and JPL engineer Al Sorkin. The group organized a variety of activities, including exhibitions, university courses, film screenings, lectures, and demonstrations by artists and scientists. Many of their programs promoted early experiments with perceptual environments, performance art, and environmental sculpture. On 18 July 1969, for example, E.A.T./L.A. organized a moon landing celebration at Caltech. It included a fog environment by Judy Gerowitz and Sam Francis; a performance involving acrobats illuminated by strobe lighting produced by artists Barbara T. Smith and Ann Ferrier and experimental musician Joseph Byrd; and an event involving searchlights by Eric Orr. From 1 to 3 May 1970, E.A.T./L.A. presented a multimedia conference and Happening in collaboration with the University of Southern California (USC) titled "Experiments in Art and Technology: In Process" (fig. 4.24). USC student Linda Biber described the event as an "experiment in how fast one could experience, absorb and synthesize impressions if bombarded with a flow of art-technology."[24] In addition to lectures, screenings, and workshops on topics such as electroencephalography (EEG) feedback and its relationship to meditation and altered states of consciousness, the three-day program included sculptural environments, such as an inflatable structure of tunnels and chambers with electronic audiovisual projections produced by the group Chrysalis (fig. 4.25);[25] performances such as Ed Bereal's *Man, Machine, & Race,* which explored "manifestations of Black life, and art & technology";[26] *Octopus City* by Channa Davis (now Channa Horwitz), in which eight women in silver costumes moved in choreographed response to light emitted from a Plexiglas floor and electronic sounds; and Allan Kaprow's *Air to Ground Feedback,* which involved a hot-air balloon.

E.A.T. New York looked to L.A. chapter affiliates and West Coast technical expertise to resolve the complex design requirements for one of its most ambitious projects: the construction

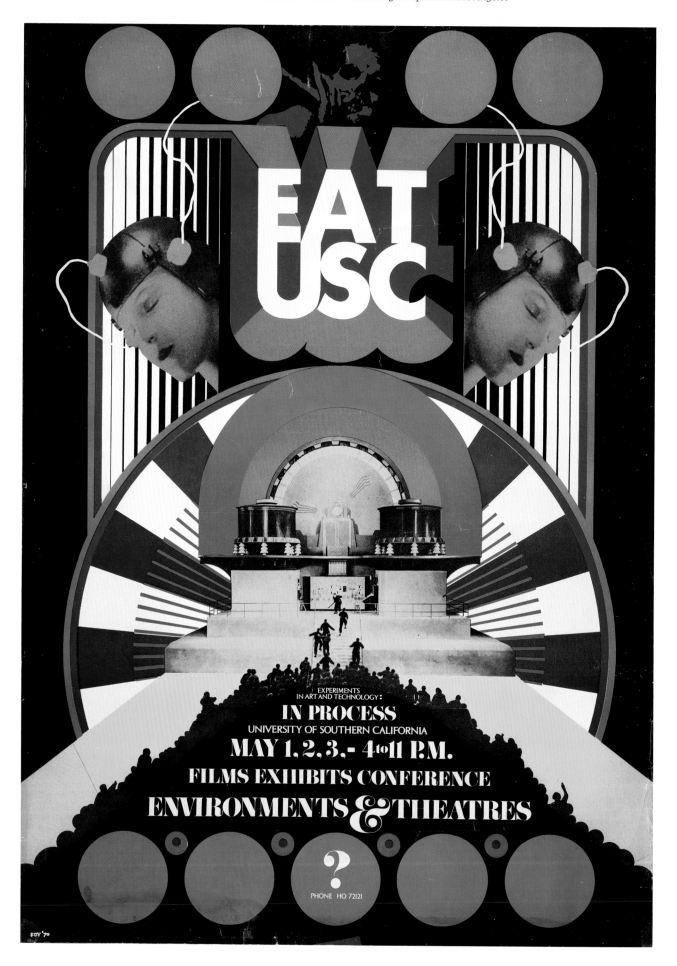

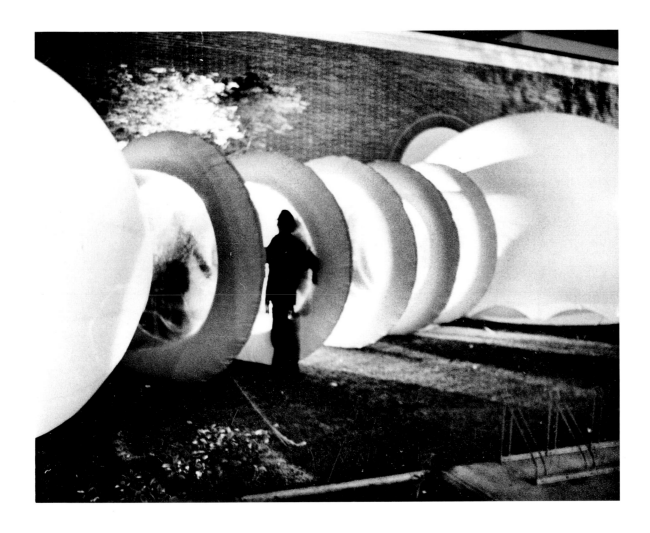

Figure 4.24.
Experiments in Art and Technology (American art and technology organization, act. 1967–). Poster for the conference "Experiments in Art and Technology: In Process," 1970. 79 × 56 cm (31 × 22 in.). Los Angeles, Getty Research Institute, 2003.M.12.

Figure 4.25.
Chrysalis (American art and architecture collective, ca. 1970–71), *Inflatable Environment*, 1970. Created for the conference "Experiments in Art and Technology: In Process." Photographer unknown. Los Angeles, Getty Research Institute, 940003.

of the Pepsi Pavilion for Expo '70 in Osaka, Japan. The pavilion project was initiated by four core artists based in New York: sculptor and filmmaker Robert Breer, sculptor Forrest Myers, experimental composer David Tudor, and cofounder of E.A.T. Robert Whitman. However, as an issue of *E.A.T. Proceedings* dated 19 May 1969 testifies, "the design and programming of the pavilion [were] developed through a collaboration between E.A.T. New York, E.A.T. Los Angeles, and E.A.T. Tokyo."[27] L.A. artists and scientists played a central role in the construction of this large-scale experimental art environment. One of the major design elements of the pavilion was a cloud of fog that enveloped the pavilion's domelike structure (fig. 4.26). Although the fog concept was originally developed by Myers, it was produced by Japanese artist Fujiko Nakaya and Thomas Mee, an L.A.-based cloud physicist and engineer. In November 1970, in an article published in *Techne: A Projects and Process Paper,* Nakaya described her four-month search for an effective system of fog production, "a fog to walk in, to feel and smell, and disappear,"[28] as well as Mee's fog experiments in his backyard in Pasadena during a blistering L.A. summer (fig. 4.27). This collaboration resulted in the largest-ever water-vapor cloud produced without the help of chemicals. In addition, while it was New York–based Whitman who first conceived of an enormous spherical mirror to envelop the Pepsi Pavilion's interior, it was E.A.T./L.A. artists and architects Chris Dawson, Denny Lord, David MacDermott, Ardison Phillips, and Alan Stanton, along with Caltech physicist and E.A.T./L.A. board member Elsa Garmire, whose innovative experiments with inflatable mirror technology made Whitman's idea a reality. After contracting with South Dakota–based satellite maker G. T. Schjeldahl and specialty materials

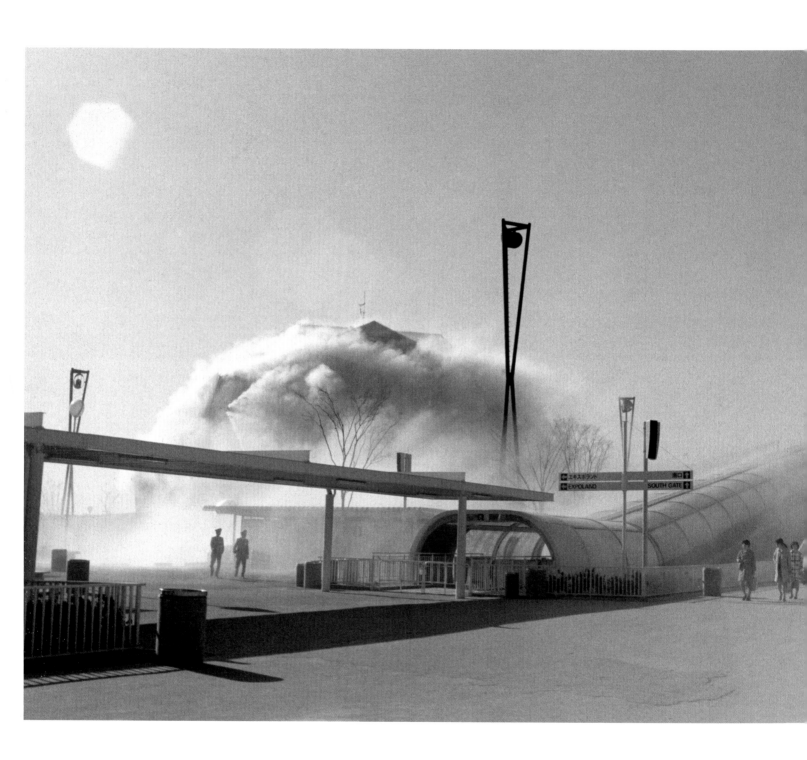

Figure 4.26.
Fujiko Nakaya (Japanese, b. 1933). *Fog Sculpture*, 1970.
Environment at the Pepsi Pavilion, Japan World Exposition '70,
Osaka, 15 March–13 September 1970. Commissioned by E.A.T.
Los Angeles, Getty Research Institute, 940003. © Fujiko Nakaya.

manufacturer Raven Industries, a full-size replica of the pavilion mirror was constructed and test-inflated in a disused Marine Corps hangar in Santa Ana (fig. 4.28). The structure was made from Mylar (a flexible DuPont polymer) that was coated with vaporized aluminum using the same materials and technology for covering the interior of a satellite.[29]

The mirrored hemisphere, 50 feet high and 90 feet wide, displayed unique optical properties. The spherical curvature of the mirror created inverted reflections that appeared to be fully three-dimensional and suspended in space, in positions that shifted depending on where a viewer stood. As Gene Youngblood wrote in the *Los Angeles Free Press,* "One is overwhelmed with a sense of vertigo. One is unable to walk in a straight line. It's there and it's not there.

Incredible phantasmagorias of color and light whirl insanely above the entire environment. You approach the wall and it comes out at you, massively, ephemerally. You reach out to touch it and grab air."[30] On 30 September 1969, E.A.T./L.A. held a dome party to introduce the project to Pepsi executives, members of the press, and E.A.T. supporters, who received it enthusiastically (figs. 4.29, 4.30).

During the second half of the 1960s, a number of other exhibitions across the United States linked art to science, including *The Machine Seen at the End of the Mechanical Age* at MoMA in 1968; *Cybernetic Serendipity* at the Institute of Contemporary Arts, London, in 1968; *Software: Information Technology: Its New Meaning for Art* at the Jewish Museum, New York, in 1970; and *Information* at MoMA in 1970. One of the most ambitious and problematic exhibitions, however, was LACMA's *Art and Technology* exhibition, the culmination of a five-year program.

Figure 4.27.
Fog demonstration in Thomas Mee's backyard, Pasadena, California, ca. 1969. Los Angeles, Getty Research Institute, 940003. Courtesy Mee Industries Inc.

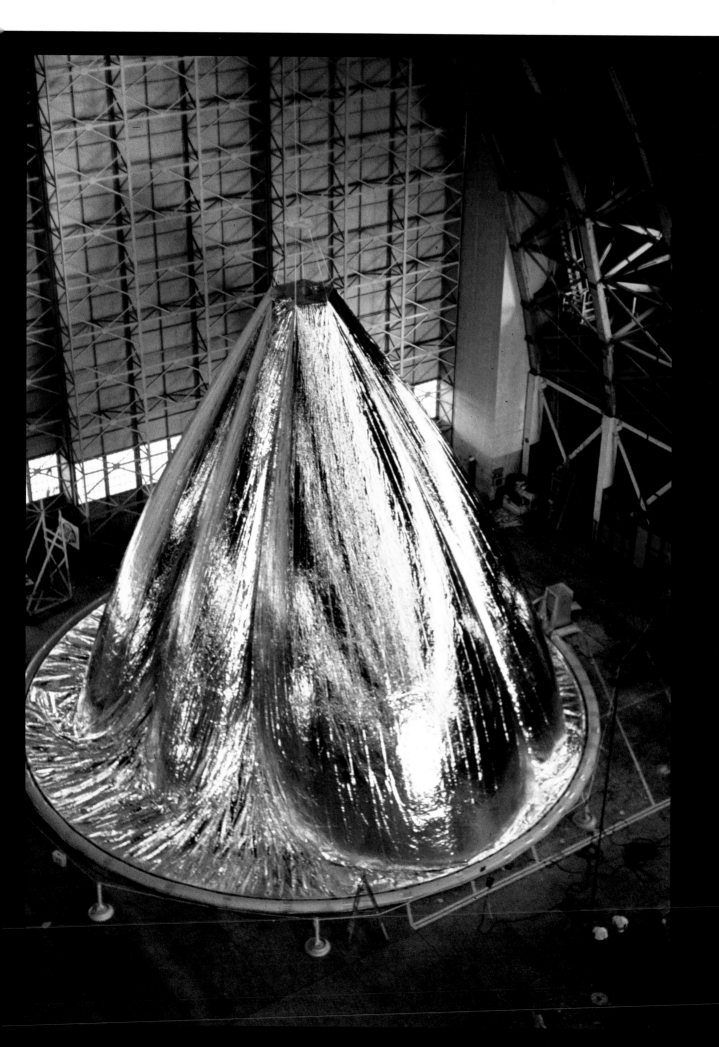

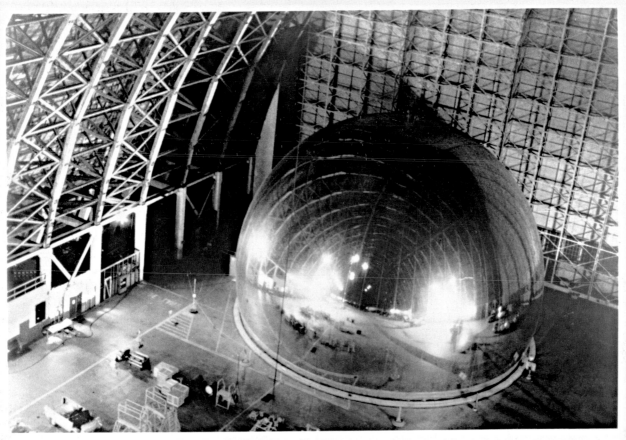

EXPERIMENTS IN ART AND TECHNOLOGY INVITES YOU TO A PARTY-DEMONSTRATION OF A 90-FOOT, 210 DEGREE
SPHERICAL MIRROR MADE OF MYLAR, A FULL-SCALE MODEL OF THE MIRROR FOR THE PEPSI-COLA PAVILION.
THE MARINE CORPS AIR STATION, SANTA ANA. SEPTEMBER 30, 7-11 PM. R.S.V.P. 213 467 2123.

DIRECTIONS FROM L.A. TO THE MARINE AIR CORPS STATION. SANTA ANA FREEWAY TO RED HILL BOULEVARD,
TURN RIGHT FOR 1½ MILES. LARGE RED MCAS SIGN ON LEFT. FROM SAN DIEGO FREEWAY TO RIVERSIDE
FREEWAY. 2ND EXIT AFTER NEWPORT BOULEVARD TO RED HILL BOULEVARD. LEFT TO LARGE SIGN.

Figure 4.28.
Mirror Dome in the process of being inflated in Santa Ana,
California, 1969. Photo by Atkinson Stedke. Los Angeles, Getty
Research Institute, 940003.

Figure 4.29.
Press invitation to the Mirror Dome viewing party, 1969.
20.3 × 25.4 cm (8 × 10 in.). Los Angeles, Getty Research Institute,
940003.

Figure 4.30.
Interior shot of the Mirror Dome showing optical properties
of projection and inversion, 1969. Photo by Oliver Andrews.
Los Angeles, Getty Research Institute, 940003.

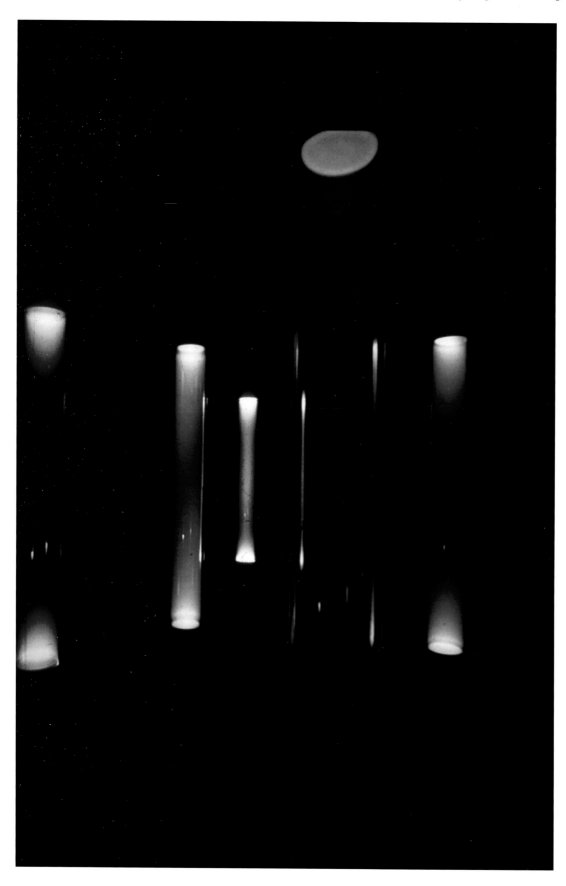

Figure 4.31.
Newton Harrison (American, b. 1932). *Artificial Aurora*, 1970.
Plexiglas tubes; each: 3.04 m (10 ft.) high, 55.9 cm (22 in.) in diam.
Designed and completed at Jet Propulsion Laboratory. Courtesy
Newton Harrison.

Curator Maurice Tuchman said that he conceived of the program in 1966, two years after his arrival in Los Angeles from New York, stating that "a newcomer to this region is particularly sensitive to the futuristic characteristic of Los Angeles, especially as it is manifested in advanced technology."[31] Tuchman worked with a curatorial team that included LACMA curators Jane Livingston and Gail Scott, and, for portions of the project, Hal Glicksman and James Monte. Rather than selecting and exhibiting existing works that explored the intersection of art and technology, the curators worked to pair artists with technically oriented industries, mostly in the L.A. area, and charged them with producing new collaboratively generated art projects. The program was as interesting for its failures as for its successes: of seventy-six artists invited to participate, only sixteen managed to produce an exhibitable artwork for the show; the remaining unrealized projects or failed partnerships between artists and corporations were documented in the exhibition's catalog. A version of the exhibition opened in Osaka as part of Expo '70, and the final version of the exhibition opened at LACMA in 1971. It was not only the most ambitious museum show linking art, science, and technology from this period, it was also the first show of this kind to take place on the West Coast. With some exceptions, however, few Southern California artists were invited to participate in the Art and Technology program, which was dominated by New York art-world stars such as Claes Oldenburg, Robert Rauschenberg, and Andy Warhol. More troubling, however, was the project's exclusion of women artists—despite their active involvement with organizations like E.A.T.—which led to protests that were a galvanizing force for the burgeoning women's movement in Los Angeles (see sidebar 22).

One of the most successful projects to emerge from the Osaka and L.A. exhibitions was Newton Harrison's *Artificial Aurora* (fig. 4.31), a work consisting of five Plexiglas columns, 22 inches in diameter and 10 feet high, containing various inert gases at low pressure that, through the application of electrical discharges, would become luminous plasmas, passing through changing, timed cycles that progressed from lightning to arc to glow to dispersal. The result of a collaboration between Harrison and JPL, the project managed to achieve what so many artists had initially proposed to LACMA: a sculptural environment of changeable masses of light. While operating his light chambers in Osaka, Harrison learned from optical scientist John Forkner that the glow discharge phenomenon works in much the same way as the natural phenomenon of the aurora borealis.[32] This prompted Harrison to imagine a series of projects to be executed with the aid of NASA rockets. The unrealized proposals included generating colored clouds, a midnight sun, and an artificial aurora borealis, where "the release of rare gases at appropriate altitudes would create a similar kind of light to the Northern Lights...where such gases are excited by the photon flow of the sun in near vacuums" (fig. 4.32).[33] Harrison was even able to secure the donation of a Nike Apache rocket, which he planned

Figure 4.32.
Newton Harrison (American, b. 1932). *Sky Proposal*, 1970. Los Angeles, Getty Research Institute, 930100. Courtesy Newton Harrison.

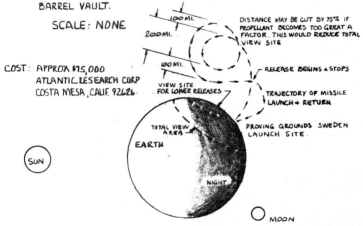

to launch at Point Mugu Naval Air Station in Ventura County until the intervention of the then secretary of defense Melvin Laird, who, when asked by LACMA board member Missy Chandler for permission to execute the work, reportedly said that he "would not give artists that much power."[34]

SENSORY DEPRIVATIONS

Of the Art and Technology projects that failed to produce an exhibitable artwork, the collaboration between Robert Irwin and James Turrell probably resonated most strongly among artists in Los Angeles. The two artists had begun an intense dialogue during the summer of 1968, and when Irwin was invited to participate in the Art and Technology program he proposed to work jointly with Turrell. They were paired with the Garrett Corporation, an L.A.-based aerospace company, where they met Edward C. Wortz, head of the company's Life Sciences Department. His

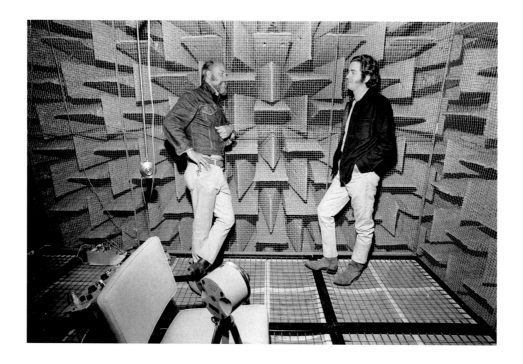

Figure 4.33.
Robert Irwin and James Turrell inside the anechoic chamber at UCLA, 1969. Photo by Malcolm Lubliner (American, b. 1933). Courtesy Malcolm Lubliner and Craig Krull Gallery, Santa Monica.

research involved developing life-support systems for NASA's manned lunar flights, which at that time were only a year away. The group began a series of experiments at UCLA's anechoic chamber—a specially constructed room designed with such high sound absorbency as to create a nearly total silence (fig. 4.33). The experiments, mostly designed by Turrell, involved recording the experiences of test subjects (including Irwin, Turrell, and Wortz) inside the totally dark anechoic space over varying time periods. Irwin noted that the subjects experienced sense perceptions in the anechoic chamber, including an increased awareness of sounds generated by the body, such as the heart pumping blood, and the perception of retinal afterimages as light. He reported, in addition, that "for a few hours after you came out . . . you really did become more energy conscious, not just that the leaves move, but that everything has a kind of aura, that nothing is wholly static, that color itself emanates a kind of energy."[35] The group introduced biofeedback studies into their process, working with EEG machines to measure brain waves and to practice "alpha conditioning," attempting to induce the "alpha" brain-wave pattern commonly associated with successful meditation. While based in scientific research, the experiments were also guided by the artistic processes of Irwin and Turrell. For instance, Wortz was convinced that Irwin's previous experiences of sitting intently in front of his paintings for

IN RESPONSE TO the *Art and Technology* exhibition of 1971 at the Los Angeles County Museum of Art (LACMA), art historian and critic Amy Goldin wrote: "Making art is not simply aesthetic behavior. It is bound into the social system in very specific ways. The idea of art as an insulated system of perpetual innovation is uncannily parallel to the ideal of unbounded technological invention."[1]

Goldin's frustration with the view that art practice can be understood in isolation from its social and political context was part of a broader response by arts professionals—Jack Burnham, Max Kozloff, and David Antin, among others—that signaled a shift away from uncritical support for collaborations among art, science, and technology. Corporate America's involvement in the Vietnam War called into question the value of unfettered scientific advancement, and the snug partnership between art and business-sponsored technology that had proliferated during the 1960s seemed increasingly untenable.

Ironically, LACMA's *Art and Technology* exhibition was the catalyst for an event that provided incontrovertible evidence that art is not produced in a social vacuum: the formation of the Los Angeles Council of Women Artists. In the fall of 1970, a year before LACMA's widely anticipated show opened but after it became known that no female artists would be participating, the council—a group of female painters, sculptors, critics, curators, and teachers, including Edith Gross, Joyce Hayashi, Joyce Kozloff, Candy Lee, Samella Lewis, Judy Reidel, and Faith Wilding—gathered to challenge the discriminatory practices of LACMA and the art world at large. The council launched an investigation into LACMA's exhibition record, and, shortly after *Art and Technology* opened in May 1971, it published its findings in a widely circulated report.[2] While *Art and Technology* had "been heralded as 'the wave of the future,'"[3] the report noted that all 16 of the artists were male. Of the 78 proposals that were published in the exhibition catalog, only 2 were by female artists: Los Angeles–based Channa Davis (now Channa Horwitz) and New York–based Aleksandra Kasuba. Furthermore, in events at LACMA between 1961 and 1971, only 4 percent of the works in group shows and only 1 of 53 solo exhibitions were by women.[4]

The council called on LACMA to make a series of structural changes to ensure that female artists would be represented in 50 percent of all solo shows, group exhibitions, and new acquisitions at the museum and that women would serve on the board of trustees and work in senior managerial and curatorial positions. Members of the council protested in front of the museum, appeared on television shows, lobbied their congressional representatives, and threatened to take legal action through the U.S. Commission on Civil Rights.

Most of the council's demands and proposals were not immediately met, but the protests opened up an important dialogue that led to two significant exhibitions at LACMA. The first, *Four Los Angeles Artists*, was curated by Jane Livingston in 1972 and included a roster of all female artists; the second, *Women Artists: 1550–1950* (the first major historical survey of paintings by women), was curated by Anne Sutherland Harris and Linda Nochlin in 1977.

The *Art and Technology* exhibition helped launch the international feminist movement by galvanizing Southern California women. It also prompted another important event in feminist art history: artists Newton Harrison and Helen Mayer Harrison produced their first environmental work, *Notations on the Ecosystem of the Western Salt Works with the Inclusion of Brine Shrimp: Survival Piece #2* (1971), for the show. This was the first work the Harrisons produced as a collaborative team; they have subsequently pursued many projects that explore the impact of advanced technologies on fragile ecosystems. They are often described as pioneers in "ecofeminist" art because their work combines environmental and feminist themes.

Notes

1. Amy Goldin, "Art and Technology in a Social Vacuum," *Art in America* 60, no. 2 (1972): 51.

2. *Los Angeles Council of Women Artists Report*, 15 June 1971, 2; Lawrence Alloway papers, Getty Research Institute (2003.M.46).

3. Goldin, "Art and Technology in a Social Vacuum," 3.

4. *Los Angeles Council of Women Artists Report*, 1.

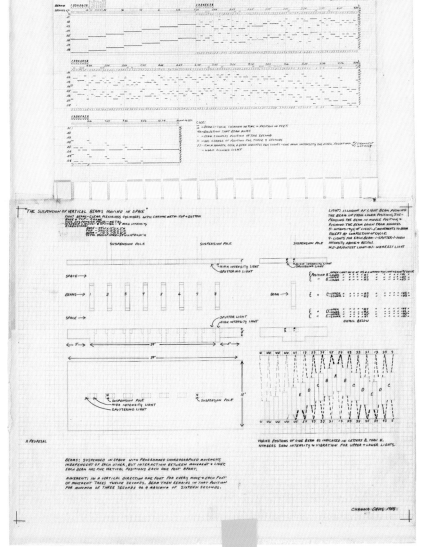

Channa Davis (American, b. 1932). Proposal/sketch for *Suspension of Vertical Beams Space,* 1968. Mixed-media collage on paper, 88.9 × 71.1 cm (35 × 28 in.). Submitted for consideration in the Los Angeles County Museum of Art's *Art and Technology* exhibition (1971). Collection of the artist.

long periods of time involved a kind of sensory deprivation.[36] Turrell, for his part, had constructed a pseudo-anechoic chamber in his studio at the former Mendota Hotel in Ocean Park as early as 1966, when he cleared out and insulated studio rooms from external sound and light in order to experiment with his cross-corner projections.[37]

Irwin, Turrell, and Wortz also experimented with ganzfelds—completely undifferentiated visual fields in which light appears to have substance (the same principle works to create the "foggy" visual effect that occurs in light environments by Turrell and Doug Wheeler) (fig. 4.34). Initially, the group planned to construct a sequenced environment combining the anechoic chamber with a ganzfeld for the *Art and Technology* exhibition. An early proposal envisioned multiple spaces: each visitor would enter the anechoic chamber after spending five to ten minutes in a prep room that was "less complex than the outside world."[38] The visitor would be seated in a specially designed chair. After five to ten minutes of sensory deprivation within the chamber, the chair would mechanically recline and, powered by a hydraulic lift, raise the viewer into a seamless Plexiglas dome above. There the participant would experience a ganzfeld that would progress through minimal changes, such as modulations at the periphery of vision or even behind the participant's head. The chair would then return the viewer back to the anechoic chamber, from which a tunnel led directly outdoors, bypassing the rest of the exhibition. Turrell described the proposed work as something that would allow people "to perceive their perceptions...and to make people conscious of their consciousness."[39] Yet the three men also began to feel that the importance of this project lay within the collaborative process itself rather than in any sculptural result, and when Turrell abruptly left the project in August 1969, Irwin and Wortz abandoned it and withdrew from the exhibition as well. (For another collaboration by Irwin, Turrell, and Wortz, see sidebar 23.)

Symbolically, however, the group's proposal distills some of the underpinnings of Light and Space at the moment when perceptual artworks were beginning to open onto other investigations. In proposing an environment of near-total sensory deprivation, the project approaches a zero point for art making, attempting to strip away nearly all external stimuli from the viewer, leaving only those inalienable perceptions that are synonymous with human life: the awareness of heartbeat, of blood flow, of neural activity within the eyes, and of other internal bodily processes normally drowned out by the world around us. Allowing a viewer to physically experience that baseline of subjectivity ("to perceive their perceptions") *was* the artwork for Irwin and Turrell—not the environment itself, not even the way this nothingness "looked," but rather the experience that a viewer would feel: "The experience is the 'thing,' the experiencing is the 'object.'"[40]

Many Light and Space works had already created situations in which what the viewer sees does not match the physical reality of the artwork: there were no floating masses of light or fields of vibration in these pieces, only the body's physiological response to unusual (and often unusually minimal) patterns of visual information. This shift in emphasis from the static form of the art object to the viewer's subjective physiological response opened up unexpected avenues for artists who were more interested in experiences than in straightforward visual appearance. For artists like Mowry Baden, sculptural objects could become tools for creating specific types of experience. Baden had begun working with polyester resin and fiberglass in the San Francisco Bay area in the mid-1960s, crafting funky and often interactive objects based on the dimensions and movements of his own body. Moving back to Los Angeles in 1968, he began to make objects that limited and decentered vision while creating unusual physical experiences. The hovering aluminum-and-steel *Instrument,* for instance, encloses the head in a narrow and vaguely undulating channel (fig. 4.35). In the work *Seat Belt, Three Points,* participants buckle around their waist a long seat belt that is joined to three other short lengths of belt anchored to the floor (fig. 4.36). They can then walk in a circle, leaning farther outward than their normal center of gravity allows, while also feeling a shifting pull as the stress transfers

Figure 4.34.
Edward C. Wortz and Gail Scott examine a ganzfeld sphere at the Garrett Corporation, Los Angeles, 1970. Photo by Malcolm Lubliner (American, b. 1933). Courtesy Malcolm Lubliner and Craig Krull Gallery, Santa Monica.

Figure 4.35.
Mowry Baden (Canadian, b. 1936). *Instrument,* **1969.**
Aluminum and steel, variable height, 487 × 20 cm (192 × 8 in.).
Los Angeles, Museum of Contemporary Art. Art © Mowry Baden.
Photo by John Walls.

Figure 4.36.
Mowry Baden (Canadian, b. 1936). *Seat Belt, Three Points,*
1970. Nylon and steel, diam.: 426 cm (168 in.). Lopez Island,
Washington, collection of Steven C. Young. Art and photo
© Mowry Baden. Photo by Willard Holmes.

between the three shorter belts. The key aspect to this work was the physical sensation it produced; the visual experience was secondary at best, a blurry side effect of moving in circles.

Bodily sensation also began to play a central role in many of the environments created by Bruce Nauman. When he moved to Pasadena from the Bay Area in 1969, Nauman had already developed a substantial practice working in a wide range of sculptural materials, including polyester resin, latex, fiberglass, concrete, lead, plaster, and wax. He had also worked with photography, drawing, film, performance, audiotape, neon, and even holography. During a winter spent in East Hampton, New York, preceding his move to Los Angeles, Nauman had begun the extraordinary series of task-based videotapes that would set a model for many subsequent video artists. Nauman rebuilt the "prop" for one of those videos—a long, narrow corridor used in *Walk with Contrapposto* (1969)—as an interactive sculpture in the Whitney Museum's *Anti-Illusion: Procedures/Materials* exhibition. The experience of walking down the dead-end corridor, just 20 inches wide, was claustrophobic and unnerving for many viewers, and Nauman began to develop other built environments that could elicit sensations of mild discomfort, confusion, or frustration.

Nauman's practice shifted predominantly to environmental installations for the next several years. For his exhibition at the Nicholas Wilder Gallery in 1970, Nauman built six corridors as a single construction, with the corridors ranging from 4 to 60 inches wide (fig. 4.37), and installed surveillance cameras and monitors at various locations within the structure. An inaccessible room, partially visible at the end of an 8-inch-wide corridor, broadcast surveillance video to monitors at the ends of two other corridors. A 23-inch-wide corridor contained a surveillance camera at one end and two stacked monitors at the other end. As viewers walked down the corridor toward the monitors, they would see an image of themselves on one monitor—an image that grew progressively smaller as they moved farther from the camera; the second monitor showed prerecorded footage of the same corridor, empty. One corridor had a surveillance camera turned on its side that broadcast footage to the adjacent corridor, allowing visitors moving from one space to the next to barely glimpse themselves appearing to fall sideways off the screen as they moved out of the view of the camera and into the view of the monitor. Many of the ideas from the Wilder exhibition were replicated as single corridors or were expanded upon further in subsequent exhibitions.

Figure 4.37.
Bruce Nauman (American, b. 1941). Study for *Corridor Installation*, 1969. Graphite and ink on paper, 58.4 × 62.5 cm (23 × 24⅝ in.). Raussmüller Collection. Art © 2011 Bruce Nauman / Artists Rights Society (ARS), New York. Image © Raussmüller Collection.

Nauman also began to incorporate perceptual ideas similar to those investigated by Light and Space artists. A series of works from 1971 explored parallax, the phenomenon involving the apparent displacement of an object depending on one's point of view. Nauman used partitions or bars to interrupt space at staggered depths along the edges of a narrow sightline, causing situations in which the eyes cannot focus properly and creating the perception of illusory floating lines and shifting movement. Nauman also experimented with creating corridors from acoustical foam similar to the type used in anechoic chambers. In a number of works, Nauman played with light, introducing mixtures of colored fluorescent light and natural light into his spaces. *Green Light Corridor* was a narrow corridor filled with intense green fluorescent light that would cause pink afterimages in the viewer's field of vision—a case in which the viewer would not fully "see" the artwork until after exiting it (fig. 4.38). Installed adjacent to a window

DONNA CONWELL

THROUGHOUT THE 1960s AND 1970s, NASA's rigorous and widely publicized studies into the physical and psychological effects of space travel fueled a growing fascination with humankind's ability to prevail in extreme habitats. In 1964, the New York World's Fair *Futurama II* exhibit—a depiction of life sixty years in the future—featured dioramas of deep-sea exploration, a lunar base, and a climate-forecasting outpost in the Antarctic.

In the summer of 1969, NASA invited Edward C. Wortz—a project scientist in the Garrett Corporation's Life Sciences Department in Torrance, California—to develop a research initiative on habitability. This project would complement Wortz's ongoing efforts to develop life-support systems for long-term manned space missions. Wortz invited artists Robert Irwin and James Turrell, along with select colleagues, to discuss the framework for the initiative. The group decided to organize a series of professional and industry-related talks as part of the First National Symposium on Habitability.[1]

From 11 to 14 May 1970, twelve researchers from a variety of disciplines, including architecture, urban planning, psychiatry, and systems engineering, presented papers that responded to two questions: "What factors influence the perception of life quality and what sets of conditions are necessary for well being and satisfaction?"[2] The symposium was not a traditional academic gathering, however; instead it combined discussions of theory with practice as participants were invited to consider how habitability might be defined.

Irwin transformed his recently acquired studio on Market Street in Venice into an immersive environment. He began by painting the walls pure white and removing a studio wall. He then installed floor-to-ceiling white cardboard tubes that blocked out sound and light. Conference participants found themselves "inside a space capsule with no awareness of the outside world at all."[3] Over the following days, Irwin gradually opened up the studio space to the outside environment. On the second day, he replaced the tubes with translucent fabric that let in light and sound; on the third day, he exposed the studio to the street, allowing passersby to wander in unhindered.

Invited speakers were seated in the center of the room facing one another, their chairs arranged on top of a raised cardboard platform. Audience members, meanwhile, balanced precariously on low, narrow bleachers made from corrugated cardboard. The seating was intentionally uncomfortable because Irwin wanted to challenge some of the conventions of human habitability.

In addition to the main conference space, nearby artists' studios were used as spaces for discussion. Each room presented a specific habitability challenge: one room was too small, another too big; one was too bright, another too dark. Artist Larry Bell had been working on two room environments in his studio across the street, which he made available for the symposium. The first was a highly reverberant room, and the second was a black room illuminated by a single electrical bulb—an environment that the researchers found too hostile for their work.

In the First National Symposium on Habitability, Irwin drew on his experiences with the Los Angeles County Museum of Art's Art and Technology program to involve participants and audiences in a concrete experience of how environment conditions the perception of habitability. With the symposium, Irwin arguably created his first site-generated perceptual environment, several months before he produced a foundational Light and Space installation for the Museum of Modern Art in New York.

Robert Irwin transforming his studio into the venue for the First National Symposium on Habitability, 1970. Art © 2011 Robert Irwin / Artists Rights Society (ARS), New York. Image courtesy Larry Bell.

Robert Irwin (American, b. 1928). Installation of *The First National Symposium on Habitability*, 1970. Photo by Malcolm Lubliner (American, b. 1933). Courtesy Malcolm Lubliner and Craig Krull Gallery, Santa Monica. Art © 2011 Robert Irwin / Artists Rights Society (ARS), New York.

Notes

1. Turrell later withdrew from the collaboration when he ended his participation in the Los Angeles County Museum of Art's Art and Technology program.

2. Edward Wortz, ed., *First National Symposium on Habitability* (Los Angeles: Garrett AiResearch, 1970), 1.

3. Robert Irwin, interview by Jennifer Winkworth and Andrew Perchuk, 14 October 2004, Pacific Standard Time collection, Getty Research Institute (2010.M.4).

Figure 4.38.
Bruce Nauman (American, b. 1941). *Green Light Corridor*
(interior), **1970.** Painted wallboard, fluorescent light fixtures
with green lamps, dimensions variable, approximately:
3 m × 12.2 m × 30.5 cm (10 × 40 × 1 ft.). New York, Solomon R.
Guggenheim Museum. Art © 2011 Bruce Nauman / Artists Rights
Society (ARS), New York. Photo © Giorgio Columbo, Milano.

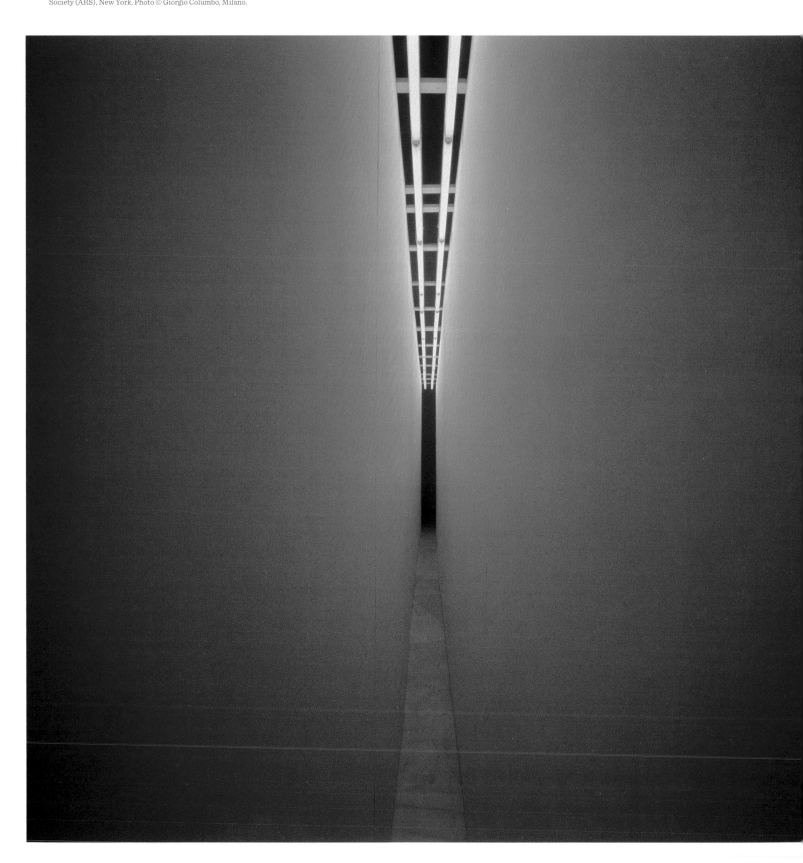

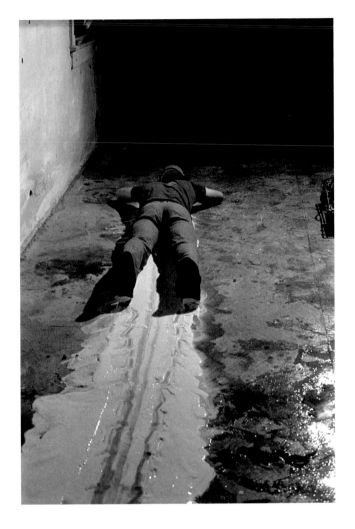

Figure 4.39.
Wolfgang Stoerchle (German, 1944–1976). Stills from *Untitled Video Works*, 1970–72. Single-channel videos, black and white, sound, 62 min., 30 sec. Los Angeles, Getty Research Institute, 2006.M.7 (A.Stoe).

Figure 4.40.
Paul McCarthy (American, b. 1945). Still from *Face Painting Floor, White Line*, 1972. Performance and video. Videographer: Mike Cram.

overlooking the ocean at the La Jolla Museum of Art in 1970, the work offered viewers a powerful experience of the afterimages.

The breadth of Nauman's prolific sculptural output created a context in which his experiments with film and video were also viewed as sculptural investigations—not only when they were integrated into installations but even when they were shown simply on a video monitor. Nauman's corridors provided a controlled perceptual and bodily experience that any viewer could choose to undergo; his films and videos depicted Nauman devising his own experiences or concentrating on tasks that he had assigned himself. But, like Barry Le Va running into walls in *Velocity Piece #1,* Nauman documented processes of exploring the body and space—topics that were closer to current sculpture than to cinema or television. In Los Angeles, young artists such as Wolfgang Stoerchle and Paul McCarthy began using video in a similar fashion, placing themselves in situations that required degrees of struggle and concentration in order to complete predetermined tasks (figs. 4.39, 4.40).

IDEAS FROM PROCESS-BASED SCULPTURE and the perceptual environments of Light and Space art found corollaries in painting in the late 1960s and early 1970s. During this era, many Southern California artists produced paintings whose imagery was not created solely by the application of paint on canvas but instead resulted from a process or action that was performed upon the work. To produce his *Constructed Paintings* of 1970 and 1971, Allan McCollum took strips of canvas that had been bleached or dyed and used adhesive caulking to assemble the strips into variegated canvas mosaics that could be stapled directly to the wall. For Joe Goode's *Torn Clouds*, begun in 1971, pretty painted canvases of clouds and skies were ripped and torn away in some areas, often revealing other painted cloud scenes underneath. For his *Shotgun* series that followed (1978–83) Goode fired a shotgun at monochrome canvases from varying distances. Sometimes the scattered buckshot punctured the work; sometimes it merely grazed the surface of the canvas, revealing additional layers and colors of paint.

Many artists worked new materials into their process-based paintings. Mary Corse incorporated reflective glass microspheres into her *White Light* paintings. The softly glowing light refracted from the microspheres shifts as the viewer changes position, thus activating the viewer's awareness of space in a manner similar to Light and Space environments. In his resin paintings from the early 1970s, Ed Moses used strings saturated with powdered pigment to snap lines across a piece of unstretched canvas. The work was then submerged in a puddle of resin that extended beyond the edges of the canvas, creating new edges for the resin-encased object. In the most extreme of these experiments, Moses used only string and resin, thus doing away with both paint and canvas entirely.

For Richard Jackson, the process of painting began to border on performance. To produce his *Wall Paintings,* which he began making in the late 1960s and is still working on, Jackson thickly applies paint in garish hues to a stretched canvas, presses the wet canvas directly against a wall, and then pulls and rotates the canvas along the wall, leaving smears of paint behind. The canvas, still pressed against the wall with the stretcher bars facing the viewer, is then nailed down and left to dry in place. The *Wall Paintings* typically involve multiple canvases whose final resting places on the wall abut one another in neat geometric formations, presenting dizzying pinwheels of action painting in which front becomes back, canvas becomes brush, wall becomes canvas, painter becomes performer, and painting itself lies somewhere between gesture and remnant.

Mary Corse (American, b. 1945). *Untitled (White Light Grid Series-V),* **1969.** Glass microspheres in acrylic on canvas, 274.3 × 274.3 cm (108 × 108 in.). Dallas, Andrea Nasher Collection. Courtesy Ace Gallery.

Joe Goode (American, b. 1937). *Torn Cloud Painting 73,* **1972.** Oil on canvas, 183 × 243.8 cm (72 × 96 in.). Collection of the artist. © Joe Goode.

Allan McCollum (American, b. 1944). *Pam Beale*, **1971.** Dyed and bleached canvas with caulk,
261.6 × 261.6 cm (103 × 103 in.). St. Louis, Washington University, Mildred Lane Kemper Art Museum,
gift of Anne V. Champ, 1974, WU 4516.

By the beginning of the 1970s, task-based performances like these were proliferating everywhere. In many cases, the conceptual bases for these performance videos were similar to the exploration of basic subjectivity found in the anechoic chamber, and the perception of one's own experiences became the starting point and justification for a startling range of bodily actions. Thus, when Robert Irwin's student Chris Burden confined himself for five days in 1971 inside a locker measuring 2 by 2 by 3 feet—with access only to a 5-gallon jug of water in the locker above him and an empty 5-gallon bucket in the locker below—he was, in a way, creating his own version of a sensory deprivation chamber. He was also creating the first in a series of extreme bodily performances that would dominate his practice for the first half of the 1970s, eventually leading him to be, among other things, drowned, electro-shocked, crucified, and, of course, shot.

A PERSONAL AND POLITICAL ART

Perceptual environments and task-based performances were founded on an abstracted and almost scientific conception of human subjectivity: any human with a normally functioning perceptual system would reliably experience a similar range of phenomena. Task-based performances, even when extreme in their content, were still quite neutral or even clinical in their presentation of the artist's choice and execution of an activity. For many artists, however, this was an unbearably narrow conception of human subjectivity. Concurrent with the development of this "sculptural" style of performance art, other artists effected a simple shift in thinking with massive ramifications for the development of art: rather than regarding artists and viewers as generic subjects, some artists began focusing on themselves and their viewers as complex individuals who have specific emotions, opinions, biographies, and stories to tell. Working in stark contrast to the predominant abstractions of phenomenological sculpture, growing numbers of artists began to integrate personal or didactic content into their increasingly politically engaged work.

Considering the turbulent political climate of the later 1960s and early 1970s, it is easy to see why many artists would feel inclined to move away from producing overly detached and abstract art. In nearly every arena, countercultural movements were casting off social norms and conventions in an effort to radically transform society. Protesters mobilized across the country, marching on Washington and the Pentagon to demonstrate against the U.S. military intervention in Vietnam. In Southern California, antiwar activists staged rallies that included sit-ins protesting the employee-recruitment efforts by napalm manufacturer Dow Chemical Company at the campuses of UCLA and Valley State College, and a "lie-in" at the National Guard base in Van Nuys. Meanwhile, "flower children" organized mass "love-ins" in L.A.'s Griffith Park and elsewhere. For both political and personal reasons, many young men did not want to be drafted into the military, and graduate-school enrollments (including those of art schools) swelled with students hoping for a draft deferment. This period of great social change was also a time of uncertainty, and simmering violence came to a boil in 1968 after the assassinations of Martin Luther King Jr. in Memphis and Robert Kennedy at the Ambassador Hotel in Los Angeles.

Domestic civil rights movements gathered momentum throughout the decade. In Los Angeles, tensions that had come to the surface in 1965 during the Watts rebellion continued to build in the later 1960s, and race riots occurred in San Francisco, Oakland, Detroit, and other U.S. cities. The L.A. chapter of the Black Panthers, a radical black-empowerment group, was one of those most active in the country. In 1967, a group of students formed the Brown Berets, a Chicano activist group modeled after the Black Panthers, and planned the Chicano Blow Out, a large-scale strike organized by L.A. Chicano high school students demanding access to quality education.

During this time, artists of color challenged their exclusion from the established L.A. art scene and struggled to define their artistic identities. They developed supportive communities and sought out new opportunities to present their work by founding arts spaces and

experimenting with alternative modes of presentation, such as street performance, billboard art, posters, and murals. A number of alternative arts venues that supported African American artists emerged in the latter half of the 1960s, such as the Watts Writers Workshop, the Watts Towers Arts Center, and the Brockman Gallery. In 1968, Suzanne Jackson transformed her studio into Gallery 32. Over a three-year period, Jackson hosted exhibitions by emerging African American artists such as Emory Douglas, David Hammons, Senga Nengudi, and Timothy Washington and provided a venue for community gatherings as well as fund-raisers for important political and social causes (fig. 4.41).

The Mexican American arts community also developed a number of alternative arts venues during this period. Mechicano Art Center was established in 1969 on La Cienega Boulevard's Gallery Row and moved to East Los Angeles in 1972; it sponsored a mural program, an exhibition space, and poster workshops. In 1972, Self Help Graphics & Art was established in Boyle Heights by artists Carlos Bueno and Antonio Ibanez and Franciscan nun Sister Karen Boccalero; it continues to provide printmaking workshops and support for local artists. Artists of color also developed informal communities and official collectives to support one another by producing work collaboratively. African American artists David Hammons, Maren Hassinger, Ulysses

Figure 4.41.
Emory Douglas (American, b. 1943). Poster for the *See Revolutionary Art* exhibition, Gallery 32, Los Angeles, 1969. 60.6 × 40.5 cm (23⅞ × 15⅞ in.). Los Angeles, collection of the Center for the Study of Political Graphics. © 2011 Emory Douglas / Artists Rights Society (ARS), New York. Image courtesy the Center for the Study of Political Graphics.

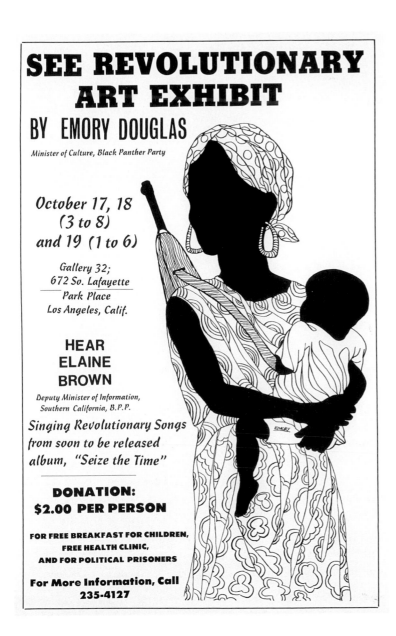

Jenkins, and Senga Nengudi were part of organized collaboratives such as Studio Z and Othervisions Studio. Individually and in concert with one another, they produced spontaneous performances in Los Angeles in the 1970s and 1980s. In 1978, Nengudi initiated Freeway Fets, a collaborative work that took place under a freeway underpass in which Nengudi, Hassinger, and others used dance, music, and costume to explore the transformative power of movement and ritual. The Chicano conceptual performance collective ASCO ("nausea" in English)—which included artists Harry Gamboa Jr., Gronk, Willie Herrón, and Patssi Valdez—staged a number of guerrilla street actions, including spray-painting graffiti on the facade of LACMA after hearing that a curator had made a derogatory comment about Chicano art (fig. 4.42) and hosting a picnic on a traffic island on Whittier Boulevard shortly after a police shooting in the 1970s.

Figure 4.42.
ASCO (American art collective, 1971–1987). *Spray Paint LACMA* (or *Project Pie in De/Face*), 1972. Performance. Photo by Harry Gamboa Jr. (American, b. 1951). © 1972 Harry Gamboa Jr. Courtesy the UCLA Chicano Studies Research Center.

During the late 1960s, a global grassroots environmental movement emerged. In 1968, Stewart Brand first published his influential countercultural tome, *Whole Earth Catalog,* which nurtured a back-to-the-land movement and fueled awareness of the planet and its limited resources. Protesters and citizen groups lobbied legislators demanding laws to protect the environment. California led the way in smog emissions control with a landmark ruling in 1963 that set mandatory emissions standards for all new cars sold in the state. On a national level, the Federal Air Quality Act, Endangered Species Act, and Safe Drinking Water Act were passed in 1967, 1973, and 1974, respectively. Concerns about pollution and air quality began to filter into Southern California art in direct and indirect ways, with some artists participating in environmental protests and others finding in L.A.'s smog-filled air an inspiration for their work (see sidebar 25). By the late 1960s, an "eco-art" movement was under way, and artists such as Newton and Helen Mayer Harrison shifted their practice to deal almost exclusively with ecological issues. In 1972, artist Richard Newton filled the University of California, Irvine, Art Gallery with discarded food he had gathered from dumpsters to create *Beggar's Banquet*

Norman Zammitt (American, b. Canada, 1931–2007). *Buffalo Blue*, 1977. Acrylic paint on canvas, 184.2 × 335.3 cm (72½ × 132 in.). Pasadena, California, Norton Simon Museum, gift of Robert Davidson in memory of Eric Michael Davidson. © Norman Zammitt Estate.

IN 1968, as part of his performance *Fresh Air*, artist Eric Orr gave away what he described as "ten thousand bags" of clean air to pedestrians in Pershing Square in downtown Los Angeles.[1] Pershing Square was an unusual location for an artwork; by the 1960s it had become a magnet for crime, vagrants, and drugs. However, it had an interesting history that may have appealed to Orr. In the 1930s and 1940s, Pershing Square was a popular green oasis that included a pavilion, a fountain, and statues, but by the late 1960s, it had fallen into disuse—a victim of increased automobile traffic, suburbanization, and changing municipal priorities. The park had been partly replaced by a parking garage; what remained was difficult to access and lacked both shade and amenities. Pershing Square's deterioration was one instance among many where car-centric urban planning encroached on Los Angeles's green spaces. The viability of an imagined urban paradise built around the automobile became increasingly untenable in the late 1960s as the region developed a reputation for congestion and all-pervasive smog.

Smog has long been part of the ecology of Los Angeles. Moist, cool air from the ocean flows into a valley surrounded by the Santa Monica and San Gabriel mountain ranges, where it becomes trapped beneath warm air flowing from inland. This "atmospheric inversion" keeps polluted air in the valley from easily rising and dispersing. By the 1940s, smog had become a major environmental hazard in the L.A. basin. On 26 July 1943, "the entire downtown area [was] engulfed by a low-hanging cloud of acrid smoke.... Visibility was cut to less than three blocks in some sections of the business district [and] office workers found the noxious fumes almost unbearable."[2]

First identified in the 1950s, photochemical smog is an especially toxic type of air pollution formed when nitrogen oxides (mostly from automobile exhaust) combine with sunlight to produce a noxious thick brown or orange haze. In the years that followed, California adopted a contradictory stance, enacting some of the nation's most rigorous air quality reforms while simultaneously encouraging dependence on cars through suburban development and disinvestment in mass transit.

While Orr's performance echoed the activism of local organizations such as Stamp Out Smog and People Pledged to Clean Air, other L.A. artists used an aesthetic, rather than political, framework to explore smog in the 1960s and 1970s.

Ed Ruscha's *Hollywood Study #8* (1968) features the Hollywood sign with a crimson backdrop—a direct reference to the region's smog-induced scarlet sunsets, which are produced when particulate pollutants scatter radiation from the sun, enhancing the red in the spectral palette. Norman Zammitt's abstract bands of color in paintings such as *Buffalo Blue* (above) also evoke the photochemical sunsets of Southern California; his rich color progressions mirror the region's frequently saturated skyline.

At the same time that Ruscha was systematically documenting the vast tracts of land dedicated to the automobile in his artist book *Thirtyfour Parking Lots in Los Angeles* (1967), Bruce Nauman was playfully inverting the taxonomy of Ruscha's studies of Los Angeles's vernacular architecture with his artist books *Clear Sky* (1967–68) and *L A AIR* (1970). Close inspection of the works in *L A AIR* reveals that five double images of cloudless blue skies range in hue from blue-gray to ultramarine, and a series of colorful images of Los Angeles's toxic stratosphere are not photographs documenting air quality after all; rather, they are pages of colored ink produced through an offset printing process.

A political catalyst and creative muse, Los Angeles's notorious air has been the subject of activism, legislation, and—at times—creative admiration. The shared experience of smog has animated Southern California environmentalists and encouraged artists to explore environmental themes through innovative pop, abstract, conceptual, and performance artworks.

Notes
1. Elizabeth Orr, "Eric Orr: Resume and Biography," date unknown.
2. "City Hunting for Source of Gas Attack," *Los Angeles Times*, 27 July 1943, 1.

(fig. 4.43). This early example of environmental art was dismantled a week later after authorities intervened and insisted the rotting debris be removed.

The women's movement and the gay liberation movement broadened their bases during this period, with Southern California becoming a major center of feminist activity. The first feminist theater groups were formed in Los Angeles and New York in 1969. The First National Lesbian Conference was organized in Los Angeles in 1973. International in scope, the women's movement would have a vast impact on the course of both art and politics in many parts of the world. By the end of the 1960s, a number of artists throughout Southern California had begun to deal with feminist issues in their art. However, one of the most important developments in this direction would begin in Fresno, a small city set amid the farms of California's San Joaquin Valley, 200 miles north of Los Angeles.

When Judy Gerowitz was hired to teach at Fresno State College (now California State University, Fresno) in the spring of 1970, she had already developed an impressive body of work that associated her with Finish Fetish, minimalism, and Light and Space environments. Her plywood-and-painted-canvas structure *Rainbow Pickett* (1966) had been included in the important *Primary Structures: Younger American and British Sculpture* exhibition at New York's Jewish Museum in 1966, and in the ensuing years she began working with molded plastics, acrylic (see fig. 3.38), and back-painted Plexiglas. Gerowitz had always directly confronted the widespread sexism she encountered as a woman artist, and her political voice grew stronger as the sixties progressed. After teaching a course in site-specific sculpture during her first semester in Fresno, Gerowitz successfully lobbied to create a new course of study for women artists only.

Figure 4.43.
Richard Newton (American, b. 1948). *Beggar's Banquet*, 1972. View of installation at the University of California, Irvine. © Richard Newton.

What would eventually become the country's first feminist art program was advertised on campus as an all-female sculpture class requiring admissions interviews. In the summer of 1970, Gerowitz legally changed her surname to that of her birthplace, Chicago, placing an advertisement in the October issue of *Artforum* that read: "Judy Gerowitz hereby divests herself of all names imposed upon her through male social dominance and freely chooses her own name: Judy Chicago."

The feminist class began that fall. The group paid for its own large off-campus studio, with the students learning (among other things) to renovate the space and build walls. Chicago's pedagogical approach was radically different from typical art-school methods and incorporated elements of consciousness-raising groups within a curriculum that was deeply engaged with feminist thought. The class discussed issues facing women, and students were encouraged to speak about highly personal matters related to sex, discrimination, and abuse. Chicago developed a women-centered art history, and the students familiarized themselves with female authors. Class assignments developed around the topics that emerged in group discussions, with students allowed to work in any medium. Performance became a classroom tool, as students approached difficult subjects through role play and performative actions. The students approached sexuality and body imagery, political topics, and personal subjects with frankness, experimenting with many of the approaches that would drive feminist art practice for the rest of the 1970s. Students did not shy away from expressing rage or resorting to violent or bloody imagery in their projects, as Faith Wilding recounts in a journal entry dating from her time in the class:

> Some of us make daily visits to a nearby slaughterhouse, watching mesmerized as the cow is stunned, her throat slit, the hot blood we have come for in the buckets. This is violent territory, a place of daily death and sacrifice as hidden from public life as are our own lives as women. We carry the buckets of steaming blood back to the Women's Studio where we first have to thoroughly comb through it with our hands pulling out the already coagulating strands so that the blood will remain liquid. Cherie [Cheryl Zurilgen] makes blood paintings, pouring the blood all over large pieces of paper and canvas on the wall, then mingling it with charcoal and paint. We take film cameras and tape recorders to the slaughterhouse, and bring back documentation to make *Slaughterhouse,* a blood sacrifice performance that is witnessed by invited guests from the Fresno college community. The performance imitates ritual sacrifice and male domination of women and animals: We project sounds and images of the slaughterhouse on the body of a young woman [Faith Wilding] dressed in a white gown who is tethered to a milking machine from which she "milks" pitchers of blood at the instigation of a "cowhand" [Cheryl Zurilgen]. Later she is suspended from a meat hook by her bound hands. Buckets of blood are thrown over her by the booted "cowhand." Sounds of bellowing cows rip through the space, as images of strung up cows play over the bloodied woman. The sickly smell of fresh blood pervades everything. Later, Cherie and I meet in the bathroom and try to comb coagulated blood out of our hair, and we're both crying and hugging hysterically.[41]

In the fall of 1971, the program moved to California Institute of the Arts (CalArts) as the Feminist Art Program (FAP), which continued under the codirection of Chicago and Miriam Schapiro. Paula Harper taught art history the first year, followed by Arlene Raven the second. Deena Metzger taught women's writing, and Sheila de Bretteville began the new Feminist Design Program. Nine of the fifteen Fresno students, including Vanalyne Green, Suzanne Lacy, and Faith Wilding, transferred to FAP or the Feminist Design Program. Chicago taught a highly influential performance workshop in which she encouraged women to act out parts of their lives. Her unconventional class projects included *Route 126,* an exercise in which Chicago and her students set off from CalArts for the coast, stopping at various points along the way to stage impromptu performances that had to be identifiable in some way as having been done by a woman. Suzanne Lacy recalls how she and other students transformed an old jalopy with pink

Figure 4.44.
Suzanne Lacy (American, b. 1945). *Car Renovation*, 1972.
Traveling project. Photo by Suzanne Lacy.

paint and red velvet into a "woman-renovated car" (fig. 4.44), and Nancy Youdelman draped herself in flowing scarves like Isadora Duncan and walked into the ocean until she disappeared.[42]

FAP's major accomplishment during this period was *Womanhouse* (1971–72), an "art environment addressing the gendered experiences of women."[43] During the fall of 1971, faculty and students transformed an abandoned Hollywood mansion into an exhibition space. The traditional relationship between women and the home was disrupted, as participants unfamiliar with construction found themselves wielding power tools, putting up drywall, and painting and glazing windows. Each woman was assigned a portion of the house, where she worked in collaboration or individually to create art that explored the female experience. *Womanhouse* opened for public viewing in 1972, and for just under a month, thousands of visitors flocked to the site to see installations and attend evening performances. The diverse array of works generated by artists associated with the project included Wilding's *Crocheted Environment,* in which the artist undermined the traditional gender-inflected division between craft and high art by hanging a massive abstract crochet work from the ceiling of a 9-by-9-foot room (fig. 4.45); Vicky Hodgett's and Robin Weltsch's critique of the traditional role

Figure 4.45.
Faith Wilding (British/Paraguayan, b. 1943). *Crocheted
Environment*, 1972. From the *Womanhouse* installation,
1971–72. California Institute of the Arts Library (Visual Resource
Collection).

of woman as nurturer and caregiver in their *Womanhouse* installations, in which the artists
placed plastic fried eggs and plastic breasts on the ceiling and walls of a flesh-pink kitchen,
demonstrating how the female body becomes literally edible (fig. 4.46); and *Birth Trilogy*, a col-
laborative affirmation of female power in which the artists—Judy Chicago, Kathy Huberland,
Judy Huddleston, Sandra Orgel, Christine Rush, Faith Wilding, Shawnee Wollenman, and Nancy
Youdelman—symbolically gave birth to one another.

Visceral imagery of the type that Faith Wilding and Cheryl Zurilgen had explored in
Slaughterhouse continued to surface in the work of feminist artists in Los Angeles, placing their
work in dialogue with earlier performances by Carolee Schneemann and the Viennese action-
ists, as well as other L.A. artists, such as Paul McCarthy, who were undertaking their own inves-
tigations into abject subject matter. In *Ablutions* (1972), Judy Chicago, Suzanne Lacy, Sandra
Orgel, and Aviva Rahmani joined raw, biting imagery to clearly articulated political content,
taking on the subject of rape. Throughout the work, which was presented at Guy Dill's studio in
Venice as part of an FAP workshop on performance art, an audiotape was played of women
recounting stories of being raped. Eggshells littered the floor, and a nude woman sitting in a

chair was slowly bound, mummylike, in gauze. Three tubs in the center of the space were filled with eggs, blood, and clay, and two nude performers bathed themselves one after the other in each tub. Meanwhile, a woman methodically nailed beef kidneys to the wall around the perimeter. Toward the conclusion of the event, two clothed women entered the space and tied up the other performers with rope (fig. 4.47).

The individual repetitive tasks performed in this work share qualities with the task-based performances seen in early videos by Bruce Nauman and Paul McCarthy. But by focusing on multiple actions and multiple performers and by presenting the actions in conjunction with bloody imagery and the horrifying real-life stories recounted in the taped interviews, the performance commanded audience members to turn their thoughts and emotions toward an urgent societal problem. Rather than specifically taking the nature of art or perception as its subject matter—as so much sculpture and performance art had done recently—*Ablutions* made use of those expanded definitions of art in order to create a new tool for educating and politicizing its viewers. (See chapter 5, sidebar 27.)

Figure 4.46.
Robin Weltsch's *The Kitchen* and Vicky Hodgett's *Eggs to Breasts,* **March 1972.** From the *Womanhouse* installation, 1971–72. Los Angeles, Getty Research Institute, 2000.M.43.

Figure 4.47.
Judy Chicago, Suzanne Lacy, Sandra Orgel, Aviva Rahmani.
Ablutions, **1972.** Performance in Venice, California, June 1972.
Photo by Lloyd Hamrol (American, b. 1937).

In doing so, feminist art effected its own radical redefinition and reorientation of artistic practice, opening it up to narrative and didactic content and to personal and political ideas. Artists such as Eleanor Antin, Nancy Buchanan, Martha Rosler, and Barbara T. Smith began incorporating fictional, political, or autobiographical narrative into their work, drawing on genres of mass media that could not successfully have been referenced by "serious" art even a few years earlier. The change was infectious. McCarthy's performances began to evolve into fictional personas, and by 1972 most video artists in Los Angeles had begun incorporating dialogue or narrative into their works. Hollywood, so rarely referenced by L.A. artists despite (or per- haps because of) its proximity, increasingly became a source for artists who were beginning to analyze, and sometimes attack, its powerful manipulations of image and meaning.

POST-STUDIO, POSTMODERN

CalArts was in only its second year of existence when the Feminist Art Program moved there.[44] Miriam Schapiro's husband, Paul Brach, had been hired as dean, and Allan Kaprow as associate dean. The remarkable ambitions of CalArts had a driving impact on Southern California art. The school purchased twenty-six Portapak video cameras for students and faculty to use (at a time when the cameras cost as much as a sensible new car) and hired Nam June Paik to teach the new medium. John Baldessari was hired to run a "post-studio art" course for "students who don't paint or do sculpture or any other activity done by hand."[45] There was an active visiting- artist program that brought in important figures from New York and Europe to meet the stu- dents and present new work, sometimes creating new installations on campus. Graduates from the early years of the school include Barbara Bloom, Ross Bleckner, Troy Brauntuch, Eric Fischl, Jack Goldstein, Matt Mullican, David Salle, and James Welling.

New arts programs at the University of California, San Diego, and the University of California, Irvine, were equally ambitious in recruiting top faculty and students, leading to a remarkable period of contact and exchange. Art schools were the best sites for arts communi- ties in the 1970s, since dematerialized and ephemeral forms of art were difficult to exhibit and sell within traditional gallery and museum settings. The artists producing these works found a special home within art schools, and teaching became a primary source of financial support for many artists, who in turn trained students in similar conceptually based practices. Those same difficult forms of dematerialized art, however, played a significant role in the globalization of the art world. Freed from the enormous expense of shipping and insuring paintings and sculp- tures, artists sent videotapes or instructions through the mail, or simply got on a plane to create works on-site or to make performances. And just as L.A. art schools were constantly hosting visiting artists from around the world, L.A. artists were themselves traveling the new circuit. The growth of art fairs in Europe and international exhibitions such as *Documenta,* in Kassel, Germany, provided opportunities to set up direct lines of communication between Los Angeles and Europe, bypassing the New York institutions that had often served as gatekeepers. Learning how this system worked became part of an artist's training. In his post-studio classes, Baldessari was particularly intent on teaching his students about the art world as a system. He took students on frequent trips to visit galleries, private collections, and artists' studios and made sure they had access to the art magazines and journals that were becoming the main dis- tribution sources of new work.

Baldessari had a particular talent for stepping back and taking in a situation as a system of rules and relationships. In his works from the late 1960s, he had examined the clash between old and new conventions for art making, delighting in conceptual paradox. After arriving at CalArts, Baldessari stepped back farther, examining art-school pedagogy and the logic of success and failure in the art world as a market and social system. In *Ingres and Other Parables,* he devised ten photo-illustrated parables about contemporary art, each complete with a moral (fig. 4.48):

THE BEST WAY TO DO ART

A young artist in school used to worship the paintings of Cezanne. He looked at and studied all the books he could find on Cezanne and copied all of the reproductions of Cezanne's work he found in the books.

He visited a museum and for the first time saw a real Cezanne painting. He hated it. It was nothing like the Cezannes he had studied in the books. From that time on, he made all of his paintings the sizes of paintings reproduced in books and he painted them in black and white. He also printed captions and explanations on the paintings as in books. Often he just used words.

And one day he realized that very few people went to art galleries and museums but many people looked at books and magazines as he did and they got them through the mail as he did.

Moral: It's difficult to put a painting in a mailbox.

Baldessari stepped back farther. So much of what we learn about both art and the world occurs through the circulation of images—photographs and reproductions in newspapers, on television, in movies. How do we make meaning from the images we see? He began working with sequences of images to show that most pictures are not self-sufficient; they operate in tandem with our collective cultural knowledge and can be recontextualized in countless ways to change their meaning. Baldessari's videotapes starring Ed Henderson from 1973 and 1974 allow sequences of film stills and newspaper photos to spin off into new narratives based on

Figure 4.48.
John Baldessari (American, b. 1931). *Ingres and Other Parables* (detail), 1971. Ten black-and-white photographs and ten typewritten sheets, each photograph: 20.3 × 25.4 cm (8 × 10 in.); each sheet: 27.9 × 21.6 cm (11 × 8½ in.). Private collection. Courtesy the artist.

Henderson's imaginative fluencies in pop culture.[46] Baldessari turned to the language of cinema in concurrent photographic works to analyze and question our notions of narrative structure and meaning.

How do images function? How do they affect our behavior? These were questions that Baldessari's students studied well, but in the early 1970s, these ideas were barely a blip on the artistic radar. Nonetheless, they were bubbling up across L.A.'s distributed field. Though many of the artists during this era intended to trigger perceptual and bodily experiences, other artists focused on triggering associative experiences in viewers based on their internalized knowledge of mass culture. In 1969, Allen Ruppersberg created a weekly pop conceptualist diner called *Al's Cafe,* which was simultaneously sculpture, environment, and performance (figs. 4.49, 4.50). The décor was designed to make the space indistinguishable from countless diners across

Figure 4.49.
Allen Ruppersberg (American, b. 1944). *Al's Cafe,* 1969.
Installation at 1913 West Sixth Street, Los Angeles, California.
Courtesy the artist.

America. Ruppersberg acted as both host and chef, serving up dishes of sculpture instead of food: "Simulated Burned Pine Needles a la Johnny Cash Served with a Live Fern" and "Fillet of Southern California Beach." In later works, Ruppersberg began to remove information, leaving more and more for the viewer to fill in. Sequences of photos and texts would suggest, but never quite achieve, narrative. He studied Houdini and produced several works riffing on the great escape artist and the subject of disappearance. The massive photo/text work *Where's Al?* suggested that Ruppersberg himself had disappeared (figs. 4.51, 4.52). In *Greetings from L.A.: A Novel* (1972), Ruppersberg produced a novel whose pages were blank, except for three pulpy fragments redolent of a sultry Hollywood novel—all that was needed to convey a full impression of the book.

Bas Jan Ader and William Leavitt moved in a similar direction. Ader's postcard *I'm Too Sad to Tell You* (1970) and its related film from 1971 show the artist sobbing, seemingly desperate, his lack of context overpowered by an abundance of melodrama (fig. 4.53). The photograph *All My Clothes* depicts just that, scattered across the roof of Ader's Claremont home (fig. 4.54). Is this a comedy or tragedy? Both works appear to be fragments from a narrative not fully recounted. Leavitt began to produce sculptural tableaux that were filled with arrested narrative

Mankind needs more than ever the healing value of contact with nature in its sublimest forms, as exemplified by these Redwood forests."
—JOHN C. MERRIAM

AL'S CAFE

FROM THE BROILER------------------

#1 TOAST AND LEAVES--------------------------$1.25

#2 DESERT PLATE WITH PURPLE GLASS-------------$5.00

#3 SIMULATED BURNED PINE NEEDLES A LA
 JOHNNY CASH SERVED WITH A LIVE FERN-------$3.00

SALADS----------------------------

#1 CHEF'S SALAD BOWL WITH CRACKERS-----------$2.00

#2 JOHN MUIR SALAD (BOTANY SPECIAL)----------$2.50

#3 SLICED BARK------------------------------$1.00

#4 LOUIE, LOUIE "ALWAYS A DELIGHT"-----------$.98

DESERTS---------------------------

#1 COTTON COVERED WITH STAR DUST-------------$1.00

#2 A DISH OF BUBBLE GUM AND RAISINS----------$1.00

#3 SMALL DISH OF PINE CONES AND COOKIE-------$1.50

#4 A MENU-----------------------------------$1.25

BEVERAGES----------------------

COFFEE---------------------------------------$.15

BEER---$.45

COKE---$.20

FOSSILES ARE EXTRA ON ALL MEALS
NO SUBSTITUTIONS, PLEASE
 MENU SUBJECT TO CHANGE WITHOUT NOTICE

AL SUGGESTS--------------------

#1 THREE ROCKS WITH CRUMPLED PAPER WAD-------$1.75

#2 ROCK VARIETIES SMOTHERED IN PINE NEEDLES--$2.25

#3 GRASS PATCH WITH FIVE ROCK VARIETIES
 SERVED WITH SEED PACKETS ON THE SIDE------$2.50

#4 ANGELES NATIONAL FOREST SPECIAL
 "A GOURMET'S DELIGHT"---------------------$3.00

SANDWICHES--------------------

#1 B.L.T. -- BRANCHES, LEAVES, AND TWIGS
 ON LAQUERED PINE BOARD--------------------$2.00

#2 PATTI MELT -- PATTI PAGE PHOTO (OR
 REASONABLE FACSIMILE) COVERED WITH
 TOASTED MARSHMELLOWS----------------------$2.00

#3 DOUBLE DECKER----------------------------$1.50

#4 AL'S BURGER -- SKY, LAND, AND WATER-------$1.75

#5 AL'S SUPER BURGER -- SKY, LAND, WATER &
 PHOTO---$2.25

SEAFOODS----------------------

#1 DISTILLED WATER AND BEACH SAND-----------$1.50

#2 SEA SHELLS AND PINTO BEANS
 SERVED WITH A MOUND OF COTTON-------------$2.50

#3 FILLET OF SOUTHERN CALIFORNIA BEACH-------$2.75

AL'S CAFE 1913 WEST SIXTH STREET LOS ANGELES, CAL.
OPEN THURSDAY 8:00 P.M. TO 11:00 P.M.
 WE WELCOME PARTIES

 NOT RESPONSIBLE FOR STOLEN ARTICLES
WE RESERVE THE RIGHT TO REFUSE SERVICE TO ANY ONE

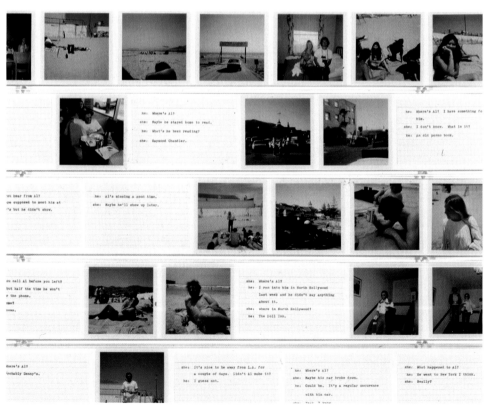

Figure 4.51.
Allen Ruppersberg (American, b. 1944). *Where's Al?*, 1972.
160 chromogenic color prints with 110 typewritten index cards,
dimensions variable. Courtesy the artist.

Figure 4.52.
Allen Ruppersberg (American, b. 1944). *Where's Al?* (detail),
1972.

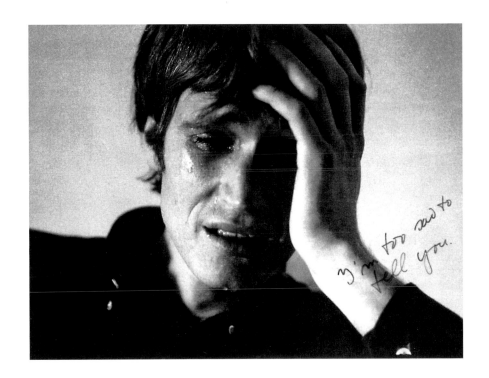

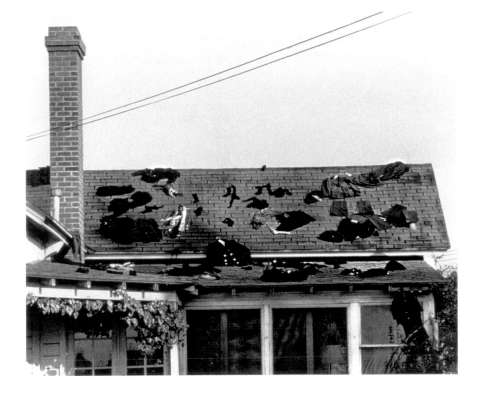

Figure 4.53.
Bas Jan Ader (Dutch, 1942–1975). *I'm Too Sad to Tell You,*
1970. Gelatin silver print, 49 × 59 cm (19¼ × 23¼ in.). Edition of 3.
© Bas Jan Ader Estate, courtesy Bas Jan Ader Estate, Mary Sue
Ader-Anderson, and Patrick Painter Editions.

Figure 4.54.
Bas Jan Ader (Dutch, 1942–1975). *All My Clothes,* **1970.** Gelatin
silver print, 28 × 35.5 cm (11 × 14 in.). Edition of 3. © Bas Jan Ader
Estate, courtesy Bas Jan Ader Estate, Mary Sue Ader-Anderson,
and Patrick Painter Editions.

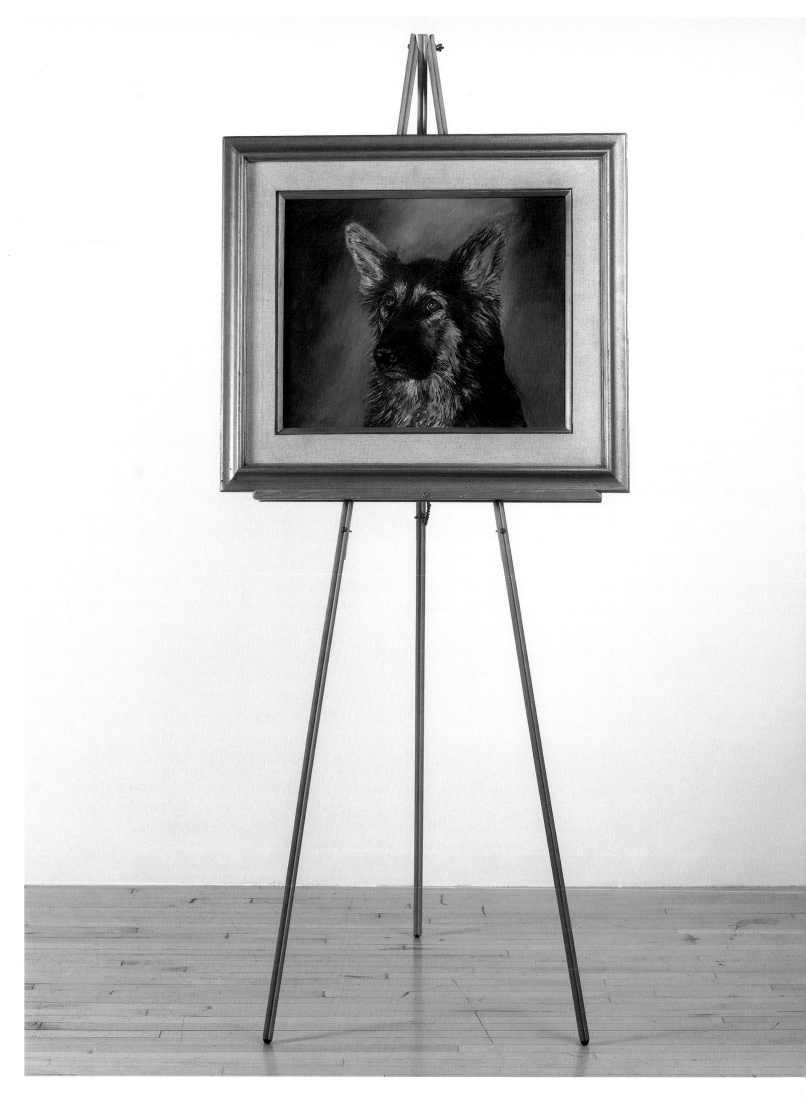

potential. *Gothic Curtain* (1970–71) consists of two curtains joined in a corner; the installation is paired with a sound track of rain and thunder obtained from a Hollywood sound-effects library. *Painted Image* transforms a painting of a German shepherd into a sculpture by placing it in a kitschy gold frame on an easel, evoking an entirely other art world of paintings sold at county fairs or on beach boardwalks—environments far removed from the museums and galleries in which so many artists aspired to exhibit (fig. 4.55). *Stage* is a low wooden platform lit by two standing spotlights, a sliver of stage filled with pure but absent potential (fig. 4.56).

Very few curators were yet sensitive to the importance of artists like Leavitt and Ader. One exception was Helene Winer, who after working as a curatorial assistant at LACMA in the mid-1960s returned to Los Angeles in 1970 following several years as assistant director of London's Whitechapel Art Gallery. In the fall of 1970, she became director and curator of the Gladys K. Montgomery Art Center at Pomona College, replacing Hal Glicksman, under whose extraordinary one-year tenure the center had hosted Michael Asher's major project (see figs. 4.15, 4.16, 4.17); installations and environments by Judy Chicago, Ron Cooper, Tom Eatherton, and Lloyd Hamrol; and the first museum exhibition of Chicano graffiti. Winer continued this energetic drive, giving Jack Goldstein (see sidebar 26) and William Wegman their first solo shows and mounting important early exhibitions of work by Ader, Leavitt, and Ruppersberg, as well as Leavitt's seminal *California Patio* of 1972. Baldessari recalls making the long trip in his Volkswagen bus from Valencia to Claremont—cities on the far peripheries of Los Angeles County—to see Winer's shows: "She would show work no one else was interested in. For every one of her shows I would load up students and take them out to Claremont."[47] A performance by Wolfgang Stoerchle in March 1972 ended with the artist urinating on a strip of carpet—a provocation that, in the context of other simmering tensions between the college administration and its arts programs, set off a chain of events that culminated with Winer being fired that November and the entire art faculty resigning the following spring.

Winer moved to New York, taking over the direction of Artists Space, where in 1977 Douglas Crimp organized the exhibition *Pictures,* including the work of CalArts transplants Jack Goldstein and Troy Brauntuch, along with that of other young artists, such as Sherrie Levine and Robert Longo. In a 1979 elaboration of his earlier catalog essay, Crimp theorized that these artists were producing a new type of work based on transposing the dominant phenomenological ideas of 1960s sculpture, via performance, into static or nearly static images: "If many of these artists can be said to have been apprenticed in the field of performance as it issued from minimalism, they have nevertheless begun to reverse its priorities, making of the literal situation and duration of the performed event a tableau whose presence and temporality are utterly psychologized."[48]

What is now referred to as the "pictures generation" would become a driving force within the art world and its incipient debates about postmodernism in the late 1970s. Yet many of those developments had happened in miniature several years earlier in Los Angeles, at a time when almost no one could see their potential. As Los Angeles moved into the middle of the 1970s, the art community there found itself at a crossroads. Many artists found more receptive audiences for their work outside of California, while others felt an urgent need for new types of spaces that could respond to new artistic developments in danger of going unnoticed.

Figure 4.55.
William Leavitt (American, b. 1941). *Painted Image,* 1972. Oil on canvas; wood easel: 167.6 × 85.1 cm (66 × 33½ in.); painting: 61.6 × 71.8 cm (24¼ × 28¼ in.). Los Angeles, Museum of Contemporary Art. Purchased with funds provided by John Baldessari. Courtesy William Leavitt.

Figure 4.56.
William Leavitt (American, b. 1941). *Stage,* 1971. Mixed media, 152.4 × 243.8 × 183 cm (60 × 96 × 72 in.). Collection of the artist. Courtesy William Leavitt.

Jack Goldstein (American, 1945–2003). Stills from *The Portrait of Père Tanguy*, 1974. 16 mm color film, 4 min. Courtesy Galerie Daniel Buchholz, Cologne / Berlin, and the Estate of Jack Goldstein.

BY THE TIME Jack Goldstein made his short film *The Portrait of Père Tanguy* in 1974, he had been deeply involved in the Los Angeles art scene for some time. Though he was born in Montreal, Goldstein graduated from L.A.'s Hamilton High School, did his undergraduate studies at Chouinard Art Institute, and went on to receive his MFA from California Institute of the Arts (CalArts) in 1972. (CalArts took over and absorbed Chouinard in 1970.) From around 1970 onward, Goldstein worked his way through a succession of artistic approaches: stacking or arranging simple materials (wood planks, cement slabs) in a minimalist or postminimalist idiom; executing performance pieces in his studio or outdoors, often along L.A. streets and highways; and making short films that were usually no more than a few minutes long. Many of these films captured simple, often repetitive actions and their effects, thus signaling their indebtedness to contemporary video work by such artists as Bruce Nauman, Vito Acconci, and Goldstein's CalArts teacher John Baldessari. *The Portrait of Père Tanguy* takes its place among other films of this type, yet it also marks a new direction emerging in Goldstein's body of work. A transitional work, it manifests Goldstein's connection to the art being made in Los Angeles at the time while anticipating some of the concerns that would come to characterize the art of his generation and raising questions about what it means to call something "Southern California art."

The film opens with a title card, followed by a dissolve onto a white field under which a hazy rectangle made up of multicolored forms is visible. It's not clear exactly what this is. A hand grasping a common felt-tip pen soon comes in from the right. It begins to trace the forms beneath the sheet, the pen making a scratching sound as it moves across the paper. First two eyes appear, then a nose and mouth, then a moustache, beard, ear, and hat—until a man's face comes into view. The tracing continues, and viewers see that the man is seated, with his hands crossed in his lap. As the film progresses, more forms emerge on the wall behind the man, although these are more difficult to decipher; they may be figures or faces, it is not entirely clear. Once the hand finishes outlining the rectangular border around these forms, it disappears off screen. A few seconds later, the sheet begins to move downward, pulled by an unseen hand. Slowly, the image under the tracing is revealed: it is Van Gogh's memorable portrait of Julien Tanguy, the paint salesman who was friend to and supporter of major impressionist and postimpressionist painters.

The simplicity of Goldstein's film belies the complex set of references it offers. Goldstein clearly has pedagogy on his mind: the act of tracing a painting recalls an age-old practice in academic art instruction of copying from the masters, whether working from plaster casts in an academic

studio or from original art in a museum collection. Similarly, the film likely references earlier works by Baldessari that had evoked the schoolroom, including the black-and-white video *I Will Not Make Any More Boring Art* (1971), which showed the artist's hands, in close-up, inscribing the title phrase over and over again on a ruled sheet of notebook paper. Goldstein's invocation of an art student copying a masterpiece may be intended as irony, given that CalArts, and Baldessari in particular, had in the preceding years inaugurated radical innovations in teaching and studying art—innovations that had thoroughly displaced such rote exercises. In the dialectical interplay it presents between drawing and painting, *The Portrait of Père Tanguy* also touches on long-standing artistic debates about the relative merits of line versus color. While for much of its length the film focuses on the black-and-white drawing, it switches to vibrant color for the "reveal"—much like the moment in the film version of *The Wizard of Oz* (1939) when Dorothy opens the door of her drab farmhouse to reveal a Technicolor Munchkinland. This reference to one of the most beloved of Hollywood films is important; at the time, Goldstein was beginning to align his artistic practice as much with Hollywood filmmaking as with minimalist and conceptual art. L.A. artists—not only Baldessari but also Chris Burden and William Leavitt—had already begun to key their work to the power and ubiquity of the mass media, an approach that would be followed by Goldstein and other artists of his generation, many of them fellow CalArts graduates. Again, location was key to this development, because studying and working in the L.A. area put the artists in close proximity, physically as well as conceptually, to the entertainment industry. This was especially true for students at CalArts. The interdisciplinary model that the institution adopted in the early 1970s, when Goldstein was a student there, was largely the brainchild of Walt Disney, an icon of American entertainment culture. Although Goldstein spent large stretches of time in New York beginning in 1974, he would often return to Los Angeles to make his films. There he could draw upon the resources of the movie industry—for trained animals, which he used in his films *Shane* and *White Dove* (both 1975), or for animation and other visual effects that he used in *Metro-Goldwyn-Mayer* (1975) and *Bone China* (1976).

Goldstein's use of color film rather than, say, black-and-white video represented an important aspect of his investigation of the mediated image. In *The Portrait of Père Tanguy*, as in his film *Time* (made the previous year), the color is of a mechanically reproduced image. This provides the dialectical complexity of Goldstein's "reveal": while the color most immediately evokes the powerfully expressive hues that have come to be so strongly identified with Van Gogh's work, they are those of a reproduction

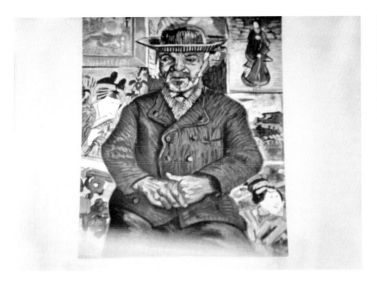

A six-year-old girl using her *Winky Dink and You* drawing kit on her home television as she watches the TV program, 1953. Photo by Walter Sanders/TIME & LIFE Pictures/Getty Images.

rather than of an actual painting. Indeed, the film can be seen as a complex reflection on various types of copying. It shows someone reproducing (copying by hand) a printed reproduction of a painting that is composed in part of "copies" of Japanese prints (which are works produced in series rather than originals). Copies upon copies upon copies: Goldstein is signaling that in his work he is interested not in the concept of the original but in the ubiquitous reproduced images that surround us. Following close on the heels of the pop artists of the 1960s (and of conceptual artists like Baldessari, whose ostensibly language-based works are surprisingly consistent in their use of mechanical reproduction), Goldstein here takes as his primary subjects the reproduced and mediated "image world."

For members of Goldstein's generation, yet another medium, in addition to photography and film, had profoundly shaped their access to and experience of images: television. *The Portrait of Père Tanguy,* with its close-up view of a traced image, may contain a more subtle, perhaps even nostalgic, reference to the way the baby boom generation experienced television as children. For several years in the mid-1950s, CBS-TV ran a popular Saturday-morning children's program hosted by Jack Barry, *Winky Dink and You,* which featured the animated adventures of the title character. In the context of the current discussion, the show is most significant for its interactivity: children were prompted, at various points in the show, to draw on a clear plastic sheet (part of a purchased kit) affixed to the television screen. Although it is difficult to know for sure whether the act of tracing in *The Portrait of Père Tanguy* was a deliberate reference to *Winky Dink*—during Goldstein's childhood in Montreal, American television shows often reached Canadian audiences—in the mid-1970s, that image certainly would have evoked nostalgic memories for Goldstein's peers. At the very least, it calls to mind the enduringly popular genre of television shows that teach simple artistic techniques; such programs were broadcast as early as the 1940s but are now probably most indelibly linked to Bob Ross, the frizzy-haired host of the PBS series *The Joy of Painting,* which aired for twelve years beginning in the mid-1980s.

Perhaps the most important question that *The Portrait of Père Tanguy* raises is this: To qualify as "Southern California art," does a work need to have been made in Southern California? This may sound like a bizarre question, but it is actually a reasonable one. As noted above, Goldstein was an artist with deep roots in the Los Angeles area. He had been trained in some of its most influential art schools, was part of a circle of artists based in the L.A. region, and had shown work at the Pomona College Museum of Art, the Los Angeles County Museum of Art, and other arts venues in the area. However, *The Portrait of Père Tanguy* was made

in 1974, the year Goldstein relocated to New York City with his then partner, Helene Winer; even those who knew him at the time are not sure whether he made the film in New York or Los Angeles. The film's very placelessness is in itself revealing. Goldstein was one of a number of artists of his L.A. cohort—which included Matt Mullican and David Salle—who relocated to New York during this period. One could say (playing on the title of Serge Guilbaut's well-known book on abstract expressionism), that this was the moment when New York stole the idea of California art. The influx of myriad artists from CalArts, as well as Winer's ascent to the helm of the influential nonprofit organization Artists Space, marked a new era in art making that effectively dominated the discourse on contemporary art for at least a decade. It was, then, perhaps an issue less of theft than of colonization. Further, the geographical unfixity of Goldstein's artistic practice can be seen as part of a broader cultural shift. Baldessari's notion of a "post-studio" art, one of the central tenets of his innovative approach to teaching at CalArts, had already undermined the traditional sense of the artist's studio as a site of invention and creation. In the work of Goldstein's generation of artists, the role of place is often less important than an engagement with images and their circulation (which is why those artists have come to be known as the "Pictures Generation"), thus auguring the global flow of information in today's networked world. In this way, Goldstein's work, like that of his contemporaries, marks changes that were occurring not only in the Southern California cultural scene but also in broader conceptions of art and culture.

Chapter Five

HERE, HERE, OR THERE
On the Whereabouts of Art in the Seventies

Jane McFadden

WORKING IN RESPONSE

A two-page meditation by painter Walter Gabrielson on the "aesthetics of flying over Los Angeles" opens the inaugural issue of *Journal,* published by the Los Angeles Institute of Contemporary Art (LAICA) in 1974 (fig. 5.1).[1] Gabrielson's essay might seem an odd way to launch a publication that would become a crucial voice for art history and criticism in Los Angeles in the 1970s and 1980s, but it perfectly captured the far-flung nature of art in L.A., a city marked by sprawling geography and diverse communities. LAICA was both an exhibition space and a publishing initiative founded by artists as "a program that involves all segments of the arts community in its operation, and fosters a new atmosphere of communication and cooperation."[2] That mandate would require the perspective afforded by Gabrielson's bird's-eye view.

In his *Journal* essay, Gabrielson presents flying as a way to get a sense of not only the city's sprawl but also its art. His unorthodox view reflected a wide array of activities by artists who, by the early 1970s, had been experimenting with a variety of sites, mediums, and experiences in art:

> Many times it has been difficult for me to judge whether flying is another variation on the body-macho riff characterized in the L.A. art community by the archetypical Bengston motorcycle number, toying with expensive baubles a la Ruscha or another over-dependence on pseudoscience and lingo via the conceptual or process guys....I have not heard of artists flocking to the sport with the exceptions of Doug Wheeler, who I have heard has a license, and Richard Dehr, who shares with me a love of gliding and building your own pair of wings. I have taken artists for rides and without exception they loved the experience, even John White, who later told me he suffers motion sickness, claustrophobia, a fear of heights and a dislike of the back of my head, was moved to include the experience in a performance piece entitled: "A puddle of yellow puke" or something as a result of a terrific glider ride we had at El Mirage.
>
> But for the art buff at least, flying above L.A. offers a unique way to get away from it all and to obtain another point of view on yourself and the mess below. It's fascinating, expensive, and it helps your breathing. You also become an instant cultural expert, demographer and observer of social phenomenon as a result of your efforts.[3]

Gabrielson's high-flying perspective humorously acknowledges the peripatetic nature of art in Los Angeles at this moment. The diverse sprawl of the art world was both geographic and conceptual: As art practices shifted from objects to sites of investigation, as the art world's demographics diversified, and as modernist traditions engaged with new media and popular cultures, how would one gain perspective on new fields of practice that were as variegated as the city itself?

Down on the ground, the art community of the time was marked by a sense of unease. Artist and critic Peter Frank recalled that "Los Angeles art crept into this decade like a mugging victim: battered, impoverished, scared, and disgusted."[4] Communities that had seemed grounded and growing were not, as established art institutions faltered: In 1974, shortly after the recession of 1973 took its toll, the Pasadena Museum of Modern Art (formerly the Pasadena Art Museum) found itself facing bankruptcy and imminent closure.[5] For John Coplans, who had briefly served as curator during the museum's struggle to stay afloat, the possibility of the institution's demise raised "acute questions about the power and accountability of museum trustees, the lack in many American art museums of carefully thought-out policies within their local communities, and the general role a museum should assume within the community of art museums throughout the country."[6] The Pasadena Museum of Modern Art's fate represented a larger crisis for museums, the most venerable sites of art. For Los Angeles, it meant the possibility of losing a major anchor of the contemporary art community and an important link to an international realm of art.

JOURNAL

Number 1 **The Los Angeles Institute of Contemporary Art** June 1974

Figure 5.1.
Cover of the Los Angeles Institute of Contemporary Art's
Journal, no. 1 (1974), featuring a photograph by Judy Fiskin
from her *Stucco* series, 1973. Courtesy the artist and Angles
Gallery, Los Angeles.

Other institutions were under fire for entrenched, long-term practices of excluding artists on the basis of gender, race, ethnicity, and medium. The Feminist Art Program (FAP) at California Institute of the Arts (CalArts) had questioned the pedagogical legacy of art schools and the inequalities of art institutions; in 1973, it moved beyond the institution, leaving CalArts and establishing an alternative community structure.[7] Throughout the decade, other communities formed outside of the established art world, from the Chicano collective ASCO to David Hammons's Studio Z, challenging traditional forms of practice and discourse.

In addition, Los Angeles consistently lost artistic talent to New York: Helene Winer's extraordinary run as curator and director at the Gladys K. Montgomery Art Center at Pomona College ended in 1973, and she headed to New York. Many young artists, particularly those who took John Baldessari's post-studio class at CalArts in the early 1970s, also left Los Angeles for New York; their exodus revealed ongoing concerns about the validity of Los Angeles's art scene for emerging artists. Baldessari's post-studio class itself was founded on an interest in "transcend[ing] the local art situation."[8] Thus, even as a larger realm of artistic practice challenged

Figure 5.2.
Press photograph of the evacuation of the U.S. Embassy, Saigon, South Vietnam, 29 April 1975. Photo by Hugh Van Es. © Bettmann/CORBIS.

the place of art, the specificity of Los Angeles made the questions at times quite literal: What were the communities for art in Los Angeles, and where were they located?

A sense of disquiet was not limited to the Los Angeles art world; it permeated a larger social consciousness. Throughout the 1960s, the city echoed with unrest—as did the nation and the world. The rebellion in Watts in 1965 and the Chicano Moratorium in 1970 made the gross inequities of postwar urban conditions violently visible. Among the middle class, the successes of the civil rights movement and emergent feminism left traditional notions of American identity, if not its inequalities, far behind. In 1974, President Richard Nixon resigned in disgrace, scarring the office of the presidency; in 1975, the final failures of the Vietnam War were encapsulated in television news footage showing swarms of Americans boarding helicopters on the roof of the U.S. Embassy in Saigon (fig. 5.2).

As the 1970s evolved, the question of the place of art reverberated through an unstable social sphere; one key trope of developing practices seemed to be *departure*. This sense of departure was reflected in a new spectrum of work produced in the 1970s that struggled with the space of the gallery. In the early part of the decade, Robert Irwin, sensing inadequacies in the current

state of practice, closed up shop; he simply left his studio—and, with it, the idea of producing objects. He decided to work instead "in response" to other sites and other questions—a decision that, he noted, "in effect left me in the middle of nowhere."[9] Irwin's choice resonated with other artists of the 1970s who also produced wide-ranging explorations of the sites of art outside of the gallery. Like several of his colleagues, Irwin spent time in the desert, which for him was an area "with the least kinds of identifications or connotations."[10] Although he was interested in the possibility of art in remote places, he grappled with issues of access and audience: "I had the problem of how any of this could be brought to bear on what we call art. How was I going to deal with these situations? Was I going to take photos? Well that didn't really make any sense.

Figure 5.3.
Robert Irwin (American, b. 1928). Installation at the Riko Mizuno Gallery, 1974. Los Angeles, Getty Research Institute, 940081. © 2011 Robert Irwin / Artists Rights Society (ARS), New York.

Make plans, draw maps? That wasn't critical. How about loading people onto buses and dragging them out there to show it to them?"[11] For Irwin, the photograph—which had long been something he resisted—still would not do, even as many of his contemporaries looked to photography and other media as crucial resources for practice. Although other artists found it productive to create site-specific works in remote locations, Irwin questioned the need for viewers to seek work in distant locales outside of the gallery. Instead, he embarked on his own wanderings.

Irwin began to accept invitations for dialogue and installation, working in his own peripatetic manner, often on the road. The results varied from guest lectures to public discussions to installed work. Many of Irwin's works from this period produced their own sense of dislocation, shifting the experience of art from the object to the perceptual environment. In the mid-1970s,

in order to make that shift more apparent, Irwin returned to the gallery and began exploring the phenomenological conditions of perception there. Finding himself again "somewhere in the middle of everything," he consciously challenged the human tendency to "organize our perceptions of things into various pre-established abstract structures."[12] In an installation at the Riko Mizuno Gallery in Los Angeles, he used a single sheet of scrim (one of his favorite materials at the time) to create a perceptual interplay between void and volume in the space (fig. 5.3). The results were subtle yet perplexing, generating confusion about the fundamental expectations for art (where is the work?) while challenging the conditions of perception (how do we see it?); one critic claimed the work was "trickery."[13] Yet Irwin's interest reflected a trend in the 1970s, in which various forms of installation focused on the experience of a singular viewer. New York artist Robert Morris noted in 1975, "The private replaces the public impulse. Space itself has come to have another meaning…centripetal and intimate.…Deeply skeptical of experiences beyond the reach of the body, the more formal aspect of the work in question provides a place in which the perceiving self might take measure of certain aspects of its own physical existence."[14] Similarly, in 1974, *Art News* critic Melinda Wortz identified spaces that "focus the viewer inward, upon his own perceptual or psychological processes" as "a Los Angeles tradition."[15]

During this period, Maria Nordman was developing her own theories of art making and experience. Early experiments with film, in particular, explored the complexities of actual and cinematic space. For example, *EAT Film Room*—which projected films over the space and the props with which they were made—encouraged attention to visual nuance and overlay (fig. 5.4). These

Figure 5.4.
Maria Nordman (German, b. 1943). Plan for *EAT Film Room*, 1966–67. From Maria Nordman, *New Conjunct City Proposals: De Musica* (artist's book, 1993), 21. Courtesy Maria Nordman.

explorations led to an interest in other forms of subtle alterations and constructions in space. In 1973, at the University of California, Irvine, Nordman created *Saddleback Mountain,* in which the interior of the gallery was directly linked to the external environment through a mirror that refracted the natural sunlight from the entrance of the gallery into the darkened space, dividing it into two rooms by means of light. The ability to see and hear the landscape through the gallery was enabled in part by the geography of Los Angeles, a place where the two could be connected by a line of sight. Nordman described her process:

> I usually will tend to stand still with a place for a while before I decide. Then it's just a matter of the floor-plan and everything is finished. When I came to Irvine to draw up the floorplan—it happened to be summer solstice when I started—I just walked around a lot. After a while the buildings seemed to recede and I began to see new animals, plants, the unspoiled parts of the landscape and the Saddleback Mountain. There were very few people.[16]

By bringing aspects of the landscape into the exhibition space, *Saddleback Mountain* continued Nordman's engagement with changing states of sunlight and environment in settings that had also included abandoned sites and storefronts. At the time of the installation, she gave a reading in which she reviewed a variety of natural elements in the environment and staged a sunset cruise, with its own explorations of light and shadow. The multifaceted nature of Nordman's work reflected both the specificity of any given experience and its continuously generative possibility in history and discourse.

Questions about the place or site of art could also lead to reconsiderations of the complex social functions of the gallery itself. In the early 1970s, Bruce Nauman made a series of gallery installations that affected the viewer in both haptic and optic terms. In these works, often rooms or corridors, Nauman literalizes the controlling aspect of installations that were designed to produce a certain perceptual experience. Nauman's work would at times aggressively isolate the viewer or manipulate a visitor's presence using surveillance cameras or video feeds. In *False Silence* (1975), installed at LAICA, Nauman used sounds to create a charged experience. Recorded voices commented upon the exchange taking place between art and spectator: "I have no control over the kinds and qualities of thoughts / I collect, I cant process / I cant react to or act on sensation / No emotional response to situations / There is no reaction of instinct to physical or mental threats / You cant reach me, you cant hurt me / I can suck you dry" (fig. 5.5). Any viewer would become both attuned to and frustrated by the sounds. The work promoted skepticism about the possibility of private space in a postwar world, where, for Nauman, privacy becomes a false silence.

Similarly, Michael Asher revealed the complex conditions of the gallery system. Viewers looking for an exhibition he mounted in 1977, jointly held at the Claire Copley and Morgan Thomas galleries, did not find a traditional installation; instead, they found gallery owner Thomas working at Copley's space, with both her curatorial choices and working methods on display, and Copley working at Thomas's gallery. During the same time period, Asher organized a work at LAICA for which he paid various visitors a small fee to sit in the gallery every day and converse with one another, with the institutional staff, and with gallery visitors about the other works of art in the exhibition (by David Askevold and Richard Long). The resultant interactions drew attention to the idiosyncrasies of the gallery as social realm (fig. 5.6).

Although their critiques of the viewer's experience were productive, Nauman's aggressive confrontation of the viewer and Asher's unveiling of the institution remained defined by the functions of the gallery, an established place for artistic practice. Work that took place outside the gallery, especially performance art, presented new complications for viewers, as artists challenged prevalent social conditions by inserting themselves into arenas not constituted for art. If site-related practices could gain meaning when viewers were prepared for the perceptual

Bruce Nauman

Bruce Nauman's piece, "False Silence," is a narrow corridor 60' x 20'' x 12'. At the center of the corridor are two opposing doorways which are entrances to two triangular rooms. The north triangle is 14' x 14' x 26', the south triangle is 14' x 14' x 20'. Upon entering the corridor, one hears a voice which becomes distinguishable as one moves into the space. The voice identifies itself as being something that takes in energy and information, but has no exhaust nor does it process either energy or information. The voice describes itself as being all powerful, "I can suck you dry," but after announcing that it does not process information, it requests to be given "a line" and states that it has memory by saying, "Arapaho, Arapaho, where did you go?" It is my feeling that even though the voice identifies itself as being all powerful, it does not say that it will necessarily bring harm.

The space as the poem is all powerful in the sense that the corridor restricts the viewer's movement in a linear fashion. The triangular rooms supply the control of the corridor; however, the viewer's freedom is limited to the size of the rooms and angles of the triangles, which eventually reflect the viewer back through the door and into the corridor space. At this point, the viewer is left with a decision to continue through the piece or leave.

The triangular rooms are the only sources of light in the piece. They offer visual relief from the dimly lit corridor, but then present a floating or disordering sensation of white atmospheric light or visual energy.

The voice and physicality of the space are synonymous. The voice says that it absorbs all information and energy but does not process either. The space literally does the same (as the viewer passes through the structure). At this level, the viewer's identity can be exchanged with information and energy. The voice asks for a line, the space asks for participation. Neither the voice nor space react to sensation, physical or mental threats. The voice is emanated through the walls of the space. The voice and space objectify each other. The voice is the spirit of the space.

FALSE SILENCES
I DONT SWEAT
I HAVE NO ODOR
I INHALE, DONT EXHALE
NO URINE
I DONT DEFECATE: NO EXCRETIONS OF ANY KIND
I CONSUME ONLY
OXYGEN, ALL FOODS, ANY FORM
I SEE, HEAR
I DONT SPEAK, MAKE NO OTHER SOUNDS, YOU CANT HEAR MY
 HEART, MY FOOTSTEPS
NO EXPRESSION, NO COMMUNICATION OF ANY KIND
AN OBSERVER, A CONSUMER, A USER ONLY
MY BODY ABSORBS ALL COMMUNICATIONS, EMOTIONS,
 SUCKS UP HEAT AND COLD
SUPER REPTILIAN SOAKING UP ALL KNOWLEDGE,
 COMPACTOR OF ALL INFORMATION
NOT GROWING
I FEEL DONT TOUCH

I HAVE NO CONTROL OVER THE KINDS AND QUALITIES OF THOUGHTS
I COLLECT, I CANT PROCESS
I CANT REACT TO OR ACT ON SENSATION
NO EMOTIONAL RESPONSE TO SITUATIONS
THERE IS NO REACTION OF INSTINCT TO PHYSICAL OR
 MENTAL THREATS
YOU CANT REACH ME, YOU CANT HURT ME
I CAN SUCK YOU DRY

YOU CANT HURT ME
YOU CANT HELP ME
SHUFFLE THE PAGES
FIND ME A LINE
ARAPAHOE, ARAPAHOE
WHERE DID YOU GO
I BLINK MY EYES
TO KEEP THE TIME

Figure 5.5.
Bruce Nauman (American, b. 1941). Sketch and text for *False
***Silence*, 1975.** From Los Angeles Institute of Contemporary
Art's *Journal*, no. 8 (1975): 54. Art © 2011 Bruce Nauman / Artists
Rights Society (ARS), New York.

Figure 5.6.
Installation by Michael Asher at Los Angeles Institute
of Contemporary Art, 1977. Photo by Michael Asher. Washington,
D.C., Smithsonian Institution, Archives of American Art, Los Angeles
Institute of Contemporary Art records, 1973–88. © Michael Asher.

experience of art, performance could do so by disrupting viewers' expectations and by creating
confusion about social norms. In 1976, Paul McCarthy, who had been staging performances
with complicated psychological elements since the early 1970s, performed *Political Disturbance*
in the Biltmore Hotel in Los Angeles, where the American Theatre Association's convention
was being held. Performances were being staged in various venues throughout the hotel, and
McCarthy obtained permission to use the roof for a performance and to simulcast the event on
hotel televisions. At the last moment, McCarthy used the staircase instead. He covered dolls
and crucifixes in ketchup, lowered them down the empty space in the middle of the stairwell,
and threw raw meat and other objects as well. Dressed in an Arab mask and kaffiyeh and play-
ing Arabic music, McCarthy created a persona that evoked the 1970s energy crisis and threats
of terrorism, which in turn echoed the perceived threat of his own performance (fig. 5.7). The
result was chaos, particularly because McCarthy would not allow himself to be controlled
at the site:

> They wanted to keep it separated. Keep the performance in its place. In the staircase people would
> come out of their rooms on any floor to see what was going on and since this chamber was right
> in the middle of it all they would automatically become part of it [the performance]. It was a way
> of getting a live performance to people who may not otherwise have gone to it....
>
> So, one, I used a space they didn't want me to use. Two, they felt the space was dangerous....
> And then it was loud. I was playing Arab music over a loudspeaker. I was singing, disturbing perople
> [*sic*], making a real loud kind of groaning sound.... And then they felt it was obscene. They also ques-
> tioned its content...that I was dressed as an Arab....It was confusing. They didn't know whether I
> was pro-Arab or not. Then they were concerned about the building.... They didn't know who I was.[17]

Figures 5.7a, 5.7b.
Paul McCarthy (American, b. 1945). *Political Disturbance,*
1976. Performance at the American Theatre Association
Convention, Biltmore Hotel, Los Angeles. Photos: Spandau Parks.

Figure 5.8.
Suzanne Lacy (American, b. 1945) and Leslie Labowitz
(American, b. 1946). *In Mourning and In Rage,* 1977. Media
performance in Los Angeles, 13 December 1977. Photo by Susan
Mogul (American, b. 1949). Los Angeles, Getty Research
Institute, 2003.M.46. Courtesy Susan Mogul and Jancar Gallery.

In the case of *Political Disturbance,* the liminal site (a stairwell, which by its nature is transitional), the ensuing confusion when the work was performed, and the use of broadcast (another taped performance was broadcast the night before his performance; the live performance was broadcast during the event) reiterated that there was no socially designated site for this practice. The difficult content of McCarthy's work of this period produced a kind of sitelessness for its reception. (*Class Fool*—another McCarthy performance in 1976, at the University of California, San Diego—caused almost the entire audience of art students and faculty to flee.) Sitelessness characterized much performative work of the time, with works occurring in a variety of places, both physical and virtual, that were outside of the traditional venues for art.

With the growth of electronic and mass media, the notion of sitelessness found new expression as artists experimented with, mined, and struggled with virtual sites of cultural experience, such as radio, television, video, and print journalism. The function of imagery in mass media and its relationship to larger structures of power, particularly with respect to the roles of women, became a focus of the work of Suzanne Lacy and Leslie Labowitz. In 1977, under the auspices of their organization Ariadne: A Social Art Network, Lacy produced *Three Weeks in May,* a series of more than thirty events and interventions focusing on violence against women and the role of mass media in influencing societal behavior and acceptance. In one of the most striking events of the series, *In Mourning and In Rage,* Lacy and Labowitz staged a press conference to protest the sensationalistic media coverage of the Hillside Strangler, a notorious serial killer in Los Angeles. The performance included a motorcade with a hearse circling City Hall. Ten women emerged from the hearse: nine wearing shrouds and one acting as the speaker (fig. 5.8). The first shrouded figure stood for the

Hillside Strangler's victims, lost amid the media spectacle. Each of the other figures stood for statistics about the larger problem of violence against women. In this way, the event focused attention on the hundreds of women murdered, raped, or assaulted during the period of the serial killings—women who were invisible to mainstream media. The performance drew attention to the struggle that women faced in controlling their image and the complications of making social injustice visible. Lacy and Labowitz produced a video of *In Mourning and In Rage* and a pamphlet titled *What Is Social Art?* to help enlighten their audience about the nature of this and other social actions: "Social art is a movement by artists to use their skills and creativity to address, articulate and make public various social and community issues and perspectives."[18] One crucial aspect of this practice was effective critique of media.

In conjunction with these projects, Labowitz produced a large-scale photomontage mural, *A Woman's Image of Mass Media*, which juxtaposed various actions by the artists, including *In Mourning and In Rage,* with images of violence against women shown in the media (fig. 5.9). The mural also presented images of journalists, who functioned as the agents of women's visibility and invisibility. The form of the work—a mural—further referenced a history of art on the street and its use by minority cultures, particularly in Los Angeles, where murals had become a crucial mode of Chicano production. The press release announced the variegation of the work: "Seven foot tall women in black, roosters on Sunset Boulevard, newspaper headlines, television cameras and the reporters themselves."[19] What could be farther from the almost obsessive environmental control Irwin and Nordman exerted over their installations and imagery (or lack thereof) than the spaces of media and their constructions? As artists took to the streets, their roles as creators would become much less stable as they negotiated untested venues for art and the ever-growing impact of visual culture.

Figure 5.9.
Leslie Labowitz (American, b. 1946). *A Woman's Image of Mass Media,* 1977. Photomural, 2.4 × 7.3 m (8 × 24 ft.). Permanent collection of Leslie Labowitz-Starus. Courtesy the artist.

Figure 5.10.
Helen Lundeberg (American, 1908–1999). *Dark View,* 1974.
Acrylic on canvas, 152.4 × 152.4 cm (60 × 60 in.). Los Angeles,
Louis Stern Fine Arts, LSFA 1318. Art © Feitelson Arts Foundation,
courtesy Louis Stern Fine Arts. © Photography by Ed Glendinning.

GETTING THE MESSAGE OUT

When LAICA launched in 1974, it did so not only with a bold embrace of new sites and forms of practice but also with a nod to history. Its inaugural exhibition, *Nine Senior Southern California Painters* (1974–75), honored artists whose work exemplified the rise of California modernism during the twentieth century and who were still actively working in Los Angeles in the 1970s: Florence Arnold, Nick Brigante, Hans Burkhardt, Annita Delano, Lorser Feitelson, Peter Krasnow, Helen Lundeberg, John McLaughlin, and Emerson Woelffer. Contemporary works by Lundeberg, Feitelson, McLaughlin, and Woelffer demonstrated the decades-long development of their abstract explorations (fig. 5.10). Hans Burkhardt's *Death of a Soldier* (or *Death of a Politician*) (fig. 5.11) and *In Memory of a Fallen Soldier in Viet Nam* (1970) brought a midcentury approach (he had studied with the seminal abstract expressionist Arshile Gorky) to bear on the contemporary content of war and political upheaval. LAICA's exhibition posited that these practices of California art were still crucially vital, present, and active—even as younger artists were reprioritizing painting itself. Visitors at the opening of *Nine Senior Southern California Painters* experienced the intersection of artistic communities across decades; however, the historical relationship between them was unclear (fig. 5.12).[20]

The exhibition emerged from an oral history project that revealed a glaring art-historical void. Guest curator Fidel Danieli, an important local critic for *Artforum* in the 1960s, noted: "Barely two months into the project it came as a startling shock to realize that there does not exist even the barest of accurate published outlines on the subject of Los Angeles art and its historical development."[21] For Danieli, the lack of historical understanding was a contemporary concern: "The events of these decades are already slipping away beyond recall. What contributions

Figure 5.11.
Hans Burkhardt (Swiss, 1904–1994). *Death of a Soldier* (or *Death of a Politician*), 1973. Oil and collage on canvas, 127 × 152.4 cm (50 × 60 in.). Los Angeles, Jack Rutberg Fine Arts. © Hans G. & Thordis W. Burkhardt Foundation. Courtesy Jack Rutberg Fine Arts, Los Angeles, and the Hans G. & Thordis W. Burkhardt Foundation.

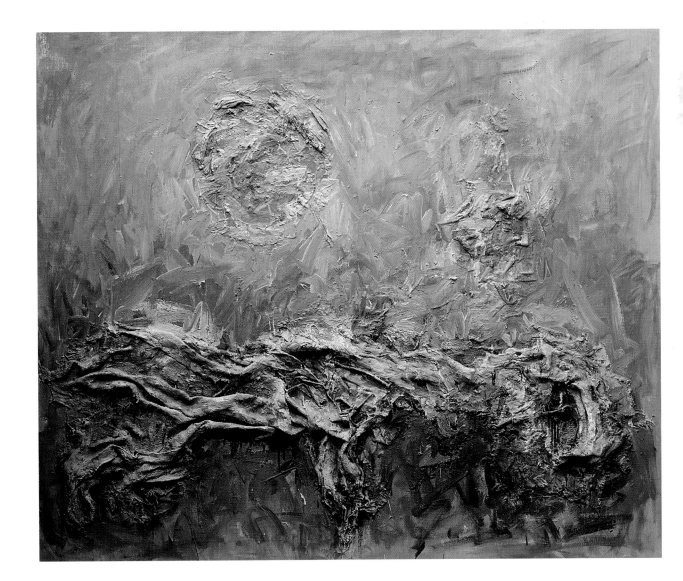

will be remembered of Southern California art of the 1960s? Of the '70s? Can we in Southern California take comfort in having invented disposable and self-destructing art and therefore art history? How long does the myth of a Lotus Land of no memories continue?"[22] The art of the 1960s and 1970s was diversifying well beyond the limits of California modernism. How was a history of this era, symbolized by Gabrielson's sweeping view from an airplane, to be understood? Further, by the 1970s, the accomplishments of California modernists were complicated by the growing realizations of and actions against long-standing exclusions in the art world. The exhibition thus represented competing tensions: the need to understand history and the desire to challenge it, a growing appreciation for California's accomplishments and a growing dialogue with an international art world. Peter Plagens, whose book *Sunshine Muse: Contemporary Art on the West Coast,*[23] the first attempt at a history of postwar art for the region, was published the same year that the LAICA exhibition debuted, later noted that "California modernism, comprising some of the best and most inventive artists to set foot in this century, should be thought the path, not the obstacle."[24] A reputation for art in Los Angeles needed to be established, not only in terms of place but also in terms of its crucial history.

Figure 5.12.
Opening of *Nine Senior Southern California Painters*, inaugural exhibition of the Los Angeles Institute of Contemporary Art, November 1974. Photographer unknown. Washington, D.C., Smithsonian Institution, Archives of American Art, Los Angeles Institute of Contemporary Art records, 1973–88.

Many of the most vibrant communities that formed in the early 1970s were grounded in their differences from that history—differences that stemmed from both institutional and ideological exclusion. Artist David Hammons, speaking of James Turrell's highly controlled perceptual environments of light and space, noted:

> I wish I could make art like that, but we're too oppressed for me to be dabbling out there....I would love to do that because that also could be very black. You know, as a black artist, dealing just with light. They would say, "How in the hell could he deal with that, coming from where he did?" I want to get to that, I'm trying to get to that, but I'm not free enough yet. I still feel I have to get my message out.[25]

Hammons's thoughts about his inability to produce work like Turrell's demonstrate the false neutrality of dominant modes of practice in the art world. His understanding of his distinction from some of his better-known colleagues aligned with Irwin's consideration of his own practice:

"I do things which from any social or political view are utterly outrageous. I mean, they absolutely ignore all the social issues of the day."[26] Yet there is a connection between Irwin and Hammons: through Irwin's exodus from the studio and his struggle to challenge the function of art, he grappled with long-standing questions about the value and place of artistic practice that had marked modernism across the twentieth century, just as Hammons's remark notes the machinations of exclusion in that same period.

Figure 5.13.
David Hammons (American, b. 1943). Installation view of *Hairpiece*, David Hammons's studio, New York, 1975. Photo by Bruce W. Talamon (American, b. 1949). © 2010 Bruce W. Talamon, all rights reserved.

In the early 1970s, Hammons began exploring the racist moniker "spade." Several assemblage forms from this series use shovels to create an awkward figure—for example, *Bird* (1973), made in reference to Charlie Parker. The rough sculptural forms of these figures, closely linked to the practice of collage and assemblage in Los Angeles, offer a sculptural counterweight to the disappearing object and the embrace of the more ephemeral light and space. These sculptural forms are instead anchored by their material presence, a grounding that the shovel metaphorically represents, just as it also speaks to the possibility of digging oneself out. In the mid-1970s, Hammons began to construct environments in which he used hair, a marker of race, as a primary material, creating wall hangings, installations, and assemblages. As another figural counterpart to Irwin's weightless scrim, these works materialized the inescapable presence of race in a society still dealing with the struggle for civil rights and equality (fig. 5.13).

Concurrently, Hammons produced a series of performances: *Spade Covered with Sand or Buried Spade* (ca. 1972) and *Murder Mystery* (at times referred to as *Spade Run Over by a Volkswagen;* 1972). In each performance, the spade (shovel), constructed from cardboard or leather, is acted upon. These performances—which were not adequately documented at the time and are not well known now—speak to the invisibility of the body, which, despite being buried or run over, must continue to assert its existence. *Murder Mystery* evoked the racial violence that erupted across the United States in the late 1960s and, in particular, the Watts rebellion. The suggestive nature of its alternative title, *Spade Run Over by a Volkswagen,* in turn adeptly aligns a racist slur with an iconic automobile—an automobile that is itself the product of a racist regime. In Hammons's work, the Nazis' "people's car," which was adopted by an emerging American culture of surfers and hippies, does not evoke the freewheeling aspects of the 1960s but instead seethes with the violence of race in Los Angeles, land of automobiles.

Hammons's practice occurred within a loose network of African American artist communities in Los Angeles that were indicative of a wider national movement among black artists in the late 1960s and 1970s: African American culture, consistently walled off from the mainstream and ignited by the unrest of the 1960s, began to make a place of its own. The Brockman Gallery, founded by Alonzo and Dale Davis in 1967, became a crucial site for African American art and culture and one of the first venues for Hammons's work (fig. 5.14). It offered a place for work that might not be shown elsewhere, a situation that was at times explicitly addressed, as in the announcement for an exhibition by Eugene Hawkins (fig. 5.15). The gallery expanded in 1973 to include Brockman Gallery Productions, a nonprofit that provided broader outreach for African American culture.[27] In the early 1970s, Hammons formed his own collective, Studio Z, which experimented with a wide array of media. The Black Arts Council, an advocacy group, lobbied the Los Angeles County Museum of Art (LACMA) to include African Americans in the museum's programming.[28] As a result, a series of exhibitions in the 1970s featured African American art, including the large-scale traveling exhibition *Two Centuries of Black American Art* in 1976. The development of critical and historical discourse in relationship to the work was crucial to the reception of African American culture. Scholar and historian Samella Lewis became a pivotal voice for this cause in Los Angeles, supporting the practices of contemporary African American artists and acting as an important author of its history. She produced books, including, with Ruth Waddy, the two-volume *Black Artists on Art* (1969, 1971), and she cofounded the journal *Black Art.* Lewis also curated exhibitions; she opened her own gallery in the early 1970s and helped to found the Museum of African American Art in Los Angeles in 1975.

Interest in creating new forms of community and new ways to disseminate information, art, and culture was also the impetus for the widespread feminist movement in the visual arts in the 1970s, a movement that was particularly strong in California. However, as the Feminist Art Program developed at CalArts, the artists involved began to feel the limitations of working within an established educational institution. In response, Judy Chicago, Sheila de Bretteville, and Arlene Raven founded the Feminist Studio Workshop in 1973 as a cooperative, independent pedagogical experiment. An early flyer called on women to take action in the city. It featured a collage by Susan Mogul, *Moses Mogul Parts Hollywood Hills* (fig. 5.16), and encouraged women to move "out of the Ivory Tower / And into the real world."[29]

Founded with and housed under the larger umbrella of the Woman's Building, the workshop shared space with Womanspace Gallery, Sisterhood Bookstore, the Los Angeles chapter of the National Organization for Women (NOW), and the Associated Feminist Press, among other organizations, creating an integrated and multifaceted site for women artists. Grounded in this community, the Feminist Studio Workshop explored methods for reaching a broader public. De Bretteville in particular was interested in using design and publication to communicate

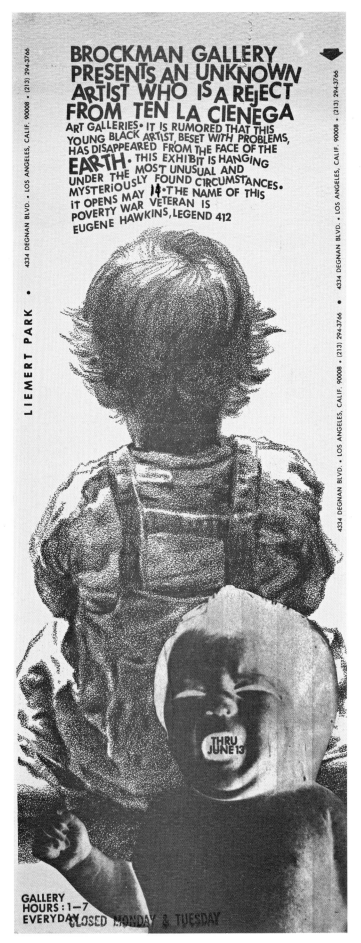

Figure 5.14.
Actor Brock Peters, Brockman Gallery co-owner Alonzo Davis, poet Beah Richards, and Pat Johnson at Brockman Gallery in April 1977. Photo by Guy Crowder. Image from the Brockman Gallery archives, special thanks to Alonzo and Dale Davis. Works in the background are by Betye Saar (left) and Joseph Sims (right). Courtesy Michael Rosenfeld Gallery, LLC, New York, NY. Courtesy Joseph Sims.

Figure 5.15.
Poster for Eugene Hawkins exhibition, Brockman Gallery, Los Angeles, ca. 1972. 32.3 × 12 cm (12¾ × 4¾ in.). Courtesy Brockman Gallery archives, special thanks to Alonzo and Dale Davis.

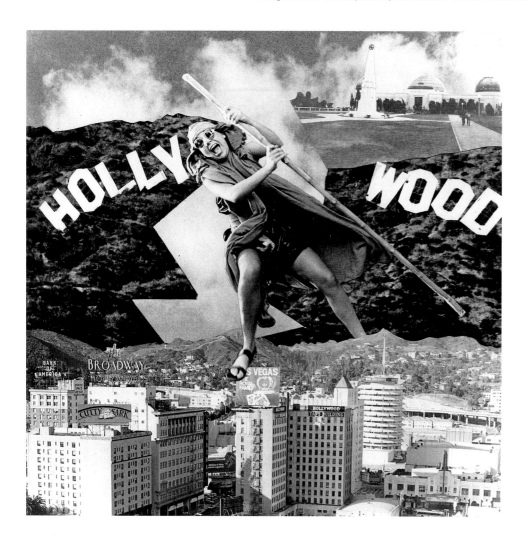

Figure 5.16.
Susan Mogul (American, b. 1949). *Moses Mogul Parts Hollywood Hills*, 1976. Photo collage, 30.5 × 30.5 cm (12 × 12 in.). From the series *Hollywood Moguls*. Collection of the artist. Courtesy Susan Mogul and Jancar Gallery.

beyond the walls of the Woman's Building: "By giving this particular visual form to information about women's experience, and posting it in the street—where people who do not frequent bookstores and galleries can see, read and think about it—my work in the printing arts and my experience as a woman become utterly implicated in the public realm."[30]

Despite its origins, the feminist movement struggled with its own exclusionary patterns, often marginalizing women artists involved in different forms of practice. In her exhibition *Black Mirror* (1973) at Womanspace, Betye Saar (who had served on Womanspace's board) continued her series of curatorial commentaries on the place of African American women in art. Her work also reflects the complex collaborations and divisions within any notion of community. *Shield of Quality*, like other examples of Saar's increasingly autobiographical work of this period, bears traces of assemblage and evokes the types of personas found in contemporary feminist performance art, yet it remains distinct from both (fig. 5.17). Her work elucidates tensions between the specific realities of a given individual practice and the larger social politics of identity.

Negotiations between the subjective interests of participants and collaborative possibilities of the space were explored throughout the Feminist Workshop itself. Its curriculum was based on alternative processes, particularly consciousness raising, and included studio training and apprenticeship (fig. 5.18). Video emerged as a crucial medium for the workshop, for both personal and communal processes. Video was open to experimental exploration of individual experience and the body, as in Lacy's ongoing work with bodies and violence. The medium also served as a crucial tool for exploring pedagogy, collaboration, and communication in multiple forms. Video was a medium of community.

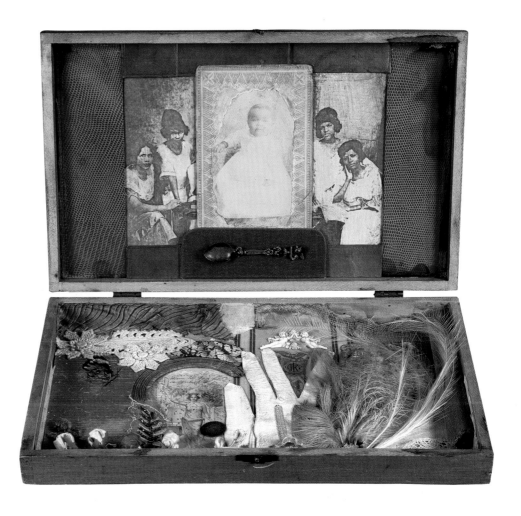

Figure 5.17.
Betye Saar (American, b. 1926). *Shield of Quality,* 1974. Mixed-media assemblage in box, dimensions of box: 45.7 × 37.4 × 2.5 cm (18 × 14¾ × 1 in.), signed and dated. Newark, Newark Museum. Courtesy Michael Rosenfeld Gallery, LLC, New York, NY.

Many artists working in video focused on the workshop itself: Jane Krauss's *I Love LA* (1973) briefly relates her tale of arriving in Los Angeles and discovering the Woman's Building. Susan Mogul's *The Woman's Building: FSW Video Letter* (1974) tours the site and presents encounters with some of its inhabitants, including Judy Chicago. In addition, the Feminist Studio Workshop produced hundreds of hours of documentary footage of their processes, including openings, interviews, and pedagogical experimentation. Many of the tapes from this period are important documents in the history of video art. Experimental and unconventional in nature, they nevertheless remain fairly obscure as records of the period. Taken together, they form an image of a community in process and represent the role a particular medium may play in departing from traditional forms of art making. The Los Angeles Women's Video Center (LAWVC), housed at the Woman's Building, became an important resource for artists using video, and it helped promote use of the new medium in the workshop. For example, the LAWVC helped produce the video for *In Mourning and In Rage.*

The collaborative nature of the workshop led to important collective projects, many influenced by the strong presence of performance in the workshop. For example, The Waitresses (Jerri Allyn, Leslie Belt, Anne Gauldin, Patti Nicklaus, Jamie Wildman, and Denise Yarfitz) performed and orchestrated a series of events around issues for working women (fig. 5.19). Each of the participants had been a waitress at some point and had quit because of "abusive treatment on the job." In their new roles, the artists produced a series of impromptu performances and organized workshops: "We continued to serve the public.... In our exploration of waitressing, we located these key issues: stereotype, i.e., waitress as mother/nurturer, servant/slave, and sex

CLASS STRUCTURE

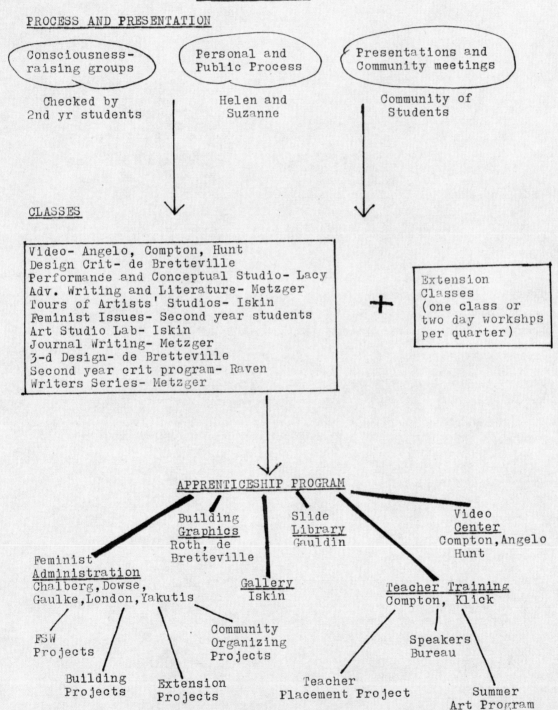

PROCESS AND PRESENTATION

(Consciousness-raising groups) (Personal and Public Process) (Presentations and Community meetings)

Checked by
2nd yr students

Helen and
Suzanne

Community of
Students

CLASSES

Video- Angelo, Compton, Hunt
Design Crit- de Bretteville
Performance and Conceptual Studio- Lacy
Adv. Writing and Literature- Metzger
Tours of Artists' Studios- Iskin
Feminist Issues- Second year students
Art Studio Lab- Iskin
Journal Writing- Metzger
3-d Design- de Bretteville
Second year crit program- Raven
Writers Series- Metzger

Extension
Classes
(one class or
two day workshps
per quarter)

APPRENTICESHIP PROGRAM

Building
Graphics
Roth, de
Bretteville

Slide
Library
Gauldin

Video
Center
Compton, Angelo
Hunt

Feminist
Administration
Chalberg, Dowse,
Gaulke, London, Yakutis

Gallery
Iskin

Teacher Training
Compton, Klick

FSW
Projects

Community
Organizing
Projects

Speakers
Bureau

Building
Projects

Extension
Projects

Teacher
Placement Project

Summer
Art Program

object; women and money; women and work; and sexual harassment. Each performance focused on one issue while naturally touching upon them all."[31]

The Waitresses represented the ways in which the centrally located community of the workshop integrated its processes and politics into the larger community beyond the workshop. Similarly, the Feminist Art Workers (Nancy Angelo, Candace Compton, Cheri Gaulke, and Laurel Klick) examined the labor of women artists in various forms. For example, Angelo and Compton's video *Nun and Deviant* (1976) reveals and resists stereotypical roles of women in society. These groups, along with the actions of Lacy and Labowitz, shared De Bretteville's interest in a situation where "experience as a woman becomes utterly implicated in the public realm" by taking feminist performance tactics out into the world of Los Angeles and beyond.

As the Feminist Studio Workshop and the Museum of African American Art provided alternative sites for art that included actual spaces for exhibition and community, other communities also emerged in the 1970s that were more transient but equally productive. Some of the more

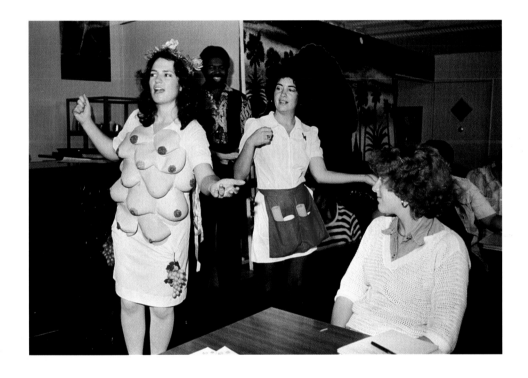

Figure 5.19.
The Waitresses (Jerri Allyn, Leslie Belt, Anne Gauldin, Patti Nicklaus, Jamie Wildman, and Denise Yarfitz). "Waitress Goddess Diana" (left to right: Anne Gauldin, unidentified customer, Denise Yarfitz, customers). Vignette from *Ready to Order?*, 1978. Conceptual performance art, 7 days, site oriented. Six restaurants and the Woman's Building, Los Angeles. Courtesy the Woman's Building Image Bank at Otis College of Art and Design, Los Angeles. © The Waitresses. Photo by Maria Karras.

provocative explorations of access and reception for art in this decade came from the collective ASCO, whose four members—Harry Gamboa Jr., Gronk, Willie Herrón, and Patssi Valdez—created work that drew attention to the place, or lack thereof, of Chicano art and identity in Los Angeles. In 1972, they famously marked their exclusion from the art world by tagging LACMA, in a work called *Project Pie in De/Face,* or *Spray Paint LACMA* (see fig. 4.42). In doing so, they used graffiti—an established cultural form of marking territory—to demarcate their difference from another realm of cultural marks found at the museum. *Chicanoismo en el arte,* a small juried exhibition at LACMA in 1975 of thirty-one young Chicano artists, might be understood as one in a series of responses to such protests about exclusion. Valdez's *Photo Booth Piece* (ca. 1974), a series of photo-booth shots that recalls Andy Warhol's famous portrait of the socialite and collector Ethel Scull, presents a face and figure of much different experience. The accompanying typed text of the collage reads: "L.A.P.D. sat. removed from my car NO reason given a friend and I were called horrible names I was accused of being on REds.... WE WERE ON the verge of arrest for mere appearance."[32] Valdez made several photo-booth pieces in this

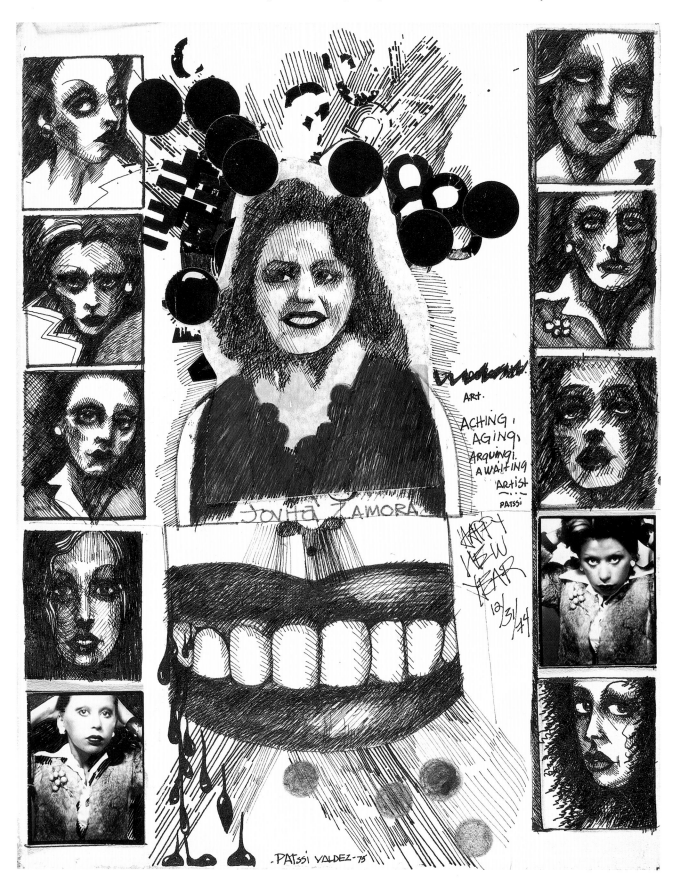

Figure 5.20.
Patssi Valdez (American, b. 1953). *Jovita Zamora Photobooth
Self-Portrait,* **1975.** Ink on paper with photograph and collage on
board, 27.9 × 21.6 cm (11 × 8½ in.). Collection of the artist. Photo ©
2011 Museum Associates / LACMA.

IN THE LATE 1960s, when performance art had already become an unwieldy hybrid art form, a distinctive trend began to emerge in Southern California, one informed by New Age spirituality, non-Western religious customs, and social critique. A broadening interest in ritual practices grew to encompass the repetitive actions of daily routines like eating and walking, which were increasingly channeled into art. The result was a surge of body-based performances that addressed topical matters, including the Vietnam War, feminism, civil rights, self-identity, and psychic health.

The work of Los Angeles–based artist Kim Jones offered a forceful representation of the dark side of human nature. Jones wore his sculptures; they were constructed of common materials such as sticks, foam, electrical tape, and rope that protruded from his head and shoulders like an exoskeleton—at once protective armor and oppressive trap. Smearing his body in mud, blood, and other organic matter, and obscuring his face and thus his identity, Jones—who had suffered from a disease of the hip bone that had confined him to a wheelchair and leg braces from age seven to ten—transformed himself into Mudman, a walking sculpture that suggested a body taking over itself.

A forbidding presence, Mudman invited comparison with the camouflaged soldiers Jones had observed in Vietnam, where he served as a marine from 1967 to 1968; with otherworldly creatures like the golems of Jewish folklore, shaped from mud and willed into action by a higher authority; and with shamans from animist religions around the world. Mudman first materialized on 28 January 1976, when he walked the length of Wilshire Boulevard, from downtown Los Angeles to the Pacific Ocean (see fig. 5.27 and p. 315). During this solitary performance, which Jones conceived of as a moving sculpture, Mudman purposefully subjected himself to the stares, inquiries, and jeers of passersby, offering in return his silent, enigmatic presence. Mudman's most controversial and notorious performance took place later that year. In *Rat Piece* (February 1976), Jones released several live rats into a gallery, doused them with lighter fluid, and set them on fire. This event provoked a range of impassioned responses, from the dismissal of the gallery director and criminal charges against Jones, to support from fellow artists, who cited traditions of animal sacrifice as a means of appeasing one's god and reconciling the feelings of guilt and penitence inherent in the act of killing.

Many performance artists, including Los Angeles–based Barbara T. Smith, defended Jones's actions, advocating for the use of extreme pleasure and pain in ceremonial performance in order to reveal the contradictions and hypocrisies inherent in social norms. *Ritual Meal,* one of Smith's first major pieces, was conducted in 1969 in a private residence. In it, sixteen guests costumed in medical garb dined using surgical tools; meanwhile, a film of open-heart surgery played to the sound of an amplified pulse. Smith's performances throughout the next decade likewise integrated food, community, and ritualistic practices as a means for deeper engagement between artist and audience. In 1981, she introduced a pivotal work, *Birthdaze,* which involved a large audience, crew, and eleven performers (including Jones as Mudman). In the final act, Smith and the audience relocated to a space arranged with candles, meditation pillows, food, and six chanting women. These ritual elements were intended to fuse art and life and to foster authentic selfhood and a sense of community among those present.

Such works were fueled by investigations into the power of personal agency as a liberating spirit of aesthetic exploration, by the lure of symbolic action, and by the tense draw of transgression and catharsis. They depended, in part, upon being witnessed by others. Audience members became participants, and in this way performance art and its rituals served to define a community of artists.

Barbara T. Smith (American, b. 1931). *Ritual Meal,* 1969. Black-and-white photographs, performance documentation. Photos by Bill Ransom. Courtesy the artist and The Box, Los Angeles.

period that grappled with identity and its staging, as in *Jovita Zamora Photobooth Self-Portrait* (fig. 5.20). These works mirrored prominent contemporary conceptual practices as well as growing concerns with persona; yet, when they were visible at all, they were relegated to a minor exhibition in the minor spaces of the institution.

The exclusionary conditions that Chicano artists experienced—like those affecting Hammons and other African American artists—went well beyond art institutions and involved larger social concerns of space and identity. ASCO's *First Supper (after a Major Riot)* was staged on a Whittier Boulevard traffic island during rush hour (fig. 5.21). Previously a site of conflict and resistance in East L.A., the space ASCO occupied had been redeveloped as an act of urban renewal and control in 1973. ASCO's performance, which combined aspects of the Christian Last Supper with the celebration of the Mexican Day of the Dead, revisualized issues of death and identity in an urban space. By enacting a banquet, the artists returned to the material reality of bodies that might engage in political action. Such staging also related to ASCO's manipulation of news media as a means to both gain access and make inaccessibility visible. In *Decoy Gang War Victim* (fig. 5.22), they similarly staged a vignette depicting the aftermath of violence, complete with a faux corpse; the scene was then photographed and distributed to media outlets. The goal was to deter violence (by creating a decoy) and to demonstrate broadcast media's culpability in perpetuating stereotypes. Such manipulations were also pivotal to ASCO's series *No Movies,* through which the group constructed imagery with cinematic evocations that were used and distributed in a variety of formats. The agile nature of ASCO and its work allowed the collective to manipulate the place of art in several ways: it produced conceptual works in Chicano neighborhoods where conceptual processes were unfamiliar and it brought Chicano identity into mainstream arenas. ASCO's practice emphasized the ways in

Figure 5.21.
ASCO (American art collective, act. 1971–1987). *First Supper (after a Major Riot),* 1974. Performance by (left to right) Patssi Valdez, Humberto Sandoval, Willie Herrón, and Gronk on 24 December 1974 during rush hour on a traffic island at Arizona Street and Whittier Boulevard, Los Angeles. Photo by Harry Gamboa Jr. (American, b. 1951). © 1974 Harry Gamboa Jr. Courtesy the UCLA Chicano Studies Research Center.

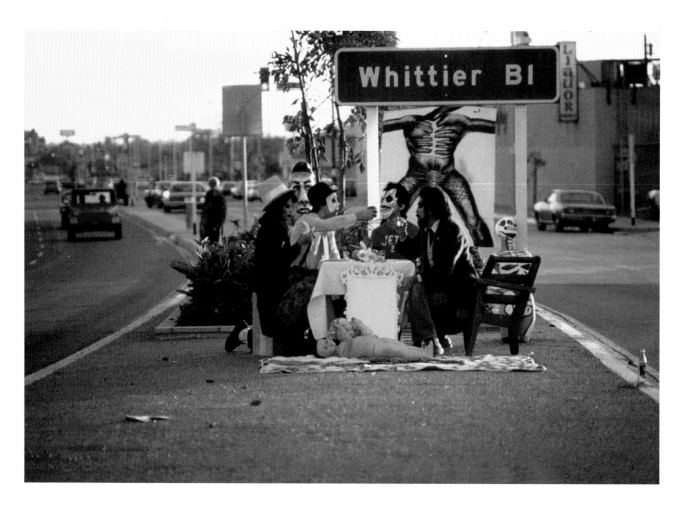

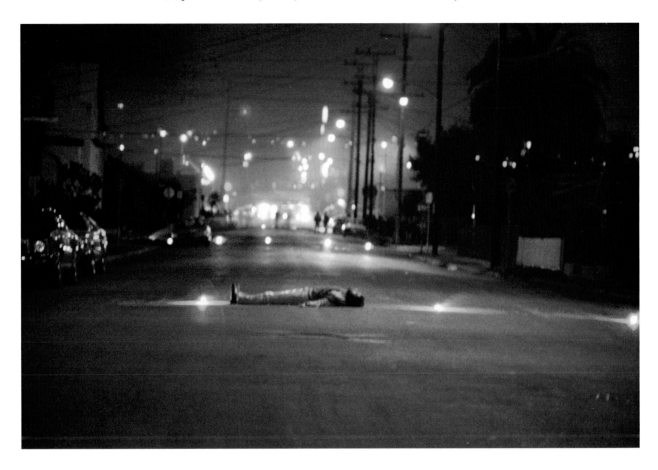

Figure 5.22.
ASCO (American art collective, act. 1971–1987). *Decoy Gang War Victim*, 1975. Performance. Photo by Harry Gamboa Jr. (American, b. 1951). © 1975 Harry Gamboa Jr. Courtesy the UCLA Chicano Studies Research Center.

which issues concerning the place of art in the 1970s moved beyond ideas of site, or even community, to include the forms of communication themselves.

WHO COULD HAVE IMAGINED LOS ANGELES?

Questions about the effect of producing art within the social and geographic specificity of Los Angeles permeated artistic discourse in the 1970s. For example, in a special section of *Art in America* in 1978, seven artists talk about working in L.A.:

> ELEANOR ANTIN: I've set up my life so that I live in a hermetic manner, in the country.... In New York, people tend to sort themselves out into groups.... [Here] I walk to the post office, I see all these old, retired people. In New York, if you live in SoHo, everyone standing in line with you is an artist...out here I discovered America....
>
> JOHN BALDESSARI: Part of it is the time and space situation here. You never live closer than 30 minutes from anywhere, so you can't exactly go outside your studio and walk to the post office and meet some other artists....
>
> CHRIS BURDEN: I guess I'd have to say that a lot of them [performances] came of isolation, long periods of just building up tension, isolation from other artists, isolation from anything I felt was interesting....
>
> ALEXIS SMITH: I spend a lot of time going from place to place in my car.... In a library, you look something up in a card catalogue; in L.A., you use the telephone book. If I want to find something, I look in the yellow pages under its category, find ten places that carry it, and drive to those places.[33]

Each account offers an experience of Los Angeles—one of isolation, which in turn evokes chance encounters, deliberate mobility, and further wandering. Los Angeles has a geography that demands movement; at a time of an ever-expanding postwar economy, its culture seemed to exist in pockets. This sense of Los Angeles was captured in photography of the period in which typologies emerge that emphasize the space's industrial sameness and the crucial nature of idiosyncratic details.

Lewis Baltz's *The New Industrial Parks near Irvine, California,* published in 1974, established a standard for capturing the anonymous and industrialized postwar landscape (fig. 5.23).[34] Judy Fiskin also created several series of photographs in this period that were anchored in Southern California experience—*Stucco* (1973–76), with its suburban sites; *Military Architecture* (1975); and *Desert Photographs* (1976). Fiskin's photographs are small in scale and extremely detailed, presented with deep foregrounds, wide white margins, and a matter-of-fact sensibility (fig. 5.24). The scale of the works calls to mind photographic reproductions, the medium through which so many artists, Fiskin included, gained access to culture, and which, like her typologies, reiterated the sameness of place.

Across this landscape, artists asserted their subjectivities, insistent on individual identity and experience as a ground for practice. This focus was made possible by the realization, in the face of the civil rights movement and feminism, that no universal subjectivity existed; it also served as counterpoint to the increasingly homogenized effects of postwar production and consumption. Both Eleanor Antin and Alexis Smith produced complicated mixtures of autobiography and fiction that were becoming prominent in performance at the time. Antin's experiments with autobiography emphasized the assertion of self within this realm:

Figure 5.23.
Lewis Baltz (American, b. 1945). *Northwest Wall, Unoccupied Industrial Spaces, 17875 C and D Skypark Circle, Irvine,* 1974. Gelatin silver print, 15.1 × 22.8 cm (6 × 9 in.). From *The New Industrial Parks near Irvine, California,* 1974, a series of 51 gelatin silver prints. © Lewis Baltz. Courtesy Gallery Luisotti.

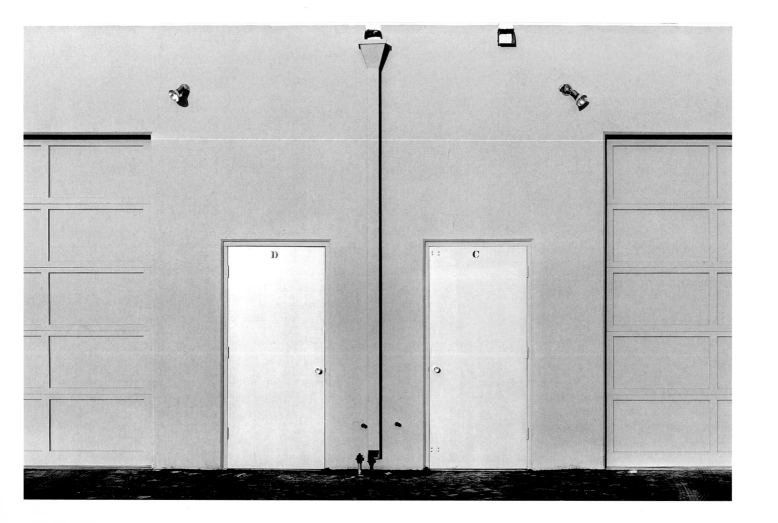

Figure 5.24.
Judy Fiskin (American, b. 1945). *Untitled,* **1975.** Gelatin silver
print, 7.1 × 5 cm (2⅞ × 2 in.). From the series *Military Architecture,*
1975. Courtesy the artist and Angles Gallery, Los Angeles.

But what if the artist makes the leap from "the body" to "my body"? "My body" is, after all, an aspect
of "my self" and one of the means by which my self projects itself into the physical world. "My self"
has not been seen in the art world for a long time.... Autobiography in its fundamental sense, is the
self getting a grip on itself.... I am a post-conceptual artist concerned with the nature of human real-
ity, specifically with the transformational nature of the self.... I am interested in defining the limits
of myself, meaning moving out to, in to, up to, and down to the frontiers of myself. The usual aids to
self-definition—sex, age, talent, time and space—are merely tyrannical limitations upon my freedom
of choice.[35]

Antin wanted to work with images that she saw as "permanent and mobile," settling on four
core personas for self in her work: Ballerina, King, Black Movie Star, and Nurse. Each developed
a life of its own, and the Movie Star was retired soon after her invention: "I have to be careful
of my Black Movie Star. She is very spectacular. For some dark reason she causes a sensation
wherever she goes."[36] Issues of race emerged later, however, in the figure of Eleanora Antinova,
the only Black Ballerina of Diaghilev's Ballets Russes and arguably Antin's most complex char-
acter. Antin takes on many roles in her work as Antinova, for example as the similarly racially
complex Pocahontas (fig. 5.25). These figures exist not only as extensions of "my self" but also
as images of the America that Antin discovered on the West Coast—an America caught in com-
plex plays of power, media, and body.

Similar explorations of mobility and persona occurred in Suzanne Lacy's *Cinderella in a
Dragster*, a work defined by her traversal of geographic expanses (fig. 5.26):

I calculated that I must have traveled fifty miles a week when I was ten, if you count vacations. When I was 20 I traveled about 350 miles a week because I was already commuting to college in another town. Now ten years later I'm 30 and although this week is a little unusual I figure that by the end of it I will have traveled 2300 miles. If you look at this you'll see that each ten years the miles per week multiplies by a factor of seven and although this is a very crude estimate, at this rate of acceleration I will be traveling 16,000 miles per week when I'm forty. I can't imagine that, but who, growing up in Wasco, could have imagined Los Angeles?[37]

Lacy's Cinderella fused the transitory conditions of Southern California with the equally mutable forms of autobiography and fiction: "Cinderella is a fairy tale and that's a lot of what performance art is about, creating elaborate structures so that everything in your life seems to relate to the story at hand."[38] Through these processes, she could build and rebuild self.

Lacy's work graced the cover of the first issue of *High Performance,* which was founded in 1978 and edited by Linda Frye Burnham. The magazine provided one of the few channels for grappling with the nature of performance, often defined by its use of alternative sites, its ephemeral nature, or its dependence on virtual locations such as video. *High Performance* became an important vehicle for recording these diverse practices, for allowing expanded forms of access and audience: "Performance art events are by nature so utterly bizarre and uncategorizable that we felt we should try to create a 'white box' for their documentation to be shown in."[39]

Lacy's place on the cover as Cinderella indicated the importance of her ongoing work, but it also acknowledged the transitory nature of performance art. In the performance of this era, artists are consistently in motion, moving from place to place: Lacy's dragster, Kim Jones's trek as Mudman along Wilshire Boulevard in 1976 (fig. 5.27 and sidebar 27), and Chris Burden's *B-Car* (constructed in 1977 for a drive across Europe), among many others, made these traversals literal demarcations in space and time.

Other artists morphed subjectivities in order to examine and challenge the limits of social identity, particularly Antin but also Richard Newton, who explored gender and body in *Touch a Penis with the Former Miss Barstow* (1977), and Nancy Buchanan, whose *Deer/Dear* investigated

Figure 5.26.
Cover of *High Performance* 1, no. 1 (1978), featuring Suzanne
Lacy's traveling project *Cinderella in a Dragster,* 1976. Photo
by Susan Mogul (American, b. 1949). Courtesy Susan Mogul and
Jancar Gallery. Cover reproduced by permission of Art in the
Public Interest.

Figure 5.27.
Kim Jones (American, b. 1944). *Wilshire Boulevard Walk,*
1976. Performance along Wilshire Boulevard (with structure),
Los Angeles, 28 January 1976. Organized and sponsored by Carp.
Photo by Jeff Gubbins. Courtesy Carp Archive, Los Angeles.

ON 8 APRIL 1978, Some Serious Business (SSB) and the Los Angeles Institute of Contemporary Art (LAICA) sponsored Viennese artist Hermann Nitsch's performance of his *Orgies Mysteries Theatre* in Los Angeles. The well-attended event represented an ongoing interest in international exchange and collaboration in Los Angeles and demonstrated the reach of seemingly improvisational organizations such as SSB. Many local artists participated: Harry Kipper was the principal protagonist and Mike Kelley and other artists played in the orchestra. Sound was central to the work, as Jim Moisan's description in *High Performance* reveals:

> Sounds ebbed and flowed, as if in waves, in the twenty or so separate actions during a two-hour performance whose elements were the pouring of blood (onto animal intestines and carcasses, on human mouths and genitals), the manipulation of entrails (stuffing into and pulling from carcasses), crucifixion (of nude males and sheep carcasses), and the playing of musical instruments into animal carcasses.... The blood was rancid, the intestines stank, the discord of metal instruments and whistles hurt one's ears.[1]

Orgies Mysteries Theatre—with its visceral sounds, sights, and smells—reflected and built upon inherent violence in human society. Nitsch argued that the performance functioned as a way to activate the senses very intensely and employed transgression as a means of addressing societal failures.[2]

The violence of the piece echoed contemporary media, which featured war and assassination on television for the first time. The performance itself—with its blood, guts, and cacophony—seemed to offer a homeopathic response to mediated violence. Nancy Buchanan, who spent time with Nitsch while he was in Los Angeles, questioned the efficacy of such rituals: "Would the ordeal of witnessing an orgy of blood and violence bring feeling to a deadened sensitivity, or would it ultimately perpetuate anesthetization? Seeing the Vietnam war on the dinnertime news should have been just such a sensitizing experience for the American public, yet it seems to have little effect."[3] Buchanan's comments express a tension between, on the one hand, the drive toward live performance and an embodied experience and, on the other hand, the effects of media on how we experience events from a distance. Nitsch's performance, and many others from this period, refused the distancing stance of burgeoning media, in which bodily destruction could be turned on and off. Similar responses were found in a spectrum of bodily rituals and manipulations by performance artists in Southern California, particularly Paul McCarthy, Chris Burden, and the Kipper Kids, and would soon be seen in the emerging cultures of punk. Buchanan's inquiry posited that Nitsch's work might allow for further anesthetization rather than remedy. Yet Nitsch's visit to Los Angeles upheld an interest in face-to-face interaction, and the literal, if ritualized, body.

Notes

1. Jim Moisan, "Nitsch's O.M. Theater in L.A.," *High Performance* 1, no. 3 (1978): 45.

2. Nancy Buchanan, "Orgies Mysteries Theatre," *High Performance* 1, no. 3 (1978): 48.

3. Nancy Buchanan, "Comments on Nitsch," *High Performance* 1, no. 3 (1978): 46.

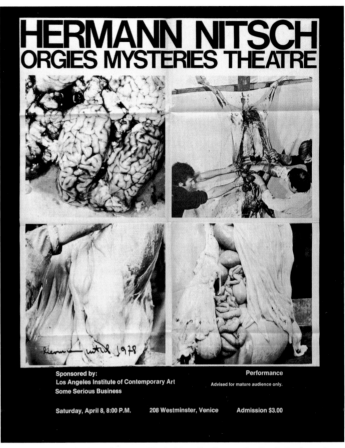

Poster for Hermann Nitsch's performance of *Orgies Mysteries Theatre* at Los Angeles Institute of Contemporary Art, 1978. 62 × 52 cm (24⅜ × 20½ in). Washington, D.C., Archives of American Art, Smithsonian Institution, Los Angeles Institute of Contemporary Art records, 1973–88. Art © 2011 Artists Rights Society (ARS), New York / VBK, Vienna.

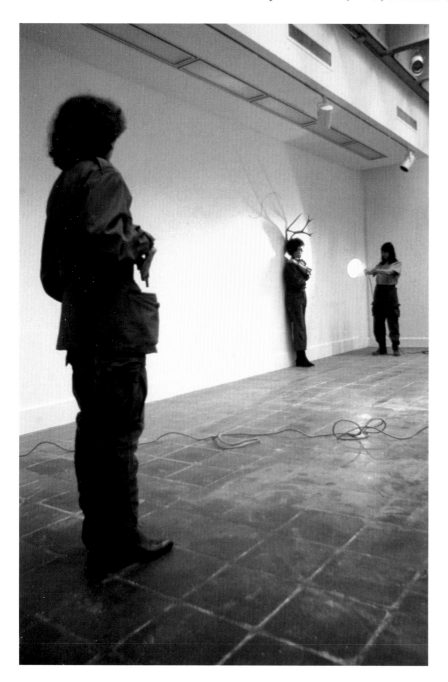

Figure 5.28.
Nancy Buchanan (American, b. 1946). *Deer/Dear*, 1978.
Performance at the Santa Ana College Gallery, Santa Ana,
California, with Merion Estes (foreground), Kitty Crow (against
wall), and Terryl Rideout (holding light). Photo by Ransom
Rideout. Courtesy Nancy Buchanan.

fear in women's lives (fig. 5.28). Performance also often crossed the boundaries of established art practice and social norms: Paul McCarthy's work; Barbara T. Smith's provocative *Feed Me* (1973), in which the artist presented herself nude and open to interaction over the course of an evening; and the Kipper Kids' staging of situations where "they act out our nightmares for us" (fig. 5.29) are all examples of transgressive work.[40] In each case, the work itself resists and defies capture. *High Performance* acted as a tentative community and archive, yet from a historical perspective, it reveals continuing issues of invisibility and access. For example, some work simply was not, could not be, or should not be documented, and therefore did not have a place in the magazine. As Moira Roth noted in an early overview of the genre: "What is common to *all* of West Coast Performance, particularly in its formative stages, is that, with the passing of time and a concurrent lack of local critical support, the vagaries of fashion and randomness of professional contact have allowed only a very few artists to achieve national fame while denying it to others equally worthy."[41]

Before performance work could be recorded, it had to be staged. The innovative, diverse, and roving possibilities of performance encouraged the emergence of a new kind of venue for art in this decade—one that had no actual location but instead consisted of a tenuous organizational network for actions and installations. The first such organization was Carp, founded by Marilyn Nix and Barbara Burden in 1975. As Marilyn Nix recalled:

> Barbara and I were interested in art in public places: the surprise of it.... With no permanent space there was a new collaboration with an artist, a curator, and a landlord. The art was transient with no emphasis on permanence. There were no sales. Experimentation was encouraged in an informal, flexible, creative atmosphere. Our resource was human energy, there was a bi-coastal network of real people—artists, and followers of new and important work.[42]

Through ad hoc organization, Carp served as a crucial venue for rethinking the sites of art. For example, it sponsored Chris Burden's *Poem for LA* (1975), a 10-second television broadcast.[43] It also offered diverse opportunities for site-related practice, for example, Alexis Smith's *Anteroom* (fig. 5.30). Set up in Joel Marshall's studio and allowing only two visitors at a time, the work consisted of furniture installed on the ceiling, which destabilized the sense of space itself. Although artists such as Gordon Matta-Clark, among others, sought out Carp's roving West Coast venue, its type of unanchored approach received little critical and historical attention; the format required a new kind of mobile and unstructured commitment, something that one critic described as a "cruisin'-for-burgers sense of adventure."[44]

Figure 5.29.
The Kipper Kids (Martin von Haselberg [b. Argentina, 1949] and Brian Routh [British, b. 1948]). Performance at Los Angeles Institute of Contemporary Art, 15 December 1974. Courtesy The Kipper Kids.

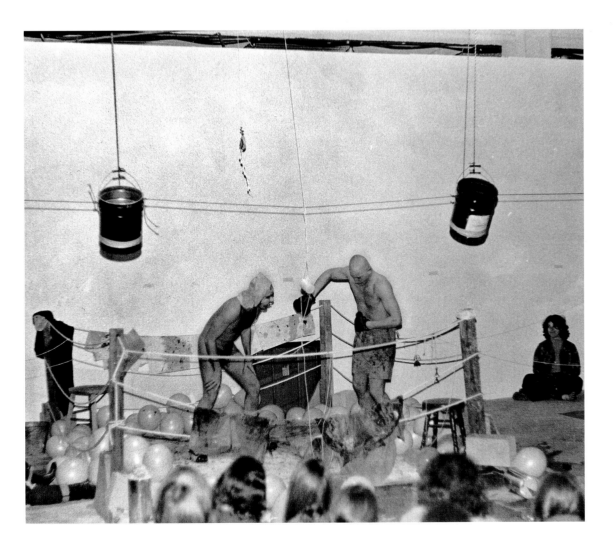

Figure 5.30.
Alexis Smith (American, b. 1949). *Anteroom*, 1975. Installation on the ceiling of a clean white room for nighttime viewing, Joel Marshall's studio, Los Angeles. Collection of the artist. Photo by Wayne Shimabukuro. Courtesy Carp Archive, Los Angeles.

Carp hosted seminal events, including Vito Acconci's first Los Angeles exhibition, for which he produced the work *Pornography in the Classroom* (fig. 5.31). Acconci's L.A. visit was part of a four-city West Coast stop: "Third stop, Los Angeles. I'd have to keep glitter in mind; I could see only veils of light, I'd think of the Silver Screen; I could build the filminess into layers—smog, flesh, perversity—that I'd want to fall into, sink in, get lost in." The work consisted of a film projected into a corner, "oozing" up the walls, "like a sea (close ups of breasts, cunts, asses . . .)"; a monitor in the center of the room that showed Acconci's "prick" rising up and "drowning" in the sea; and another corner with slide projections of theoretical phrases, providing "a way out." For Acconci, the work would ground him in this place:

> I made a center. But the center was make-shift, simulated; it couldn't hold up against the sprawl outside, the stretch of highways—Los Angeles was, after all, a city without a center, not a place to be in but a map to move across . . . (I was trying to represent bodies, to keep up the image of bodies, when, all the while, Los Angeles was peeling bodies apart, abstracting them). So I wasn't doing what I said in the piece. I wasn't drowning in bodies, I was hiding in them—I was using them to anchor myself down, to keep my own body whole.[45]

Acconci's piece revealed the difficulty he experienced locating himself in Los Angeles, a site defined by the transitoriness of the freeways and films. This tension speaks to the urgency of performance itself in this period; in the face of the anonymity of both L.A.'s geographic sprawl and its visual culture, performance art was often deeply autobiographical and corporeal. Yet such actions were inevitably tenuous—like Smith's *Anteroom,* turned upside down.

APPROXIMATELY TWO YEARS after the National Chicano Moratorium March that took place on 29 August 1970, an ambitious mural cycle began to take form in the most unexpected of places: a federal housing project in East Los Angeles named Estrada Courts.[1] The walls of this housing project were to become a site for Chicano visual expression, one that would serve the community by bringing into focus the struggles and ideologies of the Chicano experience.

The mural project began under the guidance of artist Charles "Gato" Félix. Several sponsors, including the Housing Authority of the City of Los Angeles, provided support for the murals. Through funds from the Neighborhood Youth Corps, 125 youths were paid, while many other youngsters and residents volunteered their time, making this a truly community-based enterprise.

The most visible walls, those facing Olympic Boulevard, were given to well-known artists. Two outstanding examples of such works are *Moratorium: The Black and White Mural* (1973) and *We Are Not a Minority* (1978).

Moratorium: The Black and White Mural was painted by Willie Herrón and Gronk, two core members of the Chicano art group ASCO. The mural functions like a filmstrip, presenting black-and-white cinematic snapshots of a city under siege. Using a monochromatic palette, the mural depicts various emotive scenes related to police aggression, death, love, and occupation. As Herrón began working on one end of the wall, Gronk began on the other. They met in the middle, with Gronk's side referencing cinema and cinematic wide shots, and Herrón's depicting a sacred heart, a woman screaming, and a couple embracing.

Among the images on Gronk's part of the mural is a depiction of the mime Baptiste Deburau, a character in the World War II–era French film *Les enfants du paradis* (*Children of Paradise;* 1945). According to Gronk, he included the Baptiste Deburau character to draw a parallel between the German occupation of France and the Los Angeles County Sheriff's Department's occupation of East Los Angeles during the Moratorium.[2] Both the mural and the film were created during occupations or political strife; together, they serve as a reminder that, even during times of struggle and social distress, art must still flourish.

The central frieze of the mural depicts a scene of police brutality during the Moratorium. The Moratorium was organized as a peaceful march and rally—a protest against the disproportionate number of Mexican Americans fighting and dying in the Vietnam War. The march was to culminate at a rally, where speeches were scheduled. However, the speakers never spoke. Instead, violence ensued, marked by a brutal and aggressive police response to a group of peaceful demonstrators. The violence ended with the death of Ruben Salazar, a Chicano journalist for the *Los Angeles Times* who was killed when a sheriff's deputy fired tear gas canisters into an occupied bar where Salazar was sitting.

We Are Not a Minority was made by the collective known as El Congreso de Artistas Cosmicos de las Americas de San Diego. It depicts the revolutionary leader Ernesto "Che" Guevara. The Chicano movement embraced the ideologies of Che, since his policies were internationalist and reflected the growing Third World consciousness. Che served as a unifying symbol, connecting the struggles of the Chicano movement with the struggles of similarly disenfranchised peoples around the world. Dominant American culture was labeling Chicanos "minorities," an irony for those who saw themselves as indigenous to the American continent. Thus, many Chicanos sought to subvert the dominant narratives that insisted on their marginalization. Refusing to be identified by the limits set by others, they worked to redefine those narratives, to disseminate their own history, and to shed light on the arbitrary nature of the borders as identified by the United States.[3]

The Estrada Courts murals transformed a forgotten zone into a historical monument of civic and cultural pride. The fifty-two murals read like an open book about the experiences, aesthetics, ideologies, and identities of the Chicano community of Los Angeles.

Notes

1. The National Chicano Moratoria were a series of large protests against the Vietnam War organized by the National Chicano Moratorium Committee (NCMC), an antiwar activist group that was active between 1969 and 1971. See Lorena Oropeza, *Raza Si!, Guerra No! Chicano Protest and Patriotism during the Viet Nam War Era* (Berkeley: Univ. of California Press, 2005).

2. Gronk, personal interview by Dianna M. Santillano, 5 July 2010.

3. The Pocho Research Society, personal interview by Dianna M. Santillano, 14 July 2010. The information in this paragraph is paraphrased from the interview.

Gronk (American, b. 1954) and Willie Herrón (American, b. 1951). *Moratorium: The Black and White Mural*, 1973. Acrylic on stucco, 4.5 × 7.6 m (15 × 25 ft.). Mural located at Estrada Courts, 3221 Olympic Boulevard, Los Angeles. © 1973 Willie Herrón and Gronk. Photo by Dieter Pinke. Courtesy the UCLA Chicano Studies Research Center.

Following Carp's lead, in 1976 Susan Martin, Nancy Drew, and Elizabeth Freeman founded Some Serious Business (SSB) to stage performances and exhibitions in various sites and using various media throughout the city. Martin recalls that it was a catch-as-catch-can enterprise: "it was the seventies, that was how it was done."[46] In form and resonance, events ranged broadly, from Guy de Cointet and Robert Wilhite's *Ramona,* a play staged at the California Institute of Technology in Pasadena (Caltech) in 1977 (fig. 5.32), to a Paul Sharits film that screened the same year. Some events, such as the Viennese actionist Hermann Nitsch's visit to Los Angeles in 1978, hosted by LAICA, produced wide-ranging interest throughout the Los Angeles art world (see sidebar 28). The structure of SSB complemented and encouraged the diverse and improvisational nature of art and performance in this decade, and some events seemed possible only because of their sponsor's sitelessness. Martin recalls Jimmie West's *Con Inde Selectric,* an instantaneous event involving a large glass plate covered in gunpowder and a flaming bowling ball hurling across the sky (fig. 5.33). The dramatic spectacle, which momentarily aestheticized the horror of bombs, is irretrievable. As Drew noted: "Art became what was happening at the moment."[47]

In 1970s Los Angeles, questions of how art might reach a public were also reflected in an increased interest in muralism. The Social and Public Art Resource Center (SPARC)—founded by Judith Baca, Donna Deitch, and Christina Schlessinger—promoted and disseminated murals in the city, and the Inner City Mural Program shared similar goals. Some of the most famous murals of this period—including *Moratorium: The Black and White Mural* (1973), by Gronk and Willie Herrón,

Figure 5.31.
Vito Acconci (American, b. 1940). *Pornography in the Classroom,* 1975. Multimedia installation composed of color slides and 8 mm film, installed to project in adjacent upper corners of a clean white rectangular room, darkened. © 2001 Vito Acconci / Artists Rights Society (ARS), New York. Photo by Wayne Shimabukuro. Courtesy Carp Archive, Los Angeles.

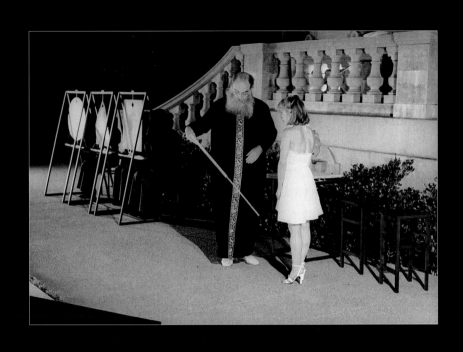

Figure 5.32.
Guy de Cointet (American, b. France, 1934–1983) and Robert Wilhite (American, b. 1946). *Ramona*, 1977. Performance at the California Institute of Technology, Pasadena, sponsored by Some Serious Business. Courtesy the Estate of Guy de Cointet / Air de Paris, Paris, and Robert Wilhite.

Figure 5.33.
Poster for Jimmie West's event *Con Inde Selectric*, 1978. 57.2 × 44.6 cm (22½ × 17½ in.).

and *We Are Not a Minority* (1978) by El Congreso de Artistas Cosmicos de las Americas de San Diego (Mario Torero, Rocky, El Lton, Zade) (see sidebar 29)—are in Estrada Courts, a low-income housing project in East Los Angeles. Exploration of public sites for art also led to new communities, particularly through the Comprehensive Employment Training Act (CETA), enacted in 1973 to train workers and provide jobs. In the late 1970s, both Gronk and Harry Gamboa Jr. were part of a group of artists hired by CETA in El Monte to create a local program for producing mural paintings. The artists, whose stature and interests varied widely (some were well known and others were students in local art schools), also founded a small gallery. After complications arose with the El Monte city council, which questioned the content of several murals, the group eventually relocated to downtown Los Angeles, and Los Angeles Contemporary Exhibitions (LACE) was born. LACE became yet another pivotal site for groundbreaking work. Its roots as a community organization with diverse ideas about the nature of the art-going public exerted a strong influence on its programming, which in 1979 included what the press release called "Two Highly Political Exhibitions from Latin America": *Testimonios de latino americas* (*Documents from Latin America*) and *America en la mira* (*America in the Viewfinder*), as well as an ongoing series of "downtown" shows through which LACE forged a local community.[48] Young Los Angeles artists such as Mike Kelley and Tony Oursler found a site for their early work there.

ELSEWHERES

Performance offered a conceptual resistance to disembodied experiences of media and technology; at the same time, artists used print and video to experiment with virtual sites of art and discourse. As artists explored new forms of dissemination, their work often existed only in the virtual realm of media. In the 1970s, video emerged as a vital medium, particularly in Southern California, where the video program at the Long Beach Museum of Art (LBMA), started by David Ross, helped promote its production. By opening a studio equipped with video technology, Ross created an environment that led to a concentration of experimental videos (see sidebar 30), and LBMA amassed a large archive of work.

Artists increasingly explored and utilized different publication avenues. The LAICA *Journal* remains one of the region's great publishing accomplishments and the venue through which LAICA could corral the diverse interests and practices of its constituents. The Feminist Studio Workshop regarded publication as crucial to its curriculum, while the artists of ASCO had initially worked together on a publication, *Regeneración*. In 1975, Tom Marioni, a young Northern California artist, began publishing a journal called *Vision*. Each issue focused on a specific place: New York, Eastern Europe, and (the subject of the first issue) California, among others. Grounded in a geographic locale, *Vision* was meant to function "like an exhibition space" by providing page spreads for artists.[49] Allen Ruppersberg's two-page spread, *No Sculpture Here, Here, or There* (fig. 5.34), cunningly acknowledged the relationship between the site and work.

The 1970s were a time when pictures—in the press, on television, in cinema, and beyond— became increasingly prominent in defining human experience and history. The moon landing in 1969, for example, had been fundamentally image based. Tensions between fact and fiction and between the virtual and the real resulted, and the 1970s became the decade in which proliferating theories of postmodern life suggested an unanchored, disembodied experience in which simulacra overtook modernist notions of presence and authenticity. In turn, artists explored both the ways that art might circulate and how the content of visual culture might circulate in art.

Theories of immaterial information were often challenged in material form, as artists examined what Ed Ruscha called "the whereabouts of things." In "The Information Man," published in the LAICA *Journal* in 1975, Ruscha pitted the idea of circulating forms of production against the material reality of things:

No sculpture here,

here, or there.

48, 49 ALLEN RUPPERSBERG

Figure 5.34.
Allen Ruppersberg (American, b. 1944). *No Sculpture Here,*
Here, or There, **1975.** From Tom Marioni, ed., *Vision,* no. 1 (1975):
48–49. Los Angeles, Getty Research Institute, 87-S964. Courtesy
the artist.

This information man would also have details as to the placement and whereabouts of things. He could tell me possibly of all the books of mine that are out in the public that only 17 are actually placed face up with nothing covering them. 2,026 are in vertical positions in libraries, while 2,715 are under books in stacks...58 have been lost; 14 totally destroyed by water and fire; while 216 could be considered badly worn...18 of the books have been deliberately thrown away or purposely destroyed. A surprising 53 books have never been opened, most of these being newly purchased and put aside momentarily. Of the approximately 5,000 books of Edward Ruscha that have been purchased, only 32 have actually been used in a directly functional manner: 13 of these have been used as weights for paper or other things. 7 have been used as swatters to kill small insects such as flies and mosquitos and 2 have been used in bodily self-defense.[50]

Ruscha's text calls to mind the kinds of changes that art was undergoing through the influx of language, performance, and other forms of media in the visual arts. Ruscha describes art that has become unmoored: "3 of the books have been in continual motion since their purchase over 2 years ago, all of these being on a boat near Seattle, Washington."[51] Yet he also suggests the material reality of such works. Ruscha's own work had addressed the content and processes of media for more than a decade, bringing material manifestation to more immaterial forms.

In the 1970s, artists pursued these explorations in a variety of forms, mining visual culture for its possibilities and effects. Paul McCarthy was particularly adept at manipulating both artistic mediums and popular media. Many of his performances were accessible only through video; in addition, in the 1970s, he was a lead organizer of *Close Radio,* a radio program on KPFK in Los Angeles that provided yet another site for complex and wide-ranging practices (see sidebar 31).

Figure 5.35.
Barbara T. Smith (American, b. 1931). *Vogue View,* 1976. From Paul McCarthy, ed., *Criss Cross Double Cross* 1 (1976): 5–6. Los Angeles, Getty Research Institute, 88-S1202. Courtesy the artist and The Box, Los Angeles. Photo by Whitney Love Sevin.

In 1976, influenced by Marioni's *Vision* publications, McCarthy produced the publication *Criss Cross Double Cross*. Eschewing traditional forms of introduction, *Criss Cross* simply lists artists and then includes page spreads produced by each of them. Works range widely, including documentation (Eleanor Antin as the king of Solana Beach); riddles (a constructed letter by Guy de Cointet); instruction (for a Happening by Allan Kaprow); photographs (by James Welling); and proposals (for a floating museum by Newton and Helen Mayer Harrison). Several artists included direct commentary on the medium itself. For example, Barbara T. Smith provided *Vogue View,* which presents the artist in a variety of poses that suggest the provocative photographs typically seen in commercial magazines, along with her printed comments: "6. See my shoe (me)! It is (I am) pretty, don't you (pl.) think?" (fig. 5.35). A series of notes analyze the images: "Nos. 1–6. Look but do not touch. Active mode." McCarthy's own contribution also exploited the site's ramifications: He reprinted perfume ads for Halston and Geminesse (fig. 5.36). One (on the left) depicts the Halston perfume bottle in its minimal form (Is there sculpture here?) and the other (on the right) presents a carefully turned-out Geminesse woman exuding signs of class and taste. McCarthy's choices point to the ability of mass media—where everything appears to be so polished and to smell so sweet—to distance us from unmediated existence. The perfume ads exist in jarring juxtaposition to McCarthy's often abject performing persona.

Ideas about media, virtual experience, fact, and fiction lead back to the specificity of Los Angeles itself, the geographic site of the most powerful engine of visual culture: Hollywood. In a conversation that took place in March 1977, Jack Goldstein (who had studied at CalArts under Baldessari) and the Los Angeles artist and filmmaker Morgan Fisher (who had once worked in Hollywood) brought their processes as artists into relationship with Hollywood's own visual impact:

Figure 5.36.
Paul McCarthy (American, b. 1945). *Untitled,* 1976. From Paul McCarthy, ed., *Criss Cross Double Cross* 1 (1976): n.p. Los Angeles, Getty Research Institute, 88-S1202.

MORGAN FISHER: What is the value of Hollywood to you?

JACK GOLDSTEIN: It's the fact that anybody has access to its resources. I was shocked when I realized that MGM goes out and rents the same props that I do.... If I had all the resources of Hollywood at my disposal I'd make weather films: blowing trees, twisting trees, floods, walking on the ocean. I would love to be able to do a performance where a black cloud comes over a hill and it would rain for thirty seconds.... A lot of the things that I want to do now are so ambitious that they can't be done as films. I wanted to do a film of a man drowning, but I did a [phonographic] record of a man drowning instead.... You can experience it in your head without having to experience it in your body.[52]

Figure 5.37.
Jack Goldstein (American, 1945–2003). *A Suite of Nine 7-Inch Records with Sound Effects* (detail), 1976. Vinyl records (45 rpm, mono) and sleeves, framed: 87.6 × 151.1 × 11.4 cm (34½ × 59½ × 4½ in.). Shown here: "A Swim against the Tide," blue vinyl; "A Faster Run," orange vinyl; "The Tornado," purple vinyl; "Two Wrestling Cats," yellow vinyl. Courtesy Galerie Daniel Buchholz, Cologne / Berlin and the Estate of Jack Goldstein.

Goldstein imagines having the ability to produce dramatic effects representing real-world events, such as rainstorms and death. His audio recording of a man drowning is, as he notes, a product of the resources he has and those he does not, and how he might work between the two. The result has no visual trace, except the record itself as object, which was carefully produced by Goldstein at the time. As slick plastic polychrome objects, his records exhibit a type of Finish Fetish (fig. 5.37).

Exterior view of the Long Beach Museum of Art, Long Beach, California, ca. 1975. Los Angeles, Getty Research Institute, 2005.M.7.

IN THE LATE 1960s, when some of the first commercially available portable video cameras arrived in the United States, artists began looking to television as a new platform for their aesthetic, political, conceptual, and personal expressions. By the early 1970s, video was becoming an increasingly accessible artistic medium, and centers for video production began to spring up across the globe. One important and lively hub for video was Long Beach, California, where in 1974 the city-operated Long Beach Museum of Art (LBMA) launched its innovative video art department. At the invitation of LBMA's director, Jan E. Adlmann, David Ross moved from Syracuse, New York, where he had started a video program at the Everson Museum, to Southern California to become LBMA's deputy director and curator and to head up its video program. As Ross explains:

> When I came out here in 1974, I just felt like I'd died and gone to heaven. *Everybody* wanted to work with video...it was in the air. If in the 1960s everyone in Southern California wanted to work with plastic and fiberglass and "Finish Fetish" and create artworks that were kind of like surfboards and kind of like sculpture, by the mid-seventies, everyone wanted to work with television.[1]

Ross's video program tried to strike a balance between local and international artists, and between early luminaries and emerging artists. His exhibition *Americans in Florence: Europeans in Florence* (1975), for example, presented a survey of some of the best European and American artists who had produced work at the renowned video gallery Art/Tapes/22 in Florence, Italy, while his *Southland Video Anthology* exhibitions in 1975 and 1976–77 featured dozens of artists living and working in Southern California.

Ross's first exhibition at the museum, in December 1974, was *Nam June Paik: TV and Paper TV*, and the project seemed to set the right tone for the burgeoning contemporary art space. Although Paik, a pioneer in the field of video art, had taught at California Institute of the Arts and worked with Shuya Abe to build one of his Paik-Abe synthesizers (a revolutionary video-distortion machine) in California, he had never exhibited there. When Paik's LBMA exhibition opened, an entirely new generation of artists—including students of video and performance artists such as

Wolfgang Stoerchle, Allan Kaprow, and John Baldessari—were exposed to the medium of video.

In 1976, recognizing that these young California artists needed access to video-editing equipment, Ross set up the Artists' Post Production Studio (APPS)—the first museum facility of its kind—in the attic of the museum, a remodeled Craftsman house perched on an ocean bluff. "There were artists making works right there in the house," explained Kathy Rae Huffman, who worked at LBMA, first as an intern, then as video coordinator, and, from 1980 to 1984, as a curator. "It was a perfect place for it. The works were on television sets and...that's what you associate television sets with—being in your home."[2]

The casual atmosphere of the museum's first production facility carried over to its next location—a converted fire station—which opened in 1979. The Video Annex, as it was called, offered state-of-the-art equipment and designated spaces for performance, production, and exhibition. It also housed the museum's rapidly growing archive of artist tapes—a collection that included works by Eleanor Antin, Chris Burden, Paul McCarthy, Bruce Nauman, Martha Rosler, Bill Viola, and William Wegman, in addition to hundreds of others. As the museum's video program continued into the 1980s, its creative output moved into the fields of cable broadcast television. LBMA also operated a successful artists' residency program and continued to present challenging exhibitions of contemporary multimedia art by an international roster of artists. The program continued through the 1990s, and a rich cache of tapes, ephemera, documents, and publications remain as a testament to its importance. In 2005, the LBMA video archive was transferred to the Getty Research Institute, marking a new chapter in California's video history—one of preservation, conservation, and scholarly study.

Notes
1. David A. Ross, quoted in "Recollections: A Brief History of the Video Programs at the Long Beach Museum of Art," in Glenn Phillips, ed., *California Video*, exh. cat. (Los Angeles: Getty Research Institute, 2008), 253.
2. Kathy Rae Huffman, quoted in "Recollections," 255.

Goldstein did performance art in the early 1970s, famously burying himself alive at CalArts in what Baldessari called "one of the most risky pieces I have ever seen."[53] After attending Baldessari's post-studio class, Goldstein made a series of works that, by dealing with the isolating aspects of popular culture, drew attention to their more distancing effects: a short film of the roaring MGM lion that was altered and looped creates an uncanny image of Hollywood (*Metro-Goldwyn-Mayer,* 1975), and a sound recording of a stampede evokes the Western (*A Faster Run,* 1976). At first, it might seem that a tension exists between work that involves performance in which the body is present and work like Goldstein's recording of a man drowning in which the viewer is distanced from the body. However, through both approaches, Goldstein prompts us to consider how we grapple with the conflation of experience and our recordings of it, and to wonder whether documentation has become primary in our experience. Coolly commenting on the tragic drowning of his colleague Bas Jan Ader—who, in the third part of his series *In Search of the Miraculous,* set out in a small boat in 1975 and never returned—Goldstein said: "The difference between Bas Jan and me is that I wouldn't have to take that boat trip; a flyer would have been enough" (fig. 5.38).[54]

Like Goldstein, Ader (a Dutch artist educated in Southern California) explored recordings, photographic and otherwise. The second part of *In Search of the Miraculous* was *One Night in Los Angeles*, a series of eighteen photographs of a nighttime journey across Los Angeles inscribed with the lyrics of the Coasters' hit *Searchin'.* In documenting his all-night walk across the city's vast terrain, Ader's snapshots also explore the mythic aspects of what the city represents, such as noir and manifest destiny (figs. 5.39, 5.40). Goldstein, however, no longer needed actual traversals (nor, we might infer, would he have needed many of the performative traversals produced during the 1970s)—he needed only the recorded representations of those traversals, which resonated with constructions we already know, like a hit song.

The shifting role for and of media in the art world was also apparent in the changing value of photography in that world: "What sort of introduction can one give to photography of the seventies? Indeed it is the most discussed medium of the last ten years, having finally earned its place in the fine arts."[55] James Welling, one of Baldessari's most successful former students, explored the formal capacity of photography in a variety of forms that revealed the conceptual potential of the medium. In his early series *Los Angeles Architecture* (1976–78), he presents small-scale, unassuming photographs that initially read as snapshots but ultimately produce complex effects. Details of mundane architectural structures move between light and shadow, flatness and void, testing the perceptual possibilities of the lens (fig. 5.41).

By the mid-1970s, photography had become a prominent form of communication in both popular culture and art: as work, in work, and as document. What, then, of art's other pictures, painting? Was Baldessari signaling the future of painting when, in 1968, he cremated all of the paintings he had produced from 1953 to 1966? David Hockney—a frequent visitor to the West Coast, an established painter, and a prolific photographer—analyzed the issue this way:

> There definitely is a kind of crisis in the visual arts. I think anybody will acknowledge it now, though we have been slow to do so. I don't think it's a very serious thing.... Art is not going to die, even painting isn't going to die.... In the case of painting, it's photography, I think, that has caused confusion. And in a sense when people say painting is dying, I think it's the other way round; I think photography is. I think photography has let us down in that it's not what we thought it was.[56]

In commenting on a focus away from painting that occurred in the 1970s, Hockney casts doubt on the ascendant medium, photography. He points out that photography has been called upon to serve many roles and stand in for many experiences. The impossibility of the camera achieving all that viewers might expect is what Hockney seems to characterize as a "letdown."

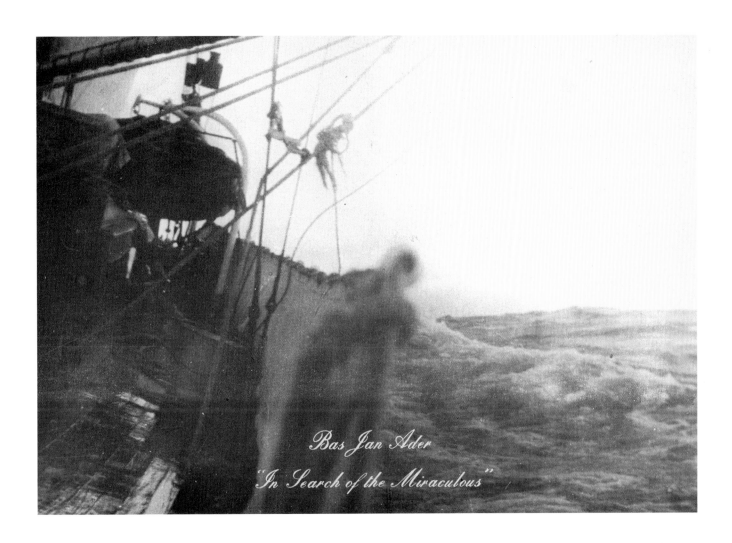

Figure 5.38.
Exhibition announcement for *Bas Jan Ader: "In Search of the Miraculous,"* Claire Copley Gallery, Los Angeles, 1975. 10.3 × 15.3 cm (4 × 6 in.). Art © Bas Jan Ader Estate, courtesy Bas Jan Ader Estate, Mary Sue Ader-Anderson, and Patrick Painter Editions.

Figure 5.39.
Bas Jan Ader (Dutch, 1942–1975). *In Search of the Miraculous (One Night in Los Angeles)* (detail), 1973. New York, collection of Philip and Shelley Fox Aarons. © Bas Jan Ader Estate, courtesy Bas Jan Ader Estate, Mary Sue Ader-Anderson, and Patrick Painter Editions.

Figure 5.40.
Bas Jan Ader (Dutch, 1942–1975). *In Search of the Miraculous*
(One Night in Los Angeles), **1973.** 18 photographs with white
ink, each: 20.3 × 25.4 cm (8 × 10 in.). New York, collection of Philip
and Shelley Fox Aarons. © Bas Jan Ader Estate, courtesy Bas Jan
Ader Estate, Mary Sue Ader-Anderson and Patrick Painter Editions.

Oh yeh Searchin'

I'm searchin'

Searchin' everywhich way

Gonna find her

Well now if I have to swim a river
you know I will

and if I have to climb a mountain
you know I will

Oh yeh searchin' my goodness

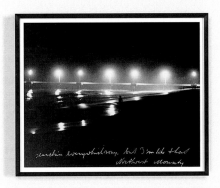

searchin' everywhich way, but I'm like that
Northwest Mountie

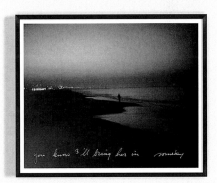

you know I'll bring her in someday

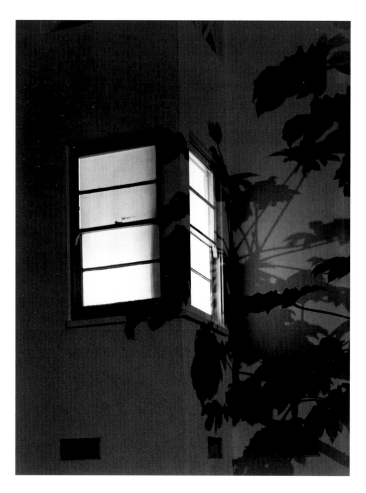

Figure 5.41.
James Welling (American, b. 1951). *LA-C 33,* 1977. Gelatin silver print, 11.7 × 9.2 cm (4⅝ × 3⅝ in.). From the series *Los Angeles Architecture 1976–1978.* Courtesy the artist.

Hockney's inquiry was part of an ongoing critical discussion in the 1970s about the demise of painting. While that dramatic outcome might today sound impossible, in the 1970s the prospect fueled real debate.[57] In 1977, Douglas Crimp curated *Pictures,* an exhibition that made representation its focus: "It is representation freed from the tyranny of the represented."[58] Crimp featured artists who were grappling with the conditions of media and the vagaries of a visual culture in which "it once seemed that pictures had the function of interpreting reality, [but] it now seems they have usurped it."[59] This seminal exhibition traveled from New York to LAICA in the spring of 1978. It included the work of Goldstein and Troy Brauntuch (at that time living in New York City) and reflected the shift from work that seemed to necessitate embodiment—in highly articulated installations, in violent performance, in fleeting exhibitions, in skin of one color or another—to work that could return to the wall, as images were seen to be a crucial currency. During the 1970s, the tensions between embodied experience and image had played out in artistic practices, in modes of documentation, and in explorations of media. The resultant ambiguities resonated equally with West Coast pop and with conceptualism in general, where light, space, language, materials, and media had refused to be easily grounded in perceptual experience.

For decades, Vija Celmins had been using photographic source material to create paintings and drawings capturing the enduring yet ephemeral conditions of desert, ocean, and sky. From 1977 to 1982, she produced a project called *To Fix the Image in Memory* (fig. 5.42). The piece consists of eleven pairs of stones; one member of each pair is a stone that Celmins found, and the other is a faux stone that she cast in bronze and painted like the original. Celmins had collected the rocks on walks in New Mexico, eventually creating a "constellation" of miniature "galaxies." The work evokes both the persistence of material on a geologic scale as well as the ephemeral nature of a sci-fi representation. For a work produced at the end of a decade dominated by fleeting and peripatetic practices, it was uncharacteristically grounded—painstakingly meticulous and precise in its representation. Celmins's process, as well as the title's reference to a fixed image, related to her long-standing use of photographs as source material. However, here she forgoes the interceding image between original and representation, and makes it nearly impossible to distinguish between the two. Like Celmins's earlier practice, these forms move between seeing and representing, thereby encouraging a slow kind of looking. They produce a perceptual quandary for the viewer, who can become confused and misled: is that a rock-solid object or not? *To Fix the Image in Memory* reflects the need for concentration in perceptually fixing an image, yet it does so in an era when the sheer number of images makes that type of concentration, and memory, difficult to achieve.

To fix an image in memory is a task that involves both the processes of making and the processes of history. It is a task that much of the work of the 1970s—work that was nomadic, personal, ephemeral, and often unfixed (including those canonical performance pieces that everyone "knows about" through a single reproduced image)—resists. Communities would form, for an evening or a decade, in a room, in a magazine, or on the radio, and then dissolve. But by the end of the decade, one of the most significant and long-lasting communities for Los Angeles art was emerging: the Museum of Contemporary Art. MOCA grew out of a variety of dynamic

forces, including a constellation of city initiatives (like the Community Redevelopment Agency), powerful patrons (like Marcia Weisman, William A. Norris, and Eli Broad), established artists (like Robert Irwin and Sam Francis), and architectural space (the Frank Gehry–designed police garage, which became the Temporary Contemporary). MOCA marked the return of high-visibility institutions of contemporary art in the city and held great promise for the future of art in Los Angeles. The inaugural exhibition, *The First Show* (1983–84, at the Temporary Contemporary), which featured painting and sculpture from eight prominent collections, provided a historical foundation of well-established international traditions of postwar art even as it marked the ongoing difficulty of collecting and exhibiting contemporary work. Several performance series were presented in conjunction with the inaugural show, but video, experimental film, performance, and photography were absent from the space of the museum.[60] This choice reflected the challenges that the practices of the 1970s presented and the questions they raised about art's place within and beyond the institution—challenges and questions that would persist in the decades to come.

For MOCA's inaugural exhibition, Maria Nordman created *165 North Central, Los Angeles* (1983), which used an undeveloped building available to MOCA. Playing on the structure and the changes in light that occurred over the course of the day, the work provided a space for reflection in dialogue with the urban site. It avoided the traditional forms of painting and sculpture in the main exhibition as well as the pictures that would so prominently mark the practices of the 1980s. Nordman's work framed the viewer, whose engagement and experience—against the urban backdrop of Los Angeles and the proliferation of visual culture—marked the place of art.

Figure 5.42.
Vija Celmins (American, b. Latvia, 1939). *To Fix the Image in Memory,* 1977–82. Stones and painted bronze, eleven pairs, dimensions variable. New York, Museum of Modern Art, gift of Edward R. Broida in honor of David and Renee McKee. Art © Vija Celmins. Digital Image © The Museum of Modern Art / Licensed by SCALA / Art Resource, NY.

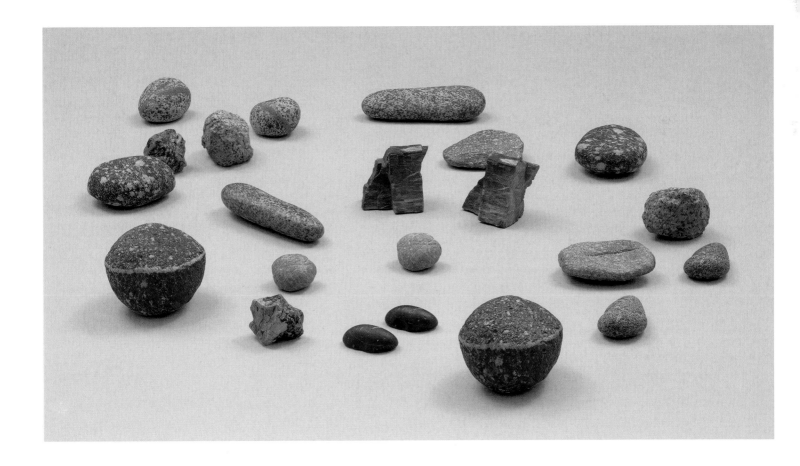

Image of *Close Radio*'s "space." Photo by Paul McCarthy (American, b. 1945).

IN 1976, artists John Duncan and Neil Goldstein launched *Close Radio*, a weekly half-hour radio program broadcast on KPFK in Los Angeles.[1] Paul McCarthy became heavily involved as an organizer almost immediately, as did Nancy Buchanan and, toward the end of the program's run, Linda Frye Burnham. The radio program offered an innovative format at a time when artists were exploring new types of media. Like many conceptual and performative practices at the time, *Close Radio* challenged the dominance of visuality. It was also an experiment in mass media for the arts—an experiment that attracted an audience of up to ten thousand listeners per show.

McCarthy and Duncan, *Close Radio*'s primary organizers, invited nearly a hundred artists to participate, providing minimum guidelines and no editing. During the show's three-year run, they broadcast an impressive array of work, including a play by Guy de Cointet, an "orchestra of automobiles" by the art collective Ant Farm, and a discussion between Donald Burgy and Douglas Huebler about Huebler's "sound drawings." The format drew attention to the already-prevalent use of sound in performance and other media: in Barton Patrick Bolin's *Dead Air: A Limited Tape* (1978), an extended silence echoed the diverse potential for sound in avant-garde music at the time; in *Radio Borne Space* (1978), Michael Brewster provided instructions for an acoustic sculpture. Through these and other experiments, *Close Radio* demonstrated the importance of the aural in a variety of work by visual artists.

Some artists used the show to expand upon autobiographical and narrative aspects of their work in the 1970s. Eleanor Antin, Nancy Buchanan, and Linda Montano explored personas that reflected their performance interests. Cheri Gaulke and Alexis Smith read narrative works. Others used the venue in a more traditional manner: The Kipper Kids performed the duet "Singing," and Suzanne Lacy read statistics on rape from her performance series *Three Weeks in May* (1977). *Close Radio* provided another media venue for social art; it also manipulated the kinds of media information one might expect to hear on the radio. In *Wiretap* (1977), Chris Burden secretly taped his phone conversations with his art dealer and with a gallerist, breaching the realms of private and public for the institutions of art.

Close Radio offered an opportunity to consider the ways in which social space and artistic practice might intersect. Barbara T. Smith took the program into a classroom via telephone (*Vaya con Dios*, 1977), calling a fourth-grade class in East Los Angeles. The exchange included a reading by Smith and a game of Simon Says in Spanish. McCarthy brought the street into the program via *Paid Strangers* (1977), during which he gave "heavy leather guys" from "down in front of the Gold Coffee shop on Hollywood Boulevard" $5 each to be on the show live via a payphone. In each case, the shifting site of the radio program allowed for a traversal of the literal and figurative topography of the city.

McCarthy noted: "I didn't think art magazines, galleries and museums were getting out to people and nobody could get on TV." Radio thus became an agile venue for art and an expanding audience. The diversity of these offerings reflects the potential of a performative medium at the time and radio's adaptability to multiple formats. The extant recordings are a vital record of this period of practice.[2]

Notes
1. Most of the original *Close Radio* broadcasts can be accessed online at http://www.getty.edu/art/exhibitions/evidence_movement/close_radio.html.
2. "Close Radio," *High Performance* 1, no. 4 (1978): 12.

NOTES: Chapters One through Five

Introduction

1. A crucial exception to this history of omission is Thomas Crow, *The Rise of the Sixties* (New York: Harry N. Abrams, 1996). Earlier, Benjamin Buchloh cited Ruscha as a key figure in a revised genealogy of conceptualism; see Buchloh's "Conceptual Art 1962–1969: From the Aesthetic of Administration to the Critique of Institutions," *October* 55 (1990): 105–43.

2. Nancy Marmer, "Pop Art in California," in Lucy R. Lippard, ed., *Pop Art* (New York: Praeger, 1966), 146–47.

3. Peter Plagens, *Sunshine Muse: Art on the West Coast, 1945–1970* (Berkeley: Univ. of California Press, 1999), 9.

4. Plagens, *Sunshine Muse,* 20.

5. Philip Leider, "The Cool School," *Artforum* 2, no. 12 (1964): 47–52.

Chapter One

1. One may cite, by way of example, the claim by critic Peter Schjeldahl that "a tiny art community in L.A. absorbed influences of triumphant New York minimalism—the stringent simplicities of Donald Judd, Carl Andre, Dan Flavin, et al.—and responded with forms and ideas that were so distinctive it was as if the movement had been reborn to more indulgent parents" ("Way Out West," *New Yorker,* 25 January 2010, 76–77).

2. The institution eventually became the Norton Simon Museum. Scheyer's gift now constitutes the Blue Four Galka Scheyer Collection at that museum.

3. In 1944, the Arensbergs signed a contract to donate their collection to the University of California, Los Angeles. However, in 1947 the contract was nullified as it became clear that the university would not build a separate museum to house the artwork as the couple had stipulated. The Arensbergs continued to search for a permanent home for their work, approaching numerous institutions, including the Art Institute of Chicago, the Denver Art Museum, Harvard University, the Honolulu Academy of Arts, the Instituto Nacional de Bellas Artes (Mexico, D.F.), the National Gallery, the San Francisco Museum of Art, Stanford University, the University of California, Berkeley, and the University of Minnesota. At the end of 1950, the Arensbergs finally reached an acceptable deal with the Philadelphia Museum of Art, where their important collection remains today.

4. Rumor had it that one version of this work had been cleverly hung in the Arensbergs' staircase, although archival photos and news clippings show it hanging in the first floor sunroom of their home.

5. It should be noted that the Arensbergs and Man Ray were likely back on good terms by 1946 when Man Ray married dancer Juliet Browner in a double wedding with Max Ernst and Dorothea Tanning at the Arensbergs' home.

6. Other notable émigrés in the area were German novelist Thomas Mann; Frankfurt-school philosopher Theodor Adorno; Russian composer Igor Stravinsky; and Austrian composer Arnold Schoenberg. In reading accounts and letters from this period, it becomes evident that many of the transplants never felt fully part of an intellectual community in Los Angeles. Quite a few returned to Europe after the war.

7. Man Ray, quoted in William Copley, "Portrait of the Artist as a Young Dealer," in *Paris—New York,* exh. cat. (Paris: Centre national d'art et culture Georges Pompidou, Musée national d'art moderne, 1979), 6.

8. Walter Hopps, Transcript from "Modern Art in L.A.: The Late Forties," a public discussion at the Getty Center, 6 February 2003.

9. William Nelson Copley, oral history interview by Paul Cummings, 30 January 1968, Archives of American Art, Smithsonian Institution.

10. The gallery premises were soon taken over by the short-lived and little-known Israeli Galleries.

11. George A. Dondero, "Modern Art Shackled to Communism," 81st Congress, 1st Session, *Congressional Record* (16 August 1949).

12. Jarvis Barlow, Kay English, Jules Langsner, Arthur Millier, and Kenneth Ross, "Jury of Selection and Recommendation for Purchase," in *1951 Annual Exhibition: Contemporary Painting in the United States, Including a Special Section of Work by Artists of Los Angeles and Vicinity,* exh. cat. (Los Angeles: Los Angeles County Museum, 1951), 5.

13. James Byrnes, interview by Andrew Perchuk, 6–7 February 2003, "Modern Art in Los Angeles: The Late Forties," Pacific Standard Time collection, Getty Research Institute (2009.M.31).

14. Byrnes interview by Perchuk.

15. "Art: Tumult in Los Angeles," *Time,* 5 November 1951, 82.

16. Although a number of L.A. organizations— including the Highland Park Art Guild, the Women's Club of Hollywood, the Native Daughters of the Golden West, and the Keep America Committee—lobbied for the termination of Rosenthal's contract, on 20 January 1955, the piece was installed as planned and remains on view today.

17. Jackson Pollock and Philip Guston were both enrolled in Los Angeles's Manual Arts High School in 1929. Pollock dropped out before graduating; Guston graduated in 1930.

18. In Los Angeles, unlike other art centers like New York or Paris, teaching became a practical profession for working artists to supplement their often slight commercial success. This phenomenon continues today, with many contemporary artists choosing to teach in addition to maintaining international careers.

19. In the summer of 1955, Mark Rothko was teaching an eight-week art session at the University of Colorado in Boulder, some 95 miles north of Colorado Springs. As a result, he had frequent contact with many of the artists at the Colorado Springs Fine Arts Center as well as the center's then director, James Byrnes.

20. Emerson Woelffer, quoted in Anne Ayres, "On and with Paper: Emerson Woelffer's Modernist Odyssey," in Anne Ayres and Roy Dowell, *Emerson Woelffer: A Modernist Odyssey; Fifty Years of Work on Paper,* exh. cat. (Los Angeles: Otis Gallery, 1992), 16. In this essay, Ayres also notes that Woelffer associated this work with a New Hebrides drum that was part of his Oceanic and African art collection. *Said* is an Islamic title of respect, especially for royal personages.

21. In honor of his teacher, Ruscha curated *Emerson Woelffer: A Solo Flight,* the inaugural exhibition at the Roy and Edna Disney/CalArts Theater (REDCAT) in downtown Los Angeles, which opened in 2003.

22. Donna Stein, "Abstract Impact," *Art & Antique* 31, no. 5 (2008): 82–91.

23. Another work by Burkhardt, *Lang Vei* (1967–68, oil and skulls on canvas, 152 × 183 cm [60 × 72 in.]), similarly incorporates human skulls to render the violence and horror of war. Burkhardt acquired these disturbing materials from Mexico.

24. It was when Mullican was in Hawaii, around 1943 or 1944, that he first encountered Wolfgang Paalen's *Dyn* magazine at the Honolulu Academy of Arts' library. In an oral history interview preserved in the Archives of American Art (conducted by Paul Karlstrom, 22 May 1992–4 March 1993), Mullican sites this encounter as a major influence on his life and work.

25. During this time, Mullican became romantically involved with Luchita Hurtado, who was then married to fellow Dynaton artist Wolfgang Paalen. Hurtado and Paalen eventually divorced, and Hurtado married Mullican, settling with him in Southern California.

26. Jules Langsner, "Mullican Paints a Picture," *Art News* 52, no. 6 (1953): 34–37, 66–67. Langsner continues, "In other words, he [Mullican] seeks complete avoidance of complication and shock, and in its place what he hopes will lead the spectator to meditative values, what Mullican poetically calls his 'preference for the fall of rain without the lightning bolt.'"

27. Just three years later, Selz would leave Los Angeles to become senior curator of painting and sculpture at New York's Museum of Modern Art.

28. Karl Benjamin, oral history interview by Andrew Perchuk, Rani Singh, Tom Learner, and Catherine Taft, 5 December 2009, Claremont, Calif.

29. Benjamin, interview by Perchuk, Singh, Learner, and Taft.

30. Jules Langsner, *Four Abstract Classicists,* exh. cat. (San Francisco: San Francisco Museum of Art and Los Angeles County Museum, July 1959), 7.

31. Langsner, *Four Abstract Classicists,* 8, 11.

32. Langsner, *Four Abstract Classicists,* 31.

33. John Coplans, "John McLaughlin: Hard-Edge and American Painting," *Artforum* 2, no. 7 (1964): 30.

34. Langsner, *Four Abstract Classicists,* 9.

35. Merle Schipper, *Karl Benjamin: Selected Works 1979–1986,* exh. cat. (Los Angeles: Los Angeles Municipal Art Gallery, 1986), 7.

36. Benjamin, interview by Perchuk, Singh, Learner, and Taft.

37. In many ways, June Harwood continued Lundeberg's investigation of organic curvilinear forms in her hard-edge canvases from the late 1950s through the late 1970s, after which Harwood moved into more geometric and gestural abstraction.

38. A strong example is Functionalists West, a group of abstract painters that included Elise Cavanna (a former screen actress, who painted under the name "Elise"), Lorser Feitelson, Stephen Longstreet (also an author and playwright), Helen Lundeberg, and, later, Leonard Edmondson, Jules Engel, Josefa Kaminski, John McLaughlin, and June Wayne. Members of the Functionalists West showed together in an exhibition at the Los Angeles Art Association in November 1952 and again in the summer of 1953 at the same venue. While the Functionalists West lasted only a couple of years, their expedient association reveals the urgency with which many L.A. artists were working to launch and to publicize their careers.

39. While organizing *Four Abstract Classicists,* Langsner had contacted Alloway at the Institute of Contemporary Art in London about taking the show, to which Alloway agreed. As Frederick Hammersley recalled, "After Lawrence [Alloway] put [the title]

'West Coast Hard-Edge' on the cover [of his exhibition catalog], it was interesting how you would hear the term. People don't want to take the energy to see *abstract classicists.*" Frederick Hammersley, oral history interview by Glenn Phillips, 6–7 February 2003, "Modern Art in Los Angeles: The Late Forties," Pacific Standard Time collection, Getty Research Institute (2009.M.31).

40. Helen Lundeberg's painting appeared in the spread "Four Expressions of Elegance," *Los Angeles Times Home Magazine,* 15 September 1963.

41. Peter Voulkos, quoted in Rose Slivka, "The Artist and His Work: Risk and Revelation," in Rose Slivka and Karen Tsujimoto, eds., *The Art of Peter Voulkos* (New York: Kodansha International, 1995), 40.

42. Paul Soldner, quoted in Slivka, "The Artist and His Work," 40.

43. Janice Roosevelt, quoted in Mary Davis MacNaughton, "Innovation in Clay: The Otis Era, 1954–1960," in Kay Koeniger, Mary Davis MacNaughton, and Martha Drexler Lynn, *Revolution in Clay: The Marer Collection of Contemporary Ceramics,* exh. cat. (Claremont, Calif.: Ruth Chandler Williamson Gallery, Scripps College, 1994), 54.

44. Ceramics has long been considered a gender-inclusive practice, and women were instrumental in other Los Angeles ceramics programs. Susan Peterson, for example, developed the ceramics department at Chouinard, where Ken Price and John Mason were her students. Mason, in particular, has cited Peterson's influence on his formational technique.

45. Garth Clark, "Otis and Berkeley: Crucibles of the American Clay Revolution," in Jo Lauria, ed., *Color and Fire: Defining Moments in Studio Ceramics, 1950–2000,* exh. cat. (Los Angeles: LACMA, 2000), 137. Garth Clark has, more than anyone, deflated the myth that the Otis ceramicists were ignored and that their work was not widely shown. See the section titled "Early Critical Reception and a Reassessment" in Clark's essay (this note), 151–55.

46. Peter Voulkos, quoted in Slivka, "The Artist and His Work," 34.

47. John Mason, quoted in Rose Slivka, *Peter Voulkos: A Dialogue with Clay* (Boston: New York Graphic Society, 1978), 29.

48. Systems theory is a transdisciplinary approach to research that considers a system as a set of independent and interacting parts. The aim is to study the general principles and functioning of systems and to apply the lessons to many fields of practice.

49. Peter Voulkos, quoted in Slivka, "The Artist and His Work," 50.

50. Although Picasso did not make pots himself, he painted ceramics made for him by local artisans in the south of France. See Daniel-Henry Kahnweiler, *Picasso: Keramik=Ceramic=Céramique* (Hannover: Fackelträger, 1957), especially 17–19.

51. Edward Lebow, "Kurt Weiser: Storied Forms," *American Craft* 54, no. 6 (1994–95): 44.

52. Kenneth Sawyer, "Exhibitions: U.S. Ceramics," *Craft Horizons* 22, no. 3 (1962): 59. The growing conviction, in conservative circles, that abstract expressionism was inherently communistic led the U.S. government to stop sponsoring exhibitions of this work. Instead, the work was supported clandestinely by the CIA and other governmental organizations, which saw it as an alternative to socialist realism, which had become identified with the Soviet Bloc. See Frances Stonor Saunders, "Modern Art Was CIA 'Weapon,'" *The Independent,* 22 October 1995, available online at http://www.independent.co.uk/news/world/modern-art-was-cia-weapon-1578808.html; R. Burstow, "The Limits of Modernist Art as a 'Weapon of the Cold War': Reassessing the Unknown Patron of the Monument to the Unknown Political Prisoner," *Oxford Art Journal* 20, no. 1 (1997): 68–80.

53. Ken Price, "A Talk with Slides," *Chinati Foundation Newsletter* 10 (2005): 24.

54. Vija Celmins, "Ken Price in Conversation with Vija Celmins," in Vija Celmins, Ken Price, and Matthew Higgs, *Ken Price,* exh. cat. (Göttingen: Steidl, 2007), 7.

55. Celmins, "Ken Price in Conversation," 7.

56. Edward Lebow, "The Ceramics of Ken Price," in Ken Price, *Ken Price,* exh. cat. (Houston: Menil Collection, 1992), 29.

57. Price, quoted in Lebow, "The Ceramics of Ken Price," 27.

58. Price, "A Talk with Slides," 23.

Chapter Two

1. *Action,* exhibition flyer, Craig Kauffman Papers, Archives of American Art, Smithsonian Institution.

2. Walter Hopps, oral history interview by Thomas Crow, Andrew Perchuk, and Rani Singh, 16 November 2003, "Modern Art in Los Angeles: Beat Years," transcript, 11, Pacific Standard Time collection, Getty Research Institute (2004.M.30). The flyer also lists James Corbett, who, according to Hopps, was not included.

3. Hotel galleries included the Dalzell Hatfield Gallery in the Ambassador Hotel, the Cowie Gallery in the Biltmore Hotel, and the Francis Taylor Gallery in the Beverly Hills Hotel.

4. Helen Wurdemann, "Variety in Los Angeles," *Art in America* 48, no. 2 (1960): 134–36.

5. Henry Tyler Hopkins, oral history interview by Wesley Chamberlain, 24 October 1980, 17 December 1980, Archives of American Art, Smithsonian Institution.

6. Wurdemann, "Variety in Los Angeles," 135.

7. Gifford Phillips, "Culture on the Coast," *Art in America* 52, no. 3 (1964): 22.

8. Jules Langsner, "Association Opens Show of 'Human Figure in Art,'" *Los Angeles Times,* 21 October 1956, D6.

9. Walter Hopps, "Edward Kienholz: A Remembrance," *American Art* 8, no. 3/4 (1994): 123.

10. Walter Hopps, "A Note from the Underworld," in idem et al., *Kienholz: A Retrospective,* exh. cat. (New York: Whitney Museum of American Art, 1996), 29.

11. Walter Hopps, interview by Thomas Crow and Andrew Perchuk, 7 February 2003, "Modern Art in Los Angeles: The Late Forties," Pacific Standard Time collection, Getty Research Institute (2009.M.31).

12. Robert Alexander, cited in Sandra Leonard Starr, ed., *Lost and Found in California: Four Decades of Assemblage Art,* exh. cat. (Santa Monica, Calif.: James Corcoran Gallery, Shoshana Wayne Gallery, Pence Gallery, 1988), 82.

13. Tosh Berman, "Wallace and His Film," in Wallace Berman and Tosh Berman, *Wallace Berman: Support the Revolution* (Amsterdam: Institute of Contemporary Art, 1992), 73.

14. Ed Moses, oral history interview by Andrew Perchuk and Rani Singh, 20 November 2009, transcript, 17, Pacific Standard Time collection, Getty Research Institute.

15. Stephen Fredman, "Surrealism Meets Kabbalah: The Place of Semina in Mid-Century California Poetry," in Robert Rehder and Patrick Vincent, eds., *American Poetry: Whitman to the Present* (Tübingen: Gunter Narr, 2006), 152.

16. Merril Greene, "Wallace Berman: Portrait of the Artist as an Underground Man," *Artforum* 16, no. 6 (1978): 55.

17. Henry J. Seldis, "Another Tired Try by Smashed-Toy School," *Los Angeles Times,* 12 March 1961, B14.

18. Peter Selz, *Funk,* exh. cat. (Berkeley: The Regents of the University of California, 1967), 3.

19. Donald Clark Hodges, "Junk Sculpture: What Does It Mean?" *Artforum* 1, no. 5 (1962): 34.

20. See Samella Lewis, *African American Art and Artists* (Berkeley: Univ. of California Press, 1990), 204.

21. John Coplans, "Sculpture in California," *Artforum* 2, no. 2 (1963): 4.

22. Gordon Wagner, oral history interview by Richard Candida Smith, 10 January 1987, at the Angel's Gate Cultural Center, San Pedro, California, Oral History Program, University of California, Los Angeles, 311.

23. See Louise Armstrong York, ed., *The Topanga Story* (Topanga, Calif.: Topanga Historical Society, 1992), 188.

24. Wallace Berman to Charles Brittin, ca. 1960, Charles Brittin papers, Getty Research Institute (2005.M.11).

25. A.M., "New-Look Art Put on View," *Los Angeles Times,* 7 April 1957, F9.

26. Jim Newman, cited in Kristine McKenna, *The Ferus Gallery: A Place to Begin* (Göttingen: Steidl, 2009), 156.

27. Vivian Rowan, quoted in McKenna, *The Ferus Gallery,* 143.

28. *Semina,* no. 2 (1957): back cover.

29. Ed Moses, oral history interview by Morgan Neville and Kristine McKenna, 2005, videodisc 2, Pacific Standard Time collection, Getty Research Institute (2010.M.7). This oral history was conducted in preparation for *The Cool School,* a documentary directed by Morgan Neville on the Ferus Gallery released in 2008.

30. Craig Kauffman, interview by Jan Butterfield, published as "On Location: Four Interviews, Six Artists—Craig Kauffman, Interview with Jan Butterfield," *Art in America* 64, no. 4 (1976): 81.

31. Billy Al Bengston, interview by Andrew Perchuk and Rani Singh, 8 March 2010, transcript, 30, Pacific Standard Time collection, Getty Research Institute.

32. Kauffman, interview by Butterfield, 81.

33. Kauffman, quoted in John Altoon et al., *Abstraction: 5 Artists,* exh. cat. (Nagoya: Nagoya City Art Museum, 1990), 47.

34. Ed Moses, interview by Andrew Perchuk and Rani Singh.

35. Dore Ashton, "Art: Downtown Stroll," *New York Times,* 28 November 1958, 24.

36. Moses, interview by Perchuk and Singh, 34.

37. Hopps, "A Note from the Underworld," 32.

38. McKenna, *The Ferus Gallery,* 4.

39. Philip Leider, "Art: Kienholz," *Frontier* 16, no. 1 (1964): 25.

40. Hopkins, interview by Chamberlain.

41. Hopkins, interview by Chamberlain.

42. Noah Purifoy, *Junk Art: 66 Signs of Neon* (Los Angeles: 66 Signs of Neon, 1966), n.p.

43. Noah Purifoy, quoted in Jerome Hall, "Out of the Ruins," *National Observer,* 11 April 1966, 22.

Chapter Three

1. Philip Leider, "The Cool School," *Artforum* 2, no. 12 (1964): 47–52.

2. John Coplans, "Circle of Styles on the West Coast," *Art in America* 52, no. 3 (1964): 40.

3. "Art: Monday Night on La Cienega," *Time,* 26 July 1963, 50.

4. John Coplans, "Introduction," in idem, *Ten from Los Angeles,* exh. cat. (Seattle: Contemporary Art Council of the Seattle Art Museum, 1966), 9.

5. Nancy Marmer, "Pop Art in California," in Lucy R. Lippard, ed., *Pop Art* (New York: Praeger, 1966), 148.

6. Barbara Rose, "Los Angeles: The Second City," *Art in America* 54, no. 1 (1966): 110–15. Peter Plagens, *Sunshine Muse: Contemporary Art on the West Coast* (New York: Praeger, 1974), ch. 8.

7. Nicholas Wilder, oral history interview by Ruth Bowman, 18 July 1988, Archives of American Art, Smithsonian Institution.

8. Helen Wurdemann, "A Stroll on La Cienega," *Art in America* 53, no. 5 (1965): 115.

9. "Art: Monday Night on La Cienega," 50.

10. "Art: Monday Night on La Cienega," 50.

11. Kirse Granat May, *Golden State, Golden Youth: The California Image in Popular Culture 1955–1966* (Chapel Hill: Univ. of North Carolina Press, 2002), 13.

12. Charles Champlin, "Los Angeles in a New Image," *Life,* 20 June 1960, 89; Mitchell Wilder, "A Stirring in the Pacific Paint Pot," *Saturday Review,* 20 October 1962, 56.

13. Lynn Zelevansky, "Ars Longa, Vita Brevis: Contemporary Art at LACMA, 1913–2007," in Michael Govan et al., *The Broad Contemporary Art Museum at the Los Angeles County Museum of Art, 2008* (Los Angeles: LACMA, 2008), 207n58.

14. Henry J. Seldis, "New Museum Realization of an Old Dream," *Los Angeles Times,* 3 January 1965, B2.

15. Walter Hopps, interview by Joanne L. Ratner, 1990, transcript, 28, UCLA Library, Center for Oral History Research. See also Jay Belloli, "Lasting Achievements: The Pasadena Art Museum," in Karen Jacobson, ed., *Radical Past: Contemporary Art & Music in Pasadena, 1960–1974* (Pasadena, Calif.: Armory Center for the Arts/Art Center College of Design, 1999), 15.

16. Amy Newman, *Challenging Art: Artforum 1962–1974* (New York: Soho, 2000), 116.

17. Leider, "The Cool School," 47.

18. Lawrence Alloway, *Six More,* exh. cat. (Los Angeles: LACMA, 1963), n.p.

19. Alloway, *Six More,* n.p.

20. Don Factor, "Six Painters and the Object and Six More," *Artforum* 2, no. 3 (1963): 13.

21. Philip Leider, "Joe Goode and the Common Object," *Artforum* 4, no. 7 (1966): 24.

22. Walter Hopps and Jim Edwards, "New Painting of Common Objects: An Interview with Walter Hopps by Jim Edwards," in David E. Brauer et al., *Pop Art: U.S./U.K. Connections, 1956–1966,* exh. cat. (Houston: Menil Collection, 2001), 43.

23. Factor, "Six Painters and the Object and Six More," 13.

24. Fidel A. Danieli, "Llyn Foulkes, Rolf Nelson Gallery," *Artforum* 2, no. 3 (1963): 17.

25. Nancy Marmer, "Pop Art in California," 149.

26. Ruscha, quoted in Bernard Blistene, "Conversation with Ed Ruscha," in Edward Ruscha, *Edward Ruscha: Paintings=Edward Ruscha: Schilderijen,* exh. cat. (Rotterdam: Museum Boymans-van Beuningen, 1989), 126.

27. Ruscha, quoted in Patricia Failing, "Ed Ruscha, Young Artist: Dead Serious About Being Nonsensical," *Art News* 81, no. 4 (1982): 81.

28. Ruscha, quoted in Gary Conklin, dir., *L.A. Suggested by the Art of Edward Ruscha* (New York: Mystic Fire Video, 1981).

29. Ruscha, quoted in Failing, "Ed Ruscha, Young Artist: Dead Serious about Being Nonsensical," 77.

30. Philip Leider, "California after the Figure," *Art in America* 51, no. 5 (1963): 77.

31. Joe Goode, oral history interview by Paul Karlstrom, 5 January 1999, 12 April 2001, Archives of American Art, Smithsonian Institution.

32. Goode, oral history interview by Karlstrom.

33. Hopps and Edwards, "New Painting of Common Objects: An Interview with Walter Hopps by Jim Edwards," 44.

34. Andy Warhol and Pat Hackett, *Popism: The Warhol '60s* (London: Hutchinson, 1981), 59.

35. For a more detailed discussion of Celmins's *Freeway* and views of Los Angeles from the car in art of this period, see Cecile Whiting, *Pop L.A.: Art and the City in the 1960s* (Berkeley: Univ. of California Press, 2006), 87–92.

36. Marco Livingstone, *David Hockney* (New York: Holt, Rinehart & Winston, 1981), 70.

37. Hockney, cited in Nikos Stangos, ed., *David Hockney by David Hockney* (London: Thames & Hudson, 1976), 99.

38. Factor, "Six Painters and the Object and Six More," 13.

39. Karen Tsujimoto, ed., *Billy Al Bengston,* exh. cat. (Frankfurt am Main: Galerie Neuendorf AG, 1993), 17.

40. Marmer, "Pop Art in California," 148.

41. Leider, "The Cool School," 47.

42. Judy Chicago, *Through the Flower: My Struggle as a Woman Artist* (New York: Doubleday, 1975), 40.

43. Peter Plagens, "Los Angeles: Judith Gerowitz, Rolf Nelson Gallery," *Artforum* 4, no. 7 (1966): 14.

44. Michael Fried, "Art and Objecthood," *Artforum* 5 (1967): 12–23; Robert Morris, "Notes on Sculpture," *Artforum* 4, no. 6 (1966): 42–44; Robert Morris, "Notes on Sculpture, Part 3," *Artforum* 5, no. 10 (1967): 24–29.

45. Peter Plagens, "Los Angeles: Norman Zammitt, Felix Landau Gallery," *Artforum* 4, no. 7 (1966): 14–15.

46. Wilder, oral history interview by Bowman.

47. John Coplans, "Introduction," in idem, ed., *Five Los Angeles Sculptors: Larry Bell, Tony De Lap, David Gray, John McCracken, Kenneth Price; and Sculptors Drawings,* exh. cat. (Irvine: Univ. of California, Irvine, Art Gallery, 1966), 3.

48. Sam Francis, quoted in Pontus Hulten, ed., *Sam Francis,* exh. cat. (Bonn: Kunst und Ausstellungshalle der Bundesrepublik Deutschland, 1993), [38–39].

49. Henry J. Seldis, "Art Walk: A Critical Guide to the Galleries," *Los Angeles Times,* 5 December 1969, G26.

50. Mary Lou Loper, "Calendars Boost Southland's Artists," *Los Angeles Times,* 12 December 1968, F1.

51. Philip Leider, "Culture and Culture-Boom," *Frontier* 16, no. 6 (1965): 25.

52. Art Siedenbaum, "Anti-Art Goes Out on Limb," *Los Angeles Times,* 3 October 1963, section C2, p. 9.

53. Peter Selz with William Wilson, "Los Angeles—A View from the Studios," *Art in America* 57, no. 6 (1969): 144.

54. John Baldessari, *John Baldessari,* trans. Nelleke van Maaren and Anna H. Berger, exh. cat. (Eindhoven: Van Abbemuseum, 1981), 6.

55. These are *Twentysix Gasoline Stations* (1963); *Various Small Fires and Milk* (1964); *Some Los Angeles Apartments* (1965); *Every Building on the Sunset Strip* (1966); *Thirtyfour Parking Lots in Los Angeles* (1967); *Royal Road Test* (1967); *Business Cards* (1968); *Nine Swimming Pools and a Broken Glass* (1968); *Crackers* (1969); *Babycakes with Weights* (1970); *Real Estate Opportunities* (1970); *A Few Palm Trees* (1971); *Dutch Details* (1971); *Records* (1971); *Colored People* (1972); and *Hard Light* (1978).

56. Ruscha, quoted in Matthew Kangas, "Just an Average Guy: Ed Ruscha Interviewed," *Vanguard* 8, no. 8 (1979): 17.

Chapter Four

1. Chris Burden, personal interview with Glenn Phillips, 18 May 2010.

2. Liza Béar and Willoughby Sharp, "Discussions with Barry Le Va," *Avalanche* 3 (1971): 65.

3. David Antin, "Talking at Pomona," *Artforum* 11, no. 1 (1972): 39, 45.

4. Philip Leider, *Robert Irwin—Kenneth Price: An Exhibition Organized by the Los Angeles County Museum of Art in Cooperation with the Museum's Contemporary Art Council,* exh. cat. (Los Angeles: LACMA, 1966), 4.

5. Robert Irwin, quoted in Lawrence Weschler, *Seeing Is Forgetting the Name of the Thing One Sees: A Life of Contemporary Artist Robert Irwin* (Berkeley: Univ. of California Press, 1982), 99.

6. Melinda Terbell, "Robert Irwin," *Arts Magazine* 42 (1968): 55.

7. Peter Plagens, "The Sculpture of Peter Alexander," *Artforum* 9, no. 2 (1970): 50.

8. Helen Pashgian, at *Modern Art in Los Angeles: The Industrialized Gesture; A Conversation with Peter Alexander, Helen Pashgian, and De Wain Valentine,* a panel discussion held 19 May 2010 at the Getty Center, Los Angeles.

9. Joseph Masheck, "New York: Masterpieces of Fifty Centuries, Metropolitan Museum of Art; Brice Marden, Bykert Gallery; California Color, Pace Gallery; Robert Smithson, Dwan Gallery," *Artforum* 9, no. 5 (1971): 72–73.

10. John Elderfield, "New Paintings by Ron Davis," *Artforum* 9, no. 7 (1971): 33.

11. Michael Fried, "Ron Davis: Surface and Illusion," *Artforum* 5, no. 8 (1967): 37.

12. Fried, "Ron Davis," 38. The article uses the word *painting* forty times without once mentioning the word *sculpture*.

13. Fried, "Ron Davis," 39–40.

14. Annette Michelson, "Jean Arp, Janis; Jasper Johns, Castelli; Ronald Davis, Castelli; Sylvia Stone, Tibor de Nagy," *Artforum* 6, no. 9 (1968): 57.

15. Michael Fried, "Art and Objecthood," *Artforum* 5, no. 10 (1967): 12–23.

16. Robert Morris, "Notes on Sculpture, Part II," *Artforum* 5, no. 2 (1966): 21.

17. Donald Judd, "Specific Objects," *Arts Yearbook* 8 (New York: Art Digest, 1965), 74–82.

18. James Turrell, "Cross Corner Projections," in Peter Noever, ed., *James Turrell: The Other Horizon,* exh. cat. (Ostfildern-Ruit: Hatje Cantz, 2001), 59.

19. William Wilson, "Wheeler's Electronic Age Art in Pasadena Exhibition," *Los Angeles Times,* 3 June 1968, F16.

20. William Wilson, "Pasadena Shows Research in Art," *Los Angeles Times,* 23 June 1967, E4.

21. Douglas M. Davis, "Art & Technology—The New Combine," *Art in America* 56, no. 1 (1968): 3.

22. E.A.T. was founded after the performance event *9 Evenings: Theatre and Engineering* at the 69th Regiment Armory in New York in 1966. Ten New York artists, who worked in collaboration with engineers and scientists from Bell Telephone Laboratories, produced performances involving new materials and technologies. E.A.T. sought to sustain and continue the relationships that had been forged during *9 Evenings;* provide artists with access to new technical information, equipment, and materials such as plastics, resins, video, and electronics; and put artists in direct contact with engineers, scientists, and manufacturers.

23. György Kepes, quoted in Douglas M. Davis, "Art & Technology—Conversations with György Kepes, Billy Klüver, and James Seawright," *Art in America* 56, no. 1 (1968): 39. Kepes developed an artists' residency program in hopes that continuous contact between artists and an academic community of scientists and engineers would stimulate interdisciplinary collaboration and the development of new ideas. For an excellent discussion on the different approaches of E.A.T. and CAVS see Anne Collins Goodyear, "The Relationship of Art to Science and Technology in the United States, 1957–1971: Five Case Studies" (PhD diss., University of Texas at Austin, 2002).

24. Linda Biber, "E.A.T. in Process at USC," *E.A.T./ L.A. Survey,* no. 5 (1970): 6, Getty Research Institute (2003.M.12).

25. Chrysalis comprised UCLA architecture and design students Mike Davies, Chris Dawson, Denny Lord, and Alan Stanton; artists David MacDermott, Diane MacDermott, Ardison Phillips, and Masami Tereoka; engineer Rob Sangster; and accountant Irv Silberman, among others.

26. *Experiments in Art and Technology, In Process* (Los Angeles: Experiments in Art and Technology, 1970), 2, Getty Research Institute (2003.M.12).

27. Experiments in Art and Technology, *Experiments in Art and Technology, October 1966– May 1969,* no. 4 (1969): 14, Getty Research Institute (940003).

28. Fujiko Nakaya, "Making of 'Fog' or 'Low-Hanging Stratus Cloud' for Pepsi Pavilion: Expo '70 Project," *Techne: A Projects and Process Paper* 1, no. 2 (1970): 3.

29. Fabricators used positive air pressure to inflate the structure in Santa Ana, whereas negative air pressure was used to enlarge the final version in Osaka.

30. Gene Youngblood, "Technology as Empire," *Los Angeles Free Press,* 3 October 1969, 25.

31. Maurice Tuchman, "Introduction," in *A Report on the Art and Technology Program of the Los Angeles County Museum of Art, 1967–71* (Los Angeles: LACMA, 1971), 9.

32. Gail R. Scott, "Newton Harrison," in *A Report on the Art and Technology Program of the Los Angeles County Museum of Art, 1967–71* (Los Angeles: LACMA, 1971), 126.

33. Newton Harrison, e-mail correspondence with Glenn Phillips, 5 February 2010.

34. Newton Harrison, e-mail correspondence with Glenn Phillips, 5 February 2010.

35. Irwin, quoted in Weschler, *Seeing Is Forgetting,* 129.

36. Irwin, quoted in Weschler, *Seeing Is Forgetting,* 130.

37. Noever, ed., *James Turrell,* 237.

38. Jane Livingston, "Robert Irwin; James Turrell," *A Report on the Art and Technology Program of the Los Angeles County Museum of Art* (Los Angeles: LACMA, 1971), 130.

39. Livingston, "Robert Irwin; James Turrell," 131.

40. Livingston, "Robert Irwin; James Turrell," 132.

41. Quoted in Faith Wilding, "Gestations in a Studio of Our Own: The Feminist Art Program in Fresno, California, 1970–71," in Laura Meyer, ed., *A Studio of Their Own: The Legacy of the Fresno Feminist Experiment* (Fresno, Calif.: The Press at the California State University, Fresno, 2009), 90–91.

42. Suzanne Lacy, oral history interview by Moira Roth, 16 March 1990, 24 March 1990, and 27 September 1990, Archives of American Art, Smithsonian Institution.

43. Faith Wilding, "The Feminist Art Programs at Fresno and CalArts, 1970–75," in Norma Broude and Mary D. Garrard, eds., *The Power of Feminist Art: The American Movement of the 1970s, History and Impact* (New York: Harry N. Abrams, 1994), 39.

44. The institution had been formed in 1961 by Roy and Walt Disney through the merger of Chouinard Art Institute and the Los Angeles Conservatory, but CalArts itself did not begin its first classes until 1970. During the first year, classes were held at an interim location in Burbank. In 1971, the college moved to its present campus in Valencia.

45. Richard Hertz, *Jack Goldstein and the CalArts Mafia* (Ojai, Calif.: Minneola, 2003), 60.

46. The videos are *Ed Henderson Reconstructs Movie Scenarios* (1973); *The Meaning of Various News Photos to Ed Henderson* (1973); and *Ed Henderson Suggests Sound Tracks for Photographs* (1974).

47. Hertz, *Jack Goldstein and the CalArts Mafia,* 62.

48. Douglas Crimp, "Pictures," *October* 8 (1979): 77.

Chapter Five

1. Walter Gabrielson, "Aesthetics of Flying over Los Angeles," *Journal* (Los Angeles Institute of Contemporary Art), no. 1 (1974): 14–15. (Beginning with issue 13 [1977], the publication was renamed *LAICA Journal.*)

2. Bob Smith, "Evolution of the Institute," *Journal* (Los Angeles Institute of Contemporary Art), no. 1 (1974): 26.

3. Gabrielson, "Aesthetics of Flying over Los Angeles," 14.

4. Peter Frank, "Patterns in the Support System for California Art," *LAICA Journal,* no. 19 (1978): 42.

5. In 1974, the museum was rescued, renovated, and refocused by Norton Simon, becoming the Norton Simon Museum of Art in 1975.

6. John Coplans, "Pasadena's Collapse and the Simon Takeover: Diary of a Disaster," *Artforum* 13, no. 6 (1975): 28.

7. The resultant Woman's Building was owned by CalArts, which oversaw the lease.

8. John Baldessari, "Reflections by John Baldessari," in Richard Hertz, *Jack Goldstein and the CalArts Mafia* (Ojai, Calif.: Minneola, 2003), 60.

9. Robert Irwin, "Notes toward a Model," in idem, *Robert Irwin,* exh. cat. (New York: Whitney Museum of American Art, 1977), 23.

10. Lawrence Weschler, *Seeing Is Forgetting the Name of the Thing One Sees: A Life of Contemporary Artist Robert Irwin* (Berkeley: Univ. of California Press, 1982), 160.

11. Weschler, *Seeing Is Forgetting,* 161.

12. Irwin, "Notes toward a Model," 24.

13. Michael Leopold, "Los Angeles," *Art International* 18, no. 6 (1974): 38.

14. Robert Morris, "Aligned with Nazca," *Artforum* 14, no. 2 (1975): 39.

15. Melinda Wortz, "Looking Inward," *Art News* 73, no. 10 (1974): 60.

16. Maria Nordman, interview by Barbara Haskell and Hal Glicksman, 18 July 1973, in *Maria Nordman: Saddleback Mountain,* exh. brochure (Irvine: Art Gallery, Univ. of California Irvine, 1973), n.p.

17. Linda Burnham, Richard Newton, and Paul McCarthy, "Performance Interruptus: Interview with Paul McCarthy," *High Performance* 1, no. 2 (1978): 8–9.

18. Suzanne Lacy and Leslie Labowitz, "What Is Social Art?" brochure produced in conjunction with Los Angeles Women's Video Center, 1979. Woman's Building records, Archives of American Art, Smithsonian Institution (box 14, folder 32).

19. Press release from the Woman's Building, "Photomontage: A Woman's Image of Mass Media," n.d. Woman's Building records, 1970–92, Archives of American Art, Smithsonian Institution.

20. LAICA was housed at the American Broadcasting Company's (ABC) Entertainment Center (LAICA rented the space for $1,000 a month). See "Evolution of the Institute," *Journal* (Los Angeles Institute of Contemporary Art), no. 1 (1974): 26–29.

21. Fidel Danieli, "Nine Senior Southern California Painters," *Journal* (Los Angeles Institute of Contemporary Art), no. 2 (1974): 32.

22. Danieli, "Nine Senior Southern California Painters," 33.

23. Peter Plagens, *Sunshine Muse: Contemporary Art on the West Coast* (New York: Praeger, 1974).

24. Peter Plagens, "70 Years of California Modernism in 340 Works by 200 Artists," *Art in America* 65, no. 3 (1977): 69.

25. Deborah Menaker Rothschild in conversation with David Hammons, "Reflections of a Long Distance Runner," in Deborah Menaker Rothschild, *Yardbird Suite: Hammons 93,* exh. cat. (Williamstown, Mass.: Williams College Museum of Art, 1994), 51.

26. Weschler, *Seeing Is Forgetting,* 165.

27. Kellie Jones, "Black West, Thoughts on Art in Los Angeles," in Lisa Gail Collins and Margo Natalie Crawford, eds., *New Thoughts on the Black Arts Movement* (New Brunswick, N.J.: Rutgers Univ. Press, 2006), 55.

28. See David C. Driskell, *Two Centuries of Black American Art,* exh. cat. (Los Angeles: LACMA, 1976).

29. Flyer. Woman's Building records, 1970–92, Archives of American Art, Smithsonian Institution.

30. Sheila Levrant de Bretteville, "Sheila Levrant de Bretteville," in *Women and the Printing Arts* [card catalog] (Los Angeles: Feminist Studio Workshop, 1975): n.p.

31. The Waitresses, "Ready to Order?," *High Performance* 1, no. 3 (1978): 25.

32. *Chicanoismo en el arte,* exh. brochure (Los Angeles: LACMA, 1975). Balch Art Research Library, LACMA.

33. Leo Rubinfien, "Through Western Eyes," *Art in America* 66, no. 5 (1979): 75–83.

34. Lewis Baltz, *The New Industrial Parks near Irvine, California* (New York: Castelli Graphics, 1974).

35. Eleanor Antin, "An Autobiography of the Artist as an Autobiographer," *Journal* (Los Angeles Institute of Contemporary Art), no. 2 (1974): 18–20.

36. Antin, "An Autobiography of the Artist," 20.

37. Suzanne Lacy, "Cinderella in a Dragster," in Paul McCarthy, ed., *Criss Cross Double Cross* 1 (1976): 16.

38. Lacy, "Cinderella in a Dragster," 16.

39. Linda Burnham, "Editor's Note," *High Performance* 1, no. 3 (1978): 1.

40. Peter Clothier, "The Kipper Kids: An Endless Ritual," *Journal* (Los Angeles Institute of Contemporary Art), no. 5 (1975): 49.

41. Moira Roth, "Toward a History of California Performance: Part Two," *Arts Magazine* 52, no. 10 (1978): 114 (emphasis Roth).

42. Marilyn Nix in personal correspondence with the author, 15 March 2010 and 23 September 2010.

43. Burden's work ran as both a 10-second and 30-second clip (which was the 10-second video × 3).

44. Frank, "Patterns in the Support System for California Art," 43.

45. Vito Acconci, "West, He Said (Notes on Framing)," *Vision,* no. 1 (1975): 59, 60–61.

46. Susan Martin in conversation with the author, 21 January 2010.

47. Nancy Drew, "L.A.'s Space Age," *LACE 10 Years Documented* (Los Angeles: Los Angeles Contemporary Exhibitions, 1988), 9.

48. Press release, 1979. Archives of Los Angeles Contemporary Exhibitions.

49. Tom Marioni, "Out Front," *Vision,* no. 1 (1975): 11.

50. Ed Ruscha, "The Information Man," *Journal* (Los Angeles Institute of Contemporary Art), no. 6 (1975): 21.

51. Ruscha, "The Information Man," 21.

52. Morgan Fisher, "Talking with Jack Goldstein," *LAICA Journal,* no. 14 (1977): 44–45.

53. John Baldessari, "Reflections by John Baldessari," in Richard Hertz, *Jack Goldstein and the CalArts Mafia* (Ojai, Calif.: Minneola, 2003), 65.

54. Jack Goldstein, "Chouinard and the Los Angeles Art Scene in the Late Sixties," in Richard Hertz, *Jack Goldstein and the CalArts Mafia* (Ojai, Calif.: Minneola, 2003), 23.

55. Deborah Irmas, "Thoughts on the Last Ten Light Years," *LAICA Journal,* no. 24 (1979): 20.

56. David Hockney, *David Hockney,* ed. Nikos Stangos (London: Thames & Hudson, 1976), 130.

57. Douglas Crimp's essay "The End of Painting" elicited a response: "Last Exit: Painting," by Thomas Lawson, a painter who later became the dean of CalArts. See Douglas Crimp, "The End of Painting," in Rosalind Krauss and Annette Michelson, eds., "Art World Follies," special issue, *October* 16 (1981): 69–86; and Thomas Lawson, "Last Exit: Painting," *Artforum* 20, no. 2 (1981): 40–47.

58. Douglas Crimp, *Pictures,* exh. cat. (New York: Committee for the Visual Arts, 1977), 5.

59. Crimp, *Pictures,* 3.

60. Two performance series were presented. The first, *Explorations,* cosponsored by CalArts and the Japanese American Cultural and Community Center, included artists ranging from Mike Kelley to Meredith Monk. The second, *Available Light,* was an original commissioned work with music by John Adams, choreography by Lucinda Childs, and sets by Frank Gehry.

1. Los Angeles art scene personalities out-
side the Los Angeles County Museum of Art,
Los Angeles, 1968. Photo by Julian Wasser
(American, b. 1900s). Courtesy Los Angeles
County Museum of Art.

MAKING THE SCENE
Fashioning an Artistic Identity

1

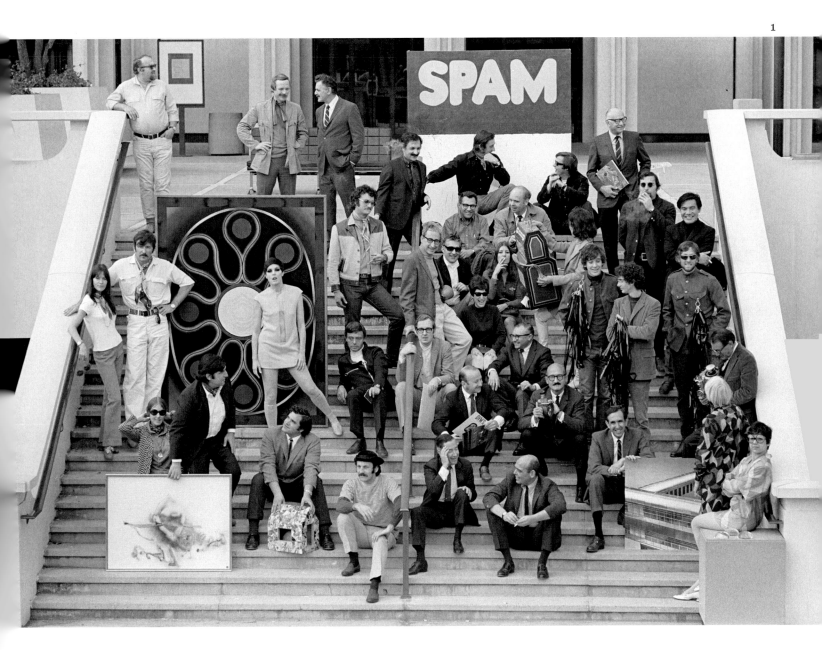

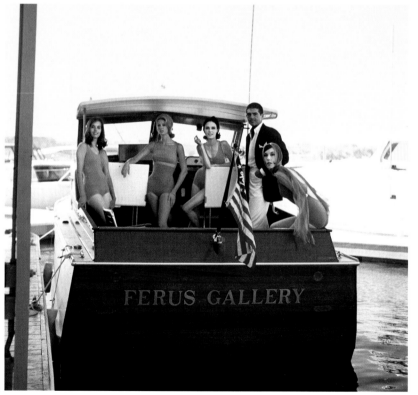

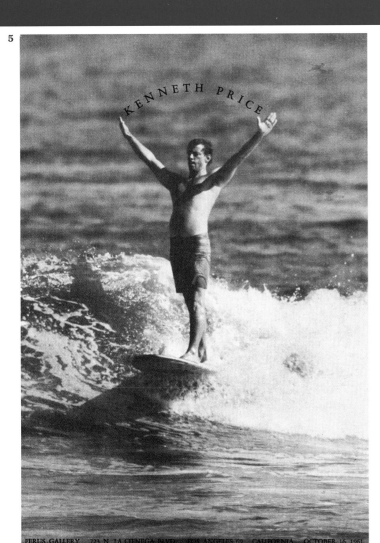

5

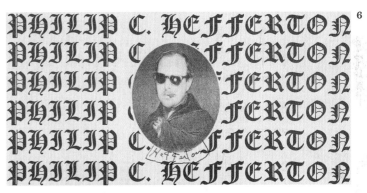

6

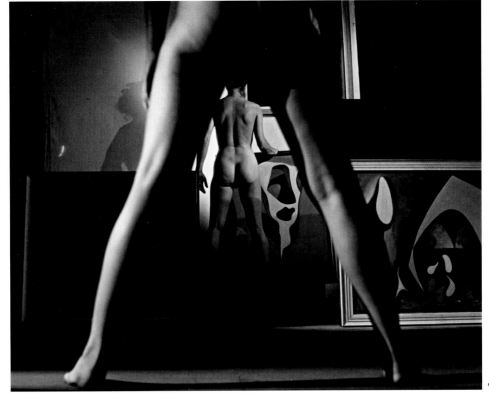

7

8

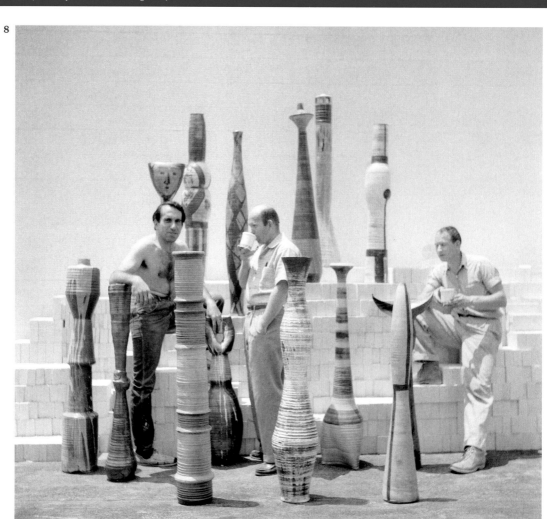

9

10

11

12

13. ASCO (American art collective, act. 1971–1987). *First Supper (after a Major Riot),* **1974.** Performance by (left to right) Patssi Valdez, Humberto Sandoval, Willie Herrón, and Gronk on 24 December 1974 during rush hour on a traffic island at Arizona Street and Whittier Boulevard, Los Angeles.

Photo by Harry Gamboa Jr. (American, b. 1951). © 1974 Harry Gamboa Jr. Courtesy the UCLA Chicano Studies Research Center.

14. Jerry McMillan (American, b. 1936) and Joe Goode (American, b. 1937). Poster for the exhibition *War Babies,* **Huysman Gallery, Los Angeles, 1961.** 55.6 × 43.4 cm (21⅞ × 17 in.). Los Angeles, Getty Research Institute, 2006.M.1. © Joe Goode. Courtesy Jerry McMillan and Craig Krull Gallery, Santa Monica.

15. (Clockwise from top right) Billy Al Bengston, Irving Blum, Ed Moses, and John Altoon outside the Ferus Gallery, Los Angeles, 1959. Photo by William Claxton (American, 1927–2008). Courtesy Demont Photo Management, LLC.

13

15

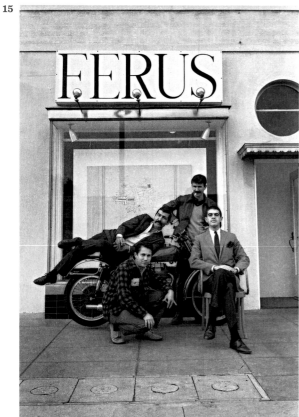

14

16

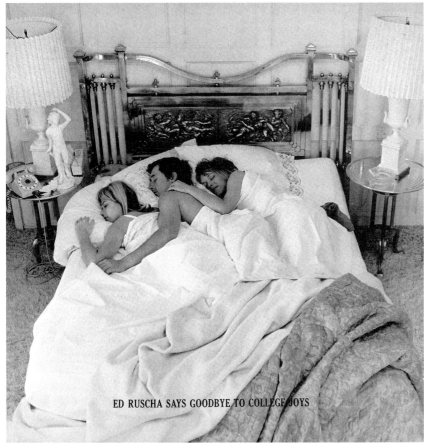

ED RUSCHA SAYS GOODBYE TO COLLEGE JOYS

18

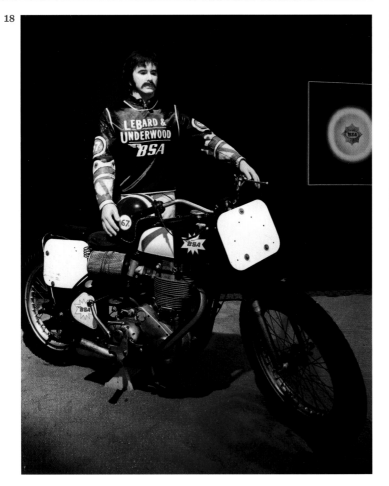

17

GRUP SHROW

FROM JUNE 17, 1972

CHUK ANOLDI

Lolly Bell

BEELY OWL BENGSTON

Dave Bungay

Via Ceramin

LON CROOPER

LODDY DIO

Eda Mossas

Tom Noodle

MIZUNO GALLERY
669 North La Cienega Blvd.
Los Angeles
Summer Hours 1 - 6 P.M.
659-3545

19

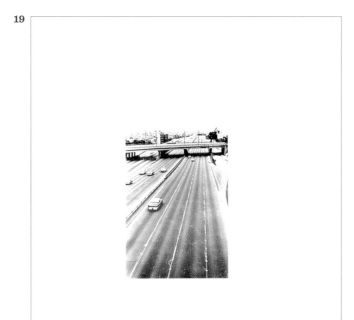

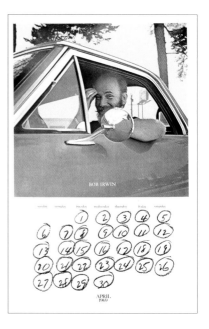

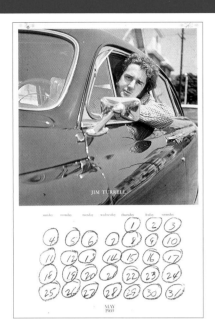

JIM TURRELL

sunday monday tuesday wednesday thursday friday saturday

MAY
1969

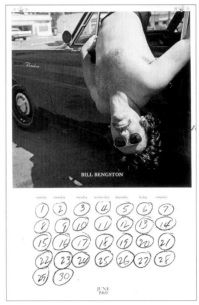

BILL BENGSTON

JUNE
1969

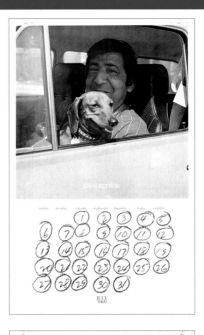

JOHN ALTOON

JULY
1969

KEN PRICE

AUGUST
1969

PETER ALEXANDER

SEPTEMBER
1969

JOHN McCRACKEN

OCTOBER
1969

RON DAVIS

NOVEMBER
1969

BOB GRAHAM

DECEMBER
1969

JOE GOODE

JANUARY
1970

313

20

21

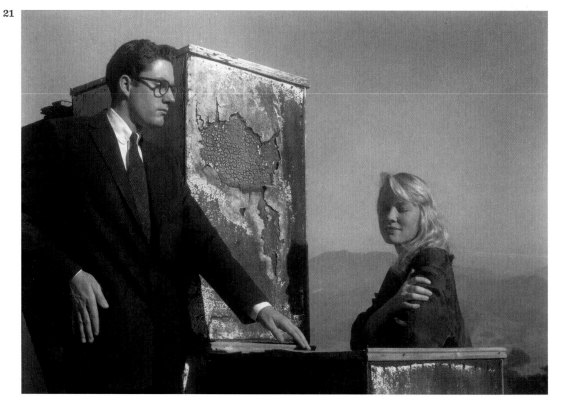

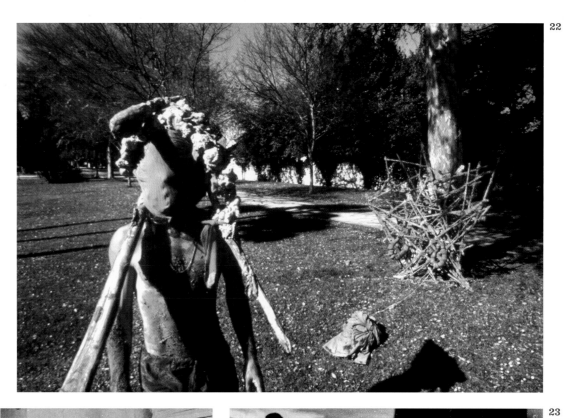

22

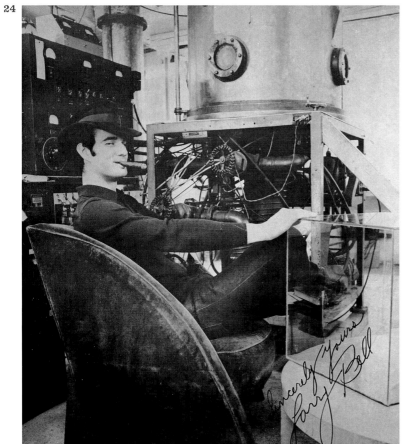

24

23

315

25

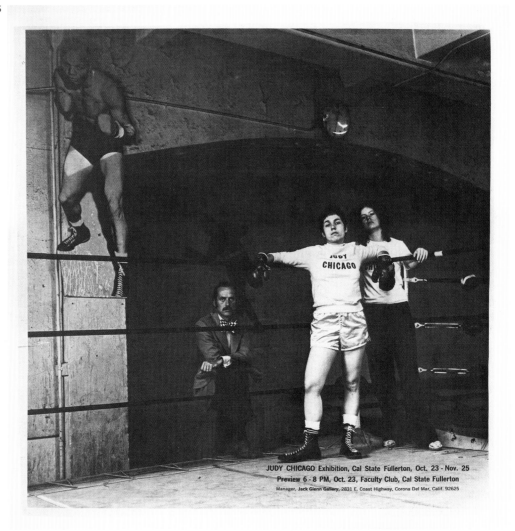

26

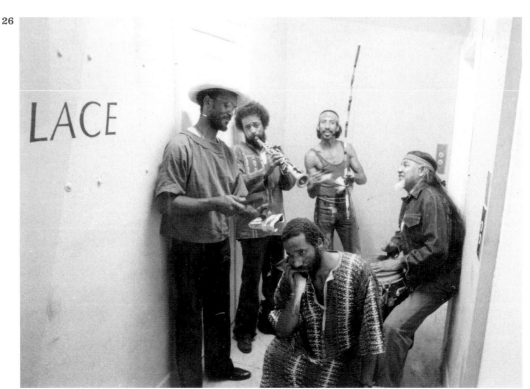

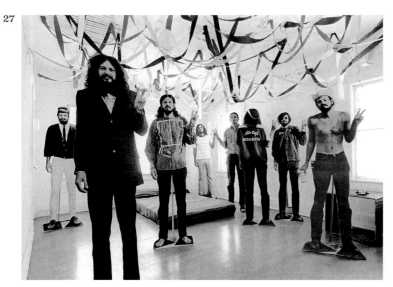

27

28

29

317

CONTRIBUTORS

Ken D. Allan is an assistant professor of art history at Seattle University. He received his PhD from the University of Chicago, and his work has been supported by fellowships from the American Council of Learned Societies/Henry Luce Foundation, the Smithsonian Institution, and the Terra Foundation for American Art. His recent writing on art in 1960s Los Angeles has appeared in *Art Bulletin, Art Journal,* and *X-TRA*.

Lucy Bradnock obtained her PhD in art history and theory from the University of Essex with a dissertation on the reception of the work of Antonin Artaud in postwar American art. From 2009 to 2011, she held a postdoctoral fellowship at the Getty Research Institute, where her research focused on assemblage art of the 1950s and 1960s. She has taught at the Slade School of Fine Art, London, and the University of Southern California.

Donna Conwell is a project specialist in the Department of Architecture and Contemporary Art at the Getty Research Institute, where she has been working on two research projects: Pacific Standard Time and Surrealism in Latin America. She has curated and co-curated contemporary art exhibitions and performances for such organizations as inSite, the Fellows of Contemporary Art, Museo Universitario Arte Contemporáneo, and the Getty Research Institute. Her writing has been published in *X-TRA,* the *Getty Research Journal, Latinart.com,* and exhibition catalogs.

Serge Guilbaut is a professor of art history at the University of British Columbia, Vancouver, and writes extensively on modern and contemporary art. His books include *How New York Stole the Idea of Modern Art: Abstract Expressionism, Freedom, and the Cold War* (1983), *Voir, ne pas voir, faut voir* (1993), and *Los espejismos de la imagen en los lindes del siglo XXI* (2009). His exhibitions include *Be-Bomb: The Transatlantic War of Images and All That Jazz, 1946–1956* (2007–8), *Théodore Géricault: The Alien Body, Tradition in Chaos* (1997), and *Up Against the Wall Mother Poster* (1999).

Margaret Honda is an artist based in Los Angeles.

Lyra Kilston is a writer and editor based in Los Angeles. She is an editor of the arts journal *East of Borneo* and an architectural research assistant at the Getty Research Institute. She received an MA in criticism from Bard College's Center for Curatorial Studies.

Annette Leddy specializes in the intersection of art and literature. She has written on contemporary artists Larry Bell, Allan Kaprow, William Leavitt, and Robert Watts, as well as Italian futurist Angelo Rognoni and Chilean writer Roberto Bolaño. In 2009, she was awarded a Warhol Foundation Arts Writer grant and was a finalist for the Frieze Writer's Prize. Leddy holds a PhD in comparative literature and is an archival cataloger and consulting curator at the Getty Research Institute. In 2006, she co-curated a GRI exhibition on Italian futurism, and she is currently co-curating an exhibition on surrealism in 1940s Mexico.

Michael Lobel is an associate professor and the director of the graduate program in art history at Purchase College, State University of New York. He is the author of *Image Duplicator: Roy Lichtenstein and the Emergence of Pop Art* (2002) and *James Rosenquist: Pop Art, Politics and History in the 1960s* (2009). His writings on postwar and contemporary art have appeared in publications such as *Artforum, Parkett,* and *Oxford Art Journal.* In 2007, he curated the exhibition *Fugitive Artist: The Early Work of Richard Prince, 1974–77* for the Neuberger Museum of Art.

Jane McFadden is an assistant professor and the director of art and design history at Art Center College of Design in Pasadena, California. Her writing has been published in *Art Journal, Grey Room, Modern Painters,* and *X-TRA*.

Richard Meyer is an associate professor of art history and fine arts at the University of Southern California, where he also directs the Visual Studies Graduate Certificate program. He is the author of *Outlaw Representation: Censorship and Homosexuality in Twentieth-Century American Art* (2002) and the coeditor, with Catherine Lord, of *Art and Queer Culture, 1885 to the Present* (2011). Meyer is currently completing *What Was Contemporary Art?,* a short history of twentieth-century art in the United States.

Rebecca Peabody is manager of research projects at the Getty Research Institute. She focuses her research on how Americans imagine race, gender, and nationality in multiple creative media. Her work has appeared, or is forthcoming, in exhibition catalogs and edited volumes, as well as the journals *Comparative Literature, Ethnic and Racial Studies, Getty Research Journal,* and *Slavery & Abolition.* She has taught at Yale University and the University of Southern California.

Andrew Perchuk is deputy director of the Getty Research Institute. A specialist in modern and contemporary art, Perchuk holds a PhD in art history from Yale University and an MA from the University of Southern California. His publications include *The Masculine Masquerade* (1996), *Allan Kaprow—Art as Life* (2008), *Harry Smith: The Avant-Garde in the American Vernacular* (2009), and essays on topics ranging from Jackson Pollock to notions of time in contemporary art. Prior to joining the GRI, Perchuk worked as an editor at the Whitney Museum of American Art and as curator at the Alternative Museum in New York. Perchuk is a co-curator of the Getty exhibition *Pacific Standard Time: Crosscurrents in L.A. Painting and Sculpture, 1950–1970* (2011).

Nancy Perloff is a curator of modern and contemporary collections at the Getty Research Institute. Her exhibitions include *Monuments of the Future: Designs by El Lissitzky* (1998), *Sea Tails: A Video Collaboration* (2004), and *Tango with Cows: Book Art of the Russian Avant-Garde, 1910–1917* (2008). She is the author of *Art and the Everyday: Popular Entertainment and the Circle of Erik Satie* (1991) and coeditor, with Brian M. Reed, of *Situating El Lissitzky: Vitebsk, Berlin, Moscow* (2003).

Glenn Phillips is principal project specialist and consulting curator in the Department of Architecture and Contemporary Art at the Getty Research Institute. He was curator of the exhibition *California Video* at the J. Paul Getty Museum in 2008. In addition to his work as consulting curator on the Getty exhibition *Pacific Standard Time: Crosscurrents in L.A. Painting and Sculpture, 1950–1970,* Phillips co-curated the Pacific Standard Time exhibition at Pomona College Museum of Art, *It Happened at Pomona: Art at the Edge of Los Angeles 1969–1973,* and co-directed the citywide Pacific Standard Time Performance Art and Public Art Festival.

Alex Potts is Max Loehr Collegiate Professor in the Department of History of Art at the University of Michigan, Ann Arbor. He is the author of the books *Flesh and the Ideal: Winckelmann and the Origins of Art History* (1994 and 2000) and *The Sculptural Imagination: Figurative, Modernist, Minimalist* (2000) and coeditor of an anthology of texts on modern sculpture, *The Modern Sculpture Reader* (2007). He is currently completing a book on postwar European and American art, *Experiments in Modern Realism c. 1945–1965.*

Dianna Marisol Santillano is a writer and educator. Her work is focused on contemporary art, particularly performance art and body art observed through a sociopolitical and philosophical lens. Santillano has conducted both academic- and museum-related research and writing. A revised chapter of her thesis on artist Daniel Joseph Martinez was published in the academic publication *Art and the Artist in Society* (2011). She teaches art history at Cerritos College and California State University, Los Angeles.

Rani Singh is a senior research associate in the Department of Architecture and Contemporary Art at the Getty Research Institute. Her background is in modern and contemporary archives and experimental, avant-garde film. Singh joined the GRI in 2000 as a scholar based on her work on experimental filmmaker and artist Harry Smith. She has been working on the GRI's Modern Art in Los Angeles project since 2003. Singh is co-curator of the Getty exhibition *Pacific Standard Time: Crosscurrents in L.A. Painting and Sculpture, 1950–1970* (2011).

Catherine Taft is a curatorial associate in the Department of Architecture and Contemporary Art at the Getty Research Institute, where she helped organize the exhibitions *California Video* (2008) and *Pacific Standard Time: Crosscurrents in L.A. Painting and Sculpture, 1950–1970* (2011). She holds an MA in art criticism and theory from Art Center College of Design and is a member of the International Association of Art Critics. Her writing appears regularly in journals, including *Artforum, Modern Painters,* and *ArtReview,* and in exhibition catalogs in the United States and abroad.

John Tain is a curator of modern and contemporary collections at the Getty Research Institute. As part of the Pacific Standard Time initiative, he curated the GRI exhibition *Greetings from L.A.: Artists and Publics, 1950–1980* (2011).

Irene Tsatsos is the director of gallery programs at the Armory Center for the Arts in Pasadena, California. From 1997 until 2005, she was the executive director and curator of Los Angeles Contemporary Exhibitions.

Lisa Turvey is an editor of the Ed Ruscha catalogue raisonné project. She received her PhD in art history from Stanford University. Her writings have appeared in *Artforum, October, Aperture,* and *Art Journal.*

ACKNOWLEDGMENTS

Long before the Getty embarked on its Pacific Standard Time initiative, the endeavor's core notion—that the modern art of Southern California deserves a degree of documentation, preservation, and study equal to that afforded to art produced in New York or Europe—was an idea central to the hearts and minds of the late Walter Hopps, Henry T. Hopkins, and the many other curators, artists, critics, dealers, and collectors committed to art made in this region. These are the people we want to acknowledge first and to whom we extend our sincere appreciation. They guided us early on as Pacific Standard Time took shape and continued to offer crucial advice at every stage.

Next, we owe deep thanks to a number of individuals who aided us in the project's research, planning, and implementation. At the Getty Research Institute, we are exceedingly fortunate to have had two directors who steadfastly supported Pacific Standard Time. Former director Thomas E. Crow brought his own passion for and insight into the arts of Southern California to the GRI; he had the remarkable foresight to identify L.A. art as an area of inquiry that merited sustained scholarly attention. The GRI's current director, Thomas W. Gaehtgens, provided the necessary resources to ensure that the project would be broad and ambitious; he was instrumental in shaping its final form, which includes exhibitions at the Getty Museum, the GRI, and the Martin-Gropius-Bau in Berlin. The late James Wood, president and CEO of the J. Paul Getty Trust, was unfailingly supportive of the project, and his efforts made possible a newly commissioned work by Robert Irwin. Early in his career, Wood had been strongly influenced by visits to Los Angeles with art historian Henry Geldzahler, and he shared his enthusiasm for L.A. art with us.

We thank Deborah Marrow, interim president and CEO of the J. Paul Getty Trust, who ensured that the institution's steadfast support for this project continued and who shared insights garnered from her long experience with the arts of Southern California. Joan Weinstein, interim director of the Getty Foundation, has been our closest collaborator at the Getty; without her ongoing vision and tireless efforts there would be no Pacific Standard Time. Michael Brand, former director of the J. Paul Getty Museum, and David Bomford, acting director, deserve special thanks for inviting the GRI to organize the exhibition *Pacific Standard Time: Crosscurrents in L.A. Painting and Sculpture, 1950–1970* and for ensuring that the exhibition would be presented at the highest standards. We are grateful to Getty Conservation Institute director Timothy P. Whalen and associate director Jeanne Marie Teutonico, who launched a concurrent research initiative and exhibition investigating modern materials and artistic techniques of the postwar period; the GCI's findings have informed the project at large.

The exhibition *Pacific Standard Time: Crosscurrents in L.A. Painting and Sculpture, 1950–1970* and this companion volume could not have been completed without the assistance and generosity of many people, both inside and outside of the Getty. We are grateful for the knowledge and participation of all of the artists included in this book and in the exhibition. In particular, George Herms, Robert Irwin, Bruce Nauman, Ed Ruscha, James Turrell, and De Wain Valentine went to great lengths to help us explore special presentations of their work as part of Pacific Standard Time at the Getty.

The GRI's Pacific Standard Time Advisory Committee proved invaluable in shaping our approach to Los Angeles's art and its history, and we are deeply indebted to the committee—Ken D. Allan, Serge Guilbaut, Michael Lobel, Jane McFadden, Richard Meyer, Alex Potts, Lisa Turvey, and Dianne Perry Vanderlip—for sharing their knowledge and time. Anthony Fontenot and Jenni Sorkin, Pacific Standard Time research fellows, made valuable contributions to the project's many scholarly activities. Additionally, the project's steering committee was instrumental in recovering the history of postwar art in Southern California and individual steering committee members shared with us their firsthand knowledge; for this we sincerely thank Irving Blum, Jack Brogan, Jim Corcoran, Monte Factor, Rosamund Felsen, Sidney B. Felsen, Peter Goulds, Stanley and Elyse Grinstein, Henry T. Hopkins, Craig Krull, Frank Lloyd, Tobey C. Moss, Jerry McMillan, Peter Nestler, Lars Nittve, Hans Neuendorf, Gerald Nordland, Louis Stern, and Diana Zlotnick.

We would also like to thank the many people at arts institutions or artist's studios who helped us with our research: Douglas Chrismas, Jennifer Kellen, and Alice L. Hutchison at ACE Gallery; Curt Klebaum at Peter Alexander's studio; Kim Schoenstadt at John Baldessari's studio; Lillian Lambrechts at Bank of America; Katy Lucas at Chris Burden's studio; Kelso Wyeth at Judy Chicago's studio; Amy Cappellazzo at Christie's in New York; Janet Blake at the E. Gene Crain Collection; Richard Grant and Carl Schmitz at the Richard Diebenkorn Foundation; Beth Ann Whittaker-Williams and Debra Burchett-Lere at the Sam Francis Foundation; Samuel Freeman and Katrina Mohn at Samuel Freeman Gallery; Candy Coleman, the late Robert Shapazian, and Deborah McLeod at Gagosian Gallery; Kristina Simonsen at Joe Goode's studio; Noriko Fujinami at Robert Graham's studio; Dorsey Waxter at Greenberg Van Doren Gallery; Kathleen Shields at the Frederick Hammersley Foundation; Evelyn Hankins and Susan Lake at the Hirshhorn Museum; Gregory Evans, George Snyder, and Julie Green at David Hockney's studio; Elizabeth East and Lisa Jann at L.A. Louver; Rita Gonzalez at the Los Angeles County Museum of Art; Michael Lord and Sam Heaton at Michael H. Lord Gallery; Melanie Crader, Clare Elliott, Brad Epley, Mary Kadish, and Judy Kwon at the Menil Collection; Kimberly Broker and Meredith Malone at the Mildred Lane Kemper Art Museum; Dan Keegan and Jane O'Meara at the Milwaukee Art Museum; Wendy Griffiths and Allie Heath at the Modern Art Museum of Fort Worth; Carol Lewis at Ed Moses's Studio; Connie Butler, John Prochilo, and Ann Temkin at the Museum of Modern Art, New York; Juliet Myers at Bruce Nauman's studio; Joni Gordon at Newspace; Victoria Rowe Berry at the Nora Eccles Harrison Museum; Leah Lehmbeck, Tom Norris, and Carol Togneri at the Norton Simon Museum; Tom DeSimone, Loni Shibuyama, and Bud Thomas at the ONE National Gay & Lesbian Archives; Sarah Bancroft, Jennifer Garpner, Karen Moss, Sharon Robinson, and Anna-Marie Sanchez at the Orange County Museum of Art; Jeff Burch, Cynthia Honores, and Jessica Pepe at Pace Gallery; Kathleen Howe, Rebecca McGrew, and Jessica Wimbley at Pomona College Museum of Art; Romy Colonius and Zoe Zimmerman at Ken Price's studio; Halley K. Harrisburg at Michael Rosenfeld Gallery; Jack Rutberg at Jack Rutberg Fine Arts, Inc.; Mary Dean and Robert Dean at Ed Ruscha's studio; Gary Garrels and Maria Naula at the San Francisco Museum of Modern Art; Kirk Delman at the Ruth Chandler Williamson Gallery at Scripps College; Marc Selwyn, Alisun Woolery, and Joshua Holzmann at Marc Selwyn Fine Art; Bonnie Campbell-Lilienfeld at the Smithsonian Institution; Louis Stern and Marie Chambers at Louis Stern Fine Arts; Matthew Gale and Chris Stephens at Tate; Sam Jornlin and Pier Voulkos at Voulkos & Co.; Dana Miller at the Whitney Museum of American Art; Barbara Odevseff at the Wichita Center for the Arts; Deedee Wigmore and Emily Lenz at D. Wigmore Fine Art; and Hanna Schouwink and David Zwirner at the David Zwirner Gallery.

A number of other individuals have provided invaluable assistance. We would like to thank David and Eleanor Antin, Pamela Barish, Teresa Barnett, Karen Baxter, Wendy Al Bengston, Shirley Berman, Tosh Berman, Alexandra Bowes, Ruth Bricker, Nancy Cantwell, Chris Claxton, Sophie Dannenmuller, Harry Drinkwater, Hunter Drohojowska-Philp, Brian Forrest, Elsa M. Garmire, Gloria Gerace, Hal Glicksman, the late Dennis Hopper, Janis Horn, Channa Horwitz, Darcy Huebler, Angelica Huston, Mako Idemitsu and Shehei Kawase, Kikuko Iwai, Charmaine Jefferson, Ulysses Jenkins, Kellie Jones, Lyn Kienholz, Naima Keith, Peter Kirby, Michael Kohn, Marissa Kuchek, Suzanne Lacy, David Lawrence, Margo Leavin, William Leavitt, Jason Linetzky, Vernita Mason, Peggy Moffitt, Cedd Moses, Eleonora Nagy, Chon A. Noriega, Elizabeth Orr, Beau R. Ott, Ardison Phillips, Jack and Joan Quinn, Sue Ann Robinson, Allen Ruppersberg, Kiana Sasaki, Alan Stanton, Dean Stockwell, Maurice Tuchman, Steven Wolf, Donald Woodman, Eric Zammitt, and Marilyn Zammitt.

The *Crosscurrents* exhibition drew on the expertise of every branch of the Getty Trust. At the J. Paul Getty Museum, we are particularly grateful to Quincy Houghton, associate director for exhibitions and public programs, and Amber Keller, senior exhibitions coordinator, both of whom brought their experience and wisdom to the complex logistics involved in carrying out this large-scale exhibition. At every step of the exhibition process, we relied heavily on the counsel and expert assistance of conservators Brian Considine, Julie Wolfe, and Laura Rivers. The exhibition's design was superbly envisioned and realized by Merritt Price, Emily Morishita, and Irma Ramirez. Maria Gilbert, Chris Keledjian, and Anne Martens skillfully handled the gallery's interpretive media. Didactic material was ably overseen by Tuyet Bach and Clare Kunny. A great debt of gratitude is owed to Kevin Marshall and the Museum's Preparations Department, who handled the installation of this exhibition with the utmost care and professionalism. Additionally, we are grateful for the efforts and support of Cherie Chen, J. V. Decemvirale, Sally Hibbard, Laurel Kishi, Sarah McCarthy, Kanoko Sasao, and Toby Tannenbaum.

We are honored that the Getty Conservation Institute carried out its own large-scale scientific research initiative in conjunction with the Pacific Standard Time initiative, and we are grateful to Tom Learner, Alan Phenix, Emma Richardson, and Rachel Rivenc, who so generously offered their expertise to the *Crosscurrents* curatorial team. At the Getty Research Institute, John Tain and Linde Brady researched and organized *Greetings from L.A.: Artists and Publics, 1950–1980,* an exhibition of the rich ephemera and documentation related to postwar art in Los Angeles, and their research crucially informed this publication. We thank them, as well as GRI exhibitions coordinator Marlyn Musicant, for producing a wonderful display of GRI special collections material, which will form an integral part of the exhibition at the Martin-Gropius-Bau. Additionally, we thank curator Virginia Heckert of the J. Paul Getty Museum's department of photographs for organizing *In Focus: Los Angeles, 1945–1980,* to be presented at the museum as one of the Getty Center's Pacific Standard Time programs.

We are grateful to many other Getty staff members (past and present) who devoted time and energy to all facets of this project in ways too numerous to describe: Susan Baldocchi, Andrea Bestow, Rick Bourn, Kenneth Brown, Diana Carroll, Robert Checchi, Susan Colangelo, Ruth Cuadra, Elizabeth Daniels, Margot Dewar, Susan Edwards, Beverly Faison, Jay Gam, Frances Guillen, Ron Hartwig, Johana Herrera, Gary Hughes, Julie Jaskol, Kathleen Johnson, Carlos Kase, Angie Kim, Melanie Lazar, Jack Ludden, Maegan Mattock, Bruce Metro, Liz McDermott, Nancy Mickelwright, Mara Naiditch, Nancy Perloff, Melissa Piper, Leah Prescott, Marcia Reed, Sabine Schlosser, Evelyn Sen, Joe Shubitowski, Michael Smith, Gloria Sutton, Rebecca Taylor, Nicole Trudeau, Maureen Whalen, Alexander Wohl, Genevieve Yue, and Katja Zelljadt.

This book could not have been completed without the steadfast, patient, and enthusiastic support of Gail Feigenbaum, the GRI's associate director of research and publications; Michele Ciaccio, managing editor; and Tobi Kaplan, editor. In addition, Alicia Houtrouw, John Hicks, and Rachelle Okawa went far beyond their titles of research assistants, diligently helping to locate and secure permission for many of the images that appear in this book. We also thank Donna Conwell, Margaret Honda, Lyra Kilston, Robert Landau, Annette Leddy, Dianna Marisol Santillano, and Irene Tsatsos for making exceptional contributions to the publication, and research assistants Alison Kozberg, Claire Rifelj, and Kay Wells for their assistance during the final stages of this publication's completion. Many of the splendid photographs that appear in these pages, including some photographs of artworks not in the Getty's collections, were taken by John Kiffe, Jobe Benjamin, and Christine Nguyen at the GRI and Jack Ross and Rebecca Vera-Martinez at the Getty Museum. None of the book's new scholarship and historical material would have a structure without the creativity of designer Stuart Smith and the oversight of production coordinator Elizabeth Kahn.

We would like to thank our colleagues who formed the core of the Getty's Pacific Standard Time team for their hard work and dedication. Glenn Phillips joined the project at a crucial moment; his curatorial insight and experience were essential in bringing a complicated exhibition to fruition, and his editorial skills greatly improved this publication. Rebecca Peabody served as manager of the Pacific Standard Time research project while also acting as the point editor overseeing this publication. Joshua Machat offered his administrative skills as the research-project coordinator, while Melissa Piper, administrative assistant, handled numerous complicated logistics. Lucy Bradnock, Pacific Standard Time postdoctoral fellow, became an essential part of the team, and her industrious, meticulous, and creative research added immensely to the project. Catherine Taft, curatorial associate, brought dedication and skill, tireless energy, and abundant enthusiasm to the myriad details of the exhibition, improving it every step of the way.

Last but not least, Pacific Standard Time is a testament to the many great artists working in Southern California between 1945 and 1980 whose brilliant work made this a project worth doing.

Andrew Perchuk
Deputy Director, the Getty Research Institute
Co-curator, *Pacific Standard Time: Crosscurrents in L.A. Painting and Sculpture, 1950–1970*

Rani Singh
Senior Research Associate, the Getty Research Institute
Co-curator, *Pacific Standard Time: Crosscurrents in L.A. Painting and Sculpture, 1950–1970*

PACIFIC STANDARD TIME EXHIBITIONS
AT THE GETTY CENTER

Pacific Standard Time: Crosscurrents in L.A. Painting and Sculpture, 1950–1970

1 October 2011 to 5 February 2012

The Getty Research Institute in collaboration with the J. Paul Getty Museum

Curated by Andrew Perchuk and Rani Singh, with Glenn Phillips and Catherine Taft

Greetings from L.A.: Artists and Publics, 1950–1980

1 October 2011 to 5 February 2012

The Getty Research Institute

Curated by John Tain with Linde Brady

From Start to Finish: De Wain Valentine's *Gray Column*

13 September 2011 to 11 March 2012

The Getty Conservation Institute in collaboration with the J. Paul Getty Museum

Curated by Tom Learner, Rachel Rivenc, and Emma Richardson

In Focus: Los Angeles, 1945–1980

20 December 2011 to 6 May 2012

The J. Paul Getty Museum

Curated by Virginia Heckert

LENDERS TO THE EXHIBITION
PACIFIC STANDARD TIME: CROSSCURRENTS IN L.A. PAINTING AND SCULPTURE, 1950–1970

Aichi Prefectural Ceramic Museum

Peter Alexander

Bunty and Tom Armstrong

The Art Institute of Chicago

The Bank of America Collection

Wendy Al and Billy Al Bengston

The Buck Collection, Laguna Beach, California

Harold Cook, PhD

D. Wigmore Fine Art, Inc., New York

Melvin Edwards

Frederick Eversley

Betty and Monte Factor

Feitelson Arts Foundation, Courtesy Louis Stern Fine Arts

The Doris and Donald Fisher Collection

Michael D. Fox, Berkeley, California, Courtesy of Steven Wolf Fine Arts, San Francisco

Danielle and David Ganek

Leon Gazarian & Monique Powell

Joe Goode and Hiromi Katayama

The Grinstein Family

George Herms

Hirshhorn Museum and Sculpture Garden, Smithsonian Institution, Washington, D.C.

Scott Hobbs

Hood Museum of Art, Dartmouth College, Hanover, New Hampshire

Janis Horn and Leonard Feldman

James Corcoran Gallery, Los Angeles

Jancar Gallery, Los Angeles

Nancy Reddin Kienholz

Nicole Klagsbrun

Phyllis and John Kleinberg

Susan and David Lawrence

Manoogian Collection

John and Vernita Mason

The Menil Collection, Houston, Texas

Michael Rosenfeld Gallery, LLC, New York, NY

Mildred Lane Kemper Art Museum, Washington University in St. Louis

Willy and Michael Miller, Los Osos, California

Ron Miyashiro and Cardwell Jimmerson Contemporary Art

The Modern Art Museum of Fort Worth

The Moderna Museet, Stockholm

The Mohn Family Trust

The Estate of Lee Mullican, Courtesy of Marc Selwyn Fine Art, Los Angeles

The Museum of Contemporary Art, Los Angeles

Andrea Nasher Collection

Nerman Family Collection

Neumann Family Collection

Jim Newman and Jane Ivory

Norton Simon Museum

The Oakland Museum of California

Onnasch Collection

Orange County Museum of Art, Newport Beach, CA

The Pace Gallery

Mr. and Mrs. Gifford Phillips

Pomona College, Claremont, California

Joan and Jack Quinn

The Robert A. Rowan Revocable Trust

Ed and Dana Ruscha

Saint Louis Art Museum

Louis Stern

Joy Stockwell

Michael Straus, Birmingham, Alabama

Tate

The Marilynn and Carl Thoma Collection

Tobey C. Moss Gallery, Los Angeles

Pier Voulkos

Ernest and Eunice White

David Yorkin and Alix Madigan

Diana Zlotnick

And those who wish to remain anonymous

INDEX